# ART HISTORY

## CUSTOM EDITION FOR PORTLAND COMMUNITY COLLEGE

## VOLUME 3

## MARILYN STOKSTAD

## MICHAEL W. COTHREN

**Note to students:** The material in this book has been specifically selected by your instructors. They have chosen to eliminate some material which is not critical to your course, and in so doing the price of this book has been adjusted to reflect the content removed. Please note because content has been removed from your text, you will see some breaks in the page numbering.

Taken from:

*Art History,* Fourth Edition
by Marilyn Stokstad and Michael W. Cothren

### Learning Solutions

New York   Boston   San Francisco
London   Toronto   Sydney   Tokyo   Singapore   Madrid
Mexico City   Munich   Paris   Cape Town   Hong Kong   Montreal

Cover Art: Courtesty of PhotoDisc/Getty Images.

Taken from:

*Art History,* Fourth Edition
by Marilyn Stokstad and Michael W. Cothren
Copyright © 2011, 2008, 2005 by Pearson Education, Inc.
Published by Prentice Hall
Upper Saddle River, New Jersey 07458

This special edition published in cooperation with Pearson Learning Solutions.

Pearson Learning Solutions, 501 Boylston Street, Suite 900, Boston, MA 02116
A Pearson Education Company
www.pearsoned.com

Printed in the United States of America

4 5 6 7 8 9 10 V202 15 14 13 12

0002000102705775770

ISBN 10: 0-558-87534-3
ISBN 13: 978-0-558-87534-3

# BRIEF CONTENTS

# CONTENTS

This new edition of *Art History* is the result of a happy and productive collaboration between two scholar-teachers who share a common vision. In certain ways, we also share a common history. Neither of us expected to become professors of art history. Marilyn Stokstad took her first art history course as a requirement of her studio arts program. Michael Cothren discovered the discipline almost by chance during a semester abroad in Provence when a painting instructor sent him on a field trip to learn from the formal intricacies of Romanesque sculpture. Perhaps as a result of the unexpected delight we found in these revelatory formative experiences, we share a conviction that first courses in the history of art should be filled with as much enjoyment as erudition, that they should foster an enthusiastic, as well as an educated, public for the visual arts. With this end firmly in mind we will continue to create books intended to help students enjoy learning the essentials of a vast and complex field of study. For millennia human beings have embodied their most cherished ideas and values in visual and tangible form. We have learned that by engaging with these works from the past, we can all enrich our lives in the present, especially because we are living in a present when images have become an increasingly important aspect of how we communicate with each other.

Like its predecessors, this new edition seeks to balance formal and iconographic analysis with contextual art history in order to craft interpretations that will engage with a diverse student population. Throughout the text, the visual arts are treated as part of a larger world, in which geography, politics, religion, economics, philosophy, social life, and the other fine arts were related components of a vibrant cultural landscape. Art and architecture have played a central role in human history, and they continue to do so today. Our book will fulfill its purpose if it introduces a broad spectrum of students to some of the richest human achievements created through the centuries and across the globe, and if it inspires those students both to respect and to cherish their historical legacy in the visual arts. Perhaps it will convince some to dedicate themselves to assuring that our own age leaves a comparable artistic legacy, thereby continuing the ever evolving history of art.

## So ... Why Use This New Edition?

We believe that even an established introductory art history text should continually respond to the changing needs of its audience—both students and educators. In this way it is more likely to make a greater difference in the role that art can and will assume in its readers' lives, both at the time of use and long into the future—indeed, long after the need for the next revision arises.

Our goal was to make this revised text an improvement over its earlier incarnations in sensitivity, readability, and accessibility without losing anything in comprehensiveness, in scholarly precision, or in its ability to engage the reader. Incorporating feedback from our many users and reviewers, we believe we have succeeded.

## SOME HIGHLIGHTS OF THE NEW EDITION INCLUDE THE FOLLOWING:

- Every chapter now opens with a **Learn About It** feature (key learning objectives) and ends with a corresponding set of **Think About It** questions that probe back to the objectives and help students think through and apply what they have learned.
- The chapters are keyed to **MyArtsLab** resources that enrich and reinforce student learning (see p. xviii).
- **Newly colorized line art and 3D renderings** throughout the book provide the opportunity for students to better visualize architectural principles and key art processes.
- New **Recovering the Past boxes** document the discovery, restoration, or conservation of works of art. Some examples include discussions of the Rosetta stone, the Riace bronzes, and the Sutton Hoo find.
-  There is **increased contextual emphasis** now visible with the linking of three key box categories by means of a "target" icon:
  - The new **Closer Look** feature, at the center of the target, pulls in for more specificity within the work of art itself, helping the student understand issues of usage, iconography, and style.
  - The **Object Speaks** box focuses on an in-depth contextual treatment of a work of art.
  - The **Art and Its Contexts** feature at the outer ring of the target represents discussions of ideas about art that are placed within the broad context of the chapter, or the history of art in general.
- **Global coverage has been deepened** with the addition of new works of art and revised discussions that incorporate new scholarship.
- A **new series of maps** has been created to enhance the clarity and accuracy of the relationship between the art discussed and its geographical location and political affiliation.
- Throughout, **images have been updated** whenever new and improved images were available. **New works have been added** to the discussion in many chapters to enhance and enrich what is said in the text.
- The **language used to characterize works of art**—especially those that attempt to capture the lifelike appearance of the natural world—has been **refined and clarified** to bring greater precision and nuance.
- In response to readers' requests, **discussion of many major monuments** has been expanded. For example, the Palette of

Narmer, Sainte Chapelle, Bosch's *Garden of Earthly Delights*, and the Contarelli Chapel.

- **Several chapters have been reorganized** for greater clarity and coherence. Prehistoric Art is now global in scope, the early nineteenth century has been incorporated into the chapter containing the eighteenth century to avoid breaking up the discussion of Neoclassicism and Romanticism, and the last two chapters now break at 1950.
- In keeping with this book's tradition of inclusivity, **an even broader spectrum of media is addressed** here, with expanded attention, for example, to Gothic stained glass, Renaissance tapestries, and Navajo textiles.

### NEW SCHOLARSHIP

Over the many years we have taught undergraduate beginners, we have always enjoyed sharing—both with our students and our fellow educators—the new discoveries and fresh interpretive perspectives that are constantly enriching the history of art. We relished the opportunity here to incorporate some of the latest thinking and most recent discoveries—whether this involved revising the dating and interpretation of well-known Prehistoric monuments like Stonehenge (fig. 1–21), presenting fascinating new recreations of familiar masterworks such as the "colorized" Aegina archer from Ancient Greece (p.113), or including a new theory on the meaning of Jan van Eyck's masterful Double Portrait (fig. 18-1). Indeed, changes have been made on many levels—from the introduction to the bibliography, and from captions to chapter introductions. Every change aims to make the text more useful to the instructors and more vibrant for the students in today's art history classrooms.

## WHAT'S NEW

## Chapter by Chapter Revisions

Some of the key highlights of this new edition include the following:

### Introduction

Completely rewritten, the introduction orients students to the process and nature of art historical investigation that underlies and, in essence, produced the historical narrative of the text itself.

### Chapter 1: Prehistoric Art

Extensive revisions reflect the most current scholarship and broaden scope to global coverage. Key sections of the chapter rewritten to accommodate up-to-date interpretations, with new objects included. Thorough reworking of Stonehenge incorporates new thinking about the monument and landscape. Çatalhöyük and 'Ain Ghazal moved to this chapter.

### Chapter 2: Art of the Ancient Near East

New chapter opener with *Stele of Naram-Sin* sets the stage for the chapter material. An historical photograph with a view of the guardian figures from the Citadel of Saragon II places the monument in context. New "Object Speaks" box on the "Great Lyre" includes a discussion of its archaeological discovery. Treatment of key monuments expanded.

### Chapter 3: Art of Ancient Egypt

Historical and contextual material reduced to allow for richer discussions of the works of art. Sphinx moved from the Introduction to this chapter. Discussion of the Egyptian canon/ grid system refined and updated. New images include stele of the sculptor Userwer and statue of Queen Karomama in the Louvre.

### Chapter 4: Art of the Ancient Aegean

Completely revised discussion of Cycladic figures in light of recent research, including two new figures. Reworked Knossos complex text acknowledges its probable role as a ceremonial center. Treatment of *Harvester Rhyton* expanded. New box on Schliemann and the "Mask of Agamemnon" outlines reasons for suspicions about both. Discussion of Mycenaean tombs reorganized to include metalwork found in the shaft graves, with tholos tombs explanation now following.

### Chapter 5: Art of Ancient Greece

Historical preludes reduced to focus on cultural and historical factors related to the history of art. Reorganized for greater clarity and coherence, including box placement. Expanded discussion of Aegina architecture and sculpture, and box on color in Greek sculpture focuses on Aegina, thus making it a model analysis for the basic points in architecture and architectural sculpture. Moved ceramic painting technique box to Archaic section in relation to the vessels where most relevant and added detailed views of use of each technique.

### Chapter 6: Etruscan and Roman Art

Expanded treatment of the Etruscans with addition of a wall painting, a sarcophagus lid, and the *Ficoroni Cista*. Added clarity to discussions of representational modes—classicizing and veristic. Added box on portraiture using the Polybius text and the *Barberini Togatus*. Expanded treatment of tetrarchic sculpture, concentrating on introduction of a new ideal along with verism and classicism. Reorganized discussion of Constantinian art.

## Chapter 7: Jewish, Early Christian, and Byzantine Art

New chapter opener introduces the eclecticism of Byzantine art and foregrounds the continuity of the classical heritage in the Byzantine world. Expanded treatment of Jewish art. Extensively revised Ravenna monuments, especially San Vitale. Reorganized Middle Byzantine discussion for clearer sense of chronology as well as geography. Much expanded section on the Chora church as a late Byzantine monument.

## Chapter 8: Islamic Art

Revised to bring greater emphasis on art and society with simpler historical periodization. New chapter opener features *Maqamat* image of a preacher in a mosque, with many new images of art and architecture throughout. Expanded material on Mughal South Asia. Added new box on the topic of ornament with exemplary illustrations. New "Object Speaks" with in-depth explanation of the Mosque at Cordoba.

## Chapter 9: Art of South and Southeast Asia before 1200

New coverage of sites, including Bamiyan whose Buddha images were destroyed in 2001. Period divisions updated for greater clarity and comprehension.

## Chapter 10: Chinese and Korean Art before 1279

New illustrations of bronze-casting technique for improved understanding of process. New images include Neolithic cong, bronze *guang*, Tang equestrian pair, and detail of *Admonitions of the Imperial Instructress to Court Ladies*. "A Closer Look" examines in detail a section of stone relief in Wu family shrine.

## Chapter 11: Japanese Art before 1333

New illustrations and discussion of art and architecture at the Great Buddha Hall (*Daibutsuden*) at Todaiji in "Recovering the Past" box. New discussion of Japan in the eighth century as the eastern terminus of the Silk Route. Increased emphasis on Japan's native religion of Shinto with addition of a Shinto painting. Expanded discussion of Chinese emigrant monks and their influence in section on Zen art.

## Chapter 12: Art of the Americas before 1300

Substantially revised and updated sections on Mesoamerican and ancient Andean art. New images include Maya stela, Moche portrait vessel, Olmec sculptural offering, and cylinder vase with image of the Maya ballgame. Expanded discussion of Maya hieroglyphic writing.

## Chapter 13: Early African Art

Revised and expanded discussion of Ife portraiture to emphasize idea that among earliest known examples of African sculpture, naturalistic representations of human body were not uncommon. Added treatment of the Ethiopian ancient sites of Lalibela, Gondar and Aksum. Fifteenth-century ivory hunting horn speaks to European contact and trade to west and central Africa that included the export of objects made in Africa for European aristocracy.

## Chapter 14: Early Medieval Art in Europe

Added new "Recovering the Past" box on the Sutton Hoo find. New "Object Speaks" box on the Lindisfarne Gospels allows comparison between the Matthew portrait and the Ezra from the Codex Amiatinus. Moved reduced discussion of Vikings before the Carolingians to permit continuity between Carolingians and Ottonians. Carolingian discussion enhanced with addition of bronze equestrian emperor, Corvey façade, new drawing of Aachen chapel, and expanded Saint Gall plan.

## Chapter 15: Romanesque Art

Abbreviated and condensed historical discussions not directly related to the situation in the art. Added Canigou to flesh out and clarify the opening discussion of "First Romanesque." Discussion of painting and mosaics at San Clemente in Rome and Saint-Savin-sur-Gartempe moved from a media-based section to the discussion of the buildings themselves. Expanded discussion of Moissac to give sense of one ensemble in some detail.

## Chapter 16: Gothic Art of the Twelfth and Thirteenth Centuries

Significant revisions in French Gothic discussion with removal of Amiens and expansion of Saint-Denis, Chartres, and Reims. Stained-glass technique box moved to coincide with the discussion of Saint-Denis and a full panel of glass from that church illustrated. Consolidated and expanded treatment of Assisi.

## Chapter 17: Fourteenth-Century Art in Europe

Discussion of Giotto and Duccio reworked to include new focus work in each program, the *Kiss of Judas* for Giotto and the *Raising of Lazarus* for Duccio. Added Simone Martini with discussion of his *Annunciation*. Introduced Hedwig Codex for more variety in German section.

## Chapter 18: Fifteenth-Century Art in Northern Europe

More developed discussion of *Hours of Mary of Burgundy* to elaborate on its evidence of new devotional practices. Expanded treatment of *Unicorn* tapestry to include technique and effect, as well as iconography. New box on the processs of oil painting. Transformed discussion of Mérode Altarpiece based on new views about authorship. Revised discussion of Jan van Eyck's *Man in a Red Turban* as self-portrait. Reworked discussion of Fouquet's Melun Diptych.

## Chapter 19: Renaissance Art in Fifteenth-Century Italy

New "Art and its Contexts" boxes on the Florentine Baptistery competition reliefs and *cassoni*. Expanded treatment of Orsanmichele including new image of building. Developed discussion of Donatello's David. Revised box on Renaissance perspective and moved to correspond with Masaccio. Expanded discussion of the Sistine mural project.

## Chapter 20: Sixteenth-Century Art in Italy

Added Leonardo's *The Virgin of the Rocks*, Raphael portraits of Agnelo Doni and Maddalena Strozzi, and Michelangelo's Laurentian Library. Enhanced discussion of Palazzo del Tè with attention to social and political context. Reoriented treatment of Titian's "Venus" of Urbino in light of Rona Goffen's work. Discussion of

Mannerism and Council of Trent reversed to conform with chronology and history.

## Chapter 21: Sixteenth-Century Art in Northern Europe and the Iberian Peninsula

Expanded discussion of *Garden of Earthly Delights* includes new interpretive ideas and incorporates exterior wing panels. New addition and discussion of Quentin Massys's *Money Changer and his Wife*. "Object Speaks" box explores two Bruegel paintings as part of a series of the months. Added "Closer Look" box for Holbein's *The French Ambassadors*.

## Chapter 22: Seventeenth-Century Art in Europe

New images include Artemisia Gentileschi's *Susannah and the Elders*, a Murillo *Immaculate Conception*, Rubens's *Self-Portrait with Isabella Brandt*, Ruisdael's *View of Haarlem from the Dunes at Overveen* and Le Nain's *A Peasant Family in an Interior*. Added technique box on etchings and drypoint.

## Chapter 23: Art of South and Southeast Asia after 1200

Expanded Southeast Asia coverage to include Islamic art. Incorporated discussion of European engagement with Mughal art. Added discussion of South Asian artists working in the Diaspora and Indian architect Charles Correa.

## Chapter 24: Chinese and Korean Art after 1279

New image by Yun Shouping, *Amaranth*. New "Closer Look" feature for detail of section of *Spring Dawn in the Han Palace*.

## Chapter 25: Japanese Art after 1333

Greater emphasis on importance of crafts with addition of porcelain plate, *kosode*, and contemporary lacquer box. New "Closer Look" highlights techniques used in creation of a *kosode* robe. Increased discussion of Japan's integration of foreign, particularly Western, influences in its art and culture. New emphasis on architecture and crafts in the postwar period. Tea Ceremony discussion consolidated into one section.

## Chapter 26: Art of the Americas after 1300

New chapter opener focuses on Navajo textile woven by Julia Jumbo. Additional contemporary Native American art incorporated into chapter. Revised and updated sections on Aztec and Inca art.

## Chapter 27: Art of Pacific Cultures

Revised and updated introduction to Australia. Reworked Melanesia section to broaden range of culture areas: added New Britain Tubuan mask, discussions of role of women and different uses of masks. Revamped Polynesia introduction to be Polynesian-centered, not European-centered. New "Object Speaks" for Maori meetinghouse with additional images to show regional difference and change over time (time depth) in Maori art. Contemporary art in Oceania included.

## Chapter 28: Art of Africa in the Modern Era

Incorporated image of 1897 British punitive expedition to Benin with short discussion of development of major collections of African art in Europe and America. Collection development tied to European expansion, political and economic interests. New "Object Speaks" created for Kuba mask with additional photographs to help to integrate the mask within its performance and meaning contexts. Moved discussion of divination among the Chokwe closer to discussion of Yoruba divination.

## Chapter 29: Eighteenth- and Early Nineteenth-Century Art in Europe and North America

Reorganized chapter now encompasses the early nineteenth century to avoid breaking up the discussion of Neoclassicism and Romanticism. Revised and expanded discussion of how courtly system of individual patronage transformed, first into a Salon system, and then into an academic system of training, exhibition, and sale of art. New images include Fragonard's *The Swing* and Boucher's *Girl Reclining: Louise O'Murphy*.

## Chapter 30: Mid- to late Nineteenth-Century Art in Europe and the United States

Revised and updated to emphasize the varying ways the academy and avant-garde envisaged and expressed modernity. Expanded discussion also includes exploration of differing concepts of modernity in France, England, the United States, and elsewhere. Photography moved to early part of chapter. Works by Manet now discussed together and in relation to Realism.

## Chapter 31: Modern Art in Europe and the Americas, 1900–1950

Reworked to extend to 1950 so chapter covers the years of Modernism more fully. Updated to reflect the early centrality of Paris in the first half of twentieth century as a center of innovation in the art-world and its subsequent displacement by New York.

## Chapter 32: The International Scene Since 1950

Reorganized and revised according to a thematic structure. Emphasis placed on the 1960s as a turning point in the global understanding of art and the subsequent globalization of art in the fast-paced communications age. Fifty percent new images reflect themes outlined in the text.

## Ordering Options

*Art History* is offered in a variety of formats to suit any course need, whether your survey is Western, global, comprehensive or concise, online or on the ground. Please contact your local representative for ordering details or visit www.pearsonhighered.com/art. In addition to this combined hardcover edition, *Art History* may be ordered in the following formats:

**Volume I**, Chapters 1–17 (ISBN: 978-0-205-74420-6)
**Volume II**, Chapters 17–32 (ISBN: 978-0-205-74421-3)

*Art History* **Portable Edition** has all of the same content as the comprehensive text in six slim volumes. Available in value-package combinations (Books 1, 2, 4, and 6) to suit **Western-focused survey** courses or available individually for period or region specific courses.

Book 1: Ancient Art, Chapters 1–6
Book 2: Medieval Art, Chapters 7, 8, 14–17
Book 3: A View of the World: Part One, Chapters 8–13
Book 4: Fourteenth to Seventeenth Century Art, Chapters 17–22
Book 5: A View of the World: Part Two, Chapters 23–28
Book 6: Eighteenth to Twenty-first Century Art, Chapters 29–32

**Books À La Carte** Give your students flexibility and savings with the new Books à la Carte edition of *Art History*. This edition features exactly the same content as the traditional textbook in a convenient three-hole-punched, loose-leaf version—allowing students to take only what they need to class. The Books à la Carte edition costs less than a used text—which helps students save about 35% over the cost of a new book.
Volume I, Books à la Carte Edition, 4/e
(ISBN: 978-0-205-79557-4)
Volume II, Books à la Carte Edition, 4/e
(ISBN: 978-0-205-79558-1)

 **CourseSmart Textbooks Online** is an exciting new choice for students looking to save money. As an alternative to purchasing the print textbook, students can subscribe to the same content online and save up to 50% off the suggested list price of the print text. For more information, or to subscribe to the CourseSmart eTextbook, visit www.coursesmart.com.

**Combined Volume** (ISBN: 978-0-205-80032-2)
**Volume I** (ISBN: 978-0-205-00189-7)
**Volume II** (ISBN: 978-0-205-00190-3)

## Digital Resources

 **www.myartslab.com** This dynamic website provides a wealth of resources geared to meet the diverse teaching and learning needs of today's instructors and students. Keyed specifically to the chapters of *Art History*, Fourth Edition, MyArtsLab's many tools will encourage students to experience and interact with works of art. Here are some of the key features:

- A complete **Pearson e-Text** of the book, enriched with multimedia, including: a unique human scale figure by all works of fine art, an audio version of the text read by the author, primary source documents, video demonstrations, and much more. Students can highlight, make notes and bookmark pages.
- 360 degree **Architectural Panoramas** for most of the major monuments in the book help students understand buildings from the inside and out.
- **Closer Look Tours** These interactive walkthroughs offer an in-depth look at key works of art, enabling the student to zoom in to see detail they could not otherwise see on the printed page or even in person. Enhanced with expert audio, they help students understand the meaning and message behind the work of art.
- A **Gradebook** that reports progress of students and the class as a whole.
- Instructors can also download the Instructor's Manual & Test Item File, PowerPoint questions for Classroom Response Systems, and obtain the PearsonMyTest assessment generation program.
- **MyArtsLab with e-Text** is available for no additional cost when packaged with any version of *Art History*, 4/e; it is also available standalone for less than the cost of a used text, and it is also available without e-Text for an even lower price.

 **The Prentice Hall Digital Art Library** Instructors who adopt *Art History* are eligible to receive this unparalleled resource containing all of the images in *Art History* at the highest resolution (over 300 dpi) and pixellation possible for optimal projection and easy download. This resource features over 1,600 illustrations in jpeg and in PowerPoint, an instant download function for easy import into any presentation software, along with a unique zoom and "Save Detail" feature. (ISBN: 978-0-205-80037-7)

# ACKNOWLEDGMENTS AND GRATITUDE

*Art History*, which was first published in 1995 by Harry N. Abrams, Inc. and Prentice Hall, Inc., continues to rely, each time it is revised, on the work of many colleagues and friends who contributed to the original texts and subsequent editions. Their work is reflected here, and we extend to them our enduring gratitude.

In preparing this fourth edition, we worked closely with two gifted and dedicated editors at Pearson/Prentice Hall, Sarah Touborg and Helen Ronan, whose almost daily support in so many ways was at the center of our work and created the foundation of what we have done. At Pearson, Barbara Cappuccio, Marlene Gassler, Melissa Feimer, Cory Skidds, Brian Mackey, David Nitti, and Carla Worner also supported us in our work. For the design we thank Kathy Mrozek and John Christiana. At Laurence King Publishing, Melissa Danny, Sophie Page, Kara Hattersley-Smith, Julia Ruxton and Simon Walsh oversaw the production of this new edition. We are very grateful for the editing of Cynthia Ward, Margaret Manos, and Robert Shore. For layout design we thank Nick Newton and for photo research we thank Emma Brown. Much appreciation also goes to Brandy Dawson, Director of Marketing, and Kate Stewart Mitchell, Marketing Manager, as well as the entire Social Sciences and Arts team at Pearson.

## From Marilyn Stokstad:

The fourth edition of *Art History* represents the cumulative efforts of a distinguished group of scholars and educators. The work done by Stephen Addiss, Chutsing Li, Marylin M. Rhie, and Christopher D. Roy for the original edition has been updated and expanded by David Binkley and Patricia Darish (Africa), Claudia Brown and Robert Mowry (China and Korea), Patricia Graham (Japan), and Rick Asher (South and Southeast Asia). Joy Sperling has reworked the modern material previously contributed by Patrick Frank, David Cateforis and Bradford R. Collins. Dede Ruggles (Islamic), Claudia Brittenham (Americas), and Carol Ivory (Pacific Cultures) also have contributed to the fourth edition.

In addition, I want to thank University of Kansas colleagues Sally Cornelison, Susan Craig, Susan Earle, Charles Eldredge, Kris Ercums, Valija Evalds, Sherry Fowler, Stephen Goddard, Saralyn Reece Hardy, Marsha Haufler, Marni Kessler, Amy McNair, John Pulz, Linda Stone Ferrier, and John Younger for their help and advice. My thanks also to my friends Katherine Giele and Katherine Stannard, David and Nancy Dinneen, William Crowe, David Bergeron, Geraldo de Sousa, and the entire Clement family for their sympathy and encouragement. Of course, my very special thanks go to my sister, Karen Leider, and my niece, Anna Leider.

## From Michael Cothren:

Words are barely adequate to express my gratitude to Marilyn Stokstad for welcoming me with such trust, enthusiasm, and warmth into the collaborative adventure of revising this book. Working alongside her—and our extraordinary editors Sarah Touborg and Helen Ronan—has been delightful and rewarding, enriching and challenging. I look forward to continuing the partnership.

My work was greatly facilitated by two extraordinary research assistants, Fletcher Coleman and Andrew Finegold, who found materials and offered opinions just when I needed them. I also have been supported by a host of colleagues at Swarthmore College. Generations of students challenged me to hone my pedagogical skills and steady my focus on what is at stake in telling the history of art. My colleagues in the Art Department—especially Stacy Bomento, June Cianfrana, Randall Exon, Constance Cain Hungerford, Janine Mileaf, Patricia Reilly, and Tomoko Sakomura—have answered all sorts of questions, shared innumerable insights on works in their areas of expertise, and offered unending encouragement and support. I am so lucky to work with them. In Classics, Gil Rose and William Turpin generously shared their expertise in Latin.

Many art historians have provided assistance, often at a moment's notice, and I am especially grateful to Betina Bergman, Claudia Brown, Brigitte Buettner, Madeline Caviness, Cheri Falkenstien-Doyle, Ed Gyllenhaal, Julie Hochstrasser, Penny Jolly, Alison Kettering, Benton Kidd, Ann Kuttner, Cary Liu, Elizabeth Marlowe, Thomas Morton, Mary Shepard, David Simon, Donna Sadler, Jeffrey Chipps Smith, and Mark Tucker.

I was fortunate to have the support of many friends. John Brendler, David Eldridge, Tricia Kramer, Stephen Lehmann, Mary Marissen, Bianca O'Keefe, and Bruce and Carolyn Stephens, patiently listened and truly relished my enjoyment of this work.

My mother and my late father, Mildred and Wat Cothren believed in me and made significant sacrifices to support my education from pre-school to graduate school. My extraordinary daughters Emma and Nora are a constant inspiration. I am so grateful for their delight in my passion for art's history, and for their dedication to keeping me from taking myself too seriously. My deepest gratitude is reserved for Susan Lowry, my wife and soul-mate, who brings joy to every facet of my life. She was not only patient and supportive during the long distraction of my work on this book; she provided help in so very many ways. The greatest accomplishment of my life in art history occurred on the day I met her at Columbia in 1973.

If the arts are ultimately an expression of human faith and integrity as well as human thought and creativity, then writing and producing books that introduce new viewers to the wonders of art's history, and to the courage and visions of the artists and art historians that stand behind it—remains a noble undertaking. We feel honored to be a part of such a worthy project.

Marilyn Stokstad        Michael W. Cothren
Lawrence, KS            Swarthmore, PA

Winter 2010

## In Gratitude:

As its predecessors did, this Fourth Edition of *Art History* benefited from the reflections and assessments of a distinguished team of scholars and educators. The authors and Pearson are grateful to the following academic reviewers for their numerous insights and suggestions for improvement:

Craig Adcock, University of Iowa
Kimberly Allen-Kattus, Northern Kentucky University
Susan Jane Baker, University of Houston
Stephen Caffey, Texas A & M University
Charlotte Lowry Collins, Southeastern Louisiana University
Cindy B. Damschroder, University of Cincinnati
Rachael Z. DeLue, Princeton University
Anne Derbes, Hood College
Caroline Downing, State University of New York at Potsdam
Suzanne Eberle, Kendall College of Art & Design of Ferris State University
April Eisman, Iowa State University
Allen Farber, State University of New York at Oneonta
Richard Gay, University of North Carolina - Pembroke
Regina Gee, Montana State University
Mimi Hellman, Skidmore College
Julie Hochstrasser, University of Iowa
Evelyn Kain, Ripon College
Nancy Kelker, Middle Tennessee State University
Patricia Kennedy, Ocean County College
Jennie Klein, Ohio University
Katie Kresser, Seattle Pacific University
Cynthia Kristan-Graham, Auburn University
Barbara Platten Lash, Northern Virginia Community College
Elisa C. Mandell, California State University, Fullerton
Elizabeth C. Mansfield, New York University
Pamela Margerm, Kean University
Elizabeth Marlowe, Colgate University
Marguerite Mayhall, Kean University
Katherine A. McIver, University of Alabama at Birmingham
Janine Mileaf, Swarthmore College
Johanna D. Movassat, San Jose State University
Jacqueline Marie Musacchio, Wellesley College
Lynn Ostling, Santa Rosa Junior College
Ariel Plotek, Clemson University
Patricia V. Podzorski, University of Memphis
Margaret Richardson, George Mason University
James Rubin, Stony Brook University
Donna Sandrock, Santa Ana College
Michael Schwartz, Augusta State University
Joshua A. Shannon, University of Maryland
Karen Shelby, Baruch College
Susan Sidlauskas, Rutgers University
Royce W. Smith, Wichita State University
Jeffrey Chipps Smith, University of Texas - Austin
Stephen Smithers, Indiana State University
Laurie Sylwester, Columbia College (Sonora)
Carolyn Tate, Texas Tech University
Rita Tekippe, University of West Georgia
Amelia Trevelyan, University of North Carolina at Pembroke
Julie Tysver, Greenville Technical College
Jeryn Woodard, University of Houston

This edition has continued to benefit from the assistance and advice of scores of other teachers and scholars who generously answered questions, gave recommendations on organization and priorities, and provided specialized critiques during the course of work on previous editions.

We are grateful for the detailed critiques that the following readers across the country who were of invaluable assistance during work on the third edition:

Charles M. Adelman, University of Northern Iowa; Fred C. Albertson, University of Memphis; Frances Altvater, College of William and Mary; Michael Amy, Rochester Institute of Technology; Jennifer L. Ball, Brooklyn College, CUNY; Samantha Baskind, Cleveland State University; Tracey Boswell, Johnson County Community College; Jane H. Brown, University of Arkansas at Little Rock; Roger J. Crum, University of Dayton; Brian A. Curran, Penn State University; Michael T. Davis,

Mount Holyoke College; Juilee Decker, Georgetown College; Laurinda Dixon, Syracuse University; Laura Dufresne, Winthrop University; Dan Ewing, Barry University; Arne Flaten, Coastal Carolina University; John Garton, Cleveland Institute of Art; Rosi Gilday, University of Wisconsin, Oshkosh; Eunice D. Howe, University of Southern California; Phillip Jacks, George Washington University; William R. Levin, Centre College; Susan Libby, Rollins College; Henry Luttikhuizen, Calvin College; Lynn Mackenzie, College of DuPage; Dennis McNamara, Triton College; Gustav Medicus, Kent State University; Lynn Metcalf, St. Cloud State University; Jo-Ann Morgan, Coastal Carolina University; Beth A. Mulvaney, Meredith College; Dorothy Munger, Delaware Community College; Bonnie Noble, University of North Carolina at Charlotte; Leisha O'Quinn, Oklahoma State University; Willow Partington, Hudson Valley Community College; Martin Patrick, Illinois State University; Albert Reischuck, Kent State University; Jeffrey Ruda, University of California, Davis; Diane Scillia, Kent State University; Stephanie Smith, Youngstown State University; Janet Snyder, West Virginia University; James Terry, Stephens College; Michael Tinkler, Hobart and William Smith Colleges; Reid Wood, Lorain County Community College. Our thanks also to additional expert readers including: Susan Cahan, Yale University; David Craven, University of New Mexico; Marian Feldman, University of California, Berkeley; Dorothy Johnson, University of Iowa; Genevra Kornbluth, University of Maryland; Patricia Mainardi, City University of New York; Clemente Marconi, Columbia University; Tod Marder, Rutgers University; Mary Miller, Yale University; Elizabeth Penton, Durham Technical Community College; Catherine B. Scallen, Case Western University; Kim Shelton, University of California, Berkeley.

Many people reviewed the original edition of *Art History* and have continued to assist with its revision. Every chapter was read by one or more specialists. For work on the original book and assistance with subsequent editions my thanks go to: Barbara Abou-el-Haj, SUNY Binghamton; Roger Aiken, Creighton University; Molly Aitken; Anthony Alofsin, University of Texas, Austin; Christiane Andersson, Bucknell University; Kathryn Arnold; Julie Aronson, Cincinnati Art Museum; Michael Auerbach, Vanderbilt University; Larry Beck; Evelyn Bell, San Jose State University; Janetta Rebold Benton, Pace University; Janet Berlo, University of Rochester; Sarah Blick, Kenyon College; Jonathan Bloom, Boston College; Suzaan Boettger; Judith Bookbinder, Boston College; Marta Braun, Ryerson University; Elizabeth Broun, Smithsonian American Art Museum; Glen R. Brown, Kansas State University; Maria Elena Buszek, Kansas City Art Institute; Robert G. Calkins; Annmarie Weyl Carr; April Clagget, Keene State College; William W. Clark, Queens College, CUNY; John Clarke, University of Texas, Austin; Jaqueline Clipsham; Ralph T. Coe; Robert Cohon, The Nelson-Atkins Museum of Art; Alessandra Comini; James D'Emilio, University of South Florida; Walter Denny, University of Massachusetts, Amherst; Jerrilyn Dodds, City College, CUNY; Lois Drewer, Index of Christian Art; Joseph Dye, Virginia Museum of Art; James Farmer, Virginia Commonwealth University; Grace Flam, Salt Lake City Community College; Mary D. Garrard; Paula Gerson, Florida State University; Walter S. Gibson; Dorothy Glass; Oleg Grabar; Randall Griffey, Amherst College; Cynthia Hahn, Florida State University; Sharon Hill, Virginia Commonwealth University; John Hoopes, University of Kansas; Reinhild Janzen, Washburn University; Wendy Kindred, University of Maine at Fort Kent; Alan T. Kohl, Minneapolis College of Art; Ruth Kolarik, Colorado College; Carol H. Krinsky, New York University; Aileen Laing, Sweet Briar College; Janet LeBlanc, Clemson University; Charles Little, The Metropolitan Museum of Art; Laureen Reu Liu, McHenry County College; Loretta Lorance; Brian Madigan, Wayne State University; Janice Mann, Bucknell University; Judith Mann, St. Louis Art Museum; Richard Mann, San Francisco State University; James Martin,; Elizabeth Parker McLachlan; Tamara Mikailova, St. Petersburg, Russia, and Macalester College; Anta Montet-White; Anne E. Morganstern, Ohio State University; Winslow Myers, Bancroft School; Lawrence Nees, University of Delaware; Amy Ogata, Cleveland Institute of Art; Judith Oliver, Colgate University; Edward Olszewski, Case Western Reserve University; Sara Jane Pearman; John G. Pedley, University of Michigan; Michael Plante, Tulane University; Eloise Quiñones-Keber, Baruch College and the Graduate Center, CUNY; Virginia Raguin, College of the Holy Cross; Nancy H. Ramage, Ithaca College; Ann M. Roberts, Lake Forest College; Lisa Robertson, The Cleveland Museum of Art; Barry Rubin; Charles Sack, Parsons, Kansas; Jan Schall, The Nelson-Atkins Museum of Art; Tom Shaw, Kean College; Pamela Sheingorn, Baruch College, CUNY; Raechell Smith, Kansas City Art Institute; Lauren Soth; Anne R. Stanton, University of Missouri, Columbia; Michael Stoughton; Thomas Sullivan, OSB, Benedictine College (Conception Abbey); Pamela Trimpe, University of Iowa; Richard Turnbull, Fashion Institute of Technology; Elizabeth Valdez del Alamo, Montclair State College; Lisa Vergara; Monica Visoná, University of Kentucky; Roger Ward, Norton Museum of Art; Mark Weil, St. Louis; David Wilkins; Marcilene Wittmer, University of Miami.

*The various features of this book reinforce each other, helping the reader to become comfortable with terminology and concepts that are specific to art history.*

**Starter Kit and Introduction**  The Starter Kit is a highly concise primer of basic concepts and tools. The Introduction explores the way they are used to come to an understanding of the history of art.

**Captions**  There are two kinds of captions in this book: short and long. Short captions identify information specific to the work of art or architecture illustrated:

> artist (when known)
> title or descriptive name of work date
> original location (if moved to a museum or other site)
> material or materials a work is made of
> size (height before width) in feet and inches, with meters
>    and centimeters in parentheses
> present location

The order of these elements varies, depending on the type of work illustrated. Dimensions are not given for architecture, for most wall paintings, or for most architectural sculpture. Some captions have one or more lines of small print below the identification section of the caption that gives museum or collection information. This is rarely required reading; its inclusion is often a requirement for gaining permission to reproduce the work.

Longer, discursive captions contain information that complements the narrative of the main text.

**Definitions of Terms**  You will encounter the basic terms of art history in three places:

> **In the Text**, where words appearing in boldface type are defined, or glossed, at their first use. Some terms are boldfaced and explained more than once, especially those that experience shows are hard to remember.

> **In Boxed Features**, on technique and other subjects, where labeled drawings and diagrams visually reinforce the use of terms.

> **In the Glossary**, at the end of the volume (p. 1137), which contains all the words in boldface type in the text and boxes.

**Maps**  At the beginning of each chapter you will find a map with all the places mentioned in the chapter.

**Boxes**  Special material that complements, enhances, explains, or extends the narrative text is set off in six types of tinted boxes.

Art and its Contexts and The Object Speaks boxes expand on selected works or issues related to the text. A Closer Look boxes use leader-line captions to focus attention on specific aspects of important works. Elements of Architecture boxes clarify specifically architectural features, often explaining engineering principles or building technology. Technique boxes outline the techniques and processes by which certain types of art are created. Recovering the Past boxes highlight the work of archaeologists who uncover and conservators who assure the preservation and clear presentation of art.

**Bibliography**  The bibliography at the end of this book beginning on page 1146 contains books in English, organized by general works and by chapter, that are basic to the study of art history today, as well as works cited in the text.

**Learn About It**  Placed at the beginning of each chapter, this feature captures in bulleted form the key learning objectives, or outcomes, of the chapter. They point to what will have been accomplished upon its completion.

**Think About It**  These critical thinking questions appear at the end of each chapter and help students assess their mastery of the learning objectives (Learn About It) by asking them to think through and apply what they have learned.

**MyArtsLab prompts**  These notations are found throughout the chapter and are keyed to MyArtsLab resources that enrich and reinforce student learning.

**Dates, Abbreviations, and Other Conventions**  This book uses the designations BCE and CE, abbreviations for "Before the Common Era" and "Common Era," instead of BC ("Before Christ") and AD ("Anno Domini," "the year of our Lord"). The first century BCE is the period from 99 BCE to 1 BCE; the first century CE is from the year 1 CE to 99 CE. Similarly, the second century CE is the period from 199 BCE to 100 BCE; the second century CE extends from 100 CE to 199 CE.

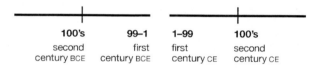

| 100's | 99–1 | 1–99 | 100's |
| --- | --- | --- | --- |
| second century BCE | first century BCE | first century CE | second century CE |

**Circa** ("about") is used with approximate dates, spelled out in the text and abbreviated to "c." in the captions. This indicates that an exact date is not yet verified.

An illustration is called a "figure," or "fig." Thus, figure 6–7 is the seventh numbered illustration in Chapter 6, and fig. Intro-3 is the third figure in the Introduction. There are two types of figures: photographs of artworks or of models, and line drawings. Drawings are used when a work cannot be photographed or when a diagram or simple drawing is the clearest way to illustrate an object or a place.

When introducing artists, we use the words *active* and *documented* with dates, in addition to "b." (for "born") and "d." (for "died"). "Active" means that an artist worked during the years given. "Documented" means that documents link the person to that date.

Accents are used for words in French, German, Italian, and Spanish only. With few exceptions, names of cultural institutions in Western European countries are given in the form used in that country.

**Titles of Works of Art**  It was only over the last 500 years that paintings and works of sculpture created in Europe and North America were given formal titles, either by the artist or by critics and art historians. Such formal titles are printed in italics. In other traditions and cultures, a single title is not important or even recognized.

In this book we use formal descriptive titles of artworks where titles are not established. If a work is best known by its non-English title, such as Manet's *Le Déjeuner sur l'Herbe (The Luncheon on the Grass)*, the original language precedes the translation.

Art history focuses on the visual arts—painting, drawing, sculpture, prints, photography, ceramics, metalwork, architecture, and more. This Starter Kit contains basic information and addresses concepts that underlie and support the study of art history. It provides a quick reference guide to the vocabulary used to classify and describe art objects. Understanding these terms is indispensable because you will encounter them again and again in reading, talking, and writing about art.

**Let us begin with the basic properties of art.** A work of art is a material object having both form and content. It is often described and categorized according to its *style* and *medium*.

## FORM

Referring to purely visual aspects of art and architecture, the term *form* encompasses qualities of *line, shape, color, light, texture, space, mass, volume,* and *composition*. These qualities are known as *formal elements*. When art historians use the term *formal*, they mean "relating to form."

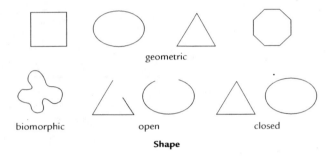

geometric

biomorphic    open    closed

**Shape**

**Line** and **shape** are attributes of form. Line is an element—usually drawn or painted—the length of which is so much greater than the width that we perceive it as having only length. Line can be actual, as when the line is visible, or it can be implied, as when the movement of the viewer's eyes over the surface of a work follows a path determined by the artist. Shape, on the other hand, is the two-dimensional, or flat, area defined by the borders of an enclosing *outline* or *contour*. Shape can be *geometric*, *biomorphic* (suggesting living things; sometimes called *organic*), *closed*, or *open*. The *outline* or *contour* of a three-dimensional object can also be perceived as line.

**Color** has several attributes. These include *hue, value,* and *saturation*.

Hue is what we think of when we hear the word *color*, and the terms are interchangeable. We perceive hues as the result of differing wavelengths of electromagnetic energy. The visible spectrum, which can be seen in a rainbow, runs from red through violet. When the ends of the spectrum are connected through the hue red-violet, the result may be diagrammed as a color wheel. The primary hues (numbered 1) are red, yellow, and blue. They are known as primaries because all other colors are made by combining these hues. Orange, green, and violet result from the mixture of two primaries and are known as secondary hues (numbered 2). Intermediate hues, or tertiaries (numbered 3), result from the mixture of a primary and a secondary. Complementary colors are the two colors directly opposite one another on the color

wheel, such as red and green. Red, orange, and yellow are regarded as warm colors and appear to advance toward us. Blue, green, and violet, which seem to recede, are called cool colors. Black and white are not considered colors but neutrals; in terms of light, black is understood as the absence of color and white as the mixture of all colors.

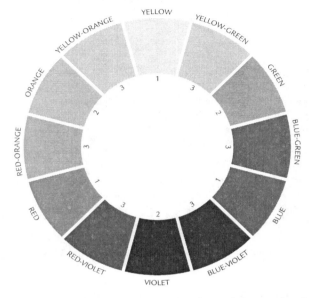

**Value** is the relative degree of lightness or darkness of a given color and is created by the amount of light reflected from an object's surface. A dark green has a deeper value than a light green, for example. In black-and-white reproductions of colored objects, you see only value, and some artworks—for example, a drawing made with black ink—possess only value, not hue or saturation.

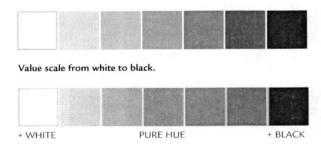

**Value scale from white to black.**

+ WHITE          PURE HUE          + BLACK

**Value variation in red.**

**Saturation**, also sometimes referred to as *intensity*, is a color's quality of brightness or dullness. A color described as highly saturated looks vivid and pure; a hue of low saturation may or look a little muddy or greyed.

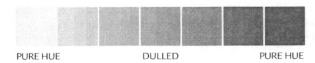

PURE HUE          DULLED          PURE HUE

**Intensity scale from bright to dull.**

**Texture**, another attribute of form, is the tactile (or touch-perceived) quality of a surface. It is described by words such as *smooth, polished, rough, prickly, grainy,* or *oily.* Texture takes two forms: the texture of the actual surface of the work of art and the implied (illusionistically described) surface of objects represented in the work of art.

**Space** is what contains forms. It may be actual and three-dimensional, as it is with sculpture and architecture, or it may be fictional, represented illusionistically in two dimensions, as when artists represent recession into the distance on a flat surface—such as a wall or a canvas--by using various systems of perspective.

**Mass** and volume are properties of three-dimensional things. Mass is solid matter—whether sculpture or architecture—that takes up space. Volume is enclosed or defined space, and may be either solid or hollow. Like space, mass and volume may be illusionistically represented on a two-dimensional surface, such as in a painting or a photograph.

**Composition** is the organization, or arrangement, of forms in a work of art. Shapes and colors may be repeated or varied, balanced symmetrically or asymmetrically; they may be stable or dynamic. The possibilities are nearly endless and artistic choice depends both on the time and place where the work was created as well as the objectives of individual artists. Pictorial depth (spatial recession) is a specialized aspect of composition in which the three-dimensional world is represented on a flat surface, or *picture plane.* The area "behind" the picture plane is called the *picture space* and conventionally contains three "zones": *foreground, middle ground,* and *background.*

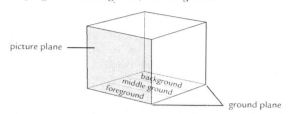

Various techniques for conveying a sense of pictorial depth have been devised by artists in different cultures and at different times. A number of them are diagrammed here. In some European art, the use of various systems of *perspective* has sought to create highly convincing illusions of recession into space. At other times and in other cultures, indications of recession are actually suppressed or avoided to emphasize surface rather than space.

**overlapping**

In overlapping, partially covered elements are meant to be seen as located behind those covering them.

**diminution**

In diminution of scale, successively smaller elements are perceived as being progressively farther away than the largest ones.

**vertical perspective**

Vertical perspective stacks elements, with the higher ones intended to be perceived as deeper in space.

**atmospheric perspective**

Through atmospheric perspective, objects in the far distance (often in bluish-gray hues) have less clarity than nearer objects. The sky becomes paler as it approaches the horizon.

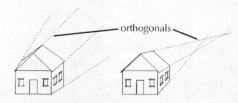

**divergent perspective**

In divergent or reverse perspective, forms widen slightly and imaginary lines called orthogonals diverge as they recede in space.

**intuitive perspective**

Intuitive perspective takes the opposite approach from divergent perspective. Forms become narrower and orthogonals converge the farther they are from the viewer, approximating the optical experience of spatial recession.

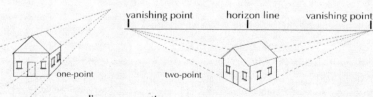

**linear perspective**

Linear perspective (also called scientific, mathematical, one-point and Renaissance perspective) is a rationalization or standardization of intuitive perspective that was developed in fifteenth-century Italy. It uses mathematical formulas to construct images in which all elements are shaped by, or arranged along, orthogonals that converge in one or more vanishing points on a horizon line.

# CONTENT

*Content* includes *subject matter*, but not all works of art have subject matter. Many buildings, paintings, sculptures, and other art objects include no recognizable references to things in nature nor to any story or historical situation, focusing instead on lines, colors, masses, volumes, and other formal elements. However, all works of art—even those without recognizable subject matter—have content, or meaning, insofar as they seek to communicate ideas, convey feelings, or affirm the beliefs and values of their makers, their patrons, and usually the people who originally viewed or used them.

Content may derive from the social, political, religious, and economic *contexts* in which a work was created, the *intention* of the artist, and the *reception* of the work by beholders (the audience). Art historians, applying different methods of *interpretation*, often arrive at different conclusions regarding the content of a work of art, and single works of art can contain more than one meaning because they are occasionally directed at more than one audience.

The study of subject matter is called *iconography* (literally, "the writing of images") and includes the identification of *symbols*—images that take on meaning through association, resemblance, or convention.

# STYLE

Expressed very broadly, *style* is the combination of form and composition that makes a work distinctive. *Stylistic analysis* is one of art history's most developed practices, because it is how art historians recognize the work of an individual artist or the characteristic manner of groups of artists working in a particular time or place. Some of the most commonly used terms to discuss *artistic styles* include *period style*, *regional style*, *representational style*, *abstract style*, *linear style*, and *painterly style*.

**Period style** refers to the common traits detectable in works of art and architecture from a particular historical era. It is good practice not to use the words "style" and "period" interchangeably. Style is the sum of many influences and characteristics, including the period of its creation. An example of proper usage is "an American house from the Colonial period built in the Georgian style."

**Regional style** refers to stylistic traits that persist in a geographic region. An art historian whose specialty is medieval art can recognize Spanish style through many successive medieval periods and can distinguish individual objects created in medieval Spain from other medieval objects that were created in, for example, Italy.

**Representational styles** are those that describe the appearance of recognizable subject matter in ways that make it seem lifelike.

> **Realism** and **Naturalism** are terms that some people used interchangeably to characterize artists' attempts to represent the observable world in a manner that appears to describe its visual appearance accurately. When capitalized, Realism refers to a specific period style discussed in Chapter 30.

> **Idealization** strives to create images of physical perfection according to the prevailing values or tastes of a culture. The artist may work in a representational style and idealize it to capture an underlying value or expressive effect.

> **Illusionism** refers to a highly detailed style that seeks to create a convincing illusion of physical reality by describing its visual appearance meticulously.

**Abstract styles** depart from mimicking lifelike appearance to capture the essence of a form. An abstract artist may work from nature or from a memory image of nature's forms and colors, which are simplified, stylized, perfected, distorted, elaborated, or otherwise transformed to achieve a desired expressive effect.

> **Nonrepresentational (or Nonobjective) Art** is a term often used for works of art that do not aim to produce recognizable natural imagery.

> **Expressionism** refers to styles in which the artist exaggerates aspects of form to draw out the beholder's subjective response or to project the artist's own subjective feelings.

**Linear** describes both styles and techniques. In linear styles artists use line as the primary means of definition. But linear paintings can also incorporate *modeling*—creating an illusion of three-dimensional substance through shading, usually executed so that brushstrokes nearly disappear.

**Painterly** describes a style of representation in which vigorous, evident brushstrokes dominate, and outlines, shadows, and highlights are brushed in freely.

# MEDIUM AND TECHNIQUE

*Medium* (plural, *media*) refers to the material or materials from which a work of art is made. Today, literally anything can be used to make a work of art, including not only traditional materials like paint, ink, and stone, but also rubbish, food, and the earth itself.

*Technique* is the process that transforms media into a work of art. Various techniques are explained throughout this book in Technique boxes. Two-dimensional media and techniques include painting, drawing, prints, and photography. Three-dimensional media and techniques are sculpture (for example, using stone, wood, clay or cast metal), architecture, and many small-scale arts (such as jewelry, containers, or vessels) in media such as ceramics, metal, or wood.

**Painting** includes wall painting and fresco, illumination (the decoration of books with paintings), panel painting (painting on wood panels), painting on canvas, and handscroll and hanging scroll painting. The paint in these examples is pigment mixed with a liquid vehicle, or binder. Some art historians also consider pictorial media such as mosaic and stained glass—where the pigment is arranged in solid form—as a type of painting.

**Graphic arts** are those that involve the application of lines and strokes to a two-dimensional surface or support, most often paper. Drawing is a graphic art, as are the various forms of printmaking. Drawings may be sketches (quick visual notes, often made in preparation for larger drawings or paintings); studies (more carefully drawn analyses of details or entire compositions); cartoons (full-scale drawings made in preparation for work in another medium, such as fresco, stained glass, or tapestry); or complete artworks in themselves. Drawings can be

made with ink, charcoal, crayon, or pencil. Prints, unlike drawings, are made in multiple copies. The various forms of printmaking include woodcut, the intaglio processes (engraving, etching, drypoint), and lithography.

**Photography** (literally, "light writing") is a medium that involves the rendering of optical images on light-sensitive surfaces. Photographic images are typically recorded by a camera.

**Sculpture** is three-dimensional art that is *carved, modeled, cast,* or *assembled.* Carved sculpture is subtractive in the sense that the image is created by taking away material. Wood, stone, and ivory are common materials used to create carved sculptures. Modeled sculpture is considered additive, meaning that the object is built up from a material, such as clay, that is soft enough to be molded and shaped. Metal sculpture is usually cast or is assembled by welding or a similar means of permanent joining.

Sculpture is either free-standing (that is, surrounded by space) or in pictorial relief. Relief sculpture projects from the background surface of the same piece of material. High-relief sculpture projects far from its background; low-relief sculpture is only slightly raised; and sunken relief, found mainly in ancient Egyptian art, is carved into the surface, with the highest part of the relief being the flat surface.

**Ephemeral arts** include processions, ceremonies, or ritual dances (often with décor, costumes, or masks); performance art; earthworks; cinema and video art; and some forms of digital or computer art. All impose a temporal limitation—the artwork is viewable for a finite period of time and then disappears forever, is in a constant state of change, or must be replayed to be experienced again.

**Architecture** creates enclosures for human activity or habitation. It is three-dimensional, highly spatial, functional, and closely bound with developments in technology and materials. Since it is difficult to capture in a photograph, several types of schematic drawings are commonly used to enable the visualization of a building:

> **Plans** depict a structure's masses and voids, presenting a view from above of the building's footprint or as if it had been sliced horizontally at about waist height.

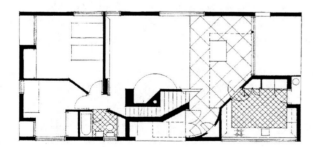

Plan: Philadelphia, Vanna Venturi House

**Sections** reveal the interior of a building as if it had been cut vertically from top to bottom.

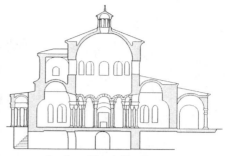

Section: Rome, Sta. Costanza

**Isometric Drawings** show buildings from oblique angles either seen from above ("bird's-eye view") to reveal their basic three-dimensional forms (often cut away so we can peek inside) or from below ("worm's-eye view") to represent the arrangement of interior spaces and the upward projection of structural elements.

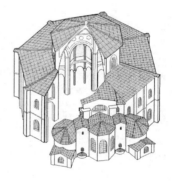

Isometric cutaway from above: Ravenna, San Vitale

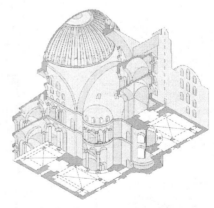

Isometric projection from below: Istanbul, Hagia Sophia

# INTRODUCTION

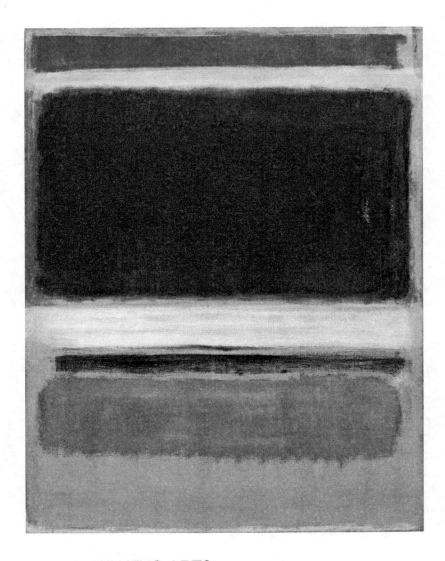

**INTRO-1 • Mark Rothko
NO. 3/NO. 13 (MAGENTA,
BLACK AND GREEN ON
ORANGE)**
1949. Oil on canvas, 7′1⅜″ × 5′5″
(2.165 × 1.648 m). Museum of
Modern Art, New York.

The title of this book seems clear. It defines a field of academic study and scholarly research that has achieved a secure place in college and university curricula across North America. But *Art History* couples two words—even two worlds—that are less well focused when separated. What is art? In what sense does it have a history? Students of art and its history should pause and engage, even if briefly, with these large questions before beginning the journey surveyed in the following chapters.

## WHAT IS ART?

Artists, critics, art historians, and the general public all grapple with this thorny question. The *Random House Dictionary* defines "art" as "the quality, production, expression, or realm of what is beautiful, or of more than ordinary significance." Others have characterized "art" as something human-made that combines creative imagination and technical skill and satisfies an innate desire for order and harmony—perhaps a human hunger for the

**HEAR MORE:** Listen to an audio file of your chapter **www.myartslab.com**

beautiful. This seems relatively straightforward until we start to look at modern and contemporary art, where there has been a heated and extended debate concerning "What is Art?" The focus is often far from questions of transcendent beauty, ordered design, or technical skill, and centers instead on the meaning of a work for an elite target audience or the attempt to pose challenging questions or unsettle deep-seated cultural ideas.

The works of art discussed in this book represent a privileged subset of artifacts produced by past and present cultures. They were usually meant to be preserved, and they are currently considered worthy of conservation and display. The determination of which artifacts are exceptional—which are works of art—evolves through the actions, opinions, and selections of artists, patrons, governments, collectors, archaeologists, museums, art historians, and others. Labeling objects as art is usually meant to signal that they transcended or now transcend in some profound way their practical function, often embodying cherished cultural ideas or foundational values. Sometimes it can mean they are considered beautiful, well designed, and made with loving care, but this is not always the case, especially in the twentieth and twenty-first centuries when the complex notion of what is art has little to do with the idea of beauty. Some critics and historians argue that works of art are tendentious embodiments of power and privilege, hardly sublime expressions of beauty or truth. After all, art can be unsettling as well as soothing, challenging as well as reassuring, whether made in the present or surviving from the past.

Increasingly we are realizing that our judgments about what constitutes art—as well as what constitutes beauty—are conditioned by our own education and experience. Whether acquired at home, in classrooms, in museums, at the movies, or on the internet, our responses to art are learned behaviors, influenced by class, gender, race, geography, and economic status as well as education. Even art historians find that their definitions of what constitutes art—and what constitutes artistic quality—evolve with additional research and understanding. Exploring works by twentieth-century painter Mark Rothko and nineteenth-century quiltmakers Martha Knowles and Henrietta Thomas demonstrates how definitions of art and artistic value are subject to change over time.

Rothko's painting, **MAGENTA, BLACK AND GREEN ON ORANGE (FIG. INTRO–1)**, is a well-known example of the sort of abstract painting that was considered the epitome of artistic sophistication by the mid-twentieth-century New York art establishment. It was created by an artist who meant it to be a work of art. It was acquired by the Museum of Modern Art in New York, and its position on the walls of that museum is a sure sign that it was accepted as such by a powerful cultural institution. However, beyond the context of the American artists, dealers, critics, and collectors who made up Rothko's art world, such paintings were often received with skepticism. They were seen by many as incomprehensible—lacking both technical skill and recognizable subject matter, two criteria that were part of the general public's definition of art at the time. Abstract paintings

soon inspired a popular retort: "That's not art; my child could do it!" Interestingly enough, Rothko saw in the childlike character of his own paintings one of the qualities that made them works of art. Children, he said, "put forms, figures, and views into pictorial arrangements, employing out of necessity most of the rules of optical perspective and geometry but without the knowledge that they are employing them." He characterized his own art as childlike, as "an attempt to recapture the freshness and naiveté of childish vision." In part because they are carefully crafted by an established artist who provided these kinds of intellectual justifications for their character and appearance, Rothko's abstract paintings are broadly considered works of art and are treasured possessions of major museums across the globe.

Works of art, however, do not always have to be created by individuals who perceive themselves as artists. Nor are all works produced for an art market surrounded by critics and collectors ready to explain, exhibit, and disperse them, ideally to prestigious museums. Such is the case with this quilt **(FIG. INTRO–2)**, made by Martha Knowles and Henrietta Thomas a century before Rothko's painting. Their work is similarly composed of blocks of color, and like Rothko, they produced their visual effect by arranging these flat chromatic shapes carefully and regularly on a rectangular field. But this quilt was not meant to hang on the wall of an art museum. It is the social product of a friendship, intended as an intimate gift, presented to a loved one for use in her home. An inscription on the quilt itself makes this clear—"From M. A. Knowles to her Sweet Sister Emma, 1843." Thousands of such friendship quilts

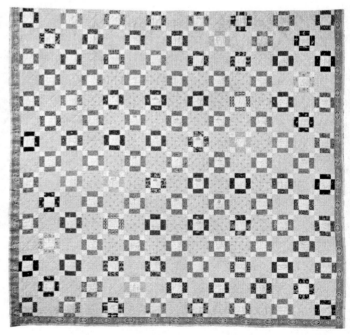

**INTRO-2 • Martha Knowles and Henrietta Thomas MY SWEET SISTER EMMA**
1843. Cotton quilt, 8′11″ × 9′1″ (2.72 × 2.77 m). International Quilt Studies Center, University of Nebraska, Lincoln, Nebraska.

## Art and Architecture

This book contains much more than paintings and textiles. Within these pages you will also encounter sculpture, vessels, books, jewelry, tombs, chairs, photographs, architecture, and more. But as with Rothko's *Magenta, Black, and Green on Orange* (SEE FIG. INTRO–1) and Knowles and Thomas's *My Sweet Sister Emma* (SEE FIG. INTRO–2), criteria have been used to determine which works are selected for inclusion in a book titled *Art History*. Architecture presents an interesting case.

Buildings meet functional human needs by enclosing human habitation or activity. Many works of architecture, however, are considered "exceptional" because they transcend functional demands by manifesting distinguished architectural design or because they embody in important ways the values and goals of the culture that built them. Such buildings are usually produced by architects influenced, like painters, by great works and traditions from the past. In some cases they harmonize with, or react to, their natural or urban surroundings. For such reasons, they are discussed in books on the history of art.

Typical of such buildings is the church of Nôtre-Dame-du-Haut in Ronchamp, France, designed and constructed between 1950 and 1955 by Swiss architect Charles-Edouard Jeanneret, better known by his pseudonym, Le Corbusier. This building is the product of a significant historical moment, rich in global cultural meaning. A pilgrimage church on this site had been destroyed during World War II, and the creation here of a new church symbolized the end of a devastating war, embodying hopes for a brighter global future. Le Corbusier's design—drawing on sources that ranged from Algerian mosques to imperial Roman villas, from crab shells to airplane wings—is sculptural as well as architectural. It soars at the crest of a hill toward the sky but at the same time seems solidly anchored in the earth. And its coordination with the curves of the natural landscape complement the creation of an outdoor setting for religious ceremonies (to the right in the figure) to supplement the church interior that Le Corbusier characterized as a "container for intense concentration." In fact, this building is so renowned today as a monument of modern architecture, that the bus-loads of pilgrims who arrive at the site are mainly architects and devotees of architectural history.

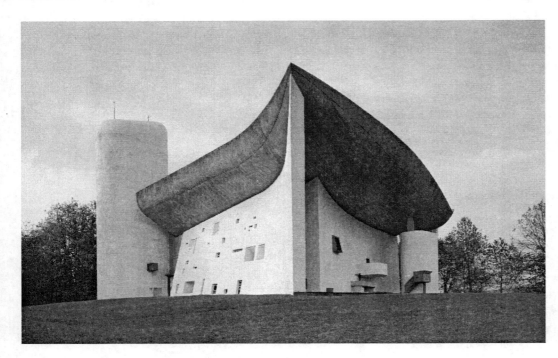

Le Corbusier **NÔTRE-DAME-DU-HAUT** 1950–1955. Ronchamp, France.

were made by women during the middle years of the nineteenth century for use on beds, either to provide warmth or as a covering spread. Whereas quilts were sometimes displayed to a broad and enthusiastic audience of producers and admirers at competitions held at state and county fairs, they were not collected by art museums or revered by artists until relatively recently.

In 1971, at the Whitney Museum in New York—an establishment bastion of the art world in which Rothko moved and worked—art historians Jonathan Holstein and Gail van der Hoof mounted an exhibition entitled "Abstract Design in American Quilts," demonstrating the artistic affiliation we have already noted in comparing the way Knowles and Thomas, like Rothko, create

abstract patterns with fields of color. Quilts were later accepted—or should the word be "appropriated?"—as works of art and hung on the walls of a New York art museum because of their visual similarities with the avant-garde, abstract works of art created by establishment, New York artists.

Art historian Patricia Mainardi took the case for quilts one significant step further in a pioneering article of 1973 published in *The Feminist Art Journal*. Entitled, "Quilts: The Great American Art," her argument was rooted not only in the aesthetic affinity of quilts with the esteemed work of contemporary abstract painters, but also in a political conviction that the definition of art had to be broadened. What was at stake here was historical veracity. Mainardi began, "Women have always made art. But for most women, the arts highest valued by male society have been closed to them for just that reason. They have put their creativity instead into the needlework arts, which exist in fantastic variety wherever there are women, and which in fact are a universal female art, transcending race, class, and national borders." She argued for the inclusion of quilts within the history of art to give deserved attention to the work of women artists who had been excluded from discussion because they created textiles and because they worked outside the male-dominated professional structures of the art world—because they were women. Quilts now hang as works of art on the walls of museums and appear with regularity in books that survey the history of art.

As these two examples demonstrate, definitions of art are rooted in cultural systems of value that are subject to change. And as they change, the list of works considered by art historians is periodically revised. Determining what to study is a persistent part of the art historian's task.

# WHAT IS ART HISTORY?

There are many ways to study or appreciate works of art. Art history represents one specific approach, with its own goals and its own methods of assessment and interpretation. Simply put, art historians seek to understand the meaning of art from the past within its original cultural contexts, both from the point of view of its producers—artists, architects, and patrons—as well as from the point of view of its consumers—those who formed its original audience. Coming to an understanding of the cultural meaning of a work of art requires detailed and patient investigation on many levels, especially with art that was produced long ago and in societies distinct from our own. This is a scholarly rather than an intuitive exercise. In art history, the work of art is seen as an embodiment of the values, goals, and aspirations of its time and place of origin. It is a part of culture.

Art historians use a variety of theoretical perspectives and a host of interpretive strategies to come to an understanding of works of art within their cultural contexts. But as a place to begin, the work of art historians can be divided into four types of investigation:

1. assessment of physical properties,
2. analysis of visual or formal structure,
3. identification of subject matter or conventional symbolism, and
4. integration within cultural context.

## ASSESSING PHYSICAL PROPERTIES

Of the methods used by art historians to study works of art, this is the most objective, but it requires close access to the work itself. Physical properties include shape, size, materials, and technique. For instance, many pictures are rectangular (e.g., SEE FIG. INTRO–1), but some are round (see page xxxi, FIG. C). Paintings as large as Rothko's require us to stand back if we want to take in the whole image, whereas some paintings (see page xxx, FIG. A) are so small that we are drawn up close to examine their detail. Rothko's painting and Knowles and Thomas's quilt are both rectangles of similar size, but they are distinguished by the materials from which they are made—oil paint on canvas versus cotton fabric joined by stitching. In art history books, most physical properties can only be understood from descriptions in captions, but when we are in the presence of the work of art itself, size and shape may be the first thing we notice. To fully understand medium and technique, however, it may be necessary to employ methods of scientific analysis or documentary research to elucidate the practices of artists at the time when and place where the work was created.

## ANALYZING FORMAL STRUCTURE

Art historians explore the visual character that artists bring to their works—using the materials and the techniques chosen to create them—in a process called **formal analysis**. On the most basic level, it is divided into two parts:

- assessing the individual visual elements or formal vocabulary that constitute pictorial or sculptural communication, and
- discovering the overall arrangement, organization, or structure of an image, a design system that art historians often refer to as **composition**.

THE ELEMENTS OF VISUAL EXPRESSION.    Artists control and vary the visual character of works of art to give their subjects and ideas meaning and expression, vibrancy and persuasion, challenge or delight (see "A Closer Look," pages xxx–xxxi). For example, the motifs, objects, figures, and environments within paintings can be sharply defined by line (SEE FIGS. INTRO–2 and INTRO–3), or they can be suggested by a sketchier definition (SEE FIGS. **INTRO–1** and INTRO–4). Painters can simulate the appearance of three-dimensional form through **modeling** or shading (SEE FIG. INTRO–3 and page xxxi, FIG. C), that is by describing the way light from a single source will highlight one side of a solid while leaving the other side in shadow. Alternatively, artists can avoid any strong sense of three-dimensionality by emphasizing patterns on a surface rather than forms in space (SEE FIG. INTRO–1 and page xxx, FIG. A). In addition to revealing the solid substance of forms through modeling, dramatic lighting can guide viewers to specific areas of a

# Visual Elements of Pictorial Expression ▸ Line, Light, Form, and Color.

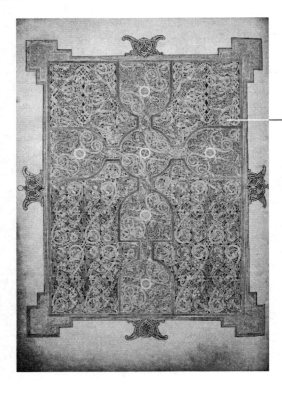

## LINE

**A.** *Carpet Page* **from the Lindisfarne Gospels**
From Lindisfarne, England.
c. 715–720. Ink and tempera
on vellum, 13⅜ × 9⁷⁄₁₆″ (34 ×
24 cm). British Library, London.
Cotton MS Nero D.IV fol. 26v

Every element in this complicated painting is sharply outlined by abrupt barriers between light and dark or between one color and another; there are no gradual or shaded transitions. Since the picture was created in part with pen and ink, the linearity is a logical feature of medium and technique. And although line itself is a "flattening" or two-dimensionalizing element in pictures, a complex and consistent system of overlapping gives the linear animal forms a sense of shallow but carefully worked-out three-dimensional relationships to one another.

## LIGHT

**B.** **Georges de la Tour** *The Education of the Virgin*
c. 1650. Oil on canvas, 33 × 39½″ (83.8 × 100.4 cm).
The Frick Collection, New York.

The source of illumination is a candle depicted within the painting. The young girl's upraised right hand shields its flame, allowing the artist to demonstrate his virtuosity in painting the translucency of human flesh.

Since the candle's flame is partially concealed, its luminous intensity is not allowed to distract from those aspects of the painting most brilliantly illuminated by it—the face of the girl and the book she is reading.

# FORM

**C. Michelangelo** *The Holy Family* (*Doni Tondo*)
c. 1503. Oil and tempera on panel, diameter 3'11¼" (1.2 m). Galleria degli Uffizi, Florence.

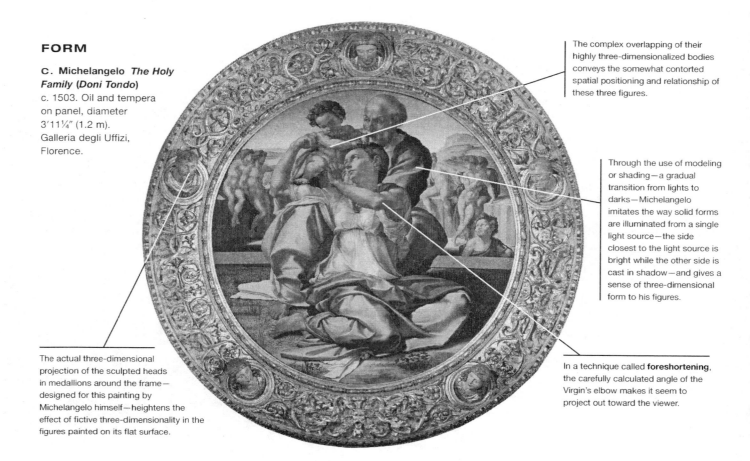

The complex overlapping of their highly three-dimensionalized bodies conveys the somewhat contorted spatial positioning and relationship of these three figures.

Through the use of modeling or shading—a gradual transition from lights to darks—Michelangelo imitates the way solid forms are illuminated from a single light source—the side closest to the light source is bright while the other side is cast in shadow—and gives a sense of three-dimensional form to his figures.

The actual three-dimensional projection of the sculpted heads in medallions around the frame—designed for this painting by Michelangelo himself—heightens the effect of fictive three-dimensionality in the figures painted on its flat surface.

In a technique called **foreshortening**, the carefully calculated angle of the Virgin's elbow makes it seem to project out toward the viewer.

Junayd chose to flood every aspect of his painting with light, as if everything in it were illuminated from all sides at once. As a result, the emphasis here is on jewel-like color. The vibrant tonalities and dazzling detail of the dreamy landscape are not only more important than the simulation of three-dimensional forms distributed within a consistently described space; they actually upstage the human drama taking place against a patterned, tipped-up ground in the lower third of the picture.

# COLOR

**D. Junayd** *Humay and Humayun,* **from a manuscript of the** *Divan* **of Kwaju Kirmani**
Made in Baghdad, Iraq. 1396. Color, ink, and gold on paper, 12⅝ × 9⁷⁄₁₆" (32 × 24 cm). British Library, London. MS Add. 18113, fol. 31r

picture (see page xxx, FIG. B), or it can be lavished on every aspect of a picture to reveal all its detail and highlight the vibrancy of its color (see page xxxi, FIG. D). Color itself can be muted or intensified, depending on the mood artists want to create or the tastes and expectations of their audiences.

Thus artists communicate with their viewers by making choices in the way they use and emphasize the elements of visual expression, and art historical analysis seeks to reveal how artists' decisions bring meaning to a work of art. For example in two paintings of women with children (SEE FIGS. INTRO–3 and INTRO–4), Raphael and Renoir work with the same visual elements of line, form, light, and color in the creation of their images, but they employ these shared elements to differing expressive ends. Raphael concentrates on line to clearly differentiate each element of his picture as a separate form. Careful modeling describes these outlined forms as substantial solids surrounded by space. This gives his subjects a sense of clarity, stability, and grandeur. Renoir, on the other hand, foregrounds the flickering of light and the play of color as he downplays the sense of three-dimensionality in individual forms. This gives his image a more ephemeral, casual sense. Art historians pay close attention to such variations in the use of visual elements—the building blocks of artistic expression—and use visual analysis to characterize the expressive effect of a particular work, a particular artist, or a general period defined by place and date.

COMPOSITION. When art historians analyze composition, they focus not on the individual elements of visual expression but on the overall arrangement and organizing design or structure of a work of art. In Raphael's **MADONNA OF THE GOLDFINCH (FIG. INTRO–3)**, for example, the group of figures has been arranged in a triangular shape and placed at the center of the picture. Raphael emphasized this central weighting by opening the clouds to reveal a patch of blue in the middle of the sky, and by flanking the figural group with lace-like trees. Since the Madonna is

at the center and since the two boys are divided between the two sides of the triangular shape, roughly—though not precisely—equidistant from the center of the painting, this is a bilaterally symmetrical composition: on either side of an implied vertical line at the center of the picture, there are equivalent forms on left and right, matched and balanced in a mirrored correspondence. Art historians refer to such an implied line—around which the elements of a picture are organized—as an **axis**. Raphael's painting has not only a vertical, but also a horizontal axis, indicated by a line of demarcation between light and dark—as well as between degrees of color saturation—in the terrain of the landscape. The belt of the Madonna's dress is aligned with this horizontal axis, and this correspondence, taken with the coordination of her head with the blue patch in the sky, relates her to the order of the natural world in which she sits, lending a sense of stability, order, and balance to the picture as a whole.

**INTRO-3 • Raphael MADONNA OF THE GOLDFINCH (MADONNA DEL CARDELLINO)**
1506. Oil on panel, 42 × 29½" (106.7 × 74.9 cm). Galleria degli Uffizi, Florence.

The vibrant colors of this important work were revealed in the course of a careful, ten-year restoration, completed only in 2008.

INTRO–4 •
Auguste Renoir
**MME. CHARPENTIER
AND HER CHILDREN**
1878. Oil on canvas,
60½ × 74⅞" (153.7 ×
190.2 cm). Metropolitan
Museum of Art, New York.

The main axis in Renoir's painting of **MME. CHARPENTIER AND HER CHILDREN (FIG. INTRO–4)** is neither vertical, nor horizontal, but diagonal, running from the upper right to the lower left corner of the painting. All major elements of the composition are aligned along this axis—dog, children, mother, and the table and chair that represent the most complex and detailed aspect of the setting. The upper left and lower right corners of the painting balance each other on either side of the diagonal axis as relatively simple fields of neutral tone, setting off and framing the main subjects between them. The resulting arrangement is not bilaterally symmetrical, but blatantly asymmetrical, with the large figural mass pushed into the left side of the picture. And unlike Raphael's composition, where the spatial relationship of the figures and their environment is mapped by the measured placement of elements that become increasingly smaller in scale and fuzzier in definition as they recede into the background, the relationship of Renoir's figures to their spatial environment is less clearly defined as they recede into the background along the dramatic diagonal axis. Nothing distracts us from the bold informality of this family gathering.

Both Raphael and Renoir arrange their figures carefully and purposefully, but they follow distinctive compositional systems that communicate different notions of the way these figures interact with each other and the world around them. Art historians pay special attention to how pictures are arranged because composition is one of the principal ways artists charge their paintings with expressive meaning.

## IDENTIFYING SUBJECT MATTER

Art historians have traditionally sought subject matter and meaning in works of art with a system of analysis that was outlined by Irwin Panofsky (1892–1968), an influential German scholar who was expelled from his academic position by the Nazis in 1933 and spent the rest of his career of research and teaching in the United States. Panofsky proposed that when we seek to understand the subject of a work of art, we derive meaning initially in two ways:

- First we perceive what he called "natural subject matter" by recognizing forms and situations that we know from our own experience.
- Then we use what he called "**iconography**" to identify the conventional meanings associated with forms and figures as bearers of narrative or symbolic content, often specific to a particular time and place.

Some paintings, like Rothko's abstractions, do not contain subjects drawn from the world around us, from stories, or from conventional symbolism, but Panofsky's scheme remains a standard method of investigating meaning in works of art that present narrative subjects, portray specific people or places, or embody cultural values with iconic imagery or allegory.

## Iconography ▸ The study and identification of conventional themes, motifs, and symbols to elucidate the subject matter of works of art.

These grapes sit on an imported, Italian silver *tazza*, a luxury object that may commemorate Northern European prosperity and trade. This particular object recurs in several of Peeters's other still lifes.

An image of the artist herself appears on the reflective surface of this pewter tankard, one of the ways that she signed her paintings and promoted her career.

Luscious fruits and flowers celebrate the abundance of nature, but because these fruits of the earth will eventually fade, even rot, they could be moralizing references to the transience of earthly existence.

These coins, including one minted in 1608–1609, help focus the dating of this painting. The highlighting of money within a still life could reference the wealth of the owner—or it could subtly allude to the value the artist has crafted here in paint.

Detailed renderings of insects showcased Peeters's virtuosity as a painter, but they also may have symbolized the vulnerability of the worldly beauty of flowers and fruit to destruction and decay.

This knife—which appears in several of Peeters's still lifes—is of a type that is associated with wedding gifts.

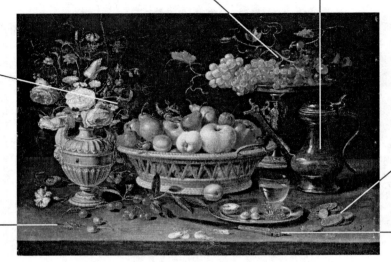

**A. Clara Peeters Still Life with Fruit and Flowers**
c. 1612. Oil on copper, 25⅕ × 35″ (64 × 89 cm). Ashmolean Museum, Oxford.

Quince is an unusual subject in Chinese painting, but the fruit seems to have carried personal significance for Zhu Da. One of his friends was known as the Daoist of Quince Mountain, a site in Hunan province that was also the subject of a work by one of his favorite authors, Tang poet Li Bai.

The artist's signature reads "Bada Shanren painted this," using a familiar pseudonym in a formula and calligraphic style that the artist ceased using in 1695.

This red block is a seal with an inscription drawn from a Confucian text: "teaching is half of learning." This was imprinted on the work by the artist as an aspect of his signature, a symbol of his identity within the picture, just as the reflection and inscribed knife identify Clara Peeters as the painter of her still life.

**B. Zhu Da (Bada Shanren) Quince (Mugua)**
1690. Album leaf mounted as a hanging scroll; ink and colors on paper, 7⅞ × 5¾″ (20 × 14.6 cm). Princeton University Art Museum.

NATURAL SUBJECT MATTER. We recognize some things in works of visual art simply by virtue of living in a world similar to that represented by the artist. For example, in the two paintings by Raphael and Renoir just examined (SEE FIGS. INTRO–3 and INTRO–4), we immediately recognize the principal human figures in both as a woman and two children, boys in the case of Raphael's painting, girls in Renoir's. We can also make a general identification of the animals: a bird in the hand of Raphael's boys, and a pet dog under one of Renoir's girls. And natural subject matter can extend from an identification of figures to an understanding of the expressive significance of their postures and facial features. We might see in the boy who snuggles between the knees of the woman in Raphael's painting, placing his own foot on top of hers, an anxious child seeking the security of physical contact with a trusted caretaker—perhaps his mother—in response to fear of the bird he reaches out to touch. Many of us have seen insecure children take this very pose in response to potentially unsettling encounters.

The closer the work of art is in both time and place to our own situation temporally and geographically, the easier it sometimes is to identify what is represented. But although Renoir painted his picture over 125 years ago in France, the furniture in the background still looks familiar, as does the book in the hand of Raphael's Madonna, painted five centuries before our time. But the object hanging from the belt of the scantily clad boy at the left in this painting will require identification for most of us. Iconographic investigation is necessary to understand the function of this form.

ICONOGRAPHY. Some subjects are associated with conventional meanings established at a specific time or place; some of the human figures portrayed in works of art have specific identities; and some of the objects or forms have symbolic or allegorical meanings in addition to their natural subject matter. Discovering these conventional meanings of art's subject matter is called iconography. (See "A Closer Look," opposite.)

For example, the woman accompanied in the outdoors by two boys in Raphael's *Madonna of the Goldfinch* (SEE FIG. INTRO–3) would have been immediately recognized by members of its intended sixteenth-century Florentine audience as the Virgin Mary. Viewers would have identified the naked boy standing between her knees as her son Jesus, and the boy holding the bird as Jesus' cousin John the Baptist, sheathed in the animal skin garment that he would wear in the wilderness and equipped with a shallow cup attached to his belt, ready to be used in baptisms. Such attributes of clothing and equipment are often critical in making iconographic identifications. The goldfinch in the Baptist's hand was at this time and place a symbol of Christ's death on the cross, an allegorical implication that makes the Christ Child's retreat into secure contact with his mother—already noted on the level of natural subject matter—understandable in relation to a specific story. The comprehension of conventional meanings in this painting would have been almost automatic among those for whom it was painted, but for us,

separated by time and place, some research is necessary to recover associations that are no longer part of our everyday world.

Although it may not initially seem as unfamiliar, the subject matter of Renoir's 1878 portrait of *Mme. Charpentier and her Children* (SEE FIG. INTRO–4) is in fact even more obscure. Although there are those in twenty-first-century American culture for whom the figures and symbols in Raphael's painting are still recognizable and meaningful, Marguérite-Louise Charpentier died in 1904, and no one living today would be able to identify her based on the likeness Renoir presumably gave to her face in this family portrait commissioned by her husband, wealthy and influential publisher George Charpentier. We need the painting's title to make that identification. And Mme. Charpentier is outfitted here in a gown created by English designer Charles Frederick Worth, the dominant figure in late nineteenth-century Parisian high fashion. Her clothing was a clear attribute of her wealth for those who recognized its source; most of us need to investigate to uncover its meaning. But a greater surprise awaits the student who pursues further research on her children. Although they clearly seem to our eyes to represent two daughters, the child closest to Mme. Charpentier is actually her son Paul, who at age three, following standard Parisian bourgeois practice, has not yet had his first hair cut and still wears clothing comparable to that of his older sister Georgette, perched on the family dog. It is not unusual in art history to encounter situations where our initial conclusions on the level of natural subject matter will need to be revised after some iconographic research.

## INTEGRATION WITHIN CULTURAL CONTEXT

Natural subject matter and iconography were only two of three steps proposed by Panofsky for coming to an understanding of the meaning of works of art. The third step he labeled "**iconology**," and its aim is to interpret the work of art as an embodiment of its cultural situation, to place it within broad social, political, religious, and intellectual contexts. Such integration into history requires more than identifying subject matter or conventional symbols; it requires a deep understanding of the beliefs and principles or goals and values that underlie a work of art's cultural situation as well as the position of an artist and patron within it.

In "A Closer Look" (opposite), the subject matter of two **still life** paintings (pictures of inanimate objects and fruits or flowers taken out of their natural contexts) is identified and elucidated, but to truly understand these two works as bearers of cultural meaning, more knowledge of the broader context and specific goals of artists and audiences is required. For example, the fact that Zhu Da (1626–1705) became a painter was rooted more in the political than the artistic history of China at the middle of the seventeenth century. As a member of the imperial family of the Ming dynasty, his life of privilege was disrupted when the Ming were overthrown during the Manchu conquest of China in 1644. Fleeing for his life, he sought refuge in a Buddhist monastery, where he wrote poetry and painted. Almost 40 years later, in the aftermath of a nervous breakdown (that could have been staged to avoid retribution for his

family background), Zhu Da abandoned his monastic life and developed a career as a professional painter, adopting a series of descriptive pseudonyms—most notably Bada Shanren ("mountain man of eight greatnesses") by which he is most often known today. His paintings are at times saturated with veiled political commentary; at times they seek to accommodate the expectations of collectors to assure their marketability; and in paintings like the one illustrated here (see page xxxiv, FIG. B), the artist seems to hark back to the contemplative, abstract, and spontaneous paintings associated with great Zen masters such as Muqi (c. 1201–after 1269), whose calligraphic pictures of isolated fruits seem almost like acts of devotion or detached contemplations on natural forms, rather than the works of a professional painter.

Clara Peeters's still life (see page xxxiv, FIG. A), on the other hand, fits into a developing Northern European painting tradition within which she was an established and successful professional, specializing in portrayals of food and flowers, fruit and reflective objects. Still-life paintings in this tradition could be jubilant celebrations of the abundance of the natural world and the wealth of luxury objects available in the prosperous mercantile society of the Netherlands. Or they could be moralizing "*vanitas*" paintings, warning of the ephemeral meaning of those worldly possessions, even of life itself. But this painting has also been interpreted in a more personal way. Because the type of knife that sits in the foreground near the edge of the table was a popular wedding gift, and since it is inscribed with the artist's own name, some have suggested that this still life could have celebrated Peeters's marriage. Or it could simply be a witty way to sign her picture. It certainly could be both personal and participate in the broader cultural meaning of still-life paintings at the same time. Mixtures of private and public meanings have been proposed for Zhu Da's paintings as well. The picture of quince illustrated here (see page xxxiv, FIG. B) has been seen as one in a series of allegorical "self-portraits" that extend across his career as a painter. Art historians frequently reveal multiple meanings when interpreting single works of art. They usually represent complex cultural and personal situations.

# A CASE STUDY: ROGIER VAN DER WEYDEN'S PHILADELPHIA CRUCIFIXION

The basic, four-part method of art historical investigation and interpretation just outlined and explored, becomes clearer when its extended use is traced in relation to one specific work of art. A particularly revealing subject for such a case study is a seminal and somewhat perplexing painting now in the Philadelphia Museum of Art—the **CRUCIFIXION WITH THE VIRGIN AND ST. JOHN THE EVANGELIST (FIG. INTRO–5)** by Rogier van der Weyden (c. 1400–1464), a Flemish artist who will be featured in Chapter 18. Each of the four levels of art historical inquiry reveals important information about this painting, information that has been used by

art historians to reconstruct its relationship to its artist, its audience, and its broader cultural setting. The resulting interpretation is rich, but also complex. An investigation this extensive will not be possible for all the works of art in the following chapters, where the text will focus only on one or two facets of more expansive research. Because of the amount and complexity of information involved in a thorough art-historical interpretation, it is sometimes only in a second reading that we can follow the subtleties of its argument, after the first reading has provided a basic familiarity with the work of art, its conventional subjects, and its general context.

## PHYSICAL PROPERTIES

Perhaps the most striking aspect of this painting's physical appearance is its division into two separate tall rectangular panels, joined by a frame to form a coherent, almost square composition. These are oak panels, prepared with chalk to form a smooth surface on which to paint with mineral pigments suspended in oil. A technical investigation of the painting in 1981 used infra-red reflectography to reveal a very sketchy underdrawing beneath the surface of the paint, proving to the investigators that this painting is almost entirely the work of Rogier van der Weyden himself. Famous and prosperous artists of this time and place employed many assistants to work in large production workshops, and they would render detailed underdrawings to assure that assistants replicated the style of the master. But in cases where the masters themselves intended to execute the work, only summary compositional outlines were needed. This modern technical investigation of Rogier's painting also used **dendrochronology** (the dating of wood based on the patterns of the growth rings) to date the oak panels and consequently the painting itself, now securely situated near the end of the artist's career, c. 1460.

The most recent restoration of the painting—during the early 1990s by Mark Tucker, Senior Conservator at the Philadelphia Museum of Art—returned it, as close as possible, to current views of its original fifteenth-century appearance (see "Recovering the Past," page xxxviii). This project included extensive technical analysis of almost every aspect of the picture, during which a critical clue emerged, one that may lead to a sharper understanding of its original use. X-rays revealed dowel holes and plugs running in a horizontal line about one-fourth of the way up from the bottom across the entire expanse of the two-panel painting. Tucker's convincing research suggests that the dowels would have attached these two panels to the backs of wooden boxes that contained sculptures in a complex work of art that hung over the altar in a fifteenth-century church.

## FORMAL STRUCTURE

The visual organization of this two-part painting emphasizes both connection and separation. It is at the same time one painting and two. Continuing across both panels is the strip of midnight blue sky and the stone wall that constricts space within the picture to a shallow corridor, pushing the figures into the foreground and close

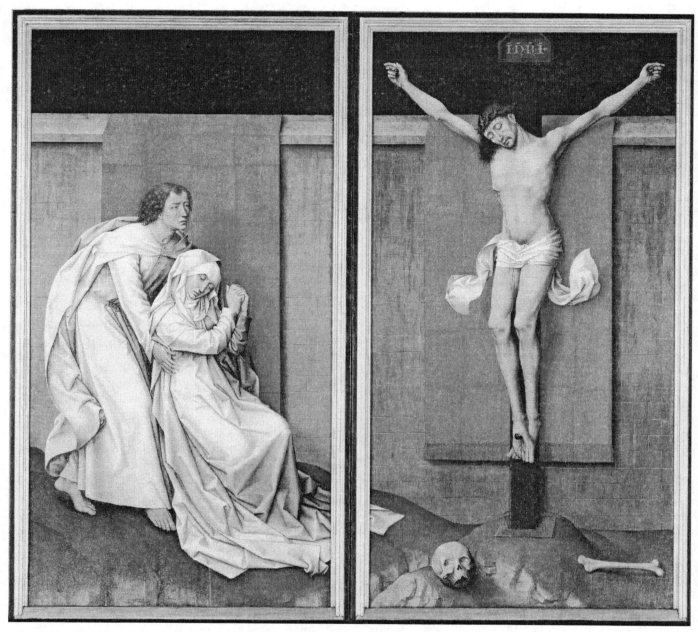

**INTRO-5** • Rogier van der Weyden **CRUCIFIXION WITH THE VIRGIN AND ST. JOHN THE EVANGELIST**
c. 1460. Oil on oak panels, 71 × 73″ (1.8 × 1.85 m). John G. Johnson Collection, Philadelphia Museum of Art.

to the viewer. The platform of mossy ground under the two-figure group in the left panel continues its sloping descent into the right panel, as does the hem of the Virgin's ice-blue garment. We look into this scene as if through a window with a mullion down the middle and assume that the world on the left continues behind this central strip of frame into the right side.

On the other hand, strong visual forces isolate the figures within their respective panels, setting up a system of "compare and contrast" that seems to be at the heart of the painting's design. The striking red cloths that hang over the wall are centered directly behind the figures on each side, forming internal frames that

highlight them as separate groups and focus our attention back and forth between them rather than on the pictorial elements that unite their environments. As we begin to compare the two sides, it becomes increasingly clear that the relationship between figures and environment is quite distinct on each side of the divide.

The dead figure of Christ on the cross, elevated to the very top of the picture, is strictly centered within his panel, as well as against the cloth that hangs directly behind him. The grid of masonry blocks and creases in the cloth emphasizes his rectilinear integration into a system of balanced, rigid regularity. His head is aligned with the cap of the wall, his flesh largely contained within

# RECOVERING THE PAST | De-restoring and Restoring Rogier van der Weyden's *Crucifixion*

Ever since Rogier van der Weyden's strikingly asymmetrical, two-panel rendering of the *Crucifixion* (SEE FIG. INTRO–5) was purchased by Philadelphia lawyer John G. Johnson in 1906 for his spectacular collection of European paintings, it has been recognized not only as one of the greatest works by this master of fifteenth-century Flemish painting, but as one of the most important European paintings in North America. Soon after the Johnson Collection became part of the Philadelphia Museum of Art in 1933, however, this painting's visual character was significantly transformed. In 1941 the museum employed freelance restorer David Rosen to work on the painting. Deciding that Rogier's work was seriously marred by later overpainting and disfigured by the discoloration of old varnish, he subjected the painting to a thorough cleaning. He also removed the strip of dark blue paint forming the sky above the wall at the top—identifying it as an 18th-century restoration—and replaced it with gold leaf to conform with remnants of gold in this area that he assessed as surviving fragments of the original background. Rosen's restoration of Rogier's painting was uncritically accepted for almost half a century, and the gold background became a major factor in the interpretations of art historians as distinguished as Irwin Panofsky and Meyer Schapiro.

In 1990, in preparation for a new installation of the work, Rogier's painting received a thorough technical analysis by Mark Tucker, the museum's Senior Conservator. There were two startling discoveries:

- The dark blue strip that had run across the top of the picture before Rosen's intervention was actually original to the painting. Remnants of paint left behind in 1941 proved to be the same azurite blue that also appears in the clothing of the Virgin, and in no instance did the traces of gold discovered in 1941 run under aspects of the original paint surface. Rosen had removed Rogier's original midnight blue sky.

- What Rosen had interpreted as disfiguring varnish streaking the wall and darkening the brilliant cloths of honor hanging over it were actually Rogier's careful painting of lichens and water stains on the stone and his overpainting on the fabric that had originally transformed a vermillion undercoat into deep crimson cloth.

In meticulous work during 1992–1993, Tucker cautiously restored the painting based on the evidence he had uncovered. Neither the lost lichens and water stains nor the toning crimson overpainting of the hangings were replaced, but a coat of blue-black paint was laid over Rosen's gold leaf at the top of the panels, taking care to apply the new layer in such a way that should a later generation decide to return to the gold leaf sky, the midnight tonalities could be easily removed. That seems an unlikely prospect. The painting as exhibited today comes as close as possible to the original appearance of Rogier's *Crucifixion*. At least we think so.

---

the area defined by the cloth. His elbows mark the juncture of the wall with the edge of the hanging, and his feet extend just to the end of the cloth, where his toes substitute for the border of fringe they overlap. The environment is almost as balanced. The strip of dark sky at the top is equivalent in size to the strip of mossy earth at the bottom of the picture, and both are visually bisected by centered horizontals—the cross bar at the top and the alignment of bone and skull at the bottom. A few disruptions to this stable, rectilinear, symmetrical order draw the viewers' attention to the panel at the left: the downward fall of the head of Christ, the visual weight of the skull, the downturn of the fluttering loin cloth, and the tip of the Virgin's gown that transgresses over the barrier to move in from the other side.

John and Mary merge on the left into a single figural mass that could be inscribed into a half-circle. Although set against a rectilinear grid background comparable to that behind Jesus, they contrast with, rather than conform to, the regular sense of order. Their curving outlines offer unsettling unsteadiness, as if they are toppling to the ground, jutting into the other side of the frame. This instability is reinforced by their postures. The projection of Mary's knee in relation to the angle of her torso reveals that she is collapsing into a curve, and the crumpled mass of drapery circling underneath her only underlines her lack of support. John reaches out to catch her, but he has not yet made contact with her body. He strikes a stance of strident instability without even touching the ground, and he looks blankly out into space with an unfocused

expression, distracted from, rather than concentrating on, the task at hand. Perhaps he will come to his senses and grab her. But will he be able to catch her in time, and even then support her given his unstable posture? The moment is tense; the outcome is unclear. But we are moving into the realm of natural subject matter. The poignancy of this concentrated portrayal seems to demand it.

## ICONOGRAPHY

The subject of this painting is among the most familiar themes in the history of European art. The dead Jesus has been crucified on the cross, and two of his closest associates—his mother and John, one of his disciples—mourn his loss. Although easily recognizable, the austere and asymmetrical presentation is unexpected. More usual is an earlier painting of this subject by the same artist, **CRUCIFIXION TRIPTYCH WITH DONORS AND SAINTS (FIG. INTRO–6)**, where he situates the crucified Christ at the center of a symmetrical arrangement, the undisputed axial focus of the composition. The scene unfolds here within an expansive landscape, populated with a wider cast of participants, each of whom takes a place with symmetrical decorum on either side of the cross. Because most crucifixions follow some variation on this pattern, Rogier's two-panel portrayal (SEE FIG. INTRO–5) in which the cross is asymmetrically displaced to one side, with a spare cast of attendants relegated to a separately framed space, severely restricted by a stark stone wall, requires some explanation. As does the mysterious dark world beyond the wall, and the artificial backdrop of the textile hangings.

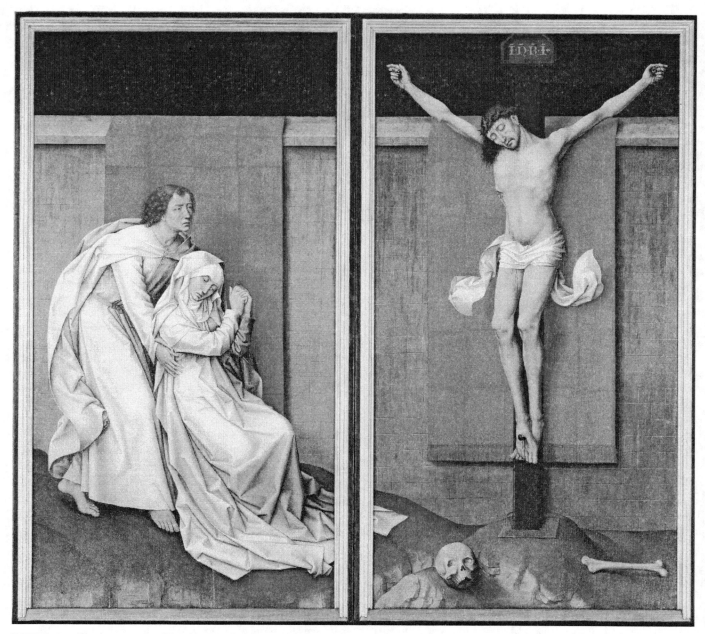

**INTRO–5** • Rogier van der Weyden **CRUCIFIXION WITH THE VIRGIN AND ST. JOHN THE EVANGELIST**
c. 1460. Oil on oak panels, 71 × 73″ (1.8 × 1.85 m). John G. Johnson Collection, Philadelphia Museum of Art.

to the viewer. The platform of mossy ground under the two-figure group in the left panel continues its sloping descent into the right panel, as does the hem of the Virgin's ice-blue garment. We look into this scene as if through a window with a mullion down the middle and assume that the world on the left continues behind this central strip of frame into the right side.

On the other hand, strong visual forces isolate the figures within their respective panels, setting up a system of "compare and contrast" that seems to be at the heart of the painting's design. The striking red cloths that hang over the wall are centered directly behind the figures on each side, forming internal frames that

highlight them as separate groups and focus our attention back and forth between them rather than on the pictorial elements that unite their environments. As we begin to compare the two sides, it becomes increasingly clear that the relationship between figures and environment is quite distinct on each side of the divide.

The dead figure of Christ on the cross, elevated to the very top of the picture, is strictly centered within his panel, as well as against the cloth that hangs directly behind him. The grid of masonry blocks and creases in the cloth emphasizes his rectilinear integration into a system of balanced, rigid regularity. His head is aligned with the cap of the wall, his flesh largely contained within

Ever since Rogier van der Weyden's strikingly asymmetrical, two-panel rendering of the *Crucifixion* (SEE FIG. INTRO–5) was purchased by Philadelphia lawyer John G. Johnson in 1906 for his spectacular collection of European paintings, it has been recognized not only as one of the greatest works by this master of fifteenth-century Flemish painting, but as one of the most important European paintings in North America. Soon after the Johnson Collection became part of the Philadelphia Museum of Art in 1933, however, this painting's visual character was significantly transformed. In 1941 the museum employed freelance restorer David Rosen to work on the painting. Deciding that Rogier's work was seriously marred by later overpainting and disfigured by the discoloration of old varnish, he subjected the painting to a thorough cleaning. He also removed the strip of dark blue paint forming the sky above the wall at the top—identifying it as an 18th-century restoration—and replaced it with gold leaf to conform with remnants of gold in this area that he assessed as surviving fragments of the original background. Rosen's restoration of Rogier's painting was uncritically accepted for almost half a century, and the gold background became a major factor in the interpretations of art historians as distinguished as Irwin Panofsky and Meyer Schapiro.

In 1990, in preparation for a new installation of the work, Rogier's painting received a thorough technical analysis by Mark Tucker, the museum's Senior Conservator. There were two startling discoveries:

- The dark blue strip that had run across the top of the picture before Rosen's intervention was actually original to the painting. Remnants of paint left behind in 1941 proved to be the same azurite blue that also appears in the clothing of the Virgin, and in no instance did the traces of gold discovered in 1941 run under aspects of the original paint surface. Rosen had removed Rogier's original midnight blue sky.

- What Rosen had interpreted as disfiguring varnish streaking the wall and darkening the brilliant cloths of honor hanging over it were actually Rogier's careful painting of lichens and water stains on the stone and his overpainting on the fabric that had originally transformed a vermillion undercoat into deep crimson cloth.

In meticulous work during 1992–1993, Tucker cautiously restored the painting based on the evidence he had uncovered. Neither the lost lichens and water stains nor the toning crimson overpainting of the hangings were replaced, but a coat of blue-black paint was laid over Rosen's gold leaf at the top of the panels, taking care to apply the new layer in such a way that should a later generation decide to return to the gold leaf sky, the midnight tonalities could be easily removed. That seems an unlikely prospect. The painting as exhibited today comes as close as possible to the original appearance of Rogier's *Crucifixion*. At least we think so.

---

the area defined by the cloth. His elbows mark the juncture of the wall with the edge of the hanging, and his feet extend just to the end of the cloth, where his toes substitute for the border of fringe they overlap. The environment is almost as balanced. The strip of dark sky at the top is equivalent in size to the strip of mossy earth at the bottom of the picture, and both are visually bisected by centered horizontals—the cross bar at the top and the alignment of bone and skull at the bottom. A few disruptions to this stable, rectilinear, symmetrical order draw the viewers' attention to the panel at the left: the downward fall of the head of Christ, the visual weight of the skull, the downturn of the fluttering loin cloth, and the tip of the Virgin's gown that transgresses over the barrier to move in from the other side.

John and Mary merge on the left into a single figural mass that could be inscribed into a half-circle. Although set against a rectilinear grid background comparable to that behind Jesus, they contrast with, rather than conform to, the regular sense of order. Their curving outlines offer unsettling unsteadiness, as if they are toppling to the ground, jutting into the other side of the frame. This instability is reinforced by their postures. The projection of Mary's knee in relation to the angle of her torso reveals that she is collapsing into a curve, and the crumpled mass of drapery circling underneath her only underlines her lack of support. John reaches out to catch her, but he has not yet made contact with her body. He strikes a stance of strident instability without even touching the ground, and he looks blankly out into space with an unfocused

expression, distracted from, rather than concentrating on, the task at hand. Perhaps he will come to his senses and grab her. But will he be able to catch her in time, and even then support her given his unstable posture? The moment is tense; the outcome is unclear. But we are moving into the realm of natural subject matter. The poignancy of this concentrated portrayal seems to demand it.

## ICONOGRAPHY

The subject of this painting is among the most familiar themes in the history of European art. The dead Jesus has been crucified on the cross, and two of his closest associates—his mother and John, one of his disciples—mourn his loss. Although easily recognizable, the austere and asymmetrical presentation is unexpected. More usual is an earlier painting of this subject by the same artist, **CRUCIFIXION TRIPTYCH WITH DONORS AND SAINTS (FIG. INTRO–6)**, where he situates the crucified Christ at the center of a symmetrical arrangement, the undisputed axial focus of the composition. The scene unfolds here within an expansive landscape, populated with a wider cast of participants, each of whom takes a place with symmetrical decorum on either side of the cross. Because most crucifixions follow some variation on this pattern, Rogier's two-panel portrayal (SEE FIG. INTRO–5) in which the cross is asymmetrically displaced to one side, with a spare cast of attendants relegated to a separately framed space, severely restricted by a stark stone wall, requires some explanation. As does the mysterious dark world beyond the wall, and the artificial backdrop of the textile hangings.

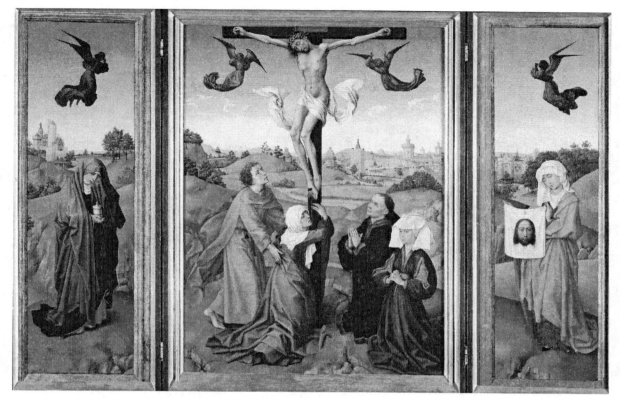

**INTRO-6** • Rogier van der Weyden **CRUCIFIXION TRIPTYCH WITH DONORS AND SAINTS**
c. 1440. Oil on wooden panels, 39¾ × 55″ (101 × 140 cm). Kunsthistorisches Museum, Vienna.

This scene is not only austere and subdued; it is sharply focused, and the focus relates it to the specific moment in the story that Rogier decided to represent. The Christian Bible contains four accounts of Jesus' crucifixion, one in each of the four Gospels. Rogier took two verses in John's account as his painting's text (John 19:26–27), cited here in the Douay-Rheims literal English translation of the Latin Vulgate Bible used by Western European Christians during the fifteenth century:

> When Jesus therefore had seen his mother and the disciple standing whom he loved, he saith to his mother: Woman, behold thy son. After that, he saith to the disciple: Behold thy mother. And from that hour, the disciple took her to his own.

Even the textual source uses conventions that need explanation, specifically the way the disciple John is consistently referred to in this Gospel as "the disciple whom Jesus loved." Rogier's painting, therefore, seems to focus on Jesus' call for a newly expanded relationship between his mother and a beloved follower. More specifically, he has projected us slightly forward in time to the moment when John needs to respond to that call—Jesus has died; John is now in charge.

There are, however, other conventional iconographic associations with the crucifixion that Rogier has folded into this spare portrayal. Fifteenth-century viewers would have understood the skull and femur that lie on the mound at the base of the cross as

the bones of Adam—the first man in the Hebrew Bible account of creation—on whose grave Jesus' crucifixion was believed to have taken place. This juxtaposition embodied the Christian belief that Christ's sacrifice on the cross redeemed believers from the death that Adam's original sin had brought to human existence.

Mary's swoon and presumed loss of consciousness would have evoked another theological idea, the *co-passio*, in which Mary's anguish while witnessing Jesus' suffering and death was seen as a parallel passion of mother with son, both critical for human salvation. Their connection in this painting is underlined visually by the similar bending of their knees, inclination of their heads, and closing of their eyes. They even seem to resemble each other in facial likeness, especially when compared to John.

### CULTURAL CONTEXT

In 1981 art historian Penny Howell Jolly published an interpretation of Rogier's Philadelphia *Crucifixion* as a product of a broad personal and cultural context. In addition to building on the work of earlier art historians, she pursued two productive lines of investigation to explain the rationale for this unusually austere presentation:

- the prospect that Rogier was influenced by the work of another artist, and
- the possibility that the painting was produced for an institutional context that called for a special mode of visual presentation and a particular iconographic focus.

**INTRO-7 • VIEW OF A MONK'S CELL IN THE MONASTERY OF SAN MARCO, FLORENCE**
Including Fra Angelico's fresco of the *Annunciation*, c. 1438–1445.

FRA ANGELICO AT SAN MARCO. We know very little about the life of Rogier van der Weyden, but we do know that in 1450, when he was already established as one of the principal painters in northern Europe, he made a pilgrimage to Rome. Either on his way to Rome, or during his return journey home, he stopped off in Florence and saw the altarpiece, and presumably also the frescos, that Fra Angelico (c. 1400–1455) and his workshop had painted during the 1440s at the monastery of San Marco. The evidence of Rogier's contact with Fra Angelico's work is found in a work Rogier painted after he returned home, based on a panel of the San Marco altarpiece. For the Philadelphia *Crucifixion*, however, it was Fra Angelico's devotional frescos on the walls of the monks' individual rooms (or cells) that seem to have had the greatest impact **(FIG. INTRO–7)**. Jolly compared the Philadelphia *Crucifixion* with a scene of

the Man of Sorrows at San Marco to demonstrate the connection **(FIG. INTRO–8)**. Fra Angelico presented the sacred figures with a quiet austerity that recalls Rogier's unusual composition. More specific parallels are the use of an expansive stone wall to restrict narrative space to a shallow foreground corridor, the description of the world beyond that wall as a dark sky that contrasts with the brilliantly illuminated foreground, and the use of a draped cloth of honor to draw attention to a narrative vignette from the life of Jesus, to separate it out as an object of devotion.

THE CARTHUSIANS. Having established a possible connection between Rogier's unusual late painting of the crucifixion and frescos by Fra Angelico that he likely saw during his pilgrimage to Rome in 1450, Jolly reconstructed a specific context of patronage and meaning within Rogier's own world in Flanders that could explain why the paintings of Fra Angelico would have had such an impact on him at this particular moment in his career.

During the years around 1450, Rogier developed a personal and profession relationship with the monastic order of the Carthusians, and especially with the Belgian Charterhouse (or Carthusian monastery) of Hérrines, where his only son was invested as a monk in 1450. Rogier gave money to Hérrines, and

**INTRO-8 • Fra Angelico MAN OF SORROWS FRESCO IN CELL 7**
c. 1441–1445. Monastery of San Marco, Florence.

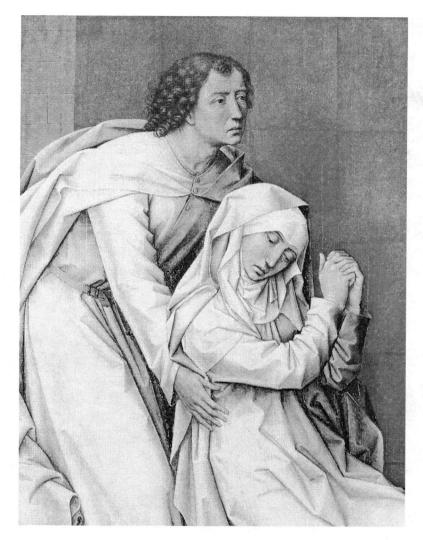

a poignant moment in the life of St. John (**FIG INTRO-9**) could have been especially meaningful to the artist himself at the time this work was painted?

**A CONTINUING PROJECT.** The final word has not been spoken in the interpretation of this painting. Mark Tucker's recent work on the physical evidence revealed by x-ray analysis points toward seeing these two panels as part of a large sculptured altarpiece. Even if this did preclude the prospect that it is the panel painting Rogier donated to the chapel of St. Catherine at Hérinnes, it does not negate the relationship Jolly drew with Fra Angelico, nor the Carthusian context she outlined for the work's original situation. It simply reminds us that our historical understanding of works such as this will evolve when new evidence about them emerges.

As the history of art unfolds in the ensuing chapters of this book, it will be important to keep two things in mind as you read the characterizations of individual works of art and the larger story of their integration into the broader cultural contexts of those who made them and those for whom they were initially made. Art-historical interpretations are built on extended research comparable to that we have just summarily surveyed for Rogier van der Weyden's Philadelphia *Crucifixion*. But the work of interpretation is never complete. Art history is a continuing project, a work perpetually in progress.

texts document his donation of a painting to its chapel of Saint Catherine. Jolly suggested that the Philadelphia *Crucifixion* could be that painting. Its subdued colors and narrative austerity are consistent with Carthusian aesthetic attitudes, and the walled setting of the scene recalls the enclosed gardens that were attached to the individual dormitory rooms of Carthusian monks. The reference in this painting to the *co-passio* of the Virgin provides supporting evidence since this theological idea was central to Carthusian thought and devotion. The *co-passio* was even reflected in the monks' own initiation rites, during which they reenacted and sought identification with both Christ's sacrifice on the cross and the Virgin's parallel suffering.

In Jolly's interpretation, the religious framework of a Carthusian setting for the painting emerges as a personal framework for the artist himself, since this *Crucifixion* seems to be associated with important moments in his own life—his religious pilgrimage to Rome in 1450 and the initiation of his only son as a Carthusian monk at about the same time. Is it possible that the sense of loss and separation that Rogier evoked in his portrayal of

## THINK ABOUT IT

I.1   How would you define a work of art?

I.2   What are the four separate steps proposed here for characterizing the methods used by art historians to interpret works of art?

I.3   Choose a painting illustrated in this chapter and analyze its composition.

I.4   Characterize the difference between natural subject matter and iconography, focusing your discussion on one work discussed in this chapter.

I.5   What aspect of the case study of Rogier van der Weyden's Philadelphia *Crucifixion* was especially interesting to you? Explain why. How did it broaden your understanding of what you will learn in this course?

**PRACTICE MORE:** Compose answers to these questions, get flashcards for images and terms, and review chapter material with quizzes
**www.myartslab.com**

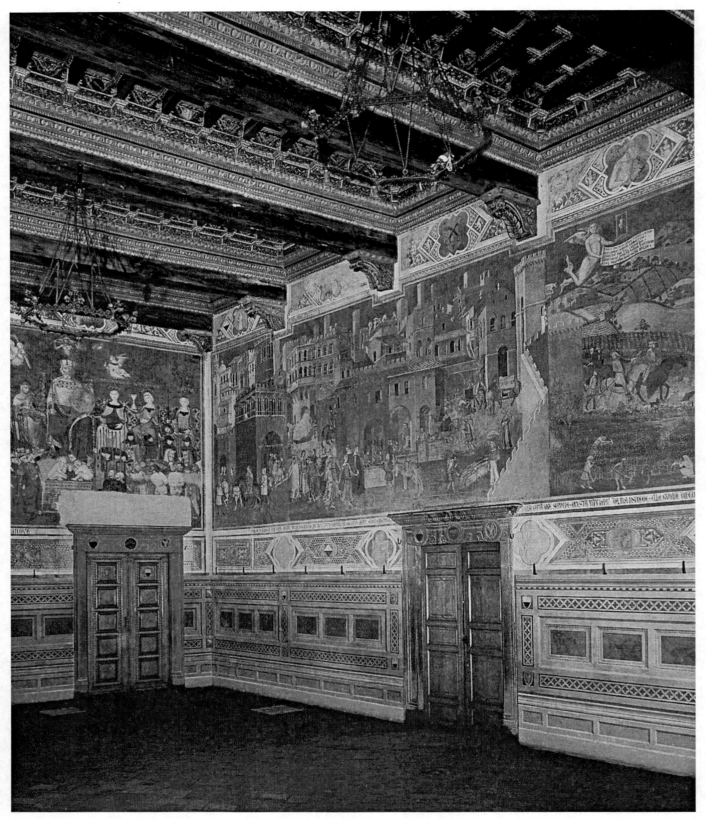

**17–1** • Ambrogio Lorenzetti **FRESCOS OF THE SALA DEI NOVE (OR SALA DELLA PACE)**
Palazzo Pubblico, Siena, Italy. 1338–1339. Length of long wall about 46′ (14 m).

**EXPLORE MORE:** Gain insight from a primary source related to the frescos in the Palazzo Pubblico
www.myartslab.com

# FOURTEENTH-CENTURY ART IN EUROPE

In 1338, the Nine—a council of merchants and bankers that governed Siena as an oligarchy—commissioned frescos from renowned Sienese painter Ambrogio Lorenzetti (c. 1295–c. 1348) for three walls in the chamber within the Palazzo Pubblico where they met to conduct city business. This commission came at the moment of greatest prosperity and security since the establishment of their government in 1287.

Lorenzetti's frescos combine allegory with panoramic landscapes and cityscapes, communicating ideology to visualize the justification for and positive effects of Sienese government. The moral foundation of the rule of the Nine is outlined in a complicated allegory in which seated personifications (far left in FIG. 17–1) of Concord, Justice, Peace, Strength, Prudence, Temperance, and Magnanimity not only diagram good governance but actually reference the Last Judgment in a bold assertion of the relationship between secular rule and divine authority. This tableau contrasts with a similar presentation of bad government, where Tyranny is flanked by the personified forces that keep tyrants in power—Cruelty, Treason, Fraud, Fury, Division, and War. A group of scholars would have devised this complex program of symbols and meanings; it is unlikely that Lorenzetti would have known the philosophical works that underlie them.

Lorenzetti's fame, however, and the wall paintings' secure position among the most remarkable surviving mural programs of the period, rests on the other part of this ensemble—the effects of good and bad government in city and country life (SEE FIG. 17–15).

Unlike the tableau showing the perils of life under tyrannical rule, the panoramic view of life under good government—which in this work of propaganda means life under the rule of the Nine—is well preserved. A vista of fourteenth-century Siena—identifiable by the cathedral dome and tower peeking over the rooftops in the background—details carefree life within shops, schools, taverns, and work-sites, as the city streets bustle with human activity. Outside, an expansive landscape highlights agricultural productivity.

Unfortunately, within a decade of the frescos' completion, life in Siena was no longer as stable and carefree. The devastating bubonic plague visited in 1348—Ambrogio Lorenzetti himself was probably one of the victims—and the rule of the Nine collapsed in 1355. But this glorious vision of joyful prosperity preserves the dreams and aspirations of a stable government, using some of the most progressive and creative ideas in fourteenth-century Italian art, ideas whose development we will trace over the next two centuries.

## LEARN ABOUT IT

**17.1** Assess the close connections between works of art and their patrons in fourteenth-century Europe.

**17.2** Compare and contrast the Florentine and Sienese narrative painting traditions as exemplified by Giotto and Duccio.

**17.3** Discover the rich references to everyday life and human emotions that begin to permeate figural art in this period.

**17.4** Explore the production of small-scale works, often made of precious materials and highlighting extraordinary technical virtuosity, that continues from the earlier Gothic period.

**17.5** Evaluate the regional manifestations of the fourteenth-century Gothic architectural style.

**HEAR MORE:** Listen to an audio file of your chapter **www.myartslab.com**

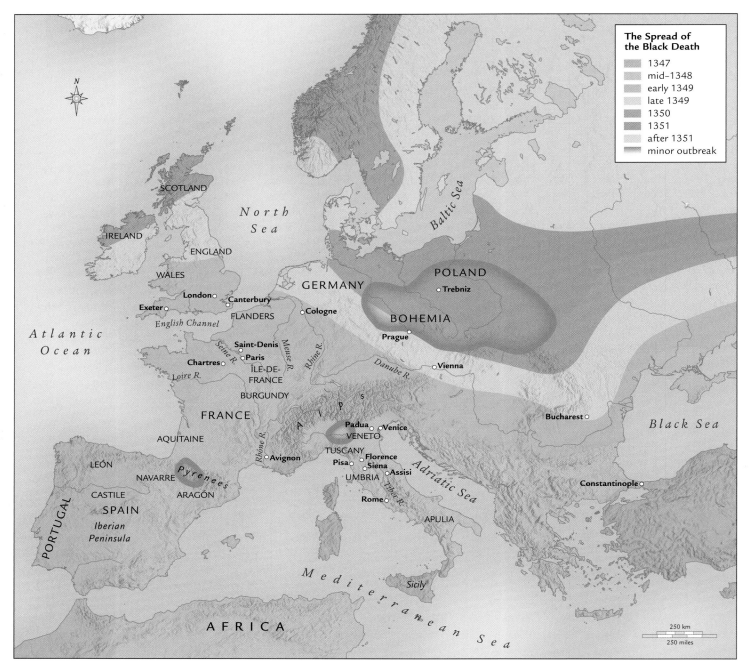

The Spread of
the Black Death

| | |
|---|---|
| | 1347 |
| | mid–1348 |
| | early 1349 |
| | late 1349 |
| | 1350 |
| | 1351 |
| | after 1351 |
| | minor outbreak |

250 km

250 miles

**MAP 17-1 • EUROPE IN THE FOURTEENTH CENTURY**

From its outbreak in the Mediterranean the Black Death in 1347 swept across the European mainland over the next four years.

# FOURTEENTH-CENTURY EUROPE

Literary luminaries Dante, Petrarch, Boccaccio, Chaucer, and Christine de Pizan (see "A New Spirit in Fourteenth-Century Literature," opposite) and the visionary painters Cimabue, Duccio, Jean Pucelle, and Giotto participated in a cultural explosion that swept through fourteenth-century Europe, and especially Italy. The poet Petrarch (1304–1374) was a towering figure in this change, writing his love lyrics in Italian, the language of everyday life, rather than Latin, the language of ceremony and high art. Similarly the deeply moving murals of Florentine painter Giotto di Bondone (c. 1277–1337) were rooted in his observation of the people around him, giving the participants in sacred narratives both great dignity and striking humanity, thus making them familiar, yet new, to the audiences that originally experienced them. Even in Paris—still the artistic center of Europe as far as refined taste and technical

## A New Spirit in Fourteenth-Century Literature

For Petrarch and his contemporaries, the essential qualifications for a writer were an appreciation of Greek and Roman authors and an ability to observe the people living around them. Although fluent in Latin, they chose to write in the language of their own time and place—Italian, English, French. Leading the way was Dante Alighieri (1265–1321), who wrote *The Divine Comedy*, his great summation of human virtue and vice, and ultimately human destiny, in Italian, establishing his daily vernacular as worthy to express great literary themes.

Francesco Petrarca, called simply Petrarch (1304–1374), raised the status of secular literature with his sonnets to his unobtainable beloved, Laura, his histories and biographies, and his writings on the joys of country life in the Roman manner. Petrarch's imaginative updating of Classical themes in a work called *The Triumphs*—which examines the themes of Chastity triumphant over Love, Death over Chastity, Fame over Death, Time over Fame, and Eternity over Time—provided later Renaissance poets and painters with a wealth of allegorical subject matter.

More earthy, Giovanni Boccaccio (1313–1375) perfected the art of the short story in *The Decameron*, a collection of amusing and moralizing tales told by a group of young Florentines who moved to the countryside to escape the Black Death. With wit and sympathy, Boccaccio presents the full spectrum of daily life in Italy. Such secular literature, written in Italian as it was then spoken in Tuscany, provided a foundation for fifteenth-century Renaissance writers.

In England, Geoffrey Chaucer (c. 1342–1400) was inspired by Boccaccio to write his own series of stories, *The Canterbury Tales*, told by pilgrims traveling to the shrine of St. Thomas à Becket (1118?–1170) in Canterbury. Observant and witty, Chaucer depicted the pretensions and foibles, as well as the virtues, of humanity.

Christine de Pizan (1364–c. 1431), born in Venice but living and writing at the French court, became an author out of necessity when she was left a widow with three young children and an aged mother to support. Among her many works are a poem in praise of Joan of Arc and a history of famous women—including artists—from antiquity to her own time. In *The Book of the City of Ladies*, she defended women's abilities and argued for women's rights and status.

These writers, as surely as Giotto, Duccio, Peter Parler, and Master Theodoric, led the way into a new era.

---

sophistication were concerned—the painter Jean Pucelle began to show an interest in experimenting with established conventions.

Changes in the way that society was organized were also under way, and an expanding class of wealthy merchants supported the arts as patrons. Artisan guilds—organized by occupation—exerted quality control among members and supervised education through an apprenticeship system. Admission to the guild came after examination and the creation of a "masterpiece"—literally, a piece fine enough to achieve master status. The major guilds included cloth finishers, wool merchants, and silk manufacturers, as well as pharmacists and doctors. Painters belonged to the pharmacy guild, perhaps because they used mortars and pestles to grind their colors. Their patron saint, Luke, who was believed to have painted the first image of the Virgin Mary, was also a physician—or so they thought. Sculptors who worked in wood and stone had their own guild, while those who worked in metals belonged to another. Guilds provided social services for their members, including care of the sick and funerals for the deceased. Each guild had its patron saint, maintained a chapel, and participated in religious and civic festivals.

Despite the cultural flourishing and economic growth of the early decades, by the middle of the fourteenth century much of Europe was in crisis. Prosperity had fostered population growth, which began to exceed food production. A series of bad harvests compounded this problem with famine. To make matters worse, a prolonged conflict known as the Hundred Years' War (1337–1453) erupted between France and England. Then, in mid century, a lethal plague known as the Black Death swept across Europe (**MAP 17–1**), wiping out as much as 40 percent of the population. In spite of these catastrophic events, however, the strong current of cultural change still managed to persist through to the end of the century and beyond.

## ITALY

As great wealth promoted patronage of art in fourteenth-century Italy, artists began to emerge as individuals, in the modern sense, both in their own eyes and in the eyes of patrons. Although their methods and working conditions remained largely unchanged from the Middle Ages, artists in Italy contracted freely with wealthy townspeople and nobles as well as with civic and religious bodies. Perhaps it was their economic and social freedom that encouraged ambition and self-confidence, individuality and innovation.

### FLORENTINE ARCHITECTURE AND METALWORK

The typical medieval Italian city was a walled citadel on a hilltop. Houses clustered around the church and an open city square. Powerful families added towers to their houses, both for defense

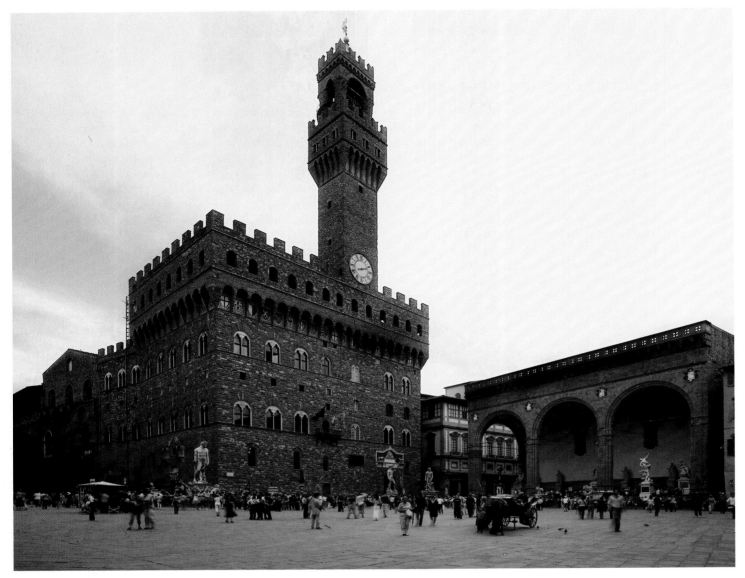

**17-2 • PIAZZA DELLA SIGNORIA WITH PALAZZO DELLA SIGNORIA (TOWN HALL) 1299-1310, AND LOGGIA DEI LANZI (LOGGIA OF THE LANCERS), 1376-1382**
Florence.

SEE MORE: Click the Google Earth link for the Palazzo della Signoria www.myartslab.com

and as expressions of family pride. In Florence, by contrast, the ancient Roman city—with its axial rectangular plan and open city squares—formed the basis for civic layout. The cathedral stood northeast of the ancient forum and a street following the Roman plan connected it with the Piazza della Signoria, the seat of the government.

**THE PALAZZO DELLA SIGNORIA.** The Signoria (ruling body, from *signore*, meaning "Lord") that governed Florence met in the **PALAZZO DELLA SIGNORIA**, a massive fortified building with a tall bell tower 300 feet high (**FIG. 17-2**). The building faces a large square, or piazza, which became the true center of Florence. The town houses around the piazza often had benches along their walls to provide convenient public seating. Between 1376 and 1382,

master builders Benci di Cione and Simone Talenti constructed a huge **loggia** or covered open-air corridor at one side—now known as the Loggi dei Lanzi (Loggia of the Lancers)—to provide a sheltered locale for ceremonies and speeches.

**THE BAPTISTERY DOORS.** In 1330, Andrea Pisano (c. 1290–1348) was awarded the prestigious commission for a pair of gilded bronze doors for the Florentine Baptistery of San Giovanni, situated directly in front of the cathedral. (Andrea's "last" name means "from Pisa;" he was not related to Nicola and Giovanni Pisano.) The doors were completed within six years and display 20 scenes from the **LIFE OF JOHN THE BAPTIST** (the San Giovanni to whom the baptistery is dedicated) set above eight personifications of the Virtues (**FIG. 17-3**). The overall effect is two-dimensional and

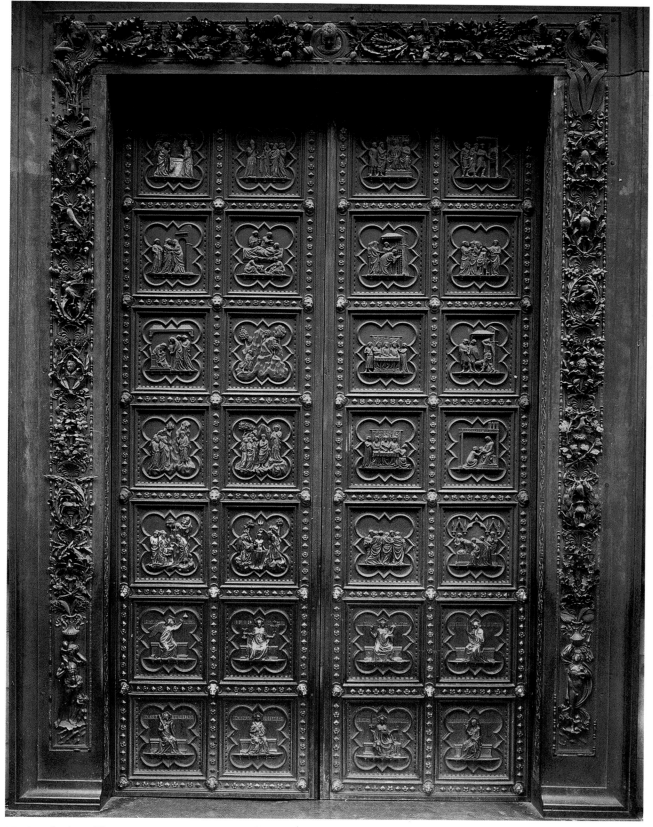

**17-3 •** Andrea Pisano **LIFE OF JOHN THE BAPTIST**
South doors, Baptistery of San Giovanni, Florence. 1330–1336. Gilded bronze, each panel 19¼ × 17"
(48 × 43 cm). Frame, Ghiberti workshop, mid-15th century.

The bronze vine scrolls filled with flowers, fruits, and birds on the lintel and jambs framing the door
were added in the mid fifteenth century.

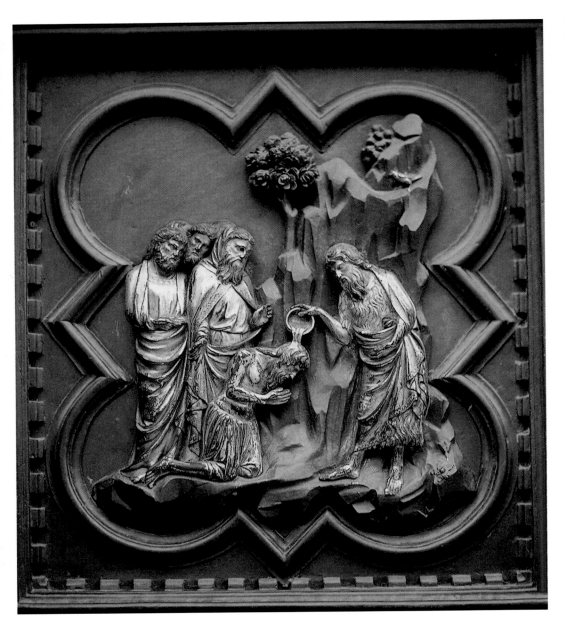

decorative: a grid of 28 rectangles with repeated quatrefoils filled by the graceful, patterned poses of delicate human figures. Within the quatrefoil frames, however, the figural compositions create the illusion of three-dimensional forms moving within the described spaces of natural and architectural worlds.

The scene of John baptizing a multitude **(FIG. 17–4)** takes place on a shelflike stage created by a forward extension of the rocky natural setting, which also expands back behind the figures into a corner of the quatrefoil frame. Composed as a rectangular group, the gilded figures present an independent mass of modeled forms. The illusion of three-dimensionality is enhanced by the way the curving folds of their clothing wrap around their bodies. At the same time, their graceful gestures and the elegant fall of their drapery reflect the soft curves and courtly postures of French Gothic art. Their quiet dignity, however, seems particular to the work of Andrea himself.

## FLORENTINE PAINTING

Florence and Siena, rivals in so many ways, each supported a flourishing school of painting in the fourteenth century. Both grew out of thirteenth-century painting traditions and engendered individual artists who became famous in their own time. The Byzantine influence—the *maniera greca* ("Greek style")—continued to provide models of dramatic pathos and narrative iconography, as well as stylized features including the use of gold for drapery folds and striking contrasts of highlights and shadows in the modeling of individual forms. By the end of the fourteenth century, the painter and commentator Cennino Cennini (see "Cennino Cennini on Panel Painting," page 544) would be struck by the accessibility and modernity of Giotto's art, which, though it retained traces of the *maniera greca*, was moving toward the depiction of a lifelike, contemporary world anchored in three-dimensional forms.

**CIMABUE.** In Florence, this transformation to a more modern style began a little earlier than in Siena. About 1280, a painter named Cenni di Pepi (active c. 1272–1302), better known by his nickname "Cimabue," painted a panel portraying the **VIRGIN AND CHILD ENTHRONED (FIG. 17–5)**, perhaps for the main altar of the church of Santa Trinità in Florence. At over 12 feet tall, this enormous painting set a new precedent for monumental altarpieces. Cimabue surrounds the Virgin and Child with angels and places a row of Hebrew Bible prophets beneath them. The hieratically scaled figure of Mary holds the infant Jesus in her lap. Looking out at the viewer while gesturing toward her son as the

path to salvation, she adopts a formula popular in Byzantine iconography since at least the seventh century (SEE FIG. 7–29).

Mary's huge throne, painted to resemble gilded bronze with inset enamels and gems, provides an architectural framework for the figures. Cimabue creates highlights on the drapery of Mary, Jesus, and the angels with thin lines of gold, as if to capture their divine radiance. The viewer seems suspended in space in front of the image, simultaneously looking down on the projecting elements of the throne and Mary's lap, while looking straight ahead at the prophets at the base of the throne and the angels at each side. These spatial ambiguities, the subtle asymmetries within the

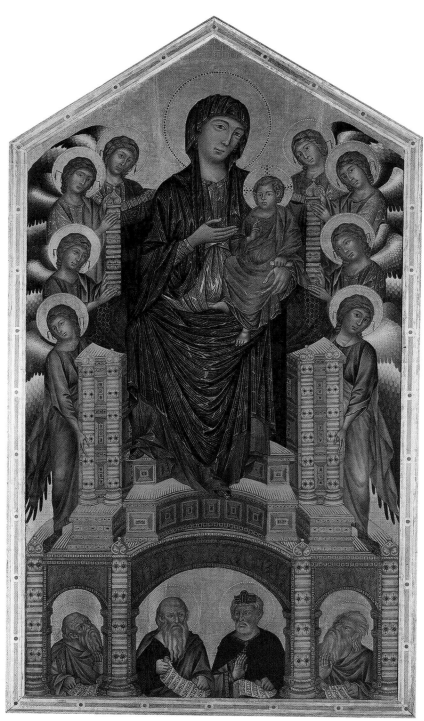

**17-5 • Cimabue VIRGIN AND CHILD ENTHRONED**
Most likely painted for the high altar of the church of Santa Trinità, Florence. c. 1280. Tempera and gold on wood panel, 12′7″ × 7′4″ (3.53 × 2.2 m). Galleria degli Uffizi, Florence.

**SEE MORE:** See a video about the egg tempera process
**www.myartslab.com**

centralized composition, the Virgin's engaging gaze, and the individually conceived faces of the old men give the picture a sense of life and the figures a sense of presence. Cimabue's ambitious attention to spatial volumes, his use of delicate modeling in light and shade to simulate three-dimensional form, and his efforts to give naturalistic warmth to human figures had an impact on the future development of Italian painting.

GIOTTO DI BONDONE. According to the sixteenth-century chronicler Giorgio Vasari, Cimabue discovered a talented shepherd boy, Giotto di Bondone, and taught him to paint—and "not only did the young boy equal the style of his master, but he became such an excellent imitator of nature that he completely banished that crude Greek [i.e., Byzantine] style and revived the modern and excellent art of painting, introducing good drawing from live natural models, something which had not been done for more than two hundred years" (Vasari, translated by Bondanella and Bondanella, p. 16). After his training, Giotto may have collaborated on murals at the prestigious church of St. Francis in Assisi. We know he worked for the Franciscans in Florence and absorbed facets of their teaching. St. Francis's message of simple, humble devotion, direct experience of God, and love for all creatures was

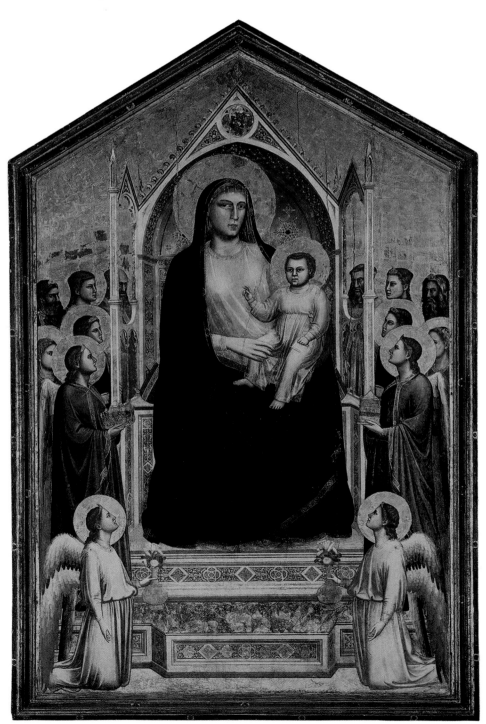

**17-6 • Giotto di Bondone VIRGIN AND CHILD ENTHRONED**
Most likely painted for the high altar of the church of the Ognissanti (All Saints), Florence. 1305–1310. Tempera and gold on wood panel, 10′8″ × 6′8¼″ (3.53 × 2.05 m). Galleria degli Uffizi, Florence.

**EXPLORE MORE:** Gain insight from a primary source by Dante Alighieri that references Giotto di Bondone
www.myartslab.com

The two techniques used in mural painting are *buon* ("true") *fresco* ("fresh"), in which paint is applied with water-based paints on wet plaster, and *fresco secco* ("dry"), in which paint is applied to a dry plastered wall. The two methods can be used on the same wall painting.

The advantage of *buon fresco* is its durability. A chemical reaction occurs as the painted plaster dries, which bonds the pigments into the wall surface. In *fresco secco*, by contrast, the color does not become part of the wall and tends to flake off over time. The chief disadvantage of *buon fresco* is that it must be done quickly without mistakes. The painter plasters and paints only as much as can be completed in a day, which explains the Italian term for each of these sections: **giornata**, or a day's work. The size of a *giornata* varies according to the complexity of the painting within it. A face, for instance, might take an entire day, whereas large areas of sky can be painted quite rapidly. In Giotto's Scrovegni Chapel, scholars have identified 852 separate *giornate*, some worked on concurrently within a single day by assistants in Giotto's workshop.

In medieval and Renaissance Italy, a wall to be frescoed was first prepared with a rough, thick undercoat of plaster known as the *arriccio*. When this was dry, assistants copied the master painter's composition onto it with reddish-brown pigment or charcoal. The artist made any necessary adjustments. These underdrawings, known as **sinopia**, have an immediacy and freshness lost in the finished painting. Work proceeded in irregularly shaped *giornate* conforming to the contours of major figures and objects. Assistants covered one section at a time with a fresh, thin coat of very fine plaster—the *intonaco*—

over the *sinopia*, and when this was "set" but not dry, the artist worked with pigments mixed with water, painting from the top down so that drips fell on unfinished portions. Some areas requiring pigments such as ultramarine blue (which was unstable in *buon fresco*), as well as areas requiring gilding, would be added after the wall was dry using the *fresco secco* technique.

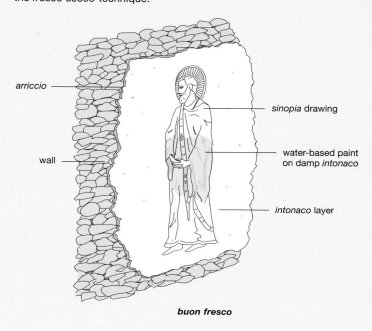

arriccio

wall

sinopia drawing

water-based paint
on damp *intonaco*

*intonaco* layer

**buon fresco**

gaining followers throughout western Europe, and it had a powerful impact on thirteenth- and fourteenth-century Italian literature and art.

Compared to Cimabue's *Virgin and Child Enthroned*, Giotto's panel of the same subject (**FIG. 17–6**), painted about 30 years later for the church of the Ognissanti (All Saints) in Florence, exhibits greater spatial consistency and sculptural solidity while retaining some of Cimabue's conventions. The position of the figures within a symmetrical composition reflects Cimabue's influence. Gone, however, are Mary's modestly inclined head and the delicate gold folds in her drapery. Instead, light and shadow play gently across her stocky form, and her action—holding her child's leg instead of pointing him out to us—seems less contrived. This colossal Mary overwhelms her slender Gothic tabernacle of a throne, where figures peer through openings and haloes overlap faces. In spite of the hieratic scale and the formal, enthroned image and flat, gold background, Giotto has created the sense that these are fully three-dimensional beings, whose plainly draped, bulky bodies inhabit real space. The Virgin's solid torso is revealed by her thin tunic, and Giotto's angels are substantial solids whose foreshortened postures project from the foreground toward us, unlike those of Cimabue, which stay on the surface along lateral strips composed of overlapping screens of color.

Although he was trained in the Florentine tradition, many of Giotto's principal works were produced elsewhere. After a sojourn in Rome during the last years of the thirteenth century, he was called to Padua in northern Italy soon after 1300 to paint frescos (see "Buon Fresco," above) for a new chapel being constructed at the site of an ancient Roman arena—explaining why it is usually referred to as the Arena Chapel. The chapel was commissioned by Enrico Scrovegni, whose family fortune was made through the practice of usury—which at this time meant charging interest when loaning money, a sin so grave that it resulted in exclusion from the Christian sacraments. Enrico's father, Regibaldo, was a particularly egregious case (he appears in Dante's *Inferno* as the prototypical usurer), but evidence suggests that Enrico followed in his father's footsteps, and the building of the Arena Chapel next to his new palatial residence seems to have been conceived at least in part as a penitential act, part of Enrico's campaign not only to atone for his father's sins, but also to seek absolution for his own. He was pardoned by Pope Benedict XI (pontificate 1303–1304).

That Scrovegni called two of the most famous artists of the time—Giotto and Giovanni Pisano (SEE FIG. 16–33)—to decorate his chapel indicates that his goals were to express his power, sophistication, and prestige, as well as to atone for his sins. The building itself has little architectural distinction. It is a simple,

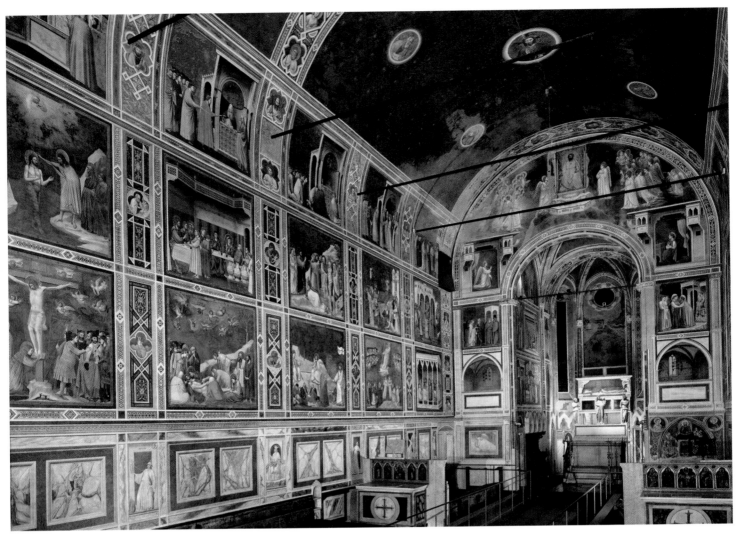

**17-7 • Giotto di Bondone SCROVEGNI (ARENA) CHAPEL**
Padua. 1305–1306. Frescos. View toward east wall.

barrel-vaulted room that provides broad walls, a boxlike space to showcase Giotto's paintings **(FIG. 17–7)**. Giotto covered the entrance wall with the *Last Judgment* (not visible here), and the sanctuary wall with three highlighted scenes from the life of Christ. The Annunciation spreads over the two painted architectural frameworks on either side of the high arched opening into the sanctuary itself. Below this are, to the left, the scene of Judas receiving payment for betraying Jesus, and, to the right, the scene of the Visitation, where the Virgin, pregnant with God incarnate, embraces her cousin Elizabeth, pregnant with John the Baptist. The compositions and color arrangement of these two scenes create a symmetrical pairing that encourages viewers to relate them, comparing the ill-gotten financial gains of Judas (a rather clear reference to Scrovegni usury) to the miraculous pregnancy that brought the promise of salvation.

Giotto subdivided the side walls of the chapel into framed pictures. A dado of faux-marble and allegorical **grisaille** (monochrome paintings in shades of gray) paintings of the Virtues and Vices support vertical bands painted to resemble marble inlay into which are inserted painted imitations of carved medallions. The central band of medallions spans the vault, crossing a brilliant, lapis-blue, star-spangled sky in which large portrait disks float like glowing moons. Set into this framework are three horizontal bands of rectangular narrative scenes from the life of the Virgin and her parents at the top, and Jesus along the middle and lower registers, constituting together the primary religious program of the chapel.

Both the individual scenes and the overall program display Giotto's genius for distilling complex stories into a series of compelling moments. He concentrates on the human dimensions of the unfolding drama—from touches of anecdotal humor to expressions of profound anguish—rather than on its symbolic or theological weight. His prodigious narrative skills are apparent in a set of scenes from Christ's life on the north wall **(FIG. 17–8)**. At top left Jesus performs his first miracle, changing water into wine at the wedding feast at Cana. The wine steward—looking very much like the jars of new wine himself—sips the results. To the right is the

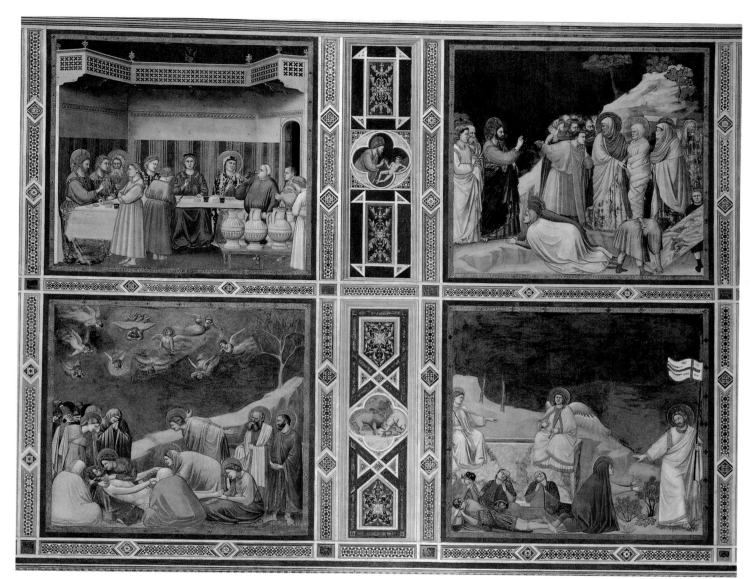

**17-8 • Giotto di Bondone MARRIAGE AT CANA, RAISING OF LAZARUS, LAMENTATION, AND RESURRECTION / NOLI ME TANGERE**
North wall of Scrovegni (Arena) Chapel, Padua. 1305–1306. Fresco, each scene approx. 6'5" × 6' (2 × 1.85 m).

Raising of Lazarus, where boldly modeled and individualized figures twist in space. Through their postures and gestures they react to the human drama by pleading for Jesus' help, or by expressing either astonishment at the miracle or revulsion at the smell of death. Jesus is separated from the crowd. His transforming gesture is highlighted against the dark blue of the background, his profile face locked in communication with the similarly isolated Lazarus, whose eyes—still fixed in death—let us know that the miracle is just about to happen.

On the lower register, where Jesus' grief-stricken followers lament over his dead body, Giotto conveys palpable human suffering, drawing viewers into a circle of personal grief. The stricken Virgin pulls close to her dead son, communing with mute intensity, while John the Evangelist flings his arms back in convulsive despair and others hunch over the corpse. Giotto has

linked this somber scene—much as he linked the scene of Judas' pact and the Visitation across the sanctuary arch—to the mourning of Lazarus on the register above through the seemingly continuous diagonal implied by the sharply angled hillside behind both scenes and by the rhyming repetition of mourners in each scene—facing in opposite directions—who throw back their arms to express their emotional state. Viewers would know that the mourning in both scenes is resolved by resurrection, portrayed in the last picture in this set.

Following traditional medieval practice, the fresco program is full of scenes and symbols like these that are intended to be contemplated as coordinated or contrasting juxtapositions. What is new here is the way Giotto draws us into the experience of these events. This direct emotional appeal not only allows viewers to imagine these scenes in relation to their own life experiences; it

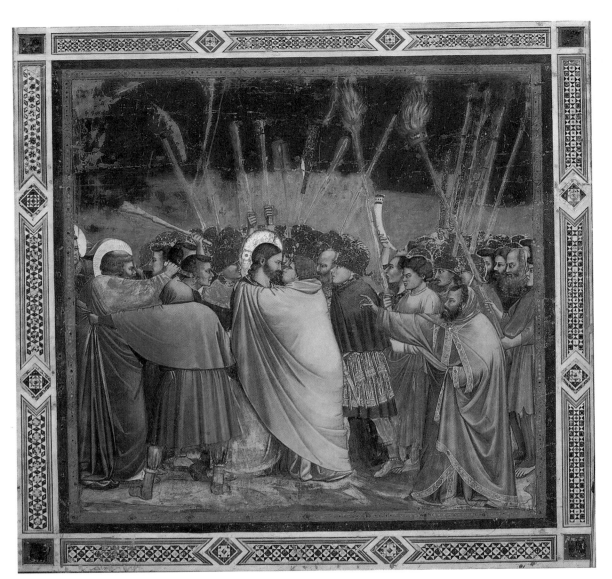

17-9 • Giotto di Bondone **KISS OF JUDAS**
South wall of Scrovegni (Arena) Chapel, Padua. 1305–1306. Fresco, 6'6¾" × 6'⅞" (2 × 1.85 m).

also embodies the new Franciscan emphasis on personal devotion rooted in empathetic responses to sacred stories.

One of the most gripping paintings in the chapel is Giotto's portrayal of the **KISS OF JUDAS**, the moment of betrayal that represents the first step on Jesus' road to the Crucifixion (**FIG. 17–9**). Savior and traitor are slightly off-center in the near foreground. The expansive sweep of Judas' strident yellow cloak—the same outfit he wore at the scene of his payment for the betrayal on the strip of wall to the left of the sanctuary arch—almost completely swallows Christ's body. Surrounding them, faces glare from all directions. A bristling array of weapons radiating from the confrontation draws attention to the encounter between Christ and Judas and documents the militarism of the arresting battalion. Jesus stands solid, a model of calm resolve that recalls his visual characterization in the Resurrection of Lazarus, and forms a striking foil to the noisy and chaotic aggression that engulfs him. Judas, in simian profile, purses his lips for the treacherous kiss that will betray Jesus to his captors, setting up a mythic confrontation of good and evil. In a subplot to the left, Peter lunges forward to sever the ear of a member of the arresting retinue. They are behind another broad sweep of fabric, this one extended by an ominous figure seen from behind and completely concealed except for the clenched hand that pulls at Peter's mantle. Indeed, a broad expanse of cloth and lateral gestures creates a barrier along the picture plane—as if to protect viewers from the compressed chaos of the scene itself. Rarely has this poignant event been visualized with such riveting power.

## SIENESE PAINTING

Like their Florentine rivals, Sienese painters were rooted in thirteenth-century pictorial traditions, especially those of Byzantine art. Sienese painting emphasized the decorative potential of narrative painting, with brilliant, jewel-like colors and elegantly posed figures. For this reason, some art historians consider Sienese art more conservative than Florentine art, but we will see that it has its own charm, and its own narrative strategy.

**DUCCIO DI BUONINSEGNA.** Siena's foremost painter was Duccio di Buoninsegna (active 1278–1318), whose creative synthesis of Byzantine and French Gothic sources transformed the tradition in which he worked. The format of a large altarpiece he painted for the church of Santa Maria Novella in Florence after 1285 **(FIG. 17–10)** is already familiar from the Florentine altarpieces of Cimabue and Giotto (SEE FIGS. 17-5 and 17-6). A monumental Virgin and Child sit on an elaborate throne, set against a gold ground and seemingly supported by flanking angels. But in striking contrast both with Cimabue's Byzantine drapery stylizations and sense of three-dimensional form and space, and with Giotto's matter-of-fact emphasis on weightiness and references to an earthly setting, Duccio's figural composition foregrounds gracefulness of pose and gesture and a color scheme rich in luminous pastels. Drapery not only models his figures into convincing forms; it also falls into graceful lines and patterns, especially apparent in the sinuous golden edge of the Virgin's deep blue mantle and the ornamental extravagance of the brocade hangings on her throne.

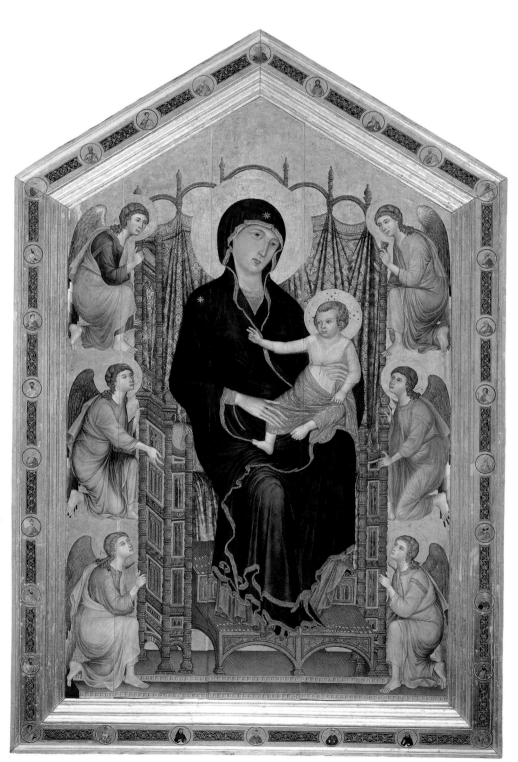

**17–10 • Duccio di Buoninsegna**
**VIRGIN AND CHILD ENTHRONED (RUCELLAI MADONNA)**
Commissioned in 1285. Tempera and gold on wood panel, 14′9⅛″ × 9′6⅛″ (4.5 × 2.9 m). Galleria degli Uffizi, Florence.

This altarpiece, commissioned in 1285 for the church of Santa Maria Novella in Florence by the Society of the Virgin Mary, is now known as the *Rucellai Madonna* because it was installed at one time in the Rucellai family's chapel within the church.

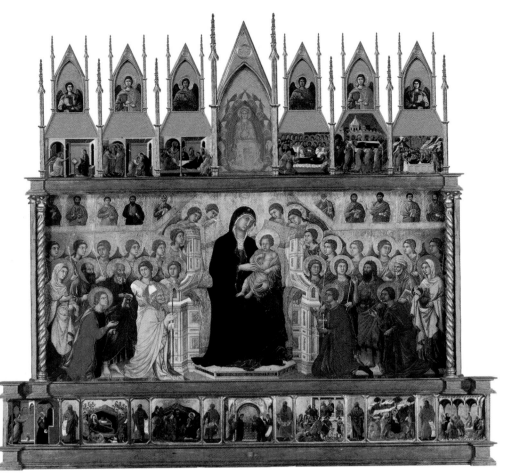

**17–11a** • Duccio di Buoninsegna
**CONJECTURAL RECONSTRUCTION OF THE FRONT OF THE MAESTÀ ALTARPIECE**
Made for Siena Cathedral. 1308–1311. Tempera and gold on wood, main front panel 7 × 13′ (2.13 × 4.12 m).

**EXPLORE MORE:** Gain insight from a primary source related to Duccio's *Maestà*
**www.myartslab.com**

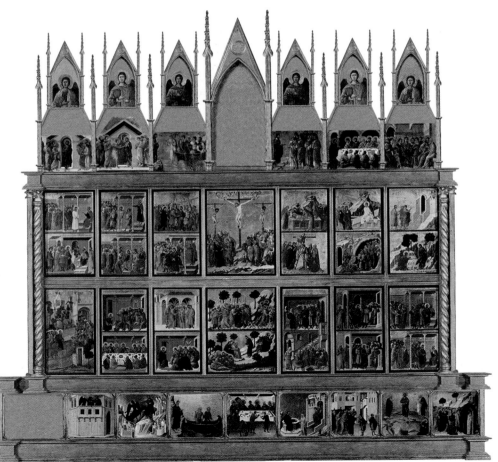

**17–11b** • Duccio di Buoninsegna
**CONJECTURAL RECONSTRUCTION OF THE BACK OF THE MAESTÀ ALTARPIECE**

Between 1308 and 1311, Duccio and his workshop painted a huge altarpiece commissioned by Siena Cathedral and known as the *Maestà* ("Majesty") **(FIG. 17–11)**. Creating this altarpiece—assembled from many wood panels bonded together before painting—was an arduous undertaking. The work was not only large—the central panel alone was 7 by 13 feet—but it had to be painted on both sides since it could be seen from all directions when installed on the main altar at the center of the sanctuary.

Because the *Maestà* was dismantled in 1771, its power and beauty can only be imagined from scattered parts, some still in Siena but others elsewhere. **FIG. 17–11a** is a reconstruction of how the front of the original altarpiece might have looked. It is dominated by a large representation of the Virgin and Child in Majesty (thus its title of *Maestà*), flanked by 20 angels and ten saints, including the four patron saints of Siena kneeling in the foreground. Above and below this lateral tableau were small narrative scenes from the last days of the life of the Virgin (above) and the infancy of Christ (spread across the predella). An inscription running around the base of Mary's majestic throne places the artist's signature within an optimistic framework: "Holy Mother of God, be thou the cause of peace for Siena and life to Duccio because he painted thee thus." This was not Duccio's first work for the cathedral. In 1288 he had designed a stunning stained-glass window portraying the Death, Assumption, and Coronation of the Virgin for the huge circular opening in the east wall of the sanctuary. It would have hovered over the installed *Maestà* when it was placed on the altar in 1311.

On the back of the *Maestà* **(FIG. 17–11b)** were episodes from the life of Christ, focusing on his Passion. Sacred narrative unfolds in elegant episodes enacted by graceful figures who seem to dance their way through these stories while still conveying emotional content. Characteristic of Duccio's narrative style is the scene of the **RAISING OF LAZARUS (FIG. 17–12)**. Lyrical figures enact the event with graceful decorum, but their highly charged glances and expressive gestures—especially the bold reach of Christ—convey a strong sense of dramatic urgency that contrasts with the tense stillness that we saw in Giotto's rendering of this same moment of confrontation (SEE FIG. 17–8). Duccio's shading of drapery, like his modeling of faces, faithfully describes the figures' three-dimensionality, but the crisp outlines of the jewel-colored shapes created by their drapery, as well as the sinuous continuity of folds and gestures, generate rhythmic patterns across the surface. Experimentation with the portrayal of space extends from the receding rocks of the mountainous landscape to carefully studied interiors, here the tomb of Lazarus whose heavy door was removed by the straining hug of a bystander to reveal the shrouded figure of Jesus' resurrected friend, propped up against the door jamb.

The enthusiasm with which citizens greeted a great painting or altarpiece like the *Maestà* demonstrates the power of images as

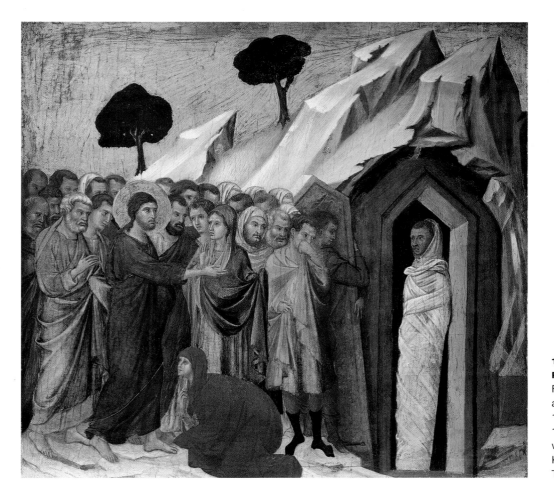

**17-12 • Duccio di Buoninsegna RAISING OF LAZARUS**
From the back of the *Maestà* altarpiece (lower right corner of FIG. 17–9b), made for Siena Cathedral. 1308–1311. Tempera and gold on wood, 17⅛ × 18¼″ (43.5 × 46.4 cm). Kimbell Art Museum, Fort Worth, Texas.

*Il Libro dell' Arte* (*The Book of Art*) of Cennino Cennini (c. 1370–1440) is a compendium of Florentine painting techniques from about 1400 that includes step-by-step instructions for making panel paintings, a process also used in Sienese paintings of the same period.

The wood for the panels, he explains, should be fine-grained, free of blemishes, and thoroughly seasoned by slow drying. The first step in preparing such a panel for painting was to cover its surface with clean white linen strips soaked in a **gesso** made from gypsum, a task, he tells us, best done on a dry, windy day. Gesso provided a ground, or surface, on which to paint, and Cennini specified that at least nine layers should be applied. The gessoed surface should then be burnished until it resembles ivory. Only then could the artist sketch the composition of the work with charcoal made from burned willow twigs. At this point, advised Cennini, "When you have finished drawing your figure, especially if it is in a very valuable [altarpiece], so that you are counting on profit and reputation from it, leave it alone for a few days, going back to it now and then to look it over and improve it wherever it still needs something. When it seems to you about right (and bear in mind that you may copy and examine things done by other good masters; that it is no shame to you) when the figure is satisfactory, take the feather and rub it over the drawing very lightly, until the drawing is practically effaced" (Cennini, trans. Thompson, p. 75). At this point, the final design would be inked in with a fine squirrel-hair brush. Gold leaf, he advises, should be affixed on a humid day, the tissue-thin sheets carefully glued down with a mixture of fine powdered clay and egg white on the reddish clay ground called bole. Then the gold is burnished with a gemstone or the tooth of a carnivorous animal. Punched and incised patterning should be added to the gold leaf later.

Fourteenth- and fifteenth-century Italian painters worked principally in tempera paint, powdered pigments mixed with egg yolk, a little water, and an occasional touch of glue. Apprentices were kept busy grinding pigments and mixing paints, setting them out for more senior painters in wooden bowls or shell dishes.

Cennini outlined a detailed and highly formulaic painting process. Faces, for example, were always to be done last, with flesh tones applied over two coats of a light greenish pigment and highlighted with touches of red and white. The finished painting was to be given a layer of varnish to protect it and intensify its colors.

**EXPLORE MORE:** Gain insight from a primary source by Cennino Cennini **www.myartslab.com**

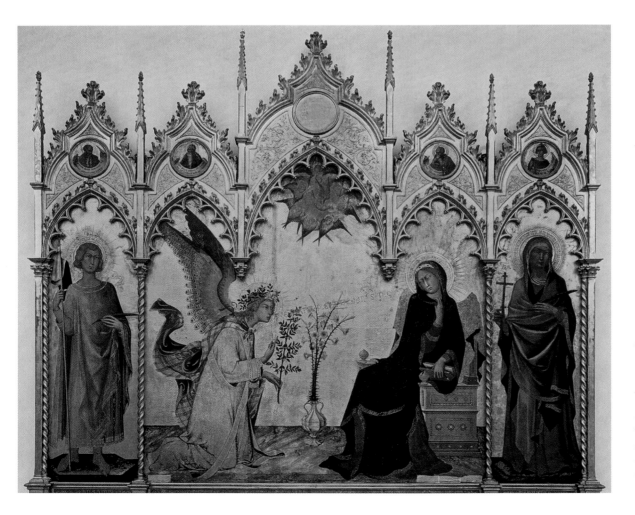

**17-13 •** Simone Martini and Lippo Memmi **ANNUNCIATION** Made for Siena Cathedral. 1333. Tempera and gold on wood, 10′ × 8′9″ (3 × 2.67 m). Galleria degli Uffizi, Florence.

**17-14 • AERIAL VIEW OF THE CAMPO IN SIENA WITH THE PALAZZO PUBBLICO (CITY HALL INCLUDING ITS TOWER) FACING ITS STRAIGHT SIDE**
Siena. Palazzo Pubblico 1297–c. 1315; tower 1320s–1340s.

well as the association of such magnificent works with the glory of the city itself. According to a contemporary account, on December 20, 1311, the day that Duccio's altarpiece was carried from his workshop to the cathedral, all the shops were shut, and everyone in the city participated in the procession, with "bells ringing joyously, out of reverence for so noble a picture as is this" (Holt, p. 69).

SIMONE MARTINI. The generation of painters who followed Duccio continued to paint in the elegant style he established, combining the evocation of three-dimensional form with a graceful continuity of linear pattern. One of Duccio's most successful and innovative followers was Simone Martini (c. 1284–1344), whose paintings were in high demand throughout Italy, including in Assisi where he covered the walls of the St. Martin Chapel with frescos between 1312 and 1319. His most famous work, however, was commissioned in 1333 for the cathedral of his native Siena, an altarpiece of the **ANNUNCIATION** flanked by two saints **(FIG. 17–13)** that he painted in collaboration with his brother-in-law, Lippo Memmi.

The smartly dressed figure of Gabriel—the extended flourish of his drapery behind him suggesting he has just arrived, and with some speed—raises his hand to address the Virgin. The words of his message are actually incised into the gold-leafed gesso of the background, running from his opened mouth toward the Virgin's ear: *Ave gratia plena dominus tecum* (Luke 1:28: "Hail, full of grace, the Lord is with thee"). Seemingly frightened—at the very least startled—by this forceful and unexpected celestial messenger, Mary recoils into her lavish throne, her thumb inserted into the book she had been reading to safeguard her place, while her other hand pulls at her clothing in an elegant gesture of nobility ultimately deriving from the courtly art of thirteenth-century Paris (see Solomon, second lancet from the right in FIG. 16–13).

AMBROGIO LORENZETTI. The most important civic structure in Siena was the **PALAZZO PUBBLICO (FIG. 17–14)**, the town hall which served as the seat of government, just as the Palazzo della Signoria did in rival Florence. There are similarities between these two buildings. Both are designed as strong, fortified structures sitting on the edge of a public piazza; both have a tall tower,

making them visible signs of the city from a considerable distance. The Palazzo Pubblico was constructed from 1297 to 1310, but the tower was not completed until 1348, when the bronze bell, which rang to signal meetings of the ruling council, was installed.

The interior of the Palazzo Pubblico was the site of important commissions by some of Siena's most famous artists. In c. 1315, Simone Martini painted a large mural of the Virgin in Majesty surrounded by saints—clearly based on Duccio's recently installed *Maestà*. Then, in 1338, the Siena city council commissioned Ambrogio Lorenzetti to paint frescos for the council room of the Palazzo known as the Sala della Pace (Chamber of Peace) on the theme of the contrast between good and bad government (SEE FIG. 17–1).

Ambrogio painted the results of both good and bad government on the two long walls. For the expansive scene of the **EFFECTS OF GOOD GOVERNMENT IN THE CITY AND IN THE COUNTRY**, and in tribute to his patrons, Ambrogio created an idealized but recognizable portrait of the city of Siena and its immediate environs (**FIG. 17–15**). The cathedral dome and the distinctive striped campanile are visible in the upper left-hand corner; the streets are filled with the bustling activity of productive citi-zens who also have time for leisurely diversions. Ambrogio shows the city from shifting viewpoints so we can see as much as possible, and renders its inhabitants larger in scale than the buildings around them so as to highlight their activity. Featured in the foreground is a circle of dancers—probably a professional troupe of male entertainers masquerading as women as part of a spring festival—and above them, at the top of the

painting, a band of masons stand on exterior scaffolding constructing the wall of a new building.

The Porta Romana, Siena's gateway leading to Rome, divides the thriving city from its surrounding countryside. In this panoramic landscape painting, Ambrogio describes a natural world marked by agricultural productivity, showing activities of all seasons simultaneously—sowing, hoeing, and harvesting. Hovering above the gate that separates city life and country life is a woman clad in a wisp of transparent drapery, a scroll in one hand and a miniature gallows complete with a hanged man in the other. She represents Security, and her scroll bids those coming to the city to enter without fear because she has taken away the power of the guilty who would harm them.

The world of the Italian city-states—which had seemed so full of promise in Ambrogio Lorenzetti's *Good Government* fresco—was transformed as the middle of the century approached into uncertainty and desolation by a series of natural and societal disasters—in 1333, a flood devastated Florence, followed by banking failures in the 1340s, famine in 1346–1347, and epidemics of the bubonic plague, especially virulent in the summer of 1348, just a few years after Ambrogio's frescos were completed. Some art historians have traced the influence of these calamities on the visual arts at the middle of the fourteenth century (see "The Black Death," page 548). Yet as dark as those days must have seemed to the men and women living through them, the strong currents of cultural and artistic change initiated earlier in the century would persist. In a relatively short span of time, the European Middle Ages gave way in Florence to a new movement that would blossom in the Italian Renaissance.

**17–15 • Ambrogio Lorenzetti  THE EFFECTS OF GOOD GOVERNMENT IN THE CITY AND IN THE COUNTRY**
Sala dei Nove (also known as Sala della Pace), Palazzo Pubblico, Siena, Italy. 1338–1339. Fresco, total length about 46′ (14 m).

# FRANCE

At the beginning of the fourteenth century, the royal court in Paris was still the arbiter of taste in western Europe, as it had been in the days of King Louis IX (St. Louis). During the Hundred Years' War, however, the French countryside was ravaged by armed struggles and civil strife. The power of the old feudal nobility, weakened significantly by warfare, was challenged by townsmen, who took advantage of new economic opportunities that opened up in the wake of the conflict. As centers of art and architecture, the duchy of Burgundy, England, and, for a brief golden moment, the court of Prague began to rival Paris.

French sculptors found lucrative new outlets for their work—not only in stone, but in wood, ivory, and precious metals, often decorated with enamel and gemstones—in the growing demand among wealthy patrons for religious art intended for homes as well as churches. Manuscript painters likewise created lavishly illustrated books for the personal devotions of the wealthy and powerful. And architectural commissions focused on smaller, exquisitely detailed chapels or small churches, often under private patronage, rather than on the building of cathedrals funded by church institutions.

## MANUSCRIPT ILLUMINATION

By the late thirteenth century, private prayer books became popular among wealthy patrons. Because they contained special prayers to be recited at the eight canonical devotional "hours" between morning and night, an individual copy of one of these books came to be called a **Book of Hours**. Such a book included everything the lay person needed for pious practice—psalms, prayers to and offices of the Virgin and other saints (like the owner's patron or the patron of their home church), a calendar of feast days, and sometimes prayers for the dead. During the fourteenth century, a richly decorated Book of Hours was worn or carried like jewelry, counting among a noble person's most important portable possessions.

THE BOOK OF HOURS OF JEANNE D'ÉVREUX. Perhaps at their marriage in 1324, King Charles IV gave his 14-year-old queen, Jeanne d'Évreux, a tiny Book of Hours—it fits easily when open within one hand—illuminated by Parisian painter Jean Pucelle (see "A Closer Look," page 550). This book was so precious to the queen that she mentioned it and its illuminator specifically in her will, leaving this royal treasure to King Charles V. Pucelle painted the book's pictures in *grisaille*—monochromatic painting in shades of gray with only delicate touches of color. His style clearly derives from the courtly mode established in Paris at the time of St. Louis, with its softly modeled, voluminous draperies gathered loosely and falling in projecting diagonal folds around tall, elegantly posed figures with carefully coiffed curly hair, broad foreheads, and delicate features. But his conception of space, with figures placed within coherent, discrete architectural settings, suggests a firsthand knowledge of contemporary Sienese art.

Jeanne appears in the initial *D* below the Annunciation, kneeling in prayer before a lectern, perhaps using this Book of Hours to guide her meditations, beginning with the words written

## The Black Death

A deadly outbreak of the bubonic plague, known as the Black Death after the dark sores that developed on the bodies of its victims, spread to Europe from Asia, both by land and by sea, in the middle of the fourteenth century. At least half the urban population of Florence and Siena—some estimate 80 percent—died during the summer of 1348, probably including the artists Andrea Pisano and Ambrogio Lorenzetti. Death was so quick and widespread that basic social structures crumbled in the resulting chaos; people did not know where the disease came from, what caused it, or how long the pandemic would last.

Mid-twentieth-century art historian Millard Meiss proposed that the Black Death had a significant impact on the development of Italian art in the middle of the fourteenth century. Pointing to what he saw as a reactionary return to hieratic linearity in religious art, Meiss theorized that artists had retreated from the rounded forms that had characterized the work of Giotto to old-fashioned styles, and that this artistic change reflected a growing reliance on traditional religious values in the wake of a disaster that some interpreted as God's punishment of a world in moral decline.

An altarpiece painted in 1354–1357 by Andrea di Cione, nicknamed Orcagna ("Archangel"), under the patronage of Tommasso Strozzi—the so-called *Strozzi Altarpiece*—is an example of the sort of paintings that led Meiss to his interpretation. The painting's otherworldly vision is dominated by a central figure of Christ, presumably enthroned, but without any hint of an actual seat, evoking the image of the judge at the Last Judgment, outside time and space. The silhouetted outlines of the standing and kneeling saints emphasize surface over depth; the gold expanse of floor beneath them does not offer any reassuring sense of spatial recession to contain them and their activity. Throughout, line and color are more prominent than form.

Recent art historians have stepped back from Meiss's theory of stylistic change in mid-fourteenth-century Italy. Some have pointed out logical relationships between style and subject in the works Meiss cites; others have seen in them a mannered outgrowth of current style rather than a reversion to an earlier style; still others have discounted the underlying notion that stylistic change is connected with social situations. But there is no denying the relationship of works such as the *Strozzi Altarpiece* with death and judgment, sanctity and the promise of salvation. These themes are suggested in the narrative scenes on the **predella** (the lower zone of the altarpiece): Thomas Aquinas's ecstasy during Mass, Christ's miraculous walk on water to rescue Peter, and the salvation of Emperor Henry II because of his donation of a chalice to a religious institution. While these are not uncommon scenes in sacred art, it is difficult not see a relationship between their choice as subject matter here and the specter cast by the Black Death over a world that had just imagined its prosperity in path-breaking works of visual art firmly rooted in references to everyday life.

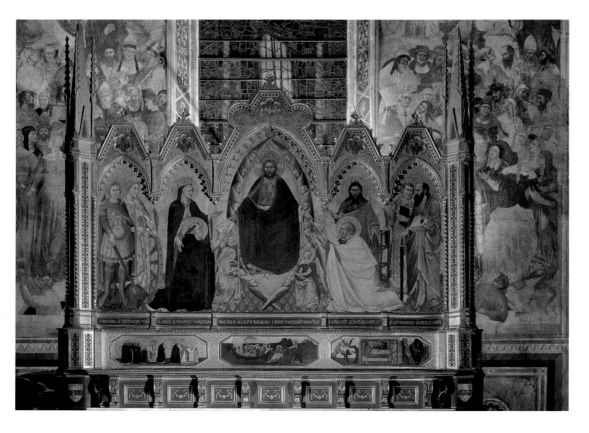

Andrea di Cione (nicknamed Orcagna) **ENTHRONED CHRIST WITH SAINTS, FROM THE STROZZI ALTARPIECE** Strozzi Chapel, Santa Maria Novella, Florence. 1354–1357. Tempera and gold on wood, 9′ × 9′8″ (2.74 × 2.95 m).

EXPLORE MORE: Gain insight from a primary source related to the Black Death
www.myartslab.com

on this page: *Domine labia mea aperies* (Psalm 51:15: "O Lord, open thou my lips"). The juxtaposition of the praying Jeanne's portrait with a scene from the life of the Virgin Mary suggests that the sacred scene is actually a vision inspired by Jeanne's meditations. The young queen might have identified with and sought to feel within herself Mary's joy at Gabriel's message. Given what we know of Jeanne's own life story and her royal husband's predicament, it might also have directed the queen's prayers toward the fulfillment of his wish for a male heir.

In the Annunciation, Mary is shown receiving the archangel Gabriel in a Gothic building that seems to project outward from the page toward the viewer, while rejoicing angels look on from windows under the eaves. The group of romping children at the bottom of the page at first glance seems to echo the angelic jubilation. Folklorists have suggested, however, that the children are playing "froggy in the middle" or "hot cockles," games in which one child was tagged by the others. To the medieval viewer, if the game symbolized the mocking of Christ or the betrayal of Judas, who "tags" his friend, it would have evoked a darker mood by referring to the picture on the other page of this opening, foreshadowing Jesus' imminent death even as his life is beginning.

## METALWORK AND IVORY

Fourteenth-century French sculpture is intimate in character. Religious subjects became more emotionally expressive; objects became smaller and demanded closer scrutiny from the viewer. In the secular realm, tales of love and valor were carved on luxury items to delight the rich (see "An Ivory Chest with Scenes of Romance," pages 552–553). Precious materials—gold, silver, and ivory—were preferred.

THE VIRGIN AND CHILD FROM SAINT-DENIS. A silver-gilt image of a standing **VIRGIN AND CHILD** (FIG. 17–16) is a rare survivor that verifies the acclaim that was accorded Parisian fourteenth-century goldsmiths. An inscription on the base documents the statue's donation to the abbey church of Saint-Denis in 1339 and the donor's name, the same Queen Jeanne d'Évreux whose Book of Hours we have just examined. In a style that recalls the work of artist Jean Pucelle in that Book of Hours, the Virgin holds Jesus in her left arm with her weight on her left leg, standing in a graceful, characteristically Gothic S-curve pose. Mary originally wore a crown, and she still holds a large enameled and jeweled *fleur-de-lis*—the heraldic symbol of royal France—which served as a reliquary container for strands of Mary's hair. The Christ Child, reaching out tenderly to caress his mother's face, is babylike in both form and posture. On the base, minuscule statues of prophets stand on projecting piers to separate 14 enameled scenes from Christ's Infancy and Passion, reminding us of the suffering to come. The apple in the baby's hand carries the theme further with its reference to Christ's role as the new Adam, whose sacrifice on the cross—medieval Christians believed—redeemed humanity from the first couple's fall into sin when Eve bit into the forbidden fruit.

**17–16 • VIRGIN AND CHILD**
c. 1324–1339. Silver gilt and enamel, height 27⅛″ (69 cm).
Musée du Louvre, Paris.

## The Hours of Jeanne d'Évreux

**by Jean Pucelle, Two-Page Opening with the Kiss of Judas and the Annunciation.**
Paris. c. 1325–1328. *Grisaille* and color on vellum, each page 3½ × 2¼" (8.9 × 6.2 cm).
Metropolitan Museum of Art, New York. The Cloisters Collection (54.1.2), fols. 15v–16r

In this opening Pucelle juxtaposes complementary scenes drawn from the Infancy and Passion of Christ, placed on opposing pages, in a scheme known as the Joys and Sorrows of the Virgin. The "joy" of the Annunciation on the right is paired with the "sorrow" of the betrayal and arrest of Christ on the left.

Christ sways back gracefully as Judas betrays him with a kiss. The S-curve of his body mirrors the Virgin's pose on the opposite page, as both accept their fate with courtly decorum.

The prominent lamp held aloft by a member of the arresting battalion informs the viewer that this scene takes place at night, in the dark.

The angel who holds up the boxlike enclosure where the Annunciation takes place is an allusion to the legend of the miraculous transportation of this building from Nazareth to Loreto in 1294.

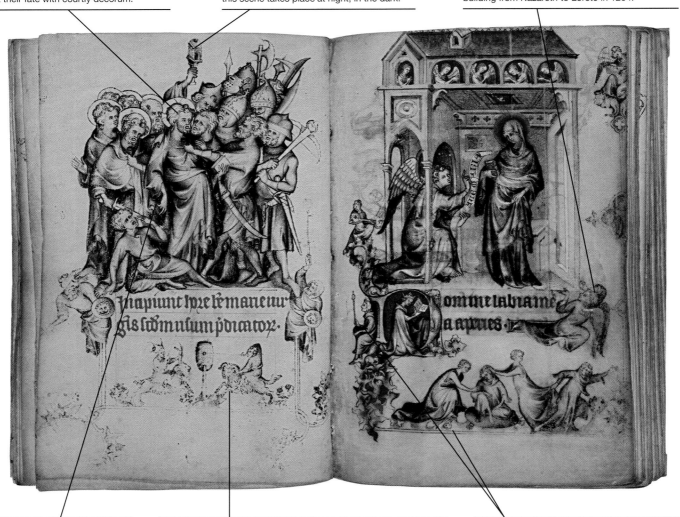

Christ reaches casually down to heal Malchus, the assistant of the high priest whose ear Peter had just cut off in angry retaliation for his participation in the arrest of Jesus.

Scenes of secular amusements from everyday life, visual puns, and off-color jokes appear at the bottom of many pages of this book. Sometimes they relate to the themes of the sacred scenes above them. These comic knights riding goats may be a commentary on the lack of valor shown by the soldiers assaulting Jesus, especially if this wine barrel conjured up for Jeanne an association with the Eucharist.

The candle held by the cleric who guards the "door" to Jeanne's devotional retreat, as well as the rabbit emerging from its burrow in the marginal scene, are sexually charged symbols of fertility that seem directly related to the focused prayers of a child bride required to produce a male heir.

SEE MORE: View the Closer Look feature for *The Hours of Jeanne d'Évreux* **www.myartslab.com**

# ENGLAND

Fourteenth-century England prospered in spite of the ravages of the Black Death and the Hundred Years' War with France. English life at this time is described in the brilliant social commentary of Geoffrey Chaucer in the *Canterbury Tales* (see "A New Spirit in Fourteenth-Century Literature," page 531). The royal family, especially Edward I (r. 1272–1307)—the castle builder—and many of the nobles and bishops were generous patrons of the arts.

## EMBROIDERY: OPUS ANGLICANUM

Since the thirteenth century, the English had been renowned for pictorial needlework, using colored silk and gold thread to create images as detailed as contemporary painters produced in manuscripts. Popular throughout Europe, the art came to be called *opus anglicanum* ("English work"). The popes had more than 100 pieces in the Vatican treasury. The names of several prominent embroiderers are known, but in the thirteenth century no one surpassed Mabel of Bury St. Edmunds, who created both religious and secular articles for King Henry III (r. 1216–1272).

THE CHICHESTER-CONSTABLE CHASUBLE. This *opus angicanum* liturgical vestment worn by a priest during Mass **(FIG. 17–17)** was embroidered c. 1330–1350 with images formed by subtle gradations of colored silk. Where gold threads were laid and couched (tacked down with colored silk), the effect resembles the burnished gold-leaf backgrounds of manuscript illuminations. The Annunciation, the Adoration of the Magi, and the Coronation of the Virgin are set in cusped, crocketed **ogee** (S-shape) arches, supported on animal-head corbels and twisting branches sprouting oak leaves with seed-pearl acorns. Because the star and crescent moon in the Coronation of the Virgin scene are heraldic emblems of Edward III (r. 1327–1377), perhaps he or a family member commissioned this luxurious vestment.

During the celebration of the Mass, especially as the priest moved, *opus anglicanum* would have glinted in the candlelight amid treasures on the altar. Court dress was just as rich and colorful, and at court such embroidered garments proclaimed the rank and status of the wearer. So heavy did such gold and bejeweled garments become that their wearers often needed help to move.

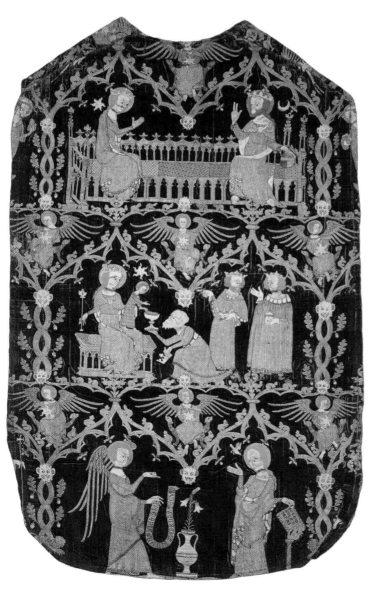

**17–17 • LIFE OF THE VIRGIN, BACK OF THE CHICHESTER-CONSTABLE CHASUBLE**

From a set of vestments embroidered in *opus anglicanum* from southern England. c. 1330–1350. Red velvet with silk and metallic thread and seed pearls, length 4′3″ (129.5 cm), width 30″ (76 cm). Metropolitan Museum of Art, New York.

Fletcher Fund, 1927 (27 162.1)

## An Ivory Chest with Scenes of Romance

Fourteenth-century Paris was renowned for more than its goldsmiths (SEE FIG. 17–16). Among the most sumptuous and sought-after Parisian luxury products were small chests assembled from carved ivory plaques that were used by wealthy women to store jewelry or other personal treasures. The entirely secular subject matter of these chests was romantic love. Indeed, they seem to have been courtship gifts from smitten men to desired women, or wedding presents offered by grooms to their brides.

A chest from around 1330–1350, now in the Walters Museum (SEE FIG. A), is one of seven that have survived intact; there are fragments of a dozen more. It is a delightful and typical example. Figural relief covers five exterior sides of the box: around the perimeter and on the hinged top. The assembled panels were joined by metal

hardware—strips, brackets, hinges, handles, and locks—originally wrought in silver. Although some chests tell a single romantic story in sequential episodes, most, like this one, anthologize scenes drawn from a group of stories, combining courtly romance, secular allegory, and ancient fables.

On the lid of the Walters casket (SEE FIG. B), jousting is the theme. Spread over the central two panels, a single scene catches two charging knights in the heat of a tournament, while trumpeting heralds call the attention of spectators, lined up above in a gallery to observe this public display of virility. The panel at right mocks the very ritual showcased in the middle panels by pitting a woman against a knight, battling not with lances but with a long-stemmed rose (symbolizing sexual surrender) and an oak bough (symbolizing fertility). Instead of

observing these silly goings-on, however, the spectators tucked into the upper architecture pursue their own amorous flirtations. Finally, in the scene on the left, knights use crossbows and a catapult to hurl roses at the Castle of Love, while Cupid returns fire with his seductive arrows.

On the front of the chest (SEE FIG. A), generalized romantic allegory gives way to vignettes from a specific story. At left, the long-bearded Aristotle teaches the young Alexander the Great, using exaggerated gestures and an authoritative text to emphasize his point. Today's lesson is a stern warning not to allow the seductive power of women to distract the young prince from his studies. The subsequent scene, however, pokes fun at his eminent teacher, who has become so smitten by the wiles of a young beauty named Phyllis that he lets

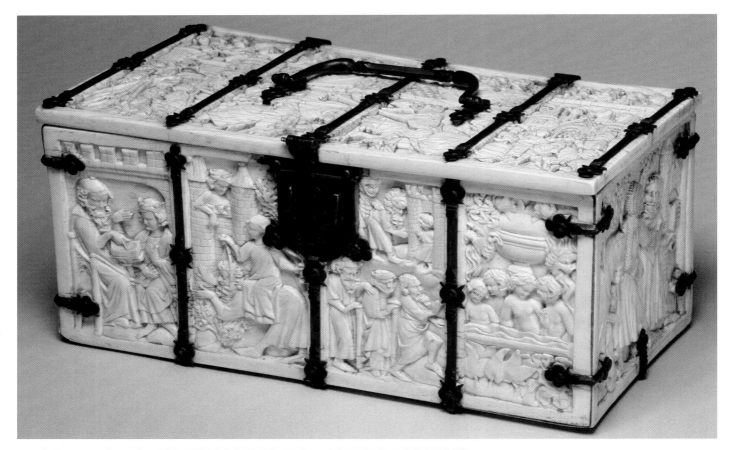

**A. SMALL IVORY CHEST WITH SCENES FROM COURTLY ROMANCES**
Made in Paris. c. 1330–1350. Elephant ivory with modern iron mounts, height 4½″ (11.5 cm), width 9¹¹⁄₁₆″ (24.6 cm), depth 4⅞″ (12.4 cm). The Walters Art Museum, Baltimore.

her ride him around like a horse, while his student observes this farce, peering out of the castle in the background. The two scenes at right relate to an eastern legend of the fountain of youth, popular in medieval Europe. A line of bearded elders approaches the fountain from the left, steadied by their canes. But after having partaken of its transforming effects, two newly rejuvenated couples, now nude, bathe and flirt within the fountain's basin. The man first in line for treatment, stepping up to climb into the

fountain, looks suspiciously like the figure of the aging Aristotle, forming a link between the two stories on the casket front.

Unlike royal marriages of the time, which were essentially business contracts based on political or financial exigencies, the romantic love of the aristocratic wealthy involved passionate devotion. Images of gallant knights and their coy paramours, who could bring intoxicating bliss or cruelly withhold their love on a whim, captured the popular Gothic imagination. They formed the

principal subject matter on personal luxury objects, not only chests like this, but mirror backs, combs, writing tablets, even ceremonial saddles. And these stories evoke themes that still captivate us since they reflect notions of desire and betrayal, cruel rejection and blissful folly, at play in our own romantic conquests and relationships to this day. In this way they allow us some access to the lives of the people who commissioned and owned these precious objects, even if we ourselves are unable to afford them.

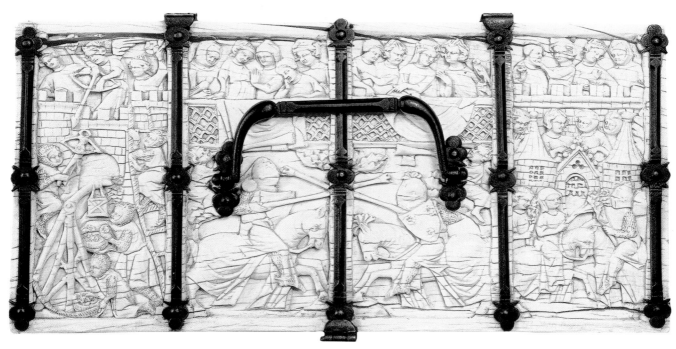

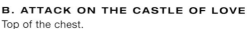

**B. ATTACK ON THE CASTLE OF LOVE**
Top of the chest.

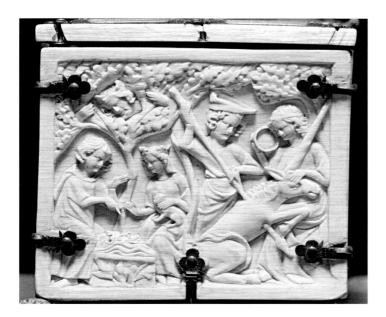

**C. TRISTAN AND ISEULT AT THE FOUNTAIN; CAPTURE OF THE UNICORN**
Left short side of the chest.

Two other well-known medieval themes are juxtaposed on this plaque from the short side of the ivory chest. At left, Tristan and Iseult have met secretly for an illicit romantic tryst, while Iseult's husband, King Mark, tipped off by an informant, observes them from a tree. But when they see his reflection in a fountain between them, they alter their behavior accordingly, and the king believes them innocent of the adultery he had (rightly) suspected. The medieval bestiary ("book of beasts") claimed that only a virgin could capture the mythical unicorn, which at right lays his head, with its aggressively phallic horn, into the lap of just such a pure maiden so that the hunter can take advantage of her alluring powers over the animal to kill it with his phallic counterpart of its horn, a large spear.

## ARCHITECTURE

In the later years of the thirteenth century and early years of the fourteenth, a distinctive and influential Gothic architectural style, popularly known as the "Decorated style," developed in England. This change in taste has been credited to Henry III's ambition to surpass St. Louis, who was his brother-in-law, as a royal patron of the arts.

**THE DECORATED STYLE AT EXETER.** One of the most complete Decorated-style buildings is **EXETER CATHEDRAL**. Thomas of Witney began construction in 1313 and remained master mason from 1316 to 1342. He supervised construction of the nave and redesigned upper parts of the choir. He left the towers of the original Norman cathedral but turned the interior into a dazzling stone forest of colonnettes, moldings, and vault ribs (**FIG. 17–18**). From piers formed by a cluster of colonnettes rise multiple moldings that make the arcade seem to ripple. Bundled colonnettes spring from sculptured foliate **corbels** (brackets that project from a wall) between the arches and rise up the wall to support conical clusters of 13 ribs that meet at the summit of the vault, a modest 69 feet above the floor. The basic structure here is the four-part vault with intersecting cross-ribs, but the designer added additional ribs, called **tiercerons**, to create a richer linear pattern. Elaborately carved **bosses** (decorative knoblike elements) signal the point where ribs meet along the ridge of the vault. Large bar-tracery clerestory windows illuminate the 300-foot-long nave. Unpolished gray marble shafts, yellow sandstone arches, and a white French stone, shipped from Caen, add subtle gradations of color to the upper wall.

Detailed records survive for the building of Exeter Cathedral, documenting work over the period from 1279 to 1514, with only two short breaks. They record where masons and carpenters were housed (in a hostel near the cathedral) and how they were paid (some by the day with extra for drinks, some by the week, some for each finished piece); how materials were acquired and transported (payments for horseshoes and fodder for the horses); and, of course, payments for the building materials (not only stone and wood but rope for measuring and parchment on which to draw forms for the masons). The bishops contributed generously to the building funds. This was not a labor only of love.

Thomas of Witney also designed the intricate, 57-foot-high bishop's throne (at right in FIG. 17–18), constructed by Richard de Galmeton and Walter of Memburg, who led a team of a dozen carpenters. The canopy resembles embroidery translated into wood, with its maze of pinnacles, bursting with leafy crockets and tiny carved animals and

**17–18 • EXETER CATHEDRAL**
Devon, England. Thomas of Witney, choir, 14th century and bishop's throne, 1313–1317; Robert Lesyngham, east window, 1389–1390.

heads. To finish the throne in splendor, Master Nicolas painted and gilded the wood. When the bishop was seated on his throne wearing embroidered vestments like the Chichester-Constable Chasuble (SEE FIG. 17–17), he must have resembled a golden image in a shrine—more a symbol of the power and authority of the Church than a specific human being.

THE PERPENDICULAR STYLE AT EXETER.    During years following the Black Death, work at Exeter Cathedral came to a standstill. The nave had been roofed but not vaulted, and the windows had no glass. When work could be resumed, tastes had changed. The exuberance of the Decorated style gave way to an austere style in which rectilinear patterns and sharp angular shapes replaced intricate curves, and luxuriant foliage gave way to simple stripped-down patterns. This phase is known as the Perpendicular style.

In 1389–1390, well-paid master mason Robert Lesyngham rebuilt the great east window (SEE FIG. 17–18), and he designed the window tracery in the new Perpendicular style. The window fills the east wall of the choir like a glowing altarpiece. A single figure in each light stands under a tall painted canopy that flows into and blends with the stone tracery. The Virgin with the Christ Child stands in the center over the high altar, with four female saints at the left and four male saints on the right, including St. Peter, to whom the church is dedicated. At a distance the colorful figures silhouetted against the silver *grisaille* glass become a band of color, conforming to and thus reinforcing the rectangular pattern of the mullions and transoms. The combination of *grisaille*, silver-oxide stain (staining clear glass with shades of yellow or gold), and colored glass produces a glowing wall, and casts a cool, silvery light over the nearby stonework.

Perpendicular architecture heralds the Renaissance style in its regularity, its balanced horizontal and vertical lines, and its plain wall or window surfaces. When Tudor monarchs introduced Renaissance art into the British Isles, builders were not forced to rethink the form and structure of their buildings; they simply changed the ornament from the pointed cusps and crocketed arches of the Gothic style to the round arches and columns and capitals of Roman Classicism. The Perpendicular style itself became an English architectural vernacular. It remains popular today in the United States for churches and college buildings.

# THE HOLY ROMAN EMPIRE

By the fourteenth century, the Holy Roman Empire existed more as an ideal fiction than a fact. The Italian territories had established their independence, and in contrast to England and France, Germany had become further divided into multiple states with powerful regional associations and princes. The Holy Roman emperors, now elected by Germans, concentrated on securing the fortunes of their families. They continued to be patrons of the arts, promoting local styles.

## MYSTICISM AND SUFFERING

The by-now-familiar ordeals of the fourteenth century—famines, wars, and plagues—helped inspire a mystical religiosity in Germany that emphasized both ecstatic joy and extreme suffering. Devotional images, known as *Andachtsbilder* in German, inspired worshipers to contemplate Jesus' first and last hours, especially during evening prayers, or vespers, giving rise to the term *Vesperbild* for the image of Mary mourning her son. Through such religious exercises, worshipers hoped to achieve understanding of the divine and union with God.

VESPERBILD.    In this well-known example (FIG. 17–19), blood gushes from the hideous **rosettes** that form the wounds of an emaciated and lifeless Jesus who teeters improbably on the lap of his hunched-over mother. The Virgin's face conveys the intensity

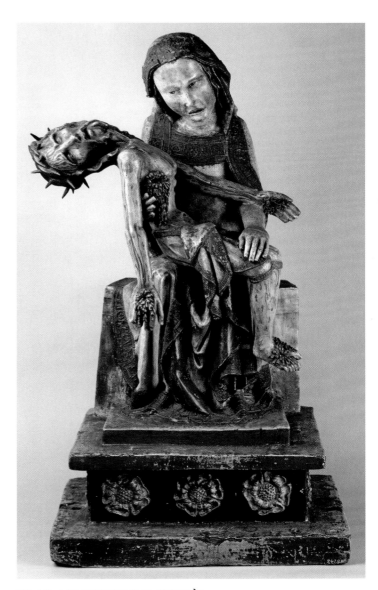

**17-19 • VESPERBILD (PIETÀ)**
From the Middle Rhine region, Germany. c. 1330. Wood and polychromy, height 34½″ (88.4 cm). Landesmuseum, Bonn.

of her ordeal, mingling horror, shock, pity, and grief. Such images took on greater poignancy since they would have been compared, in the worshiper's mind, to the familiar, almost ubiquitous images of the young Virgin mother holding her innocent and loving baby Jesus.

THE HEDWIG CODEX.    The extreme physicality and emotionalism of the *Vesperbild* finds parallels in the actual lives of some medieval saints in northern Europe. St. Hedwig (1174–1243), married at age 12 to Duke Henry I of Silesia and mother of his seven children, entered the Cistercian convent of Trebniz (in modern Poland) on her husband's death in 1238. She devoted the rest of her life to caring for the poor and seeking to emulate the suffering of Christ by walking barefoot in the snow. As described in her *vita*, she had a

particular affection for a small ivory statue of the Virgin and Child, which she carried with her at all times, and which "she often took up in her hands to envelop it in love, so that out of passion she could see it more often and through the seeing could prove herself more devout, inciting her to even greater love of the glorious Virgin. When she once blessed the sick with this image they were cured immediately" (translation from Schleif, p. 22). Hedwig was buried clutching the statue, and when her tomb was opened after her canonization in 1267, it was said that although most of her body had deteriorated, the fingers that still gripped the beloved object had miraculously not decayed.

A picture of Hedwig serves as the frontispiece **(FIG. 17–20)** of a manuscript of her *vita* (biography) known as the Hedwig Codex, commissioned in 1353 by one her descendants, Ludwig I of

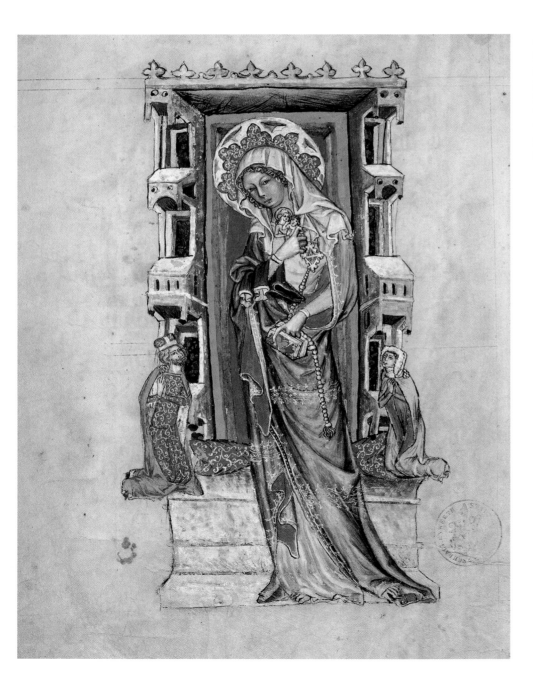

**17–20 • ST. HEDWIG OF SILESIA WITH DUKE LUDWIG I OF LIEGNITZ-BRIEG AND DUCHESS AGNES**
Dedication page of the Hedwig Codex. 1353. Ink and paint on parchment. 13⁷⁄₁₆ × 9¾" (115 × 94 cm). J. Paul Getty Museum, Los Angeles. MS. Ludwig XI 7, fol. 12v

Liegnitz-Brieg. Duke Ludwig and his wife, Agnes, are shown here kneeling on either side of St. Hedwig, dwarfed by the saint's architectural throne and her own imposing scale. With her prominent, spidery hands, she clutches the famous ivory statue, as well as a rosary and a prayer book, inserting her fingers within it to maintain her place as if our arrival had interrupted her devotions. She has draped her leather boots over her right wrist in a reference to her practice of removing them to walk in the snow. Hedwig's highly volumetric figure stands in a swaying pose of courtly elegance derived from French Gothic, but the fierce intensity of her gaze and posture are far removed from the mannered graciousness of the smiling angel of Reims (see statue at far left in FIG. 16–16), whose similar gesture and extended finger are employed simply to grasp his drapery and assure its elegant display.

## THE SUPREMACY OF PRAGUE

Charles IV of Bohemia (r. 1346–1375) was raised in France, and his admiration for the French king Charles IV was such that he changed his own name from Wenceslas to Charles. He was officially crowned king of Bohemia in 1347 and Holy Roman Emperor in 1355. He established his capital in Prague, which, in the view of its contemporaries, replaced Constantinople as the "New Rome." Prague had a great university, a castle, and a cathedral overlooking a town that spread on both sides of a river joined by a stone bridge, a remarkable structure itself.

When Pope Clement VI made Prague an archbishopric in 1344, construction began on a new cathedral in the Gothic style—to be named for St. Vitus. It would also serve as the coronation church and royal pantheon. But the choir was not finished for Charles's first coronation, so he brought Peter Parler from Swabia to complete it.

THE PARLER FAMILY. In 1317, Heinrich Parler, a former master of works on Cologne Cathedral, designed and began building the church of the Holy Cross in Schwäbisch Gmünd, in southwest Germany. In 1351, his son Peter (c. 1330–1399), the most brilliant architect of this talented family, joined the workshop. Peter designed the choir (FIG. 17–21) in the manner of a hall church whose triple-aisled form was enlarged by a ring of deep

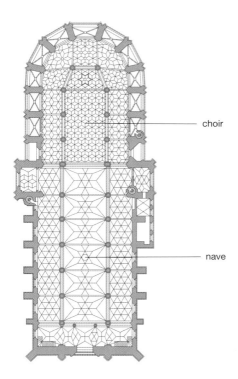

choir

nave

**17–21 • Heinrich and Peter Parler PLAN AND INTERIOR OF CHURCH OF THE HOLY CROSS**
Schwäbisch Gmünd, Germany. Begun in 1317 by Henrich Parler; choir by Peter Parler begun in 1351; vaulting completed 16th century.

**17-22 • Master Theodoric ST. LUKE**
Holy Cross Chapel, Karlstejn Castle, near Prague. 1360–1364. Paint and gold on panel. 45¼ × 37″ (115 × 94 cm).

chapels between the buttresses. The contrast between Heinrich's nave and Peter's choir (seen clearly in the plan of FIG. 17–21) illustrates the increasing complexity of rib patterns covering the vaults, which emphasizes the unity of interior space rather than its division into bays.

Called by Charles IV to Prague in 1353, Peter turned the unfinished St. Vitus Cathedral into a "glass house," adding a vast clerestory and glazed triforium supported by double flying buttresses, all covered by net vaults that created a continuous canopy over the space. Because of the success of projects such as this, Peter and his family became the most successful architects in the Holy Roman Empire. Their concept of space, luxurious decoration, and intricate vaulting dominated central European architecture for three generations.

MASTER THEODORIC. At Karlstejn Castle, a day's ride from Prague, Charles IV built another chapel, covering the walls with gold and precious stones as well as with paintings. There were 130 paintings of the saints serving as reliquaries, with relics inserted into their frames. Master Theodoric, the court painter, provided drawings on the wood panels, and he painted about 30 images himself. Figures are crowded into—even extend over—their frames, emphasizing their size and power. Master Theodoric was head of the Brotherhood of St. Luke, and the way that his painting of ST. LUKE (FIG. 17–22), patron saint of painters, looks out at the viewer has suggested to scholars that this may be a self-portrait. His personal style combined a preference for substantial bodies, oversized heads and hands, dour and haunted faces, and soft, deeply modeled drapery, with a touch of grace derived from the French Gothic style. The chapel, consecrated in 1365, so pleased the emperor that in 1367 he gave the artist a farm in appreciation of his work.

Prague and the Holy Roman Empire under Charles IV had become a multicultural empire where people of different religions (Christians and Jews) and ethnic heritages (German and Slav) lived side by side. Charles died in 1378, and without his strong central government, political and religious dissent overtook the empire. Jan Hus, dean of the philosophy faculty at Prague University and a powerful reforming preacher, denounced the immorality he saw in the Church. He was burned at the stake, becoming a martyr and Czech national hero. The Hussite Revolution in the fifteenth century ended Prague's—and Bohemia's—leadership in the arts.

## THINK ABOUT IT

**17.1** Discuss the circumstances surrounding the construction and decoration of the Scrovegni (Arena) Chapel, with special attention to its relationship to the life and aspirations of its patron.

**17.2** Compare and contrast Giotto's and Duccio's renderings of the biblical story of Christ's Raising of Lazarus (FIGS. 17–8, 17–12).

**17.3** Discuss Ambrogio Lorenzetti's engagement with secular subject matter in his frescos for Siena's Palazzo Pubblico (FIG. 17–15). How did these paintings relate to their sociopolitical context?

**17.4** Choose one small work of art in this chapter that is crafted from precious materials with exceptional technical skill. Explain how it was made and how it was used. How does the work of art relate to its cultural and social context?

**17.5** Analyze how the Decorated Gothic style of Exeter Cathedral (FIG. 17–18) preserves certain traditions from the thirteenth-century Gothic that you learned about in Chapter 16, and assess how it departs from the traditional Gothic style.

**PRACTICE MORE:** Compose answers to these questions, get flashcards for images and terms, and review chapter material with quizzes
**www.myartslab.com**

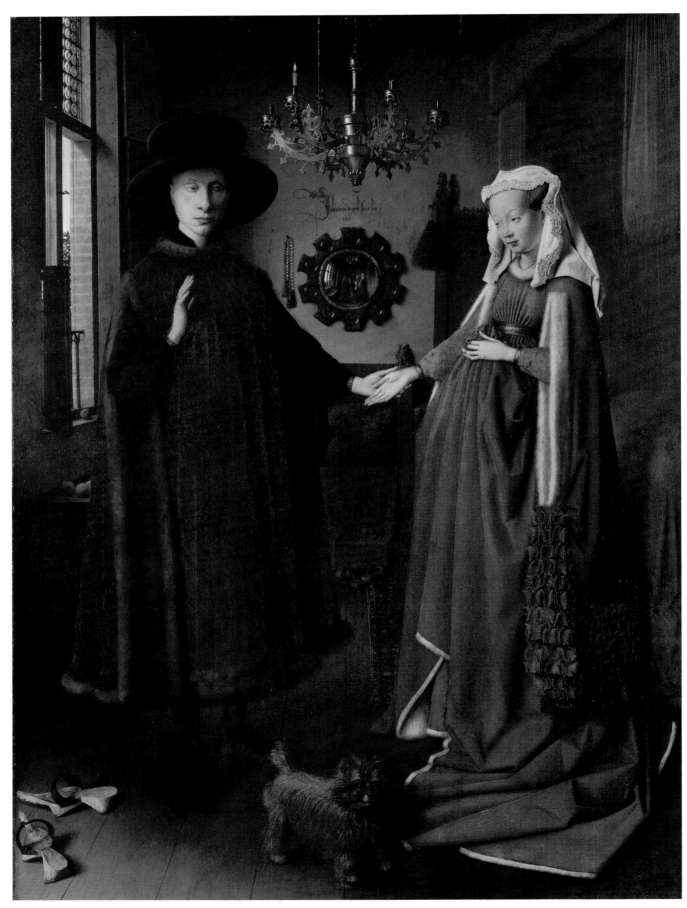

**18–1 • Jan van Eyck DOUBLE PORTRAIT OF A GIOVANNI ARNOLFINI AND HIS WIFE**
1434. Oil on wood panel, 33 × 22½″ (83.8 × 57.2 cm). The National Gallery, London.

# FIFTEENTH-CENTURY ART IN NORTHERN EUROPE

Fifteenth-century Europe saw the emergence of wealthy merchants whose rise to power was fueled by individual accomplishment, rather than hereditary succession within noble families. Certainly Giovanni Arnolfini—the pasty gentleman with the extravagant hat in this double portrait (FIG. 18–1)—earned, rather than inherited, the right to have himself and his wife recorded by renowned artist Jan van Eyck. It was the wealth and connections he made as an Italian cloth merchant providing luxury fabrics to the Burgundian court that put him in the position to commission such a precious picture, in which both patron and painter are identified with conspicuous clarity. Giovanni's face looks more like a personal likeness than anything we have seen since ancient Rome, and not only did Jan van Eyck inscribe his name above the convex mirror ("Jan van Eyck was here, 1434") but his personal painting style carries an equally sure stamp of authorship. The doll-like face of the woman standing next to Giovanni is less individualized. Has she lifted her skirt over her belly so she can follow Giovanni, who has taken her by the hand? Or are most modern observers correct in assuming that she is pregnant? This painting is full of mysteries.

The precise identity of the couple is still open to scholarly debate. And is this a wedding, a betrothal, or perhaps security for a shady financial deal? Recently it has been interpreted as a memorial to a beloved wife lost to death. Only the wealth of the couple is beyond dispute. They are surrounded by luxury objects: lavish bed hangings, sumptuous chandelier, precious oriental carpet, rare oranges, not to mention their extravagant clothing. The man wears a fur-lined, silk velvet *heuque* (sleeveless overgarment). The woman's gown not only employs more costly wool fabric than necessary to cover her slight body; the elaborate cutwork decoration and white fur lining of her sleeves is an ostentatious indicator of cost. In fact, the painting itself—probably hung in the couple's home—was an object of considerable value.

Even within its secular setting, however, the picture resonated with sacred meaning. The Church still provided spiritual grounding for men and women of the Renaissance. The crystal prayer beads hanging next to the convex mirror imply the couple's piety, and the mirror itself—a symbol of the all-seeing eye of God—is framed with a circular cycle of scenes from Christ's Passion. A figure of St. Margaret—protector of women in childbirth—is carved at the top of a post in the high-backed chair beside the bed, and the perky *Affenpinscher* in the foreground may be more than a pet. Dogs served as symbols of fidelity and also have funerary associations, but choosing a rare, ornamental breed for inclusion here may have been yet another opportunity to express wealth.

## LEARN ABOUT IT

**18.1** Analyze how Flemish painters gave scrupulous attention to describing the textures and luminosity of objects in the natural world and in domestic interiors.

**18.2** Trace the development of an extraordinary interest in evoking human likeness in portraits, unlike anything seen since ancient Rome.

**18.3** Explore how paintings in northern Europe of the fifteenth century captured in concrete form visions of their meditating donors.

**18.4** Uncover the complex symbolic meanings that saturated the settings of Flemish paintings.

**18.5** Investigate how prints developed into a major pictorial medium.

**HEAR MORE:** Listen to an audio file of your chapter **www.myartslab.com**

# THE NORTHERN RENAISSANCE

Revitalized civic life and economic growth in the late fourteenth century gave rise to a prosperous middle class that supported scholarship, literature, and the arts. Their patronage resulted in the explosion of learning and creativity we call the Renaissance (French for "rebirth")—a term that was assigned to this period by later historians.

A major manifestation of the Renaissance in northern Europe was a growing and newly intense interest in the natural world manifested in the close observation and detailed recording of nature. Artists depicted birds, plants, and animals with breathtaking descriptive accuracy. They applied the same scrutiny to people and objects, modeling forms with light and shadow to give them the semblance of three-dimensionality. These carefully described subjects were situated into spatial settings, applying an **intuitive perspective** system by diminishing their scale as they receded into the distance. In the portrayal of landscapes—which became a northern specialty—artists used **atmospheric** or **aerial perspective** in which distant elements appear increasingly indistinct and less colorful as they approach the background. The sky, for instance, becomes paler near the horizon and the distant landscape turns bluish-gray.

One aspect of the desire for accurate visual depictions of the natural world was a new interest in individual personalities. Fifteenth-century portraits have an astonishingly lifelike quality, combining careful—sometimes seemingly unflattering—surface description with an uncanny sense of vitality. Indeed, the individual becomes important in every sphere. More names of artists survive from the fifteenth century, for example, than in the entire span from the beginning of the Common Era to the year 1400, and some artists begin regularly to sign their work.

The new power of cities in Flanders and the greater Netherlands (present-day Belgium, Luxembourg, and the Netherlands; SEE MAP 18.1) provided a critical tension and balance with the traditional powers of royalty and the Church. Increasingly, the urban lay public sought to express personal and civic pride by sponsoring secular architecture, sculptured monuments, or paintings directed toward the community. The commonsense values of the merchants formed a solid underpinning for the Northern Renaissance, but their influence remained intertwined with the continuing power of the Church and the royal and noble courts. Giovanni Arnolfini's success at commerce and negotiation provided the funding for his extraordinary double portrait, but he was able to secure the services of Jan van Eyck only with the cooperation of the duke of Burgundy.

# ART FOR THE FRENCH DUCAL COURTS

The dukes of Burgundy were the most powerful rulers in northern Europe for most of the fifteenth century. They controlled not only Burgundy itself but also the Flemish and Netherlandish centers of finance and trade, including the thriving cities of Ghent, Bruges, Tournai, and Brussels. The major seaport, Bruges, was the commercial center of northern Europe, rivaling the Italian city-states of Florence, Milan, and Venice as an economic hub. In the late fourteenth century, Burgundian Duke Philip the Bold (r. 1363–1404) had acquired territory in the Netherlands—including the politically desirable region of Flanders—by marrying the daughter of the Flemish count. Though dukes Philip the Bold of Burgundy, Jean of Berry, and Louis of Anjou were brothers of King Charles V of France, their interests rarely coincided. Even the threat of a common enemy, England, during the Hundred Years' War was not a strong unifying factor, since Burgundy and England were often allied because of common financial interests in Flanders.

While the French king held court in Paris, the dukes held even more splendid courts in their own cities. The dukes of Burgundy (including present-day east-central France, Belgium, Luxembourg, and the Netherlands) and Berry (central France), not the king in Paris, were the real arbiters of taste. Especially influential was Jean, duke of Berry, who commissioned many works from Flemish and Netherlandish painters in the fashionable International Gothic style.

This new, composite style emerged in the late fourteenth century from the multicultural papal court in Avignon in southern France, where artists from Italy, France, and Flanders worked side by side. The International Gothic style became the prevailing manner of late fourteenth-century Europe. It is characterized by slender, gracefully posed figures whose delicate features are framed by masses of curling hair and extraordinarily complex headdresses. Noble men and women wear rich brocaded and embroidered fabrics and elaborate jewelry. Landscape and architectural settings are miniaturized; however, details of nature—leaves, flowers, insects, birds—are rendered with nearly microscopic detail. Spatial recession is represented by rising tiled floors in rooms that are open to view like stage sets, by fanciful mountains and meadows with high horizon lines, and by progressive diminution in the size of receding objects and by atmospheric perspective. Artists and patrons preferred light, bright colors and a liberal use of gold in manuscript and panel paintings, tapestries, and polychromed sculpture. The International Gothic was so appealing that it endured well into the fifteenth century.

## PAINTING AND SCULPTURE FOR THE CHARTREUSE DE CHAMPMOL

One of Philip the Bold's most lavish projects was the Carthusian monastery, or *chartreuse* ("charterhouse"), at Champmol, near Dijon, his Burgundian capital city. Land was acquired in 1377 and 1383, and construction began in 1385. The monastic church was intended to house the family's tombs, and the monks were expected to pray continuously for the souls of Philip and his family. Carthusian monasteries were particularly expensive to maintain because Carthusian monks did not provide for themselves by farming or other physical work but were dedicated exclusively to prayer and solitary meditation.

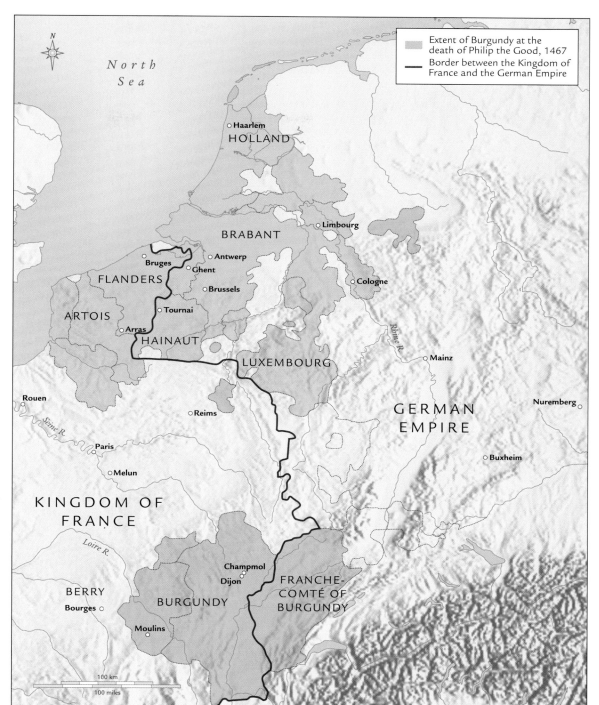

**MAP 18–1 •
FIFTEENTH-CENTURY
NORTHERN EUROPE**

The dukes of Burgundy—
whose territory included
much of present-day
Belgium and Luxembourg,
the Netherlands, and
eastern France—became
the cultural and political
leaders of western Europe.
Their major cities of
Bruges (Belgium) and
Dijon (France) were
centers of art and
industry as well as
politics.

**MELCHIOR BROEDERLAM.** The duke ordered a magnificent carved and painted altarpiece (see "Altars and Altarpieces," page 564) for the Chartreuse de Champmol. The interior of the altarpiece, carved and gilded by Jacques de Baerze, depicts scenes of the Crucifixion flanked by the Adoration of the Magi and the Entombment. The exteriors of the protective shutters of this triptych were covered not by carvings but by two paintings by Melchior Broederlam (active 1381–1410) showing scenes from the life of the Virgin and the infancy of Christ (FIG. 18–2). Broederlam situates his closely observed, International Style figures within

fanciful miniature architectural and landscape settings. His lavish use of brilliantly seductive colors foregrounds one of the features that made International Gothic so popular.

The archangel Gabriel greets Mary while she is at prayer. She sits in a Gothic room with a back door leading into the dark interior of a Romanesque rotunda that symbolizes the Temple of Jerusalem as a repository of the Old Law. According to legend, Mary was an attendant in the Temple prior to her marriage to Joseph. The tiny enclosed garden and conspicuous pot of lilies are symbols of Mary's virginity. In International Gothic fashion, both

## Altars and Altarpieces

The altar in a Christian church symbolizes both the table of Jesus' Last Supper and the tombs of Christ and the saints. As a table, the altar is the site where priests celebrate Mass. And as a tomb, it traditionally contained a relic before the Reformation, placed in a reliquary on the altar, beneath the floor on which the altar rests, or even enclosed within the altar itself.

Altarpieces are painted or carved constructions placed at the back of or behind the altar so that altar and altarpiece appear visually to be joined. By the fifteenth century, important altarpieces had evolved into large and elaborate architectural structures filled with images and protected by movable wings that function like shutters. An altarpiece can sit on a base, called a predella. A winged altarpiece can be a **diptych**, in which two panels are hinged together; a **triptych**, in which two wings fold over a center section, forming a diptych when closed; or a **polyptych**, consisting of many panels.

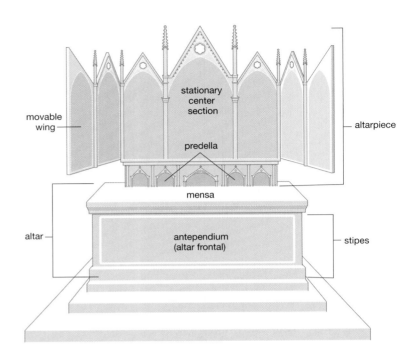

**diptych**          **triptych**                    **altar and polyptych altarpiece**

---

the interior and exterior of the building are shown, and the floors are tilted up at the back to give clear views of the action. Next, in the Visitation, just outside the temple walls, the now-pregnant Mary greets her older cousin Elizabeth, who will soon give birth to John the Baptist.

On the right shutter is the Presentation in the Temple. Mary and Joseph have brought the newborn Jesus to the Temple for his redemption as a first-born son and for Mary's purification, where Simeon takes the baby in his arms to bless him (Luke 2:25–32). At the far right, the Holy Family flees to Egypt to escape King Herod's order that all Jewish male infants be killed. The family travels along treacherous terrain similar to that in the Visitation scene, where a path leads the viewers' eyes up from the foreground and into the distance along a rising ground plane. Broederlam has created a sense of light and air around his solid figures. Anecdotal details drawn from the real world are scattered throughout the pictures—a hawk flies through the golden sky, the presented baby looks anxiously back at his mother, and Joseph drinks from a flask and carries the family belongings in a satchel over his shoulder on the journey to Egypt. The statue of a pagan god, visible at the upper right, breaks and tumbles from its pedestal as the Christ Child approaches. A new era dawns and the New Law replaces the Old, among both Jews and gentiles.

CLAUS SLUTER. Flemish sculptor Jean de Marville (active 1366–1389) initially directed the decoration of the Chartreuse, and when he died in 1389, he was succeeded by his talented assistant Claus Sluter (c. 1360–1406), from Haarlem, in Holland. Sluter's distinctive work survives in a monumental **WELL OF MOSES** carved for the main cloister (FIG. 18–3), begun in 1395 and left unfinished at Sluter's death.

The design of this work is complex. A pier rose from the water to support a large free-standing figure of Christ on the cross, mourned by the Virgin Mary, Mary Magdalen, and John the Evangelist. Forming a pedestal for this Crucifixion group at the viewers' eye level are life-size stone figures from the Hebrew Bible who Christians believe foretold the coming of Christ: Moses, David, and the prophets Jeremiah, Zachariah, Daniel, and Isaiah. This concept may have been inspired by contemporary mystery plays, in which prophets foretell and explain events of Christ's Passion. Sluter's patriarchs and prophets are distinct individuals, physically and psychologically. Moses' sad old eyes blaze out from a memorable face entirely covered with a fine web of wrinkles. Even his horns are wrinkled. (These horns are traditional attributes based on a mistranslation of Exodus 34:29–35 in the Latin Vulgate Bible, where the rays of light radiating from Moses's face become horns.) A mane of curling hair and beard cascades over his heavy

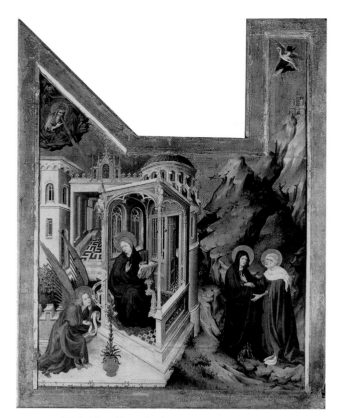

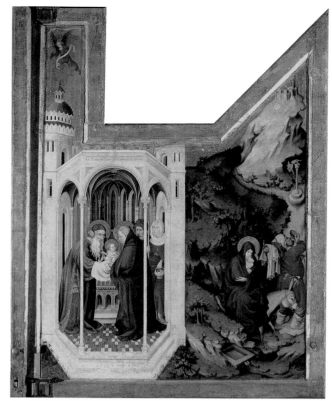

**18-2 • Melchior Broederlam ANNUNCIATION, VISITATION, PRESENTATION IN THE TEMPLE, AND FLIGHT INTO EGYPT**
Exterior of the wings of the altarpiece of the Chartreuse de Champmol. 1393–1399. Oil on wood panel, 5′5¾″ × 4′1¼″ (1.67 × 1.25 m). Musée des Beaux-Arts, Dijon.

shoulders and chest, and an enormous cloak envelops his body. Beside him stands David, in the voluminous robes of a medieval king, the very personification of nobility.

Sluter looked at human figures in new ways—as a weighty mass defined by voluminous drapery that lies in deep folds and falls in horizontal arcs and cascading lines—both concealing and revealing the body, creating strong highlights and shadows. With these vigorous, imposing, and highly individualized figures of the Well of Moses, Sluter abandoned the idealized faces, elongated figures, and vertical drapery of International Gothic for surface realism and the broad horizontal movement of forms. He retained, however, the detailed naturalism and rich colors (now almost lost but revealed in recent cleaning) and surfaces still preferred by his patrons.

**18-3 • Claus Sluter WELL OF MOSES, DETAIL OF MOSES AND DAVID**
The Chartreuse de Champmol, Dijon, France. 1395–1406. Limestone with traces of paint, height of figures about 5′8″ (1.69 m).

The sculpture's original details included metal used for buckles and even eyeglasses. It was also painted: Moses wore a gold mantle with a blue lining over a red tunic; David's gold mantle had a painted lining of ermine, and his blue tunic was covered with gold stars and wide bands of ornament.

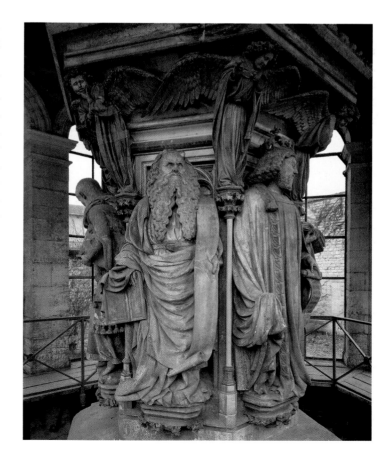

# Women Artists in the Middle Ages and the Renaissance

Since most formal apprenticeships were not open to them, medieval and Renaissance women artists typically learned to paint from their husbands and fathers. Noblewomen, who were often educated in convents, also learned to draw, paint, and embroider. One of the earliest examples of a signed work by a woman is in a tenth-century Spanish manuscript of the Apocalypse illustrated by an artist named Ende (SEE FIG. 14–8), who describes herself as "painter and servant of God." In the twelfth century, a German nun named Guda not only signed her work but also included a self-portrait (SEE FIG. 15–32).

Examples proliferate during the later Middle Ages. In the fourteenth century, Jeanne de Montbaston and her husband, Richart, worked together as book illuminators under the auspices of the University of Paris. After Richart's death, Jeanne maintained the workshop and, following the custom of the time, was sworn in as a *libraire* (publisher) by the university in 1353. Bourgot, the daughter of the miniaturist Jean le Noir, illuminated books for King Charles V of France and Duke Jean of Berry. In the fifteenth century, women could be admitted to guilds in the Flemish towns of Ghent, Bruges, and Antwerp. By the 1480s, one-quarter of the membership in the painters' guild of Bruges was female.

In a French edition of a book by the Italian author Boccaccio entitled *Concerning Famous Women*, there is a picture of Thamyris, an artist of antiquity, at work in her studio. She appears in fifteenth-century dress, painting an image of the Virgin and Child. At the right, an assistant grinds and mixes her colors. In the foreground, her brushes and paints are laid out neatly and conveniently on a table.

**PAGE WITH THAMYRIS**
From Giovanni Boccaccio's *De Claris Mulieribus (Concerning Famous Women)*. 1402. Ink and tempera on vellum, 14 × 9½" (35.5 × 24 cm). Bibliothèque Nationale, Paris.

## MANUSCRIPT ILLUMINATION

Besides religious texts, wealthy patrons treasured richly illuminated secular writings such as herbals (encyclopedias of plants), health manuals, and works of history and literature. A typical manuscript page might have leafy tendrils framing the text, decorated opening initials, and perhaps a small inset picture (see the illustration in "Women Artists in the Middle Ages and the Renaissance," above). Only the most lavish books would have full-page miniature paintings, set off with frames. These inset pictures are like windows looking into rooms or out onto landscapes with distant horizons.

THE LIMBOURG BROTHERS. Among the finest Netherlandish painters at the beginning of the century were three brothers—Paul, Herman, and Jean Limbourg—their "last" name referring to

their home region. At this time people generally did not have family names in the modern sense, but were known instead by their first names, often followed by a reference to their place of origin, parentage, or occupation.

About 1404 the Limbourg brothers entered the service of avid bibliophile Duke Jean of Berry (1340–1416), for whom they produced their most impressive surviving work, the so-called **TRÈS RICHES HEURES** (Very Sumptuous Book of Hours), between 1413 and 1416 (**FIGS. 18–4, 18–5**). A Book of Hours, in addition to containing prayers and readings used in daily devotion, also included a calendar of holy days. The Limbourgs created full-page illustrations for the calendar in the *Très Riches Heures*, with subjects including both peasant labors and aristocratic pleasures in a framed lower field while elaborate calendar devices, with the chariot of

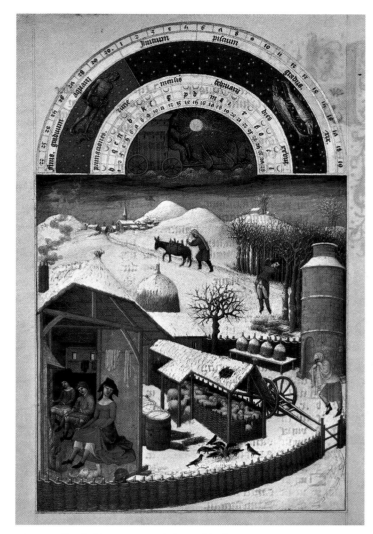

**18-4 • Paul, Herman, and Jean Limbourg FEBRUARY, LIFE IN THE COUNTRY. TRÈS RICHES HEURES**
1411–1416. Colors and ink on parchment, 11⅜ × 8¼″ (29 × 21 cm). Musée Condé, Chantilly, France.

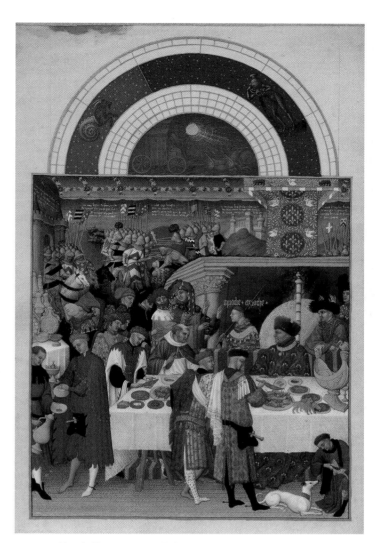

**18-5 • Paul, Herman, and Jean Limbourg JANUARY, THE DUKE OF BERRY AT TABLE. TRÈS RICHES HEURES**
1411–1416. Colors and ink on parchment, 11⅜ × 8¼″ (29 × 21 cm). Musée Condé, Chantilly, France.

the sun and the zodiac symbols, fill the upper part of the page. Like most European artists of the time, the Limbourgs showed the laboring classes in a light acceptable to aristocrats—that is, happily working for the nobles' benefit or displaying an uncouth lifestyle for aristocratic amusement. At times they also seem to be depicting peasants enjoying the pleasures of their leisure moments.

In the February page (SEE FIG. 18–4), farm folks relax cozily before a blazing fire. Although many country people at this time lived in hovels, this farm looks comfortable and well maintained, with timber-framed buildings, a row of beehives, a sheepfold, and tidy woven wattle fences. In the distance are a village and church. Within this scene, although all are much lower in social standing than the duke himself, there is a hierarchy of class. Largest in scale and most elegantly dressed is the woman closest to us, perhaps the owner of the farm, who carefully lifts her overgarment, balancing it daintily with both hands as she warms herself. She shares her fire with a couple, smaller because farther in the background, who

wear more modest clothing and are considerably less well behaved, especially the uncouth man, who exposes himself as he lifts his clothing to take advantage of the fire's warmth.

One of the most remarkable aspects of this painting is the way it conveys the feeling of cold winter weather: the leaden sky and bare trees, the soft snow and huddled sheep, the steamy breath of the bundled-up worker blowing on his hands, and the comforting smoke curling from the farmhouse chimney. The artists employ several International Gothic conventions: the high placement of the horizon line, the small size of trees and buildings in relation to people, and the cutaway view of the house showing both interior and exterior. The muted palette is sparked with touches of yellowish-orange, blue, and patches of bright red, including the man's turban at the lower left. Scale relationships seem consistent with our experience in the natural world since as the landscape recedes, the size of figures and buildings diminishes progressively in stages from foreground to middle ground to background.

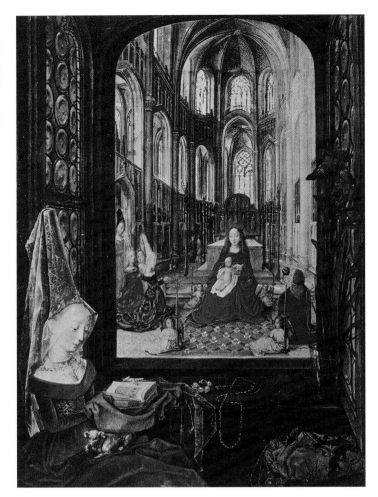

**18-6 • Mary of Burgundy Painter MARY AT HER DEVOTIONS, HOURS OF MARY OF BURGUNDY** Before 1482. Colors and ink on parchment, size of image 7½ × 5¼" (19.1 × 13.3 cm). Österreichische Nationalbibliothek, Vienna.

In contrast, the illustration for the other winter month—January—depicts an aristocratic household (SEE FIG. 18–5). The duke of Berry sits behind a table laden with food and rich tableware, presiding over his new year's feast and surrounded by servants and allies. His chamberlain invites smartly dressed courtiers to greet the duke (the words written overhead say "approach"), who is himself singled out visually by the red cloth of honor with his heraldic arms—swans and the lilies of France—hanging over him and by a large fire screen that circles his head like a secular halo. Tapestries with battle scenes cover the walls. Such luxury objects attest to the wealth and lavish lifestyle of this great patron of the arts, a striking contrast to the farm life that will be revealed inFebruary when turning the book to its next page.

**THE MARY OF BURGUNDY PAINTER.** One of the finest painters of Books of Hours later in the century was an artist known as the Mary of Burgundy Painter—so called because he painted a Book of Hours for Mary of Burgundy (1457–1482), only child of Charles the Bold. Within a full-page miniature in a book only 7½

by 5¼ inches, earthly reality and a religious vision have been rendered equally tangible (FIG. 18–6). The painter conjures up a complex pictorial space. We look not only through the "window" of the illustration's frame but through another window in the wall of the room depicted in the foreground of the painting. The artist shows real virtuosity in representing these worlds. Spatial recession leads the viewer into the far reaches of the church interior, past the Virgin and the gilded altarpiece in the sanctuary to two people conversing in the far distance. The filmy veil covering Mary's steeple headdress is exquisitely described, as is the transparency of the glass vase, and the distinctive bull's eye glass (circular panes whose center "lump" was formed by the glassblower's pontil) filling the foreshortened, open window.

Mary of Burgundy appears twice. She is seated in the foreground by a window, reading from, or contemplating a picture within, her Book of Hours, held carefully and protected by a lush green cloth, perhaps from the diminutive dog cuddled into her lap. She appears again in the background, within the representation of the personal vision inspired by her private meditations. For a glorious Gothic church may form the setting for her vision, but it results not from attendance at Mass nor from the direction of a priestly advisor. She experiences it in private, a reward of her personal faith. Christians were encouraged in this period to imagine themselves participating in biblical stories and sacred events so as to feel within bodies and souls the experiences of the protagonists. Secluded into her private space, and surrounded by devotional aids on the window ledge—book, rosary, and symbolic flowers (carnations symbolized the nails of the Crucifixion, the irises Mary's sorrow)—it seems that Mary of Burgundy is doing just that. In her vision, she kneels with attendants and angels in front of a gracefully human Virgin and Child.

## TEXTILES

In the fifteenth and sixteenth centuries, the best European tapestries came from Flanders. Major weaving centers at Brussels, Tournai, and Arras produced intricately woven wall hangings for royal and aristocratic patrons across Europe, important church officials including the pope, and even town councils. Among the most common subjects were foliage and flower patterns, scenes from the lives of the saints, and themes from classical mythology and history, such as the Battle of Troy seen hanging on the walls of Duke Jean of Berry's reception room (SEE FIG. 18–5). Tapestries provided both insulation and luxurious decoration for the stone walls of castle halls, churches, and municipal buildings, and because they were much more expensive than wall or panel paintings, they also showed off the owners' wealth. Since they were portable, many were included among aristocratic baggage as courts moved from residence to residence.

The price of a tapestry depended on the artists involved, the work required, and the materials used. Rarely was a fine, commissioned series woven only with wool; instead, tapestry producers enhanced the weaving with silk, and with silver and

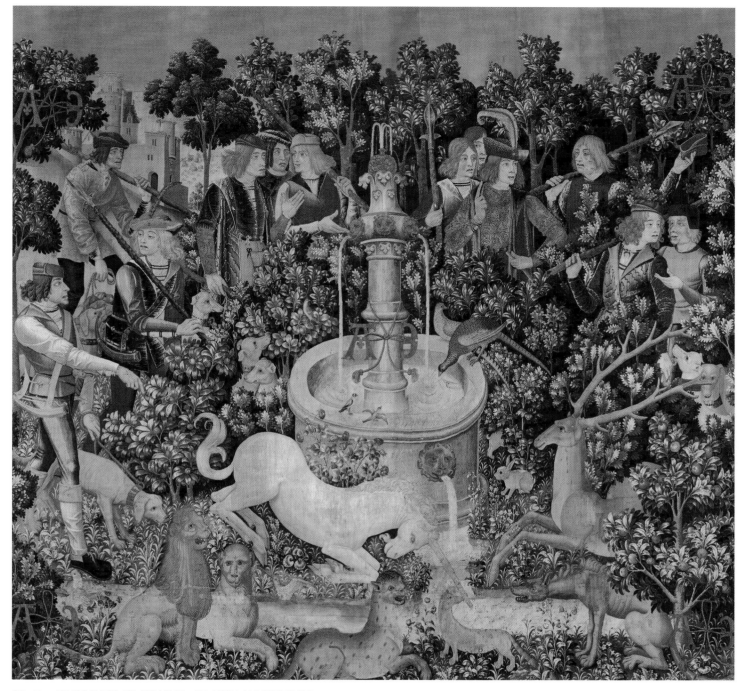

**18-7 • UNICORN IS FOUND AT THE FOUNTAIN**
From the Hunt of the Unicorn tapestry series. c. 1495–1505. Wool, silk, and silver- and gilt-wrapped thread (13–21 warp threads per inch), 12′1″ × 12′5″ (3.68 × 3.78 m). Metropolitan Museum of Art, New York.
Gift of John D. Rockefeller Jr., The Cloisters Collection, 1937 (37.80.2)

gold threads that must have glittered on the walls of princely residences, especially at night, illuminated by flickering lamps or candles. Because silver and gold threads were made of silk wrapped with real silver and gold, people later burned many tapestries to retrieve the precious materials. As a result, few royal tapestries in France survived the French Revolution. If a greater percentage had survived, these luxurious and monumental textile wall paintings would surely figure more prominently in the history of art.

THE UNICORN TAPESTRY. Tapestries were often produced in series. One of the best known is the Hunt of the Unicorn series from c. 1500. Four of the seven surviving hangings present scenes of people and animals set against a dense field of trees and flowers, with a distant view of a castle, as in the **UNICORN IS FOUND AT THE FOUNTAIN** (**FIG. 18–7**). The unusually fine condition of the tapestry allows us to appreciate its rich colors and the subtlety in modeling the faces, the tonal variations in the animals' fur, and

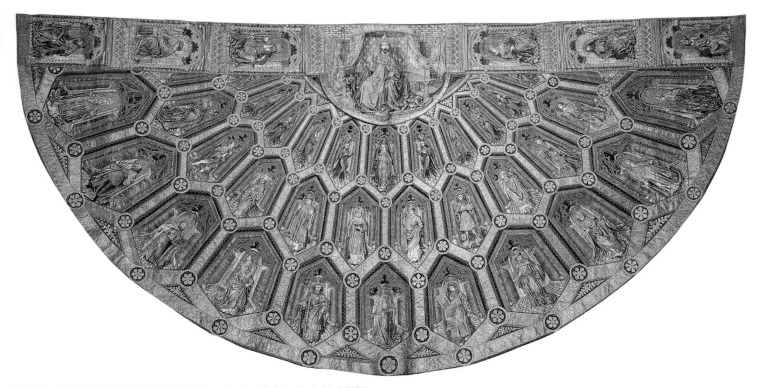

**18-8 • COPE OF THE ORDER OF THE GOLDEN FLEECE**
Flemish. Mid 15th century. Cloth with gold and colored silk embroidery, 5'4⁹⁄₁₆" × 10'9⁵⁄₁₆" (1.64 × 3.3 m).
Imperial Treasury, Vienna.

even the depiction of reflections in the water. The technical skill of its weavers is astonishing.

In tapestry, designs are woven directly into the fabric. The Unicorn tapestries seem to have been woven on huge, horizontal looms, where weavers interwove fine weft yarn of wool and silk—dyed in a multitude of colors from the creative combination of three vegetal dyes—onto the parallel strands of the coarser wool warp. Weavers worked from behind what would be the front surface of the finished tapestry, following the design on a full-scale cartoon laid on the floor under the loom. They could only see the actual effect of their work by checking the front with mirrors. Making a tapestry panel this large was a collaborative effort that required the organizational skills of a talented production manager and five or six weavers working side by side on a single loom. What is so extraordinary about their work is the skillful way they created curving lines—since the tapestry process is based on a rectilinear network of threads, curves have be simulated—and the lighting effects of shading and reflections, which require using yarn in the same hue with a multitude of values.

The subject of this series concerns the unicorn, a mythical horselike animal with a single long twisted horn, said to be supernaturally swift; it could only be captured by a virgin, to whom it came willingly. Thus, the unicorn became both a symbol of the Incarnation (Christ is the unicorn captured by the Virgin Mary) and also a metaphor for romantic love (see page 553, FIG. C). The capture and killing of the unicorn was also equated with Christ's death on the cross to save humanity.

The natural world represented so splendidly in this tapestry also has potential symbolic meaning. For instance, lions represented valor, faith, courage, and mercy, and even—because they were thought to breathe life into their cubs—the Resurrection of Christ. The stag is another Resurrection symbol (it sheds and grows its antlers) and a protector against poisonous serpents and evil in general. Even today we see rabbits as symbols of fertility, and dogs of fidelity. Many of the easily identifiable flowers and trees also carry both religious and secular meaning. There is a strong theme of marriage: the strawberry is a common symbol of sexual love; the pansy means remembrance; and the periwinkle, a cure for spiteful feelings and jealousy. The trees include oak for fidelity, beech for nobility, holly for protection against evil, hawthorn for the power of love, and pomegranate and orange for fertility.

COPE OF THE ORDER OF THE GOLDEN FLEECE. Surviving vestments of the Order of the Golden Fleece are remarkable examples of Flemish textiles. The Order of the Golden Fleece was an honorary fraternity founded by Duke Philip the Good of Burgundy in 1430 with 23 knights chosen for their moral character and bravery. Religious services were an integral part of the order's meetings, and opulent liturgical and clerical objects were created for the purpose.

The surface of the sumptuous cope (cloak) in FIG. 18–8 is divided into compartments filled with the standing figures of saints. At the top of the neck edge, as if presiding over the company, is an enthroned figure of Christ, flanked along the front edge by

Whereas Italian artists favored tempera, using it almost exclusively for panel painting until the end of the fifteenth century (see "Cennino Cennini on Panel Painting," page 544), Flemish artists preferred oil paints, in which powdered pigments are suspended in linseed—and occasionally walnut—oil. They exploited the potential of this medium during the fifteenth century with a virtuosity that has never been surpassed.

Tempera had to be applied in a very precise manner because it dried almost as quickly as it was laid down. Shading was restricted to careful overlying strokes in graded tones ranging from white and gray to dark brown and black. Because tempera is opaque—light striking its surface does not penetrate to lower layers of color and reflect back—the resulting surface is **matte**, or dull, taking on a sheen only with burnishing or an overlay of varnish.

On the other hand, oil paint is a viscous medium which takes much longer to dry, and while it is still wet changes can be made easily.

Once applied, the paint has time to smooth out during the drying process, erasing traces of individual brushstrokes on the surface of the finished panel. Perhaps even more importantly, oil paint is translucent when applied in very thin layers, called glazes. Light striking a surface built up of glazes penetrates to the lower layers and is reflected back, creating the appearance of an interior glow. These luminous effects enabled artists to capture jewel-like colors and the varying effects of light on changing textures, enhancing the illusion that viewers are looking at real objects rather than their painted imitation.

So brilliant was Jan van Eyck's use of oil paint that he was credited by Giorgio Vasari with inventing the medium. Actually, it had been in use at least since the twelfth century, when it is described in Theophilus Presbyter's *De diversis artibus* (see "Stained Glass Windows," page 497).

**SEE MORE:** View videos about the processes of oil painting and grinding oil paint **www.myartslab.com**

scholar-saints in their studies. The embroiderers worked with great precision to match the illusionistic effects of contemporary Flemish painting. The particular stitch used here is known as couching. Gold threads are tacked down using unevenly spaced colored silk threads to create images and an iridescent effect.

## PAINTING IN FLANDERS

A strong economy based on the textile industry and international trade provided stability and money for a Flemish efflorescence in the arts. Civic groups, town councils, and wealthy merchants were important patrons in the Netherlands, where the cities were self-governing and largely independent of landed nobility. Guilds oversaw nearly every aspect of their members' lives, and high-ranking guild members served on town councils and helped run city governments. Even experienced artists who moved from one city to another usually had to work as assistants in a local workshop until they met the requirements for guild membership.

Throughout most of the fifteenth century, Flemish art and artists were greatly admired across Europe. Artists from abroad studied Flemish works, and their influence spread even to Italy. Only at the end of the fifteenth century did a pervasive preference for Netherlandish painting give way to a taste for the new styles of art and architecture developing in Italy.

### THE FOUNDERS OF THE FLEMISH SCHOOL

Flemish panel painters preferred using an oil medium rather than the tempera paint that was standard in the works of Italian artists. Since it was slow to dry, oil paint provided flexibility, and it had a luminous quality (see "Oil Painting," above). Like manuscript illuminations, Flemish panel paintings provided a window onto a scene rendered with keen attention to describing individual features—people, objects, or aspects of the natural world—with consummate skill.

THE MASTER OF FLÉMALLE. Some of the earliest and most outstanding exponents of the new Flemish style were painters in the workshop of an artist known as the Master of Flémalle, identified by some art historians as Robert Campin (active 1406–1444). About 1425–1430, these artists painted the triptych now known as the **MÉRODE ALTARPIECE**, after its later owners **(FIG. 18–9)**. Its relatively small size—slightly over 2 feet tall and about 4 feet wide with the wings open—suggests that it was probably made for a small private chapel.

The Annunciation of the central panel is set in a Flemish home and incorporates common household objects, many invested with symbolic religious meaning. The lilies in the **majolica** (glazed earthenware) pitcher on the table, for example, often appear in Annunciations to symbolize Mary's virginity. The hanging water pot in the background niche refers to Mary's purity and her role as the vessel for the Incarnation of God. What seems at first to be a towel hung over the prominent, hinged rack next to the niche may be a tallis (Jewish prayer shawl). Some art historians have referred to these as "hidden" or "disguised" symbols because they are treated as a normal part of the setting, but their routine religious meanings would have been obvious to the intended audience.

Some have interpreted the narrative episode captured in the central panel as the moment immediately following Mary's acceptance of her destiny. A rush of wind riffles the book pages and snuffs the candle (the flame, symbolic of God's divinity, extinguished at the moment he takes human form) as a tiny figure of Christ carrying a cross descends on a ray of light. Having accepted the miracle of the Incarnation (God assuming human

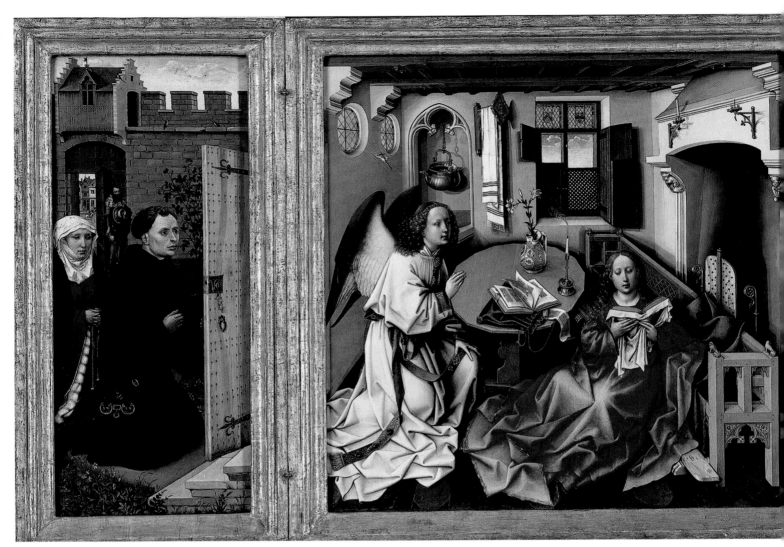

**18-9 • Workshop of the Master of Flémalle**
**MÉRODE ALTARPIECE (TRIPTYCH OF THE**
**ANNUNCIATION) (OPEN)**

c. 1425–1430s. Oil on wood panel, center 25¼ × 24⅞″ (64.1 × 63.2 cm); each wing approx. 25⅜ × 10¾″ (64.5 × 27.6 cm). Metropolitan Museum of Art, New York. The Cloisters Collection, 1956 (56.70)

In the late nineteenth century, this triptych was associated with a group of stylistically related works and assigned to an artist called the Master of Flémalle, who was subsequently identified by some art historians as a documented artist named Robert Campin. Recently, however, experts have questioned this association and proposed that the triptych we now see was the work of several artists working within the workshop that created the stylistic cluster. Current opinion holds that the Annunciation was initially created as an independent panel, and a short time later expanded into a triptych with the addition of the side panels under the patronage of the donor in the foreground at left. Finally, some time later in the 1430s, the figure of his wife was added behind him, presumably on the occasion of his marriage.

form), Mary reads her Bible while sitting humbly on the footrest of the long bench. Her position becomes a symbol of her submission to God's will. Other art historians have proposed that the scene represents the moment just prior to the Annunciation. In this view, Mary is not yet aware of Gabriel's presence, and the rushing wind is the result of the angel's rapid entry into the room, where he appears before her, half kneeling and raising his hand in salutation.

In the left wing of the triptych, the donors—presumably a married couple—kneel in an enclosed garden, another symbol of Mary's virginity, before the open door of the house where the Annunciation is taking place, implying that the scene is a vision brought on by their faithful meditations, comparable to the vision we have already seen in the Hours of Mary of Burgundy (SEE FIG. 18–6). Such presentations, very popular with Flemish patrons, allowed those who commissioned a religious work to appear in the same space and time, and often on the same scale, as religious figures. The donors' eyes, which seem oddly unfocused, are directed not outward but inward, intent on the spiritual exercise of imagining their own presence within this sacred narrative.

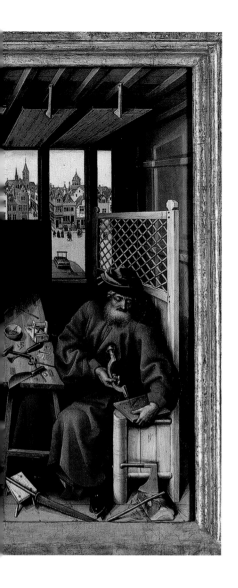

**18–10 • Workshop of the Master of Flémalle A FLEMISH CITY**
Detail of the right wing of the Mérode Altarpiece in FIG. 18–9.

On the right wing, Joseph is working in his carpentry workshop. A prosperous Flemish city is exquisitely detailed in the view through the shop window, with people going about their daily business **(FIG. 18–10)**. Even here there is religious symbolism. On the windowsill of Joseph's shop is a mousetrap (another sits on the workbench next to him), which fifteenth-century viewers would understand as a reference to Christ as the bait in a trap set by God to catch Satan. Joseph is drilling holes in a small board used as a drainboard for making wine, calling to mind the Eucharist and Christ's Passion.

The complex and consistent treatment of light in the Mérode Altarpiece represents a major preoccupation of Flemish painters. The strongest illumination comes from an unseen source at the upper left in front of the **picture plane** (the picture's front surface) as if sunlight were entering through the opened front of the room. More light comes from the rear windows, and a few painted, linear rays come from the round window at left, a symbolic vehicle for the Christ Child's descent. Jesus seems to slide down the rays of light linking God with Mary, carrying the cross of human salvation over his shoulder. The light falling on the Virgin's lap emphasizes this connection, and the transmission of the symbolic light through a transparent panel of glass (which remains intact) recalls the virginal nature of Jesus' conception.

JAN VAN EYCK. In 1425 Jan van Eyck (active 1420s–1441) became court painter to Duke Philip the Good of Burgundy (r. 1419–1467), who was the uncle of the king of France and one of the most sophisticated men in Europe. He made Jan one of his confidential employees and even sent him on a diplomatic mission to Portugal, charged with painting a portrait of a prospective bride for Philip. The duke alluded to Jan's remarkable technical skills in a letter of 1434–1435, saying that he could find no other painter equal to his taste or so excellent in art and science. So brilliant was Jan's use of oil glazes that he was mistakenly credited with the invention of oil painting (see "Oil Painting," page 571).

Jan's 1433 portrait of a **MAN IN A RED TURBAN (FIG. 18–11)** projects a particularly strong sense of personality, and the signed and dated frame also bears Jan's personal motto—"As I can, [but

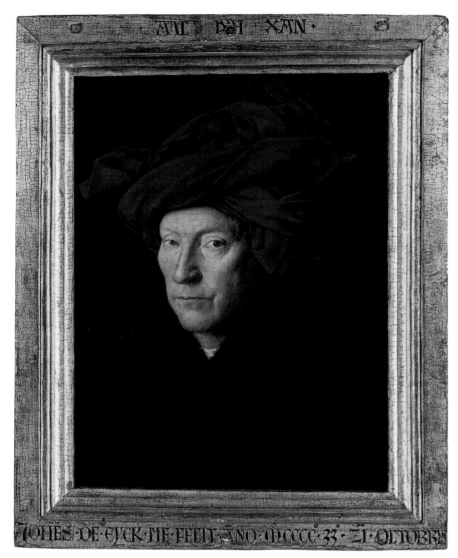

**18-11 • Jan van Eyck MAN IN A RED TURBAN**
1433. Oil on wood panel, 13⅛ × 10¼″ (33.3 × 25.8 cm). National Gallery, London.

as well as their remarkable surface realism, and the scrupulous attention to the luminous details of textures as variable as jewels and human flesh, are magnificent examples of Jan's artistic wizardry. He has carefully controlled the lighting within this multi-panel ensemble to make it appear that the objects represented are illuminated by sunlight coming through the window of the very chapel where it was meant to be installed. Jan's painting is firmly grounded in the terrestrial world even when he is rendering a visionary subject.

The Ghent altarpiece may have been Jan's most famous painting during his lifetime, but his best-known painting today is a distinctive double portrait of a couple identified as a Giovanni Arnolfini and his wife (SEE FIG. 18–1). Early interpreters saw this fascinating work as a wedding or betrothal. Above the mirror on the back wall **(FIG. 18–12)**, the artist inscribed the words: *Johannes de eyck fuit hic 1434* ("Jan van Eyck was here 1434"). More normal on a signature would have been, "Jan van Eyck made this," so the words "was here" might suggest that Jan served as a witness to a matrimonial episode portrayed in the painting. Jan is not the only witness recorded in the painting. The convex mirror between the figures reflects not only the back of the couple but a front view of two visitors standing in the doorway, entering the room. Perhaps one of them is the artist himself.

New research has complicated the developing interpretation of this painting by revealing that the Giovanni Arnolfini traditionally identified as the man in this painting married his wife Giovanna Cenami only in 1447, long after the date on the wall and Jan van Eyck's own death. One scholar has proposed that the picture is actually a prospective portrait of Giovanni and Giovanna's marriage in the future, painted in 1434 to secure the early transfer of the dowry from her father to her future husband. Others have more recently suggested the man portrayed here is a different Giovanni Arnolfini, accompanied either by his putative second wife or a memorial portrait of his first wife, Costanza Trenta, who died the year before this picture was painted, perhaps in childbirth. The true meaning of this fascinating masterpiece may remain a mystery, but it is doubtful that scholars will stop trying to solve it.

not as I would]"—in Greek letters at the top. Since these letters also form an anagram of his own name, most scholars see this painting as a self-portrait in which physical appearance seems recorded in a magnifying mirror. We see the stubble of a day's growth of beard on his chin and cheeks, and every carefully described wrinkle around the artist's eyes, reddened from the strain of his work, and reflecting light that seems to emanate from our own space. That same light source gives the inscriptions the *trompe l'oeil* sense of having been engraved into the frame, heightening the illusionistic wizardry of Jan's painting. Is Jan looking out directly at us, or are we seeing his reflection in a mirror?

In his lifetime, one of the most famous works of Jan van Eyck was a huge polyptych with a very complicated and learned theological program that he (perhaps in collaboration with his brother Hubert) painted for a chapel in what is now the Cathedral of St. Bavo in Ghent (see "The Ghent Altarpiece," pages 576–577). The three-dimensional mass of the figures, the voluminous draperies

**ROGIER VAN DER WEYDEN.** Little as we know about Jan van Eyck, we know even less about the life of Rogier van der Weyden (c. 1400–1464). Not a single existing work of art bears his name. He may have studied under the Master of Flémalle, but the relationship is not altogether clear. First establishing himself in

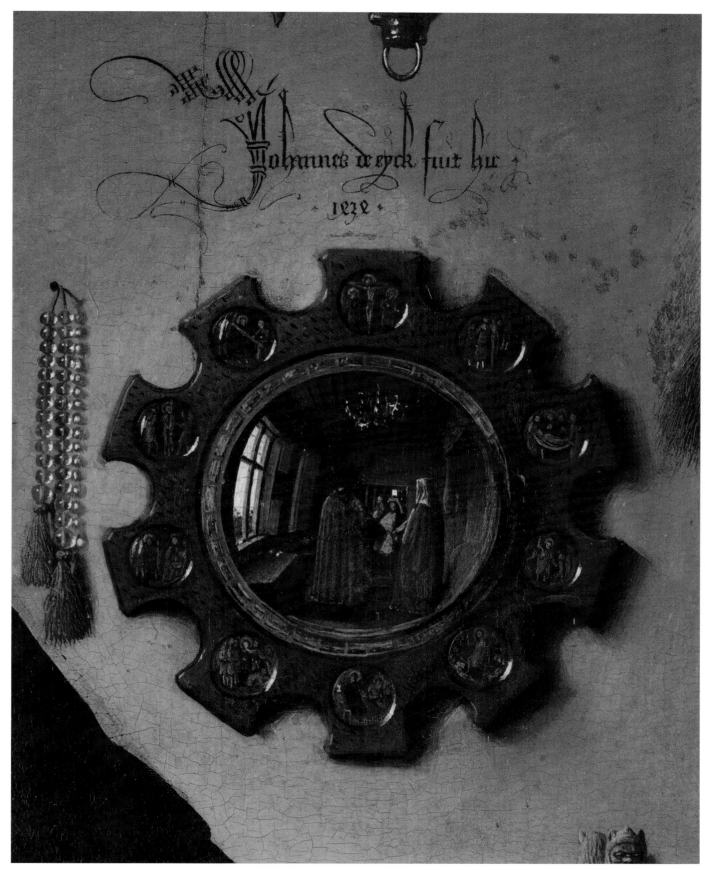

**18-12** • Jan van Eyck **DETAIL OF MIRROR AND SIGNATURE IN A DOUBLE PORTRAIT OF A GIOVANNI ARNOLFINI AND HIS WIFE (FIG. 18-1)**

1434. Oil on wood panel. The National Gallery, London.

# The Ghent Altarpiece

An inscription on the frame of the Ghent Altarpiece seems to identify both Jan and Hubert van Eyck as its artists: "The painter Hubert van Eyck, greater than whom no one was found, began [this work]; and Jan, his brother, second in art, having carried through the task at the expense of Jodocus Vyd, invites you by this verse, on the sixth of May [1432], to look at what has been done."

Many art historians believe Hubert began this altarpiece, and after his death in 1426, Jan completed it, when free of ducal responsibilities in 1430–1432. Others believe the entire painting was produced by Jan and his workshop, Hubert perhaps being responsible for the frame. At least commission and situation are clear. Jodocus Vijd, who appears with his wife Isabella Borluut on the outside of the polyptych's shutters—both visible only when the altarpiece is closed—commanded the work. Part of a wealthy family of financiers, Jodocus was a city official in Ghent—holding an office comparable to mayor in 1433–1434—and the altarpiece was part of a renovation he funded in the family chapel at the parish church of St. John (now the Cathedral of St. Bavo). He also endowed daily Masses in the chapel for the couple's salvation, and that of their ancestors.

When the altarpiece was closed, the exterior of the shutters displayed the striking likenesses of the donor couple kneeling to face painted statues of SS. John the Baptist (patron of Ghent) and John the Evangelist (patron of this church) that recall those on Sluter's Well of Moses (SEE FIG. 18–3). Above this row is an expansive rendering of the Annunciation—whose somber color scheme coordinates with the *grisaille* statues painted below—situated in an upstairs room that looks out over a panoramic cityscape. As in Simone Martini's Annunciation altarpiece (SEE FIG. 17–13), the words that issue from Gabriel's mouth ("Hail, full of grace, the Lord is with thee") appear on the painting's surface, and here there is Mary's response as well ("Behold the handmaid of the Lord"), only it is painted upside down since it is

directed to God, who hovers above her head as the dove of the Holy Spirit. Prophets and sibyls perch in the irregular compartments at the top, unfurling scrolls recording their predictions of Christ's coming.

When the shutters were opened on Sundays and feast days, the mood changed. The effect is no longer muted, but rich in

both color and implied sound. Dominating the altarpiece by size, central location, and brilliant color is the enthroned figure of God, wearing the triple papal crown, with an earthly crown at his feet, and flanked by the Virgin Mary and John the Baptist, each holding an open book. To either side are first angel musicians and then Adam and Eve,

**A. Jan and Hubert (?) van Eyck  GHENT ALTARPIECE (CLOSED), ANNUNCIATION WITH DONORS**
Completed 1432. Oil on panel, height 11'5¾" (3.5 m). Cathedral of St. Bavo, Ghent.

represented as lifelike nudes. Adam seems to have been painted from a model, from whom Jan reproduced even the "farmer's tan" of his hands and face. Eve displays clear features of the female anatomy; the pigmented line running downward from her navel appears frequently during pregnancy. Each of the three themes of the upper register—God with Mary and John, musical angels, and Adam and Eve—is set in a distinct space: the holy trio in a golden shrine, angels against a blue sky, Adam and Eve in shallow stone niches.

The five lower panels present a unified field. A vast landscape with meadows, woods, and distant cities is set against a continuous horizon. A diverse array of saints—apostles, martyrs, confessors, virgins, hermits, pilgrims, warriors, judges—assemble to adore the Lamb of God as described in the book of Revelation. The Lamb stands on an altar, blood flowing into a chalice, ultimately leading to the fountain of life.

The Ghent altarpiece became a famous work of art almost as soon as it was completed. To celebrate Duke Philip the Good's visit to the city in 1458, citizens of Ghent welcomed him with *tableaux vivants* (living pictures) of its scenes. German artist Albrecht Dürer traveled to Ghent to see the altarpiece in 1521. During the French occupation of Flanders in 1794 it was transferred to Paris (returned in 1815), and during World War II it was confiscated by the Nazis. It is now displayed within a secure glass case in the baptismal chapel of the church for which it was made.

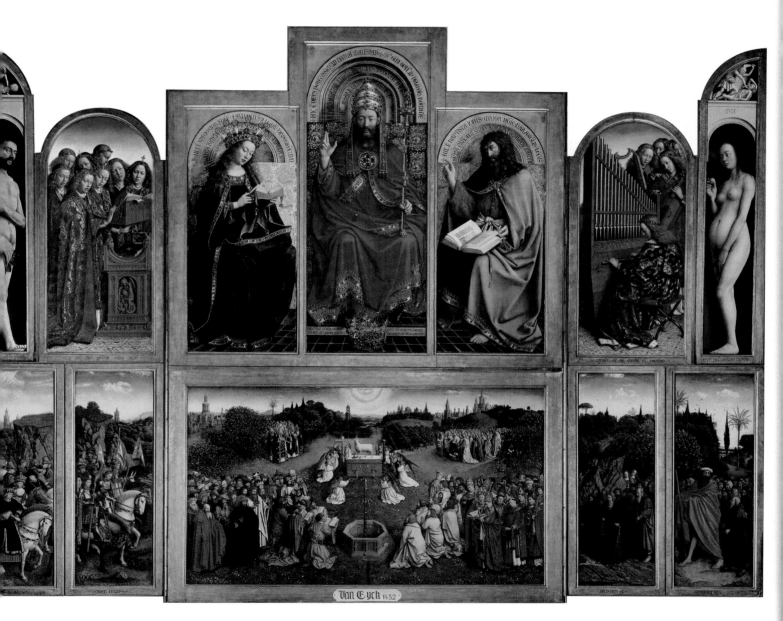

**B.** Jan and Hubert (?) van Eyck **GHENT ALTARPIECE (OPEN), ADORATION OF THE MYSTIC LAMB**
Completed 1432. Oil on panel, 11′5¾″ × 15′1½″ (3.5 × 4.6 m). Cathedral of St. Bavo, Ghent.

**18–13 • Rogier van der Weyden  DEPOSITION**
From an altarpiece commissioned by the crossbowmen's guild, Louvain, Belgium. Before 1443, possibly
c. 1435–1438. Oil on wood panel, 7′2⅝″ × 8′7⅛″ (2.2 × 2.62 m). Museo del Prado, Madrid.

**EXPLORE MORE:** Gain insight from a primary source regarding Rogier van der Weyden
www.myartslab.com

1432 as an independent master in Tournai, at the peak of his career, Rogier maintained a large workshop in Brussels, where he was the official city painter, attracting apprentices and shop assistants from as far away as Italy. To establish the stylistic characteristics of Rogier's art, scholars have turned to a painting of the **DEPOSITION** (**FIG. 18–13**), an altarpiece commissioned by the Louvain crossbowmen's guild (crossbows can be seen in the tracery painted in the upper corners) sometime before 1443, the date of the earliest known copy of it by another artist.

The Deposition was a popular theme in the fifteenth century because of its potential for dramatic, personally engaging portrayal. Rogier sets the act of removing Jesus' body from the cross on the shallow stage of a gilt wooden box, just like the case of a carved and painted altarpiece. The ten solid, three-dimensional figures, however, are not simulations of polychromed wood carving, but near life-size renderings of actual human figures who seem to press forward into the viewer's space, allowing them no escape from the forceful expressions of heartrending grief. Jesus' friends seem palpably real, with their portraitlike faces and scrupulously described contemporary dress, as they tenderly and sorrowfully remove his body from the cross for burial. Jesus' corpse dominates the center of the composition, drooping in a languid curve, framed by jarringly thin, angular arms. His pose is echoed by the rhyming form of the swooning Virgin. It is as if mother and son share in the redemptive passion of his death on the cross, encouraging viewers to identify with them both, or join their assembled companions in mourning their fate. Although united by their sorrow, the mourning figures react in personal ways, from the intensity of Mary Magdalen at far right, wringing her hands in anguish, to John the Evangelist's blank stare at left, lost in grief as he reaches to support

the collapsing Virgin. The anguish of the woman behind him, mopping her tear-soaked eyes with the edge of her veil, is almost unbearably poignant.

Rogier's choice of color and pattern balances and enhances his composition. The complexity of the gold brocade worn by Joseph of Arimathea, who offered his new tomb for the burial, and the contorted pose and vivid dress of Mary Magdalen increase the visual impact of the right side of the panel to counter the pictorial weight of the larger number of figures at the left. The palette contrasts subtle, slightly muted colors with brilliant expanses of blue and red, while white accents focus the viewers' attention on the main subjects. The whites of the winding cloth and the tunic of the youth on the ladder set off Jesus' pale body, as the white turban and shawl emphasize the ashen face of Mary.

Another work by Rogier, painted at about the same time as the Deposition, is both quieter and more personal. It represents the evangelist St. Luke executing a preparatory drawing in silverpoint for a painting of the Virgin and Child who seem to have materialized to pose for him **(FIG. 18–14)**. The painting is based on a legend with origins in sixth-century Byzantium of a miraculous appearance of the Virgin and Child to Luke so he could record their appearance and pass on his authentic witness to his Christian followers. Rogier's version takes place in a carefully defined interior

**18–14** • Rogier van der Weyden **ST. LUKE DRAWING THE VIRGIN AND CHILD** c. 1435–1440. Oil and tempera on wood panel, 54¼ × 43⅝″ (137.7 × 110.8 cm). Museum of Fine Arts, Boston.

space that opens onto a garden, and from there into a distant vista of urban life before dissolving into the countryside through which a winding river guides our exploration all the way to the horizon. The Virgin is preoccupied with a routine maternal activity. Her baby has pulled away from her breast, producing a smile and flexing his hand—familiar gestures of actual babies during nursing. The good mother and happy baby are observed by Luke, who perches on his knees and captures the scene in a silverpoint sketch, a common preliminary step used by fifteenth-century Flemish painters in the planning of their paintings, especially portraits. And the portraitlike quality of Luke's face here has led scholars to propose that this image of a saint is a self-portrait of its artist.

Art historians have traditionally interpreted this painting in two ways. Some see it—especially if it is a self-portrait—as a

document of Rogier's sense of his own profession. They see him distancing himself and his fifteenth-century Flemish colleagues from identification with the laboring artisans of the Middle Ages, and staking a claim for his special role as an inspired creator who recorded sacred visions in valuable, individualistic works of art. The notion of Rogier's own identification with Luke in this painting is supported by the fact that later artists emulated his composition in creating their own self-portraits as the century progressed. But other art historians, proposing that this painting was created for the chapel of the guildhall of the painters in Brussels (the evidence is suggestive but unclear), have interpreted it as a claim for the importance of the painters' profession because it is rooted in saintly legend. Perhaps this extraordinary picture was both self-fashioning and professional propaganda. But it was also a devotional image.

Luke's tenuous, half-kneeling perch, and his dreamy, introspective gaze certainly remind us that one of the tasks of painters in this period was to create inspiring pictures of religious visions that are also materialized by meticulous references to the real world. This most certainly is that.

## PAINTING AT MID CENTURY: THE SECOND GENERATION

The extraordinary accomplishments of the Master of Flémalle, Jan van Eyck, and Rogier van der Weyden attracted many followers in Flanders. The work of this second generation of Flemish painters may have been simpler, more direct, often easier to understand than that of their predecessors, but they produced extraordinary works of great emotional power. They were in large part responsible for the rapid spread of the Flemish style throughout Europe.

PETRUS CHRISTUS.    Among the most interesting of these painters was Petrus Christus (active 1444–c. 1475/1476), who became a citizen of Bruges in 1444 and signed and dated six paintings in a career that extended over three decades.

In 1449, Christus painted a portrait of a goldsmith, serving two well-dressed customers in his shop (see "A Closer Look," opposite). A halo around the head of the seated figure—not originally a part of the painting—was removed by restorers in 1993. This coincided with a reevaluation of the subject matter of the work, now seen as a vocational portrait of an actual goldsmith, rather than an image of St. Eloi, patron saint of goldsmiths, set in the present. Both finished products and raw materials of the jeweler's trade sit on the shelves behind the goldsmith: containers, rings, brooches, a belt buckle, a string of beads, pearls, gemstones, coral, and crystal cylinders. A betrothal belt curls across the counter. Such a combination of objects suggests that the painting expresses the hope for health and well-being for the couple who may be in the process of procuring rings for their upcoming marriage.

As in Jan van Eyck's double portrait, a convex mirror extends the viewer's field of vision, in this instance to the street outside, where two men appear. One is stylishly dressed in red and black, and the other holds a falcon, another indication of high status. Whether or not the reflected image has symbolic meaning, the mirror would have had practical value in a goldsmith's shop, allowing him to observe the approach of potential customers to the counter outside his shop window.

DIRCK BOUTS.    Dirck Bouts (active c. 1444–1475) is best known among Flemish painters as a storyteller, and he exercised those skills in a series of large altarpieces, with narrative scenes drawn from the life of Christ and the lives of the saints. But he also created more intimate pictures, such as this tender rendering of the **VIRGIN AND CHILD**, just 8½ inches tall **(FIG. 18–15)**. Even it evokes a story. Mary holds her baby securely, using both of her plain, strong hands to surround completely the lower part of his body. The baby reaches across his mother's chest and around her neck, pulling himself closer to press his face next to hers, cheek to cheek,

**18–15 • Dieric Bouts VIRGIN AND CHILD**
c. 1455–1460. Oil on wood panel, 8½ × 6½″ (21.6 × 16.5 cm). Metropolitan Museum of Art, New York.

nose to nose, mouth to mouth, eyes locked together, forming a symmetrical system that links them in pattern and almost melds them into a single mirrored form. It is as if a fifteenth-century St. Luke had captured a private moment between the Virgin and Child—a dimpled mother and baby looking very much like the actual people in the artist's world—during their miraculous appearance to sit as his model (compare FIG. 18–14). The concept is actually not so far fetched. Bouts's painting is modeled after a fourteenth-century Italian image in the cathedral of Cambrai that in the fifteenth century was believed to have been painted by St. Luke himself.

HUGO VAN DER GOES.    Hugo van der Goes (c. 1440–1482), dean of the painters' guild in Ghent (1468–1475), united the intellectual prowess of Jan van Eyck with the emotional sensitivity of Rogier van der Weyden to create an entirely new personal style. Hugo's major work was an exceptionally large altarpiece, more than 8 feet tall, of the Nativity **(FIG. 18–16)**, commissioned by Tommaso Portinari, head of the Medici bank in Bruges. Painted probably

## A Goldsmith in his Shop

by Petrus Christus. 1449. Oil on oak panel, 38⅝ × 33½″ (98 × 85 cm).
Metropolitan Museum of Art, New York, Robert Lehman Collection, 1975. 1975.1.110

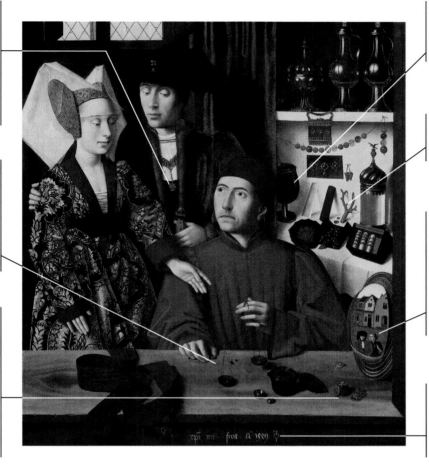

The coat of arms of the dukes of Guelders hangs from a chain around this man's neck, leading some to speculate that the woman, who is the more active of the pair, is Mary of Guelders, niece of Duke Philip the Good, who married King James II of the Scots the same year this picture was painted.

Goldsmiths were expected to perform all their transactions, including the weighing of gold, in public view to safeguard against dishonesty. Here the scales tip toward the couple, perhaps an allusion to the scales of the Last Judgment, which always tip to the side of the righteous.

Three types of coins rest on the shop counter: "florins" from Mainz, "angels" from English King Henry VI's French territories, and "riders" minted under Philip the Good. Such diversity of currency could show the goldsmith's cosmopolitanism, or they could indicate his participation in money changing, since members of that profession belonged to the same guild as goldsmiths.

This coconut cup was supposed to neutralize poison. The slabs of porphyry and rock crystal were "touchstones," used to test gold and precious stones.

The red coral and serpents' tongues (actually fossilized sharks' teeth) were intended to ward off the evil eye.

Two men, one with a falcon on his arm, are reflected in the obliquely placed mirror as they stand in front of the shop. The edges of the reflection catch the red sleeve of the goldsmith and the door frame, uniting the interior and exterior spaces and drawing the viewer into the painting.

The artist signed and dated his work in a bold inscription that appears just under the tabletop at the bottom of the painting: "Master Petrus Christus made me in the year 1449."

SEE MORE: View the Closer Look feature for *A Goldsmith in his Shop* **www.myartslab.com**

between 1474 and 1476, the triptych was sent to Florence and installed in 1483 in the Portinari family chapel, where it had a noticeable impact on Florentine painters.

Tommaso, his wife Maria Baroncelli, and their three oldest children are portrayed kneeling in prayer on the side panels of the wing interiors. On the left wing, looming larger than life behind Tommaso and his son Antonio, are the saints for whom they are named, St. Thomas and St. Antony. Since the younger son, Pigello, born in 1474, was apparently added after the original composition was set, his name saint is lacking. On the right wing, Maria and her daughter Margherita are presented by SS. Mary Magdalen and Margaret.

The theme of the altarpiece is the Nativity as told by Luke (2:10–19). The central panel represents the Adoration of the newborn Christ Child by Mary and Joseph, a host of angels, and the shepherds who have rushed in from the fields. In the middle ground of the wings are additional scenes. Winding their way through the winter landscape are two groups headed for Bethlehem. On the left wing, Mary and Joseph travel there to take part in a census. Near term in her pregnancy, Mary has dismounted from her donkey and staggers, supported by Joseph. On the right wing, a servant of the three Magi, who are coming to honor the awaited Savior, asks directions from a peasant.

Hugo paints meadows and woods meticulously, and he used atmospheric perspective to approximate distance in the landscape. He shifts figure size for emphasis: The huge figures of Joseph, Mary, and the shepherds are the same size as the patron saints on the wings, in contrast to the much smaller Portinari family and still

**18–16 • Hugo van der Goes PORTINARI ALTARPIECE (OPEN)**

c. 1474–1476. Tempera and oil on wood panel; center 8′3½″ × 10′ (2.53 × 3.01 m), wings each 8′3½″ × 4′7½″ (2.53 × 1.41 m). Galleria degli Uffizi, Florence.

smaller angels. Hugo also uses light, as well as the gestures and gazes of the figures, to focus our eyes on the center panel where the mystery of the Incarnation takes place. Instead of lying swaddled in a manger or in his mother's arms, Jesus rests naked and vulnerable on the barren ground. Rays of light emanate from his body. This image was based on the visionary writing of the medieval Swedish mystic St. Bridget (who composed her work c. 1360–1370), which describes Mary kneeling to adore the Christ Child immediately after giving birth.

As in the work of Jan van Eyck, aspects of the setting of this painting are infused with symbolic meaning. In the foreground, the wheatsheaf refers both to the location of the event at Bethlehem, which in Hebrew means "house of bread," and to the Eucharistic Host, which represents the body of Christ. The majolica albarello is decorated with vines and grapes, alluding to the Eucharistic wine, which represents the blood of Christ. It holds a red lily for Christ's blood and three irises—white for purity and purple for Christ's royal ancestry. The seven blue columbines in the glass vessel remind the viewer of the Virgin's future sorrows, and scattered on the ground are violets, symbolizing humility. But Hugo's artistic vision transcends such formal religious symbolism. For example, the shepherds, who stand in unaffected awe before the miraculous event, are among the most sympathetically rendered images of common people to be found in the art of any period, and the portraits of the Portinari children are unusually sensitive renderings of the delicate features of youthful faces.

HANS MEMLING. The artist who seems to summarize and epitomize painting in Flanders during the second half of the fifteenth century is German-born Hans Memling (c. 1435–1494). Memling combines the intellectual depth and virtuoso rendering of his predecessors with a delicacy of feeling and exquisite grace, a "prettiness" that made his work exceptionally popular. Memling may have worked in Rogier van der Weyden's Brussels workshop in the 1460s, but soon after Rogier's death in 1464, Memling moved to Bruges, where he developed an international clientele that supported a thriving workshop. He also worked for local patrons.

In 1487, the 24-year-old Maarten van Nieuwenhove (1463–1500), member of a powerful political family in Bruges (he would himself become mayor of Bruges in 1497), commissioned from Memling a diptych that combined a meticulously detailed portrait with a visionary apparition of the Virgin and Child, presented as a powerful fiction of their physical encounter in Maarten's own home (FIG. 18–17). This type of devotional diptych was a specialty of Rogier van der Weyden, but Memling transforms the type into something more intimate by placing it in a domestic setting. An expensively outfitted figure of Maarten appears in the right wing of the diptych, seen from an oblique angle, hands folded in prayer. He seems caught in a moment of introspection inspired by personal devotions—his Book of Hours lies still open on the table in front of him. The window just over his shoulder holds a stained-glass rendering of his name saint, Martin, in the top pane, while a recognizable landmark in Bruges can be seen through the pane below. The Virgin and Child on the adjacent panel are presented frontally, and the strong sense of specific likeness characterizing Maarten's portrait has given way to an idealized delicacy and grace in the visage of the Virgin that complements the extravagance of her clothing. Although she does not seem to be

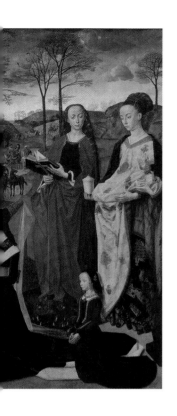

focusing on him, a completely nude Jesus stretches out on the silk pillow in front of her; she stabilizes him with one hand and offers him an apple with the other. This seems a clear reference to their roles as the new Adam and Eve, ready to redeem the sin brought into the world by the first couple. The stained glass behind them is filled with heraldry, devices, and a motto associated with Maarten's family.

Memling's construction of a coherent interior space for these figures is both impressive and meaningful. We are looking through two windows into a rectangular room containing this devotional group. The pillow under the Christ Child casts a shadow, painted on the lower frame of the left panel, to intensify the illusion, and the Virgin's scarlet mantle extends under the division between the two wings of the diptych to reappear on Maarten's side of the painting underneath his Book of

Hours. This mantle not only connects the two sides of the painting spatially but also relates Maarten's devotional exercise and the apparition of the Virgin and Child. This relationship is also documented with a device already familiar to us in paintings by Jan van Eyck (SEE FIG. 18–12) and Petrus Christus (see "A Closer Look," page 581). On the shadowy back wall, over the Virgin's right shoulder and set against the closed shutters of a window, is a convex mirror that reflects the backs of both Maarten and Mary, bearing visual witness to their presence together within his domestic space and undoing the division between them that is endemic to the diptych format. Maarten's introspective gaze signals that for him the encounter is internal and spiritual, but Memling transforms Maarten's private devotion into a public statement that promotes an image of his piety and freezes him in perpetual prayer. We bear witness to his vision as an actual event.

## EUROPE BEYOND FLANDERS

Flemish art—its complex symbolism, its coherent configurations of atmospheric space, its luminous colors and sensuous surface textures—delighted wealthy patrons and well-educated courtiers both inside and outside Flanders. At first, Flemish artists worked in foreign courts or their works were commissioned and exported abroad. Flemish manuscripts, tapestries, altarpieces, and portraits

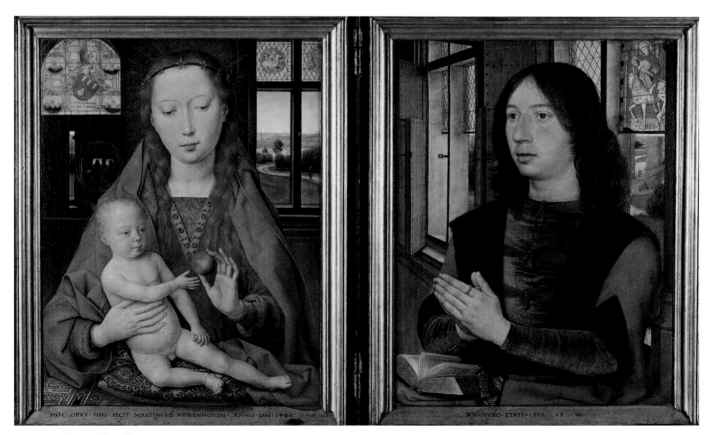

**18–17 • Hans Memling DIPTYCH OF MAARTEN VAN NIEUWENHOVE**
1487. Oil on wood panel, each panel (including frames) 20½ × 16¼″ (52 × 41.5 cm). Hans Memling Museum, Musea Brugge, Sint-Jans Hospital, Bruges.

appeared in palaces and chapels throughout Europe. Soon regional artists traveled to Flanders to learn oil-painting techniques and practice emulating the Flemish style. By the end of the fifteenth century, distinctive regional variations of Flemish art could be found throughout Europe, from the Atlantic Ocean to the Danube.

## FRANCE

The centuries-long struggle for power and territory between France and England continued well into the fifteenth century. When King Charles VI of France died in 1422, England claimed the throne for the king's 9-month-old grandson, Henry VI of England. The plight of Charles VII, the late French king's son, inspired Joan of Arc to lead a crusade to return him to the throne. Thanks to Joan's efforts, Charles was crowned at Reims in 1429. Although Joan was burned at the stake in 1431, the revitalized French forces drove the English from French lands. In 1461, Louis XI succeeded his father, Charles VII, as king of France. Under his rule the French royal court again became a major source of patronage for the arts.

JEAN FOUQUET. The leading court artist of fifteenth-century France, Jean Fouquet (c. 1425–1481), was born in Tours and may have trained in Paris as an illuminator and in Bourges in the workshop of Jacob de Littemont, Flemish court painter to Charles VII. He was part of a French delegation to Rome in 1446–1448, but by mid century he had established a workshop in Tours and was a renowned painter. Fouquet drew from contemporary Italian

Classicism, especially in rendering architecture, and he was also strongly influenced by Flemish illusionism. He painted pictures of Charles VII, the royal family, and courtiers, and he illustrated manuscripts and designed tombs.

Among the court officials who commissioned paintings from Fouquet was Étienne Chevalier, treasurer of France under Charles VII. Fouquet painted a diptych for him that was installed over the tomb of Chevallier's wife Catherine Budé (d. 1452) in the church of Notre-Dame in Melun (FIG. 18–18). Chevalier appears in the left panel, kneeling in prayer with clasped hands and an introspective, meditative gaze within an Italianate palace, accompanied by his name saint Stephen (Étienne in French). Fouquet describes the courtier's ruddy features with a mirrorlike precision that is reminiscent of Flemish art. He is expensively dressed in a heavy red wool garment lined with fur, and his "bowl cut" represents the latest Parisian fashion in hair styling. St. Stephen's features convey a comparable sense of likeness and sophistication. A deacon in the Early Christian church in Jerusalem, Stephen was the first Christian martyr, stoned to death for defending his beliefs. Here he wears the fifteenth-century liturgical, or ritual, vestments of a deacon and carries a large stone on a closed Gospel book as evidence of his martyrdom. A trickle of blood can be seen on his tonsured head (male members of religious orders shaved the tops of their heads as a sign of humility). Placing his arm around Étienne Chevalier's back, the saint seems to be introducing the treasurer to the Virgin and Child in the adjacent panel.

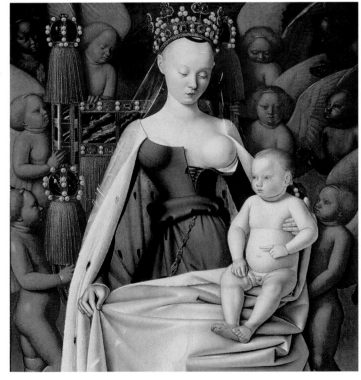

18–18 • Jean Fouquet ÉTIENNE CHEVALIER AND ST. STEPHEN, VIRGIN AND CHILD
The Melun Diptych. c. 1452–1455. Oil on oak panel. Left wing: 36½ × 33½″ (92.7 × 85.5 cm), Staatliche Museen zu Berlin, Preussischer Kulturbesitz, Gemäldegalerie; right wing: 37¼ × 33½″ (94.5 × 85.5 cm). Koninklijk Museum voor Schone Kunsten, Antwerp, Belgium.

The Virgin and Child, however, exist in another world. A supernatural vision unfolds here as the queen of heaven is enthroned surrounded by red and blue seraphim and cherubim, who form a tapestrylike background. Even the Virgin seems a celestial being, conceived by Fouquet as a hybrid of careful description and powerful abstraction. Her fashionable, tightly waisted bodice has been unlaced so she can present her spherical breast to a substantial, seated baby, who points across the juncture between the two wings of the diptych to acknowledge Chevalier. According to tradition, Fouquet gave this image of the Virgin the features of the king's much loved and respected mistress, Agnès Sorel, who died in 1450. The original frame that united these two panels—now divided between two museums—into a diptych is lost, but among the fragments that remain is a stunning medallion self-portrait that served as the artist's signature.

JEAN HEY, THE MASTER OF MOULINS. Perhaps the greatest French follower of Jean Fouquet is an artist who for many years was known as the Master of Moulins after a large triptych he painted at the end of the fifteenth century under the patronage of Duke Jean II of Bourbon, for the Burgundian Cathedral of Moulins. This triptych combines the exuberance of Flemish attention to brilliant color and the differentiation of surface texture with a characteristically French air of reserved detachment. Recently the work of this artist has been associated with the name Jean Hey, a painter of Flemish origin, who seems to have been trained in the workshop of Hugo van der Goes, but who pursued his career at the French court.

This charming portrait (FIG. 18–19)—which may have been one half of a devotional diptych comparable to that painted by Memling for Maarten van Nieuwenhove (SEE FIG. 18–17)—portrays Margaret of Austria (1480–1530), daughter of Emperor Maximilian I, who had been betrothed to the future French king Charles VIII (r. 1483–1498) at age 2 or 3 and was being brought up at the French court. She would return home to her father in 1493 after Charles decided to pursue another, more politically expedient marriage (after two political marriages of her own, the widowed Margaret would eventually become governor of the Habsburg Netherlands), but Hey captures her at a tender moment a few years before those troubled times. She kneels in front of a strip of wall between two windows that open onto a lush country landscape, fingering the pearl beads of her rosary. Details of her lavish velvet and ermine outfit not only proclaim her wealth but provide the clues to her identity—the *Cs* and *Ms* embroidered on her collar signal her betrothal to Charles and the ostentatious *fleur-de-lis* pendant set with large rubies and pearls proclaims her affiliation with the French court. But it is the delicacy and sweet vulnerability of this 10-year-old girl that are most arresting. They recall Hugo van der Goes's sensitivity to the childlike qualities of the young members of donor families (SEE FIG. 18–16) and provide one strong piece of evidence for ascribing Hey's training to the workshop of this Flemish master.

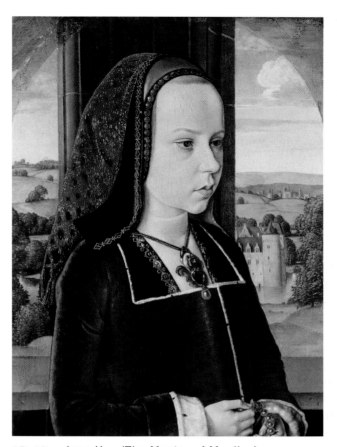

18–19 • Jean Hey (The Master of Moulins)
**PORTRAIT OF MARGARET OF AUSTRIA**
c. 1490. Oil on wood panel, 12⅞ × 9⅛″ (32.7 × 23 cm). Metropolitan Museum of Art, New York, Robert Lehman Collection.

FLAMBOYANT ARCHITECTURE. The great age of cathedral building that had begun in the mid twelfth century was essentially over by the end of the fourteenth century, but growing urban populations needed houses, city halls, guildhalls, and more parish churches. It was in buildings such as these that late Gothic architecture took form in a style we call "Flamboyant" because of its repeated, twisted, flamelike tracery patterns. Late Gothic masons covered their buildings with increasingly elaborate, complex, and at times playful architectural decoration. Like painters, sculptors also turned to describing the specific nature of the world around them, and they covered capitals and moldings with ivy, hawthorn leaves, and other vegetation, not just the conventional acanthus motifs rooted in the Classical world.

The church of Saint-Maclou in Rouen, which was begun after a fund-raising campaign in 1432 and dedicated in 1521, is an outstanding and well-preserved example of Flamboyant Gothic (FIG. 18–20) probably designed by the Paris architect Pierre Robin. A projecting porch bends to enfold the façade of the church in a screen of tracery. Sunlight on the flame-shape openings casts ever-changing shadows across the intentionally complex surface. **Crockets**—small, knobby leaflike ornaments that line the steep gables and slender buttresses—break every defining line. In

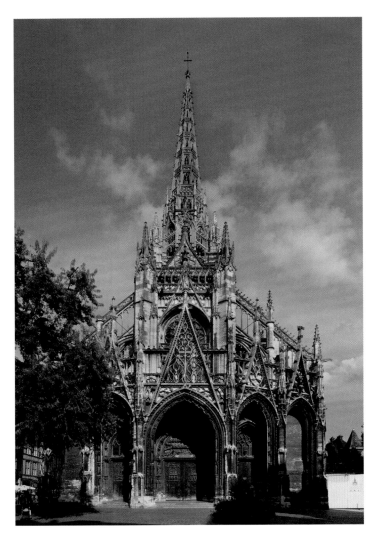

**18-20 • Pierre Robin (?) CHURCH OF SAINT-MACLOU, ROUEN**
Normandy, France. West façade, 1432–1521; façade c. 1500–1514.

SEE MORE: Click the Google Earth link for Saint-Maclou
www.myartslab.com

## GERMANY AND SWITZERLAND

Present-day Germany and Switzerland were situated within the Holy Roman Empire, a loose confederation of primarily German-speaking states. Artisan guilds grew powerful and trade flourished under the auspices of the Hanseatic League, an association of cities and trading outposts, stimulating a strengthening of the merchant class. The Fugger family, for example, began their spectacular rise

**18-21 • PLAN OF JACQUES COEUR HOUSE**
Bourges, France. 1443–1451.

**18-22 • INTERIOR COURTYARD OF JACQUES COEUR HOUSE**
Bourges, France. 1443–1451.

the Flamboyant style, decoration sometimes disguises structural elements with an overlay of tracery and ornament in geometric and natural shapes, all to dizzying effect.

The house of Jacques Coeur, a fabulously wealthy merchant in Bourges, reflects the popularity of the Flamboyant style for secular architecture (**FIGS. 18–21, 18–22**). Built at great expense between 1443 and 1451, it survives almost intact, although it has been stripped of its rich furnishings. The rambling, palatial house is built around an irregular open courtyard, with spiral stairs in octagonal towers giving access to the upper-floor rooms. Tympana over doors indicate the function of the rooms within; for example, over the door to the kitchen a cook stirs the contents of a large bowl. Among the carved decorations are puns on the patron's surname, Coeur (meaning "heart" in French). The house was also Jacques Coeur's place of business, so it had large storerooms for goods and a strongroom for treasure.

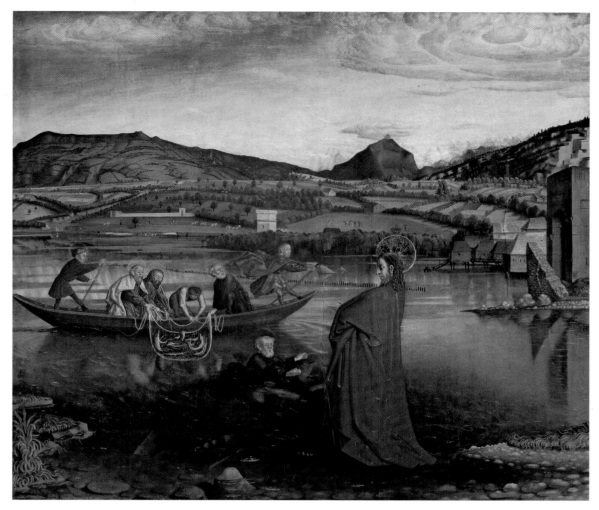

**18-23 • Konrad Witz MIRACULOUS DRAFT OF FISHES**
From an altarpiece for the Cathedral of St. Peter, Geneva, Switzerland. 1444. Oil on wood panel,
4′3″ × 5′1″ (1.29 × 1.55 m). Musée d'Art et d'Histoire, Geneva.

from simple textile workers and linen merchants to bankers for the Habsburgs and the popes.

KONRAD WITZ. Germanic fifteenth-century artists worked in two very different styles. Some, clustered around Cologne, continued the International Gothic style with increased prettiness, softness, and sweetness of expression. Other artists began an intense investigation and detailed description of the physical world. The major exponent of the latter style was Konrad Witz (active 1434–1446). A native of Swabia in southern Germany, Witz moved to Basel (in present-day Switzerland), where he found a rich source of patronage in the Church.

Witz's last large commission before his early death in 1446 was an altarpiece dedicated to St. Peter for the Cathedral of Geneva, signed and dated to 1444. In one of its scenes—the **MIRACULOUS DRAFT OF FISHES** (FIG. 18–23)—Jesus appears posthumously to his disciples as they fish on the Sea of Galilee and Peter leaps from the boat to greet him. But Witz sets the scene on the Lake of Geneva, with the distinctive dark mountain (the Mole) rising on the north

shore and the snow-covered Alps shining in the distance. Witz records every nuance of light and water—the rippling surface, the reflections of boats, figures, and buildings, even the lake bottom. Peter's body and legs, visible through the water, are distorted by the refraction. For one of the earliest times in European art, an artist captures both the appearance and the spirit of nature.

MICHAEL PACHER. In Germanic lands, patrons preferred altarpieces that featured polychromed wood carvings rather than the large ensembles of panel paintings that we saw in Flanders (see, for example, "The Ghent Altarpiece," pages 576–577). One of the greatest artists working in this tradition was painter and sculptor Michael Pacher (1435–1498), based in Bruneck, now in the Italian Alps. In 1471, Benedict Eck, abbot of Mondsee, commissioned from Pacher for the pilgrimage church of St. Wolfgang a grand high altarpiece that is still installed in its original church setting (FIG. 18–24). The surviving contract specifies materials and subject matter and even documents the cost—1,200 Hungarian florins—but sets no time limit for its completion. Pacher and his shop worked on it for ten years.

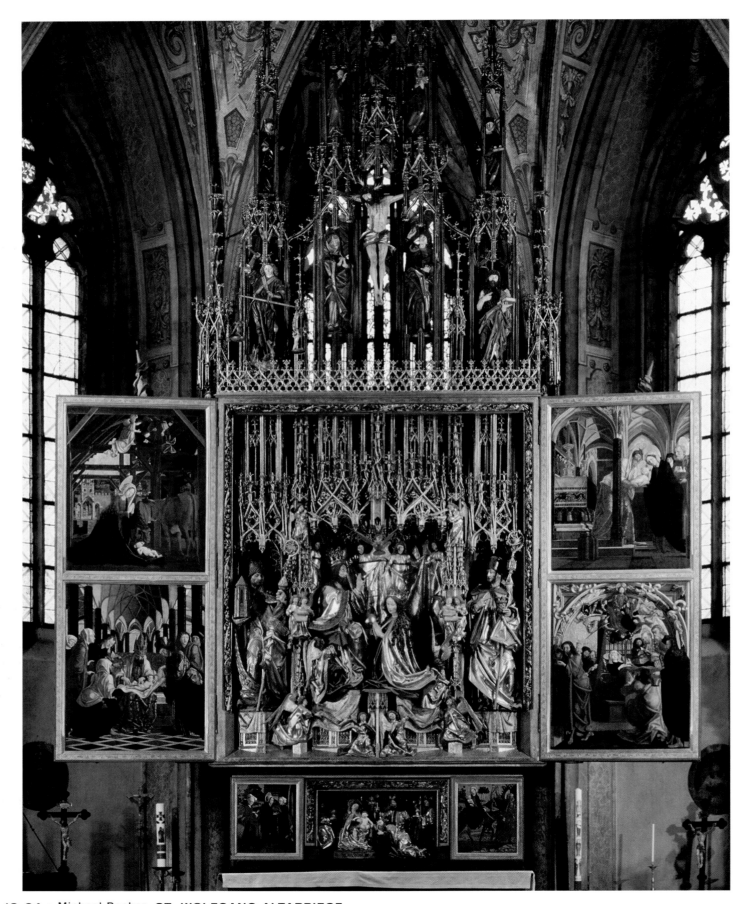

**18-24 • Michael Pacher** **ST. WOLFGANG ALTARPIECE**
St. Wolfgang, Austria, 1471–1481. Carved, painted, and gilt wood; wings are oil on wood panel.

When it is open (as in FIG. 18–24), a dizzyingly complicated sculptural ensemble aligns up the middle, flanked by four large panel paintings portraying scenes from the life of the Virgin on the opened shutters. Both the design and execution were supervised by Pacher, but many other artists collaborated with him on the actual carving and painting. In the main scene, the wood carvings create a vision in Paradise where Christ crowns his mother as the queen of heaven flanked by imposing images of local saints. The use of soft wood facilitated deep undercutting and amazing detail in the rendering of these figures, and the elaborate polychromy and gold leaf sheathed them in a shimmering finish that glitters in the changing patterns of natural light or the flickering glow of candles. It must have been an otherworldly sight.

## THE GRAPHIC ARTS

Printmaking emerged in Europe at the end of the fourteenth century with the development of printing presses and the increased local manufacture and wider availability of paper. The techniques used by printmakers during the fifteenth century were woodcut and engraving (see "Woodcuts and Engravings on Metal," page 590). **Woodblocks** cut in relief had long been used to print designs on cloth, but only in the fifteenth century did the printing of images and texts on paper and the production of books in multiple copies of a single edition, or version, begin to replace the copying of each book by hand. Both hand-written and printed books were often illustrated, and printed images were sometimes hand-colored.

### SINGLE SHEETS

Large quantities of single-sheet prints were made using woodcut and engraving techniques in the early decades of the fifteenth century. Often artists drew the images for professional woodworkers to cut from the block.

THE BUXHEIM ST. CHRISTOPHER.    Devotional images were sold as souvenirs to pilgrims at holy sites. The **BUXHEIM ST. CHRISTOPHER** was found in the Carthusian Monastery of Buxheim, in southern Germany, glued to the inside of the back cover of a manuscript **(FIG. 18–25)**. St. Christopher, patron saint of travelers and protector from the plague, carries the Christ Child across the river. His efforts are witnessed by a monk holding out a light to guide him to the monastery door, but ignored by the hardworking millers on the opposite bank. Both the cutting of the block and the quality of the printing are very high. Lines vary in width to strengthen major forms. Delicate lines are used for inner modeling (facial features) and short parallel lines to indicate shadows (the inner side of draperies). The date 1423, which is cut into the block, was once thought to identify this print as among the earliest to survive. Recent studies have determined that the date refers to some event, and the print is now dated at mid century.

MARTIN SCHONGAUER.    Engraving may have originated with goldsmiths and armorers, who recorded their work by rubbing

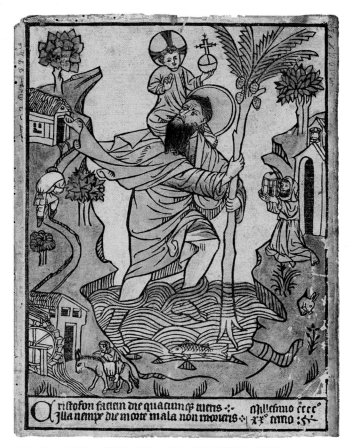

**18-25 • THE BUXHEIM ST. CHRISTOPHER**
Mid 15th century. Hand-colored woodcut, 11⅜ × 8⅛" (28.85 × 20.7 cm). Courtesy of the Director and Librarian, the John Rylands University Library, the University of Manchester, England

The Latin text reads, "Whenever you look at the face of St. Christopher, you will not die a terrible death that day."

lampblack into the engraved lines and pressing paper over the plate. German artist Martin Schongauer (c. 1435–1491), who learned engraving from his goldsmith father, was an immensely skillful printmaker who excelled both in drawing and in the difficult technique of shading from deep blacks to faintest grays using only line. In **DEMONS TORMENTING ST. ANTHONY**, engraved about 1470–1475 **(FIG. 18–26)**, Schongauer illustrated the original biblical meaning of temptation as a physical assault rather than a subtle inducement. Wildly acrobatic, slithery, spiky demons lift Anthony up off the ground to torment and terrify him in midair. The engraver intensified the horror of the moment by condensing the action into a swirling vortex of figures beating, scratching, poking, tugging, and no doubt shrieking at the stoical saint, who remains impervious to all, perhaps because of his power to focus inwardly on his private meditations.

### PRINTED BOOKS

The explosion of learning in Europe in the fifteenth century encouraged experiments in faster and cheaper ways of producing books than by hand-copying them. The earliest printed books were block books, for which each page of text, with or without

**Woodcuts** are made by drawing on the smooth surface of a block of fine-grained wood, then cutting away all the areas around the lines with a sharp tool called a gouge, leaving the lines in high relief. When the block's surface is inked and a piece of paper pressed down hard on it, the ink on the relief areas transfers to the paper to create a reverse image. The effects can be varied by making thicker and thinner lines, and shading can be achieved by placing the lines closer or farther apart. Sometimes the resulting black-and-white images were then painted by hand.

**Engraving** on metal requires a technique called **intaglio**, in which the lines are cut into the plate with tools called gravers or **burins**. The engraver then carefully burnishes the plate to ensure a clean, sharp image. Ink is applied over the whole plate and forced down into the lines, then the plate's surface is carefully wiped clean of the excess ink. When paper and plate are held tightly together by a press, the ink in the recessed lines transfers to the paper.

**Woodblocks** and metal plates could be used repeatedly to make nearly identical images. If the lines of the block or plate wore down, the artists could repair them. Printing large numbers of identical prints of a single version, called an edition, was usually a team effort in a busy workshop. One artist would make the drawing. Sometimes it was drawn directly on the block or plate with ink, in reverse of its printed direction, sometimes on paper to be transferred in reverse onto the plate or block by another person, who then cut the lines. Others would ink and print the images.

In the illustration of books, the plates or blocks would be reused to print later editions and even adapted for use in other books. A set of blocks or plates for illustrations was a valuable commodity and might be sold by one workshop to another. Early in publishing, there were no copyright laws, and many entrepreneurs simply had their workers copy book illustrations onto woodblocks and cut them for their own publications.

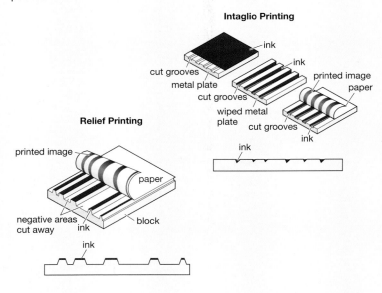

illustrations, was cut in relief on a single block of wood. Movable-type printing, in which individual letters could be arranged and locked together, inked, and then printed onto paper, was first achieved in Europe in the workshop of Johann Gutenberg in Mainz, Germany. More than 40 copies of Gutenberg's Bible, printed around 1455, still exist. As early as 1465, two German printers were working in Italy, and by the 1470s there were presses in France, Flanders, Holland, and Spain. With the invention of this fast way to make a number of identical books, the intellectual and spiritual life of Europe—and with it the arts—changed forever.

**THE NUREMBERG CHRONICLE.** The publication of the *Nuremberg Chronicle* by prosperous Nuremberg printer Anton Koburger was the culmination of his complicated collaboration with scholars, artists, and investors, in an early capitalist enterprise that is a landmark in the history of printed books. The text of this history of the world was compiled by physician and scholar Hartmann Schedel, drawing from the work of colleagues and the extensive holdings of his private library. When Koburger set out to publish Schedel's compilation, he sought financial support from Sebald Schregel and his brother-in-law Sebastian Kammermaister,

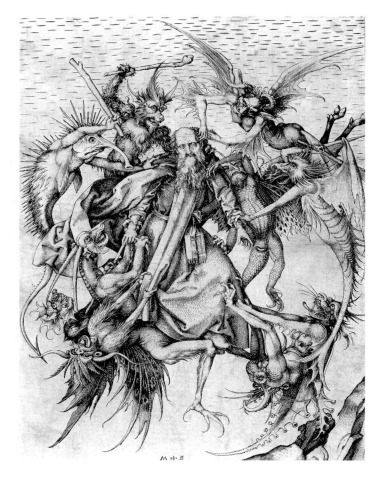

**18-26 • Martin Schongauer DEMONS TORMENTING ST. ANTHONY**
c. 1480–1490. Engraving, 12¼ × 9″ (31.1 × 22.9 cm). Metropolitan Museum of Art, New York. Rogers Fund, 1920 (20.5.2)

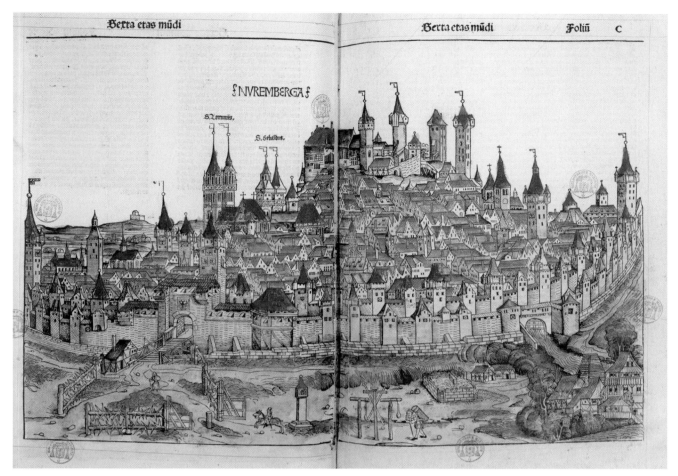

**18–27 • Michael Wolgemut, Wilhelm Pleydenwurff and workshop** **THE CITY OF NUREMBERG**
*Nuremberg Chronicle*, published by Anton Koberger in 1493. Woodcut within a printed book, hand-colored after printing, each page 18½ × 12¾″ (47 × 32.4 cm). Bibliothèque Mazarine, Paris.

who had a proven record of patronage in book publishing. He also contracted in the 1480s with artists Michael Wolgemut and Wilhelm Pleydenwurff to produce the woodcut illustrations and in 1491 to work on the layout.

The *Nuremberg Chronicle* was published in 1493 in an edition of 2,500. Woodcut illustrations—1,809 in total—were dispersed throughout the book, spreading across the width of whole pages or tucked into the text along either margin. Those interested in purchasing the book could obtain it in Latin or German, on parchment or on paper, bound or unbound, as it came from the press or tinted with color. It seems fitting that the only instance of a double-page picture—filling the entire expanse of an opening with text restricted to headings and labels—is a panoramic view of the city of Nuremberg where this collaborative enterprise was centered **(FIG. 18–27)**. Illustrated here is a view of this expansive cityscape in a copy of the book that was originally owned by a bibliophile who could afford to have the woodcuts painted by hand with color to enhance the appearance of this proud Renaissance city's portrait. As we will see, it was the site of significant artistic developments in the sixteenth century as well.

## THINK ABOUT IT

**18.1** Explain how oil-painting technique allowed fifteenth-century Flemish painters to achieve unprecedented descriptive effects in their work. Support your answer by discussing one specific work in this chapter.

**18.2** Discuss the development of portraiture in northern Europe during the fifteenth century. Choose one example in this chapter and elucidate the portrait's social purpose for the patron.

**18.3** How have fifteenth-century northern paintings been characterized as devotional visions of the patrons who are portrayed within them? Use a specific work discussed in this chapter as the focus of your answer.

**18.4** Discuss the symbolic meanings that fifteenth-century viewers would have comprehended in the objects contained in the domestic environment of either the Merode Altarpiece (FIG. 18–9) or the Arnolfini double portrait (FIG. 18–1).

**18.5** Why did printmaking become a major pictorial medium in northern Europe during the fifteenth century? Choose a work discussed in this chapter and explain how it supports your answer.

**PRACTICE MORE:** Compose answers to these questions, get flashcards for images and terms, and review chapter material with quizzes
**www.myartslab.com**

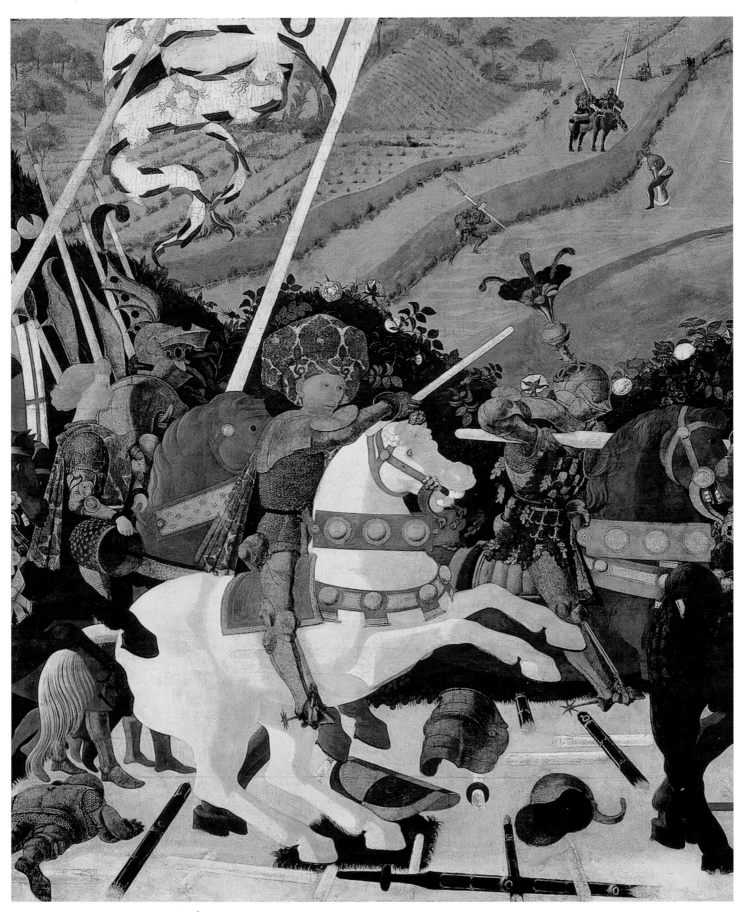

**19–1 • Paolo Uccello** **NICCOLÒ DA TOLENTINO LEADING THE CHARGE**
Detail from *The Battle of San Romano* (FIG. 19–21), 1438–1440. Tempera on wood panel. National Gallery, London.

# RENAISSANCE ART IN FIFTEENTH-CENTURY ITALY

This ferocious but bloodless battle seems to take place only in a dream (FIG. 19–1). Under an elegantly fluttering banner, the Florentine general Niccolò da Tolentino leads his men against the Sienese at the Battle of San Romano, which took place on June 1, 1432. The battle rages across a shallow stage defined by the debris of warfare arranged in a neat pattern on a pink ground and backed by blooming hedges. In the center foreground, Niccolò holds aloft a baton of command, the sign of his authority. His bold gesture—together with his white horse and outlandish, though quite fashionable, crimson and gold damask hat— ensures that he dominates the scene. His knights charge into the fray, and when they fall, like the soldier at the lower left, they join the many broken lances on the ground—all arranged in conformity with the new mathematical depiction of receding space called **linear perspective**, posed to align with the implied lines that would converge at a single point on the horizon.

An eccentric Florentine painter nicknamed Paolo Uccello ("Paul Bird") created the panel painting (SEE FIG. 19–21) from which the detail in FIG. 19–1 is taken. It is one of three related panels now separated, hanging in major museums in Florence, London, and Paris. The complete history of these paintings has only recently come to light.

Lionardo Bartolini Salimbeni (1404–1479), who led the Florentine governing Council of Ten during the war against Lucca and Siena, probably commissioned the paintings. Uccello's remarkable accuracy when depicting armor from the 1430s, heraldic banners, and even fashionable fabrics and crests surely would have appealed to Lionardo's civic pride. The hedges of oranges, roses, and pomegranates—all ancient fertility symbols—suggest that Lionardo might have commissioned the paintings at the time of his wedding in 1438. Lionardo and his wife, Maddalena, had six sons, two of whom inherited the paintings. According to a complaint brought by Damiano, one of the heirs, Lorenzo de' Medici, the powerful *de facto* ruler of Florence, "forcibly removed" the paintings from Damiano's house. They were never returned, and Uccello's masterpieces are recorded in a 1492 inventory as hanging in the Medici palace. Perhaps Lorenzo, who was called "the Magnificent," saw Uccello's heroic pageant as a trophy more worthy of a Medici merchant prince. We will certainly discover that princely patronage was a major factor in the genesis of the Italian Renaissance as it developed in Florence during the early years of the fifteenth century.

## LEARN ABOUT IT

19.1 Explore the development and use of linear perspective in fifteenth-century Florentine painting.

19.2 Examine how sculptors were instrumental in the early development of the Italian Renaissance by increasing the lifelike qualities of human figures and drawing inspiration from ancient Roman sculpture.

19.3 Assess the role of wealthy merchants and *condottieri* in driving the development of Renaissance art and architecture.

19.4 Consider how the new focus on artistic competition and individual achievement created a climate for innovative and ambitious works.

19.5 Evaluate the importance of the Classical past to the development of early Renaissance architecture.

**HEAR MORE:** Listen to an audio file of your chapter **www.myartslab.com**

# HUMANISM AND THE ITALIAN RENAISSANCE

By the end of the Middle Ages, the most important Italian cultural centers lay north of Rome in the cities of Florence, Milan, and Venice, and in the smaller duchies of Mantua, Ferrara, and Urbino. Much of the power and influential art patronage was in the hands of wealthy families: the Medici in Florence, the Montefeltro in Urbino, the Gonzaga in Mantua, the Visconti and Sforza in Milan, and the Este in Ferrara (MAP 19–1). Cities grew in wealth and independence as people moved to them from the countryside in unprecedented numbers. As in northern Europe, commerce became increasingly important. Money conferred status, and a shrewd business or political leader could become very powerful. The period saw the rise of mercenary armies led by entrepreneurial (and sometimes brilliant) military commanders called *condottieri*. Unlike the knights of the Middle Ages, they owed allegiance only to those who paid them well; their employer might be a city-state, a lord, or even the pope. Some *condottieri*, like Niccolò da Tolentino (SEE FIG. 19–1), became rich and famous. Others, like Federico da Montefeltro (SEE FIG. 19–27), were lords or dukes themselves, with their own territories in need of protection. Patronage of the arts was an important public activity with political overtones. As one Florentine merchant, Giovanni Rucellai, succinctly noted, he supported the arts "because they serve the glory of God, the honour of the city, and the commemoration of myself" (cited in Baxandall, p. 2).

The term Renaissance (French for "rebirth") was only applied to this period by later historians. However, its origins lie in the thought of Petrarch and other fourteenth-century Italian writers, who emphasized the power and potential of human beings for great individual accomplishment. These Italian humanists also looked back at the thousand years extending from the disintegration of the Western Roman Empire to their own day and determined that the achievements of the Classical world were followed by what they perceived as a period of decline—a "middle" or "dark" age. They proudly saw their own era as a third age characterized by a revival, rebirth, or renaissance, when humanity began to emerge from what they erroneously saw as intellectual and cultural stagnation to appreciate once more the achievement of the ancients and the value of rational, scientific investigation. They looked to the accomplishments of the Classical past for inspiration and instruction, and in Italy this centered on the heritage of ancient Rome. They sought the physical and literary records of the ancient world—assembling libraries, collecting sculpture and fragments of architecture, and beginning archaeological investigations. Their aim was to live a rich, noble, and productive life—usually within the framework of Christianity, but always adhering to a school of philosophy as a moral basis.

Artists, like the humanists, turned to Classical antiquity for inspiration, emulating what they saw in ancient Roman sculpture and architecture, even as they continued to fulfill commissions for predominantly Christian subjects and buildings. But from the secular world a number of home furnishings such as birth trays and marriage chests have survived, richly painted with allegorical and mythological themes (see "The Morelli-Nerli Wedding Chests," page 616). Patrons began to collect art for their personal enjoyment.

Like the Flemish artists, Italian painters and sculptors increasingly focused their attention on rendering the illusion of physical reality. They did so in a more analytical way than the northerners. Rather than seeking to describe the detailed visual appearance of nature through luminosity and textural differentiation, Italian artists aimed at achieving lifelike but idealized weighty figures set within a rationally configured space organized through strict adherence to a mathematical system called linear perspective, which achieved the illusion of a measured and continuously receding space (see "Renaissance Perspective," page 608).

# FLORENCE

In seizing Uccello's battle painting (SEE FIG. 19–1), Lorenzo de' Medici was asserting the role his family had come to expect to play in the history of Florence. The fifteenth century witnessed the rise of the Medici from among the most successful of a newly rich middle class (comprising primarily merchants and bankers) to become the city's virtual rulers. Unlike the hereditary aristocracy, the Medici emerged from obscure roots to make their fortune in banking. And from their money came their power.

The competitive Florentine atmosphere that had fostered mercantile success and civic pride also cultivated competition in the arts and encouraged an interest in ancient literary texts. This has led many to consider Florence the cradle of the Italian Renaissance. Under Cosimo the Elder (1389–1464), the Medici became leaders in intellectual and artistic patronage. They sponsored philosophers and other scholars who wanted to study the Classics, especially the works of Plato and his followers, the Neoplatonists. Neoplatonism distinguished between the spiritual (the ideal or Idea) and the physical (Matter) and encouraged artists to represent ideal figures. But it was writers, philosophers, and musicians—and not artists—who dominated the Medici Neoplatonic circle. Architects, sculptors, and painters learned their craft in apprenticeships and were therefore considered manual laborers. Nevertheless, interest in the ancient world rapidly spread from the Medici circle to visual artists, who gradually began to see themselves as more than laborers. Florentine society soon recognized their best works as achievements of a very high order.

Although the Medici were the *de facto* rulers, Florence was considered to be a republic. The Council of Ten (headed for a time by Salimbeni, who commissioned Uccello's *Battle of San Romano*) was a kind of constitutional oligarchy where wealthy men formed the government. At the same time, the various guilds wielded tremendous power; evidence of this is provided by the fact that guild membership was a prerequisite for holding government office. Consequently, artists could look to the Church and the

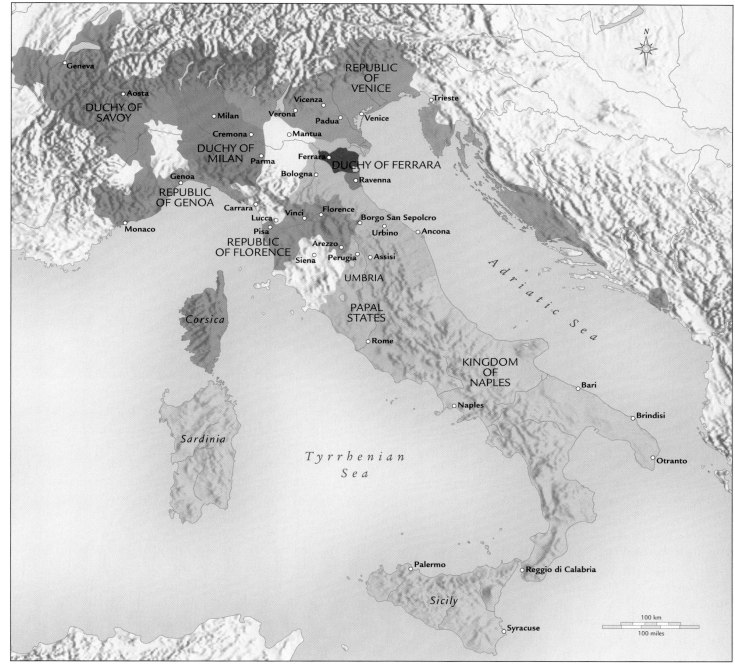

**MAP 19–1 • FIFTEENTH-CENTURY ITALY**

Powerful families divided the Italian peninsula into city-states—the Medici in Florence, the Visconti and Sforza in Milan, the Montefeltro in Urbino, the Gonzaga in Mantua, and the Este in Ferrara. After 1420, the popes ruled Rome, while in the south Naples and Sicily were French and then Spanish (Aragonese) territories. Venice maintained its independence as a republic.

state—the city government and the guilds—as well as private individuals for patronage, and these patrons expected the artists to re-affirm and glorify their achievements with works that were not only beautiful but intellectually powerful.

## ARCHITECTURE

The defining civic project of the early years of the fifteenth century was the completion of Florence Cathedral with a magnificent

dome over the high altar. The construction of the cathedral had begun in the late thirteenth century and had continued intermittently during the fourteenth century. As early as 1367, builders had envisioned a very tall dome to span the huge interior space of the crossing, but they lacked the engineering know-how to construct it. When interest in completing the cathedral revived, around 1407, the technical solution was proposed by a young sculptor-turned-architect, Filippo Brunelleschi.

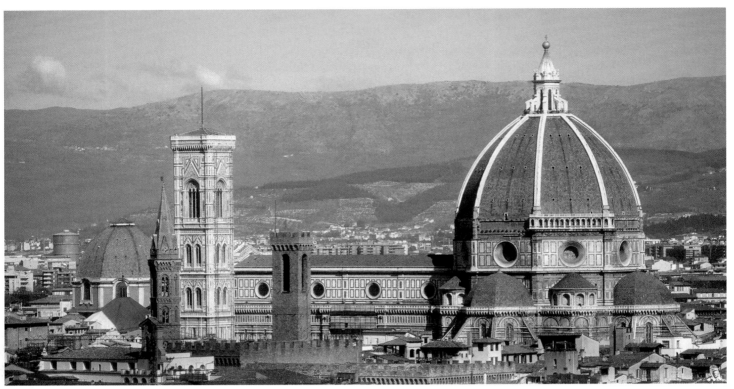

**19-2 •** Filippo Brunelleschi **DOME OF FLORENCE CATHEDRAL (SANTA MARIA DEL FIORE)**
1420–1436; lantern completed 1471.

**SEE MORE:** View a simulation about doming
**www.myartslab.com**

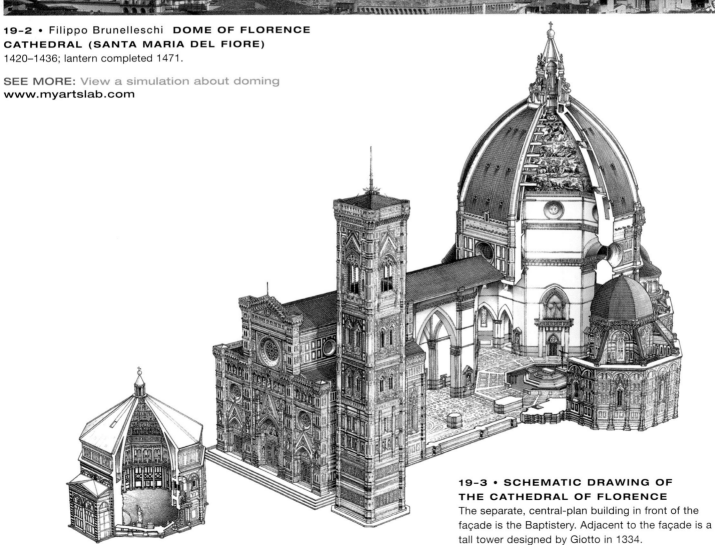

**19-3 • SCHEMATIC DRAWING OF THE CATHEDRAL OF FLORENCE**
The separate, central-plan building in front of the façade is the Baptistery. Adjacent to the façade is a tall tower designed by Giotto in 1334.

FILIPPO BRUNELLESCHI. Filippo Brunelleschi (1377–1446), whose father had been involved in the original plans for the cathedral dome in 1367, achieved what many considered impossible: He solved the problem of the dome. Brunelleschi had originally trained as a goldsmith (see "The Competition Reliefs," page 601). To further his education, he traveled to Rome to study ancient Roman sculpture and architecture, and it was on his return to Florence that he tackled the dome. After the completion of a tall octagonal drum in 1412, Brunelleschi designed the dome itself in 1417, and it was built between 1420 and 1436 (FIGS. 19–2, 19–3). A revolutionary feat of engineering, the dome is a double shell of masonry 138 feet across. The octagonal outer shell is supported on eight large and 16 lighter ribs. Instead of using a costly and even dangerous scaffold and centering, Brunelleschi devised a system in which temporary wooden supports were cantilevered out from the drum. He moved these supports up as building progressed. As the dome was built up course by course, each portion of the structure reinforced the next one. Vertical marble ribs interlocked with horizontal sandstone rings, connected and reinforced with iron rods and oak beams. The inner and outer shells were linked internally by a system of arches. When completed, this self-buttressed unit required no external support to keep it standing.

An oculus (round opening) in the center of the dome was surmounted by a lantern designed in 1436. After Brunelleschi's death, this crowning structure, made up of Roman architectural forms, was completed by another Florentine architect, Michelozzo di Bartolomeo (1396–1472). The final touch—a gilt bronzed ball—was added in 1468–1471.

Other commissions came quickly after the cathedral dome project established Brunelleschi's fame. From about 1418 until his death in 1446, Brunelleschi was involved in a series of influential projects. In 1419, he designed a foundling hospital for the city (see "The Foundling Hospital," pages 598–599). Between 1419 and 1423, he built the elegant Capponi Chapel in the church of Santa Felicità (SEE FIG. 20–25). For the Medicis' parish church of San Lorenzo, he designed and built a centrally planned sacristy (a room where ritual attire and vessels are kept), from 1421 to 1428, and also conceived plans for a new church.

Brunelleschi's SAN LORENZO has a basilican plan with a long nave flanked by side aisles that open into shallow lateral chapels (FIG. 19–4). A short transept and square crossing lead to a square sanctuary flanked by additional chapels opening off the transept. Projecting from the left transept, as one faces the altar, are Brunelleschi's sacristy and the older Medici tomb. Brunelleschi based his mathematically regular plan on a square module—a basic unit of measure that could be multiplied or divided and

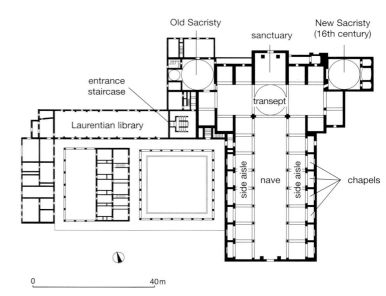

19–4 • Filippo Brunelleschi; continued by Michelozzo di Bartolomeo **INTERIOR AND PLAN OF CHURCH OF SAN LORENZO, FLORENCE**
c. 1421–1428; nave (designed 1434?) 1442–1470.

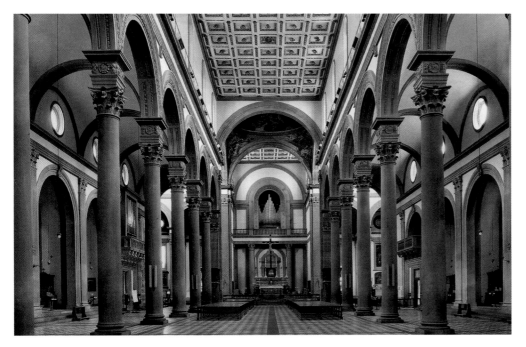

## The Foundling Hospital

In 1419, the guild of silk manufacturers and goldsmiths (Arte della Seta) in Florence undertook a significant public service: It established a large public orphanage and commissioned the brilliant young architect Filippo Brunelleschi to build it next to the church of the Santissima Annunziata (Most Holy Annunciation), which housed a miracle-working painting of the Annunciation, making it a popular pilgrimage site. Completed in 1444, the Foundling Hospital—*Ospedale degli Innocenti*—was unprecedented in terms of scale and design (FIG. A).

Brunelleschi created a building that paid homage to traditional forms while introducing features that we associate with the Italian Renaissance style. Traditionally, a

charitable foundation's building had a portico open to the street to provide shelter, and Brunelleschi built an arcade of unprecedented lightness and elegance, using smooth round columns and richly carved capitals—his own interpretation of the Classical Corinthian order. Although we might initially assume that the sources for this arcade lay in the Roman architecture of Classical antiquity, columns were not actually used in antiquity to support free-standing arcades, only to support straight architraves. In fact, it was local Romanesque architecture that was the source for Brunelleschi's graceful design. It is the details of capitals and moldings that bring an air of the antique to this influential building.

The underlying mathematical basis for Brunelleschi's design—traced to the same Pythagorean proportional systems that were believed to create musical harmony—creates a distinct sense of harmony in this graceful arcade. Each bay encloses a cube of space defined by the 10-*braccia* (20-foot) height of the columns and the diameter of the arches. Hemispherical pendentive domes, half again as high as the columns, cover the cubes. The bays at the end of the arcade are slightly larger than the rest, creating a subtle frame for the composition. Brunelleschi defined the perfect squares and semicircles of his building with dark gray stone (*pietra serena*) against plain white walls. His training as a goldsmith and sculptor (see "The

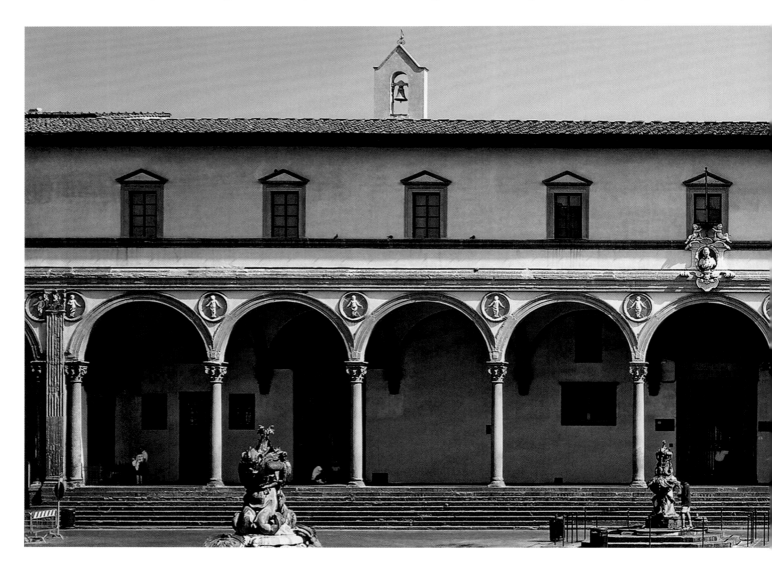

Competition Reliefs," page 601) served him well as he led his artisans to carve crisp, elegantly detailed capitals and moldings for the covered gallery.

A later addition to the building seems eminently suitable: About 1487, Andrea della Robbia, who had inherited the family firm and its secret glazing formulas from his uncle Luca, created for the interstices between the arches glazed terra-cotta medallions (FIG. B) that signified the building's function. Molds were used in the ceramic workshop to facilitate the production of the series of identical babies in swaddling clothes that float at the center of each medallion. The molded terra-cotta forms were covered with a tin glaze to make the sculptures both weatherproof and decorative, and the baby-blue ceramic backgrounds—a signature color for the della Robbia family workshop—makes them seem to float as celestial apparitions. This is not altogether inappropriate: They are meant to evoke the "innocent" baby boys martyred by King Herod in his attempt to rid his realm of the potential rival the Magi had journeyed to venerate (Matthew 2:16).

Andrea della Robbia's adorable ceramic babies—which remain among the most beloved images of the city of Florence—seem to lay claim to the human side of Renaissance humanism, reminding viewers that the city's wealthiest guild cared for the most helpless members of society. Perhaps the Foundling Hospital spoke to fifteenth-century Florentines of an increased sense of social responsibility. Or perhaps, by so publicly demonstrating social concerns, the wealthy guild that sponsored it solicited the approval and support of the lower classes in the cut-throat power politics of the day.

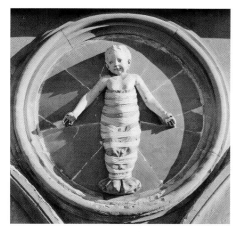

**B.** Andrea della Robbia **INFANT IN SWADDLING CLOTHES (ONE OF THE HOLY INNOCENTS MASSACRED BY HEROD)**
Ospedale degli Innocenti (Foundling Hospital), Florence. 1487. Glazed terra cotta.

**A.** Filippo Brunelleschi **OSPEDALE DEGLI INNOCENTI (FOUNDLING HOSPITAL), FLORENCE**
Designed 1419; built 1421–1444.

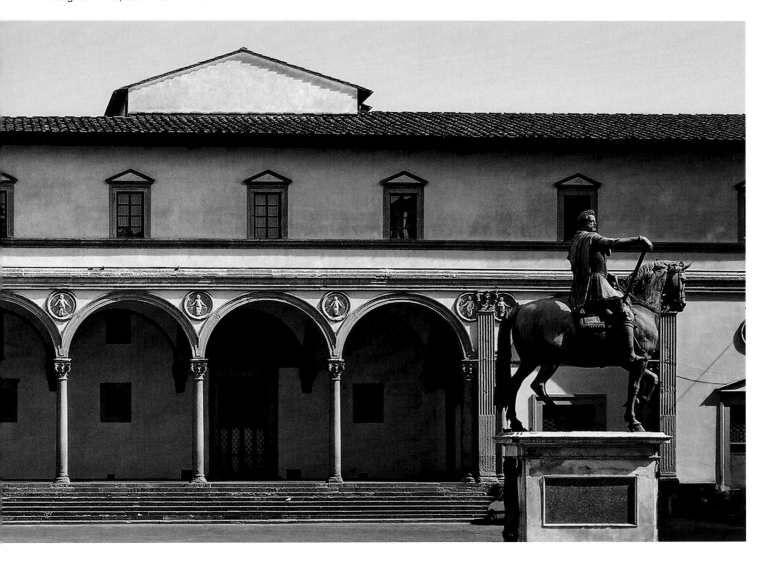

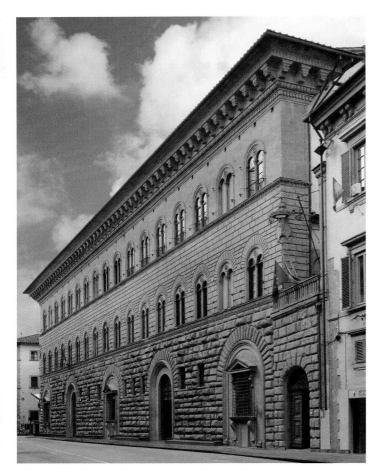

**19-5 • Attributed to Michelozzo di Bartolomeo FAÇADE, PALAZZO MEDICI-RICCARDI, FLORENCE**
Begun 1446.

For the palace site, Cosimo de' Medici the Elder chose the Via de' Gori at the corner of the Via Larga, the widest city street at that time. Despite his practical reasons for constructing a large residence and the fact that he chose simplicity and austerity over grandeur in the exterior design, his detractors commented and gossiped. As one exaggerated: "[Cosimo] has begun a palace which throws even the Colosseum at Rome into the shade."

SEE MORE: Click the Google Earth link for the Palazzo Medici-Riccardi www.myartslab.com

**THE MEDICI PALACE.** Brunelleschi may have been involved in designing the nearby Medici Palace (now known as the Palazzo Medici-Riccardi) in 1446. According to Giorgio Vasari, the sixteenth-century artist and theorist who wrote what some consider the first history of art, Cosimo de' Medici the Elder rejected Brunelleschi's model for the **palazzo** as too grand (any large house was called a *palazzo*—"palace"). Many now attribute the design of the building to Michelozzo. The austere exterior (**FIG. 19-5**) was in keeping with the Florentine political climate and concurrent religious attitudes, imbued with the Franciscan ideals of poverty and charity. Like many other European cities, Florence had sumptuary laws, which forbade ostentatious displays of wealth—but they were often ignored. For example, private homes were supposed to be limited to a dozen rooms, but Cosimo acquired and demolished 20 small houses to provide the site for his new residence. His house was more than a dwelling place; it was his place of business, his company headquarters. The palazzo symbolized the family and established its proper place in the Florentine social hierarchy.

Huge in scale—each story is more than 20 feet high—the building is marked by harmonious proportions and elegant, Classically inspired details. On one side, the ground floor originally opened through large, round arches onto the street, creating in effect a loggia that provided space for the family business. These arches were walled up in the sixteenth century and given windows designed by Michelangelo. The large, **rusticated** stone blocks—that is, blocks with their outer faces left rough—facing the lower story clearly set it off from the upper two levels. In fact, all three stories are distinguished by stone surfaces that vary from sculptural at the ground level to almost smooth on the third floor.

The builders followed the time-honored tradition of placing rooms around a central courtyard. Unlike the plan of the house of Jacques Coeur (**SEE FIG. 18–22**), however, the **PALAZZO MEDICI-RICCARDI COURTYARD** is square in plan with rooms arranged symmetrically (**FIG. 19–6**). Round arches on slender columns form a continuous arcade under an enclosed second story. Tall windows

applied to every element of the design, creating a series of clear, harmonious spaces. Architectural details, all in a Classical style, were carved in **pietra serena**, a gray Tuscan sandstone that became synonymous with Brunelleschi's interiors. Below the plain clerestory with its unobtrusive openings, the arches of the nave arcade are carried on tall, slender Corinthian columns made even taller by the insertion of an **impost block** between the column capital and the springing of the round arches—one of Brunelleschi's favorite details. Flattened architectural moldings in *pietra serena* repeat the arcade in the outer walls of the side aisles, and each bay is covered by its own shallow domical vault. Brunelleschi's rational approach, clear sense of order, and innovative incorporation of Classical motifs inspired later Renaissance architects, many of whom learned from his work firsthand by completing his unfinished projects.

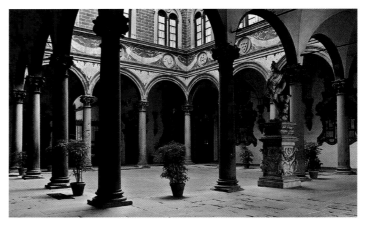

**19-6 • COURTYARD WITH SGRAFFITO DECORATION, PALAZZO MEDICI-RICCARDI, FLORENCE**
Begun 1446.

## The Competition Reliefs

In 1401, the building supervisors of the Baptistery of Florence Cathedral decided to commission a new pair of bronze doors, funded by the powerful wool merchants' guild. Instead of choosing a well-established sculptor with a strong reputation, a competition was announced for the commission. This prestigious project would be awarded to the artist who demonstrated the greatest talent and skill in executing a trial piece: a bronze relief representing Abraham's sacrifice of Isaac (Genesis 22:1–13) composed within the same Gothic quatrefoil framework used in Andrea Pisano's first set of bronze doors for the Baptistery, made in the 1330s (SEE FIG. 17–3). The narrative subject was full of dramatic potential. Abraham, commanded by God to slay his beloved son Isaac as a burnt offering, has traveled to the mountains for the sacrifice. Just as he is about to slaughter Isaac, an angel appears, commanding him to save his son and substitute a ram tangled in the bushes behind him.

Two competition panels have survived, those submitted by the presumed finalists—Filippo Brunelleschi and Lorenzo Ghiberti, both young artists in their early twenties. Brunelleschi's composition (FIG. A) is rugged and explosive, marked by raw dramatic intensity. Abraham lunges in from the left, grabbing his son by the neck, while the angel swoops energetically to stay his hand just as the knife is about to strike. Isaac's awkward pose embodies his fear and struggle. Ghiberti's version (FIG. B) is quite different, suave and graceful rather than powerful and dramatic. Poses are controlled and choreographed; the harmonious pairing of son and father contrasts sharply with the wrenching struggle in Brunelleschi's rendering. And Ghiberti's Isaac is not a stretched, scrawny youth, but a fully idealized Classical figure exuding calm composure.

The cloth merchants chose Ghiberti to make the doors. Perhaps they preferred the suave elegance of his figural composition. Perhaps they liked the prominence of elegantly disposed swags of cloth, reminders of the source of their patronage and prosperity. But they also may have been swayed by the technical superiority of Ghiberti's relief. Unlike Brunelleschi, Ghiberti cast background and figures mostly as a single piece, making his bronze stronger, lighter, and less expensive to produce. The finished doors—installed in the Baptistery in 1424—were so successful that Ghiberti was commissioned to create another set (SEE FIG. 19–12), his most famous work, hailed by Michelangelo as the "Gates of Paradise." Brunelleschi would refocus his career on buildings rather than bronzes, becoming one of the most important architects of the Italian Renaissance (SEE FIGS. 19–2 TO 19–4).

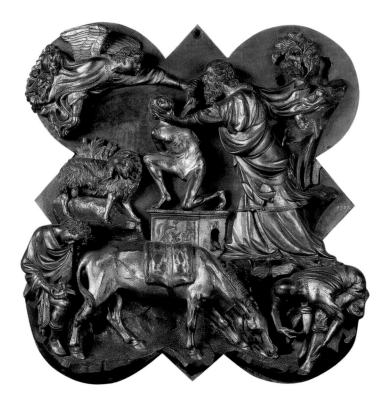

**A.** Filippo Brunelleschi **SACRIFICE OF ISAAC**
1401–1402. Bronze with gilding, 21 × 17½" (53 × 44 cm) inside molding. Museo Nazionale del Bargello, Florence.

**B.** Lorenzo Ghiberti **SACRIFICE OF ISAAC**
1401–1402. Bronze with gilding, 21 × 17½" (53 × 44 cm) inside molding. Museo Nazionale del Bargello, Florence.

in the second story match the exterior windows on this same level. Disks bearing the Medici arms surmount each arch in a frieze decorated with swags in **sgraffito** work (decoration produced by scratching through a darker layer of plaster or glaze). Such classicizing elements, inspired by the study of Roman ruins, gave the great house an aura of dignity and stability that enhanced the status of its owners. The Medici Palace inaugurated a new fashion for monumentality and regularity in residential Florentine architecture. Wealthy Florentine families soon emulated it in their own houses.

## SCULPTURE

The new architectural language inspired by ancient Classical forms was accompanied by a similar impetus in sculpture. By 1400, Florence had enjoyed internal stability and economic prosperity for over two decades. However, until 1428, the city and its independence were challenged by two great antirepublican powers: the duchy of Milan and the kingdom of Naples. In an atmosphere of wealth and civic patriotism, Florentines turned to commissions that would express their self-esteem and magnify the importance of their city. A new attitude toward realism, space, and the Classical past set the stage for more than a century of creativity. Sculptors led the way.

ORSANMICHELE. In 1339, 14 of Florence's most powerful guilds had been assigned to fill the ground-floor niches that decorated the exterior of **ORSAN-MICHELE**—a newly completed loggia that served as a grain market—with sculpted images of their patron saints **(FIG. 19–7)**. By 1400, only three had fulfilled this responsibility. In the new climate of republicanism and civic pride, the government pressured the guilds to furnish their niches with statuary. In the wake of this directive, Florence witnessed a dazzling display of sculpture produced by the most impressive local practitioners, including Nanni di Banco, Lorenzo Ghiberti, and Donatello, each of whom took responsibility for filling three niches.

In about 1409, Nanni di Banco (c. 1385–1421), son of a sculptor in the Florence Cathedral workshop, was commissioned by the stonecarvers and woodworkers' guild (to which he himself belonged) to produce **THE FOUR CROWNED MARTYRS (FIG. 19–8)**. According to tradition, these third-century Christian martyrs were sculptors, executed for refusing to make an image of a pagan Roman god for Emperor Diocletian. Although the architectural setting is Gothic in style, Nanni's figures—with their solid bodies, heavy, form-revealing togas, noble hair and beards, and portraitlike features—reveal his interest in ancient Roman sculpture, particularly portraiture. They stand as a testimony to this sculptor's role in the Florentine revival of interest in antiquity.

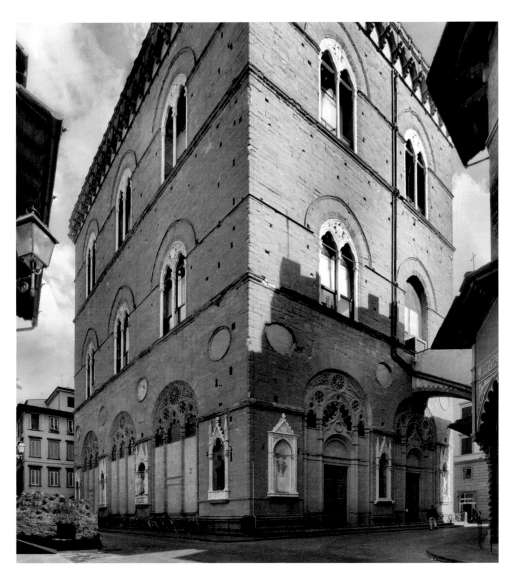

**19-7 • EXTERIOR VIEW OF ORSANMICHELE SHOWING SCULPTURE IN NICHES**
Florence, begun in 1337.

At street level, Orsanmichele was constructed originally as an open loggia (similar to the Loggia dei Lanzi in FIG. 17–2); in 1380 the spaces under the arches were filled in. In this view of the southeast corner, appearing on the receding wall to the left is first (in the foreground on the corner pier) Donatello's *St. George*, then, Nanni di Banco's *Four Crowned Martyrs*. However, the sculptures seen in this photograph are modern replicas; the originals have been removed to museums for safekeeping.

SEE MORE: Click the Google Earth link for Orsanmichele
www.myartslab.com

The saints convey a new spatial relationship to the building and to the viewer. They stand in a semicircle, with feet and drapery protruding beyond the floor of the niche and into the viewer's space. The saints appear to be four individuals interacting within their own world, but a world that opens to engage with pedestrians (SEE FIG. 19–7). The relief panel below the niche shows the four sculptors at work, embodied with a similar solid vigor. Nanni deeply undercut both figures and objects to cast shadows that enhance the illusion of three-dimensionality.

Donatello (Donato di Niccolò di Betto Bardi, c. 1386/1387–1466) also received three commissions for the niches at Orsanmichele during the first quarter of the century. A member of

19-9 • Donatello  **ST. GEORGE**
1417–1420. Marble, height 6′5″ (1.95 m). Bargello, Florence. Formerly Orsanmichele, Florence.

19-8 • Nanni di Banco  **THE FOUR CROWNED MARTYRS**
c. 1409–1417. Marble, height of figures 6′ (1.83 m). Orsanmichele, Florence (photographed before removal of figures to a museum).

the guild of stonecarvers and woodworkers, he worked in both media, as well as in bronze. During a long and productive career, he developed into one of the most influential and distinguished figures in the history of Italian sculpture, approaching each commission as if it were the opportunity for a new experiment. One of Florence's lesser guilds—the armorers and sword-makers—called on Donatello to carve a majestic and self-assured St. George for their niche **(FIG. 19–9)**. As originally conceived, the saint would have been a standing advertisement for their trade, carrying a metal

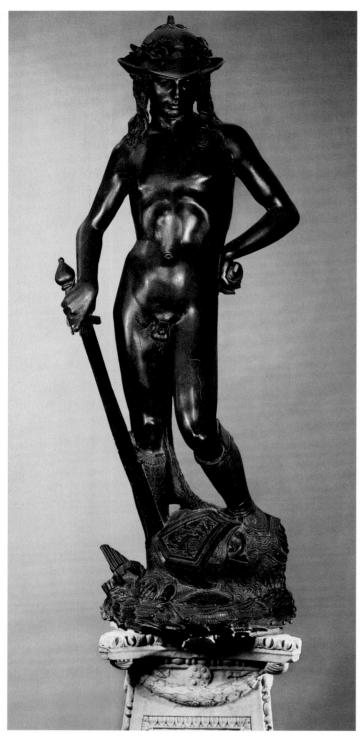

**19-10 • Donatello DAVID**
c. 1446–1460(?). Bronze, height 5′2¼″ (1.58 m). Museo Nazionale del Bargello, Florence.

This sculpture is first recorded as being in the courtyard of the Medici Palace in 1469, where it stood on a base inscribed with these lines:

The victor is whoever defends the fatherland.
All-powerful God crushes the angry enemy.
Behold, a boy overcomes the great tyrant.
Conquer, O citizens!

**SEE MORE:** View a video about the process of lost-wax casting www.myartslab.com

sword in his right hand and probably wearing a metal helmet and sporting a scabbard, all now lost. The figure has remarkable presence, even without his accessories. St. George stands in solid contrapposto, legs braced to support his armor-heavy torso, the embodiment of alertness and determination. He seems to be staring out into our world, perhaps surveying his most famous adversary—a dragon that was holding a princess captive—lurking unsettlingly in the space behind us. With his wrinkled brow and fierce expression, he is tense, alert, focused, if perhaps also somewhat worried. Donatello's complex psychological characterization of this warrior-saint particularly impressed Donatello's contemporaries, not least among them his potential patrons.

For the base of the niche, Donatello carved a remarkable shallow relief showing St. George slaying the dragon and saving the princess, the next scene in his story. The contours of the foreground figures are slightly undercut to emphasize their mass, while the landscape and architecture are in progressively lower relief until they are barely incised rather than carved, an ingenious emulation of the painters' technique of atmospheric perspective. This is also a pioneering example of linear perspective (see "Renaissance Perspective," page 608), in which the orthogonals converge on the figure of the saint himself, using this burgeoning representational system not only to simulate spatial recession but also to provide narrative focus.

**DONATELLO.** Donatello's long career as a sculptor in a broad variety of media established him as one of the most successful and admired sculptors of the Italian Renaissance. He excelled in part because of his attentive exploration of human emotions and expression, as well as his ability to solve the technical problems posed by various media—from lost-wax casting in bronze and carved marble to polychromed wood. In a bronze **DAVID**, he produced the first life-size male nude since antiquity **(FIG. 19–10)**, and in his portrait of the soldier Erasmo da Narni, one of the first life-size bronze equestrian portraits of the Renaissance (SEE FIG. 19–11).

Since nothing is known about the circumstances of its creation, the *David* has been the subject of continuing inquiry and speculation. Although the statue clearly draws on the Classical tradition of heroic nudity, the meaning of this sensuous, adolescent boy in a jaunty laurel-trimmed shepherd's hat and boots has long piqued interest. Some art historians have stressed an overt homoeroticism, especially in the openly effeminate conception of David and the way a wing from the helmet on Goliath's severed head caresses the young hero's inner thigh. Others have seen in David's angular pose and boyish torso a sense that he is poised between childish interests and adult responsibility, an image of improbable heroism. David was a potent political image in Florence, a symbol of the citizens' resolve to oppose tyrants regardless of their superior power, since virtue brings divine support and preternatural strength. Indeed, an inscription engraved into the base where the sculpture once stood suggests that it could have celebrated the

Florentine triumph over the Milanese in 1425, a victory that brought resolution to a quarter-century struggle with despots and helped give Florence a vision of itself as a strong, virtuous republic.

In 1443, Donatello was probably called to Padua to execute an **EQUESTRIAN STATUE (FIG. 19–11)** to commemorate the Paduan general of the Venetian army, Erasmo da Narni, nicknamed "Gattamelata" (meaning "Honeyed Cat"—a reference to his mother, Melania Gattelli). If any image could be said to characterize the self-made men of the Italian Renaissance, surely it would be those of the *condottieri*—the brilliant generals such as Gattamelata and Niccolò da Tolentino (SEE FIG. 19–1) who organized the armies and fought for any city-state willing to pay for their services. As guardians for hire, they were tough, opportunistic mercenaries. But they also subscribed to an ideal of military and civic virtue. Horsemanship was more than a necessary skill for the *condottieri*.

The horse, a beast of enormous brute strength, symbolized animal passions, and skilled horsemanship demonstrated physical and intellectual control—self-control, as well as control of the animal—the triumph of the intellect, of "mind over matter."

Donatello's sources for this statue were surviving Roman bronze equestrian portraits, notably the famous image of Marcus Aurelius (SEE FIG. 6–52), which the sculptor certainly knew from his stay in Rome. Viewed from a distance, Donatello's man–animal juggernaut, installed on a high marble base in front of the church of Sant'Antonio in Padua, seems capable of thrusting forward at the first threat. Seen up close, however, the man's sunken cheeks, sagging jaw, ropy neck, and stern but sad expression suggest a warrior grown old and tired from the constant need for military vigilance and rapid response.

**THE GATES OF PARADISE.** The bronze doors that Lorenzo Ghiberti (1381?–1455) produced for the Florentine Baptistery after winning his famous competition with Brunelleschi in 1401 (see "The Competition Reliefs," page 601) were such a success that in 1425 he was awarded the commission for yet another set of bronze doors for the east side of the Baptistery, and his first set was moved to the north side. The new door panels, funded by the wool manufacturers' guild, were a significant conceptual leap from the older schemes of 28 small scenes employed for Ghiberti's earlier doors and those of Andrea Pisano in the fourteenth century (SEE FIG. 17–3). Ghiberti departed entirely from the old arrangement, producing a set of ten scenes from the Hebrew Bible—from the Creation to the reign of Solomon—composed in rectangular fields, like a set of framed paintings. Michelangelo reportedly said that the results, installed in 1452, were worthy of the **"GATES OF PARADISE"**—the name by which they are now commonly known **(FIG. 19–12)**.

Ghiberti organized the space in the ten square reliefs either by a system of linear perspective with obvious orthogonal lines (see "Renaissance Perspective," page 608)

**19-11 • Donatello EQUESTRIAN STATUE OF ERASMO DA NARNI (GATTAMELATA)**
Piazza del Santo, Padua. 1443–1453.
Bronze, height approx. 12'2" (3.71 m).

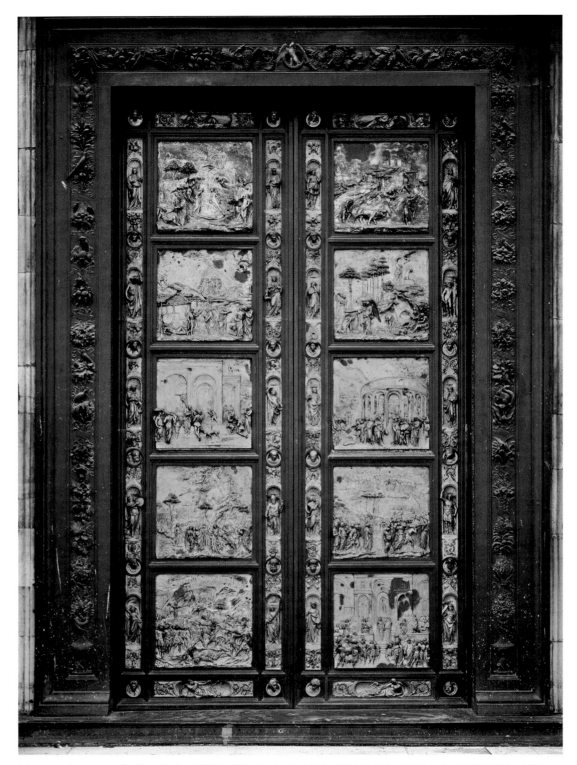

**19–12 •** Lorenzo Ghiberti **"GATES OF PARADISE" (EAST DOORS), BAPTISTERY OF SAN GIOVANNI, FLORENCE**

1425–1452. Gilt bronze, height 15′ (4.57 m). Museo dell'Opera del Duomo, Florence.

The door panels, commissioned by the wool manufacturers' guild, depict ten scenes from the Hebrew Bible beginning with the Creation in the upper left panel. The murder of Abel by his brother, Cain, follows in the upper right panel, succeeded in the same left–right paired order by the Flood and the drunkenness of Noah, Abraham sacrificing Isaac, the story of Jacob and Esau, Joseph sold into slavery by his brothers, Moses receiving the Tablets of the Law, Joshua and the fall of Jericho, David and Goliath, and finally Solomon and the queen of Sheba. Ghiberti placed his own portrait as a signature in the frame at the lower right corner of the Jacob and Esau panel. He wrote in his *Commentaries* (c. 1450–1455): "I strove to imitate nature as clearly as I could, and with all the perspective I could produce, to have excellent compositions with many figures."

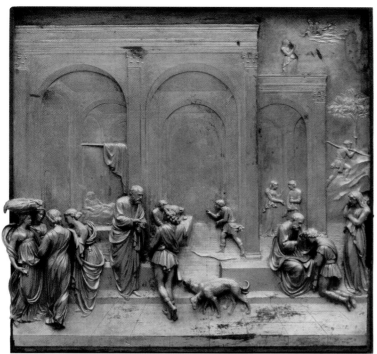

**19–13 • Lorenzo Ghiberti JACOB AND ESAU, PANEL OF THE "GATES OF PARADISE" (EAST DOORS)**
Formerly on the Baptistery of San Giovanni, Florence. c. 1435. Gilded bronze, 31¼" (79 cm) square. Museo dell'Opera del Duomo, Florence.

POLLAIUOLO. Sculptors in the fifteenth century not only worked on a monumental scale in the public sphere; they also created small works, each designed to inspire the mind and delight the eye of its private owner. The ambitious and multi-talented Antonio del Pollaiuolo—goldsmith, embroiderer, printmaker, sculptor, and painter—who came to work for the Medici family in Florence about 1460, mostly created small bronze sculptures. His **HERCULES AND ANTAEUS** of about 1475 is one of the largest **(FIG. 19–14)**. This study of complex interlocking figures has an explosive energy that can best be appreciated by viewing it from every angle.

Statuettes of religious subjects were still popular, but humanist patrons began to collect bronzes of Classical subjects. Many sculptors, especially those trained as goldsmiths, started to cast small copies after well-known ancient works. Some artists also executed

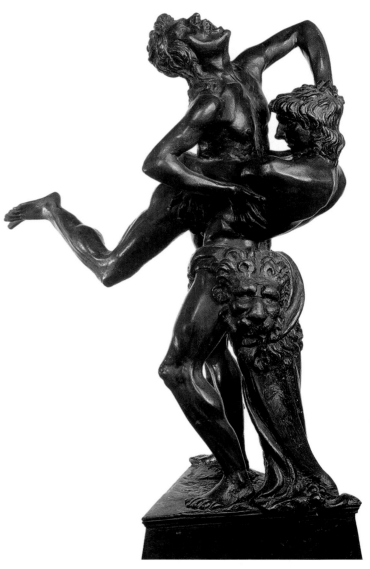

**19–14 • Antonio del Pollaiuolo HERCULES AND ANTAEUS**
c. 1475. Bronze, height with base 18" (45.7 cm). Museo Nazionale del Bargello, Florence.

or more intuitively by a series of arches or rocks or trees charting the path into the distance. Foreground figures are grouped in the lower third of each panel, while the other figures decrease gradually in size to map their positioning in deep space. The use of a system of perspective, with clearly differentiated background and foreground, also helped Ghiberti combine a series of related events, separated by narrative time, within a single pictorial frame.

The story of Jacob and Esau (Genesis 25 and 27) fills the center panel of the left door. Ghiberti creates a coherent and measurable space peopled by graceful, idealized figures **(FIG. 19–13)**. He pays careful attention to one-point perspective in laying out the architectural setting. Squares in the pavement establish the receding lines of the orthogonals that converge to a central vanishing point under the loggia, while towering arches overlap and gradually diminish in size from foreground to background to define the receding space above the figures. The story unfolds in a series of individual episodes and begins in the background. On the rooftop (upper right) Rebecca stands, listening as God warns of her unborn sons' future conflict; under the left-hand arch she gives birth to the twins. The adult Esau sells his rights as oldest son to his brother Jacob, and when he goes hunting (center right), Rebecca and Jacob plot against him. Finally, in the right foreground, Jacob receives Isaac's blessing, while in the center, Esau faces his father. Ghiberti's portrayal of the scene relates more closely to developments in painting than to contemporary sculpture. Ghiberti not only signed his work, but also included his self-portrait in the medallion beside the lower right-hand corner of this panel.

Fifteenth-century Italian artists developed a system known as linear, or mathematical perspective that enabled them to represent three dimensions on a two-dimensional surface, simulating the recession of space in the visible world pictorially in a way they found convincing. The sculptor and architect Filippo Brunelleschi first demonstrated the system about 1420, and the theorist and architect Leon Battista Alberti codified it in 1436 in his treatise *Della Pittura* (*On Painting*).

For Alberti, in one-point linear perspective a picture's surface was conceived as a flat plane that intersected the viewer's field of vision at right angles. This highly artificial concept presumed a viewer standing dead center at a prescribed distance from a work of art. From this single fixed vantage point, everything would appear to recede into the distance at the same rate, following imaginary lines called **orthogonals** that met at a single **vanishing point** on the horizon. By using orthogonals in concert with controlled diminution of scale as forms move back toward the vanishing point, artists could replicate the optical illusion that things appear to grow smaller, rise higher, and come closer together as they get farther away from us. Linear perspective makes pictorial spaces seem almost like extensions of the viewer's real space, creating a compelling, even exaggerated sense of depth.

Linear perspective is not the only way to simulate spatial recession in two-dimensional painting. In atmospheric perspective, variations in color and clarity convey the feeling of distance when objects and landscape are portrayed less clearly, and colors become grayer, in the background, imitating the natural effects of a loss of clarity and color when viewing things in the distance through an atmospheric haze.

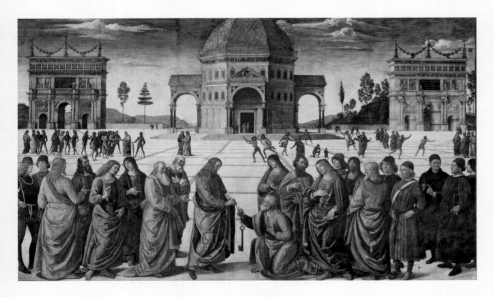

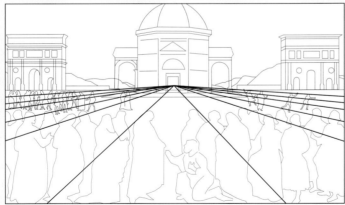

Perugino **THE DELIVERY OF THE KEYS TO ST. PETER, WITH A SCHEMATIC DRAWING SHOWING THE ORTHOGONALS AND VANISHING POINT**
Fresco on the right wall of the Sistine Chapel, Vatican, Rome. 1481. 11'5½" × 18'8½" (3.48 × 5.70 m).

*The Delivery of the Keys to St. Peter* is a remarkable study in linear perspective. The clear demarcation of the paving stones of the piazza provides a network of orthogonal and horizontal lines for the measured placement of the figures. People and buildings become increasingly, and logically, smaller as the space recedes. Horizontally, the composition is divided between the foreground frieze of figures and the widely spaced background buildings, vertically by the open space at the center between Christ and Peter and by the symmetrical architectural forms on either side of this central axis. Perugino's painting is, among other things, a representation of Alberti's ideal city, described in *De re aedificatoria* as having a "temple" (that is, a church) at the very center of a great open space raised on a dais and separate from any other buildings that might obstruct its view.

original designs *all'antica* ("in the antique style") to appeal to a cultivated humanist taste. Hercules was always a popular figure; as a patron of Florence, he was on the city seal. Among the many courageous acts by which Hercules gained immortality was the slaying of the evil Antaeus in a wrestling match by lifting him off the earth, the source of the giant's great physical power.

An engraving by Pollaiuolo, **THE BATTLE OF THE NUDES (FIG. 19–15)**, reflects two interests of Renaissance scholars—the study of Classical sculpture and anatomical research. Pollaiuolo may have intended this, his only known—but highly influential—print, as a study in composition involving the human figure in action. The naked men, fighting each other ferociously against a tapestrylike

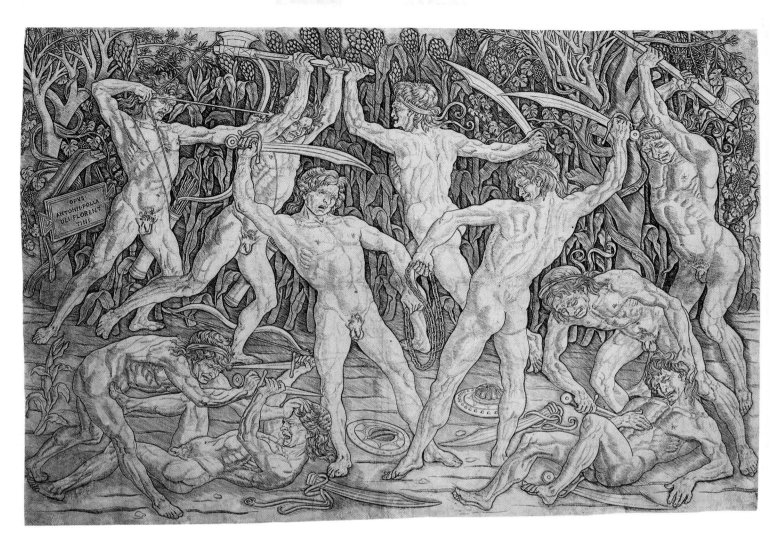

**19-15** • Antonio del Pollaiuolo **THE BATTLE OF THE NUDES**
c. 1465–1470. Engraving, 15⅛ × 23¼″ (38.3 × 59 cm). Cincinnati Art Museum, Ohio. Bequest of Herbert Greer French. 1943.118

background of foliage, seem to have been drawn from a single model in a variety of poses, many of which were taken from Classical sources. Like the artist's *Hercules and Antaeus*, much of the engraving's fascination lies in how it depicts muscles of the male body reacting under tension.

## PAINTING

Italian patrons commissioned murals and large altarpieces for their local churches and smaller panel paintings for their houses and private chapels. Artists experienced in fresco were in great demand and traveled widely to execute wall and ceiling decorations. At first the Italians showed little interest in oil painting, for the most part using tempera even for their largest works. But, in the last decades of the century, oil painting became popular in Venice.

MASACCIO. Even though his brief career lasted less than a decade, Tommaso di Ser Giovanni di Mone Cassai (1401–1428/1429?), nicknamed "Masaccio" (meaning "Big Tom"), established a new direction in Florentine painting, much as Giotto had a

century earlier. He did this by integrating monumental and consistently scaled figures into rational architectural and natural settings using linear perspective. The chronology of Massacio's works is uncertain, but his fresco of the **TRINITY** in the church of Santa Maria Novella in Florence must have been painted around 1426, the date on the Lenzi family tombstone that once stood in front of it (FIGS. 19–16, 19–17).

Masaccio's fresco was meant to give the illusion of a stone funerary monument and altar table set below a deep **aedicula** (framed niche) in the wall. The effect of looking up into a barrel-vaulted niche was made plausible through precisely rendered linear perspective. The eye level of an adult viewer standing within the church determined the horizon line on which the vanishing point was centered, just below the kneeling figures above the altar. And the painting demonstrates not only Masaccio's intimate knowledge of Brunelleschi's perspective experiments (see "Renaissance Perspective," opposite), but also his architectural style (SEE FIG. 19–4). The painted architecture is an unusual combination of Classical orders. On the wall surface, Corinthian pilasters support a

plain architrave below a cornice, while inside the niche Renaissance variations on Ionic columns support arches on all four sides. The "source" of the consistent illumination of the architecture lies in front of the picture, casting reflections on the coffers, or sunken panels, of the ceiling.

The figures are organized in a measured progression through space. At the near end of the recessed, barrel-vaulted space is the Trinity—Jesus on the cross, the dove of the Holy Spirit poised in downward flight above his tilted halo, and God the Father, who stands behind to support the cross from his elevated perch on a high platform, apparently supported on the rear columns. As in many scenes of the Crucifixion, Jesus is flanked by the Virgin Mary and John the Evangelist, who contemplate the scene on either side of the cross. Mary gazes calmly out at us, her raised hand drawing our attention to the Trinity. Members of the Lenzi family kneel in front of the pilasters—thus closer to us than the Crucifixion; the red robes of the male donor signify that he was a member of the governing council of Florence. Below these donors, in an open sarcophagus, is a skeleton, a grim reminder of the Christian belief that since death awaits us all, our only hope is redemption and the promise of life in the hereafter, rooted in Christ's sacrifice on the cross. The inscription above the skeleton reads: "I was once that which you are, and what I am you also will be."

**19–16 • Masaccio  TRINITY WITH THE VIRGIN, ST. JOHN THE EVANGELIST, AND DONORS**
Church of Santa Maria Novella, Florence. c. 1425–1427/1428. Fresco, 21′ × 10′5″ (6.4 × 3.2 m).

**19–17 • SECTION DIAGRAM OF THE ILLUSIONISTIC SPATIAL WORLD PORTRAYED IN MASACCIO'S TRINITY**
After Gene Brucker, *Florence: The Golden Age*, Berkeley, 1998.

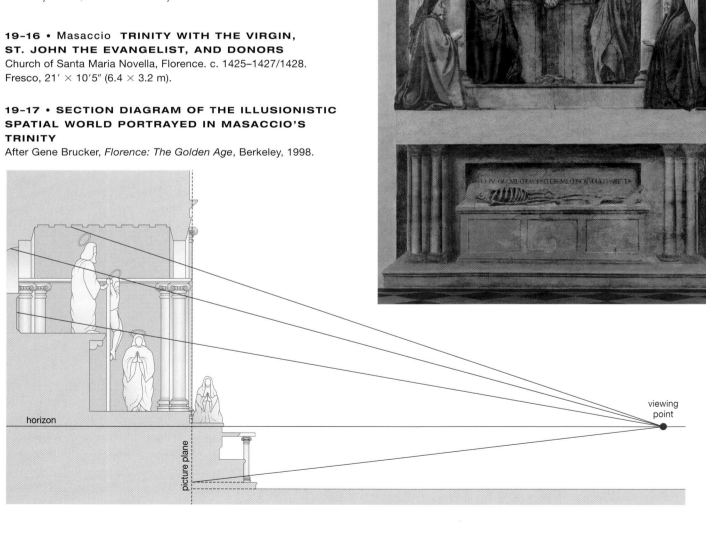

horizon

picture plane

viewing point

**THE BRANCACCI CHAPEL.** Masaccio's brief career culminated in the frescos he painted on the walls of the Brancacci Chapel in the church of Santa Maria del Carmine in Florence. Reproduced here are two of the best-known scenes: **THE EXPULSION OF ADAM AND EVE FROM PARADISE (FIG. 19–18)** and **THE TRIBUTE MONEY (FIG. 19–19)**. In *The Expulsion*, he presented Adam and Eve as monumental nude figures, combining his studies of the human figure with an intimate knowledge of ancient Roman sculpture. In contrast to Flemish painters, who sought to record every visible detail of a figure's surface (compare Adam and Eve from the Ghent Altarpiece, page 577, FIG. B), Masaccio focused on the mass of bodies formed by the underlying bone and muscle structure, and a single light source emphasizes their tangibility with modeled forms and cast shadows. Departing from earlier interpretations of the event that emphasized wrongdoing and the fall from grace, Masaccio concerns himself with the psychological impact of shame on these first humans, who have been cast out of paradise mourning and protesting, thrown naked into the world.

In *The Tribute Money* (SEE FIG. 19–19), Masaccio portrays an incident from the life of Jesus that highlights St. Peter (Matthew 17: 24–27), to whom this chapel was dedicated. In the central scene a tax collector (dressed in a short red tunic and seen from behind) asks Peter (in the left foreground with the short gray beard) if Jesus pays the Jewish temple tax (the "tribute money" of the title). Set against the stable backdrop of a semicircular block of apostolic observers, a masterful series of dynamic diagonals in the postures and gestures of the three main figures interlocks them in a compositional system that imbues their interaction with a sense of tension calling out for resolution. Jesus instructs Peter to "go to the sea, drop in a hook, and take the first fish that comes up," which Peter does at the far left. In the fish's mouth is a coin worth twice the tax demanded, which Peter gives to the tax collector at the far right. The tribute story was especially significant for Florentines because in 1427, to raise money for defense against military aggression, the city enacted a graduated tax, based on the value of people's personal property.

*The Tribute Money* is particularly remarkable for its early use of both linear and atmospheric perspective to integrate figures, architecture, and landscape into a consistent whole. The group of disciples around Jesus and his disciples forms a clear central focus, from which the landscape seems to recede naturally into the far distance. To foster this illusion, Masaccio used linear perspective in the depiction of the house, and then reinforced it by diminishing the sizes of the barren trees and reducing the size of the crouching Peter at far left. At the central vanishing point established by the orthogonals of the house is the head of Jesus. A second vanishing point determines the position of the steps and stone rail at the right.

The cleaning of the painting in the 1980s revealed that it was painted in 32 *giornate* (a *giornata* is a section of fresh plaster that could be prepared and painted in a single day; see "Buon Fresco," page 537). The cleaning also uncovered Masaccio's subtle use of

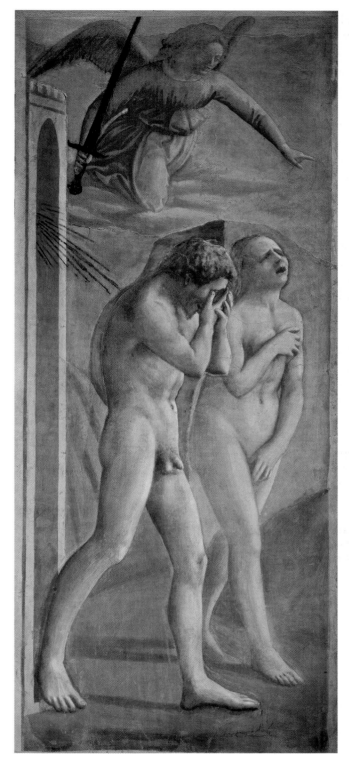

**19–18 • Masaccio THE EXPULSION OF ADAM AND EVE FROM PARADISE**
Brancacci Chapel, church of Santa Maria del Carmine, Florence. c. 1427. Fresco, 7′ × 2′11″ (214 × 90 cm).

Cleaning and restoration of the Brancacci Chapel paintings revealed the remarkable speed and skill with which Masaccio worked. He painted Adam and Eve in four *giornate* (each *giornata* of fresh plaster representing a day's work). Working from the top down and left to right, he painted the angel on the first day; on the second day, the portal; Adam on the third day; and Eve on the fourth.

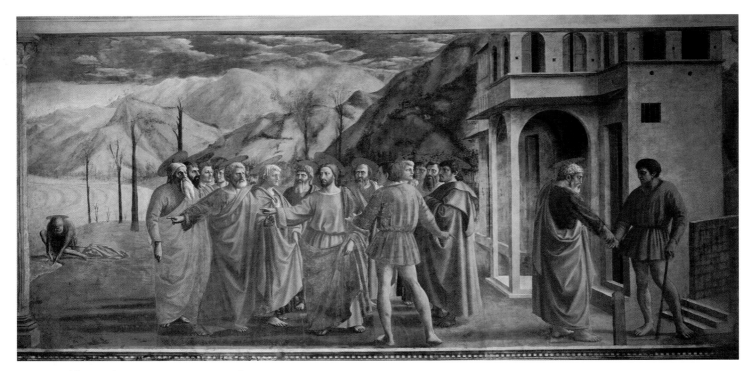

**19-19 • Masaccio THE TRIBUTE MONEY**
Brancacci Chapel, church of Santa Maria del Carmine, Florence. c. 1427. Fresco, 8′1″ × 19′7″ (2.46 × 6 m).

color to create atmospheric perspective in the distant landscape, where mountains fade from grayish-green to grayish-white and the houses and trees on their slopes are loosely sketched to simulate the lack of clear definition when viewing things in the distance through a haze. Green leaves were painted on the branches *al secco* (meaning "on the dry plastered wall").

As in *The Expulsion*, Masaccio modeled the foreground figures here with bold highlights and long shadows on the ground toward the left, giving a strong sense of volumetric solidity and implying a light source at the far right, as if the scene were lit by the actual window in the rear wall of the Brancacci Chapel. Not only does the lighting give the forms sculptural definition, but the colors vary in tone according to the strength of the illumination. Masaccio used a wide range of hues—pale pink, mauve, gold, blue-green, seafoam-green, apple-green, peach—and a sophisticated shading technique using contrasting colors, as in Andrew's green robe which is shaded with red instead of darker green. The figures of Jesus and the apostles originally had gold-leaf haloes, several of which have flaked off. Rather than silhouette the heads against consistently flat gold circles in the medieval manner, however, Masaccio conceived of haloes as gold disks hovering in space above each head that moved with the heads as they moved, and he foreshortened them depending on the angle from which each head is seen.

Some stylistic innovations take time to be fully accepted, and Masaccio's innovative depictions of volumetric solidity, consistent lighting, and spatial integration were best appreciated by a later generation of painters. Many important sixteenth-century Italian artists, including Michelangelo, studied and sketched Masaccio's Brancacci Chapel frescos, as they did Giotto's work in the Scrovegni Chapel. In the meantime, painting in Florence after Masaccio's death developed along somewhat different lines.

## PAINTING IN FLORENCE AFTER MASACCIO

The tradition of covering walls with paintings in fresco continued uninterrupted through the fifteenth century. Between 1438 and 1445, the decoration of the Dominican monastery of San Marco in Florence, where Fra Angelico lived, was one of the most extensive projects.

FRA ANGELICO. Guido di Piero da Mugello (c. 1395/1400–1455), earned his nickname "Fra Angelico" ("Angelic Brother") through his piety as well as his painting: in 1984, he was beatified, the first step toward sainthood. Fra Angelico is first documented painting in Florence in 1417–1418, and he remained an active painter after taking vows as a Dominican monk in nearby Fiesole between 1418 and 1421.

Between 1438 and 1445, in the monastery of San Marco, Fra Angelico and his assistants—probably working under the patronage of Cosimo de' Medici—created paintings to inspire meditation in each monk's cell (44 in all; SEE FIGS INTRO-7, INTRO-8), in the chapter house (meeting room), and even in the corridors (hallways). At the top of the stairs in the north corridor, where the monks would pass frequently on their way to their individual cells, Fra Angelico painted a serene picture of the **ANNUNCIATION (FIG. 19–20)**. To describe the quiet, measured space where the demure

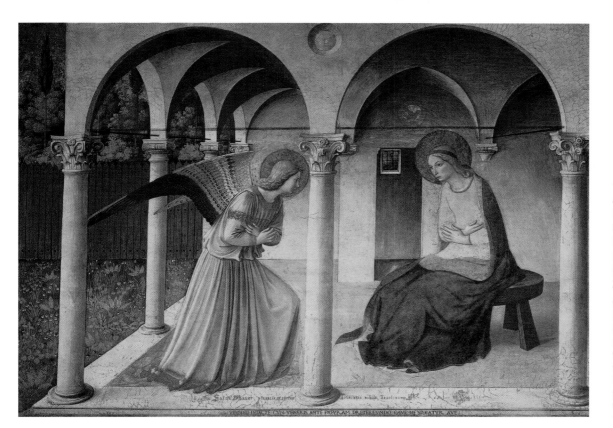

**19-20 • Fra Angelico**
**ANNUNCIATION**
North dormitory corridor, monastery of San Marco, Florence. c. 1438–1445. Fresco, 7'1" × 10'6" (2.2 × 3.2 m).

The shadowed vault of the portico is supported by a wall on one side and by slender Ionic and Corinthian columns on the other, a new building technique being used by Brunelleschi in the very years when the painting was being created.

archangel greets the unassuming, youthful Mary, Fra Angelico used linear perspective with unusual skill, extending the monks' stairway and corridor outward into an imagined portico and garden beside the Virgin's home. The slender, graceful figures, wearing quietly flowing draperies, assume modest poses. Natural light falling from the left models their forms gently, casting an almost supernatural radiance over their faces and hands. The scene is a sacred vision rendered in a contemporary setting, welcoming the monks to the most intimate areas of the monastery and preparing them for their private meditations.

UCCELLO. At mid century, when Fra Angelico was still painting his radiant visions of Mary and Jesus in the monastery of San Marco, a new generation of artists began to emerge. Thoroughly conversant with the theories of Brunelleschi and Alberti, they had mastered the techniques (and tricks) of depicting figures in a constructed architectural space. Some artists became specialists, among them Paolo Uccello, who devoted his life to the study of linear perspective (**FIG. 19–21**; SEE ALSO FIG. 19–1). Vasari

devoted a chapter in his biographies of Italian artists to Uccello, whom he described as a man so obsessed with the science of perspective that he neglected his painting, his family, and even his pet birds (his *uccelli*). According to Vasari, Uccello's wife complained that he sat up drawing all night and when she called to him to come to bed he would say, "Oh, what a sweet thing this perspective is!" (Vasari, trans. Bondanella and Bondanella, p. 83).

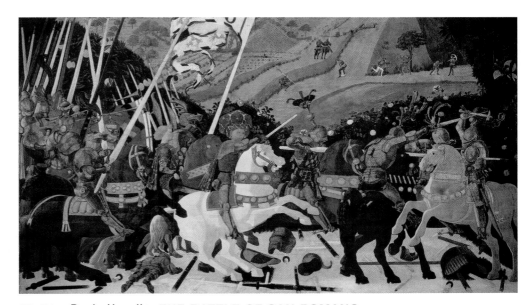

**19-21 • Paolo Uccello  THE BATTLE OF SAN ROMANO**
1438–1440. Tempera on wood panel, approx. 6' × 10'7" (1.83 × 3.23 m). National Gallery, London.

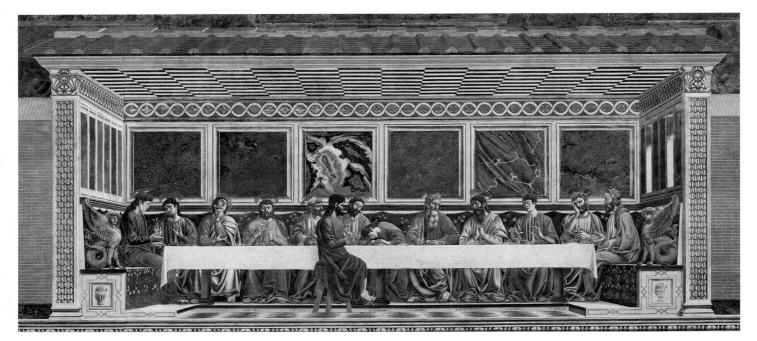

**19-22 •** Andrea del Castagno **THE LAST SUPPER**
Refectory, convent of Sant'Apollonia, Florence. 1447. Fresco, width approx. 16 × 32′ (4.6 × 9.8 m).

CASTAGNO. Notable Florentine painter Andrea del Castagno (c. 1417/19–1457) painted a fresco of **THE LAST SUPPER** for a convent of Benedictine nuns in 1447 (**FIG. 19–22**). The Last Supper was often painted in monastic refectories (dining halls) to remind the monks or nuns of Christ's Last Supper with his first followers and encourage them to see their daily gatherings for meals almost as a sacramental act rooted in this biblical tradition. Here Castagno has not portrayed the scene in the biblical setting of an "upper room." Rather, the humble house of the original account has become a great palace with sumptuous marble revetment. The most brilliantly colored and wildly patterned marble panel frames the heads of Christ and Judas to focus viewers on the most important part of the picture. Judas sits on the viewer's side of the table, separated from the other apostles, and St. John sleeps, head collapsed onto the tabletop. The strong perspective lines of floor tiles, ceiling rafters, and paneled walls draw viewers into the scene, especially the nuns

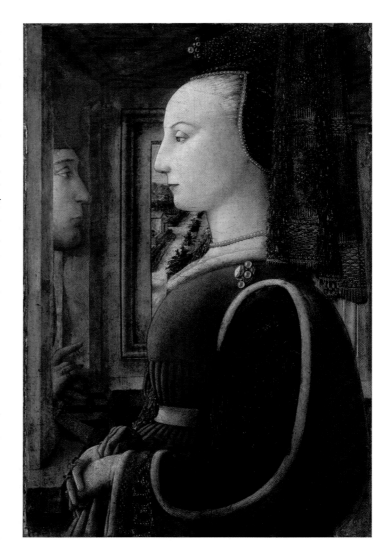

**19-23 •** Fra Filippo Lippi **PORTRAIT OF A WOMAN AND MAN (ANGIOLA DI BERNARDO SAPITI AND LORENZO DI RANIERI SCOLARI?)**
c. 1435–1445. Tempera on wood panel, 25¼ × 16½″ (64.1 × 41.9 cm). Metropolitan Museum of Art, New York

Some art historians have seen in the sumptuousness of this woman's costume an indication that she is a newlywed, especially since the pearls sewn with gold threads into the embroidery on her sleeve spell out the word *lealtà*, meaning "loyalty." But since technical evidence shows that the face of the man was added after the portrait of the woman, and since he is unable to meet her gaze, others speculate that this was transformed into a memorial portrait after her death.

who would have seen the painting as an extension of their own dining hall. At first, the lines of the orthogonals seem perfectly logical, but close examination reveals that only the lines of the ceiling converge to a single point, below the hands of St. John. Two windows light the painting's room from the direction of the actual refectory windows, further unifying the two spaces. Castagno worked quickly, completing this huge mural in at most 32 days.

FRA FILIPPO LIPPI. Not all Florentine paintings of the mid fifteenth century were sacred scenes on the walls of religious buildings. It is during this period that portraiture comes into its own as a major artistic form in Italy, and among the most extraordinary—if enigmatic—examples is this **PORTRAIT OF A WOMAN AND MAN** (FIG. 19–23), an early work of Fra Filippo Lippi (c. 1406–1469). This painting is also the earliest surviving double portrait of the Italian Renaissance. Lippi grew up as an orphan in the Carmelite church where Masaccio had painted frescos in the Brancacci Chapel, and art historians have stressed the impact this work had on Lippi's development as an artist. But although he may have absorbed Massacio's predilection for softly rounded forms situated in carefully mapped spaces, in Lippi's hands these artistic tools became the basis for pictures that often ask more questions than they answer, by stressing outline at the same time as form, and by creating complex and often confusing spatial systems.

The emphasis in this double portrait is squarely on the woman. She is spotlighted in the foreground, sharply profiled against a window that serves as an unsettling internal frame, not big enough to contain her. This window opens onto a vista, clearly a fragment of a larger world, but one that highlights an orthogonal to emphasize a spatial recession only partially revealed. The woman blocks most of this vista with her shining visage and sumptuous costume—notably its embroidered velvet, fur lining, and luminous pearls. There is no engagement with the viewer and little sense of likeness. And it is not at all clear where or to what she directs her attention, especially since the gaze of the man in the background does not meet hers. He is even more of a mystery. We see only a masklike sliver of his profile, although the substantiality of his face is reinforced by the strong shadow it casts against the window casement through which he looks. Unlike the woman, who clasps her inert hands in front of her as if to highlight her rings, this man fidgets with his fingers, perhaps to draw our attention to the heraldic device below him that may identify him as a member of the Scolari family. This could be a double portrait of Lorenzo di Ranieri Scolari and Angiola di Bernardo Sapiti, who married in 1436. But what does the painting say about them? Does it commemorate their marriage, celebrate the birth of their child, or memorialize one of their deaths? All have been proposed by art historians as an explanation for this innovative double portrait, but it remains a puzzle to be pondered. Could that pondering be the point of the picture?

# ITALIAN ART IN THE SECOND HALF OF THE FIFTEENTH CENTURY

In the second half of the fifteenth century, the ideas and ideals of artists like Brunelleschi, Donatello, and Masaccio began to spread from Florence to the rest of Italy, as artists who had trained or worked in Florence traveled to other cities to work, carrying the style with them. Northern Italy embraced the new Classical ideas swiftly, especially in the ducal courts at Urbino and Mantua. Venice and Rome also emerged as innovative art centers in the last quarter of the century.

## URBINO

Under Federico da Montefeltro, Urbino developed into a thriving artistic center. A new palace was under construction, and prominent architects and artists were brought into the court to make the new princely residence a showcase of ducal splendor.

THE PALACE AT URBINO. Construction of the palace had been under way for about 20 years in 1468 when Federico hired Luciano Laurana (c. 1420/1425–1479) to direct the work. Among Laurana's major contributions to the palace were closing the courtyard with a fourth wing and redesigning the courtyard façades (FIG. 19–24). The result is a superbly rational solution to the problems

**19-24 • Luciano Laurana COURTYARD, DUCAL PALACE, URBINO**
Courtyard c. 1467–1472; palace begun c. 1450.

# The Morelli–Nerli Wedding Chests

The palazzos of wealthy Florentine families housed not only panels painted with portraits or Madonnas; they were also appointed with massive pieces of elaborate furniture. Constructed of richly carved wood that was gilded and often covered with paintings, these household objects were not a minor sideline, but a central feature of the fifteenth-century Florentine art world. Some of the most impressive surviving examples of Renaissance furniture are a series of great chests—called **cassoni**—that were used to store clothing and other precious personal objects in a couple's bedroom. They were frequently commissioned in pairs on the occasion of a wedding.

Marriages between members of wealthy Florentine families were not the result of romantic connections between two young people. They were political alliances and economic transactions that involved the transfer of capital and the exchange of gifts as a display of wealth. In preparation for such high-class marriages, husbands refurbished their living quarters in the family palazzo in preparation for bringing a bride into the household. We have a detailed accounting of the extent of work, as well as the required expenditure, when 30-year-old Lorenzo di Matteo Morelli prepared his apartments for the arrival of his young bride, Vaggia di Tanai Nerli, after their marriage in 1472. His commissioning of a pair of *cassoni*—one for him and one for Vaggia—represented almost two-thirds of the entire cost of redecoration. Fortunately, the two chests still survive. They are among the most important and best-preserved Renaissance *cassoni* that have come down to us, especially since they still maintain the original backboard—called a *spalliera*—that was produced concurrent with and hung on the wall directly behind the chests when they were placed in Lorenzo's bedroom. The lion's feet on which the chests now stand are modern additions, and the *spalliera* was originally a long, continuous painting hung over both *cassoni*, not a separate panel mounted behind the lid, but otherwise these chests give a strong sense of their original appearance.

Like most Renaissance *cassoni*, Lorenzo's chest is painted with pictures drawn from stories that extol moral virtues, and intended to reflect some of their values and glories on Lorenzo himself. The long painted scene on the front tells the story of ancient Roman hero Marcus Furius Camillus' defeat of the Gauls as he chases them out of Rome. On the *spalliera*, *trompe-l'oeil* curtains part to reveal the scene of another Roman hero defending a bridge against insurmountable odds. Presumably Lorenzo wanted to be seen as a heroic descendant of such illustrious Romans—strong, brave, and triumphant. The scenes portrayed on Vaggia's chest (like Lorenzo's, identified by her coat of arms) challenge her to care for the children she is expected to produce and practice the virtues of temperance, prudence, and patience that were valued in Florentine patrician brides.

The Morelli–Nerli *cassoni* passed from Lorenzo to his son, and they remained in the Morelli family at least until 1680, maybe into the nineteenth century, when they first appeared together in the art market. Elaborate Renaissance furniture became coveted items in the homes of wealthy art collectors in late nineteenth-century Europe and America, where the new owners doubtless saw themselves as worthy successors to the wealthy and powerful merchants who had commissioned them at the height of the Italian Renaissance.

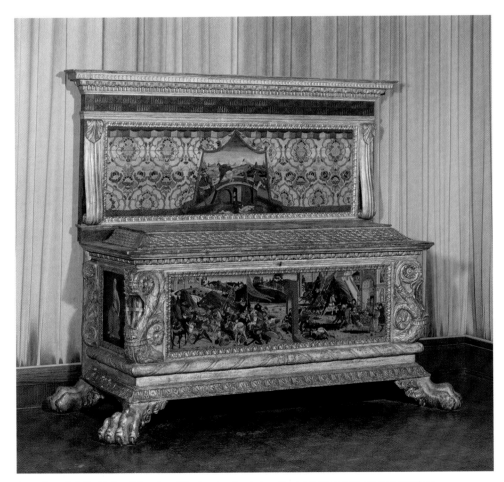

Jacabo del Sellaio, Biagio d'Antonio (painters), and Zanobi di Domenico (woodworker) **CASSONE MADE FOR THE MARRIAGE OF LORENZO DI MATTEO MORELLI AND VAGGIA DI TANAI NERLI**
1472. Tempera and gold on wood, chest 83½ × 75 × 30" (212 × 193 × 76.2 cm). Courtauld Gallery, London.

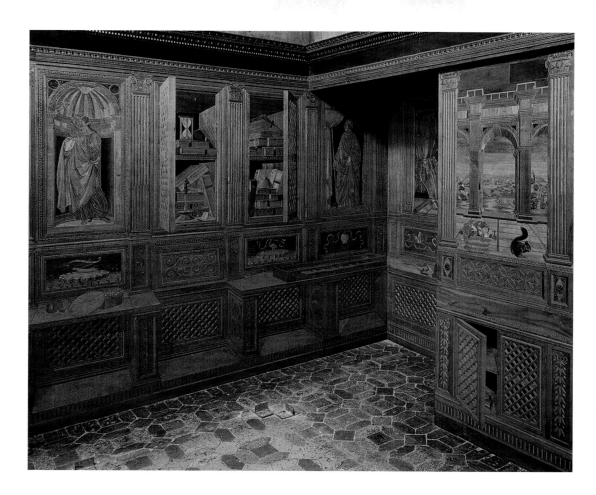

**19-25 •** Giuliano da Maiano (?) **STUDIOLO OF FEDERICO DA MONTEFELTRO**
Ducal Palace, Urbino. 1476. Intarsia, height 7′3″ (2.21 m).

created in courtyard design by the awkward juncture of the arcades at the four corners. The ground-level portico on each side has arches supported by columns, but piers embellished with pilasters bridge the corner angles. This arrangement avoided the awkward visual effect of two arches springing from a single column and gave the corner a greater sense of stability. A variation of the composite capital (a Corinthian capital with added Ionic volutes) was used, perhaps for the first time, on the ground level. Corinthian pilasters flank the windows in the story above, forming divisions that repeat the bays of the portico. (The two low upper stories were added later.) The plain architrave was engraved with inscriptions lauding Federico's many virtues, added when the count became duke of Urbino in 1476.

The interior of the Urbino palace likewise reflected its patron's embrace of new Renaissance ideas and interest in Classical antiquity, seen in carved marble fireplaces and window and door surrounds. In creating luxurious home furnishings and interior decorations for sophisticated clients such as Federico, Italian artists found freedom to experiment with new subjects, treatments, and techniques. Among these was the creation of remarkable **trompe-l'oeil** ("fool-the-eye") effects using scrupulously applied linear perspective and foreshortening in **intarsia** (wood inlay) decoration. An extraordinary example is on the walls of Federico da Montefeltro's **studiolo**, or study, a room for private conversation and the owner's collection of fine books and art objects (**FIG. 19–25**). The work was

probably done by the architect and woodworker Giuliano da Maiano (1432–1490) and carries the date 1476.

The elaborate scenes in the small room are created entirely of wood inlaid on flat surfaces. Each detail is rendered with convincing illusionism: pilasters, carved cupboards with latticed doors, niches with statues, paintings, and built-in tables. Prominent in the decorative scheme is the prudent and industrious squirrel, a Renaissance symbol of the ideal ruler: in other words, of Federico da Montefeltro. A large window looks out onto an elegant marble loggia with a distant view of the countryside through its arches; and the shelves, cupboards, and tables are filled with all manner of fascinating things—scientific instruments, books, even the duke's armor hanging like a suit in a closet.

PIERO DELLA FRANCESCA.   Federico brought the artist Piero della Francesca (c. 1415–1492) to Urbino. Piero had worked in Florence in the 1430s before settling in his native Borgo San Sepolcro, a Tuscan hill town under papal control. He knew current art theory and art practice—including Brunelleschi's system of spatial illusion and linear perspective, Masaccio's powerful modeling of forms and atmospheric perspective, and Alberti's theoretical treatises. Piero was one of the few practicing artists who also wrote his own books of theory. Not surprisingly, in his treatise on perspective he emphasized the geometry and the volumetric construction of forms and spaces that were so apparent in his own work.

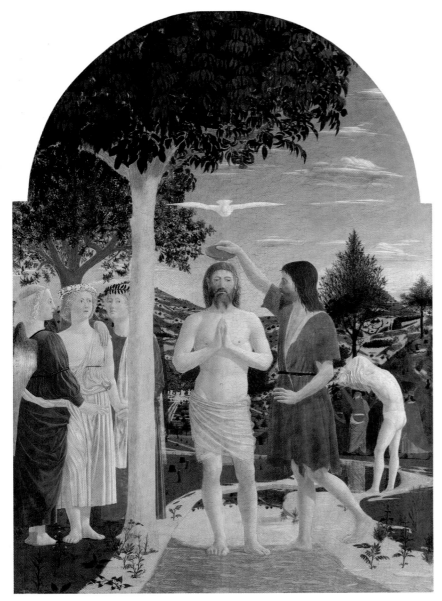

**19-26** • Piero della Francesca  **BAPTISM OF CHRIST**
c. 1450. Tempera on wood panel, 66 × 45¾″ (1.67 × 1.16 m).
National Gallery, London.

The three angels standing in a cluster at left, partially overlapped by the foreground tree, have been interpreted as an emblem of concord—representing the rapprochement reached between the Roman and Byzantine Christian churches in 1439 at the Council of Florence. Another reference to this council has been seen in the exotic costumes of the figures in the far background. Since the accord reached at the council was very short-lived, this interpretation would place the date of the painting in the early 1440s rather than the 1450s.

These characteristic features of Piero's painting are marvelously apparent in a serene image of the **BAPTISM OF CHRIST** that has become one of Piero's signature works **(FIG. 19–26)**. It was commissioned by the Graziani family, probably during the 1450s, for the priory of San Giovanni Battista in Borgo San Sepolchro. The central figure of Christ dominates the painting, standing in a shallow stream of glassy water under a tree of manicured regularity. Christ's legs and the sleek tree trunk set up a series of emphatically

upright forms, one of many formal relationships that reverberate both across the picture's surface and into its carefully measured space. Feet and ankles rotate across the lower quarter of the painting, providing a clear and well-distributed sense of grounding for the figural composition, while the radically foreshortened dove (Holy Spirit), John's baptismal dish, and the clouds create a rhythmic line of horizontals that adds stability above and creates a staccato rhythm that merges foreground and background on the painting's surface. The mirrored profiles and gestures of the outside angel and the baptizing John provide an internal frame for the central action. Such carefully crafted formal correspondences infuse this picture with an air of beatific calm and peaceful stasis—a stillness suggesting that nothing will ever change, no one will ever move in this frozen moment within a story that for Christian believers actually changed everything.

Piero traveled widely—to Rome, to the Este court in Ferrara, and especially to Urbino. In about 1474, he painted the portraits of Federico da Montefeltro and his recently deceased wife, Battista Sforza **(FIG. 19–27)**. The small panels resemble Flemish painting in their detail and luminosity, their record of surfaces and textures, and their vast landscapes. But in traditional Italian fashion, figures are portrayed in strict profile, disengaged psychologi-cally from the viewer. The profile format also allowed for an accurate recording of Federico's likeness without emphasizing two disfiguring scars—the loss of his right eye from a sword blow and his broken nose. His good left eye is shown, and the angular profile of his nose might easily be merely a distinctive family trait. Typically, Piero emphasized the underlying geometry of the forms. Dressed in the most elegant fashion (Federico wears his red ducal robe and Battista's jewels are meticulously recorded), they are silhouetted against a panoramic landscape. These are the hills around Urbino, seemingly dissolving into infinity through an atmospheric perspective as subtle and luminous as in any Flemish panel painting. Piero used another northern European device in the harbor view just in front of Federico, where the water narrows into a river that leads us into the distant landscape (SEE FIG. 18–14). He would have had contact in Urbino with the Flemings who were also working there.

The painting on the reverse of the portraits reflects the humanist interests of the Urbino court **(FIG. 19–28)**. "Engraved" on the fictive parapets in letters inspired by ancient Roman inscriptions are stanzas praising the couple—the fame of Federico's virtue and Battista's restraint, shining in the reflected glory of her

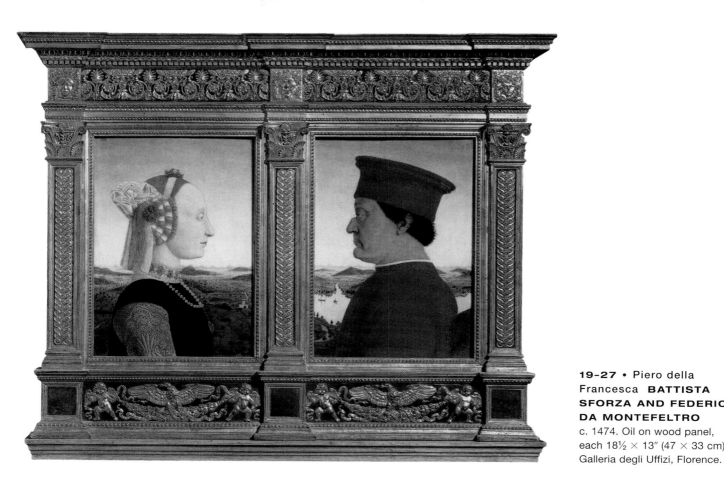

**19-27 •** Piero della Francesca **BATTISTA SFORZA AND FEDERICO DA MONTEFELTRO**
c. 1474. Oil on wood panel, each 18½ × 13″ (47 × 33 cm). Galleria degli Uffizi, Florence.

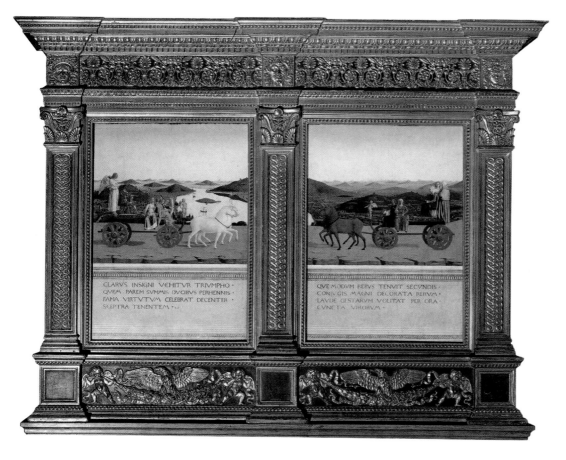

**19-28 •** Piero della Francesca **TRIUMPH OF FEDERICO AND BATTISTA**
Reverse of FIG. 19–27.

Federico's inscription can be translated: "He that the perennial fame of virtues rightly celebrates holding the scepter, equal to the highest dukes, the illustrious, is borne in outstanding triumph." Battista had been dead two years when hers was written: "She that kept her modesty in favorable circumstances, flies on the mouths of all men, adorned with the praise of the acts of her great husband."

husband. Behind these laudatory inscriptions a wide landscape of hills and valleys runs nearly continuously across the two panels. In the foreground, triumphal carts roll, and we catch a glimpse of the kind of pageantry and spectacle that must have been enacted at court. The *Triumphs* of Petrarch—poetic allegories of love, chastity, fame, time, eternity (Christianized as divinity), and death—inspired many of these extravaganzas. White horses pull Federico's wagon. The duke is crowned by a winged figure—either Victory or Fortune—and accompanied by personifications of Justice, Prudence, Fortitude, and Temperance. Battista's cart is controlled by a winged putto (nude little boy) driving a team of unicorns. The virtues standing behind her may be personifications of Chastity and Modesty. Seated in front of her are Faith and Charity, who holds a pelican. This bird, believed to feed its young from its own blood, may symbolize the recently deceased Battista's maternal sacrifices. She died in 1472 at age 26, shortly after the birth of her ninth child, a son who would one day be duke. We are told that Federico was disconsolate. Some arranged aristocratic marriage alliances blossomed into loving partnerships.

## MANTUA

Lodovico Gonzaga, the marquis of Mantua, ruled a territory that lies on the north Italian plain between Venice and Milan. Like Federico, he made his fortune as a *condottiere*. Lodovico was schooled by humanist teachers and created a court where humanist ideas flourished in art as well as in literature.

**MANTEGNA.** Working at Lodovico's court was Andrea Mantegna (1431–1506), a painter trained in Padua and profoundly influenced by the sculptor Donatello, who arrived in Padua in 1443 and worked there for a decade. Mantegna learned the Florentine system of linear perspective and pushed to their limits experiments in radically foreshortened forms and dramatic spatial recessions. He went to work for Ludovico Gonzaga in 1460, and he continued to work for the Gonzaga family for the rest of his life.

Perhaps his finest works are the frescos of the **CAMERA PICTA** ("Painted Room"), a tower chamber in Ludovico's palace, which Mantegna decorated between 1465 and 1474 **(FIG. 19–29)**. Around the walls the family—each member seemingly identified by a portrait likeness—receives in landscapes and in loggias the return of Ludovico's son, Cardinal Francesco Gonzaga. On the domed ceiling, the artist painted a *tour de force* of radical perspective in a technique called *di sotto in sù* ("from below upwards"). The room appears to be open to a cloud-filled sky through a large oculus in a simulated marble- and mosaic-covered vault. On each side of a precariously balanced planter, three young women and an exotically turbaned African man peer over a marble balustrade into the room below. A fourth young woman in a veil looks dreamily upward. Joined by a large peacock, several putti play around the balustrade, three standing on the interior ledge of a cornice, unprotected by the balustrade, toes projecting into space but seemingly oblivious to the danger of their perch. This ceiling began a long tradition of illusionistic ceiling painting that

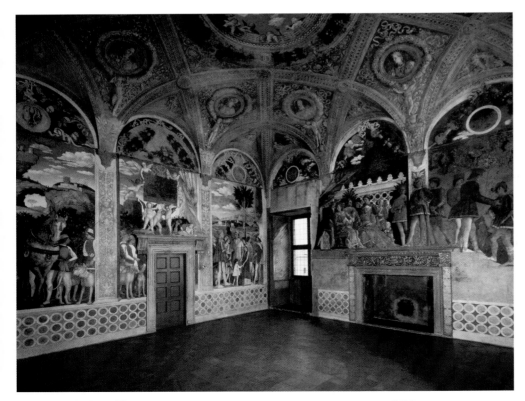

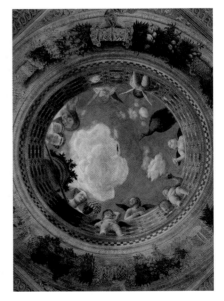

**19-29 •** Andrea Mantegna **TWO VIEWS OF THE CAMERA PICTA, DUCAL PALACE, MANTUA**
1465–1474. Fresco, diameter of false oculus 8′9″ (2.7 m); room 26′6″ square (8 m square).

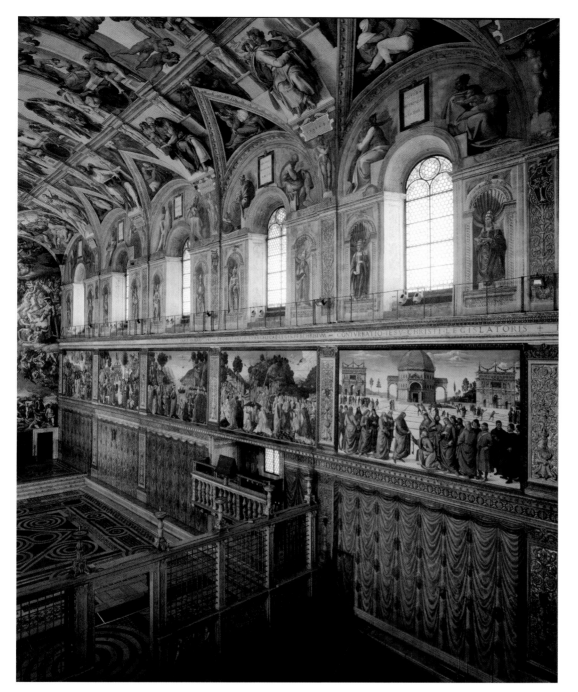

Vatican, Rome.
At lower right, Perugino's *Christ Giving the Keys to St. Peter*, c. 1480–1482. 11'5½" × 18'8½" (3.48 × 5.70 m).

culminated in the extravagant and explosive ceilings of Baroque churches (see Chapter 22).

## ROME

Rome's development into a Renaissance center of the arts was greatly enhanced when Pope Sixtus IV called to the city in the early 1480s a group of young Florentine and Umbrian artists to decorate the walls of his newly built chapel (1479–1481), now named the **SISTINE CHAPEL** after him **(FIG. 19–30)**. Botticelli and Ghirlandaio were among the most famous artists summoned to the chapel to paint, but many art historians believe that Perugino was the supervising artist in charge of the project.

**PERUGINO.** Pietro Vannucci, called "Perugino" (c. 1445–1523), was originally from near the town of Perugia in Umbria (thus the nickname), and he worked for a while in Florence, but by 1479 he was in Rome. Two years later, he was working on the Sistine murals. One of his contributions, *The Delivery of the Keys to St. Peter* (foreground painting at lower right in FIG. 19–30; see also "Renaissance Perspective," page 608), portrayed the event that provided biblical support for the supremacy of papal authority (Matthew 16:19). In a light-filled piazza in which banded paving stones provide a geometric grid for perspectival recession, the figures stand like chess pieces on the squares, scaled to size according to their distance from the picture plane and modeled by a consistent light source from the

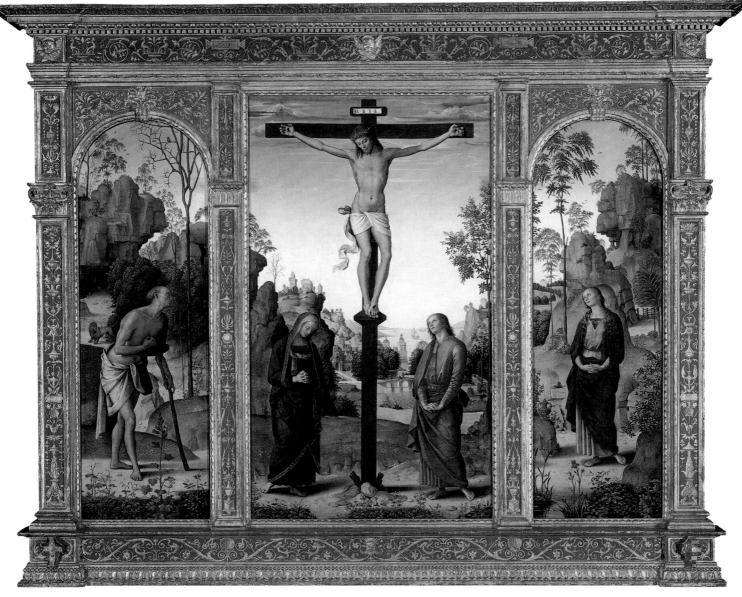

**19–31 • Perugino CRUCIFIXION WITH SAINTS**
1480s. Tempera on wood panel (now transferred to canvas) center panel 40 × 22¼″ (101 × 56 cm),
side panels 37½ × 12″ (95 × 30 cm). National Gallery of Art, Washington, D.C.

upper left. Triumphal arches inspired by ancient Rome frame the church and focus the attention on the center of the composition, where the vital key is being transferred. The carefully calibrated scene is softened by the subdued colors, the distant idealized landscape and cloudy skies, and the variety of the figures' positions.

Just as carefully organized is Perugino's transcendent portrayal of the **CRUCIFIXION (FIG. 19–31)** as a measured tableau, where a line of decorous saints, and the Crucifixion itself, are aligned on a narrow, flat shelf of land in the foreground, close to the picture plane. Behind them a craggy but verdant landscape plunges into the background, clearly rooted in the influence of Flemish painters, matching their attention to fine detail—especially in the flowers growing along the front edge of the painting—and their sensitive use of atmospheric perspective. Unlike in most Italian Crucifixions, Perugino's figures are eerily calm. Christ's composure suppresses any sign of suffering; his mourning companions convey much more elegance than grief. Jesus is uniquely disconnected from the landscape setting, which dips at the center to frame him. His elevation into the upper half of the paining, isolated against the shaded expanse of an ethereal blue sky, separates him from his grounded mother and disciple, so that he appears almost like an elevated crucifix rather than the protagonist in a tragic narrative.

## THE LATER FIFTEENTH CENTURY IN FLORENCE

In the final decades of the fifteenth century, Florentine painting was characterized on one hand by a love of material opulence and an interest in describing the natural world, and on the other by a poetic, mystical spirit. The first trend was encouraged by the

influence of Netherlandish art and the patronage of citizens who sought to advertise their wealth and prestige, the second by intellectual circles surrounding the Medici and the religious fervor that arose at the very end of the century.

GHIRLANDAIO. In Florence, the most prolific painting workshop of the later fifteenth century was that of the painter Domenico di Tommaso Bigordi (1449–1494), known as Domenico "Ghirlandaio" ("Garland-Maker"), a nickname first adopted by his father, who was a goldsmith noted for his floral wreaths. A skilled storyteller, the younger Ghirlandaio reinterpreted the art of earlier fifteenth-century painters into a visual language of descriptive immediacy.

Among Ghirlandaio's most effective narrative programs were the frescos of the **LIFE OF ST. FRANCIS** created between 1483 and 1486 for the Sassetti family burial chapel in the church of Santa Trinità, Florence (**FIG. 19–32**). In the uppermost tier of the paintings, Pope Honorius confirms the Franciscan order, with the Loggia dei Lanzi and the Palazzo della Signoria (SEE FIG. 17–2) in the background. All the figures, including those coming up the stairs, are portrait likenesses of well-known Florentines. In the middle register, a small boy who has fallen from an upper window is resurrected by St. Francis. The miracle is witnessed by contemporary Florentines, including members of the Sassetti family, and the scene takes place in the piazza outside the actual church. Ghirlandaio has transferred the events of the traditional story from thirteenth-century Rome to contemporary Florence, painting views of the city and portraits of living Florentines, delighting in local color and anecdotal detail. Perhaps Renaissance painters, like Gothic painters, represented sacred narratives in contemporary settings to emphasize their current relevance, or perhaps they and their patrons simply enjoyed seeing themselves in their fine clothes acting out the dramas in the cities of which they were justifiably proud.

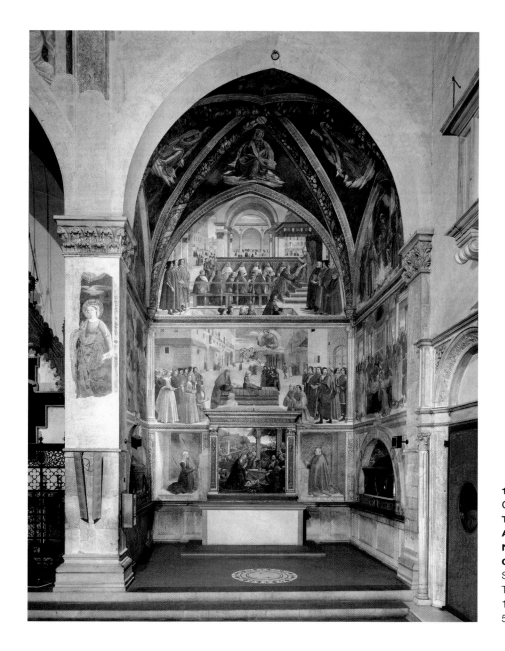

**19-32 •** Domenico Ghirlandaio **SCENES FROM THE LIFE OF ST. FRANCIS; ALTARPIECE WITH NATIVITY AND ADORATION OF THE SHEPHERDS**
Sassetti Chapel, Church of Santa Trinità. 1483–1486. Fresco, chapel 12′2″ deep × 17′2″ wide (3.7 × 5.25 m).

The altarpiece Ghirlandaio painted for the Sassetti Chapel portrays the **NATIVITY AND ADORATION OF THE SHEPHERDS (FIG. 19–33)**. It is still in its original frame, still in the place for which it was painted (SEE FIG. 19–32). The influence of Hugo's Portinari Altarpiece (SEE FIG. 18–16), which had been placed on the high altar of the church of Sant'Egidio two years earlier, in 1483, is strong. Ghirlandaio's Christ Child also lies on the ground, adored by the Virgin while rugged shepherds kneel at the right. Ghirlandaio even copies some of Hugo's flowers—although here the iris, a symbol of the Passion, springs not from a vase, but from the earth in the lower right corner. But Ghirlandaio highlights references to Classical Rome. First to catch the eye are the two

Classical pilasters with Corinthian capitals, one of which has the date 1485 on it. The manger is an ancient sarcophagus with an inscription that promises resurrection (as in the fresco directly above the altarpiece where St. Francis is reviving a child); and in the distance a Classical arch inscribed with a reference to the Roman general Pompey the Great frames the road along which the Magi travel. Weighty, restrained actors replace the psychologically intense figures of Hugo's painting. Ghirlandaio joins a clear foreground, middle ground, and background in part by the road and in part by aerial perspective, which creates a seamless transition of color, from the sharp details and primary hues of the Adoration to the soft gray mountains in the distance.

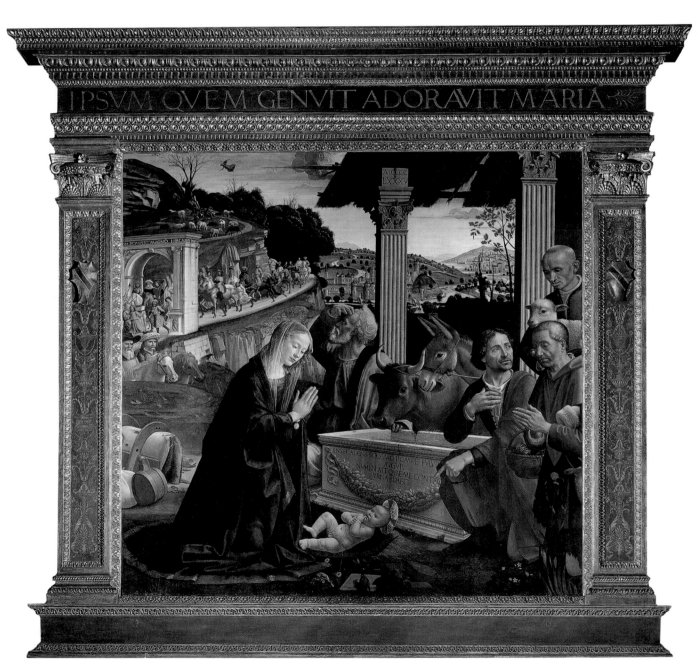

**19-33 • Domenico Ghirlandaio  NATIVITY AND ADORATION OF THE SHEPHERDS**
Altarpiece in the Sassetti Chapel, Santa Trinità, Florence, 1485. Panel, 65¾″ square (1.67 m square).

BOTTICELLI. Like most artists in the second half of the fifteenth century, Sandro Botticelli (1445–1510) learned to draw and paint sculptural figures that were modeled by light from a consistent source and placed in a setting rendered illusionistic by linear perspective. An outstanding portraitist, he, like Ghirlandaio, often included recognizable contemporary figures among the saints and angels in religious paintings. He worked in Florence, often for the Medici, then was called to Rome in 1481 by Pope Sixtus IV to help decorate the new Sistine Chapel along with Ghirlandaio, Perugino, and other artists.

Botticelli returned to Florence that same year and entered a new phase of his career. Like other artists working for patrons steeped in Classical scholarship and humanistic thought, he was exposed to philosophical speculations on beauty—as well as to the examples of ancient art in his employers' collections. For the Medici, Botticelli produced secular paintings of mythological subjects inspired by ancient works and by contemporary Neoplatonic thought. Art historian Michael Baxandall has shown that these works were also patterned on the slow movements of fifteenth-century Florentine dance, in which figures acted out their relationships to one another in public performances that would have influenced the thinking and viewing habits of both painters and their audience.

The overall appearance of Botticelli's *Primavera*, or *Spring* (see "A Closer Look," page 626), recalls Flemish tapestries (SEE FIG. 18–7), which were very popular in Italy at the time. And its subject—like the subjects of many tapestries—is a highly complex **allegory** (a symbolic illustration of a concept or principle), interweaving Neoplatonic ideas with esoteric references to Classical sources. In simple terms, Neoplatonic philosophers and poets conceived Venus, the goddess of love, as having two natures.

The first ruled over earthly, human love and the second over universal, divine love. In this way the philosophers could argue that Venus was a Classical equivalent of the Virgin Mary. *Primavera* was painted at the time of the wedding of Lorenzo di Pierfrancesco de' Medici and Semiramide d'Appiano in 1482. The theme suggests love and fertility in marriage, and the painting can be read as a lyrical wish for a similar fecundity in the union of Lorenzo and Semiramide—a sort of highly refined fertility dance.

Several years later, some of the same mythological figures reappeared in Botticelli's **BIRTH OF VENUS (FIG. 19–34)**, in which the central image represents the Neoplatonic idea of divine love in the form of a nude Venus based on an antique statue type known as the "modest Venus" that ultimately derives from Praxiteles' *Aphrodite of Knidos* (SEE FIG. 5–45). Botticelli's Classical goddess of love and beauty, born of sea foam, averts her eyes from our gaze as she floats ashore on a scallop shell, gracefully arranging her hands and hair to hide—but actually drawing attention to—her sexuality. Indeed, she is an arrestingly alluring figure, with voluminous hair highlighted with gold. Blown by the wind—Zephyr (with his love, the nymph Chloris)—Venus arrives at her earthly home. She is welcomed by a devotee who offers Venus a garment embroidered with flowers. The circumstances of this commission are uncertain. It is painted on canvas, which suggests that it may have been a banner or a painted tapestrylike wall hanging.

Botticelli's later career was affected by a profound spiritual crisis. While the artist was creating his mythologies for the Medici, a Dominican monk, Fra Girolamo Savonarola (active in Florence 1490–1498), had begun to preach impassioned sermons denouncing the worldliness of Florence. Many Florentines reacted with orgies of self-recrimination, and processions of weeping penitents wound through the streets. Botticelli, too, fell into a state of religious fervor.

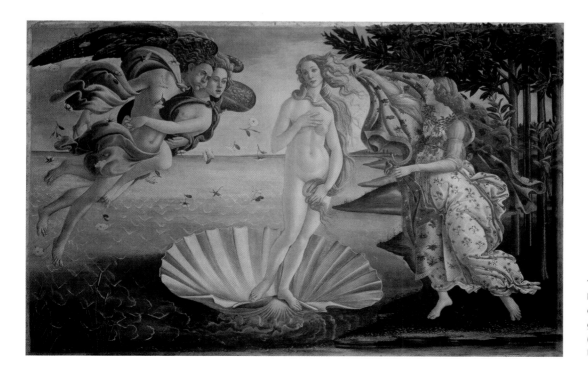

**19-34 • Sandro Botticelli BIRTH OF VENUS**
c. 1484–1486. Tempera and gold on canvas, 5′8⅞″ × 9′1⅞″ (1.8 × 2.8 m). Galleria degli Uffizi, Florence.

***Primavera*** by Sandro Botticelli, c. 1482. Tempera on wood panel. 6'8" × 10'4" (2.03 × 3.15 m). Galleria degli Uffizi, Florence.

Mercury, the sign for the month of May, disperses the winter clouds with his caduceus. This staff wound with serpents became a symbol for the medical profession. The name Medici means "doctors."

Venus, clothed in contemporary costume and crowned with a marriage wreath, appears in her role as the goddess of wedded love. The presence of both Venus and Mercury may be an astrological reference; prominent Neoplatonist Marsilio Ficino told Lorenzo de Pierfrancesco de' Medici that these planets were aligned in his horoscope.

The setting of the painting is a grove of orange trees. These hold a double meaning—both suggestive of Venus's Garden of the Hesperides, with its golden fruit, and perhaps an allusion to the Medici, whose coat of arms featured golden orbs.

This three-figure grouping tells a story. Zephyrus, the west wind, is accosting the virgin nymph Chloris, identifiable from the roses pouring out of her mouth. Once Zephyrus makes her his bride, Chloris is transformed into the goddess Flora, the elaborately dressed personification of spring at the front of the group.

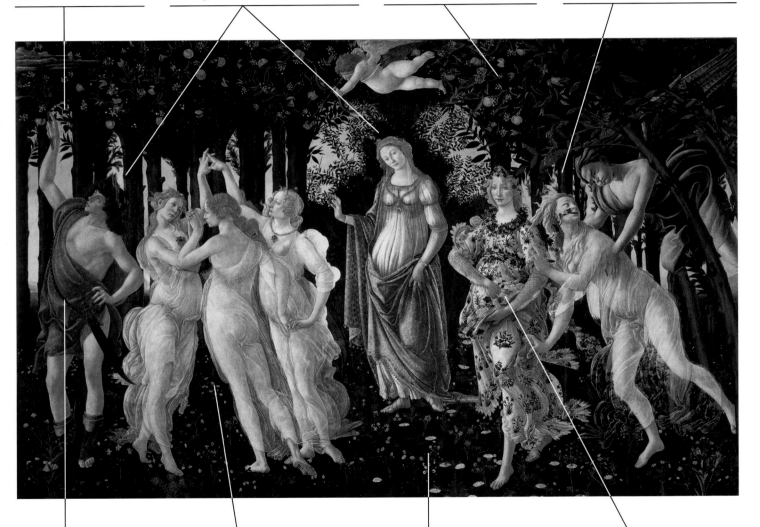

These gold flames are also an attribute of St. Lawrence, the namesake of Lorenzo di Pierfrancesco de' Medici, for whom this painting was made. The laurel tree (*laurus* in Latin) behind Zephyrus also alludes to Lorenzo's name.

The Three Graces symbolize ideal female virtues—Chastity, Beauty, Love. Venus' son Cupid—the embodiment of romantic desire—playfully aims his arrow at them.

So accurate is their representation, 138 of the 190 flowering plants depicted in the painting have been identified. Almost all grow in the neighborhood of Florence between the months of March and April, and most carry symbolic associations with love and marriage.

Flora scatters flowers held in a fold of her dress at the level of her womb, equating the fecundity brought about by changing seasons with female procreative fertility.

SEE MORE: View the Closer Look feature for *Primavera* **www.myartslab.com**

In a dramatic gesture of repentance, he burned many of his earlier paintings and began to produce highly emotional pictures pervaded by an intense religiosity.

## VENICE

In the last quarter of the fifteenth century, Venice emerged as a major Renaissance art center. Ruled as an oligarchy (government by a select few) with an elected duke (*doge* in the Venetian dialect), the city government was founded at the end of the Roman Empire and survived until the Napoleonic era. In building their city, the Venetians had turned marshes into a commercial seaport, and they saw the sea as a resource, not a threat. They depended on naval power and on the natural defense of their lagoons rather than city walls. Venice turned toward the east, especially after the crusaders' conquest of 1204, designing the church of St. Mark as a great Byzantine building sheathed in mosaics (SEE FIG. 7–36). Venice excelled in the arts of textiles, gold and enamel, glass and mosaic, and fine printing as well as bookbinding.

**VENETIAN PALACES.** Venice was a city of waterways with few large public spaces. Even palaces had only small interior courtyards and tiny gardens, and were separated by narrow alleys. Their façades overlooked the canals, whose waters gave protection and permitted the owners to project on these major thoroughfares the large portals, windows, and loggias that proclaimed their importance through the lavishness of their residences—a sharp contrast to the fortresslike character of most Florentine town houses (SEE FIG. 19–5). But, as with the Florentine great houses, Venician owners combined in these structures a place of business with a dwelling.

The Ca d'Oro (House of Gold), home of the wealthy nobleman Marino Contarini, has a splendid front with three super-imposed loggias facing the Grand Canal **(FIG. 19–35)**. The house was constructed between 1421 and 1437, and its asymmetrical elevation is based on a traditional Byzantine plan. A wide central hall ran from front to back all the way through the building to a small inner courtyard with a well and garden. An outside stair led to the main floor on the second level. The entrance on the canal permitted goods to be delivered directly into the warehouse that constituted the ground floor. The principal floor, on the second level, had a salon and reception room opening on the richly decorated loggia. It was filled with light from large windows, and more light reflected off the polished terrazzo floor. Private family rooms filled the upper stories. Contarini's instructions to his contractors and workers specified that the façade was to be painted with white enamel and ultramarine blue and that the red stones in the patterned wall should be oiled to make them even brighter. Details of carving, such as coats of arms and balls on the crest at the roofline, were to be gilded. Beautiful as the palace is today, in the fifteenth and sixteenth centuries it must have been truly spectacular.

**THE BELLINI BROTHERS.** The domes of the church of St. Mark dominated the city center, and the rich colors of its glowing mosaics captured painters' imaginations. Perhaps it was their love of color that encouraged the Venetian painters to embrace the oil medium for both panel and canvas painting.

The most important Venetian artists of this period were two brothers: Gentile (c. 1429–1507) and Giovanni (c. 1430–1516) Bellini, whose father, Jacopo (c. 1400–1470), had also been a central figure in Venetian art. Andrea Mantegna was also part of this circle, for he had married Jacopo's daughter in 1453.

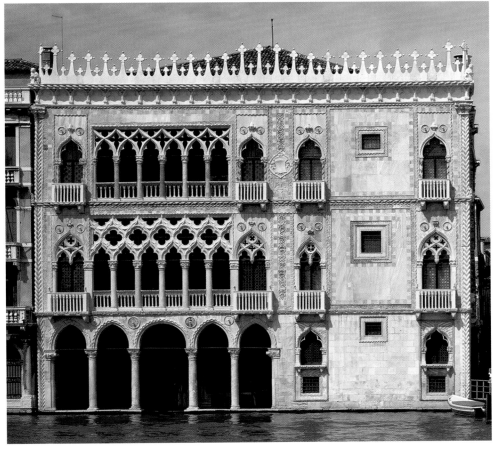

**19-35 • CA D'ORO (CONTARINI PALACE), VENICE**
1421–1437.

SEE MORE: Click the Google Earth link for the Ca d'Oro www.myartslab.com

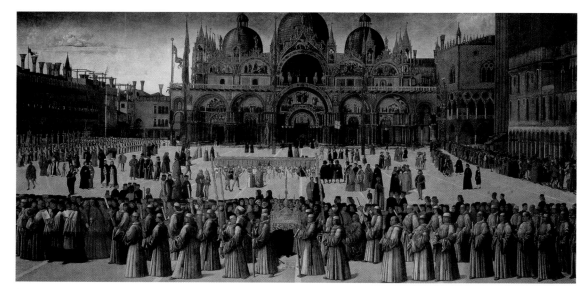

Gentile Bellini celebrated the daily life of the city in large, lively narratives, such as the **PROCESSION OF THE RELIC OF THE TRUE CROSS BEFORE THE CHURCH OF ST. MARK** (FIG. 19–36). Every year on the feast of St. Mark (April 25), the Confraternity of St. John the Evangelist carried the miracle-working relic of the true cross in a procession through the square in front of the church. Bellini's painting of 1496 depicts an event that had occurred in 1444: the miraculous recovery of a sick child whose father (the man in red kneeling to the right of the relic) prayed for help as the relic passed by. Gentile has rendered the cityscape with great attention to detail. The mosaic-encrusted Byzantine Cathedral of St. Mark (SEE FIG. 7–36) forms a backdrop for the procession, and the doge's palace and base of the bell tower can be seen at the right. The gold reliquary is carried under a canopy, surrounded by marchers with giant candles, led by a choir and followed at the far right by the doge and other officials. Gentile's procession serves as a reminder that fifteenth-century piazzas and buildings were sites of ritual ceremony, and it was in moments such as this that they were brought to life.

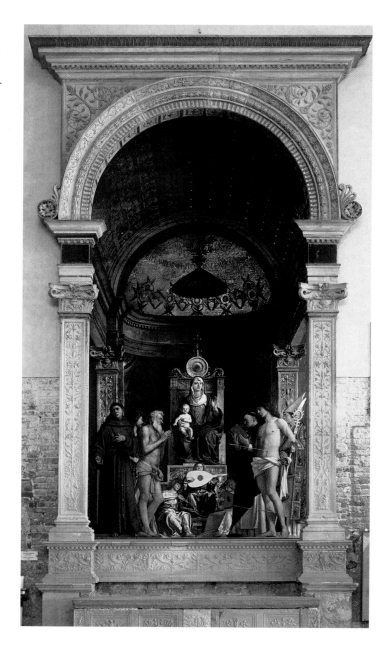

**19-37 • Giovanni Bellini VIRGIN AND CHILD ENTHRONED WITH SS. FRANCIS, JOHN THE BAPTIST, JOB, DOMINIC, SEBASTIAN, AND LOUIS OF TOULOUSE**
(Computer reconstruction). Originally commissioned for the chapel of the Hospital of San Giobbe, Venice. c. 1478. Oil on wood panel, 15′4″ × 8′4″ (4.67 × 2.54 m). Galleria dell'Accademia, Venice. The original frame is in the chapel of the Hospital of San Giobbe, Venice.

Art historians have given the special name *sacra conversazione* ("holy conversation") to this type of composition that shows saints, angels, and sometimes even the painting's donors in the same pictorial space with the enthroned Virgin and Child. Despite the name, no "conversation" or spoken interaction takes place in a literal sense. Instead, the individuals portrayed are joined in a mystical and eternal communion that occurs outside human time and space.

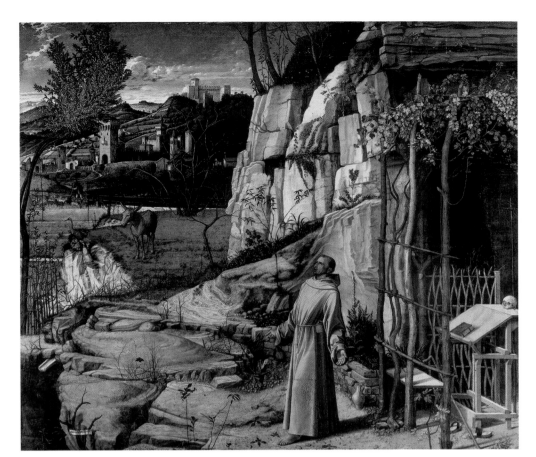

19-38 • Giovanni Bellini
**ST. FRANCIS IN ECSTASY**
c. 1470s. Oil and tempera on wood panel, 49 × 55⅞″ (125 × 142 cm). The Frick Collection, New York.

sylvan delight. Like most of the fifteenth-century religious art we have seen, however, Bellini presents viewers with a natural world saturated in symbolism. Here a relationship between St. Francis and Moses is outlined. The tree symbolizes the burning bush; the stream, the miraculous spring brought forth by Moses. The crane and donkey represent the monastic virtue of patience. The detailed description, luminous palette, and symbolic surroundings suggest Flemish art, but the golden light suffusing the painting is unmistakably Venetian.

Gentile's brother Giovanni amazed and attracted patrons with his artistic virtuosity for almost 60 years. The **VIRGIN AND CHILD ENTHRONED WITH SS. FRANCIS, JOHN THE BAPTIST, JOB, DOMINIC, SEBASTIAN, AND LOUIS OF TOULOUSE** (FIG. 19–37), painted about 1478 for the chapel of the Hospital of San Giobbe (St. Job), exhibits a dramatic perspectival view up into a tunnel vault that leads to an apse. Giovanni may have known his brother-in-law Mantegna's early experiments in radical foreshortening and in the use of a low vanishing point. Here Giovanni positions the vanishing point for the rapidly converging lines of the architecture at bottom center, on the feet of the lute-playing angel. His figures stand in a Classical architectural interior with a coffered barrel vault reminiscent of Masaccio's *Trinity* (SEE FIG. 19–16). The gold mosaic, with its identifying inscription and stylized seraphim (angels of the highest rank), recalls Byzantine art and the long tradition of Byzantine-inspired painting and mosaics produced in Venice.

Giovanni Bellini's early painting of **ST. FRANCIS IN ECSTASY** (FIG. 19–38), painted in the 1470s, recalls Flemish painting in the fine detail with which he rendered the natural world. The saint stands bathed in early morning sunlight, his outspread hands showing his stigmata. Francis had moved to a cave in the barren wilderness in his search for communion with God, but in the world Giovanni creates for him, the fields blossom and flocks of animals graze. The grape arbor over his desk adds to the atmosphere of

**THINK ABOUT IT**

19.1 Discuss Masaccio's use of linear perspective in either *The Tribute Money* or *Trinity with the Virgin, St. John the Evangelist, and Donors*. How does he use this technique? Illustrate your points with a comparative reference to a work discussed earlier in this chapter or in a previous chapter.

19.2 Explain how one Florentine sculptor discussed in this chapter helped establish the increasing naturalism and growing emulation of Classical models that would be central to the early Italian Renaissance.

19.3 Choose a wealthy merchant or *condottiere* and discuss how his patronage fostered the emergence of the Renaissance in fifteenth-century Italy. Make reference to specific works in forming your answer.

19.4 Discuss the 1401 competition to choose an artist to create the bronze doors of the Florence Baptistery. How did the competition affect the careers of the two finalists, Ghiberti and Brunelleschi?

19.5 Discuss the role of the Classical past in Brunelleschi's architecture, focusing on one of the buildings he designed in Florence.

**PRACTICE MORE:** Compose answers to these questions, get flashcards for images and terms, and review chapter material with quizzes
**www.myartslab.com**

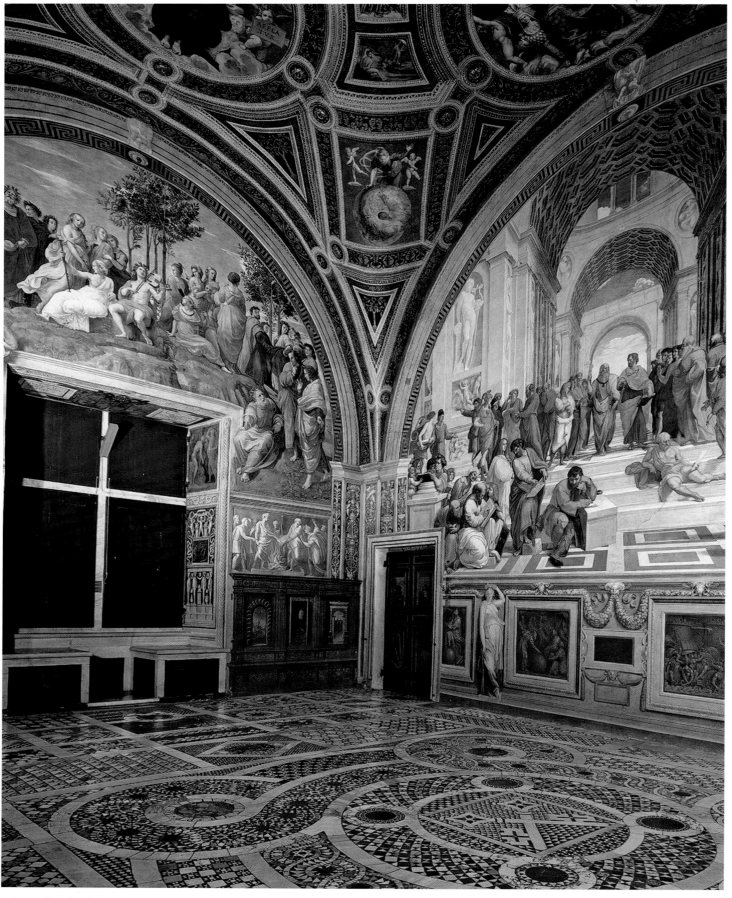

**20-1 • Raphael STANZA DELLA SEGNATURA** Vatican, Rome. Fresco in the left lunette, *Parnassus*; in the right lunette, *The School of Athens*. 1510–1511.

# SIXTEENTH CENTURY ART IN ITALY

Two young artists—Raphael and Michelangelo—although rivals in almost every sense, were linked in service to Pope Julius II (pontificate 1503–1513) in the early years of the sixteenth century. Raphael was painting the pope's private library (1509–1511) while, nearby, Michelangelo painted the ceiling of his Sistine Chapel (1508–1512). The pope demanded an art that reflected his imperial vision of a new, worldwide Church based on humanistic ideas, which he would lead as a new St. Peter, founding a second great age of papal dominion. In fulfilling this proud demand, Raphael and Michelangelo united Renaissance principles of harmony and balance with a new monumentality based on Classical ideals, and they knit these elements into a dynamic and synthetic whole, rich in color and controlled by cohesive design. Working alongside the architect Donato Bramante and the multifaceted genius Leonardo da Vinci, they created a style we call the High Renaissance.

Julius II intended the **STANZA DELLA SEGNATURA**, or Room of the Signature, to be his personal study (FIG. 20–1). Raphael sought to create an ideal setting for papal activities, with murals proclaiming that all human knowledge exists under the power of divine wisdom. He organized the mural program itself like a library, separated into divisions of theology, philosophy, the arts, and justice. He created pictorial allegories to illustrate each theme. On one wall, churchmen discussing the sacraments represent theology, while across the room ancient philosophers led by Plato and Aristotle debate in the School of Athens. Plato holds his book *Timaeus*, in which creation is seen in terms of geometry, and in which humanity encompasses and explains the universe. Aristotle holds his *Nicomachean Ethics*, a decidedly human-centered book concerned with relations among people. Ancient representatives of the academic curriculum—Grammar, Rhetoric, Dialectic, Arithmetic, Music, Geometry, and Astronomy—surround them. On a window wall, Justice, holding a sword and scales, assigns each his due. Across the room, Poetry and the Arts are represented by Apollo and the Muses, and the poet Sappho reclines against the fictive frame of an actual window. Raphael included his own portrait among the onlookers on the extreme lower right in the *School of Athens* fresco and signed the painting with his initials—a signal that both artists and patrons were becoming increasingly aware of their individual significance.

Raphael achieved a lofty style in keeping with papal ambition —using ideals of Classical grandeur, professing faith in human rationality and perfectibility, and celebrating the power of the pope as God's earthly administrator. But when Raphael died at age 37 on April 6, 1520, the grand moment was already passing: Luther and the Protestant Reformation were challenging papal authority, and the world would never be the same again.

## LEARN ABOUT IT

**20.1** Trace the shift in the artistic center of Italy from Florence to Rome, and recognize the efforts of Pope Julius II to create a new "golden age."

**20.2** Understand the Vatican as a site for the creative energies of the most important artists of the Italian Renaissance.

**20.3** Explore the intentional subversion of Classical style and decorum in the work of Mannerist artists.

**20.4** Compare and contrast the emphasis on drawing and clearly structured compositions in the work of Roman and Florentine painters with the expressive potential of color that characterizes the work of their Venetian counterparts.

**20.5** Examine the architectural creativity lavished on the design of both grand churches and pleasurable retreats for the wealthy in sixteenth-century Italy.

**HEAR MORE:** Listen to an audio file of your chapter www.myartslab.com

# EUROPE IN THE SIXTEENTH CENTURY

The sixteenth century was an age of social, intellectual, and religious ferment that transformed European culture. It was marked by continual warfare triggered by the expansionist ambitions of warring rulers. The humanism of the fourteenth and fifteenth centuries, with its medieval roots and its often uncritical acceptance of the authority of Classical texts, slowly developed into a critical exploration of new ideas, the natural world, and distant lands. Cartographers began to acknowledge the Earth's curvature and the degrees of distance, giving Europeans a more accurate understanding of their place within the world. The printing press sparked an explosion in book production, spreading new ideas through the translation and publication of ancient and contemporary texts, broadening the horizons of educated Europeans and encouraging the development of literacy. Since travel was growing more common, artists and their work became mobile, and the world of art was transformed into a more international community.

At the start of the sixteenth century, England, France, and Portugal were nation-states under strong monarchs. German-speaking central Europe was divided into dozens of principalities, counties, free cities, and small territories. But even states as powerful as Saxony and Bavaria acknowledged the supremacy of the Habsburg Holy Roman Empire—in theory the greatest power in Europe. Charles V, elected emperor in 1519, also inherited Spain, the Netherlands, and vast territories in the Americas. Italy, which was divided into numerous small states, was a diplomatic and military battlefield where, for much of the century, the Italian city-states, Habsburg Spain, France, and the papacy fought each other in shifting alliances. Popes behaved like secular princes, using diplomacy and military force to regain control over central Italy and in some cases to establish family members as hereditary rulers.

The popes' incessant demands for money, to finance the rebuilding of St. Peter's as well as their self-aggrandizing art projects and luxurious lifestyles, aggravated the religious dissent that had long been developing, especially north of the Alps. Early in the century, religious reformers within the established Church challenged beliefs and practices, especially Julius II's sale of indulgences promising forgiveness of sins and assurance of salvation in exchange for a financial contribution to the Church. Because they protested, these northern European reformers came to be called Protestants; their demand for reform gave rise to a movement called the Reformation.

The political maneuvering of Pope Clement VII (pontificate 1523–1534) led to a direct clash with Holy Roman Emperor Charles V. In May 1527, Charles's German mercenary troops attacked Rome, beginning a six-month orgy of killing, looting, and burning. The Sack of Rome, as it is called, shook the sense of stability and humanistic confidence that until then had characterized the Renaissance, and it sent many artists fleeing from the ruined city. Nevertheless, Charles saw himself as the leader of the Catholic forces—and he was the sole Catholic ally Clement had at the time. In 1530, Clement VII crowned Charles emperor in Bologna.

Sixteenth-century patrons valued artists highly and rewarded them well, not only with generous commissions but sometimes even with high social status. Charles V, for example, knighted the painter Titian. Some painters and sculptors became entrepreneurs and celebrities, selling prints of their works on the side and creating international reputations for themselves. Many artists recorded their activities—professional and private—in diaries, notebooks, and letters that have come down to us. In addition, contemporary writers began to report on the lives of artists, documenting their physical appearance and assessing their individual reputations. In 1550, Giorgio Vasari wrote the first survey of Italian art history—*Lives of the Best Architects, Painters, and Sculptors*—organized as a series of critical biographies but at its core a work of critical judgment. Vasari also commented on the role of patrons, and argued that art had become more realistic and more beautiful over time, reaching its apex of perfection in his own age. From his characterization developed our notion of this period as the High Renaissance—that is, as a high point in art since the early experiments of Cimabue and Giotto, marked by a balanced synthesis of Classical ideals and a lifelike rendering of the natural world.

During this period, the fifteenth-century humanists' notion of painting, sculpture, and architecture not as manual arts but as liberal (intellectual) arts, requiring education in the Classics and mathematics as well as in the techniques of the craft, became a topic of intense interest. And from these discussions arose the Renaissance formulation—still with us today—of artists as divinely inspired creative geniuses, a step above most of us in their gifts of hand and mind. This idea weaves its way through Vasari's work like an organizing principle. And this newly elevated status to which artists aspired favored men. Although few artists of either sex had access to the humanist education required by the sophisticated, often esoteric, subject matter used in paintings (usually devised by someone other than the artist), women were denied even the studio practice necessary to draw lifelike nude figures in foreshortened poses. Furthermore, it was almost impossible for an artist to achieve international status without traveling extensively and frequently relocating to follow commissions—something most women could not do. Still, some European women managed to follow their gifts and establish careers as artists during this period despite the obstacles that blocked their entrance into the profession.

# ITALY IN THE EARLY SIXTEENTH CENTURY: THE HIGH RENAISSANCE

Italian art from the 1490s to about the time of the Sack of Rome in 1527 has been called the "High Renaissance." As we have already seen with the "High Classical" period in ancient Athens, the term "High Renaissance" encapsulates an art-historical

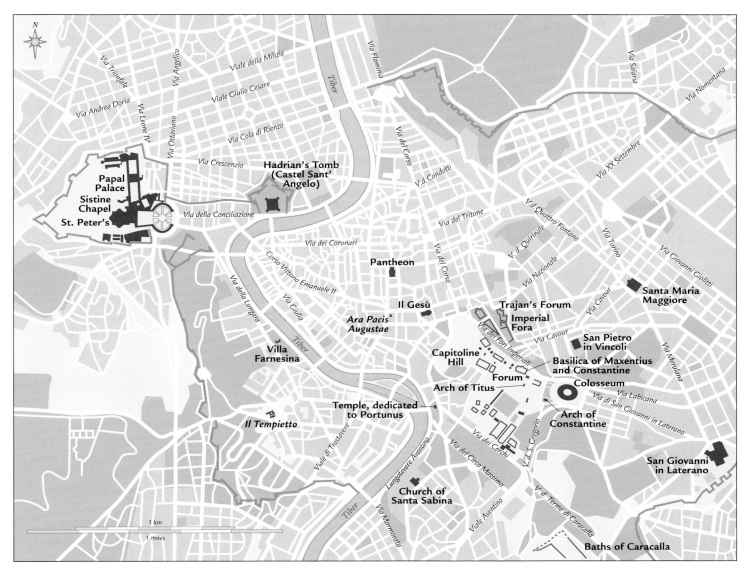

**MAP 20-1 • RENAISSANCE AND EARLIER MONUMENTS IN ROME**

In addition to situating the principal works of the Roman Renaissance that emerged from Julius II's campaign to revitalize the papal city, this map also locates the surviving works of Roman antiquity that would have been available to the Renaissance artists and architects who masterminded the Classical revival.

judgment, claiming that what happened in Rome at this time represents a pinnacle of achievement within a longer artistic movement, and that it set standards for the future **(MAP 20–1)**. High Renaissance art is characterized by a sense of gravity and decorum, a complex but ordered relationship of individual parts to the whole, and an emulation of the principles artists saw in ancient Classical art. Art historian Sydney Freedberg has stressed the way High Renaissance art fuses the real and the ideal, characterizing Leonardo's *Mona Lisa*, for example, as "a rare perfection between art and reality; an image in which a breathing instant and a composure for all time are held in suspension" (Freedberg, p. 28).

Two important practical developments at the turn of the sixteenth century affected the arts in Italy. Technically, the use of tempera gave way to the more flexible oil painting medium; and economically, commissions from private sources increased so that artists no longer depended so exclusively on the patronage of the Church, the court, or civic associations.

## THREE GREAT ARTISTS OF THE EARLY SIXTEENTH CENTURY

Florence's renowned artistic tradition attracted a stream of young artists to that city, traveling there to study Masaccio's solid, monumental figures, with their eloquent facial features, poses, and gestures, in the Brancacci Chapel paintings. The young Michelangelo's sketches of the chapel frescos document the importance of Masaccio to his developing style. In fact, Michelangelo, Leonardo, and Raphael—the three leading artists of the High Renaissance—all began their careers in Florence, although they soon moved to other centers of patronage and their influence spread well beyond that city, even beyond Italy.

**LEONARDO DA VINCI.** Leonardo da Vinci (1452–1519) was 12 or 13 when his family moved to Florence from the Tuscan village of Vinci. After an apprenticeship in the shop of the Florentine painter and sculptor Verrocchio, and a few years on his own, Leonardo traveled to Milan in 1481 or 1482 to work for the ruling Sforza family.

Leonardo spent much of his time in Milan on military and civil engineering projects, including both urban-renewal and fortification plans for the city, but he also created a few key monuments of Renaissance painting. In April 1483, Leonardo contracted with the Confraternity of the Immaculate Conception to paint an altarpiece

for their chapel in the church of San Francesco Grande in Milan, a painting now known as *The Virgin of the Rocks* (**FIG. 20–2**). The contract stipulates a painting of the Virgin and Child with angels, but Leonardo added a figure of the young John the Baptist, who balances the composition at the left, pulled into dialogue with his younger cousin Jesus by the long, protective arm of the Virgin. She draws attention to her child by extending her other hand over his head, while the enigmatic figure of the angel—who looks out without actually making eye contact with the viewer—points to the center of interaction. The stable, balanced, pyramidal figural group—a compositional formula that will become a standard feature of High Renaissance Classicism—is set against an exquisitely detailed landscape that dissolves mysteriously into the misty distance.

To assure their dominance in the picture, Leonardo picks out the four figures with spotlights, creating a strong **chiaroscuro** (from the Italian words *chiaro*, meaning "light," and *oscuro*, meaning "dark") that enhances their modeling as three-dimensional forms. This painting is an excellent early example of a specific variant of this technique, called **sfumato** ("smoky"), in which there are subtle, almost imperceptible, transitions between light and dark in shading, as if the picture were seen through smoke or fog. *Sfumato* becomes a hallmark of Leonardo's style, and the effect is artificially enhanced in this painting by the yellowing of its thick varnish, which masks the original vibrancy of its color.

At Duke Ludovico Sforza's request, Leonardo painted **THE LAST SUPPER** (**FIGS. 20–3, 20–4**) in the refectory, or dining hall, of the monastery of Santa Maria delle Grazie in Milan between 1495 and 1498. In fictive space defined by a coffered ceiling and four pairs of tapestries that seem to extend the refectory itself into another room, Jesus and his disciples are seated at a long table placed parallel to the picture plane and to the monastic diners who would have been seated in the hall below. In a sense, Jesus' meal with his disciples prefigures the daily gathering of this local monastic community at mealtimes. The stagelike space recedes from the table to three windows on the back wall, where the vanishing point of the one-point linear perspective lies behind Jesus' head. A stable, pyramidal Jesus at the center is

**20-2 • Leonardo da Vinci THE VIRGIN OF THE ROCKS**
c. 1485. Oil on wood panel (now transferred to canvas), 6′6″ × 4′ (1.9 × 1.2 m). Musée du Louvre, Paris.

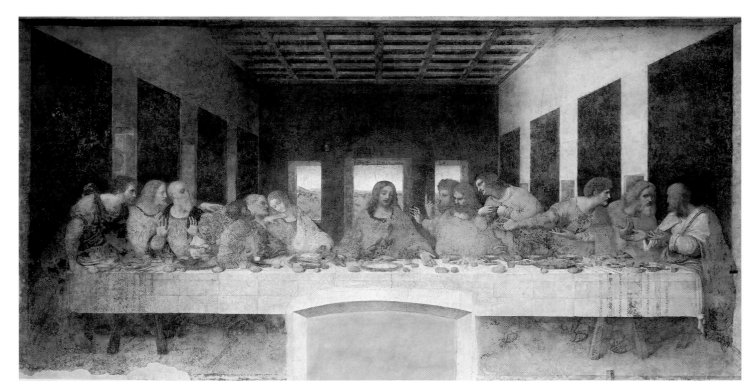

**20-3** • Leonardo da Vinci **THE LAST SUPPER**
Refectory of the monastery of Santa Maria delle Grazie, Milan, Italy. 1495–1498. Tempera and oil on plaster, 15′2″ × 28′10″ (4.6 × 8.8 m).

**SEE MORE:** View a video about Leonardo da Vinci's *The Last Supper* **www.myartslab.com**

**20-4** • **REFECTORY OF THE MONASTERY OF SANTA MARIA DELLE GRAZIE, SHOWING LEONARDO'S LAST SUPPER**
Milan, Italy.

Instead of painting in fresco, Leonardo devised an experimental technique for this mural. Hoping to achieve the freedom and flexibility of painting on wood panel, he worked directly on dry *intonaco*— a thin layer of smooth plaster—with an oil-and-tempera paint for which the formula is unknown. The result was disastrous. Within a short time, the painting began to deteriorate, and by the middle of the sixteenth century its figures could be seen only with difficulty. In the seventeenth century, the monks saw no harm in cutting a doorway through the lower center of the composition. The work has barely survived the intervening period, despite many attempts to halt its deterioration and restore its original appearance. The painting narrowly escaped complete destruction in World War II, when the refectory was bombed to rubble. The coats of arms at the top are those of patron Ludovico Sforza, the duke of Milan (r. 1494–1499), and his wife, Beatrice.

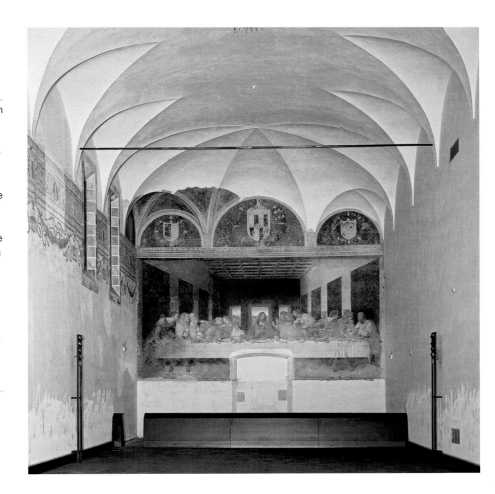

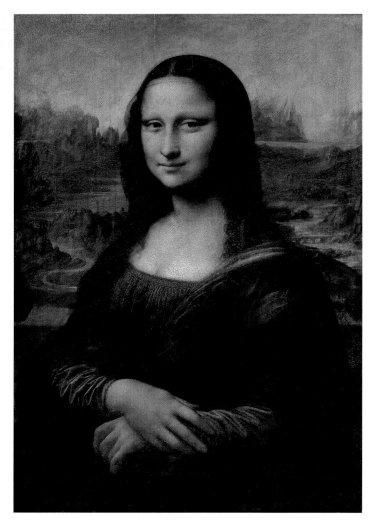

**20-5 • Leonardo da Vinci MONA LISA**
c. 1503–1506. Oil on wood panel, 30¼ × 21" (77 × 53 cm).
Musée du Louvre, Paris. (INV. 779)

**EXPLORE MORE:** Gain insight from a primary source by
Leonardo www.myartslab.com

flanked by his 12 disciples, grouped in four interlocking sets of three.

On one level, Leonardo has painted a scene from a story—one that captures the individual reactions of the apostles to Jesus' announcement that one of them will betray him. Leonardo was an acute observer of human behavior, and his art captures human emotions with compelling immediacy. On another level, *The Last Supper* is a symbolic evocation of Jesus' coming sacrifice for the salvation of humankind, the foundation of the institution of the Mass. Breaking with traditional representations of the subject (SEE FIG. 19–22), Leonardo placed the traitor Judas—clutching his money bags in the shadows—within the first triad to the left of Jesus, along with the young John the Evangelist and the elderly Peter, rather than isolating him on the opposite side of the table. Judas, Peter, and John were each to play an essential role in Jesus' mission: Judas set in motion the events leading to Jesus' sacrifice; Peter led the Church after Jesus' death; and John, the visionary, foretold the Second Coming and the Last Judgment in the book of Revelation.

The painting's careful geometry, the convergence of its perspective lines, the stability of its pyramidal forms, and Jesus' calm demeanor at the mathematical center of all the commotion together reinforce the sense of gravity, balance, and order. The clarity and stability of this painting epitomize High Renaissance style.

Leonardo returned to Florence in 1500, after the French, who had invaded Italy in 1494, claimed Milan by defeating Leonardo's Milanese patron, Ludovico Sforza. Perhaps the most famous of his Florentine works is the portrait he painted between about 1503 and 1506 known as the **MONA LISA** (FIG. 20–5). The subject may have been 24-year-old Lisa Gherardini del Giocondo, the wife of a prominent Florentine merchant. Leonardo never delivered the painting and kept it with him for the rest of his life. In a departure from tradition, the young woman is portrayed without jewelry, not even a ring. The solid pyramidal form of her halflength figure—another departure from traditional portraiture, which was limited to the upper torso—is silhouetted against distant hazy mountains, giving the painting a sense of mystery reminiscent of *The Virgin of the Rocks* (SEE FIG. 20–2). Mona Lisa's facial expression has been called "enigmatic" because her gentle smile is not accompanied by the warmth one would expect to see in her eyes, which have boldly—perhaps flirtatiously—shifted to the side to look straight out at the viewer. It is this expressive complexity, and the sense of psychological presence it gives the human face—especially in the context of the masklike detachment that was more characteristic of Renaissance portraiture (compare FIG. 19–27, or even FIG. 20–8)—that makes the innovative *Mona Lisa* so arresting and haunting, even today.

A fiercely debated topic in Renaissance Italy was the question of the relative merits of painting and sculpture. Leonardo insisted on the supremacy of painting as the best and most complete means of creating an illusion of the natural world, while Michelangelo argued for sculpture. Yet in creating a painted illusion, Leonardo considered color to be secondary to the depiction of sculptural volume, which he achieved through his virtuosity in *sfumato*. He also unified his compositions by covering them with a thin, lightly tinted varnish, which enhanced the overall smoky haze. Because early evening light tends to produce a similar effect naturally, Leonardo considered dusk the finest time of day and recommended that painters set up their studios in a courtyard with black walls and a linen sheet stretched overhead to reproduce twilight.

Leonardo's fame as an artist is based on only a few works, for his many interests took him away from painting. Unlike his humanist contemporaries, he was not particularly interested in Classical literature or archaeology. Instead, his passions were mathematics, engineering, and the natural world. He compiled volumes of detailed drawings and notes on anatomy, botany, geology, meteorology, architectural design, and mechanics. In his drawings of human figures, he sought not only the precise details of anatomy but also the geometric basis of perfect proportions (see "The Vitruvian Man," opposite). Leonardo's searching mind is

## The Vitruvian Man

Artists throughout history have turned to geometric shapes and mathematical proportions to seek the ideal representation of the human form. Leonardo, and before him the first-century BCE Roman architect and engineer Vitruvius, equated the ideal man with both circle and square. Ancient Egyptian artists laid out square grids as aids to design (see "Egyptian Pictorial Relief," page 65). Medieval artists adapted a variety of figures, from triangles to pentagrams (see "Villard de Honnecourt," page 510).

Vitruvius, in his ten-volume *De architectura* (*On Architecture*), wrote: "For if a man be placed flat on his back, with his hands and feet extended, and a pair of compasses centered at his navel, the fingers and toes of his two hands and feet will touch the circumference of a circle described therefrom. And just as the human body yields a circular outline, so too a square figure may be found from it. For if we measure the distance from the soles of the feet to the top of the head, and then apply that measure to the outstretched arms, the breadth will be found to be the same as the height" (Book III, Chapter 1, Section 3). Vitruvius determined that the ideal body should be eight heads high. Leonardo added his own observations in the reversed writing he always used in his notebooks when he created his well-known diagram for the ideal male figure, called the Vitruvian Man.

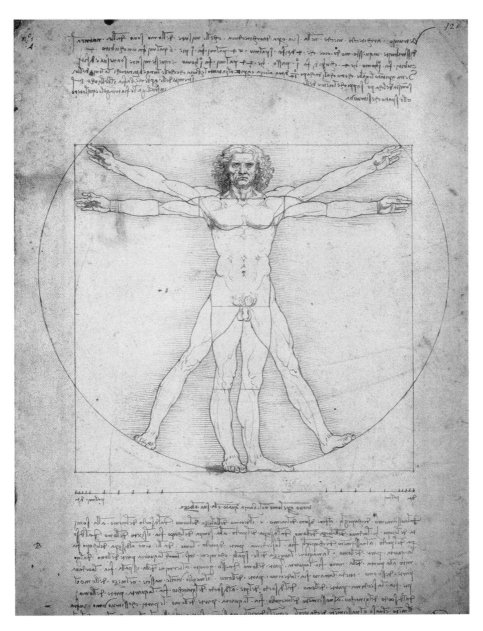

Leonardo da Vinci
**VITRUVIAN MAN**
c. 1490. Ink, 13½ × 9⅝"
(34.3 × 24.5 cm).
Galleria dell'Accademia, Venice.

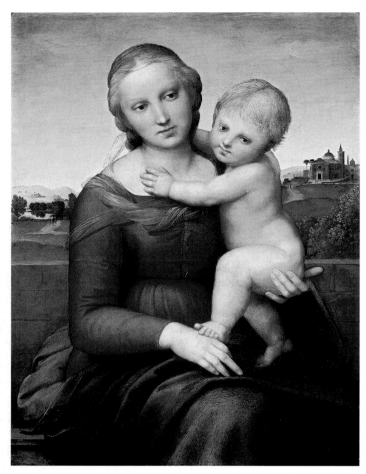

**20-6 • Raphael THE SMALL COWPER MADONNA**
c. 1505. Oil on wood panel, 23⅜ × 17⅝" (59.5 × 44.1 cm).
National Gallery of Art, Washington, D.C.
Widener Collection (1942.9.57)

In the distance on a hilltop, Raphael has painted a scene he knew
well from his childhood, the domed church of San Bernardino, two
miles outside Urbino. The church contains the tombs of dukes of
Urbino, Federico and Guidobaldo da Montefeltro, and their wives
(SEE FIG. 19–27). Donato Bramante, whose architecture was key in
establishing the High Renaissance style, may have designed the
church.

evident in his drawings, not only of natural objects and human
beings, but also of machines, so clearly and completely worked
out that modern engineers have used them to construct working
models. He designed flying machines, a kind of automobile, a
parachute, and all sorts of military equipment, including a mobile
fortress. His imagination outran his means to bring his creations
into being. For one thing, he lacked a source of power other than
men and horses. For another, he may have lacked focus and
follow-through. His contemporaries complained that he never
finished anything and that his inventions distracted him from his
painting.

Leonardo returned to Milan in 1508 and lived there until
1513. He also lived for a time in the Vatican at the invitation of
Pope Leo X, but there is no evidence that he produced any works
of art during his stay. In 1516, he accepted the French king Francis

I's invitation to relocate to France as an advisor on architecture,
taking the *Mona Lisa* with him. He remained at Francis's court
until his death in 1519.

RAPHAEL. About 1505—while Leonardo was working on the
*Mona Lisa*—Raphael (Raffaello Santi or Sanzio, 1483–1520)
arrived in Florence from his native Urbino after studying in
Perugia with the city's leading artist, Perugino (SEE FIG. 19–31).
Raphael quickly became successful in Florence, especially with
small, polished paintings of the Virgin and Child, such as **THE
SMALL COWPER MADONNA** (named for a modern owner) of about
1505 (FIG. 20–6). Already a superb painter technically, the youthful
Raphael shows his indebtedness to his teacher in the delicate tilt of
the figures' heads, the brilliant tonalities, and the pervasive sense of
serenity. But Leonardo's impact is also evident here in the simple
grandeur of these monumental shapes, the pyramidal composition
activated by the spiraling movement of the child, and the draperies
that cling to the Virgin's substantial form. In other Madonnas from
this period, Raphael included the young John the Baptist (SEE FIG.
INTRO–3), experimenting with the multiple figure interactions
pioneered by Leonardo in *The Virgin of the Rocks* (SEE FIG. 20–2).

At the same time as he was producing engaging images
of elegant Madonnas, Raphael was also painting portraits of
prosperous Florentine patrons. To commemorate the marriage in
1504 of 30-year-old cloth merchant Agnelo Doni to Maddalena
Strozzi, the 15-year-old daughter of a powerful banking family,
Doni commissioned from Raphael pendent portraits of the newly-
weds (FIGS. 20–7, 20–8). They are flawlessly executed by the
mature painter at the peak of his illusionistic virtuosity. Like Piero
della Francesca in his portraits of Battista Sforza and Federico da
Montefeltro (SEE FIG. 19–27), Raphael silhouettes Maddalena and
Agnelo against a meticulously described panoramic landscape. But
unlike their predecessors, they turn to address the viewer. Agnelo is
commanding but casual, leaning his arm on a balustrade to add
three-dimensionality to his posture. Maddalena's pose imitates
Leonardo's innovative presentation of his subject in the *Mona Lisa*
(SEE FIG. 20–5), which Raphael had obviously seen in progress,
but with Maddalena there is no sense of mystery, indeed little
psychological presence, and Raphael follows tradition in
emphasizing the sumptuousness of her clothing and making
ostentatious display of her jewelry. Only the wisps of hair
that escape from her sculpted coiffure offer a hint of human
vulnerability in her haughty demeanor.

Raphael left Florence about 1508 for Rome, where Pope
Julius II put him to work almost immediately decorating rooms
(*stanze*, singular *stanza*) in the papal apartments. In the Stanza della
Segnatura (SEE FIG. 20–1)—the papal library—Raphael painted the
four branches of knowledge as conceived in the sixteenth century:
Religion (the *Disputà*, depicting discussions concerning the true
presence of Christ in the Eucharistic Host), Philosophy (the
School of Athens), Poetry (Parnassus, home of the Muses), and Law
(the Cardinal Virtues under Justice).

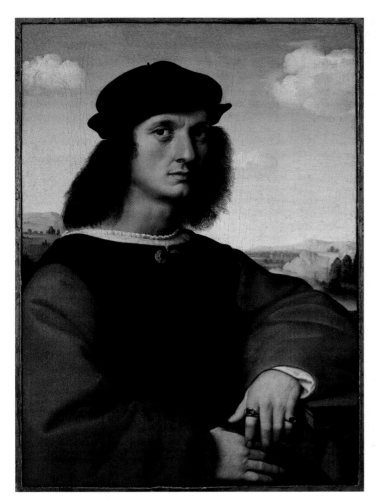

**20–7 • Raphael AGNELO DONI**
c. 1506. Oil on wood panel, 24½ × 17¼″ (63 × 45 cm). Palazzo Pitti, Florence.

These portraits were not the only paintings commissioned by Agnelo Doni to commemorate his upwardly mobile marriage alliance with Maddalena Strozzi. He ordered a *tondo* portraying the holy family from rival artist Michelangelo (see Introduction, "A Closer Look"). Tradition holds that Doni tried to haggle with Michelangelo over the cost of the painting, but ultimately had to pay the price demanded by the artist.

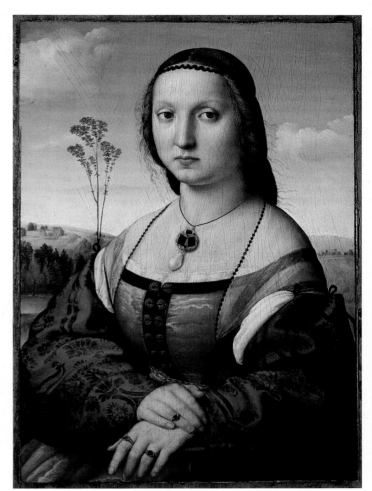

**20–8 • Raphael MADDALENA STROZZI**
c. 1506. Oil on wood panel, 24½ × 17¼″ (63 × 45 cm). Palazzo Pitti, Florence.

Raphael's most influential achievement in the papal rooms was *The School of Athens*, painted about 1510–1511 (see "A Closer Look," page 640). Here, the painter seems to summarize the ideals of the Renaissance papacy in a grand conception of harmoniously arranged forms in a rational space, as well as in the calm dignity of the figures that occupy it. If the learned Julius II did not actually devise the subjects, he certainly must have approved them. Greek philosophers Plato and Aristotle take center stage—placed to the right and left of the vanishing point—silhouetted against the sky and framed under three successive barrel vaults. Surrounding Plato and Aristotle are mathematicians, naturalists, astronomers, geographers, and other philosophers, debating and demonstrating their theories with and to onlookers and each other. The scene takes place in an immense barrel-vaulted interior, flooded with a clear, even light from a single source, and seemingly inspired by the

new design for St. Peter's, under construction at the time. The grandeur of the building is matched by the monumental dignity of the philosophers themselves, each of whom has a distinct physical and intellectual presence. The sweeping arcs of the composition are activated by the variety and energy of their poses and gestures, creating a dynamic unity that is a prime characteristic of High Renaissance art.

In 1515, Raphael was commissioned by Pope Leo X (pontificate 1513–1521) to provide designs on themes from the Acts of the Apostles to be woven into tapestries for the strip of blank wall below the fifteenth-century wall paintings of the Sistine Chapel (SEE FIG. 19–30). For the production of the tapestries, woven in Brussels, Raphael and his large workshop of assistants made full-scale charcoal drawings, then painted over them with color for the weavers to match (see "Raphael's Cartoons for Tapestries in the Sistine Ceiling," pages 646–647). Pictorial weaving was the most prestigious and expensive kind of wall decoration. With murals by the leading painters of the fifteenth century above and Michelangelo's work circling over all, Raphael must have felt both honored and challenged. The pope had given him the place of honor among the artists in the papal chapel.

*The School of Athens* ➤ by Raphael, fresco in the Stanza della Segnatura, Vatican, Rome. c. 1510–1511. 19 × 27′ (5.79 × 8.24 m).

Looking down from niches in the walls are sculptures of Apollo, the god of sunlight, rationality, poetry, music, and the fine arts; and of Minerva, the goddess of wisdom and the mechanical arts.

Plato points upward to the realm of ideas and pure forms that were at the center of his philosophy. His pupil Aristotle gestures toward his surroundings, signifying the empirical world that for him served as the basis for understanding.

The figure bent over a slate with a compass is Euclid, the father of geometry. Vasari claimed that Raphael gave this mathematician the portrait likeness of Bramante, the architect whose redesigned St. Peter's was under construction not far from this room.

Raphael placed his own portrait in a group that includes the geographer Ptolemy, who holds a terrestrial globe, and the astronomer Zoroaster, who holds a celestial globe.

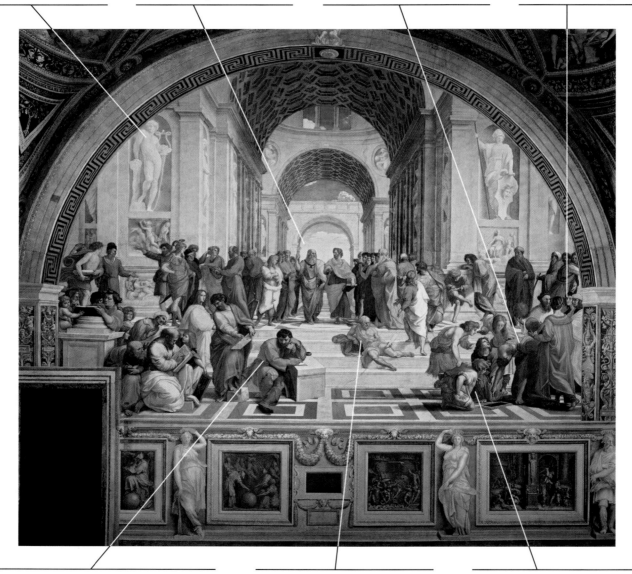

The brooding figure of Heraclitus, a late addition to the composition, is a portrait of Michelangelo, who was working next door on the ceiling of the Sistine Chapel, and whose monumental figural style is here appropriated (or is it mimicked?) by Raphael. The stonecutter's boots on his feet refer to Michelangelo's self-identification—or Raphael's insistence that he be seen—as a sculptor rather than a painter.

This figure is usually identified as Diogenes the Cynic following Vasari's account of the painting. It is more likely that he is Socrates, however. The cup next to him could refer to his deadly draught of hemlock, and his recumbent position recalls his teaching from his prison bed.

The group of figures gathered around Euclid illustrate the various stages of understanding: literal learning, dawning comprehension, anticipation of the outcome, and assisting the teacher. Raphael received acclaim for his ability to communicate so clearly through the poses and expressions of his figures.

SEE MORE: View the Closer Look feature for *The School of Athens* **www.myartslab.com**

MICHELANGELO'S EARLY WORK. Michelangelo Buonarroti (1475–1564) was born in the Tuscan town of Caprese into an impoverished Florentine family that laid a claim to nobility—a claim the artist carefully advanced throughout his life. He grew up in Florence, where at age 13 he was apprenticed to Ghirlandaio (SEE FIG. 19–32), in whose workshop he learned the technique of fresco painting and studied drawings of Classical monuments. Soon the talented youth joined the household of Lorenzo the Magnificent, head of the ruling Medici family, where he came into contact with Neoplatonic philosophy and studied sculpture with Bertoldo di Giovanni, a pupil of Donatello. After Lorenzo died in 1492, Michelangelo traveled to Venice and Bologna, then returned to Florence.

Michelangelo's major early work at the turn of the century was a marble sculpture of the **PIETÀ**, commissioned by a French cardinal and installed as a tomb monument in Old St. Peter's **(FIG. 20–9)**. The theme of the *pietà* (in which the Virgin supports and mourns the dead Jesus in her lap), long popular in northern Europe (SEE FIG. 17–19), was an unusual theme in Italy at the time. Michelangelo traveled to the marble quarries at Carrara in central Italy to select the block from which to make this large work, a practice he was to continue for nearly all of his sculpture. The choice of stone was important to him because he envisioned his sculpture as already existing within the marble, needing only his tools to set it free. Michelangelo was a poet as well as an artist, and later wrote in his Sonnet 15: "The greatest artist has no conception which a single block of marble does not potentially contain within its mass, but only a hand obedient to the mind can penetrate to this image."

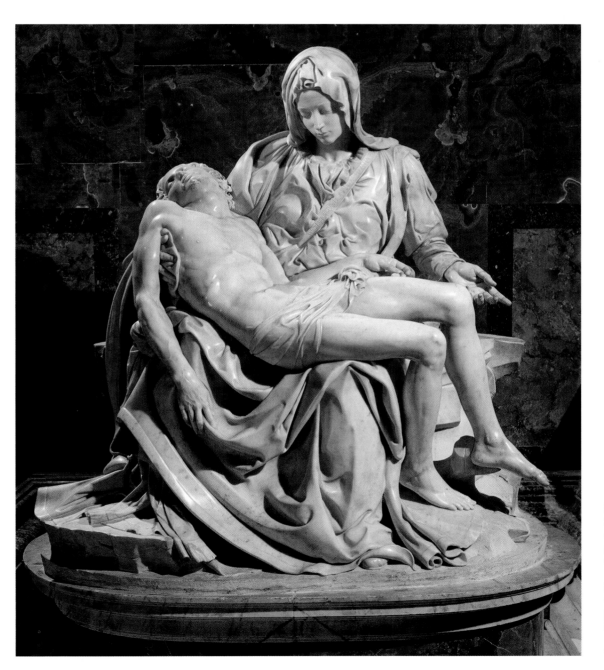

**20-9 • Michelangelo
PIETÀ**
c. 1500. Marble, height
5′8½″ (1.74 m). St. Peter's,
Vatican, Rome.

**EXPLORE MORE:**
Gain insight from a primary source by Michelangelo on his *Pietà*
**www.myartslab.com**

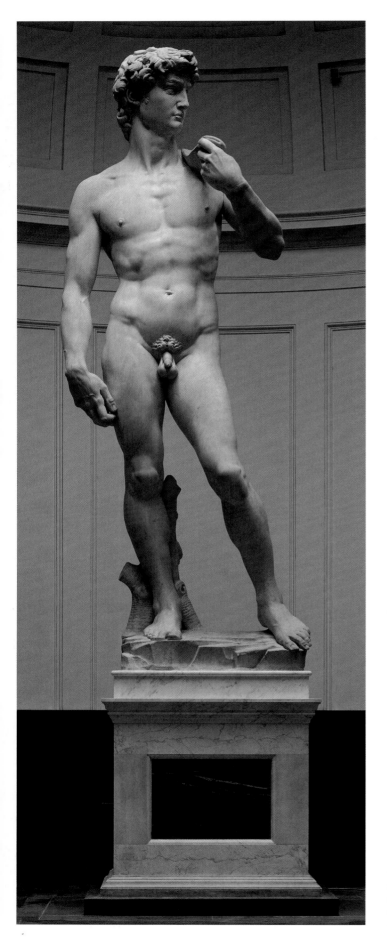

Michelangelo's Virgin is a young woman of heroic stature holding the unnaturally smaller, lifeless body of her grown son. Inconsistencies of scale and age are forgotten, however, when contemplating the sweetness of expression, technical virtuosity of the carving, and smooth modeling of the luscious forms. Michelangelo's compelling vision of beauty was meant to be seen up close so that the viewer can look directly into Jesus' face. The 25-year-old artist is said to have slipped into the church at night to sign the statue on a strap across the Virgin's breast after it was finished, answering directly questions that had come up about the identity of its creator.

In 1501, Michelangelo accepted a Florentine commission for a statue of the biblical hero **DAVID** (FIG. 20–10), to be placed high atop a buttress of the cathedral. But when it was finished in 1504, the *David* was so admired that the city council instead placed it in the principal city square, next to the Palazzo della Signoria (SEE FIG. 17–2), the seat of Florence's government. There it stood as a reminder of Florence's republican status, which was briefly reinstated after the expulsion of the powerful Medici oligarchy in 1494. Although in its muscular nudity Michelangelo's *David* embodies the antique ideal of the athletic male nude, the emotional power of its expression and its concentrated gaze are entirely new. Unlike Donatello's bronze *David* (SEE FIG. 19–10), this is not a triumphant hero with the trophy head of the giant Goliath already under his feet. Slingshot over his shoulder and a rock in his right hand, Michelangelo's *David* knits his brow and stares into space, seemingly preparing himself psychologically for the danger ahead, a mere youth confronting a gigantic experienced warrior. No match for his opponent in experience, weaponry, or physical strength, Michelangelo's powerful *David* stands for the supremacy of right over might—a perfect emblem for the Florentines, who had recently fought the forces of Milan, Siena, and Pisa, and still faced political and military pressure.

THE SISTINE CHAPEL. Despite Michelangelo's contractual commitment to Florence Cathedral for additional statues, in 1505, Pope Julius II, who saw Michelangelo as an ideal collaborator in

**20–10 • Michelangelo DAVID**
1501–1504. Marble, height 17′ (5.18 m) without pedestal. Galleria dell'Accademia, Florence.

Michelangelo's most famous sculpture was cut from an 18-foot-tall marble block. The sculptor began with a small model in wax, then sketched the contours of the figure as they would appear from the front on one face of the marble. Then, according to his friend and biographer Vasari, he chiseled in from the drawn-on surface, as if making a figure in very high relief. The completed statue took four days to move on tree-trunk rollers down the narrow streets of Florence from the premises of the cathedral shop where he worked to its location outside the Palazzo della Signoria (SEE FIG. 17–2). In 1504, the Florentines gilded the tree stump and added a gilded wreath to the head and a belt of 28 gilt-bronze leaves, since removed. In 1873, the statue was replaced by a copy, and the original was moved into the museum of the Florence Academy.

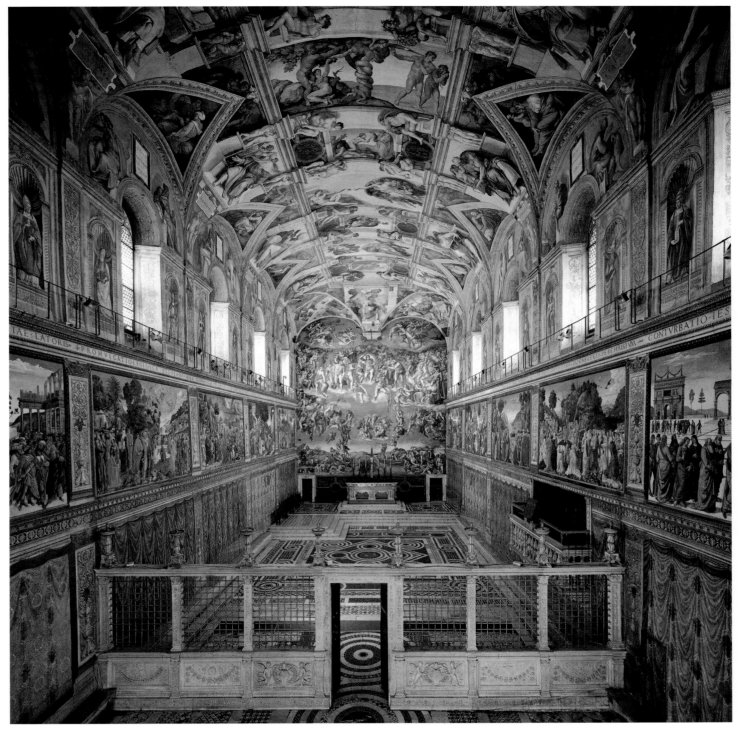

**20–11 • INTERIOR, SISTINE CHAPEL**
Vatican, Rome. Built 1475–1481; ceiling painted 1508–1512; end wall, 1536–1541. The ceiling measures 45 × 128′ (13.75 × 39 m).

the artistic aggrandizement of the papacy, arranged for him to come to Rome to work on the spectacular tomb Julius planned for himself. Michelangelo began the tomb project, but two years later the pope ordered him to begin painting the ceiling of the **SISTINE CHAPEL** instead (FIG. 20–11).

Michelangelo considered himself a sculptor, but the strong-minded pope wanted paintings; work began in 1508. Michelangelo

complained bitterly in a sonnet to a friend: "This miserable job has given me a goiter….The force of it has jammed my belly up beneath my chin. Beard to the sky….Brush splatterings make a pavement of my face…. I'm not a painter." Despite his physical misery as he stood on a scaffold, painting the ceiling just above him, the results were extraordinary, and Michelangelo established a new and remarkably powerful style in Renaissance painting.

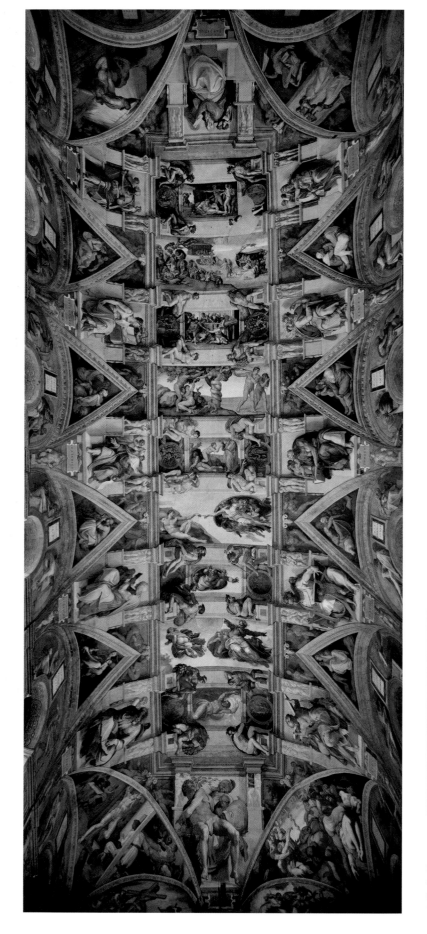

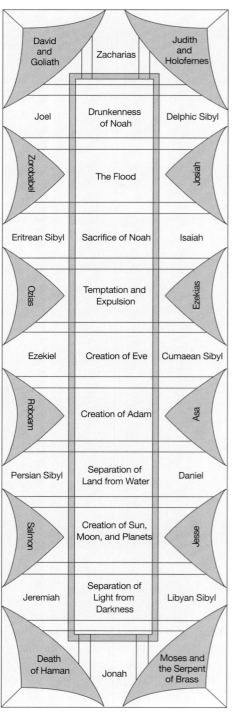

| David and Goliath | Zacharias | Judith and Holofernes |
| Joel | Drunkenness of Noah | Delphic Sibyl |
| Zorobabel | The Flood | Josiah |
| Eritrean Sibyl | Sacrifice of Noah | Isaiah |
| Ozias | Temptation and Expulsion | Ezekias |
| Ezekiel | Creation of Eve | Cumaean Sibyl |
| Roboam | Creation of Adam | Asa |
| Persian Sibyl | Separation of Land from Water | Daniel |
| Salmon | Creation of Sun, Moon, and Planets | Jesse |
| Jeremiah | Separation of Light from Darkness | Libyan Sibyl |
| Death of Haman | Jonah | Moses and the Serpent of Brass |

ALTAR

**20–12 • Michelangelo SISTINE CHAPEL CEILING WITH DIAGRAM IDENTIFYING SCENES**
1508–1512. Fresco.

Julius's initial order for the ceiling was simple: *trompe-l'oeil* coffers to replace the original star-spangled blue decoration. Later he wanted the 12 apostles seated on thrones on the triangular spandrels between the lunettes framing the windows. According to Michelangelo, when he objected to the limitations of Julius's plan, the pope told him to paint whatever he liked. This Michelangelo presumably did, although he was certainly guided by a theological advisor and his plan no doubt required the pope's approval. Then, as master painter, Michelangelo assembled a team of expert assistants to work with him.

In Michelangelo's design, an illusionistic marble architecture establishes a framework for the figures and narrative scenes on the vault of the chapel (FIG. 20–12). Running completely around the ceiling is a painted cornice with projections supported by pilasters decorated with "sculptured" *putti*. Between the pilasters are figures of prophets and sibyls (female seers from the Classical world) who were believed to have foretold Jesus' birth. Seated on the fictive cornice are heroic figures of nude young men (called **ignudi**, singular, *ignudo*), holding sashes attached to large gold medallions. Rising behind the *ignudi*, shallow bands of fictive stone span the center of the ceiling and divide it into nine compartments containing successive scenes from Genesis—the Creation, the Fall, and the Flood—beginning over the altar and ending near the chapel entrance. God's earliest acts of creation are therefore closest to the altar, the Creation of Eve at the center of the ceiling, followed by the imperfect actions of humanity: Temptation, Fall, Expulsion from Paradise, and God's eventual destruction of all people except Noah and his family by the Flood. The eight triangular spandrels over the windows contain paintings of the ancestors of Jesus.

Perhaps the most familiar scene on the ceiling is the **CREATION OF ADAM** (FIG. 20–13), where Michelangelo captures the moment when God charges the languorous Adam with the spark of life. As if to echo the biblical text, Adam's heroic body, outstretched arm, and profile almost mirror those of God, in whose image he has been created. Emerging under God's other arm, and looking across him in the direction of her future mate, is the robust and energetic figure of Eve before her creation. Directly below Adam, an *ignudo* grasps a bundle of oak leaves and giant acorns, which refer to Pope Julius's family name (della Rovere, or "of the oak") and possibly also to a passage in the prophecy of Isaiah (61:3): "They will be called oaks of justice, planted by the Lord to show his glory."

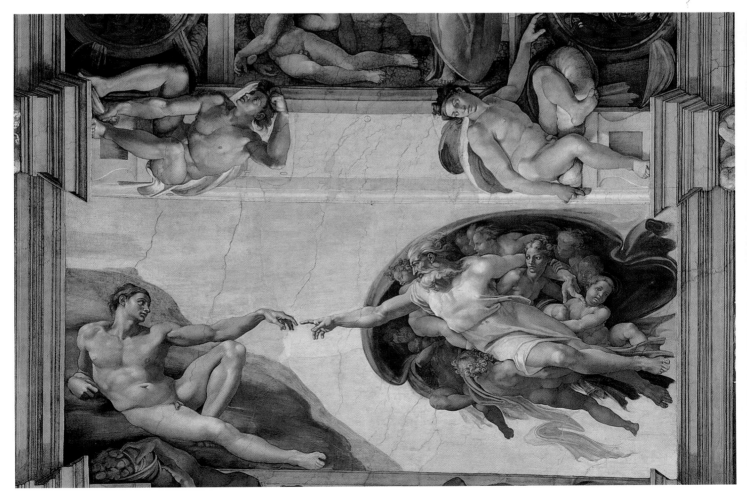

**20-13 •** Michelangelo **CREATION OF ADAM, SISTINE CHAPEL CEILING**
1511–1512. Fresco. 9′2″ × 18′8″ (2.8 × 5.7 m).

# Raphael's Cartoons for Tapestries in the Sistine Chapel

The Sistine Chapel was a major focus of papal patronage during the Renaissance. The building was constructed in 1475–1481 by Sixtus IV, who also began its painted embellishment by calling a constellation of illustrious artists to Rome in the early 1480s to create a band of framed frescos recounting the life of Moses on one wall and the life of Christ on the other (SEE FIG. 19–30). Between 1508 and 1512, Michelangelo painted the chapel's ceiling at the behest of Julius II. And soon after he became pope in 1513, Leo X commissioned Raphael to produce ten cartoons (full-size preparatory designs for a work of art executed in another medium) for a lavish set of tapestries portraying scenes from the lives of SS. Peter and Paul that would complete the decorative program on the chapel's lower level. At the time, these would have been considered its most prestigious and expensive works of art. The tapestry program cost Leo X more than five times what Julius II had paid Michelangelo to paint the ceiling. For designing the program and producing the cartoons, however, Raphael only received a sixteenth of the total cost of the tapestries; the expense here involved production more than design.

The cartoons were created in Raphael's workshop between 1515 and 1516. Raphael was clearly the intellect behind the compositions, and he participated in the actual preparation and execution. This was a prestigious commission that would reflect directly on the reputation of the master. But he could not have accomplished this imposing task in a little over a year without the collaboration of numerous assistants working in his thriving workshop. The completed cartoons—first drawn with charcoal on paper (160–170 separate sheets were glued together to form the expanse of a single tapestry) and then overpainted with color—were sent to Brussels, where they were woven into tapestries in the workshop of Pieter van Aelst. The first was complete in 1517, seven were hanging in the chapel for Christmas 1519, and the entire cycle was installed by Leo X's death in 1521.

The process of creation, from design through production, can be charted by examining the tapestry portraying *Christ's Charge to Peter* (John 21:15–17; Matthew 16:17–19) at three stages in its development. We have Raphael's preliminary drawing (FIG. A), where models—it is tempting to see these as Raphael's assistants, stripped to their drawers to help the master work out his composition—are posed to enact the moment when Jesus addresses his apostles. This is a preliminary idea for the pose of Christ. In the final cartoon (FIG. B), Raphael changes Christ's gesture so that he addresses the kneeling Peter specifically rather than the whole apostolic group; for the patron, this would be an important detail since papal power rested in the belief that Christ had transferred authority to Peter, who was considered the first pope, with subsequent popes inheriting this authority in unbroken succession. Comparison of drawing and cartoon also reveals an important aspect of the design process.

The cartoon reverses the figural arrangement of the drawing because in the production process the tapestry would be woven from the back, and if the weavers followed the reversed version of the composition on the cartoon, the resulting tapestry (FIG. C) would show the scene in its intended orientation. Comparison of cartoon and tapestry also indicates that the weavers were not required to follow their models slavishly. They have embellished the costume of Christ, perhaps in an attempt to assure that the viewers' attention will be immediately directed to this most important figure in the scene.

After they had been used to create the tapestries hung in the Sistine Chapel, Raphael's cartoons remained in Brussels, where several additional sets of tapestries were made from them—one for Henry VIII of England, another for Francis I of France—before seven surviving cartoons were acquired in 1623 by the future Charles I of England. They remain in the British Royal Collection. The tapestries themselves, although still in the Vatican, are displayed in the museum rather than on the walls of the chapel for which they were originally conceived, as one of the most prestigious artistic projects from the peak of the Roman High Renaissance.

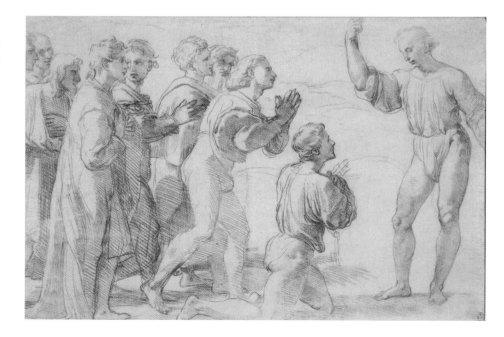

**A. Raphael STUDY FOR CHRIST'S CHARGE TO PETER** c. 1515. Red chalk. Royal Library, Windsor Castle.

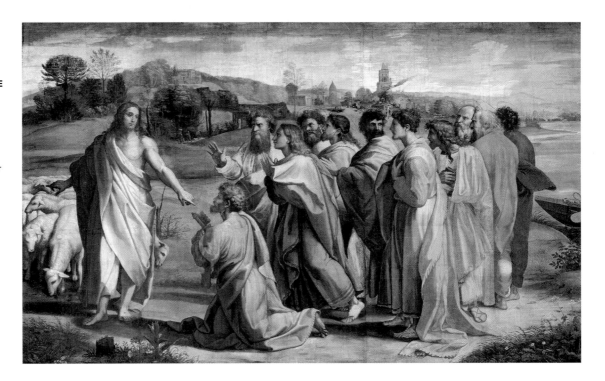

**B.** Raphael
**CARTOON FOR TAPESTRY PORTRAYING CHRIST'S CHARGE TO PETER**
c. 1515–1516. Distemper on paper (now transferred to canvas), 11'1" × 17'4" (3.4 × 5.3 m). Lent by Her Majesty the Queen to the Victoria & Albert Museum, London

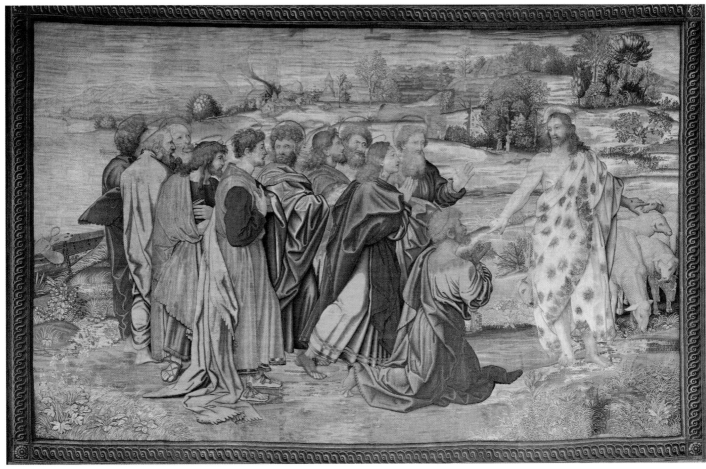

**C.** Shop of Pieter van Aelst, Brussels, after cartoons by Raphael and assistants **CHRIST'S CHARGE TO PETER**
Woven 1517, installed 1519 in the Sistine Chapel. Wool and silk with silver-gilt wrapped threads. Musei Vaticani, Pinacoteca, Rome.

**MICHELANGELO AT SAN LORENZO.** After the Medici regained power in Florence in 1512, and Leo X succeeded Julius in 1513, Michelangelo became chief architect for Medici family projects at the church of San Lorenzo in Florence—including a new chapel for the tombs of Lorenzo the Magnificent, his brother Giuliano, and two younger dukes, also named Lorenzo and Giuliano, ordered in 1519 for the so-called New Sacristy (SEE FIG. 19–4). The older men's tombs were never built to Michelangelo's designs, but the unfinished tombs for the younger relatives were placed on opposite side walls (FIG. 20–14).

Each of the two monuments consists of an idealized portrait of the deceased, who turns to face the family's unfinished ancestral tomb. The men are dressed in a sixteenth-century interpretation of Classical armor and seated in wall niches above pseudo-Classical sarcophagi. Balanced precariously atop the sarcophagi are male and female figures representing the times of day. Their positions would not seem so unsettling had reclining figures of river gods been installed below them, as originally planned, but even so there is a conspicuous tension here between the substantiality of the figures and the limitations imposed on them by their architectural surrounds. In the tomb illustrated here, Michelangelo represents Giuliano as the Active Life, and his sarcophagus figures are allegories of Night and Day. Night at left is accompanied by her symbols: a star and crescent moon on her tiara; poppies, which induce sleep; and an owl under the arch of her leg. The huge mask at her back may allude to Death, since Sleep and Death were said to be the children of Night. Some have seen in this mask that glares out at viewers in the chapel a self-portrait of the artist, serving both as signature and as a way of proclaiming his right to be here because of his long relationship with the family. On the other tomb, Lorenzo, representing the Contemplative Life, is supported by Dawn and Evening.

Concurrent with work on the Medici tombs was the construction of a new library at San Lorenzo. The idea for the library belongs to Cardinal Giulio de' Medici and dates to 1519, but it was only after he was elected Pope Clement VII in 1523 that the money became available to realize it. Michelangelo was commissioned to design and also supervise construction of the new **VESTIBULE** (FIG. 20–15) and reading room and to spare no expense in making them both grand and ambitious. The pope paid keen attention to the library's progress—not, he said, to verify the quality of the design, but because the project had a special interest for him.

**20–14 • Michelangelo TOMB OF GIULIANO DE' MEDICI WITH ALLEGORICAL FIGURES OF NIGHT AND DAY**
New Sacristy (Medici Chapel), church of San Lorenzo, Florence. 1519–1534. Marble, height of seated figure approx. 5′10″ (1.8 m).

Michelangelo coordinated his work within a decorative tradition established at San Lorenzo when Brunelleschi designed the church itself a century earlier (SEE FIG. 19–4), using stylized architectural elements carved in dark gray *pietra serena*, set against and within a contrasting white wall. However, Michelangelo plays with the Classical architectural etiquette that Brunelleschi had used to create such clarity, harmony, and balance in the nave. In Michelangelo's vestibule, chunky columns are recessed into rectangular wall niches that can barely contain them. They are crowded and overlapped by the aggressive lateral extension of the pediment over the door. The door itself is broken into parts, sides jutting forward as fluted pilasters that are then partially obscured by the frame around the opening. The three flights of stairs leading up to the reading room almost fill the vestibule, and the central stairs cascade forward forcefully toward visitors, hardly encouraging them to go against the flow and step up. Through their playfulness, these creative combinations of architectural forms draw attention to themselves and their design rather than the function of the building or the comfortable accommodation of its users.

Fearing for his life when ongoing political struggles flared up in Florence, Michelango returned to Rome in 1534 and settled permanently. He had left both the Medici chapel and the library unfinished. In 1557, he sent a plaster model of the library staircase to Florence to assure that its completion conformed to his design. In 1545, his students had assembled the tomb sculptures, including unfinished figures of the times of day, into the composition we see today.

The figures of the dukes are finely finished, but the times of day are notable for their contrasting areas of rough unfinished and polished marble. These are the only unfinished sculptures Michelangelo apparently permitted to be put in place, and we do not know what his reasons were. Michelangelo specialists, characterizing these works with the word *nonfinito* ("unfinished"), propose that Michelangelo had begun to view his artistic creations as symbols of human imperfection. Indeed, Michelangelo's poetry often expressed his belief that humans could achieve perfection only in death.

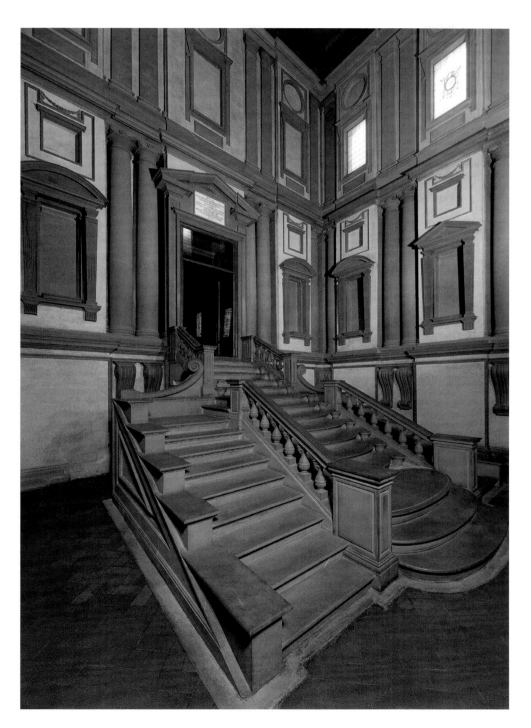

**20–15 • Michelangelo**
**VESTIBULE OF THE**
**LAURENTIAN LIBRARY**
Church of San Lorenzo, Florence. Begun 1524; stairway designed 1550s.

## ARCHITECTURE IN ROME AND THE VATICAN

The election of Julius II as pope in 1503 crystallized a resurgence of papal power, but France, Spain, and the Holy Roman Empire all had designs on Italy. During his ten-year papacy, Julius fought wars and formed alliances to consolidate his power. He also enlisted Bramante, Raphael, and Michelangelo as architects to carry out his vision of a revitalized Rome as the center of a new Christian architecture, inspired by the achievements of their fifteenth-century predecessors as well as the monuments of antiquity. Although most commissions were for churches, opportunities also arose to build urban palaces and country villas.

BRAMANTE. Donato Bramante (1444–1514) was born near Urbino and trained as a painter, but turned to architectural design early in his career. About 1481, he became attached to the Sforza court in Milan, where he would have known Leonardo da Vinci. In 1499, Bramante settled in Rome, but work came slowly. The architect was nearing 60 when Julius II asked him to redesign St. Peter's (see "St. Peter's Basilica," opposite) and the Spanish rulers Queen Isabella and King Ferdinand commissioned a small shrine over the spot in Rome where the apostle Peter was believed to have been crucified (FIG. 20–16). In this tiny building, known as *Il Tempietto* ("Little Temple"), Bramante combined his interpretation of the principles of Vitruvius and Alberti from the stepped base, to the Doric columns and frieze (Vitruvius had advised that the Doric order be used for temples to gods of particularly forceful character), to the elegant balustrade. The centralized plan and the tall drum (circular wall) supporting a hemispheric dome recall Early Christian shrines built over martyrs' relics, as well as ancient Roman circular temples. Especially notable is the sculptural effect of the building's exterior, with its deep wall niches and sharp contrasts of light and shadow. Bramante's design called for a circular cloister around the church, but the cloister was never built.

### ARCHITECTURE, PAINTING, AND SCULPTURE IN NORTHERN ITALY

While Rome was Italy's preeminent arts center at the beginning of the sixteenth century, wealthy and powerful families elsewhere also patronized the arts and letters just as the Montefeltro and Gonzaga had in Urbino and Mantua during the fifteenth century. The architects and painters working for these sixteenth-century patrons created fanciful structures and developed a new colorful, illusionistic painting style. The result was witty, elegant, and finely executed art designed to appeal to the jaded taste of the intellectual elite in cities such as Mantua, Parma, and Venice.

GIULIO ROMANO. In Mantua, Federigo II Gonzaga (r. 1519–1540) continued the family tradition of patronage when, in 1524, he lured a Roman follower of Raphael, Giulio Romano (c. 1499–1546), to Mantua to build him a pleasure palace. Indeed, the Palazzo del

20-16 • Donato Bramante
**IL TEMPIETTO, CHURCH OF SAN PIETRO IN MONTORIO**
Rome. 1502–1510; dome and lantern were restored in the 17th century.

# St. Peter's Basilica

The history of St. Peter's in Rome is an interesting case of the effects of individual and institutional demands on a religious building of major sacred significance. The original church, now referred to as Old St. Peter's, was built in the fourth century by Constantine, the first Christian Roman emperor, to mark the grave of the apostle Peter, the first bishop of Rome and therefore considered the first pope. Because the site was so holy, Constantine's architect had to build a structure large enough to hold the crowds of pilgrims who came to visit St. Peter's tomb. To provide a platform for the church, a huge terrace was cut into the side of the Vatican Hill, across the Tiber River from the city. Here Constantine's architect erected a basilica with a new feature, a transept, to allow large numbers of visitors to approach the shrine at the front of the apse. The rest of the church was, in effect, a covered cemetery, carpeted with the tombs of believers who wanted to be buried near the apostle's grave. When it was built, Constantine's basilica, as befitted an imperial commission, was one of the largest buildings in the Roman world (interior length 368 feet, width 190 feet). For more than a thousand years it was the most important pilgrimage site in Europe.

In 1506, Pope Julius II made the astonishing decision to demolish the Constantinian basilica, which had fallen into disrepair, and to replace it with a new building. That anyone, even a pope, should have had the nerve to pull down such a venerated building is an indication of the extraordinary self-assurance of the Renaissance—and of Julius himself. To design and build the new church, the pope appointed Donato Bramante, who envisioned the new St. Peter's as a central-plan building, in this case a Greek cross (with four arms of equal length) crowned by an enormous dome. This design was intended to emulate the Early Christian tradition of constructing domed and round buildings over the tombs of martyrs (SEE FIG. 7–20), itself derived from the Roman practice of building centrally planned tombs (see "Central-Plan Churches," page 228). In Renaissance thinking, the central plan and dome symbolized the perfection of God.

The deaths of pope and architect in 1513–1514 put a temporary halt to the project. Successive plans by Raphael, Antonio da Sangallo, and others changed the Greek cross into a Latin cross (with three shorter arms and one long one) to provide the church with an extended nave. However, when Michelangelo was appointed architect in 1546, he returned to the Greek-cross plan and simplified Bramante's design to create a single, unified space covered with a hemispherical dome. The dome was finally completed some years after Michelangelo's death by Giacomo della Porta, who retained Michelangelo's basic design but gave the dome a taller profile (SEE FIG. 20–35).

During the Counter-Reformation, the Catholic Church emphasized congregational worship; as a result, more space was needed to house the congregation and allow for processions. To expand the church—and to make it more closely resemble Old St. Peter's—Pope Paul V in 1606 commissioned the architect Carlo Maderno to change Michelangelo's Greek-cross plan back once again into a Latin-cross plan. Maderno extended the nave to its final length of slightly more than 636 feet and added a new façade, thus completing St. Peter's as we see it is today. Later in the seventeenth century, the sculptor and architect Gianlorenzo Bernini changed the approach to the basilica by surrounding it with a great colonnade, like a huge set of arms extended to embrace the faithful as they approach the principal church of Western Christendom.

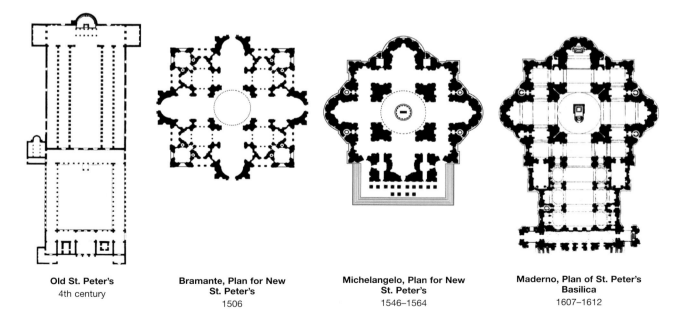

**Old St. Peter's**
4th century

**Bramante, Plan for New St. Peter's**
1506

**Michelangelo, Plan for New St. Peter's**
1546–1564

**Maderno, Plan of St. Peter's Basilica**
1607–1612

SEE MORE: View a simulation about plans for St. Peter's Basilica www.myartslab.com

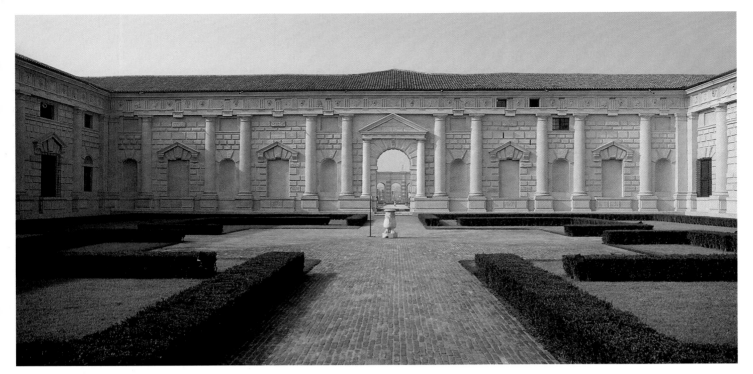

**20–17 • Giulio Romano COURTYARD FAÇADE, PALAZZO DEL TÈ, MANTUA**
1527–1534.

SEE MORE: Click the Google Earth link for the Palazzo del Tè www.myartslab.com

Tè **(FIG. 20–17)** devoted more space to gardens, pools, and stables than to rooms for residential living. Since Federigo and his erudite friends would have known Classical orders and proportions, they could appreciate the playfulness with which they are used here. The building is full of visual jokes, such as lintels masquerading as arches and triglyphs that slip sloppily out of place. Like the similar, if more sober, subversions of Classical architectural decorum in Michelangelo's contemporary Laurentian Library (SEE FIG. 20–15), its sophisticated humor and exquisite craft have been seen as a precursor to Mannerism or as a manifestation of Mannerism itself.

Giulio Romano continued his witty play in the decoration of the two principal rooms. One, dedicated to the loves of the gods, depicted the marriage of Cupid and Psyche. The other room is a remarkable feat of *trompe-l'oeil* painting in which the entire building seems to be collapsing about the viewer as the gods defeat the giants **(FIG. 20–18)**. Here, Giulio Romano accepted the challenge Andrea Mantegna had laid down in the Camera Picta of the Gonzaga Palace (SEE FIG. 19–29), painted for Federigo's grandfather: to dissolve architectural barriers and fantasize a world of playful delight beyond the walls and ceilings. But the Palazzo del Tè was not just fun and games. The unifying

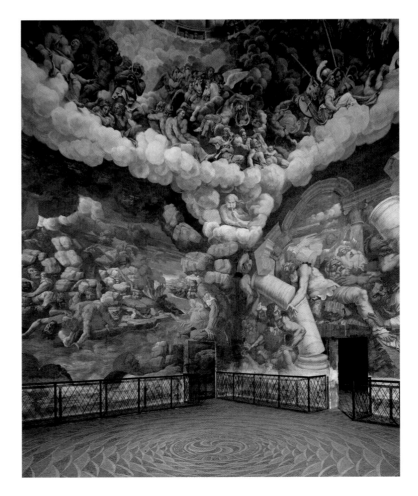

**20–18 • Giulio Romano FALL OF THE GIANTS**
Sala dei Giganti, Palazzo del Tè. 1530–1532. Fresco.

themes were love and politics, the former focused on the separate apartments built to house Federigo's mistress, Isabella Boschetti. The palace was constructed in part as a place where they could meet beyond the watchful gaze of her husband. But the decoration also seems to reflect Federigo's dicey alliance with Charles V, who stayed in the palace in 1530 and again in 1532, when the scaffolding was removed from the Sala dei Giganti so the emperor could see the paintings in progress. He must have been impressed with his host's lavish new residence, and doubtless he saw a connection between these reeling paintings and his own military successes.

CORREGGIO. At about the same time that Giulio Romano was building and decorating the Palazzo del Tè, in nearby Parma an equally skillful master, Correggio (Antonio Allegri da Correggio, c. 1489–1534), was creating similarly theatrical effects with dramatic foreshortening in Parma Cathedral. Correggio's great work, the ASSUMPTION OF THE VIRGIN (FIG. 20–19), a fresco painted between about 1526 and 1530 in the cathedral's dome, distantly recalls the illusionism of Mantegna's ceiling in the Gonzaga Palace, but Correggio has also assimilated Leonardo da Vinci's use of *sfumato* and Raphael's idealism into his personal style. Correggio's

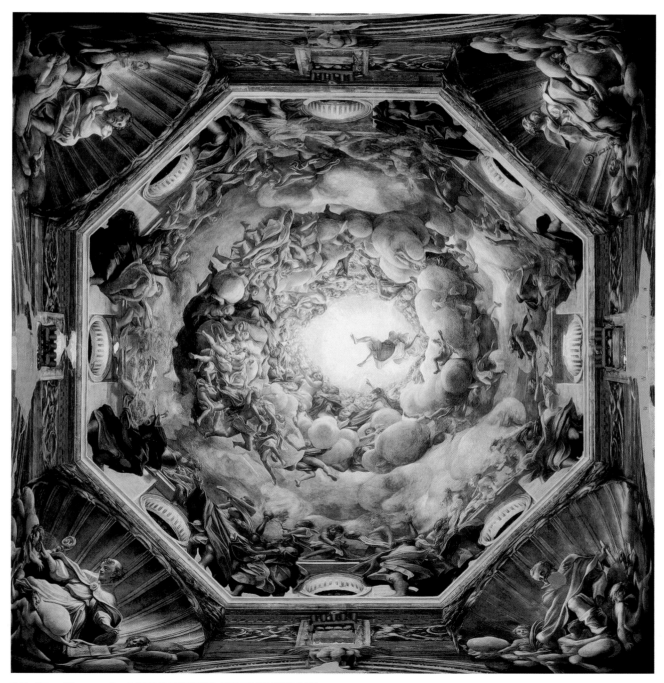

**20–19 • Correggio ASSUMPTION OF THE VIRGIN**
Main dome, interior, Parma Cathedral, Italy. c. 1526–1530. Fresco, diameter of base of dome approx. 36′ (11 m).

## VENICE AND THE VENETO

In the sixteenth century the Venetians did not see themselves as rivals of Florence and Rome, but rather as their superiors. Their city was the greatest commercial sea power in the Mediterranean; they had challenged Byzantium and now they confronted the Muslim Turks. Favored by their unique geographical situation—protected by water and controlling sea routes in the Adriatic Sea and the eastern Mediterranean—the Venetians became wealthy and secure patrons of the arts. Their Byzantine heritage, preserved by their conservative tendencies, encouraged an art of rich patterned surfaces emphasizing light and color.

The idealized style and oil-painting technique initiated by the Bellini family in the late fifteenth century (see Chapter 19) were developed further by sixteenth-century Venetian painters. Venetians were the first in Italy to use oils for painting on both wood panel and canvas. Possibly because they were a seafaring people accustomed to working with large sheets of canvas, and possibly because humidity made their walls crack and mildew, the Venetians were also the first to cover walls with large canvas paintings instead of frescos. Because oils dried slowly, errors could be corrected and changes made easily during the work. The flexibility of the canvas support, coupled with the radiance and depth of oil-suspended pigments, eventually made oil on canvas the preferred medium, especially since it was particularly well suited to the rich color and lighting effects favored by Giorgione and Titian, two of the city's major painters of the sixteenth century.

*Assumption* is a dazzling illusion—the architecture of the dome seems to dissolve and the forms seem to explode through the building, drawing viewers into the swirling vortex of saints and angels who rush upward amid billowing clouds to accompany the Virgin as she soars into heaven. Correggio's sensual rendering of the figures' flesh and clinging draperies contrasts with the spirituality of the theme (the miraculous transporting of the Virgin to heaven at the moment of her death). The viewer's strongest impression is of a powerful, upward-spiraling motion of alternating cool clouds and warm, alluring figures.

PROPERZIA DE' ROSSI. Very few women had the opportunity or inclination to become sculptors. Properzia de' Rossi (c. 1490–1529/30), who lived in Bologna, was an exception. She mastered many arts, including engraving, and was famous for her miniature sculptures, including an entire *Last Supper* carved on a peach pit! She carved several pieces in marble—two sibyls, two angels, and this relief of **JOSEPH AND POTIPHAR'S WIFE**—for the Cathedral of San Petronio in Bologna (FIG. 20–20). Vasari wrote that a rival male sculptor prevented her from being paid fairly and from securing additional commissions. This particular relief, according to Vasari, was inspired by her own love for a young man, which she got over by carving this panel. Joseph escapes, running, as the partially clad seductress snatches at his cloak. Properzia is the only woman Vasari included in the 1550 edition of *Lives of the Artists*.

GIORGIONE. The career of Giorgione (Giorgio da Castelfranco, c. 1475–1510) was brief—he died from the plague—and most scholars accept only four or five paintings as entirely by his hand. But his importance to Venetian painting is critical. He introduced new, enigmatic pastoral themes, known as *poesie* (or "painted poems"), that were inspired by the contemporary literary revival of ancient pastoral verse. He is significant for his sensuous nude figures, and, above all, for his appreciation of nature in his landscape painting. His early life and training are undocumented, but his work suggests that he studied with Giovanni Bellini. Perhaps Leonardo da Vinci's subtle lighting system and mysterious, intensely observed landscapes also inspired him.

Giorgione's most famous work, called today **THE TEMPEST** (FIG. 20–21), was painted shortly before his death, potentially in

response to personal, private impulses—as with many modern artists—rather than to fulfill an external commission. Simply trying to understand what is happening in the picture piques our interest. At the right, a woman is seated on the ground, nude except for the end of a long white cloth thrown over her shoulders. Her nudity seems maternal rather than erotic as she nurses the baby at her side. Across the dark, rock-edged spring stands a man wearing the uniform of a German mercenary soldier. His head is turned in the direction of the woman, but he only appears to have paused for a moment before continuing to turn toward the viewer. X-rays of the painting show that Giorgione altered his composition while he was still at work on it—the soldier replaces a second woman. Inexplicably, a spring gushes forth between the figures to feed a lake surrounded by substantial houses, and in the far distance a bolt of lightning splits the darkening sky. Indeed, the artist's attention seems more focused on the landscape and the unruly elements of nature than on the figures.

**TITIAN.** In 1507, Giorgione took on a new assistant, Tiziano Vecellio, better known today as Titian (c. 1488–1576). For the next

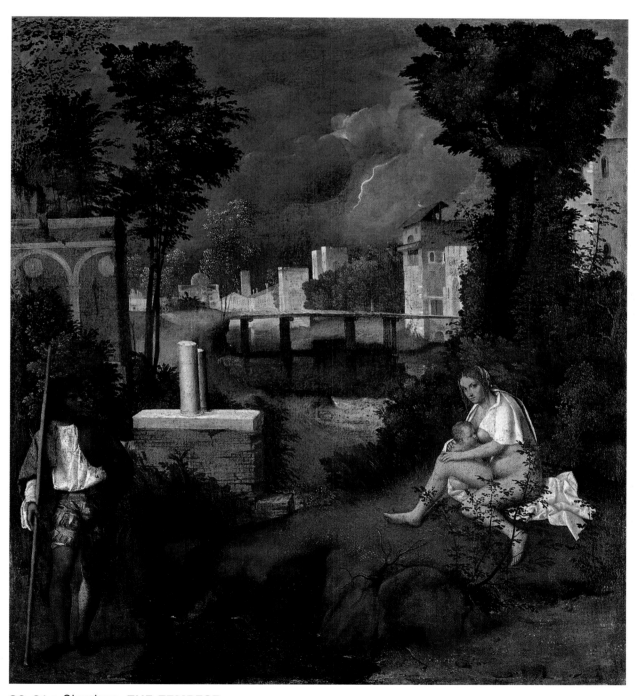

**20–21 • Giorgione THE TEMPEST**
c. 1506. Oil on canvas, 32 × 28¾" (82 × 73 cm). Galleria dell'Accademia, Venice.

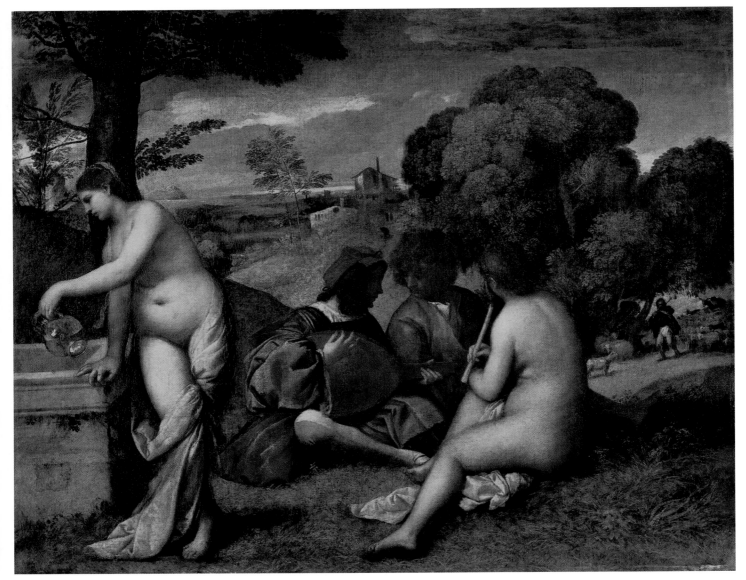

**20-22 • Titian THE PASTORAL CONCERT OR ALLEGORY ON THE INVENTION OF PASTORAL POETRY**
c. 1510. Oil on canvas, 41¼ × 54¾″ (105 × 136.5 cm). Musée du Louvre, Paris.

three years, before Giorgione's untimely death, the two artists' careers were closely bound together. The painting known as **THE PASTORAL CONCERT (FIG. 20–22)** has been attributed to both of them, although today scholarly opinion favors Titian. As in Giorgione's *The Tempest*, the idyllic, fertile landscape, here bathed in golden, hazy late-afternoon sunlight, seems to be one of the main subjects of the painting. In this mythic world, two men—an aristocratic musician in rich red silks and a barefoot, singing peasant in homespun cloth—turn toward each other, seemingly unaware of the two naked women in front of them. One woman plays a pipe and the other pours water into a well; their swaths of white drapery sliding to the ground enhance rather than hide their nudity. Are they the musicians' muses? Behind the figures the sunlight illuminates another shepherd and his animals near lush woodland. The painting evokes a golden age of love and innocence recalled in

ancient Roman pastoral poetry. In fact, the painting is now interpreted as an allegory on the invention of poetry. Titian displays here his renowned talent for painting sensuous female nudes whose bodies seem to glow with an incandescent light, inspired by flesh and blood beauty as much as any source from poetry or art.

Titian's early life is obscure. He supposedly began an apprenticeship as a mosaicist, then studied painting under Gentile and Giovanni Bellini. He was about 20 when he began work with Giorgione, and whatever Titian's early work had been, he had completely absorbed Giorgione's style by the time Giorgione died two years later. Titian completed paintings that they had worked on together, and when Giovanni Bellini died in 1516, Titian became the official painter to the republic of Venice.

In 1519, Jacopo Pesaro, commander of the papal fleet that had defeated the Turks in 1502, commissioned Titian to commemorate

the victory in a votive altarpiece for a side-aisle chapel in the Franciscan church of Santa Maria Gloriosa dei Frari in Venice. Titian worked on the painting for seven years and changed the concept three times before he finally came up with a revolutionary composition—one that complemented the viewer's approach from the left. He created an asymmetrical setting of huge columns on high bases soaring right out of the frame (FIG. 20–23). Into this architectural setting, he placed the Virgin and Child on a high throne at one side and arranged saints and the Pesaro family below on a diagonal axis, crossing at the central figure of St. Peter (a reminder of Jacopo's role as head of the papal forces in 1502). The red of Francesco Pesaro's brocade garment and of the banner diagonally across sets up a contrast of primary colors against St. Peter's blue tunic and yellow mantle and the red and blue draperies of the Virgin. St. Maurice (behind the kneeling Jacopo at the left) holds the banner with the papal arms, and a cowering

**20-23** • Titian
**PESARO MADONNA**
1519–1526. Oil on canvas,
16′ × 8′10″ (4.9 × 2.7 m).
Side-aisle altarpiece, Santa Maria
Gloriosa dei Frari, Venice.

## Women Patrons of the Arts

In the sixteenth century, many wealthy women, from both the aristocracy and the merchant class, were enthusiastic patrons of the arts. The Habsburg princesses Margaret of Austria and Mary of Hungary presided over brilliant humanist courts. The marchesa of Mantua, Isabella d'Este (1474–1539), became a patron of painters, musicians, composers, writers, and literary scholars. Married to Francesco II Gonzaga at age 15, she had great beauty, great wealth, and a brilliant mind that made her a successful diplomat and administrator. A true Renaissance woman, her motto was the epitome of rational thinking—"Neither through Hope nor Fear." An avid collector of manuscripts and books, she sponsored the publication of an edition of Virgil while still in her twenties. She also collected ancient art and objects, as well as works by contemporary Italian artists such as Mantegna, Leonardo, Perugino, Correggio, and Titian. Her study in her Mantuan palace was a veritable museum. The walls above the storage and display cabinets were painted in fresco by Mantegna, and the carved wood ceiling was covered with mottoes and visual references to Isabella's impressive literary interests.

Titian **ISABELLA D'ESTE**
1534–1536. Oil on canvas, 40⅛ × 25³⁄₁₆″ (102 × 64.1 cm).
Kunsthistorisches Museum, Vienna.

Turkish captive reminds the viewer of the Christian victory. The arresting image of the youth who turns to meet our gaze at lower right guarantees our engagement, and light floods in from above, illuminating not only this and other faces, but also the great columns, where *putti* in the clouds carry a cross. Titian was famous for his mastery of light and color even in his own day, but this altarpiece demonstrates that he also could draw and model as solidly as any Florentine. The perfectly balanced composition, built on diagonals instead of a vertical and horizontal grid, looks forward to the art of the seventeenth century.

In 1529, Titian, who was well known outside Venice, began a long professional relationship with Emperor Charles V, who vowed to let no one else paint his portrait and ennobled Titian in 1533. The next year Titian was commissioned to paint a portrait of Isabella d'Este (see "Women Patrons of the Arts," above). Isabella was past 60 when Titian portrayed her in 1534–1536, but she asked to appear as she had in her twenties. Titian was able to satisfy her wish by referring to an early portrait by another artist, but he also conveyed the mature Isabella's strength, self-confidence, and energy.

No photograph can convey the vibrancy of Titian's paint surfaces, which he built up in layers of pure colors, chiefly red, white, yellow, and black. A recent scientific study of Titian's paintings revealed that he ground his pigments much finer than had earlier wood-panel painters. The complicated process by which he produced many of his works began with a charcoal drawing on the prime coat of lead white that was used to seal the pores and smooth the surface of the rather coarse Venetian canvas. The artist then built up the forms with fine glazes of different colors, sometimes in as many as 10 to 15 layers. Titian and others had the advantage of working in Venice, the first place to have professional retail "color sellers." These merchants produced a wide range of specially prepared pigments, even mixing their oil paints with ground glass to increase their glowing transparency. Not until the second half of the sixteenth century did color sellers open their shops in other cities.

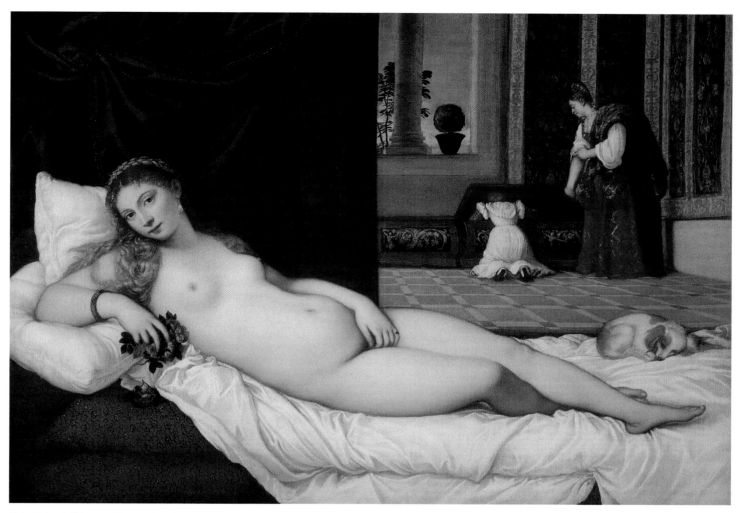

**20-24 • Titian "VENUS" OF URBINO**
c. 1538. Oil on canvas, 3'11" × 5'5" (1.19 × 1.65 m). Galleria degli Uffizi, Florence.

Paintings of nude reclining women became especially popular in sophisticated court circles, where male patrons could enjoy and appreciate the "Venuses" under the cloak of respectable Classical mythology. Seemingly typical of such paintings is the **"VENUS"** Titian delivered to Guidobaldo della Rovere, duke of Urbino, in spring 1538 **(FIG. 20–24)**. Here, we seem to see a beautiful Venetian courtesan, with deliberately provocative gestures, stretching languidly on her couch in a spacious palace, her glowing flesh and golden hair set off by white sheets and pillows. But for its original audience, art historian Rona Goffen has argued, the painting was more about marriage than mythology or seductiveness. The multiple matrimonial references in this work include the pair of *cassoni* (see "The Morelli–Nerli Wedding Chests," page 616) where servants are removing or storing the woman's clothing in the background, the bridal symbolism of the myrtle and roses she holds in her hand, and even the spaniel snoozing at her feet—a traditional symbol of fidelity and domesticity, especially when sleeping so peacefully. Titian's picture might be associated with Duke Guidobaldo's marriage in 1534 to the 10-year-old Giulia Verano. Four years later, when this painting arrived, she would have been considered an adult rather than a child bride. It seems to represent not a Roman goddess nor a Venetian courtesan, but a physically and emotionally mature bride welcoming her husband into their lavish bedroom.

In his late work from a very lengthy career, Titian sought the essence of form and idea, not the surface perfection of his youthful paintings, in part because he was beset by failing eyesight and a trembling hand. Like Michelangelo, Titian outlived the Classical phase of the Renaissance and his late style profoundly influenced Italian art of the later years of the sixteenth century.

## MANNERISM

A new style developed in Florence and Rome in the 1520s that art historians have associated with the death of Raphael and labeled "Mannerism," a word deriving from the Italian *maniera* (meaning "style"). Mannerism was an anti-Classical movement in which artificiality, grace, and elegance took priority over the ordered balance and lifelike references that were hallmarks of High Renaissance art. Patrons favored esoteric subjects, displays of extraordinary technical virtuosity, and the pursuit of beauty for its

own sake. Painters and sculptors quoted from ancient and modern works of art in the same self-conscious manner that contemporary poets and authors were quoting from ancient and modern literary classics. Architects working in the Mannerist style designed buildings that defied uniformity and balance and used Classical orders in unconventional ways.

## PAINTING

Painters working in the Mannerist style fearlessly manipulated and distorted accepted formal conventions, creating contrived compositions and irrational spatial environments. Figures take on elongated proportions, complicated artificial poses, enigmatic gestures, and dreamy expressions. The pictures are full of quoted references to the works of illustrious predecessors.

**PONTORMO.** The frescos and altarpieces painted between 1525 and 1528 by Jacopo da Pontormo (1494–1557) for the 100-year-old **CAPPONI CHAPEL** in the church of Santa Felicità in Florence **(FIG. 20–25)** bear the hallmarks of early Mannerist painting. Open on two sides, Brunelleschi's chapel forms an interior loggia in which frescos on the right-hand wall depict the Annunciation and **tondi** (circular paintings) under the cupola represent the four evangelists. In the *Annunciation* the Virgin accepts the angel's message but also seems moved by the adjacent vision of her future sorrow, as she sees her son's body lowered from the cross in the **ENTOMBMENT**, portrayed in the altarpiece on the adjoining wall **(FIG. 20–26)**.

Pontormo's ambiguous composition in the *Entombment* enhances the visionary quality of the altarpiece. Shadowy ground

**20-25 • CAPPONI CHAPEL, CHURCH OF SANTA FELICITÀ, FLORENCE**
Chapel by Filippo Brunelleschi for the Barbadori family, 1419–1423; acquired by the Capponi family, who ordered paintings by Pontormo, 1525–1528.

**20-26 • Pontormo ENTOMBMENT**
Altarpiece in Capponi Chapel, church of Santa Felicità, Florence. 1525–1528. Oil and tempera on wood
panel, 10′3″ × 6′4″ (3.1 × 1.9 m).

and cloudy sky give no sense of a specific location, and little sense of grounding for the figures. Some press forward into the viewer's space, while others seem to levitate or stand precariously on tiptoe. Pontormo chose a moment just after Jesus' removal from the cross, when the youths who have lowered him pause to regain their hold on the corpse, which recalls Michelangelo's Vatican *Pietà* (SEE FIG. 20–9). Odd poses and drastic shifts in scale charge the scene emotionally, but perhaps most striking is the use of weird colors in odd juxtapositions—baby blue and pink with accents of olive-green, yellow, and scarlet. The overall tone of the picture is set by the unstable youth crouching in the foreground, whose skintight bright pink shirt is shaded in iridescent, pale gray-green, and whose anxious expression is projected out of the painting, directly at the viewer.

PARMIGIANINO. When Parmigianino (Francesco Mazzola, 1503–1540) left his native Parma in 1524 for Rome, the strongest influence on his work was Correggio. In Rome, however, Parmigianino met

**20-28 • Bronzino PORTRAIT OF A YOUNG MAN**
c. 1540–1545. Oil on wood panel, 37½ × 29½″ (95.5 × 74.9 cm). Metropolitan Museum of Art, New York. The H. O. Havemayer Collection 29.100.16

Giulio Romano; he also studied the work of Raphael and Michelangelo. What he assimilated developed into a distinctive Mannerist style, calm but strangely unsettling. After the Sack of Rome in 1527, he moved to Bologna and then back to Parma.

Left unfinished at the time of his early death is a disconcerting painting known as the **MADONNA WITH THE LONG NECK (FIG. 20–27)**. The unnaturally proportioned figure of Mary, whose massive legs and lower torso contrast with her narrow shoulders and long neck and fingers, is presumably seated on a throne, but there is no seat in sight. The languid expanse of the sleeping child recalls the pose of the ashen Christ in a *pietà*. The plunge into a deep background to the right reveals a startlingly small St. Jerome, who unrolls a scroll in front of huge white columns that support absolutely nothing, whereas at the left a crowded mass of blushing boys blocks any view into the background. Like Pontormo, Parmigianino presents a well-known image in a challenging manner calculated to unsettle viewers.

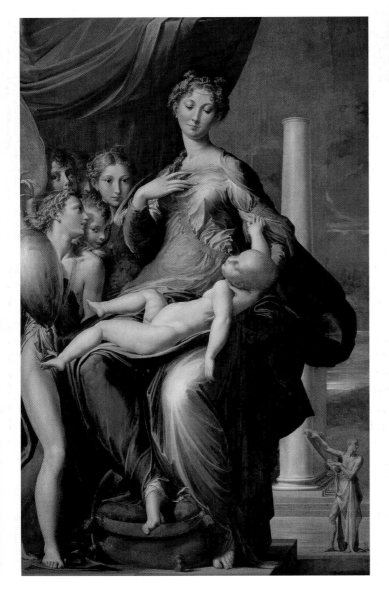

**20-27 • Parmigianino MADONNA WITH THE LONG NECK**
1534–1540. Oil on wood panel, 7′1″ × 4′4″ (2.16 × 1.32 m). Galleria degli Uffizi, Florence.

**BRONZINO.** About 1522, Agnolo di Cosimo (1503–1572), whose nickname of "Bronzino" means "copper-colored" (just as we might call someone "Red"), became Pontormo's assistant, probably helping with the tondi in the corners of the Capponi Chapel (SEE FIG. 20–25). In 1530, he established his own workshop, though he continued to work with Pontormo on occasional large projects. In 1540, Bronzino became court painter to the Medici. Although he was a versatile artist who produced altarpieces, fresco decorations, and tapestry designs over his long career, he is best known today for his elegant portraits. Bronzino's virtuosity in rendering costumes and settings creates a rather cold and formal effect, but the self-contained demeanor of his subjects admirably conveys their haughtiness. **PORTRAIT OF A YOUNG MAN (FIG. 20–28)** demonstrates Bronzino's characteristic portrayal of his subjects as intelligent, aloof, elegant, and self-assured. The youth's spidery fingers toy with a book, suggesting his scholarly interests, but his wall-eyed stare creates a slightly unsettling, artificial effect, associating his face with the carved masks on the furniture. His costume seems more present than his personality.

Bronzino's **ALLEGORY WITH VENUS AND CUPID** is one of the strangest paintings of the sixteenth century **(FIG. 20–29)**. It contains all the formal, iconographical, and psychological characteristics of Mannerist art and could almost stand alone as a summary of the movement. Seven figures, two masks, and a dove interweave in an intricate, claustrophobic formal composition pressed breathlessly into the foreground plane. Taken as individual images, they display the exaggerated poses, graceful forms, polished surfaces, and delicate colors that characterize Mannerist art. But a closer look into this composition uncovers disturbing erotic attachments and bizarre irregularities. The painting's complex allegory and relentless ambiguity probably delighted mid-sixteenth-century courtiers who enjoyed equally sophisticated wordplay and esoteric Classical references, but for us it defies easy explanation. Nothing is quite what it seems.

Venus and her son Cupid engage in an unsettlingly lascivious dalliance, encouraged by a *putto* sauntering in from the right—representing Folly, Jest, or Playfulness—who is about to throw pink roses at them while stepping on a thorny branch that draws blood from his foot. Cupid gently kisses his mother and pinches her erect nipple while Venus snatches an arrow from his quiver, leading some scholars to suggest that the painting's title should be *Venus Disarming Cupid*. Venus holds the golden apple of discord given to her by Paris; her dove conforms to the shape of Cupid's foot without actually touching it, while a pair of masks lying at her feet reiterates the theme of duplicity. An old man, Time or Chronos, assisted by an outraged Truth or Night, pulls back a curtain to expose the couple. Lurking just behind Venus a monstrous serpent—which has the upper body and head of a beautiful young girl and the legs and claws of a lion—crosses her hands to hold a honeycomb and the stinger at the end of her tail. This strange hybrid has been identified both as Fraud and Pleasure.

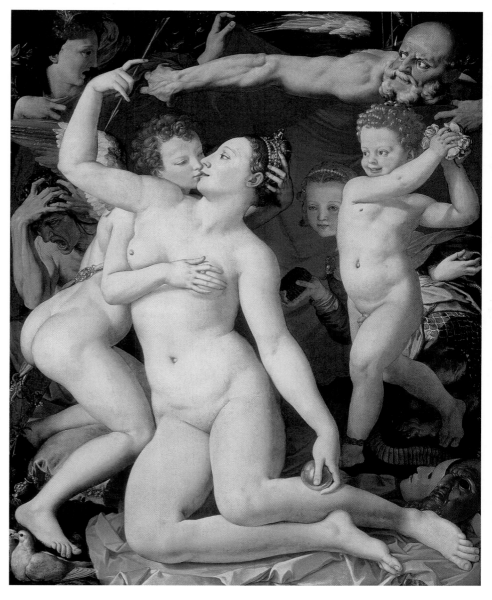

**20-29 • Bronzino ALLEGORY WITH VENUS AND CUPID**
Mid 1540s. Oil on panel, 57½ × 46″ (1.46 × 1.16 m). National Gallery, London.
Reproduced by courtesy of the Trustees of the National Gallery, London

In the shadows to the left, a pale and screaming man tearing at his hair has recently been identified as a victim of syphilis, which raged as an epidemic during this period. This interpretation suggests that the painting could be a warning of the dangers of this disease, believed in the sixteenth century to be spread principally by coitus, kissing, and breast feeding, all of which are alluded to in the intertwined Cupid and Venus. But the complexity of the painting makes room for multiple meanings, and deciphering them would be typical of the sorts of games enjoyed by sixteenth-century intellectuals. Perhaps the allegory tells of the impossibility of constant love and the folly of lovers, which becomes apparent across time. Or perhaps it is an allegorical warning of the dangers of illicit sexual liaisons, including the pain, hair loss, and disfiguration of venereal disease. Maybe it is both, and even more. Duke Cosimo ordered the painting himself, and presented it as a diplomatic gift to King Francis I of France, who would doubtless have relished its overt eroticism and flawless execution.

SOFONISBA ANGUISSOLA.   Northern Italy, more than any other part of the peninsula, produced a number of gifted women artists. In the latter half of the sixteenth century, Bologna, for example, boasted some two dozen women painters and sculptors, as well as a number of learned women who lectured at the university. Sofonisba Anguissola (c. 1532–1625), born into a noble family in Cremona (between Bologna and Milan), was unusual in that she was not the daughter of an artist. Her father gave all his children a humanistic education and encouraged them to pursue careers in literature, music, and especially painting. He consulted Michelangelo about Sofonisba's artistic talents in 1557, asking for a drawing that she might copy and return to be critiqued. Michelangelo evidently obliged because Sofonisba Anguissola's father wrote an enthusiastic letter of thanks.

Anguissola was a gifted portrait painter who also created miniatures, an important aspect of portraiture in the sixteenth century, when people had few means of recording the features of a lover, friend, or family member. Anguissola painted a miniature **SELF-PORTRAIT** holding a medallion, the border of which spells out her name and home town, Cremona **(FIG. 20–30)**. The interlaced letters at the center of the medallion pose a riddle; they seem to form a monogram with the first letters of her sisters' names: Minerva, Europa, Elena. Such names are further evidence of the Anguissola family's enthusiasm for the Classics.

In 1560, Anguissola accepted the invitation of the queen of Spain to become a lady-in-waiting and court painter, a post she held for 20 years. Unfortunately, most of her Spanish works were lost in a seventeenth-century palace fire, but a 1582 Spanish inventory described her as "an excellent painter of portraits above all the painters of this time"—extraordinary praise in a court that patronized Titian. After her years at court, she returned to Sicily (a Spanish territory), where she died at age 92. Anthony Van Dyck met her in Palermo in 1624, where he sketched her and claimed that she was then 96 years old. He wrote that she

**20-30** • Sofonisba Anguissola **SELF-PORTRAIT**
c. 1552. Oil on parchment on cardboard, 2½ × 3¼″ (6.4 × 8.3 cm). Museum of Fine Arts, Boston. Emma F. Munroe Fund 60.155

advised him on positioning the light for her portrait, asking that it not be placed too high because the strong shadows would bring out her wrinkles.

LAVINIA   FONTANA.   Bolognese artist Lavinia Fontana (1552–1614) learned to paint from her father. By the 1570s, her success was so well rewarded that her husband, the painter Gian Paolo Zappi, gave up his own painting career to care for their large family and help his wife with the technical aspects of her work, such as framing. In 1603, Fontana moved to Rome as an official painter to the papal court. She also soon came to the attention of the Habsburgs, who became major patrons.

While still in her twenties, Fontana painted a **NOLI ME TANGERE (FIG. 20–31)**, where Christ reveals himself for the first time to Mary Magdalen following his Resurrection, warning her not to touch him (John 20:17). Christ's broad-brimmed hat and spade refer to the passage in the Gospel of John that tells us that Mary Magdalen at first thought Christ was the gardener. In the middle distance Fontana portrays a second version of the Resurrection, where women followers of Christ discover an angel in his empty tomb. This secondary scene's dizzying diagonal plunge into depth is a typical feature of late Mannerist painting in Italy.

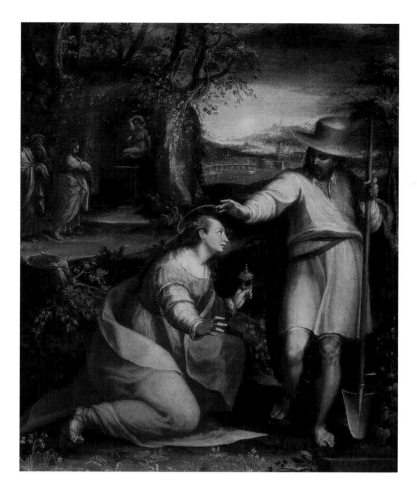

**20-31 • Lavinia Fontana NOLI ME TANGERE**
1581. Oil on canvas, 47⅜ × 36⅝" (120.3 × 93 cm).
Galleria degli Uffizi, Florence.

## SCULPTURE

Mannerist sculpture—often small in size and made from precious metals—stylizes body forms and foregrounds displays of technical skill in ways that are reminiscent of Mannerist painting.

CELLINI. The Florentine goldsmith and sculptor Benvenuto Cellini (1500–1571), who wrote a dramatic—and scandalous—autobiography and a practical handbook for artists, worked in the French court at Fontainebleau. There he made the famous **SALTCELLAR OF KING FRANCIS I (FIG. 20–32)**, a table accessory transformed into an elegant sculptural ornament by fanciful imagery and superb execution. In gold and enamel, the Roman sea god Neptune, representing the source of salt, sits next to a tiny boat-shape container that carries the seasoning, while a personification of Earth guards the plant-derived pepper, contained in the triumphal arch to her right. Representations of the seasons and the times of day on the base refer to both daily meal schedules and festive seasonal celebrations. The two main figures lean away from each other at impossible angles yet are connected and visually balanced by glance, gestures, and coordinated poses—they mirror each other with one bent and one straight leg. Their supple, elongated bodies and small heads reflect the Mannerist conventions of artists like Parmigianino. Cellini wrote, "I represented the Sea and the Land, both seated, with their legs intertwined just as some branches of the sea run into the land and the land juts into the sea…" (Cellini, *Autobiography*, trans G. Bull, p. 291).

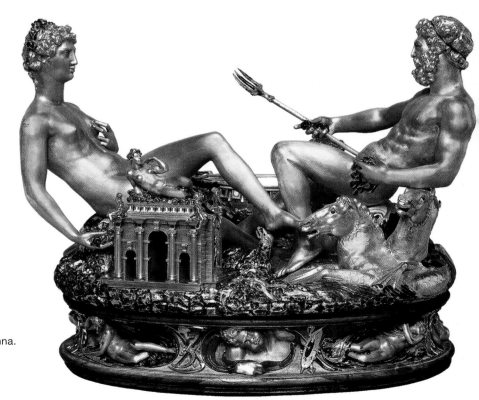

**20-32 • Benvenuto Cellini SALTCELLAR
OF KING FRANCIS I OF FRANCE**
1540–1543. Gold and enamel, 10½ × 13⅛"
(26.67 × 33.34 cm). Kunsthistorisches Museum, Vienna.

**EXPLORE MORE:** Gain insight from a
primary source about Benvenuto Cellini
**www.myartslab.com**

**GIAMBOLOGNA.** In the second half of the sixteenth century, probably the most influential sculptor in Italy was Jean de Boulogne, better known by his Italian name, Giovanni da Bologna or Giambologna (1529–1608). Born in Flanders, he had settled by 1557 in Florence, where both the Medici family and the sizable Netherlandish community were his patrons. He not only influenced a later generation of Italian sculptors, he also spread the Mannerist style to the north through artists who came to study his work. Although inspired by Michelangelo, Giovanni favored graceful forms and poses, as in his gilded-bronze **ASTRONOMY, OR VENUS URANIA** (FIG. 20–33) of about 1573. The figure's identity is suggested by the astronomical device on the base of the plinth. Although she is based on a Classical prototype, Giambologna has twisted Venus' upper torso and arms to one side

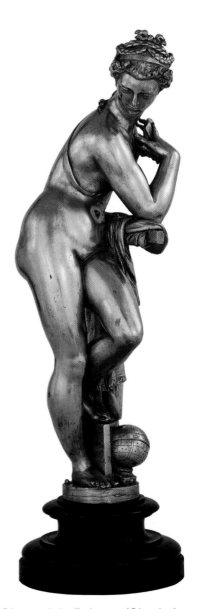

**20-33** • Giovanni da Bologna (Giambologna) **ASTRONOMY, OR VENUS URANIA**
c. 1573. Bronze gilt, height 15¼″ (38.8 cm). Kunsthistorisches Museum, Vienna.

and bent her neck back in the opposite direction so that her chin is over her right shoulder, straining the torsion of the human body to its limits. Consequently, viewers are encouraged to walk around this figure to explore it fully; it cannot be understood from any single viewpoint. The elaborate coiffure and the detailed engraving of drapery texture contrast strikingly with the smooth, gleaming flesh of Venus' body. Following standard practice for cast-metal sculpture, Giambologna replicated this statuette several times for different patrons.

# ART AND THE COUNTER-REFORMATION

Pope Clement VII, whose miscalculations had spurred Emperor Charles V to attack and destroy Rome in 1527, also misjudged the threat to the Church and to papal authority posed by the Protestant Reformation. His failure to address the issues raised by the reformers enabled the movement to spread. His successor, Paul III (pontificate 1534–1549), the rich and worldly Roman noble Alessandro Farnese, was the first pope to pursue church reform in response to the rise of Protestantism. In 1536, he appointed a commission to investigate charges of church corruption and convened the Council of Trent (1545–1563) to define Catholic dogma, initiate disciplinary reforms, and regulate the training of clerics.

Pope Paul III also addressed Protestantism through repression and censorship. In 1542, he instituted the Inquisition, a papal office that sought out heretics for interrogation, trial, and sentencing. The enforcement of religious unity extended to the arts. Traditional images of Christ and the saints were sanctioned, but art was scrutinized for traces of heresy and profanity. Guidelines issued by the Council of Trent limited what could be represented in Christian art and led to the destruction of some works. At the same time, art became a powerful weapon of propaganda, especially in the hands of members of the Society of Jesus, a new religious order founded by the Spanish nobleman Ignatius of Loyola (1491–1556) and confirmed by Paul III in 1540. Dedicated to piety, education, and missionary work, the Jesuits, as they are known, spread worldwide and became important leaders of the Counter-Reformation movement and the revival of the Catholic Church.

## ART AND ARCHITECTURE IN ROME AND THE VATICAN

To restore the heart of the city of Rome, Paul III began rebuilding the Capitoline Hill as well as continuing work on St. Peter's. His commissions include some of the finest art and architecture of the late Italian Renaissance. His first major commission brought Michelangelo, after a quarter of a century, back to the Sistine Chapel.

**MICHELANGELO'S LATE WORK.** In his early sixties, Michelangelo complained bitterly of feeling old, but he nonetheless undertook the important and demanding task of painting the **LAST JUDGMENT** on the 48-foot-high end wall above the Sistine Chapel altar between 1536 and 1541 (FIG. 20–34).

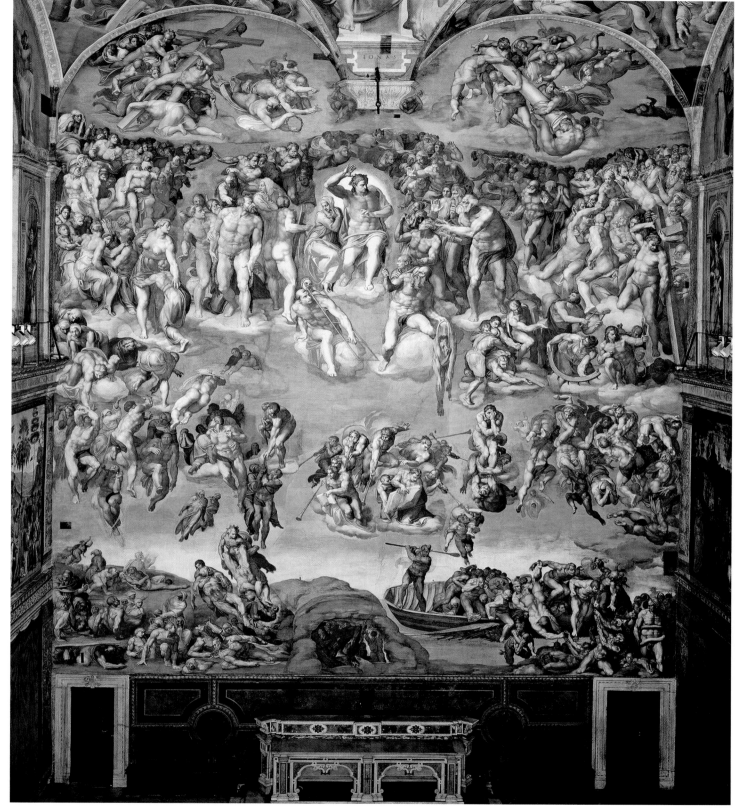

**20–34 • Michelangelo LAST JUDGMENT, SISTINE CHAPEL**
1536–1541. Fresco, 48 × 44′ (14.6 × 13.4 m).

Dark, rectangular patches left by recent restorers (visible, for example, in the upper left and right corners) contrast with the vibrant colors of the chapel's frescos. These dark areas show just how dirty the walls had become over the centuries before their recent cleaning.

**EXPLORE MORE:** Gain insight from a primary source of Michelangelo's poetry **www.myartslab.com**

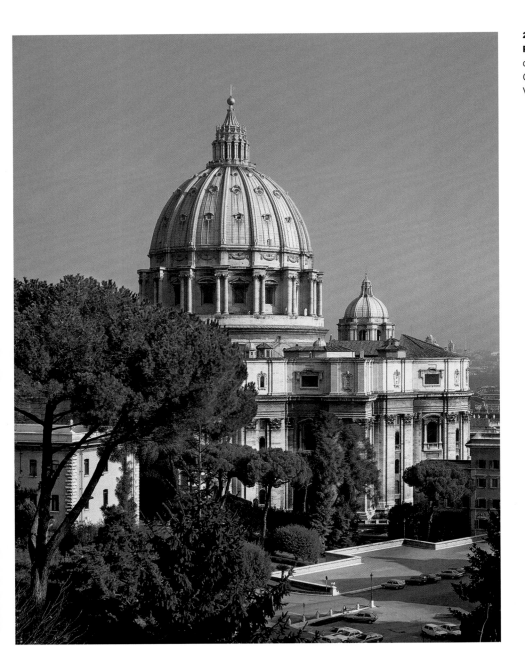

Abandoning the clearly organized medieval conception of the Last Judgment, in which the saved are neatly separated from the damned, Michelangelo painted a writhing swarm of resurrected humanity. At left (on Christ's right side), the dead are dragged from their graves and pushed up into a vortex of figures around Christ, who wields his arm like a sword of justice. The shrinking Virgin under Christ's raised right arm represents a change from Gothic tradition, where she had sat enthroned beside, and equal in size to, her son. To the right of Christ's feet is St. Bartholomew, who in legend was martyred by being skinned alive. He holds his flayed skin, and Michelangelo seems to have painted his own distorted features on the skin's face. Despite the efforts of several saints to save them at the last minute, the damned are plunged toward hell on the right, leaving the elect and still-unjudged in a dazed, almost uncomprehending state. On the lowest level of the mural, right above the altar, is the gaping, fiery entrance to hell, toward which Charon, the ferryman of the dead to the underworld, propels his craft. The painting was long interpreted as a grim and constant reminder to celebrants of the Mass—the pope and his cardinals—that ultimately they too would face stern judgment at the end of time. Conservative clergy criticized the painting for its frank nudity, and after Michelangelo's death they ordered bits of drapery to be added by artist Daniele da Volterra to conceal the offending areas, earning Daniele the unfortunate nickname *Il Braghettone* ("breeches painter").

Another of Paul III's ambitions was to complete the new St. Peter's, a project that had been under way for 40 years (see "St. Peter's Basilica," page 651). Michelangelo was well aware of the work done by his predecessors—from Bramante to Raphael to Antonio da Sangallo the Younger. The 71-year-old sculptor, confident of his

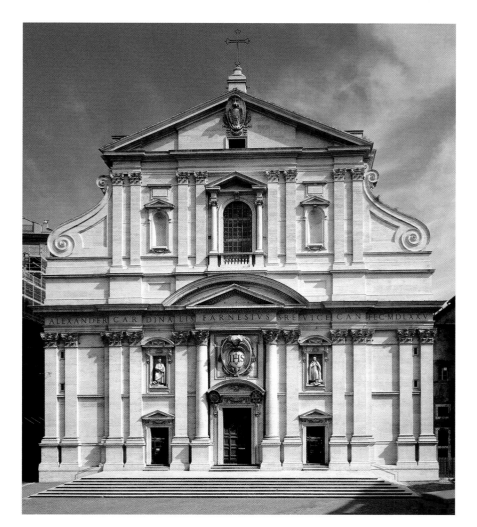

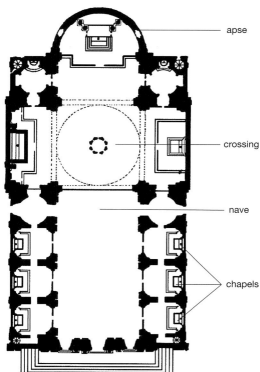

20-36 • Giacomo della Porta and Vignola
**FAÇADE AND PLAN OF THE CHURCH OF IL GESÙ, ROME**
c. 1573–1584.

architectural expertise, demanded the right to deal directly with the pope, rather than through a committee of construction deputies. Michelangelo further shocked the deputies—but not the pope—by tearing down or canceling parts of Sangallo's design and returning to Bramante's central plan, long associated with shrines of Christian martyrs. Although seventeenth-century additions and renovations dramatically changed the original plan of the church and the appearance of its interior, Michelangelo's **ST. PETER'S (FIG. 20–35)** still can be seen in the contrasting forms of the flat and angled exterior walls and the three surviving hemicycles (semicircular structures). Colossal pilasters, blind windows (frames without openings), and niches surround the sanctuary of the church. The current dome, erected by Giacomo della Porta in 1588–1590, retains Michelangelo's basic design: segmented with regularly spaced ribs, seated on a high drum with pedimented windows between paired columns, and surmounted by a tall lantern reminiscent of Bramante's *Il Tempietto* (SEE FIG. 20–16).

Michelangelo—often described by his contemporaries as difficult and even arrogant—alternated between periods of depression and frenzied activity. Yet he was devoted to his friends and helpful to young artists. He believed that his art was divinely inspired; later in life, he became deeply absorbed in religion and

dedicated himself to religious works—many left unfinished—that subverted Renaissance ideals of human perfectibility and denied his own youthful idealism. In the process he pioneered new stylistic directions that would inspire succeeding generations of artists.

VIGNOLA. A young artist who worked to meet the need for new Roman churches was Giacomo Barozzi (1507–1573), known as Vignola after his native town. He worked in Rome during the late 1530s, surveying ancient Roman monuments and providing illustrations for an edition of Vitruvius. From 1541 to 1543, he was in France with Francesco Primaticcio at the château of Fontainebleau. After returning to Rome, he secured the patronage of the Farnese family and profited from the Counter-Reformation program of church building.

Catholicism's new emphasis on individual, emotional participation brought a focus on sermons and music, requiring churches with wide naves and unobstructed views of the altar, instead of the complex interiors of medieval and earlier Renaissance churches. Ignatius of Loyola was determined to build **IL GESÙ**, the Jesuit headquarters church in Rome, according to these precepts, although he did not live to see it finished **(FIG. 20–36)**. The

cornerstone was laid in 1540, but construction of *Il Gesù* did not begin until 1568; the Jesuits had considerable funds to raise first. Cardinal Alessandro Farnese (Paul III's namesake and grandson) donated to the project in 1561 and selected Vignola as architect. After Vignola died in 1573, Giacomo della Porta finished the dome and façade.

*Il Gesù* was admirably suited for congregational worship. Vignola designed a wide, barrel-vaulted nave with shallow connected side chapels; there are no aisles and only truncated transepts contained within the line of the outer walls—enabling all worshipers to gather in the central space. A single huge apse and dome over the crossing directed attention to the altar. The design also allows the building to fit compactly into a city block—a requirement that now often overrode the desire to orient a church along an east–west axis. The symmetrical façade emphasized the central portal with Classical pilasters, engaged columns and pediments, and volutes scrolling out laterally to hide the buttresses of the central vault and to link the tall central section with the lower sides.

As finally built by Giacomo della Porta, the façade design would have significant influence well into the next century. The early Renaissance grid of Classical pilasters and entablatures is abandoned for a two-story design that coordinates paired columns or pilasters, aligned vertically to tie together the two stories of the central block which corresponds with the nave elevation. The main entrance, with its central portal aligned with a tall upper-story window, became the focus of the composition. Centrally aligned pediments break into the level above, leading the eye upward to the cartouches with coats of arms—here of both Cardinal Farnese, the patron, and the Jesuits (whose arms display the initials IHS, the monogram of Christ).

## LATER SIXTEENTH-CENTURY ART IN VENICE AND THE VENETO

By the second half of the sixteenth century, Venice ruled supreme as "queen of the Adriatic." Her power was not, however, unchallenged, and the Turks were a constant threat. In 1571, allied with Spain and the pope, the Christian fleet with Venetian ships defeated the Turkish fleet at the Battle of Lepanto, establishing Christian preeminence for future generations. Victorious and wealthy, Venetians built palaces and villas to contain their lavish lifestyle, filling them with lush oil paintings.

### OIL PAINTING

Rather than the cool, formal, technical perfection sought by Mannerist painters, Venetian artists expanded upon the manner initiated by Giorgione and Titian, concerning themselves above all with color, light, and expressively loose brushwork.

**VERONESE.** Paolo Caliari (1528–1588) took his nickname "Veronese" from his hometown, Verona, but he worked mainly in Venice. His paintings are nearly synonymous today with the popular image of Venice as a splendid city of pleasure and pageantry sustained by a nominally republican government and great mercantile wealth. Veronese's elaborate architectural settings and costumes, still lifes, anecdotal vignettes, and other everyday details—often unconnected with the main subject—proved immensely appealing to Venetian patrons.

Veronese's most famous work is a Last Supper that he renamed *Feast in the House of Levi* (see "Veronese is Called before the Inquisition," opposite), painted in 1573 for the Dominican Monastery of Santi Giovanni e Paolo. At first glance, the subject of the painting seems to be primarily its architectural setting and only secondarily Christ seated at the table. Levi's house is an enormous loggia framed by colossal arches and reached by balustraded stairs. Beyond the loggia gleams an imaginary city of white marble. Within this grand setting, lifelike figures in lavish costumes strike theatrical poses, and Veronese has included the sort of anecdotal details loved by the Venetians—like parrots and monkeys—but detested by the Church's Inquisitors, who saw them as profane distractions.

**TINTORETTO.** Jacopo Robusti (1518–1594), called Tintoretto ("Little Dyer," because his father was a dyer), carried Venetian painting in another direction. Tintoretto's goal, declared on a sign in his studio, was to combine Titian's color with the drawing of Michelangelo. His large painting of **THE LAST SUPPER (FIG. 20–37)** for the choir of Palladio's church of San Giorgio Maggiore (SEE FIG. 20–38) is quite different from Leonardo da Vinci's painting of the same subject almost a century earlier (SEE FIG. 20–3). Instead of Leonardo's frontal view of a closed and logical space with massive figures reacting in individual ways to Jesus' statement, Tintoretto views the scene from a corner, with the vanishing point on a high horizon line at far right. The table, coffered ceiling, and inlaid floor all seem to plunge dramatically into the distance. The figures, although still large bodies modeled by flowing draperies, turn and move in a continuous serpentine line that unites apostles, servants, and angels. Tintoretto used two light sources: one real, the other supernatural. Over the near end of the table, light streams from the oil lamp flaring exuberantly, with angels swirling out from the flame and smoke. A second light emanates from Jesus himself and is repeated in the glow of the apostles' halos. The intensely spiritual, otherworldly mood is enhanced by deep colors flashed with dazzling highlights, recalling Byzantine art. The elongated figures, however, are consistent with Mannerist tendencies. The still lifes on the tables and homey details like the cat that peers in the foreground basket connect with viewers' own experiences. And the narrative emphasis has shifted from Leonardo's more worldly study of personal betrayal to Tintoretto's reference to the institution of the Eucharist. Jesus offers bread and wine to a disciple in the manner of a priest administering the sacrament at the altar next to the painting.

The speed with which Tintoretto drew and painted was the subject of comment in his own time, and the brilliance and

## Veronese is Called before the Inquisition

According to the New Testament, Jesus revealed his impending death to his disciples during a seder, a meal celebrating the Jewish festival of Passover. This occasion, known to Christians as the Last Supper, and situated in the Gospels on the evening before the Crucifixion, was a popular subject in sixteenth-century European art. But in 1573, when the painter Veronese delivered an enormous canvas of this subject to fulfill a commission, the patrons were shocked. Some were offended by the grandiose pageantry of the scene. Others protested the impiety of surrounding Jesus with a man picking his teeth, scruffy dogs, and foreign soldiers. As a result of the furor, Veronese was called before the Inquisition to explain his painting. There he justified himself first by asserting that the picture actually depicted not the Last Supper, but rather the feast in the house of Simon, a small dinner held shortly before Jesus' final entry into Jerusalem. He also noted that artists customarily invent details in their pictures and that he had received a commission to paint the piece "as I saw fit." His argument fell on unsympathetic ears, and he was ordered to change the painting. Later he sidestepped the issue by changing its title to that of another banquet, one given by the tax collector Levi, whom Jesus had called to follow him (Luke 5:27–32). Perhaps with this change of subject, Veronese took a modest revenge on the Inquisitors: When Jesus himself was criticized for associating with such unsavory people at this meal, he replied, "I have not come to call the righteous to repentance but sinners" (Luke 5:32).

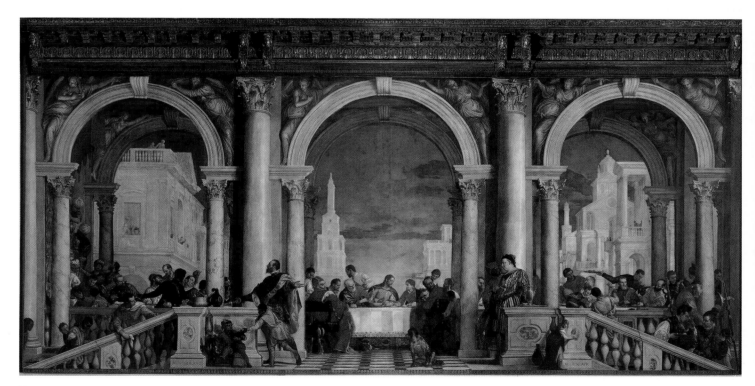

Veronese **FEAST IN THE HOUSE OF LEVI**
From the refectory of the monastery of Santi Giovanni e Paolo, Venice. 1573. Oil on canvas, 18′3″ × 42′ (5.56 × 12.8 m). Galleria dell'Accademia, Venice.

EXPLORE MORE: Gain insight from a primary source about Paolo Veronese **www.myartslab.com**

immediacy so admired in his work today—his slashing brushwork was much appreciated by twentieth-century gestural painters—were derided as evidence of carelessness in his own time. Rapid production may have been a byproduct of his working methods. Tintoretto had a large workshop of assistants and he usually provided only the original conception, the beginning drawings, and the final brilliant touches on the finished paintings. Tintoretto's workshop included members of his family—of his eight children, four became artists. His oldest daughter, Marietta Robusti, worked with him as a portrait painter, and two or perhaps three of his sons

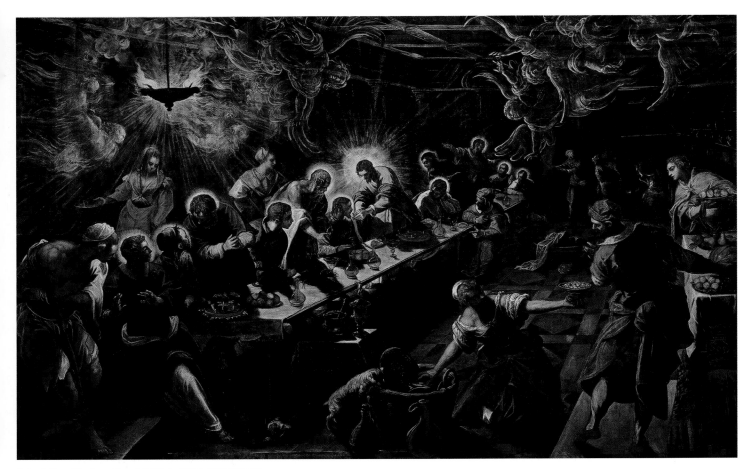

**20-37 • Tintoretto THE LAST SUPPER**
1592–1594. Oil on canvas, 12′ × 18′8″ (3.7 × 5.7 m). Church of San Giorgio Maggiore, Venice.

Tintoretto, who had a large workshop, often developed a composition by creating a small-scale model like a miniature stage set, which he populated with wax figures. He then adjusted the positions of the figures and the lighting until he was satisfied with the entire scene. Using a grid of horizontal and vertical threads placed in front of this model, he could easily sketch the composition onto squared paper for his assistants to copy onto a large canvas. His assistants also primed the canvas, blocking in the areas of dark and light, before the artist himself, free to concentrate on the most difficult passages, finished the painting. This efficient working method allowed Tintoretto to produce a large number of paintings in all sizes.

also joined the shop. So skillfully did Marietta capture her father's style and technique that today art historians cannot identify her work in the shop.

## ARCHITECTURE: PALLADIO

Just as Veronese and Tintoretto expanded upon the rich Venetian tradition of oil painting initiated by Giorgione and Titian, Andrea Palladio dominated architecture during the second half of the century by expanding upon the principles of Alberti and ancient Roman architecture. His buildings—whether villas, palaces, or churches—were characterized by harmonious symmetry and controlled ornamentation. Born Andrea di Pietro della Gondola (1508–1580), probably in Padua, Palladio began his career as a stonecutter. After moving to Vicenza, he was hired by the nobleman, humanist scholar, and amateur architect Giangiorgio Trissino, who gave him the nickname "Palladio" for the Greek goddess of wisdom, Pallas Athena, and the fourth-century Roman

writer Palladius. Palladio learned Latin at Trissino's small academy and accompanied his benefactor on three trips to Rome, where he made drawings of Roman monuments.

Over the years, Palladio became involved in several publishing ventures, including a guide to Roman antiquities and an illustrated edition of Vitruvius. He also published his own books on architecture—including ideal plans for country estates, using proportions derived from ancient Roman buildings—that for centuries would be valuable resources for architectural design. Despite their theoretical bent, his writings were often more practical than earlier treatises. Perhaps his early experience as a stonemason provided him with the knowledge and self-confidence to approach technical problems and discuss them as clearly as he did theories of ideal proportion and uses of the Classical orders. By the eighteenth century, Palladio's *Four Books of Architecture* had been included in the libraries of most educated people. Thomas Jefferson had one of the first copies in America.

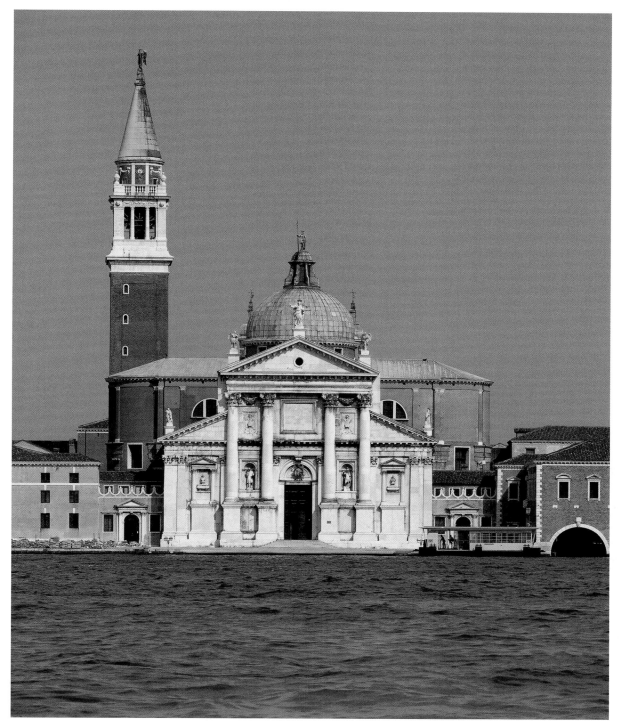

**20-38 • Palladio CHURCH OF SAN GIORGIO MAGGIORE, VENICE**
Plan 1565; construction 1565–1580; façade 1597–1610; campanile 1791.
Finished by Vincenzo Scamozzi following Palladio's design.

SAN GIORGIO MAGGIORE. By 1559, when he settled in Venice, Palladio was one of the foremost architects in Italy. In 1565, he undertook a major architectural commission: the monastery **CHURCH OF SAN GIORGIO MAGGIORE (FIG. 20–38)**. His variation on the traditional Renaissance façade for a basilica— a wide lower level fronting the nave and side aisles, surmounted by a narrower front for the nave clerestory—creates the illusion of two temple fronts of different heights and widths, one set inside the other. At the center, colossal columns on high pedestals support an entablature and pediment; these columns correspond to

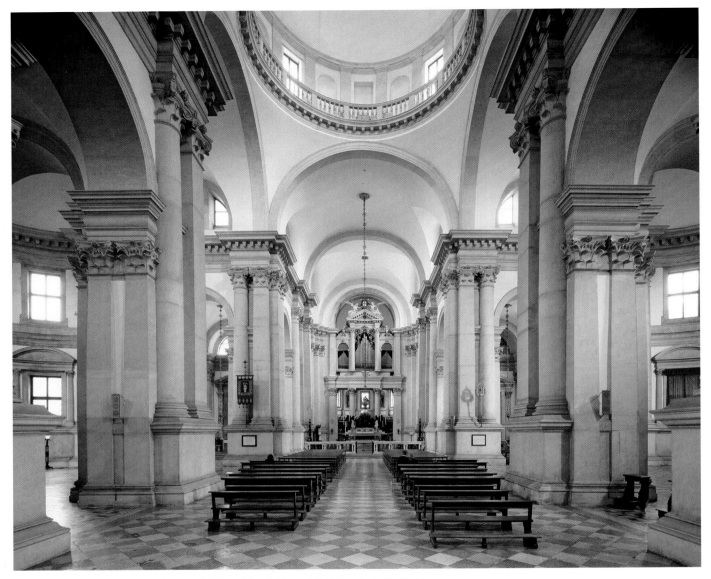

**20-39 • NAVE, CHURCH OF SAN GIORGIO MAGGIORE, VENICE**
Begun 1566. Tintoretto's *Last Supper* (not visible) hangs to the left of the altar.

the width of the nave within. Behind the taller temple front, a second front consists of pilasters supporting another entablature and pediment; this wider front spans the entire width of the church, including the triple aisle. Although the façade was not built until after the architect's death, his original design was followed.

The interior of **SAN GIORGIO (FIG. 20–39)** is a fine example of Palladio's harmoniously balanced geometry, expressed here in strong verticals and powerfully opened arches. The tall engaged columns and shorter pilasters of the nave arcade piers echo the two levels of orders on the façade, thus unifying the building's exterior and interior.

THE VILLA ROTONDA.   Palladio's versatility was already apparent in numerous villas built early in his career. In the 1560s, he started his most famous and influential villa just outside Vicenza. Although

villas were traditionally working farms, Palladio designed this one as a retreat, literally a party house. To maximize vistas of the countryside, he placed a porch elevated at the top of a wide staircase on each face of the building. The main living quarters are on this second level, and the lower level is reserved for the kitchen, storage, and other utility rooms. Upon its completion in 1569, the building was dubbed the **VILLA ROTONDA (FIG. 20–40)** because it had been inspired by another round building, the Roman Pantheon. The plan **(FIG. 20–41)** shows the geometric clarity of Palladio's conception: a circle inscribed in a small square inside a larger square, with symmetrical rectangular compartments and identical rectangular projections from each of its faces. The use of a central dome on a domestic building was a daring innovation that effectively secularized the dome and initiated what was to become a long tradition of domed country houses, particularly in England and the United States.

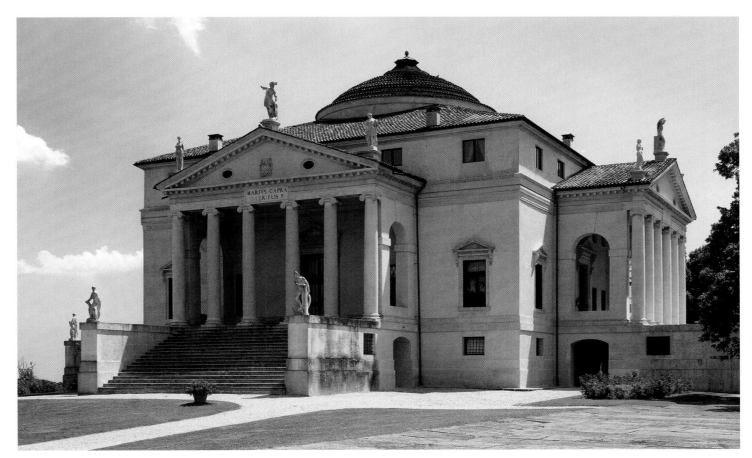

**20-40 • Palladio EXTERIOR VIEW OF VILLA ROTONDA, VICENZA**
Italy. Begun 1560s.

After its purchase in 1591 by the Capra family, the Villa Rotonda became known as the Villa Capra.

**SEE MORE:** Click the Google Earth link for the Villa Rotonda, Vicenza **www.myartslab.com**

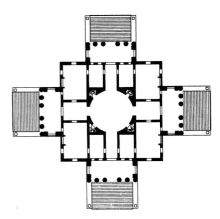

**20-41 • Palladio PLAN OF VILLA ROTONDA, VICENZA**
Italy. Begun 1560s.

**EXPLORE MORE:** Gain insight from a primary source by Andrea Palladio **www.myartslab.com**

## THINK ABOUT IT

**20.1** Discuss Julius II's efforts to aggrandize the city of Rome and create a new golden age of papal art. Focus your answer on at least two specific works he commissioned.

**20.2** Write about either Michelangelo's or Raphael's extensive work in the Sistine Chapel. How did papal commissions push these two established artists in new creative directions?

**20.3** Select either Pontormo's *Entombment* (FIG. 20–26) or Parmigianino's *Madonna with the Long Neck* (FIG. 20–27), and explain why the painting characterizes Mannerist style. How does your chosen work depart from the Classical norms of the High Renaissance?

**20.4** Elaborate on the idea that whereas Rome and Florence were oriented toward drawing, Venice was oriented toward color. Compare and contrast a specific work from each tradition in forming your answer.

**20.5** Analyze either the Palazzo del Tè (FIG. 20–17) or the Villa Rotonda (FIG. 20–40). Explain how the design of the building differs from the design of grand churches during this same period, even though architects clearly used Classical motifs in both sacred and secular contexts.

**PRACTICE MORE:** Compose answers to these questions, get flashcards for images and terms, and review chapter material with quizzes **www.myartslab.com**

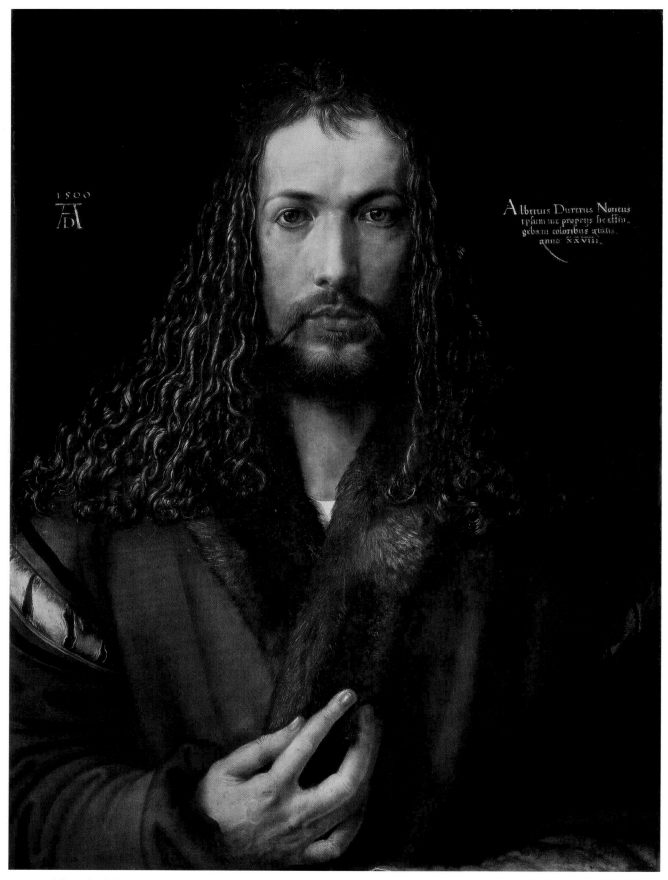

1500

AD

Albertus Durerus Noricus
ipsum me proprijs sic essin
gebam coloribus aetatis
anno XXVIII.

**21–1 • Albrecht Dürer SELF-PORTRAIT**  1500. Signed "Albrecht Dürer of Nuremberg…age 28."
Oil on wood panel, 26¼ × 19¼" (66.3 × 49 cm). Alte Pinakothek, Munich.

**EXPLORE MORE:** Gain insight from a primary source by Albrecht Dürer **www.myartslab.com**

# SIXTEENTH-CENTURY ART IN NORTHERN EUROPE AND THE IBERIAN PENINSULA

This striking image (FIG. 21–1), dated 1500, seems to depict a blessing Christ, meant to rivet our attention and focus our devotion. But an inscription to the right of the iconic visage identifies this as a **SELF-PORTRAIT** by Albrecht Dürer, painted when he was 28 years old. We are already familiar with the practice of artists painting their own image. Self-portraits appear with some frequency during the Middle Ages (SEE FIGS. 15–32, 16–20); they truly blossom during the Renaissance (SEE FIGS. 18–11, 20–30). But this image is still peculiar, marked by an artistic hubris that may embarrass us. The picture becomes less puzzling, however, seen in context.

Dürer strikes an odd pose for a self-portrait—frontal and hieratic, intentionally recalling iconic images of Christ as *salvator mundi* (savior of the world) that were very popular in northern Europe. Dürer even alters the natural color of his own hair to align the image more closely with contemporary notions of Christ's physical appearance. But there is no reason to see this as blasphemous. Since a principal component of contemporary Christian devotion was the attempt to imitate Christ in the believer's own life, Dürer could be visualizing a popular spiritual practice. He could also be literalizing the biblical statement that humans are created in the image of God. But he is also claiming that artists are learned and creative geniuses—perhaps God-like—not laboring craftsmen. He wrote, "The more we know, the more we resemble the likeness of Christ who truly knows all things" (Snyder, p. 314).

Dürer had traveled to Italy in 1494–1495, where he encountered a new conception of artists as noble intellectuals, participants in humanistic discourse, purveyors of ideas as well as pictures. In 1498, back in Nuremberg, he published a woodcut series on the Apocalypse (SEE FIG. 21–6) that brought him a kind of international notice that was new to the German art world. He certainly had reason to feel pride. This stable, triangular composition—so consistent with High Renaissance norms of harmony and balance—could reflect Dürer's Italian adventure. But at its core, this picture fits into a long-standing northern European interest in the meticulous description of surface texture—the soft sheen of human flesh, the reflective wetness of eyes, the matte softness of cloth, and the tactile quality of hair, emphasized here by the way Dürer's hand fingers the fur collar of his outfit, encouraging viewers also to feel it as they see it. Ultimately what is showcased here are Dürer's awesome artistic gifts of hand as much as his intellectual gifts of mind, two aspects perhaps emblemized by the brightly illuminated body parts that align on a vertical axis to dominate this arresting self-portrait.

## LEARN ABOUT IT

**21.1** Investigate the broadening of regional interaction in the art of European courts as artists traveled across Europe to work for wealthy patrons and study with acclaimed masters.

**21.2** Evaluate the impact of Italian ideas on the traditions of northern art and architecture, including the developing notion of artists as uniquely gifted individuals.

**21.3** Analyze the developments that led to the creation of an art market in the Netherlands.

**21.4** Assess the relationship between the religious conflicts in northern Europe and the growing interest in new secular subjects in works of art.

**21.5** Recognize the continuing interest among northern European artists and patrons in the virtuosity of works in media such as wood and gold.

**HEAR MORE:** Listen to an audio file of your chapter **www.myartslab.com**

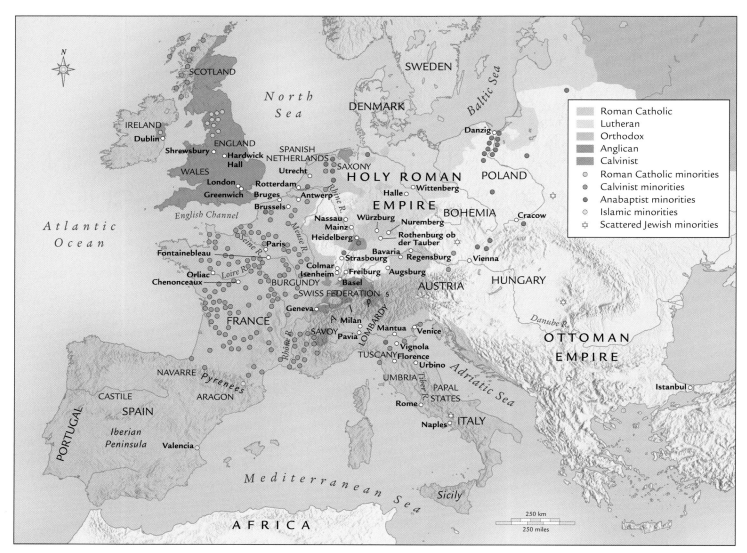

**MAP 21-1 • WESTERN EUROPE DURING THE REFORMATION, C. 1560**

Sixteenth-century Europe remained largely Roman Catholic, except in Switzerland and the far north, where the impact of the Protestant Reformation was strongest.

# THE REFORMATION AND THE ARTS

In spite of the dissident movements and heresies that had challenged the Roman Catholic Church through the centuries, its authority and that of the pope always prevailed—until the sixteenth century (**MAP 21–1**). Then, against a backdrop of broad dissatisfaction with financial abuses and decadent lifestyles among the clergy, religious reformers from within the Church itself challenged first its practices and then its beliefs.

Two of the most important reformers in the early sixteenth century were themselves Catholic priests and trained theologians: Desiderius Erasmus (1466?–1536) of Rotterdam in Holland, who worked to reform the Roman Catholic Church from within, and Martin Luther (1483–1546) in Germany, who eventually broke with it. Indeed, many locate the beginning of the Reformation in 1517, when Luther issued his "95 Theses" calling for church reform. Among Luther's concerns were the practice of selling indulgences

(guarantees of relief from the punishment required after death for forgiven sins) and the excessive veneration of saints and their relics, which he considered superstitious. Luther and others emphasized individual faith and regarded the Bible as the ultimate religious authority. As they challenged the pope's supremacy, it became clear that the Protestants had to break away from Rome. The Roman Catholic Church condemned Luther in 1521.

Increased literacy and the widespread use of the printing press aided the reformers and allowed scholars throughout Europe to enter the religious debate. In Germany, the wide circulation of Luther's writings—especially his German translation of the Bible and his works maintaining that salvation comes through faith alone—eventually led to the establishment of the Protestant (Lutheran) Church there. In Switzerland, John Calvin (1509–1564) led an even more austere Protestant revolt; and in England, King Henry VIII (r. 1509–1547) also broke with Rome in

1534, for reasons of his own. By the end of the sixteenth century, Protestantism in some form prevailed throughout northern Europe.

Leading the Catholic cause was Holy Roman Emperor Charles V. Europe was wracked by religious war from 1546 to 1555 as Charles battled Protestant forces in Germany, until a meeting of the provincial legislature of Augsburg in 1555 determined that the emperor must accommodate the Protestant Reformation in his lands. By the terms of the peace, local rulers could select the religion of their subjects—Catholic or Protestant. Tired of the strain of government and prematurely aged, Charles abdicated in 1556 and retired to a monastery in Spain, where he died in 1558. His son Philip II inherited Habsburg Spain and the Spanish colonies, while his brother Ferdinand led the Austrian branch of the dynasty.

The years of political and religious strife had a grave impact on artists and art. Some artists found their careers at an end because of their reformist religious sympathies. Then as Protestantism gained ascendancy, Catholic artists had to leave their homes to seek patronage abroad. There was also widespread destruction of religious art. In some places, Protestant zealots smashed sculpture and stained-glass windows and destroyed or whitewashed religious paintings to rid the churches of what they considered idols—though Luther himself never directly supported **iconoclasm** (the smashing of religious images). With the sudden loss of patronage for religious art in the newly Protestant lands, many artists turned to portraiture and other secular subjects, including moralizing depictions of human folly and weaknesses, still lifes (paintings of inanimate objects), and landscapes. The popularity of these themes stimulated the burgeoning of a free art market, centered in Antwerp.

## GERMANY

In German-speaking regions, the arts flourished until religious upheavals and iconoclastic purges took their toll at mid century. German cities had strong business and trade interests, and their merchants and bankers accumulated self-made, rather than inherited, wealth. They ordered portraits of themselves and fine furnishings for their large, comfortable houses. Entrepreneurial artists, like Albrecht Dürer, became major commercial successes.

### SCULPTURE

Although, like the Italians, German Renaissance sculptors worked in stone and bronze, they produced their most original work in wood, especially fine-grained limewood. Most of these wooded images were gilded and painted, continuing an interest in heightening naturalism, until Tilman Riemenschneider began to favor natural wood finishes.

TILMAN RIEMENSCHNEIDER. Tilman Riemenschneider (c. 1460–1531) became a master in 1485 and soon had the largest workshop in Würzburg, which included specialists in both wood and stone sculpture. Riemenschneider attracted patrons from other cities, and

in 1501 he signed a contract with the church of St. James in Rothenburg, where a relic said to be a drop of Jesus' blood was preserved. The **ALTARPIECE OF THE HOLY BLOOD** (FIG. 21–2) is a spectacular limewood construction standing nearly 30 feet high.

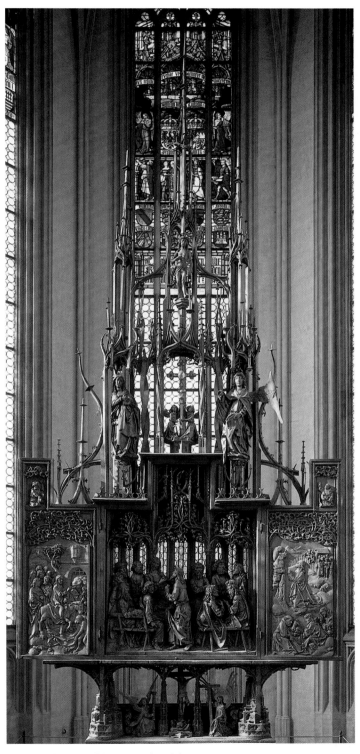

**21-2 • Tilman Riemenschneider ALTARPIECE OF THE HOLY BLOOD (WINGS OPEN)**
Center, *Last Supper*. c. 1499–1505. Limewood, glass, height of tallest figure 39″ (99.1 cm), height of altar 29′6″ (9 m). Sankt Jakobskirche (Church of St. James), Rothenburg ob der Tauber, Germany.

In Nuremberg, a city known for its master metalworkers, Hans Krug (d. 1519) and his sons Hans the Younger and Ludwig were among the finest. They created marvelous display pieces for the wealthy, such as this silver-gilt apple cup. Made about 1510, a gleaming apple, in which the stem forms the handle of the lid, balances on a leafy branch that forms its base.

The Krug family was responsible for the highly refined casting and finishing of the final product, but several artists worked together to produce such pieces—one drawing designs, another making the models, and others creating the final piece in metal. A drawing by Dürer may have been the basis for the apple cup. Though we know of no piece of goldwork by the artist himself, Dürer was a major catalyst in the growth of Nuremberg as a key center of German goldsmithing. He accomplished this by producing designs for metalwork throughout his career. Designers played an essential role in the metalwork process. With design in hand, the modelmaker created a wooden form for the goldsmith to follow. The result of this artistic collaboration was a technical *tour de force*, an intellectual conceit, and an exquisite object.

**Workshop of Hans Krug (?)  APPLE CUP**
c. 1510–1515. Gilt silver, height 8½″ (21.5 cm). Germanisches Nationalmuseum, Nuremberg.

---

Erhart Harschner, a specialist in architectural shrines, had begun work on the elaborate Gothic frame in 1499, and was paid 50 florins for his work. Riemenschneider was commissioned to provide the figures and scenes to be placed within this frame. He was paid 60 florins for the sculpture, giving us a sense of the relative value patrons placed on their contributions.

The main panel of the altarpiece portrays the moment at the Last Supper when Christ revealed that one of his followers would betray him. Unlike Leonardo da Vinci, who chose the same moment (SEE FIG. 20–3), Riemenschneider puts Judas at center stage and Jesus off-center at the left. The disciples sit around the table. As the event is described in the Gospel of John (13:21–30), Jesus extends a morsel of food to Judas, signifying that he will be the traitor who sets in motion the events leading to the Crucifixion. One apostle points down, a strange gesture until we realize that he is pointing to the crucifix in the predella, to the relic of Christ's blood, and to the altar table, the symbolic representation of the table of the Last Supper and the tomb of Christ.

Rather than creating individual portraits of the apostles, Riemenschneider repeated a limited number of facial types. His figures have large heads, prominent features, sharp cheekbones, sagging jowls, baggy eyes, and elaborate hair with thick wavy locks and deeply drilled curls. The muscles, tendons, and raised veins of hands and feet are also especially lifelike. His assistants and apprentices copied these faces and figures, either from drawings or from three-dimensional models made by the master. In the altarpiece, deeply hollowed folds create active patterns in the voluminous draperies whose strong highlights and dark shadows harmonize the figural composition with the intricate carving of the framework. The Last Supper is set in a "real" room containing actual benches for the figures. Windows in the back wall are glazed with bull's-eye glass so that natural light shines in from two directions to illuminate the scene, producing changing effects depending on the time of day and the weather. Although earlier sculpture had been painted and gilded, Riemenschneider introduced the use of a natural wood finish toned with varnish. This meant that details of both figures and environment had to be carved into the wood itself, not quickly added later with paint. Since this required more skillful carvers and more time for them to carve, this new look was a matter of aesthetics, not cost-saving.

In addition to producing an enormous number of religious images for churches, Riemenschneider was politically active in the city's government, and he even served as mayor in 1520. His career ended during the Peasants' War (1524–1526), an early manifestation of the Protestant movement. His support for the peasants led to a fine and imprisonment in 1525, and although he survived, Riemenschneider produced no more sculpture and died in 1531.

NIKOLAUS HAGENAUER.  Prayer was the principal source of solace and relief to the ill before the advent of modern medicine. About 1505, the Strasbourg sculptor Nikolaus Hagenauer (active

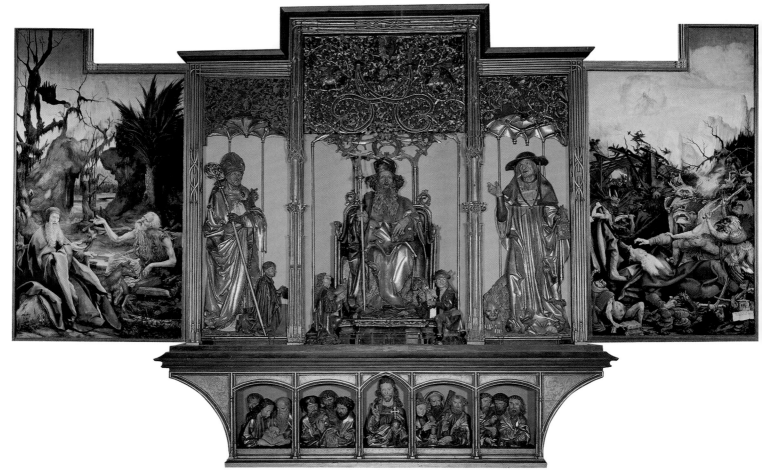

**21-3 • Nikolaus Hagenauer** **ST. ANTHONY ENTHRONED BETWEEN SS. AUGUSTINE AND JEROME, SHRINE OF THE ISENHEIM ALTARPIECE (OPEN, SHOWING GRÜNEWALD WINGS)**
From the Community of St. Anthony, Isenheim, Alsace, France. c. 1500. Painted and gilt limewood, center panel 9′9½″ × 10′9″ (2.98 × 3.28 m), predella 2′5½″ × 11′2″ (0.75 × 3.4 m), wings 8′2½″ × 3′½″ (2.49 × 0.93 m). Predella: *Christ and the Apostles*. Wings: *SS. Anthony and Paul the Hermit* (left); *The Temptation of St. Anthony* (right). 1510–1515. Musée d'Unterlinden, Colmar, France.

1493–1530s) carved an altarpiece for the abbey of St. Anthony in Isenheim near Colmar (**FIG. 21–3**) where a hospital specialized in the care of patients with skin diseases, including the plague, leprosy, and St. Anthony's Fire (caused by eating rye and other grains infected with the ergot fungus). The shrine includes images of SS. Anthony, Jerome, and Augustine. Three tiny men—their size befitting their subordinate status—kneel at the feet of the saints: the donor, Jean d'Orliac, and two men offering a rooster and a piglet.

In the predella below, Jesus and the apostles bless the altar, Host, and assembled patients in the hospital. This limewood sculpture was painted in lifelike colors, and the shrine itself was gilded to enhance its resemblance to a precious reliquary. A decade later, Matthias Grünewald painted wooden shutters to cover the shrine (SEE FIGS. 21–4, 21–5).

## PAINTING

The work of two very different German artists has come down to us from the first decades of the sixteenth century. Matthias

Grünewald continued currents of medieval mysticism and emotional spirituality to create extraordinarily moving paintings. Albrecht Dürer, on the other hand, used intense observation of the world to render lifelike representations of nature, mathematical perspective to create convincing illusions of space, and a reasoned canon of proportions to standardize depictions of the human figure.

MATTHIAS GRÜNEWALD. As a court artist to the archbishop of Mainz, Matthias Grünewald (Matthias Gothart Neithart, c. 1470/ 1475–1528) was a man of many talents, who worked as an architect and hydraulic engineer as well as a painter. He is best known today for painting the shutters or wings attached to Nikolaus Hagenauer's carved Isenheim Altarpiece (SEE FIG. 21–3). The completed altarpiece is impressive in size and complexity. Grünewald painted one set of fixed wings and two sets of movable ones, plus one set of sliding panels to cover the predella. The altarpiece could be exhibited in different configurations depending upon the church calendar. The wings and carved wooden shrine

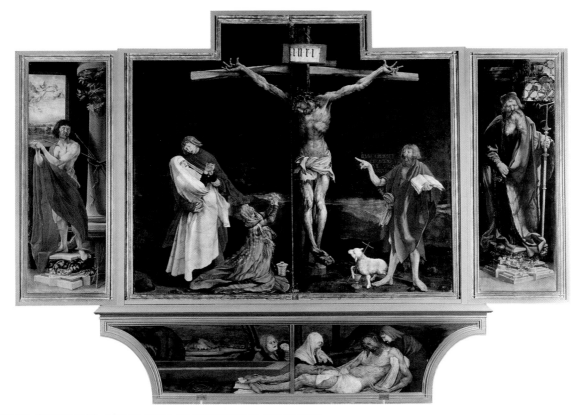

**21–4 • Matthias Grünewald ISENHEIM ALTARPIECE (CLOSED)**
From the Community of St. Anthony, Isenheim, Alsace, France. Center panels: *Crucifixion*; predella: *Lamentation*; side panels: *SS. Sebastian* (left) and Anthony Abbot (right). c. 1510–1515. Date 1515 on ointment jar. Oil on wood panel, center panels 9′9½″ × 10′9″ (2.97 × 3.28 m) overall; each wing 8′2½″ × 3′½″ (2.49 × 0.93 m); predella 2′5½″ × 11′2″ (0.75 × 3.4 m). Musée d'Unterlinden, Colmar, France.

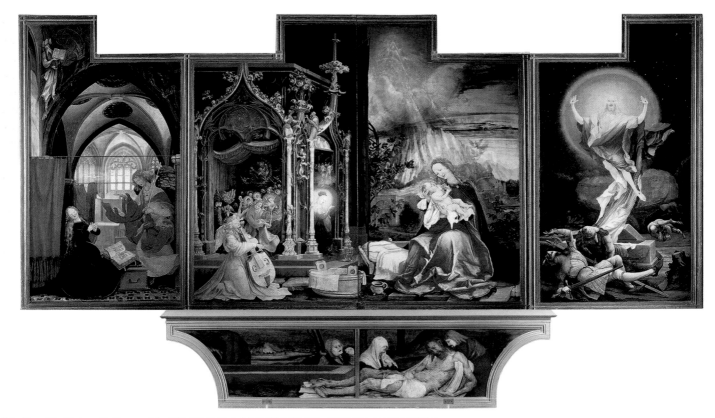

**21–5 • Matthias Grünewald ISENHEIM ALTARPIECE (FIRST OPENING)**
Left to right: *Annunciation*, *Virgin and Child with Angels*, *Resurrection*. c. 1510–1515. Oil on wood panel, center panel 9′9½″ × 10′9″ (2.97 × 3.28 m), each wing 8′2½″ × 3′½″ (2.49 × 0.92 m). Musée d'Unterlinden, Colmar, France.

complemented one another, the inner sculpture seeming to bring the surrounding paintings to life, and the painted wings protecting the precious carvings.

On weekdays, when the altarpiece was closed, viewers saw a grisly image of the Crucifixion in a darkened landscape, a *Lamentation* below it on the predella, and life-size figures of SS. Sebastian and Anthony Abbot—both associated with the plague—standing on *trompe l'oeil* pedestals on the fixed wings **(FIG. 21–4)**. The intensity of feeling here has suggested that Grünewald may have been inspired by the visions of St. Bridget of Sweden, a fourteenth-century mystic whose works—including morbidly detailed descriptions of the Crucifixion—were published in Germany beginning in 1492. Grünewald has scrupulously described the horrific character of the tortured body of Jesus, covered with gashes from his beating and pierced by the thorns used to form a crown for his head. His ashen body, clotted blood, open mouth, and blue lips signal his death. In fact, he appears already to be decaying, an effect enhanced by the palette of putrescent green, yellow, and purplish-red—all described by St. Bridget. She wrote, "The color of death spread through his flesh…." An immaculately garbed Virgin Mary has collapsed in the arms of a ghostlike John the Evangelist, and Mary Magdalen has fallen in anguish to her knees; her clasped hands with outstretched fingers seem to echo Jesus' fingers, cramped in rigor mortis. At the right, John the Baptist points to Jesus and repeats his prophecy, "He shall increase." The Baptist and the lamb, holding a cross and bleeding from its breast into a golden chalice, allude to baptism, the Eucharist, and to Christ as the sacrificial Lamb of God. In the predella below, Jesus' bereaved mother and friends prepare his racked body for burial—an activity that must have been a common sight in the abbey's hospital.

In contrast to these grim scenes, the first opening displays events of great joy—the Annunciation, the Nativity, and the Resurrection—appropriate for Sundays and feast days **(FIG. 21–5)**. Praying in front of these pictures, the patients must have hoped for miraculous recovery and taken comfort in these visions of divine rapture and orgiastic color. Unlike the awful darkness of the Crucifixion, the inner scenes are brilliantly illuminated, in part by phosphorescent auras and haloes, and stars glitter in the night sky of the Resurrection. The technical virtuosity of Grünewald's painting alone is enough to inspire euphoria.

The *Annunciation* on the left wing may be related to a special liturgy called the Golden Mass, which celebrated the divine motherhood of the Virgin. The Mass included a staged reenactment of the angel's visit to Mary, as well as readings from the story of the Annunciation (Luke 1:26–38) and the Hebrew Bible prophecy of the Savior's birth (Isaiah 7:14–15), which is inscribed in Latin on the pages of the Virgin's open book.

The central panels show the heavenly and earthly realms joined in one space. In a variation on the northern European visionary tradition, the new mother adores her miraculous Christ Child while envisioning her own future as queen of heaven amid angels and cherubims. Grünewald portrayed three distinct types of angels in the foreground—young, mature, and a feathered hybrid with a birdlike crest on its human head. The range of ethnic types in the heavenly realm may have emphasized the global dominion of the Church, whose missionary efforts were expanding as a result of European exploration. St. Bridget describes the jubilation of the angels as "the glowing flame of love."

The second opening of the altarpiece (SEE FIG. 21–3) reveals Hagenauer's sculpture and was reserved for the special festivals of St. Anthony. The wings in this second opening show to the left the meeting of St. Anthony with the hermit St. Paul, and to the right St. Anthony attacked by horrible demons, perhaps inspired by the horrors of the diseased patients, but also modeled in part on Schongauer's well-known print of the same subject (SEE FIG. 18–26). The meeting of the two hermits in the desert glorifies the monastic life, and in the wilderness Grünewald depicts medicinal plants used in the hospital's therapy. Grünewald painted the face of St. Paul with his own self-portrait, while St. Anthony is a portrait of the donor and administrator of the hospital, the Italian Guido Guersi, whose coat of arms Grünewald painted on the rock next to him.

Like Riemenschneider, Grünewald's involvement with the Peasants' War may have damaged his artistic career. He left Mainz and spent his last years in Halle, whose ruler was the chief protector of Martin Luther and a long-time patron of Grünewald's contemporary Albrecht Dürer.

**ALBRECHT DÜRER.** Studious, analytical, observant, and meticulous —and as self-confident as Michelangelo—Albrecht Dürer (1471–1528) was the foremost artist of the German Renaissance. He made his home in Nuremberg, where he became a prominent citizen. Nuremberg was a center of culture as well as of business, with an active group of humanists and internationally renowned artists. It was also a leading publishing center. Dürer's father was a goldsmith and must have expected his son to follow in his trade (see "German Metalwork: A Collaborative Venture," page 680). Dürer did complete an apprenticeship in gold-working, as well as in stained-glass design, painting, and the making of woodcuts—which he learned from Michael Wolgemut, illustrator of the *Nuremberg Chronicle* (SEE FIG. 18–27). But ultimately it was as a painter and graphic artist that he built his artistic fame.

In 1490, Dürer began traveling to extend his education. He went to Basel, Switzerland, hoping to meet Martin Schongauer, but arrived after the master's death. By 1494, Dürer had moved from Basel to Strasbourg. His first trip to Italy (1494–1495) introduced him to Italian Renaissance ideas and attitudes and, as we considered at the beginning of this chapter, to the concept of the artist as an independent creative genius. In his self-portrait of 1500 (SEE FIG. 21–1), Dürer represents himself as an idealized, Christ-like figure in a severely frontal pose, staring directly at the viewer.

On his return to Nuremberg, Dürer began to publish his own prints to bolster his income, and ultimately it was prints, not

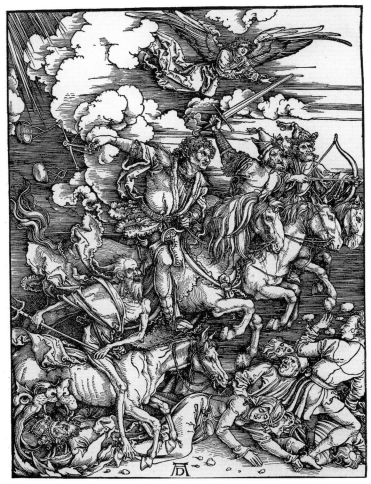

**21-6 • Albrecht Dürer  THE FOUR HORSEMEN OF THE APOCALYPSE**
From *The Apocalypse*. 1497–1498. Woodcut, 15½ × 11⅛″ (39.4 × 28.3 cm). Metropolitan Museum of Art, New York. Gift of Junius S. Morgan, 1919 (19.73.209)

as a goldsmith is evident in his meticulous attention to detail, and in his decorative cloud and drapery patterns. Following the tradition established by his late fifteenth-century predecessors, he fills the foreground with large, active figures.

Perhaps as early as the summer of 1494, Dürer began to experiment with engravings, cutting the metal plates himself with an artistry rivaling Schongauer's. His growing interest in Italian art and his theoretical investigations are reflected in his 1504 engraving **ADAM AND EVE** (FIG. **21–7**), which represents his first documented use of ideal human proportions based on Roman copies of ancient Greek sculpture. He may have seen figures of Apollo and Venus in Italy, and he would have known ancient sculpture from contemporary prints and drawings. But around these idealized human figures he represents plants and animals with typically northern attention to descriptive detail.

Dürer filled the landscape with symbolic content reflecting the medieval theory that after Adam and Eve disobeyed God, they and their descendants became vulnerable to imbalances in the body fluids that controlled human temperament. An excess of black bile from the liver would produce melancholy, despair, and greed. Yellow bile caused anger, pride, and impatience; phlegm in the lungs resulted in lethargy and disinterest; and an excess of

paintings, that made his fortune. His first major publication, *The Apocalypse*, appeared simultaneously in German and Latin editions in 1497–1498. It consisted of a woodcut title page and 14 full-page illustrations with the text printed on the back of each. Perhaps best known is **THE FOUR HORSEMEN OF THE APOCALYPSE (FIG. 21–6)**, based on figures described in Revelation 6:1–8: a crowned rider, armed with a bow, on a white horse (Conquest); a rider with a sword, on a red horse (War); a rider with a set of scales, on a black horse (Plague and Famine); and a rider on a sickly pale horse (Death). Earlier artists had simply lined up the horsemen in the landscape, but Dürer created a compact, overlapping group of wild riders charging across the world and trampling its cowering inhabitants, men and women, clerical and lay.

Dürer probably did not cut his own woodblocks but employed a skilled carver who followed his drawings faithfully. Dürer's dynamic figures show affinities with Schongauer's *Temptation of St. Anthony* (SEE FIG. 18–26). He adapted Schongauer's metal-engraving technique to the woodcut medium, using a complex pattern of lines to model the forms. Dürer's early training

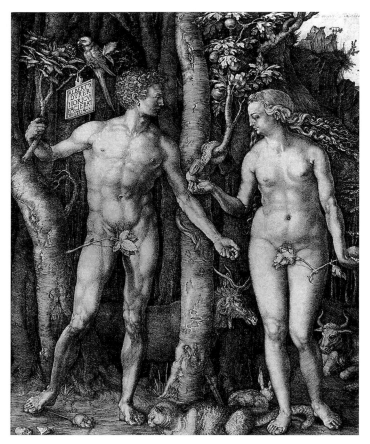

**21-7 • Albrecht Dürer  ADAM AND EVE**
1504. Engraving, 9⅞ × 7⅝″ (25.1 × 19.4 cm). Philadelphia Museum of Art. Purchased: Lisa Nora Elkins Fund

**21-8** • Albrecht Dürer
**FOUR APOSTLES**
1526. Oil on wood panel,
each panel 7'1½" × 2'6"
(2.15 × 0.76 m).
Alte Pinakothek, Munich.

blood made a person unusually optimistic but also compulsively interested in the pleasures of the flesh. These four human temperaments, or personalities, are symbolized here by the melancholy elk, the choleric cat, the phlegmatic ox, and the sanguine (or sensual) rabbit. The mouse is a symbol of Satan (see the mousetrap in FIG. 18–10), whose earthly power, already manifest in the Garden of Eden, was capable of bringing human beings to a life of woe through their own bad choices. Adam seems to be releasing the mouse into the world of his paradise as he contemplates eating the forbidden fruit that Eve receives from the snake. Dürer placed his signature prominently on a placard hung on a tree branch in Adam's grasp and on which perches a parrot—possibly symbolizing false wisdom, since it can only repeat mindlessly what it hears.

Dürer's familiarity with Italian art was greatly enhanced by a second, leisurely trip over the Alps in 1505–1506. Thereafter, he seems to have resolved to reform the art of his own country by

publishing theoretical writings and manuals that discussed Renaissance problems of perspective, ideal human proportions, and the techniques of painting.

Dürer admired Martin Luther, but they never met. In 1526, the artist openly professed his Lutheranism in a pair of inscribed panels, the **FOUR APOSTLES (FIG. 21–8)**. On the left panel, the elderly Peter, who normally has a central position as the first pope, has been displaced with his keys to the background by Luther's favorite evangelist, John, who holds an open Gospel that reads "In the beginning was the Word," reinforcing the Protestant emphasis on the Bible. On the right panel, Mark stands behind Paul, whose epistles were particularly admired by the Protestants. A long inscription on the frame warns the viewer not to be led astray by "false prophets" but to heed the words of the New Testament as recorded by these "four excellent men." Below each figure are excerpts from their letters and from the Gospel of Mark—drawn from Luther's German translation of the New Testament—warning

**21-9 • Lucas Cranach the Elder  NYMPH OF THE SPRING**
c. 1537. Oil on panel, 19 × 28½″ (48.5 × 72.9 cm). National Gallery of Art, Washington, D.C.

against those who do not understand the true Word of God. These paintings were surely meant to chart the possibility of a Protestant visual art.

Dürer presented the panels to the city of Nuremberg, which had already adopted Lutheranism as its official religion. Dürer wrote, "For a Christian would no more be led to superstition by a picture or effigy than an honest man to commit murder because he carries a weapon by his side. He must indeed be an unthinking man who would worship picture, wood, or stone. A picture therefore brings more good than harm, when it is honourably, artistically, and well made" (Snyder, p. 333).

LUCAS CRANACH THE ELDER.    Martin Luther's favorite painter, Lucas Cranach the Elder (1472–1553), moved his workshop to Wittenberg in 1504, after a number of years in Vienna. In addition to the humanist milieu of its university and library, Wittenberg offered the patronage of the Saxon court. Appointed court painter to Elector Frederick the Wise, Cranach created woodcuts, altarpieces, and many portraits.

Just how far German artists' style and conception of the figure could differ from Italian Renaissance idealism is easily seen in

Cranach's **NYMPH OF THE SPRING** (FIG. **21–9**), especially when compared with Titian's *"Venus" of Urbino* (SEE FIG. 20–24). The sleeping nymph was a Renaissance theme, not an ancient one. Cranach was inspired by a fifteenth-century inscription on a fountain beside the Danube, cited in the upper left corner of the painting: "I am the nymph of the sacred font. Do not interrupt my sleep for I am at peace." Cranach records the Danube landscape with characteristic northern attention to detail and turns his nymph into a rather provocative young woman, who glances slyly out at the viewer through half-closed eyes. She has cast aside a fashionable red velvet gown, but still wears her jewelry, which together with her transparent veil enhances rather than conceals her nudity—especially those coral beads that fall between her breasts, outlining their contours. Unlike other artists working for Protestant patrons, many of whom looked on earthly beauty as a sinful vanity, Cranach seems delighted by earthly things—the lush foliage that provides the nymph's couch, the pair of partridges (symbols of Venus and married love), and Cupid's bow and quiver of arrows hanging on the tree. Could this nymph be a living beauty from the Wittenburg court? She is certainly not an embodiment of an idealized, Classical Venus.

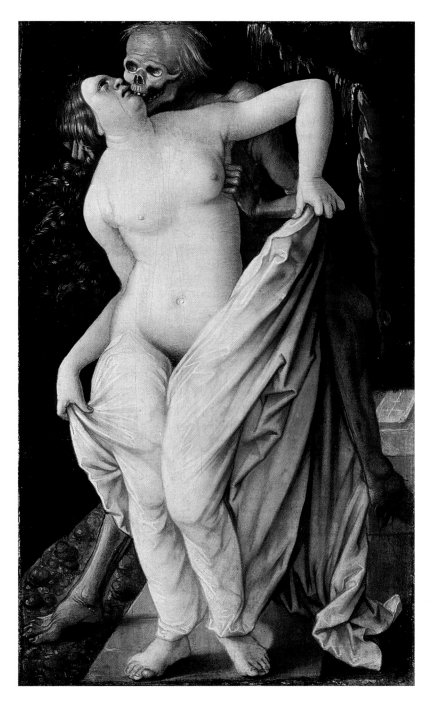

**21-10 • Hans Baldung Grien DEATH AND THE MATRON**
c. 1520–1525. Oil on wood panel, 12⅜ × 7⅜″ (31.3 × 18.7 cm). Öffentliche Kunstsammlung, Basel.

Although more erotically charged and certainly more dramatic than Dürer's Eve in FIG. 21–7, Baldung's woman is based in certain ways on this famous image, which was engraved while he was assisting in Dürer's workshop. In many respects, the similarities in pose (especially the feet) and form (wide hips with narrowing waist and torso) only point up the differences in expressive content.

HANS BALDUNG GRIEN. Cranach's slightly younger contemporary Hans Baldung (1484/1485–1545)—his nickname tag "Grien" ("green," apparently a favorite color) dates from his apprenticeship days and was used to distinguish him from the numerous other apprentices named Hans—is known for very different visualizations of women. Born into an affluent and well-educated family, Baldung was working in Strasbourg by 1500, before moving to Nuremberg in 1503 and eventually joining Dürer's workshop in 1505–1507. Over the course of his long career, he also worked in Halle and Freiburg, but his principal artistic home was Strasbourg, where he lived out a prosperous professional life as a painter, printmaker, and stained-glass designer.

During the first half of his career, Baldung created a series of paintings on the theme of **DEATH AND THE MATRON** that juxtapose sensuality with mortality, voluptuousness with decay, attraction with repulsion. The example in **FIG. 21–10**—painted in about 1520–1525 for a private collector in Basel—uses brilliant illumination and expansive posture to draw our attention first to the voluptuous nude, fleshier and considerably more sensual than Cranach's nymph (SEE FIG. 21–9) or Dürer's Eve (SEE FIG. 21–7). But this focus is soon overtaken by a sense of surprise that mirrors her own, as she turns her head to discover that the figure stroking her hair and clutching at her breast is not her lover but Death himself. The putrid decay of his yellowing flesh contrasts sharply

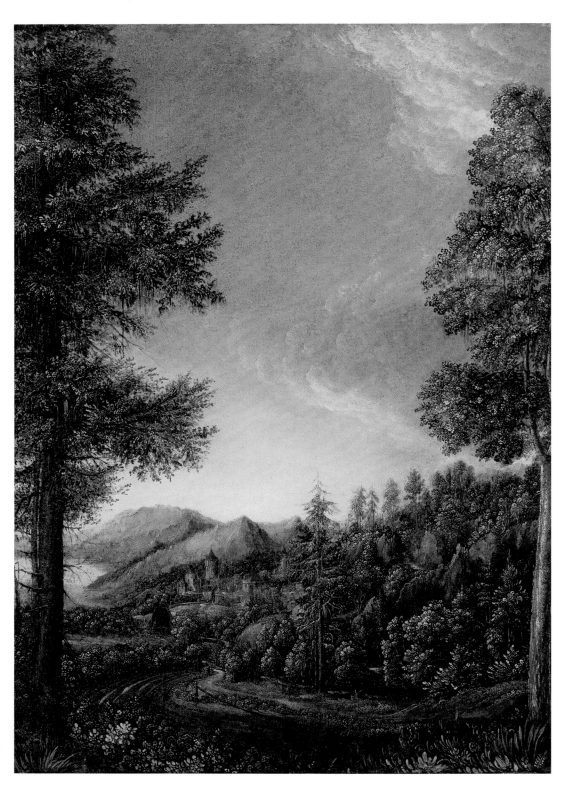

21–11 • Albrecht Altdorfer
**DANUBE LANDSCAPE**
c. 1525. Oil on vellum on wood
panel, 12 × 8½″
(30.5 × 22.2 cm).
Alte Pinakothek, Munich.

with her soft contours, and his bony molting head is the antithesis of her full pink cheeks, flowing tresses, and soft traces of body hair. That the encounter takes place in a cemetery, on top of a tombstone, serves to underline the warning against the transitory pleasures of the flesh, but Baldung also seems to depend on the viewers' own erotic engagement to make the message not only moral but personal.

ALBRECHT ALTDORFER.   Landscape, with or without figures, became a popular theme in the sixteenth century. In the fifteenth century, northern artists had examined and recorded nature with the care and enthusiasm of biologists, but painted landscapes were reserved for the backgrounds of figural compositions, usually sacred subjects. In the 1520s, however, religious art found little favor among Protestants. Landscape painting, on the other hand,

had no overt religious content, although it could be seen as a reflection or even glorification of God's works on Earth. The most accomplished German landscape painter of the period was Albrecht Altdorfer (c. 1480–1538).

Altdorfer probably received his early training in Bavaria from his father, but he became a citizen of Regensburg in 1505 and remained there painting the Danube River Valley for the rest of his life. **DANUBE LANDSCAPE** of about 1525 (FIG. 21–11) is an early example of pure landscape painting, without a narrative subject, human figures, or overt religious significance. A small work on vellum laid down on a wood panel, it shows a landscape that seems to be a minutely detailed reproduction of the natural terrain, but the forest seems far more poetic and mysterious than Dürer's or Cranach's carefully observed views of nature. The low mountains, gigantic lacy pines, neatly contoured shrubberies, and fairyland castle with red-roofed towers at the end of a winding path announce a new sensibility. The eerily glowing yellow–white horizon below moving gray and blue clouds in a sky that takes up more than half the composition prefigures the Romanticism of German landscape painting in later centuries.

# FRANCE

Renaissance France followed a different path from that taken in Germany. In 1519, Pope Leo X came to an agreement with French King Francis I (r. 1515–1547) that spared the country the turmoil suffered in Germany. Furthermore, whereas Martin Luther had devoted followers in France, French reformer John Calvin (1509–1564) fled to Switzerland in 1534, where he led a theocratic state in Geneva.

During the second half of the century, however, warring political factions favoring either Catholics or Huguenots (Protestants) competed to exert power over the French crown, with devastating consequences. In 1560, the devoutly Catholic Catherine de' Medici, widow of Henry II (r. 1547–1559), became regent for her young son, Charles IX, and tried, but failed, to balance the warring factions. Her machinations ended in religious polarization and a bloody conflict that began in 1562. When her third son, Henry III (r. 1574–1589), was murdered by a fanatical Dominican friar, a Protestant cousin, Henry, king of Navarre, the first Bourbon king, inherited the throne. Henry converted to Catholicism and ruled as Henry IV. Backed by a country sick of bloodshed, he quickly settled the religious question by proclaiming tolerance of Protestants in the Edict of Nantes in 1598.

### A FRENCH RENAISSANCE UNDER FRANCIS I

Immediately after his ascent to the throne, Francis I sought to "modernize" the French court by acquiring the versatile talents of Leonardo da Vinci, who moved to France in 1516. Officially, Leonardo was there to advise the king on royal architectural projects and, the king said, for the pleasure of his conversation. Francis supported an Italian-inspired Renaissance in French art and architecture throughout his long reign.

JEAN CLOUET.   Not all the artists working at the court of Francis I, however, were Italian. Flemish artist Jean Clouet (c. 1485–c. 1540) found great favor at the royal court, especially as a portrait painter. About the same time that he became principal court painter in 1527, he produced an official portrait of the king (FIG. 21–12). Clouet created a flattering image of Francis by modulating the king's distinctive features with soft shading and highlighting the nervous activity of his fingers. At the same time he conceived an image of pure power. Elaborate, puffy sleeves broaden the king's

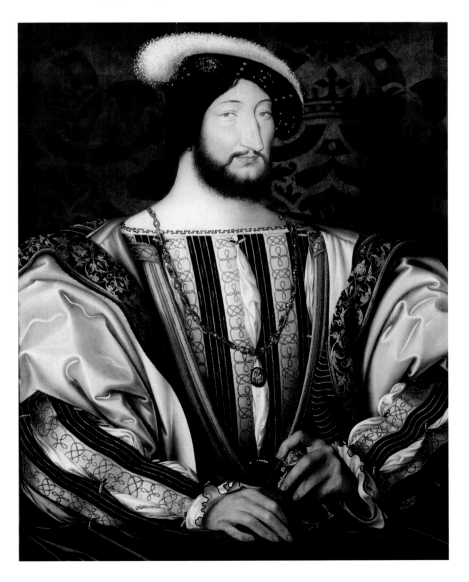

**21-12 • Jean Clouet FRANCIS I**
1525–1530. Oil and tempera on wood panel,
37¾ × 29⅛″ (95.9 × 74 cm). Musée du Louvre, Paris.

## The Castle of the Ladies

Women played an important role in the patronage of the arts during the Renaissance. Nowhere is their influence stronger than in the châteaux of the Loire River Valley. At Chenonceau, built beside and literally over the River Cher, a tributary of the Loire, women built, saved, and restored the château. Catherine Briconnet and her husband, Thomas Bohier, originally acquired the property, including a fortified mill, on which they built their country residence. Catherine supervised the construction, which included such modern conveniences as a straight staircase (an Italian and Spanish feature) instead of traditional medieval spiral stairs, and a kitchen inside the château instead of in a distant outbuilding. After Thomas died in 1524 and Catherine in 1526, their son gave Chenonceau to King Francis I.

King Henry II, Francis's son, gave Chenonceau to his mistress Diane de Poitiers in 1547. She managed the estate astutely, increased its revenue, developed the vineyards, added intricately planted gardens in the Italian style, and built a bridge across the Cher. When Henry died in a tournament, his queen, Catherine de' Medici (1519–1589), appropriated the château for herself.

Catherine, like so many in her family a great patron of the arts, added the two-story gallery to the bridge at Chenonceau, as well as outbuildings and additional formal gardens. Her parties were famous: mock naval battles on the river, fireworks, banquets, dances, and on one occasion two choruses of young women dressed as mermaids in the moat and nymphs in the shrubbery—who were then chased about by young men costumed as satyrs!

When Catherine's third son became king as Henry III in 1574, she gave the château to his wife, Louise of Lorraine, who lived in mourning at Chenonceau after Henry III was assassinated in 1589. She wore only white and covered the walls, windows, and furniture in her room with black velvet and damask. She gave Chenonceau to her niece when she died.

In the eighteenth and nineteenth centuries, the ladies continued to determine the fate of Chenonceau. During the French Revolution (1789–1793), the owner, Madame Dupin, was so beloved by the villagers that they protected her and saved her home. Then, in 1864, Madame Pelouze bought Chenonceau and restored it by removing Catherine de' Medici's Italian "improvements."

Chenonceau continued to play a role in the twentieth century. During World War I, it was used as a hospital. During the German occupation in World War II (1940–1942), when the River Cher formed the border with Vichy "Free" France, the gallery bridge at Chenonceau became an escape route.

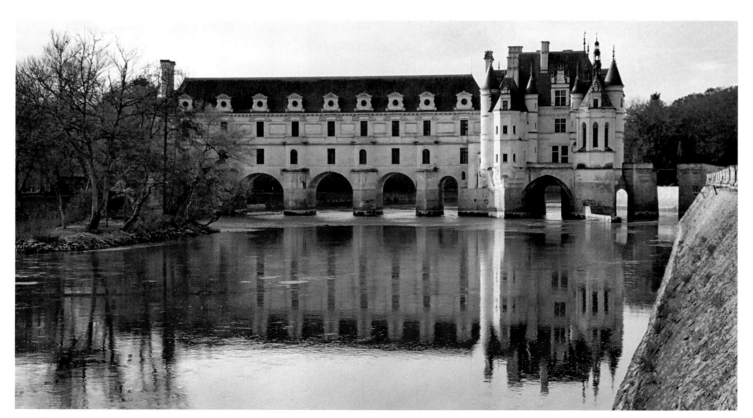

**CHÂTEAU OF CHENONCEAU**
Touraine, France. Original building (at right) 1513–1521; gallery on bridge at left by Philibert de l'Orme, finished c. 1581.

shoulders to fill the entire width of the panel, much as Renaissance parade armor turned scrawny men into giants. The detailed rendering of the delicately worked costume of silk, satin, velvet, jewels, and gold embroidery could be painted separately from the portrait itself. Royal clothing was often loaned to the artist or modeled by a servant to spare the "sitter" the boredom of posing. In creating such official portraits, the artist sketched the subject, then painted a prototype that, upon approval, became the model for numerous replicas made for diplomatic and family purposes.

THE CHÂTEAU OF CHENONCEAU. With the enthusiasm of Francis for things Italian and the widening distribution of Italian books on architecture, the Italian Renaissance style soon infiltrated French architecture. Builders of elegant rural palaces, called **châteaux**, were quick to introduce Italianate decoration to otherwise Gothic buildings, but French architects soon adapted Classical principles of building design as well.

One of the most beautiful châteaux was not built as a royal residence, although it soon became one. In 1512, Thomas Bohier, a royal tax collector, bought the castle of Chenonceau on the River Cher, a tributary of the Loire (see "The Castle of the Ladies," opposite). He demolished the old castle, leaving only a tower. Using the piers of a water mill on the river bank as part of the foundations, he and his wife erected a new Renaissance home. The plan reflects the Classical principles of geometric regularity and symmetry—a rectangular building with rooms arranged on each side of a wide central hall. Only the library and chapel, which are corbelled out over the water, break the line of the walls. In the upper story, the builders used traditional features of medieval castles—

battlements, corner turrets, steep roofs, and dormer windows. The owners died soon after the château was finished in 1521, and their son gave it to Francis I, who turned it into a hunting lodge.

Later, Roman-trained French Renaissance architect Philibert de l'Orme (d. 1570) designed a gallery on a bridge across the river for Catherine de' Medici, completed about 1581 and incorporating contemporary Italianate window treatments, wall molding, and cornices that harmonized almost perfectly with the forms of the original turreted building.

FONTAINEBLEAU. Having chosen as his primary residence the medieval hunting lodge at Fontainebleau, Francis I began transforming it into a grand country palace. In 1530, he imported a Florentine artist, the Mannerist painter Rosso Fiorentino (1495–1540), to direct the project. After Rosso died, he was succeeded by his Italian colleague Francesco Primaticcio (1504–1570), who had earlier worked with Giulio Romano in Mantua (SEE FIG. 20–18), then joined Rosso in 1532, and would spend the rest of his career working on the decoration of Fontainebleau. During that time, he also commissioned and imported a large number of copies and casts of original Roman sculpture, from the newly discovered Laocoön (SEE FIG. 5–55) to the relief decoration on the Column of Trajan (SEE FIG. 6–44). These works provided an invaluable visual resource of figures and techniques for the northern European artists employed on the Fontainebleau project.

Among Primaticcio's first projects at Fontainebleau was the redecoration, in the 1540s, of the rooms of the king's official mistress, Anne, duchess of Étampes (FIG. 21–13). The artist

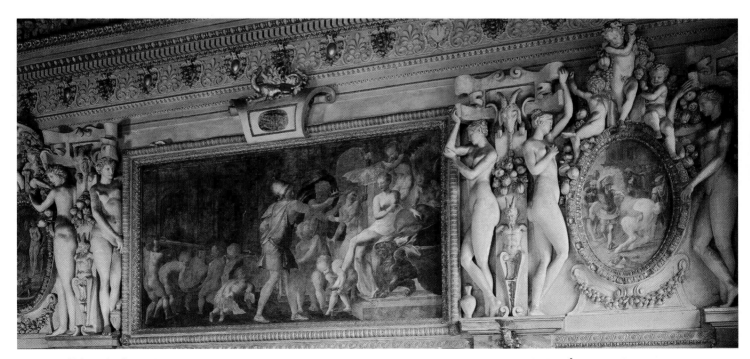

21-13 • Primaticcio  STUCCO AND WALL PAINTING, CHAMBER OF THE DUCHESS OF ÉTAMPES, CHÂTEAU OF FONTAINEBLEAU
France. 1540s.

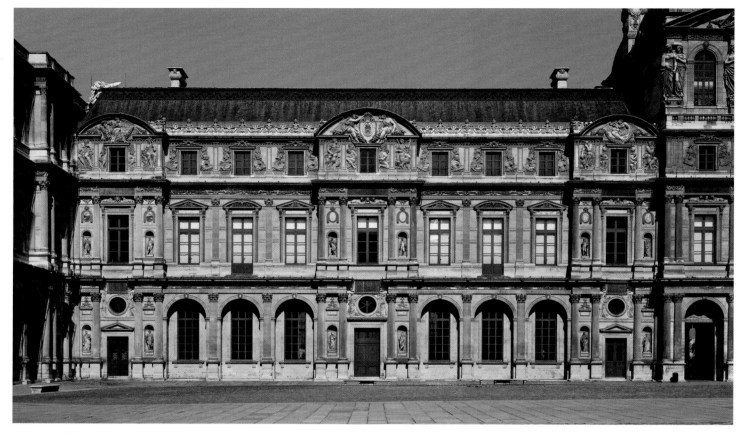

**21-14** • Pierre Lescot and Jean Goujon  **WEST WING OF THE COUR CARRÉE, PALAIS DU LOUVRE**
Paris. Begun 1546.

combined woodwork, stucco relief, and fresco painting in his complex but whimsical and graceful interior design. The lithe figures of stucco nymphs, with their elongated bodies and small heads, recall Parmigianino's paintings (SEE FIG. 20–27). Their spiraling postures and teasing bits of clinging drapery are playfully erotic. Garlands, mythological figures, and Roman architectural ornament almost overwhelm the walls with visual enrichment, yet the whole remains ordered and lighthearted. The first School of Fontainebleau, as this Italian phase of the palace decoration is called, established an Italianate tradition of Mannerism in painting and interior design that spread to other centers in France and into the Netherlands.

THE LOUVRE.   Before the defeat of Francis I at Pavia by Holy Roman Emperor Charles V, and the king's subsequent imprisonment in Spain in 1525, the French court had been a mobile unit, and the locus of French art resided outside Paris in the Loire Valley. After his release in 1526, Francis made Paris his bureaucratic seat, and the Île-de-France—Paris and its region—took the artistic lead. The move to the capital gave birth to a style of French Classicism when Francis I and Henry II decided to modernize the medieval castle of the Louvre. Work began in 1546, with the replacement of the west wing of the square court, or **COUR CARRÉE** (FIG. **21–14**), by architect Pierre Lescot (c. 1510–1578) working with sculptor

Jean Goujon (1510–1568). They designed a building that incorporated Renaissance ideals of balance and regularity with Classical architectural details and rich sculptural decoration. The irregular rooflines seen in a château such as the one at Chenonceau (see "The Castle of the Ladies," page 690, right side of the photograph) gave way to discreetly rounded arches and horizontal balustrades. Classical pilasters and entablatures replaced Gothic buttresses and stringcourses. A round-arched arcade on the ground floor suggests an Italian loggia. On the other hand, the sumptuousness of the decoration recalls the French Flamboyant style (see Chapter 18), only with Classical pilasters and acanthus replacing Gothic colonnettes and cusps.

# SPAIN AND PORTUGAL

The sixteenth century saw the high point of Spanish political power. The country had been united in the fifteenth century by the marriage of Isabella of Castile and Ferdinand of Aragon. Only Navarre (in the Pyrenees) and Portugal remained outside the union of the crowns. (See "Sculpture for the Knights of Christ at Tomar," opposite.) When Isabella and Ferdinand's grandson Charles V abdicated in 1556, his son Philip II (r. 1556–1598) became the king of Spain, the Netherlands, and the Americas, as well as ruler of Milan, Burgundy, and Naples, but Spain was

# Sculpture for the Knights of Christ at Tomar

One of the most beautiful, if also one of the strangest, sixteenth-century sculptures in Portugal seems to float over the cloisters of the Convent of Christ in Tomar. Unexpectedly, in the heart of the castle-monastery complex, one comes face to face with the Old Man of the Sea. He supports on his powerful shoulders an extraordinary growth—part roots and trunk of a gnarled tree; part tangled mass of seaweed, algae, ropes, and anchor chains. Barnacle- and coral-encrusted piers lead the eye upward, revealing a large lattice-covered window, the great west window of the church of the Knights of Christ.

When, in 1314, Pope Clement V disbanded the Templars (a monastic order of knights founded in Jerusalem after the First Crusade), King Dinis of Portugal offered them a renewed existence as the Knights of Christ. As a result, in 1356, they made the former Templar castle and monastery in Tomar their headquarters. When Prince Henry the Navigator (1394–1460) became the grand master of the order, he invested their funds in the exploration of the African coast and the Atlantic Ocean. The Templar insignia, the squared cross, became the emblem used on the sails of Portuguese ships.

King Manuel I of Portugal (r. 1495–1521) commissioned the present church, with its amazing sculpture by Diogo de Arruda, in 1510. So distinctive is the style developed under King Manuel by artists like the Arruda brothers, Diogo (active 1508–1531) and Francisco (active 1510–1547), that Renaissance art in Portugal is called "Manueline." In the window of Tomar, every surface is carved with architectural and natural detail associated with the sea. Twisted ropes form the corners of the window; the coral pillars support great swathes of seaweed. Chains and cables drop through the watery depths to the place where the head of a man—could this Old Man of the Sea be a self-portrait of Diogo de Arruda?—emerges from the roots of a tree. Above the window, more ropes, cables, and seaweed support the emblems of the patron—armillary spheres at the upper outside corners (topped by pinnacles) and at dead center, the coat of arms of Manuel I with its Portuguese castles framing the five wounds of Christ. Topping the composition is the square cross of the Order of Christ—clearly delineated against the wall of the chapel.

The armillary sphere became a symbol of the era. This complex form of a celestial globe, with the sun at the center surrounded by rings marking the paths of the planets, was a teaching device that acknowledged the new scientific theory that the sun, not the Earth, is the center of the solar system. (Copernicus, teaching in Germany at this time, only published his theories in 1531 and 1543.) King Manuel's use of the armillary sphere as his emblem signals his determination to make Portugal the leader in the exploration of the sea. Indeed, in Manuel's reign the Portuguese reached India and Brazil.

Diogo de Arruda **WEST WINDOW, CHURCH IN THE CONVENT OF CHRIST**
Tomar, Portugal. c. 1510. Commissioned by King Manuel I of Portugal.

Philip's permanent residence. For more than half a century, he supported artists in Spain, Italy, and the Netherlands. His navy, the famous Spanish Armada, halted the advance of Islam in the Mediterranean and secured control of most American territories. Despite enormous effort, however, Philip could not suppress the revolt of the northern provinces of the Netherlands, nor could he prevail in his war against the English, who destroyed his navy in 1588. He was able to gain control of the entire Iberian peninsula, however, by claiming Portugal in 1580, and it remained part of Spain until 1640.

## ARCHITECTURE

Philip built **THE ESCORIAL** (FIG. 21–15), the great monastery-palace complex outside Madrid, partly to comply with his father's direction to construct a "pantheon" in which all Spanish kings might be buried and partly to house his court and government. In 1559, Philip summoned from Italy Juan Bautista de Toledo (d. 1567), who had been Michelangelo's supervisor of work at St. Peter's from 1546 to 1548. Juan Bautista's design for the monastery-palace reflected his indoctrination in Bramante's Classical principles in Rome, but the king himself dictated the severity and size of the structure. The Escorial's grandeur comes from its overwhelming size, fine proportions, and excellent masonry. The complex includes not only the royal residence but also the Royal Monastery of San Lorenzo, a school, a library, and a church, its crypt serving as the royal burial chamber. The plan was said to resemble a gridiron, the instrument of martyrdom of its patron saint, Lawrence, who was roasted alive.

In 1572, Juan Bautista's assistant, Juan de Herrera, was appointed architect, and he immediately changed the design, adding second stories on all wings and breaking the horizontality of the main façade with a central frontispiece that resembled the superimposed temple fronts that were fashionable on Italian churches at this time (SEE FIGS. 20–36, 20–38). Before beginning the church in the center of the complex, Philip solicited the advice of Italian architects—including Vignola and Palladio. The final design combined ideas that Philip approved and Herrera carried out, and it embodies Italian Classicism in its geometric clarity, symmetry, and superimposed temple-front façade. In its austerity, it embodies the deep religiosity of Philip II.

## PAINTING

Although Philip II was a great patron of the Venetian painter Titian, and he collected Netherlandish artists such as Bosch, the most famous painter working in Spain during the last quarter of the sixteenth century is Domenikos Theotokopoulos (1541–1614), who arrived in Spain in 1577 after working for ten years in Italy. "El Greco" ("The Greek"), as he is called, was trained as an icon painter in the Byzantine manner in his native Crete, then under Venetian rule. In about 1566, he went to Venice and entered Titian's studio, where he also studied the paintings of Tintoretto and Veronese. From about 1570 to 1577, he worked in Rome, apparently without finding sufficient patronage, although he lived for a time in the Farnese Palace. Probably encouraged by Spanish church officials whom he met in Rome, El Greco settled in Toledo, seat of the Spanish archbishop. He had hoped for a court appointment, but Philip II disliked the painting he had commissioned from El Greco for The Escorial and never again gave him work.

In Toledo, El Greco joined the circle of humanist scholars. He wrote that the artist's goal should be to copy nature, that Raphael relied too heavily on the ancients, and that the Italians' use of mathematics to achieve ideal proportions hindered their painting of nature. At this same time an intense religious revival was under way in Spain, expressed in the impassioned preaching of Ignatius of Loyola, as well as in the poetry of two great Spanish mystics: St. Teresa of Ávila (1515–1582) and her follower St. John of the Cross (1542–1591). El Greco's style—rooted in Byzantine icon painting and strongly reflecting the rich colors and loose brushwork of Venetian painting—was well equipped to express the intense spirituality of these mystics.

In 1586, the Orgaz family commissioned El Greco to paint a large altarpiece honoring an illustrious fourteenth-century ancestor. Count Orgaz had been a great benefactor of the Church, and at his funeral in 1323, SS. Augustine and Stephen were said to have appeared to lower his body into his tomb as his soul was seen ascending to heaven. El Greco's painting the **BURIAL OF COUNT ORGAZ** (FIG. 21–16) captures these miracles. An angel lifts Orgaz's

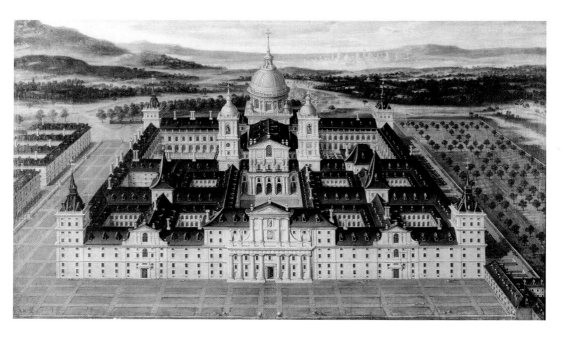

**21-15 • Juan Bautista de Toledo and Juan de Herrera**
**THE ESCORIAL**
Madrid. 1563–1584. Detail from an anonymous 18th-century painting.

**SEE MORE:** Click the Google Earth link for The Escorial
**www.myartslab.com**

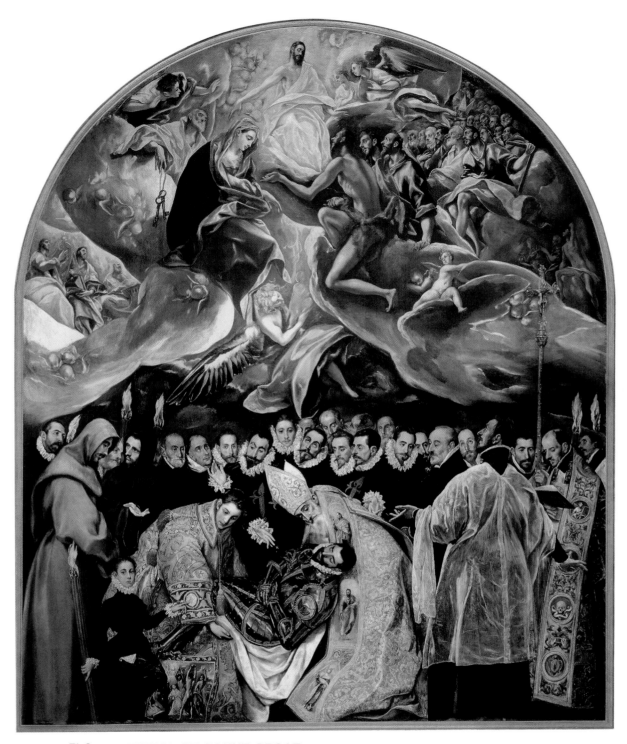

**21-16 • El Greco BURIAL OF COUNT ORGAZ**
1586. Oil on canvas, 16′ × 11′10″ (4.88 × 3.61 m). Church of Santo Tomé, Toledo, Spain.

ghostly soul along the central axis of the painting toward the enthroned Christ at the apex of the canvas. El Greco filled the space around the burial scene with portraits of the local aristocracy and religious notables. He placed his own 8-year-old son at the lower left next to St. Stephen and signed the painting on the boy's white kerchief. El Greco may also have put his own features on the man just above the saint's head, the only other

figure who, like the child, looks straight out at the viewer.

In composing the painting, El Greco used Mannerist devices reminiscent of Pontormo (SEE FIG. 20–26), packing the pictorial field with figures and eliminating specific reference to the spatial setting. Yet he has distinguished between heaven and earth by the light emanating from Christ, whose otherworldly luminescence is quite unlike the natural light below.

# THE NETHERLANDS

In the Netherlands, the sixteenth century was an age of bitter religious and political conflict. Despite the opposition of the Spanish Habsburg rulers, the Protestant Reformation took hold in the northern provinces. Seeds of unrest were sown still deeper over the course of the century by continued religious persecution, economic hardship, and inept governors. Widespread iconoclasm characterized 1566–1567, and a long battle for independence began with a revolt in 1568 that lasted until Spain relinquished all claims to the region 80 years later. As early as 1579, when the seven northern Protestant provinces declared themselves the United Provinces, the discord split the Netherlands, eventually dividing it along religious lines into the United Provinces (the present-day Netherlands) and Catholic Flanders (present-day Belgium).

Even with the turmoil, the Netherlanders found the resources to pay for art, and Antwerp and other cities developed into thriving art centers. The Reformation led artists to seek patrons outside the Church. While courtiers and burghers alike continued to commission portraits, the demand arose for small paintings with interesting secular subjects appropriate for homes. For example, some artists became specialists known for their landscapes or satires. In addition to painting, textiles, ceramics, printmaking, and sculpture in wood and metal flourished in the Netherlands. Flemish tapestries were sought after and highly prized across Europe, as they had been in the fifteenth century, and leading Italian artists made cartoons to be woven into tapestries in Flemish workshops (see "Raphael's Cartoons for Tapestries in the Sistine Chapel," pages 646–647). The graphic arts emerged as an important medium, providing many artists with another source of income. Pieter Bruegel the Elder began his career drawing amusing and moralizing images to be printed and published by At the Four Winds, an Antwerp publishing house. Artists such as Hendrick Goltzius, who traveled with sketchbook in hand, turned their experiences to profit when they returned home.

Like Vasari in Italy, Carel van Mander (1548–1606) recorded the lives of his Netherlandish contemporaries in engaging biographies that mix fact and gossip. He, too, intended his 1604 book *Het Schilder-boeck* (*The Painter's Book*) to be a survey of the history of art, and he included material from the ancient Roman writers Pliny and Vitruvius as well as from Vasari's revised and expanded *Lives*, published in 1568.

## ART FOR ARISTOCRATIC AND NOBLE PATRONS

Artistic taste among the wealthy bourgeoisie and noble classes in the early sixteenth-century Netherlands was characterized by a striking diversity, encompassing the imaginative and difficult visions of Hieronymus Bosch, as well as the more Italianate compositions of Jan Gossaert. In the later years of his life, Bosch's membership in a local but prestigious confraternity called the Brotherhood of Our Lady seems to have opened doors to noble patrons such as Count Hendrick III of Nassau and Duke Philip the Fair. His younger contemporary Gossaert left the city of Antwerp as a young man to spend the majority of his active years as the court painter for the natural son of Duke Philip the Good. His art also attracted members of the Habsburgs, including Charles V, who were seduced by Gossaert's combination of northern European and Italian styles.

HIERONYMUS BOSCH.    Among the most fascinating Netherlandish painters to modern viewers is Hieronymus Bosch (1450–

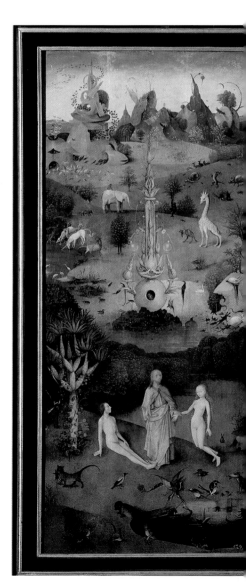

**21-17 • Hieronymus Bosch  GARDEN OF EARTHLY DELIGHTS (OPEN)**
c. 1505–1515. Oil on wood panel, center panel 7′2½″ × 6′4¾″ (2.20 × 1.95 m), each wing 7′2½″ × 3′2″ (2.20 × 0.97 m). Museo del Prado, Madrid.

Despite—or perhaps because of—its bizarre subject matter, this triptych was woven in 1566 into tapestries, and at least one painted copy was made as well. Bosch's original triptych was sold at the onset of the Netherlands Revolt and sent in 1568 to Spain, where it entered the collection of Philip II.

**EXPLORE MORE:** Gain insight from a primary source on Hieronymus Bosch
**www.myartslab.com**

1516), who depicted the sort of imaginative fantasies more often associated with medieval than Renaissance art. A superb colorist and virtuoso technician, Bosch spent his career in the town whose name he adopted, 's-Hertogenbosch. Bosch's religious devotion is certain, and his range of subjects shows that he was well educated. Challenging and unsettling paintings such as his **GARDEN OF EARTHLY DELIGHTS** (FIG. **21–17**) have led modern scholars to label Bosch both a mystic and a social critic. The subject of the triptych seems to be founded on Christian belief in the natural state of human sinfulness, but it was not painted for a church.

In the left wing, God introduces doll-like figures of Adam and Eve, under the watchful eye of the owl of perverted wisdom. The owl symbolizes both wisdom and folly. Folly had become an important concept to the northern European humanists, who believed in the power of education. They believed that people would choose to follow the right way once they knew it. Here the owl peers out from an opening in the spherical base of a fantastic

pink fountain in a lake from which vicious creatures creep out into the world.

In the central panel, the Earth teems with such monsters, but also with vivacious human revelers and luscious huge fruits, symbolic of fertility and sexual abandon. In hell, at the right, sensual pleasures—eating, drinking, music, and dancing—become instruments of torture in a dark world of fire and ice. The emphasis in the right wing on the torments of hell, with no hint of the rewards of heaven, seems to caution that damnation is the natural outcome of a life lived in ignorance and folly, that humans ensure their damnation through their self-centered pursuit of pleasures of the flesh—the sins of gluttony, lust, greed, and sloth—outlined with such fantastic and graphic abandon in the central panel.

One scholar has proposed that the central panel is a parable on human salvation in which the practice of alchemy—the process that sought to turn common metals into gold—parallels Christ's power to convert human dross into spiritual gold. In this theory, the bizarre fountain at the center of the lake in the middle distance can

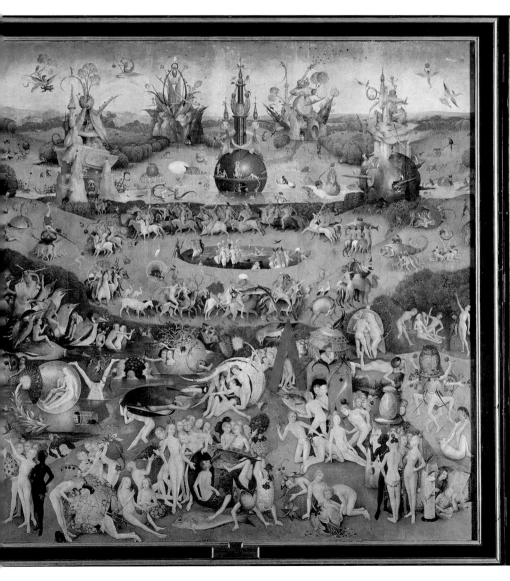

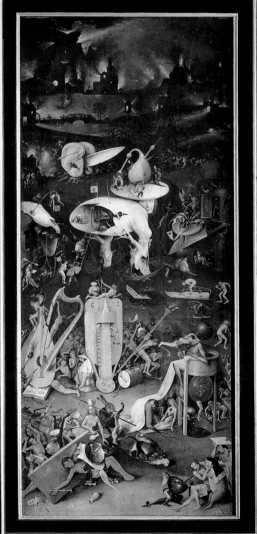

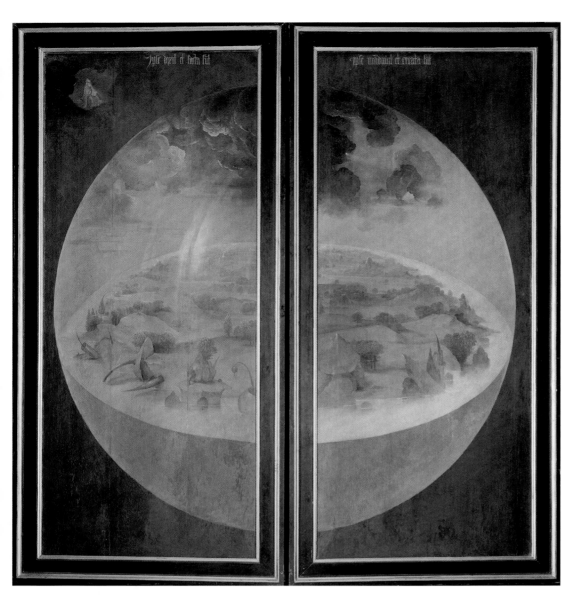

21–18 • Hieronymus Bosch **GARDEN OF EARTHLY DELIGHTS (CLOSED)**

be seen as an alchemical "marrying chamber," complete with the glass vessels for collecting the vapors of distillation. Others see the theme known as "the power of women." In this interpretation, the central pool is the setting for a display of seductive women and sex-obsessed men. Women frolic alluringly in the pool while men dance and ride in a mad circle trying to attract them. In this strange garden, men are slaves to their own lust. An early seventeenth-century critic focused on the fruit, writing that the triptych was known as *The Strawberry Plant* because it represented the "vanity and glory and the passing taste of strawberries or the strawberry plant and its pleasant odor that is hardly remembered once it has passed." Luscious fruits of obvious sexual symbolism—straw-berries, cherries, grapes, and pomegranates—appear every-where in the garden, serving as food, as shelter, and even as a boat. Is human life as fleeting and insubstantial as the taste of a straw-berry? Yet another modern reading sees the central tableau imagin-ing the course of life in paradise, assuming that Adam and Even had not consigned humanity to sin by eating the forbidden fruit.

Conforming to a long tradition of triptych altarpieces made for churches, Bosch painted a more sober, *grisaille* picture on the reverse of the side wings. When the triptych is closed, a less enigmatic, but equally fascinating, scene is displayed **(FIG. 21–18)**. A transparent, illusionistic rendering of a receding sphere floating within a void encloses the flat circular shelf of Earth on its third day of creation. Fragments of the fantastic fruit that will appear fully formed in the interior pictures float here in the primordial sea, while ominous dark clouds promise the rain that will nurture them into their full seductive ripeness. A tiny crowned figure of God the Creator hovers in a bubble within dark clouds at upper left, displaying a book, perhaps a Bible opened to the words from Psalm 33:9 that are inscribed across the top: "For he spoke, and it came to be; he commanded, and it stood firm."

The *Garden of Earthly Delights* was commissioned by an aristocrat (probably Count Hendrick III of Nassau) for his Brussels town house, and the artist's choice of a triptych format, which suggests an altarpiece, may have been an understated irony. In a

private home the painting surely inspired lively discussion, even ribald commentary, much as it does today in the Prado Museum. Perhaps that, rather than a single meaning or interpretation, is the true intention behind this dazzling display of artistic imagination.

JAN GOSSAERT. In contrast to the private visions of Bosch, Jan Gossaert (c. 1478–c. 1533) maintained traditional subject matter and embraced the new Classical art of Italy. Gossaert (who later called himself Mabuse after his native city Maubeuge) entered the service of Philip, the illegitimate son of the duke of Burgundy, accompanying him to Italy in 1508, and remaining in his service after Philip became archbishop of Utrecht in 1517.

Gossaert's "Romanizing" style—inspired by Italian Mannerist paintings and decorative details drawn from ancient Roman art—is evident in his painting of **ST. LUKE DRAWING THE VIRGIN MARY** **(FIG. 21–19)**, a traditional subject we already know from a painting

**21-19 • Jan Gossaert**
**ST. LUKE DRAWING THE VIRGIN MARY**
1520. Oil on panel, 43⅜ × 32¼″ (110.2 × 81.9 cm). Kunsthistorisches Museum, Vienna.

by Rogier van der Weyden (SEE FIG. 18–14). In Gossaert's version, the artist's studio is an extraordinary structure of Classical piers and arches, carved with a dense ornament of foliage and medallions. Mary and the Christ Child appear in a blaze of golden light and clouds before the saint, who kneels at a desk, his hand guided by an angel as he records the vision in a drawing. Luke's crumpled red robe replicates fifteenth-century drapery conventions in a seeming reference to Rogier's famous picture. Seated above and behind Luke on a round, columnar structure, Moses holds the Tablets of the Law, referencing his own visions of God on Mount Sinai. Just

as Moses had removed his shoes in God's presence, so has Luke in the presence of his vision. Gossaert, like Dürer before him, seems to be staking a claim for the divine inspiration of the artist.

## ANTWERP

During the sixteenth century, Antwerp was the commercial and artistic center of the southern Netherlands. Its deep port made it an international center of trade (it was one of the European centers for trade in spices), and it was the financial center of Europe. Painting, printmaking, and book production flourished in this

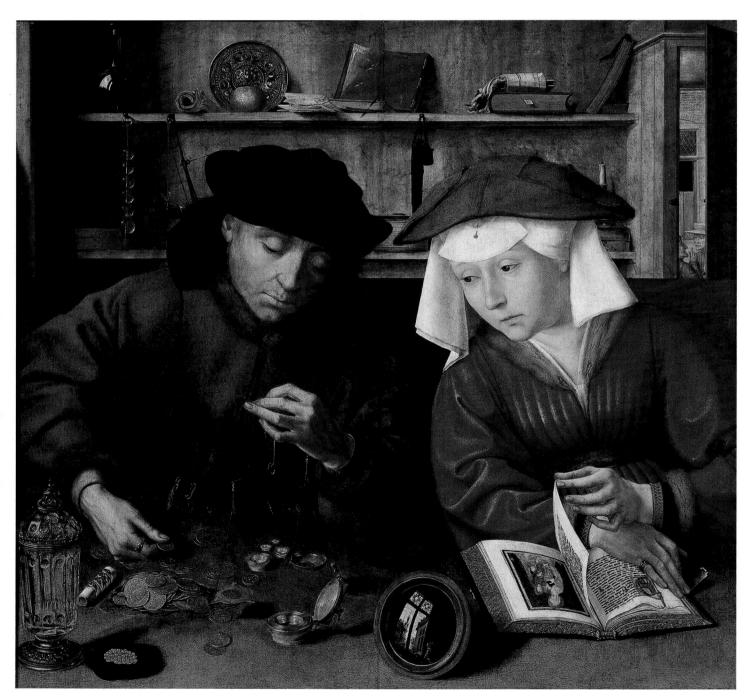

**21–20 • Quentin Massys MONEY CHANGER AND HIS WIFE**
1514. Oil on panel, 28 × 26¾″ (71.2 × 68 cm). Kunsthistorisches Museum, Vienna.

environment, attracting artists and craftsmen from all over Europe. The demand for luxury goods fostered the birth of the art market, in which art was transformed into a commodity for both local and international consumption. In responding to this market system, many artists became specialists in one area, such as portraiture or landscape, working with art dealers, who emerged as middlemen, further shaping the commodification of art, its production, and its producers.

QUENTIN MASSYS. Early accounts of the prosperous Antwerp artist Quentin Massys (1466–1530) claim that he began working in his native Louvain as a blacksmith (his father's profession) but changed to painting to compete with a rival for the affections of a young woman; Carel van Mander claims he was a self-trained artist. We know he entered the Antwerp painters' guild in 1491, and at his death in 1530 he was among its most prosperous and renowned members, supervising a large workshop to meet the market in this burgeoning art center.

One of his most fascinating paintings—**MONEY CHANGER AND HIS WIFE (FIG. 21–20)**—recalls, like Gossaert's *St. Luke*, a famous fifteenth-century work, in this case the picture of a goldsmith painted for the Antwerp goldsmiths' guild by Petrus Christus (see "A Closer Look," page 581). Here, however, a couple is in charge of business, and they present us with two different profiles of engagement. The soberly dressed proprietor himself focuses intently on weighing coins in a suspended balance. His brightly outfitted wife —dressed in an archaic fifteenth-century costume that harks back to a golden age of Flemish painting—looks to the side, distracted by her husband's activity from the attention she was giving to the meticulously described Book of Hours spread out on the table in front of her. It would be easy to jump to the conclusion that this is a moral fable, warning of the danger of losing "sight" of religious obligations because of a preoccupation with affairs of business. But the painting is not that simple. An inscription that ran around the original frame quoted Leviticus 19:36—"You shall have honest balances and honest weights"—claiming just business practices as a form of righteous living. Is it possible the moral here juxtaposes not worldliness and spirituality, but attentive and distracted devotional practice? The sidetracked wife seems to have been idly flipping through her prayer book before turning to observe what her husband is doing, whereas a man in a red turban reflected in the convex mirror next to her Book of Hours is caught in rapt attention to the book in front of him, and the nature of his reading is suggested by

21-21 • Caterina van Hemessen **SELF-PORTRAIT**
1548. Oil on wood panel, 12¼ × 9¼″ (31.1 × 23.5 cm). Öffentliche Kunstsammlung, Basel, Switzerland.

the church steeple through the window behind him. The sermon here concerns the challenge of godly living in a worldly society, but wealth itself is not necessarily the root of the problem.

CATERINA VAN HEMESSEN. Antwerp painter Caterina van Hemessen (1528–1587) developed an illustrious reputation as a portraitist. She had learned to paint from her father, the Flemish Mannerist Jan Sanders van Hemessen, who was dean of the Antwerp painters' guild in 1548, but the quiet realism and skilled rendering of her subjects is distinctively her own. To maintain focus on her foreground subjects, van Hemessen painted them against even, dark-colored backgrounds, on which she identified the sitter by name and age, signing and dating each work. The inscription in her **SELF-PORTRAIT (FIG. 21–21)** reads: "I Caterina van Hemessen painted myself in 1548. Her age 20." In delineating

# THE OBJECT SPEAKS

## Bruegel's Cycle of the Months

Cycles, or series, of paintings unified by a developing theme or allegorical subject—for instance, the Times of the Day, the Four Seasons, or the Five Senses—became popular wall decorations in prosperous Flemish homes during the sixteenth century. In 1565, Pieter Bruegel the Elder was commissioned to paint a series of six large paintings, each over 5 feet wide, surveying the months of the year, two months to a picture. They were made to be hung together in a room—probably the dining room since food figures prominently in these pictures—in the suburban villa of wealthy merchant Niclaes Jonghelinck, just outside Antwerp.

*Return of the Hunters* (FIG. A) represents December and January. The bleak landscape is gripped by winter as hunters return home at dusk with meager results: a single rabbit slung over the largest man's shoulder. But the landscape, rather than the figures, seems to be the principal subject here. A row of trees forms a receding set, consistently diminishing in scale, to draw our attention into the space of the painting along the orthogonal descent on the hillside of houses on the left. Like the calendar illustrations of medieval Books of Hours, the landscape is filled with behavior emblematic of the time of year: the singeing of the pig outside the farmhouse at left, the playful movement of ice skaters across frozen fields. We see it all from an omnipotent elevated viewpoint, like one of the birds that perch in the trees or glide across the snow-covered fantasy of an alpine background.

The mood is very different in the painting representing the hazy late summer days of August and September (FIG. B). Birds still perch and glide, and a silhouetted tree still dominates the foreground—as if Bruegel wanted to set up obvious relationships between the scenes so that viewers would assess them comparatively—but the setting here is more rural than residential. Architecture keeps its distance or is screened by foliage. Agricultural workers trudge through their labor, harvesting grain, and gathering stalks into tidy sheaves, ready for transport. The figural focus, however, is in the foreground, on a

**A.** Pieter Bruegel the Elder **RETURN OF THE HUNTERS**
1565. Oil on wood panel, 3′10½″ × 5′3¾″ (1.18 × 1.61 m). Kunsthistorisches Museum, Vienna.

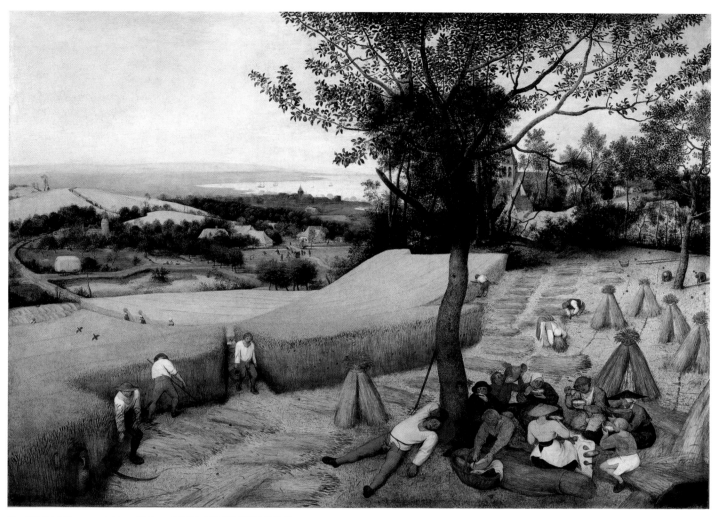

**B.** Pieter Bruegel the Elder **THE HARVESTERS**
1565. Oil on wood panel, 46⅞ × 63¾″ (1.17 × 1.6 m). Metropolitan Museum of Art, New York.

shift of workers on their lunch break—serving themselves from baskets, gnawing on hard pieces of bread, spooning milk from bowls, or gulping from an uplifted jug. One man takes the opportunity of this break for a quick nap. Some have seen in this lounging figure an emblem of sloth, or a wanton display of uncouth behavior, reminiscent of the embarrassing exposure of the peasant couple invited in to warm themselves before the fire in the farmhouse of the February page of Duke Jean de Berry's *Très Riches Heures* (SEE FIG. 18–4), painted by the Netherlandish Limbourg brothers a century and a half earlier.

Indeed, Bruegel's series of the months invites comparison with this venerable tradition—dating to the early Middle Ages—of showing peasant activity within the calendar cycles of prayer books made for wealthy patrons. Were they amused by peasant behavior? Did they enjoy representations of the productivity of their land and the availability of willing laborers to work it? Or do these vignettes embody their own longings for a simpler life, idealized for them as a harmony between the natural world and the people who live on it, and off it? But the peasants enjoying the good life in this sunny scene of harvesting are only on a lunch break. Another shift is already hard at work in the fields, and the wealth of the patrons who supported the growth of an art market was dependent on the labor of countless folks like them.

**EXPLORE MORE:** Gain insight from a primary source on Pieter Bruegel **www.myartslab.com**

## The French Ambassadors ►

by Hans Holbein the Younger. 1533. Oil on wood panel. 81⅛ × 82⅝″ (2.07 × 2.1 m). National Gallery, London.

Embossing on the sheath of the dagger tells us that de Dinteville is 28, while an inscription on the edge of the book (Bible?) under de Selve's arm records that he is 24.

This globe has Polisy, the de Dinteville family estate, marked at the center. It was here that this painting was hung when the ambassador returned to France at the end of 1533.

These objects on the top shelf were used to observe natural heavenly phenomena and chart the passage of time. The items displayed on the lower shelf relate more to terrestrial concerns.

Music is a common symbol of harmony in this period, and the broken string on this lute has been understood as an allusion to the discord created by the sweep of Protestant reform across Europe.

This bizarre, but prominently placed skull—as well as the skull badge that appears on de Dinteville's cap—reminded viewers of their own mortality. The foreground skull is distorted by anamorphosis, in which images are stretched horizontally with the use of a trapezoidal grid so that they must be viewed from the side to appear correctly proportioned.

This pavement—known as "Cosmati work" after the thirteenth-century Italian family that specialized in it—is copied from the floor in Westminster Abbey and may proclaim the ambassadors' involvement in a holy enterprise of reconciliation. The artist signed the painting on the left edge of the floor: "Johannes Holbein pingebat, 1533."

This is a Lutheran hymnal published in 1527, open at one of Luther's best-known compositions: "Come, Holy Ghost, our souls inspire." Neither man was a Protestant, but some of de Selve's contemporaries saw him as sympathetic to the cause of the reformers.

SEE MORE: View the Closer Look feature for *The French Ambassadors* **www.myartslab.com**

her own features, van Hemessen presented a serious young person who looks up to acknowledge us, interrupting her work on a portrait of a woman client. Between the date of this self-portrait and 1552, she painted ten signed and dated portraits of women, which seems to have been a specialty. She became a favored court artist to Mary of Hungary, sister of Emperor Charles V and regent of the Netherlands, for whom she painted not only portraits but also religious works, and whom she followed back to Spain when Mary ceased to be regent in 1556.

PIETER BRUEGEL THE ELDER.  So popular did the works of Hieronymus Bosch remain that, nearly half a century after his death, Pieter Bruegel (c. 1525–1569) began his career by imitating them. Like Bosch, he often painted large narrative works crowded with figures, and he chose moralizing or satirical subject matter. He traveled throughout Italy, but, unlike many Renaissance artists, he did not record the ruins of ancient Rome or the wonders of the Italian cities. Instead, he seems to have been fascinated by the landscape, particularly the formidable jagged rocks and sweeping panoramic views of Alpine valleys, which he recorded in detailed drawings. Back home in his studio, he made an impressive leap of the imagination as he painted the flat and rolling lands of Flanders as broad panoramas, even adding imaginary mountains on the horizon. He also visited country fairs to sketch the farmers and townspeople who became the focus of his paintings, presenting humans not as unique individuals but as well-observed types, whose universality makes them familiar even today.

Bruegel depicted nature in all seasons and in all moods. *Return of the Hunters* (see "Bruegel's Cycle of the Months," pages 702–703, FIG. A) captures the bleak atmosphere of early nightfall during a damp, cold winter, with a freshness that recalls the much earlier paintings of his compatriots the Limbourgs (SEE FIG. 18–4). The hunters are foregrounded before a sharp plunge into space; the juxtaposition of near and far without middle ground is a typically sixteenth-century device. But this is clearly not an accidental image; it is a slice of everyday life faithfully reproduced within a carefully calculated composition. The same can be said of Breugel's portrayal of late summer harvest (SEE "Bruegel's Cycle of the Months," pages 702–703, FIG. B), where the light is warmer, the landscape lush and verdant, the human activity rooted in agricultural labor or a momentary respite from it. As a depiction of Netherlandish life, these peasant scenes focusing on landscape represent a relative calm before the storm. Three years after they were painted, the anguished struggle of the northern provinces for independence from Spain began.

Pieter the Elder died in 1569, leaving two children, Pieter the Younger (1564/1565–1637/1638) and Jan (1568–1625), both of whom became successful painters. And the dynasty continued with Jan's son, Jan the Younger (1601–1678), who changed the family name from Bruegel to Brueghel.

# ENGLAND

Tudor England, in spite of the disruption caused by the Reformation, was economically and politically stable enough to provide sustained support for the arts, as Henry VIII strived to compete with the wealthy, sophisticated court of Francis I. Music, literature, and architecture flourished, but painting was principally left to foreigners.

As a young man, Henry VIII (r. 1509–1547) was loyal to the Church, defending it against Luther's attacks. He was rewarded by the pope in 1521 by being granted the title "Defender of the Faith." But when the pope refused to annul his marriage to Catherine of Aragon, Henry broke with Rome. By action of Parliament in 1534 he became the "Supreme Head on Earth of the Church and Clergy of England." He mandated an English translation of the Bible in every church, and in 1536 and 1539, he dissolved the monasteries, confiscating their great wealth and rewarding his followers with monastic lands and buildings. Shrines and altars were stripped of their jewels and precious metals to bolster the royal purse, and in 1548, during the reign of Henry's son, Edward VI, religious images were officially prohibited.

During the brief reign of Mary (r. 1553–1558), England officially returned to Catholicism, but the accession of Elizabeth in 1558 confirmed England as a Protestant country. So effective was Elizabeth, who ruled until 1603, that the last decades of the sixteenth century in England are called the Elizabethan Age.

## ARTISTS IN THE TUDOR COURT

A remarkable record of the appearance of Tudor notables survives in portraiture. Since the Tudors had long favored Netherlandish and German artists, it is hardly surprising that it was a German-born painter, Hans Holbein the Younger (c. 1497–1543), who shaped the taste of the English court and upper classes.

HANS HOLBEIN.  Holbein first visited London from 1526 to 1528 and was introduced by the Dutch scholar Erasmus to the humanist circle around the English statesman Thomas More. He returned to England in 1532 and was appointed court painter to Henry VIII about four years later. During the 1530s, he created a spectacular series of portraits of nobles and diplomats associated with the Tudor court. The court's climate of international interaction is embodied in a double portrait that Holbein painted in 1533 (see "A Closer Look," opposite)—a German painter's rendering in England of two French diplomats, one of them representing the court of Francis I in the Vatican. *The French Ambassadors* foregrounds Holbein's virtuosity as a painter and constructs a rich characterization of Jean de Dinteville, French ambassador to England, and his friend Georges de Selve, bishop of Lavaur and ambassador to the Holy See. With a loving detail that recalls the work of Jan van Eyck, the artist describes the surface textures and luminosity of the many objects placed in the painting to reflect the intellectual gifts and symbolize the political accomplishments of these two men. References in these objects to the conflicts

**21-22 • Marcus Gheeraerts the Younger QUEEN ELIZABETH I (THE DITCHLEY PORTRAIT)**
c. 1592. Oil on canvas, 95 × 60″ (2.4 × 1.5 m). National Portrait Gallery, London.

between European states, and within the Catholic Church itself, imply that these bright and confident young ambassadors will apply their considerable diplomatic skills to finding a resolution.

PORTRAITS OF ELIZABETH. Queen Elizabeth I carefully controlled the way artists represented her in official portraits and was known to have imprisoned artists whose unofficial images did not meet with her approval. A stark and hieratic regal image by Flemish artist Marcus Gheeraerts typifies the look she was after

(FIG. 21–22). Called the *Ditchley Portrait* because it seems to have been commissioned for Ditchley, the estate of her courtier Sir Henry Lee, to commemorate the Queen's visit in 1592, the full-length figure of Elizabeth—more costume than body—stands supreme on a map of her realm with her feet in Oxfordshire, near Ditchley. The stark whiteness of her elaborate dress and the pale abstraction of her severe face assert the virginal purity that she cultivated as a part of her image. A storm passes out of the picture on the right while the sun breaks through on the left. It is as if the queen is in control not only of England but of nature itself.

NICHOLAS HILLIARD. In 1570, Nicholas Hilliard (1547–1619) arrived in London from southwest England to pursue a career as a jeweler, goldsmith, and painter of miniatures. Hilliard never received a court appointment, but he created miniature portraits of the queen and court notables, including George Clifford, third earl of Cumberland (FIG. 21–23). Cumberland was a regular participant in the annual tilts and festivals celebrating the anniversary of Elizabeth's ascent to the throne. In Hilliard's miniature, Cumberland, a

**21-23 • Nicholas Hilliard GEORGE CLIFFORD, THIRD EARL OF CUMBERLAND (1558-1605)**
c. 1595. Watercolor on vellum on card, oval 2¾ × 2³⁄₁₆″ (7.1 × 5.8 cm). The Nelson-Atkins Museum of Art, Kansas City, Missouri. Gift of Mr. and Mrs. John W. Starr through the Starr Foundation. F58-60/188

## Armor for Royal Games

The medieval tradition of holding tilting, or jousting, competitions at English festivals and public celebrations continued during Renaissance times. Perhaps most famous were the Accession Day Tilts, held annually to celebrate the anniversary of Elizabeth I's coming to the throne. The gentlemen of the court, dressed in armor made especially for the occasion, held mock battles in the queen's honor. They rode their horses from opposite directions, trying to strike each other with long lances during six passes, as judges rated their performances.

The elegant armor worn by George Clifford, third Earl of Cumberland, at the Accession Day Tilts has been preserved in the collection of the Metropolitan Museum of Art in New York. Tudor roses and back-to-back capital *E*s in honor of the queen decorate the armor's surface. As the queen's champion, beginning in 1590, Clifford also wore her jeweled glove attached to his helmet as he met all comers in the tiltyard of Whitehall Palace in London.

Made by Jacob Halder in the royal armories at Greenwich, the 60-pound suit of armor is recorded in the sixteenth-century Almain Armourers' Album along with its "exchange pieces." These allowed the owner to vary his appearance by changing mitts, side pieces, or leg protectors, and also provided backup pieces if one were damaged.

Jacob Halder **ARMOR OF GEORGE CLIFFORD, THIRD EARL OF CUMBERLAND**
Made in the royal workshop at Greenwich, England. c. 1580–1585. Steel and gold, height 5′9½″ (1.77 m). Metropolitan Museum of Art, New York. Munsey Fund, 1932 (32.130.6)

man of about 30, wears a richly engraved and gold-inlaid suit of armor, forged for his first appearance in 1583 (see "Armor for Royal Games," page 707). Hilliard gives him a marked air of courtly jauntiness, with a stylish beard, mustache, and curled hair, but Cumberland is also humanized by his direct gaze and receding hairline. Cumberland's motto—"I bear lightning and water"—is inscribed on a stormy sky, with a lightning bolt in the form of a caduceus, one of his emblems. After all, he was that remarkable Elizabethan type—a naval commander and a gentleman pirate.

## ARCHITECTURE

To increase support for the Tudor dynasty, Henry and his successors granted titles to rich landowners. To display their wealth and status, many of these newly created aristocrats embarked on extensive building projects, constructing lavish country residences, which sometimes surpassed the French châteaux in size and grandeur. Rooted in the Perpendicular Gothic style (SEE FIG. 17–18), Elizabethan architecture's severe walls and broad expanses of glass were modernized by replacing medieval ornament with Classical motifs copied from architectural handbooks and pattern books. The first architectural manual in English, published in 1563, was written by John Shute, one of the few builders who had spent time in Italy. Most influential were the treatises on architectural design by the Italian architect Sebastiano Serlio.

HARDWICK HALL. One of the grandest of all the Elizabethan houses was Hardwick Hall, the home of Elizabeth, Countess of Shrewsbury, known as "Bess of Hardwick" (FIG. 21–24). When she was in her seventies, the redoubtable countess—who inherited riches from all four of her deceased husbands—employed Robert Smythson (c. 1535–1614), England's first Renaissance architect, to build Hardwick Hall (1591–1597).

The medieval great hall was transformed into a two-story entrance hall, with rooms arranged symmetrically around it—a nod to Classical balance. A sequence of rooms leads to a grand stair up to the long gallery and high great chamber on the second floor that featured an ornately carved fireplace (FIG. 21–25). It was here the countess received guests, entertained, and sometimes dined. The room seems designed to showcase a precious set of six Brussels tapestries featuring the story of Ulysses and is illuminated by its enormous windows. They serve as yet another reminder of the international character of the lavish decoration of residences created for wealthy patrons across Europe during this Renaissance century.

**21–24 • Robert Smythson HARDWICK HALL**
Derbyshire, England. 1591–1597.

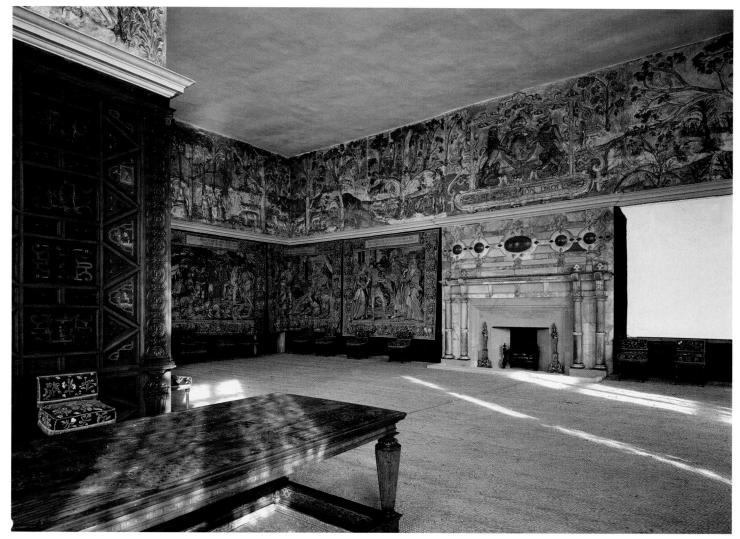

**21–25 • Robert Smythson HIGH GREAT CHAMBER, HARDWICK HALL**
Derbyshire, England. 1591–1597. Brussels tapestries 1550s; painted plaster sculpture by Abraham Smith.

## THINK ABOUT IT

**21.1** Choose one European court that patronized artists working in a "foreign" tradition from another part of Europe and assess how this internationalism fostered breaking down regional and national boundaries in European art. Be sure to ground your discussion in the work of specific artists.

**21.2** Explore the impact of Italian art and ideas on the work and persona of German artist Albrecht Dürer. Choose one of his works from the chapter, and discuss its Italianate features and the ways in which it departs from and draws on earlier northern European traditions.

**21.3** Summarize the factors that led to a burgeoning art market in the Netherlands in the sixteenth century. Who are some of the artists who benefited from this more fluid system of patronage? How and why were they successful within it?

**21.4** Discuss the impact of the Protestant Reformation on the visual arts in northern Europe, focusing your discussion on types of subject matter that patrons sought.

**21.5** Choose a work of art discussed in this chapter that displays extraordinary technical skill in more than one medium. How was its virtuosity achieved, and how is it highlighted as an important factor in the work's significance?

**PRACTICE MORE:** Compose answers to these questions, get flashcards for images and terms, and review chapter material with quizzes
**www.myartslab.com**

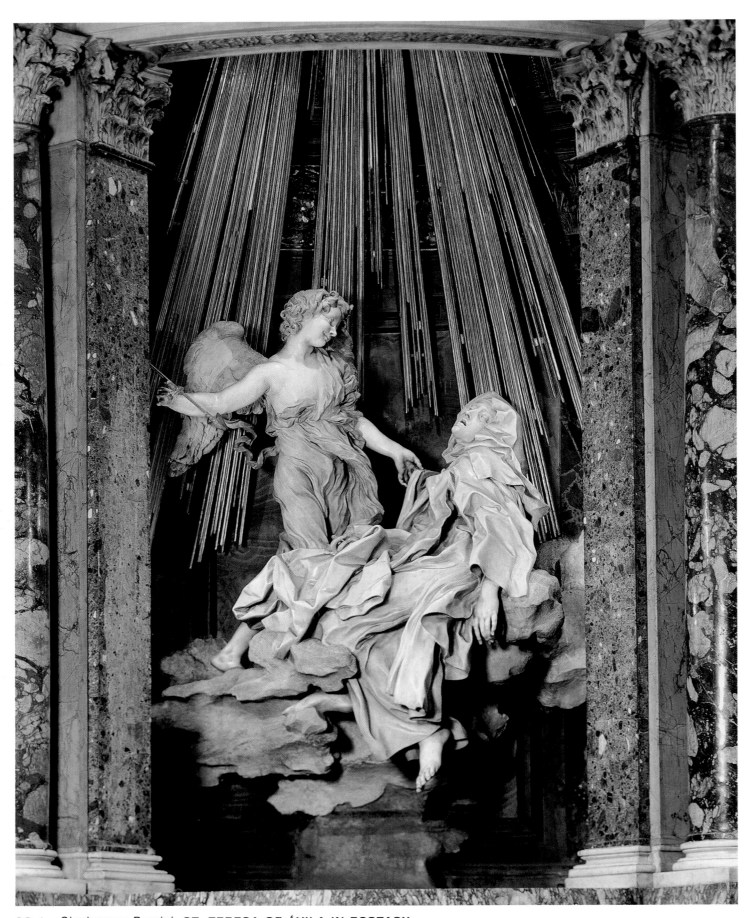

**22-1 • Gianlorenzo Bernini ST. TERESA OF ÁVILA IN ECSTASY**
1645–1652. Marble, height of the group 11'6" (3.5 m). Cornaro Chapel, church of Santa Maria della Vittoria, Rome.

# SEVENTEENTH-CENTURY ART IN EUROPE

In the Church of Santa Maria della Vittoria in Rome, the sixteenth-century Spanish mystic St. Teresa of Ávila (1515–1582, canonized 1622) swoons in ecstasy on a bank of billowing marble clouds (FIG. 22–1). A puckish angel tugs open her robe, aiming a gilded arrow at her breast. Gilded bronze rays of supernatural light descend, even as actual light illuminates the figures from a hidden window above. This dramatic scene, created by Gianlorenzo Bernini (1598–1680) between 1645 and 1652, represents a famous vision described with startling physical clarity by Teresa, in which an angel pierced her body repeatedly with an arrow, transporting her to a state of ecstatic oneness with God, charged with erotic associations.

The sculpture is an exquisite example of the emotional, theatrical style perfected by Bernini in response to the religious and political climate in Rome during the period of spiritual renewal known as the Counter-Reformation. Many had seen the Protestant Reformation of the previous century as an outgrowth of Renaissance Humanism with its emphasis on rationality and independent thinking. In response, the Catholic Church took a reactionary, authoritarian position, supported by the new Society of Jesus founded by Ignatius Loyola (d. 1556, canonized 1622). In the "spiritual exercises"

(1522–1523) initiated by St. Ignatius, Christians were enjoined to use all their senses to transport themselves emotionally as they imagined the events on which they were meditating. They were to feel the burning fires of hell or the bliss of heaven, the lashing of the whips and the flesh-piercing crown of thorns. Art became an instrument of propaganda and also a means of leading the spectator to a reinvigorated Christian practice and belief.

Of course, the arts had long been used to convince or inspire, but nowhere more effectively than by the Catholic Church in the seventeenth century. To serve the educational and evangelical mission of the revitalized and conservative Church, paintings and sculpture had to depict events and people accurately and clearly, following guidelines established by religious leaders. Throughout Catholic Europe, painters such as Rubens and Caravaggio created brilliant religious art under official Church sponsorship. And although today some viewers find this sculpture of St. Teresa uncomfortably charged with sexuality, the Church approved of the depictions of such sensational and supernatural mystical visions. They helped worshipers achieve the emotional state of religious ecstasy that was a goal of the Counter-Reformation.

## LEARN ABOUT IT

**22.1** Assess the impact of the Council of Trent's guidelines for the Counter-Reformation art of the Roman Catholic Church.

**22.2** Explore how the work of Bernini and Caravaggio established a new dramatic intensity, technical virtuosity, and unvarnished naturalism that blossomed into the Baroque.

**22.3** Trace the broad influence of Caravaggio's style on art across Europe during the seventeenth century.

**22.4** Assess the resurgence of Classicism, especially in the work of seventeenth-century French artists and architects.

**22.5** Analyze the way that seventeenth-century artists created works that embodied the power and prestige of the monarchy.

**22.6** Examine the development of portraiture, still life, landscape, and genre scenes as major subjects for painting, especially within the prosperous art market of the Netherlands.

**HEAR MORE:** Listen to an audio file of your chapter **www.myartslab.com**

# "BAROQUE"

The intellectual and political forces set in motion by the Renaissance and Reformation of the fifteenth and sixteenth centuries intensified during the seventeenth century. Religious wars continued, although gradually the Protestant forces gained control in the north, where Spain recognized the independence of the Dutch Republic in 1648. Catholicism maintained its primacy in southern Europe, the Holy Roman Empire, and France through the efforts of an energized papacy, aided by the new Society of Jesus, also known as the Jesuit Order (MAP 22–1). At the same time, scientific advances compelled people to question their worldview. Of great importance was the growing understanding that the Earth was not the center of the universe but rather was a planet revolving around the sun. As rulers' economic strength began to slip away, artists found patrons in the Church and the secular state, as well as in the newly confident and prosperous urban middle class. What evolved was a style that art historians have called "the Baroque." The label may be related to the Italian word *barocco*, a jeweler's term for an irregularly shaped pearl—something beautiful, fascinating, and strange.

Baroque art deliberately evokes intense emotional responses from viewers. Dramatically lit, theatrical compositions often combine several media within a single work as artists highlight their technical virtuosity. But the seventeenth century also saw its own version of Classicism, a more moving and dramatic variant of Renaissance ideals and principles featuring idealization based on observation of the material world; balanced (though often asymmetrical) compositions; diagonal movement in space; rich, harmonious colors; and the inclusion of visual references to ancient Greece and Rome. Many seventeenth-century artists sought lifelike depiction of their world in portraiture, **genre paintings** (scenes from everyday life), still life (paintings of inanimate objects such as food, fruit, or flowers), and religious scenes enacted by ordinary people in ordinary settings. Intense emotional involvement, lifelike renderings, and Classical references may exist in the same work, and are all part of the stylistic complexion of the seventeenth century.

The role of viewers also changed. Italian Renaissance painters and patrons had been fascinated with the visual possibilities of perspective and treasured idealism of form and subject which kept viewers at a distance, reflecting intellectually on what they were seeing. Seventeenth-century masters, on the other hand, sought to engage viewers as participants in the work of art, and often reached out to incorporate or activate the world beyond the frame into the nature and meaning of the work itself. In Catholic countries, representations of horrifying scenes of martyrdom or the passionate spiritual life of a mystic in religious ecstasy were intended to inspire viewers to a renewed faith by making them feel what was going on, not simply by causing them to think about it. In Protestant countries, images of communal parades and city views sought to inspire pride in civic accomplishments. Viewers participated in works of art like audiences in a theater—vicariously but completely—as the work of art drew them visually and emotionally

into its orbit. The seventeenth-century French critic Roger de Piles (1635–1709) described this exchange when he wrote: "True painting … calls to us; and has so powerful an effect, that we cannot help coming near it, as if it had something to tell us" (Puttfarken, p. 55).

# ITALY

Italy in the seventeenth century remained a divided land in spite of a common history, language, and geography, with borders defined by the seas. The Kingdom of Naples and Sicily was Spanish; the Papal States crossed the center; Venice maintained its independence as a republic; and the north remained divided among small principalities. Churchmen and their families remained powerful patrons of the arts, especially as they recognized the visual arts' role in revitalizing the Roman Catholic Church. The Council of Trent (1563) had set guidelines for Church art that went against the arcane, worldly, and often lascivious trends exploited by Mannerism. The clergy's call for clarity, simplicity, chaste subject matter, and the ability to rouse a very Catholic piety in the face of Protestant revolt found a response in the fresh approaches to subject matter and style offered by a new generation of artists.

## ARCHITECTURE AND SCULPTURE IN ROME

A major goal of the Counter-Reformation was to embellish churches properly, and Pope Sixtus V (pontificate 1585–1590) had begun the renewal in Rome by cutting long, straight avenues through the city to link the major pilgrimage churches with one another and with the main gates of Rome. Sixtus also ordered open spaces—piazzas—to be cleared in front of major churches, marking each site with an Egyptian obelisk. In a practical vein, he also reopened one of the ancient aqueducts to stabilize the city's water supply. Unchallengeable power and vast financial resources were required to carry out such an extensive plan of urban renewal and to refashion Rome—parts of which had been the victim of rapacity and neglect since the Middle Ages—once more into the center of spiritual and worldly power.

The Counter-Reformation popes had great wealth, although they eventually nearly bankrupted the Church with their building programs. Sixtus began to renovate the Vatican and its library; he completed the dome of St. Peter's and built splendid palaces. The Renaissance ideal of the central-plan church continued to be used for the shrines of saints, but Counter-Reformation thinking called for churches with long, wide naves to accommodate large congregations assembled to hear inspiring sermons as well as to participate in the Mass. In the sixteenth century, the decoration of new churches had been relatively austere, but seventeenth- and eighteenth-century Catholic taste favored opulent and spectacular visual effects to heighten the emotional involvement of worshipers.

ST. PETER'S BASILICA IN THE VATICAN. Half a century after Michelangelo had returned St. Peter's Basilica to Bramante's original

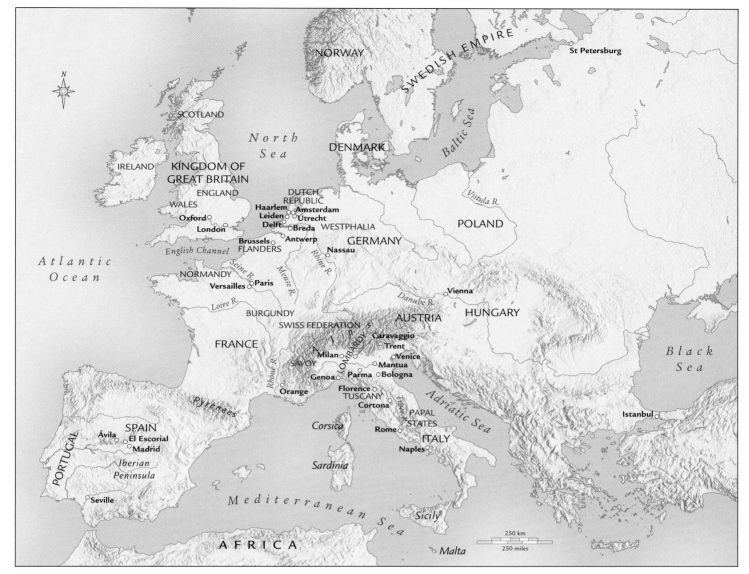

**MAP 22-1 • SEVENTEENTH-CENTURY EUROPE**

Protestantism still dominated northern Europe, while in the south Roman Catholicism remained strong after the Counter-Reformation. The Habsburg Empire was now divided into two parts, under separate rulers.

vision of a central-plan building, Pope Paul V Borghese (pontificate 1605–21) commissioned Carlo Maderno (1556–1629) to provide the church with a longer nave and a new façade **(FIG. 22–2)**. Construction began in 1607, and everything but the façade bell towers was completed by 1615 (see "St. Peter's Basilica," page 651). In essence, Maderno took the concept of *Il Gesù*'s façade (SEE FIG. 20–36) and enlarged it for the most important church of the Catholic world. Maderno's façade for St. Peter's "steps out" in three progressively projecting planes: from the corners to the doorways flanking the central entrance area, then the entrance area, then the central doorway itself. Similarly, the colossal orders connecting the first and second stories are flat pilasters at the corners but fully round columns where they flank the doorways. These columns support a continuous entablature that also steps out—following the columns—as it moves toward the central door.

When Maderno died in 1629, he was succeeded as Vatican architect by his collaborator of five years, Gianlorenzo Bernini (1598–1680). The latter was taught by his father, and part of his training involved sketching the Vatican collection of ancient sculpture, such as *Laocoön and His Sons* (SEE FIG. 5–55) and the *Farnese Hercules* (SEE FIG. 5–47), as well as the many examples of Renaissance painting in the papal palace. Throughout his life, Bernini admired antique art and, like other artists of this period, considered himself a Classicist. Today, we not only appreciate his strong debt to the Renaissance tradition but also acknowledge the way he broke through that tradition to take us into a new, Baroque style.

When Urban VIII was elected pope in 1623, he unhesitatingly gave the young Bernini the daunting task of designing an enormous bronze baldachin, or canopy, over the high altar of St. Peter's. The church was so large that a dramatic focus on the altar

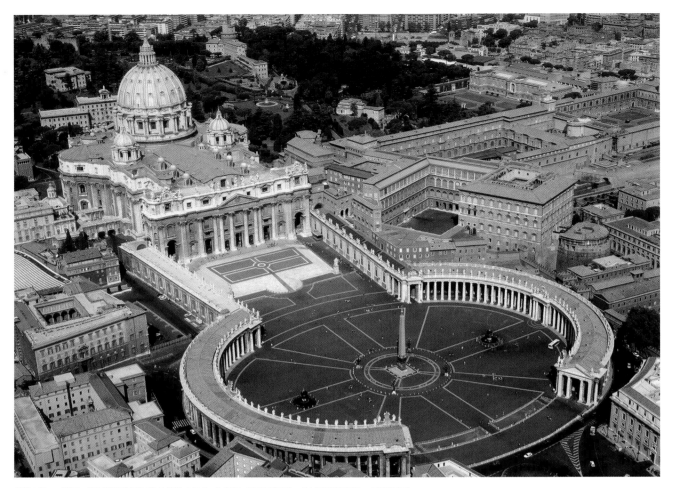

**22-2 • ST. PETER'S BASILICA AND PIAZZA, VATICAN, ROME**
Carlo Maderno, façade, 1607–1626; Gianlorenzo Bernini, piazza design, c. 1656–1657.

Perhaps only a Baroque artist of Bernini's talents could have unified the many artistic periods and styles that come together in St. Peter's Basilica (starting with Bramante's original design for the building in the sixteenth century). The basilica in no way suggests a piecing together of parts made by different builders at different times but rather presents itself as a triumphal unity of all the parts in one coherent whole.

**SEE MORE:** Click the Google Earth link for an aerial view of St. Peter's, Vatican City
**www.myartslab.com**

was essential. The resulting *baldacchino* (**FIG. 22–3**), completed in 1633, stands almost 100 feet high and exemplifies the Baroque objective to create multimedia works, combining architecture and sculpture—and sometimes painting as well—that defy simple categorization. The gigantic corner columns symbolize the union of Christianity and its Jewish tradition—the vine of the Eucharist climbing the twisted columns associated with the Temple of Solomon. They support an entablature with a crowning element topped with an orb (a sphere representing the universe) and a cross (symbolizing the reign of Christ). Figures of angels and *putti* decorate the entablature, which is hung with tasseled panels in imitation of a cloth canopy. This imposing work not only marks the site of the tomb of St. Peter, but also serves as a tribute to Urban VIII and his family, the Barberini, whose emblems—honeybees and suns on the tasseled panels, and laurel leaves on the climbing vines—are prominently displayed.

Between 1627 and 1641, Bernini and several other sculptors, again in multimedia extravaganzas, rebuilt Bramante's crossing piers as giant reliquaries. Statues of SS. Helena, Veronica, Andrew, and Longinus stand in niches below alcoves containing their relics, to the left and right of the *baldacchino*. Visible through the *baldacchino*'s columns in the apse of the church is another reliquary: the gilded-stone, bronze, and stucco shrine made by Bernini between 1657 and 1666 for the ancient wooden throne thought to have belonged to St. Peter as the first bishop of Rome. The Chair of Peter symbolized the direct descent of Christian authority from Peter to the current pope, a belief rejected by Protestants and therefore deliberately emphasized in Counter-Reformation Catholicism. Above the shrine, a brilliant stained-glass window portrays the Holy Spirit as a dove surrounded by an oval of golden rays. Adoring gilded angels and gilt-bronze rays fan out around the window and seem to extend the penetration of the natural light—

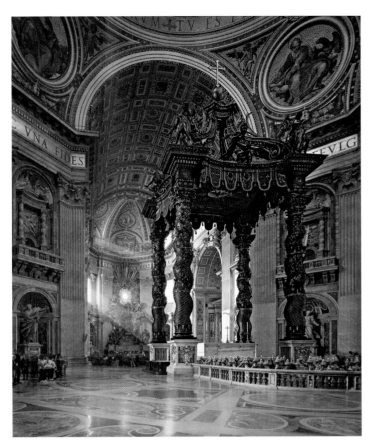

**22–3 • Gianlorenzo Bernini BALDACCHINO**
1624–1633. Gilt bronze, height approx. 100′ (30.48 m). Chair of Peter shrine, 1657–1666. Gilt bronze, marble, stucco, and glass. Pier decorations, 1627–1641. Gilt bronze and marble. Crossing, St. Peter's Basilica, Vatican, Rome.

made the basilica and its setting an even more awe-inspiring vision. The approach today—along the grand avenue of the Via della Conciliazione running from the Tiber to the Basilica—was conceived by Mussolini in 1936 as part of his masterplan to transform Rome into a grand fascist capital.

BERNINI AS SCULPTOR. Even after Bernini's appointment as Vatican architect in 1629, he was still able to accept outside commissions by virtue of his large workshop. In fact, he first became famous as a sculptor, and he continued to work as one throughout his career, for both the papacy and private clients. A man of many talents, he was also a painter and even a playwright—an interest that dovetailed with his genius for theatrical and dramatic presentation.

Bernini's *David* (**FIG. 22–4**), made for a nephew of Pope Paul V in 1623, introduced a new type of three-dimensional composition that intrudes forcefully into the viewer's space. The young hero bends at the waist and twists far to one side, ready to launch the lethal rock at Goliath. Unlike Donatello's already victorious sassy

and the Holy Spirit—into the apse of the church. The gilding also reflects the light back to the window, creating a dazzling, ethereal effect that the seventeenth century, with its interest in mystics and visions, would equate with the activation of divinity.

At approximately the same time that he was at work on the Chair of Peter, Bernini designed and supervised the building of a colonnade to form a huge double piazza in front of the entrance to St. Peter's (SEE FIG. 22–2). The open space that he had to work with was irregular, and an Egyptian obelisk and a fountain previously installed by Sixtus V had to be incorporated into the overall plan. Bernini's remarkable design frames the oval piazza with two enormous curved porticos, or covered walkways, supported by Doric columns. These curved porticos are connected to two straight porticos, which lead up a slight incline to the two ends of the church façade. Bernini characterized his design as the "motherly arms of the Church" reaching out to the world. He had intended to build a third section of the colonnade closing the side of the piazza facing the church so that only after pilgrims had crossed the Tiber River bridge and made their way through narrow streets, would they encounter the enormous open space before the imposing church. This element of surprise would have

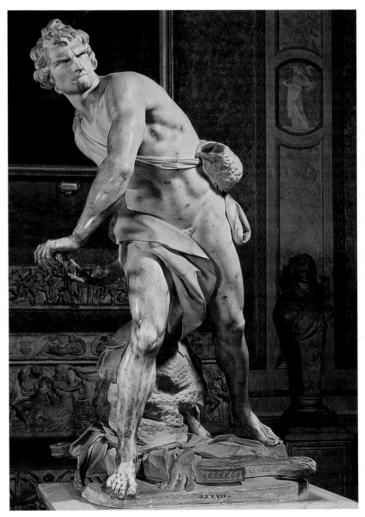

**22–4 • Gianlorenzo Bernini DAVID**
1623. Marble, height 5′7″ (1.7 m). Galleria Borghese, Rome.

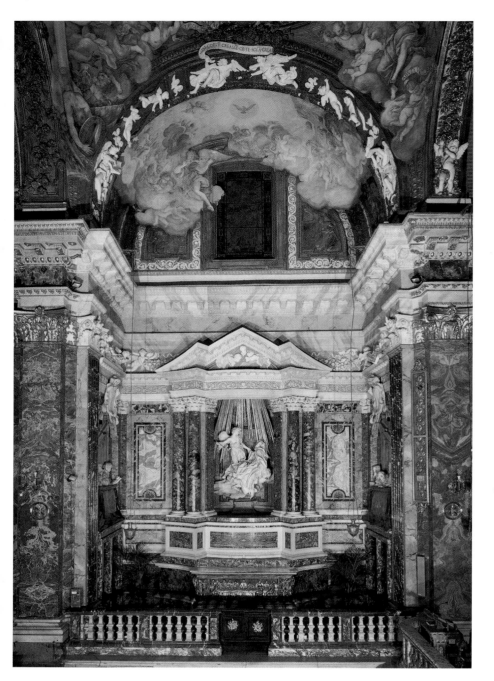

**22-5 • Gianlorenzo Bernini**
**CORNARO CHAPEL, CHURCH
OF SANTA MARIA DELLA VITTORIA,
ROME**
1642–1652.

**EXPLORE MORE:** Gain insight from
a primary source on Gianlorenzo
Bernini **www.myartslab.com**

**SEE MORE:** View a simulation related
to the Cornaro Chapel
**www.myartslab.com**

was dedicated to the Spanish saint Teresa of
Ávila, canonized only 20 years earlier. Bernini
designed it as a rich and theatrical setting for
the portrayal of a central event in Teresa's life.
He covered the walls with multicolored
marble panels and crowned them with a pro-
jecting cornice supported by marble pilasters.

In the center of the chapel and framed
by columns in the huge oval niche above the
altar, Bernini's marble group *St. Teresa of Ávila
in Ecstasy* (SEE FIG. 22–1) represents a vision
described by the Spanish mystic in which
an angel pierced her body repeatedly with
an arrow, transporting her to a state of
indescribable pain, religious ecstasy, and a
sense of oneness with God. St. Teresa and the
angel, who seem to float upward on clouds of
stucco (a moistened mixture of lime and
marble dust that can be molded), are cut from
a heavy mass of solid marble supported on a seemingly drifting
pedestal that was fastened by hidden metal bars to the chapel wall.
Bernini's skill at capturing the movements and emotions of these
figures is matched by his virtuosity in simulating different textures
and colors in the pure white medium of marble; the angel's gauzy,
clinging draperies seem silken in contrast with Teresa's heavy
woolen monastic robe. Bernini effectively used the configuration
of the garment's folds to convey the saint's swooning, sensuous
body beneath, even though only Teresa's face, hands, and bare feet
are actually visible.

Kneeling against what appear to be balconies on both sides of
the chapel are marble portrait sculptures of Federigo, his deceased
father (a Venetian doge), and six cardinals of the Cornaro family.

adolescent (SEE FIG. 19–10), or Michelangelo's pensive young man
contemplating the task ahead (SEE FIG. 20–10), Bernini's more
mature David, with his lean, sinewy body, tightly clenched mouth,
and straining muscles, is all tension, action and determination.
By creating a twisting figure caught in movement, Bernini
incorporates the surrounding space within his composition,
implying the presence of an unseen adversary somewhere behind
the viewer. Thus, the viewer becomes part of the action, rather
than its displaced and dispassionate observer.

From 1642 until 1652, Bernini worked on the decoration of
the funerary chapel of Venetian cardinal Federigo Cornaro **(FIG.
22–5)** in the Church of Santa Maria della Vittoria, designed by
Carlo Maderno earlier in the century. The Cornaro family chapel

The figures are informally posed and naturalistically portrayed. Two read from their prayer books, others exclaim at the miracle taking place in the light-infused realm above the altar, and one leans out from his seat, apparently to look at someone entering the chapel—perhaps the viewer, whose space these figures share. Bernini's intent was not to produce a spectacle for its own sake, but to capture a critical, dramatic moment at its emotional and sensual height, and by doing so guide viewers to identify totally with the event—and perhaps be transformed in the process.

**BORROMINI'S CHURCH OF SAN CARLO.** The intersection of two of the wide, straight avenues created by Pope Sixtus V inspired city planners to add a special emphasis, with fountains marking each of the four corners of the crossing. In 1634, Trinitarian monks

decided to build a new church at the site and awarded the commission for **SAN CARLO ALLE QUATTRO FONTANE** (St. Charles at the Four Fountains) to Francesco Borromini (1599–1667). Borromini, a nephew of architect Carlo Maderno, had arrived in Rome in 1619 from northern Italy to enter his uncle's workshop. Later, he worked under Bernini's supervision on the decoration of St. Peter's, and some details of the Baldacchino, as well as its structural engineering, are now attributed to him, but San Carlo was his first independent commission. Unfinished at Borromini's death, the church was nevertheless completed according to his design.

San Carlo stands on a narrow piece of land, with one corner cut off to accommodate one of the four fountains that give the church its name **(FIG. 22–6)**. To fit the irregular site, Borromini created an elongated central-plan interior space with undulating walls **(FIG. 22–7)**. Robust pairs of columns support a massive entablature, over which an oval dome, supported on pendentives, seems to float **(FIG. 22–8)**. The coffers (inset panels in geometric shapes) filling the interior of the oval-shaped dome form an eccentric honeycomb of crosses, elongated hexagons, and octagons. These coffers decrease sharply in size as they approach the apex, or highest point, where the dove of the Holy Spirit hovers in a climax that brings together the geometry used in the chapel: oval, octagon, circle, and—very important—a triangle, symbol of the Trinity as well as of the church's patrons. The dome appears to be shimmering and inflating—almost floating up and away—thanks to light sources placed in the lower coffers and the lantern.

It is difficult today to appreciate how audacious Borromini's design for this small church was. In it he abandoned the modular,

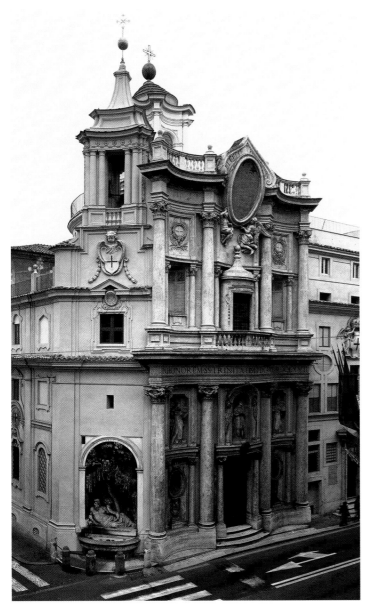

**22-6 • Francesco Borromini FAÇADE, CHURCH OF SAN CARLO ALLE QUATTRO FONTANE, ROME**
1638–1667.

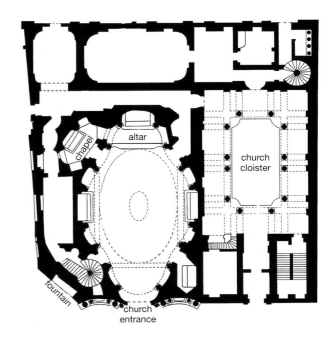

**22-7 • Francesco Borromini PLAN OF THE CHURCH OF SAN CARLO ALLE QUATTRO FONTANE, ROME**
1638–1667.

additive system of planning taken for granted by every architect since Brunelleschi. He worked instead from an overriding geometrical scheme, as a Gothic architect might, subdividing modular units to obtain more complex, rational shapes. For example, the elongated, octagonal plan of San Carlo is composed of two triangles set base to base along the short axis of the plan (SEE FIG. 22–7). This diamond shape is then subdivided into secondary triangular units made by calculating the distances between what will become the concave centers of the four major and five minor niches. Yet Borromini's conception of the whole is not medieval. The chapel is dominated horizontally by a Classical entablature that breaks any surge upward toward the dome. Borromini's treatment of the architectural elements as if they were malleable was also unprecedented. His contemporaries understood immediately what an extraordinary innovation the church represented; the Trinitarian monks who had commissioned it received requests for plans from visitors from all over Europe. Although Borromini's innovative work had little impact on the architecture of Classically minded Rome, it was widely imitated in northern Italy and beyond the Alps.

Borromini's design for San Carlo's façade (SEE FIG. 22–6), executed more than two decades later, was as innovative as his planning of the interior. He turned the building's front into an undulating, sculpture-filled screen punctuated with large columns and deep concave and convex niches that create dramatic effects of light and shadow. Borromini also gave his façade a strong vertical thrust in the center by placing over the tall doorway a statue-filled niche, then a windowed niche covered with a canopy, then a giant, forward-leaning cartouche held up by angels carved in such high relief that they appear to hover in front of the wall. The entire composition is crowned with a balustrade broken by the sharply pointed frame of the cartouche. As with the design of the building itself, Borromini's façade was enthusiastically imitated in northern Italy and especially in northern and eastern Europe.

## PAINTING

Painting in seventeenth-century Italy followed one of two principal paths: the ordered Classicism of the Carracci or the dramatic naturalism of Caravaggio. Although the leading exponents of these paths were northern Italians—the Carracci family was from Bologna, and Caravaggio was born in or near Milan—they were all eventually drawn to Rome, the center of power and patronage. The Carracci family, like Caravaggio, were schooled in northern Italian Renaissance traditions, with its emphasis on *chiaroscuro*, as well as in Venetian color and *sfumato*. The Carracci quite consciously rejected the artifice of the Mannerist style and fused their northern roots with the central Italian Renaissance insistence on line (*disegno*), compositional structure, and figural solidity. They looked to Raphael, Michelangelo, and antique Classical sculpture for their ideal figural types and their expressive but decorous compositions. Caravaggio, on the other hand, satisfied the Baroque demand for drama and clarity by developing realism in a powerful new direction. He painted people he saw in the world around him—even the lowlife of Rome—and worked directly from models without elaborate drawings and compositional notes. Unlike the Carracci, he claimed to ignore the influence of the great masters so as to focus steadfastly on a sense of immediacy and invention.

THE CARRACCI. The brothers Agostino (1557–1602) and Annibale Carracci (1560–1609) and their cousin Ludovico (1555–1619) shared a studio in Bologna. As their re-evaluation of the High Renaissance masters attracted interest among their peers, they opened their doors to friends and students and then, in 1582, founded an art academy, where students drew from live models and studied art theory, Renaissance painting, and antique Classical sculpture. The Carracci placed a high value on accurate drawing, complex figure compositions, complicated narratives, and technical expertise in both oil and fresco painting. During its short life, the academy had an impact on

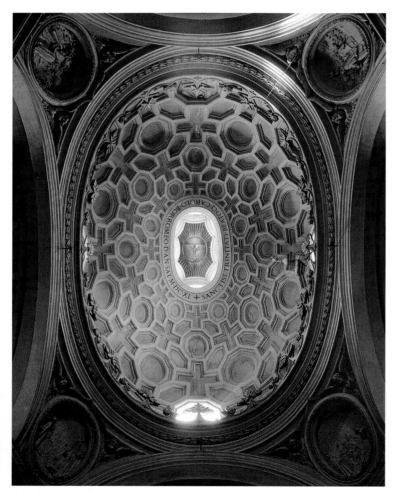

22-8 • Francesco Borromini **VIEW INTO THE DOME OF THE CHURCH OF SAN CARLO ALLE QUATTRO FONTANE, ROME**
1638–1667.

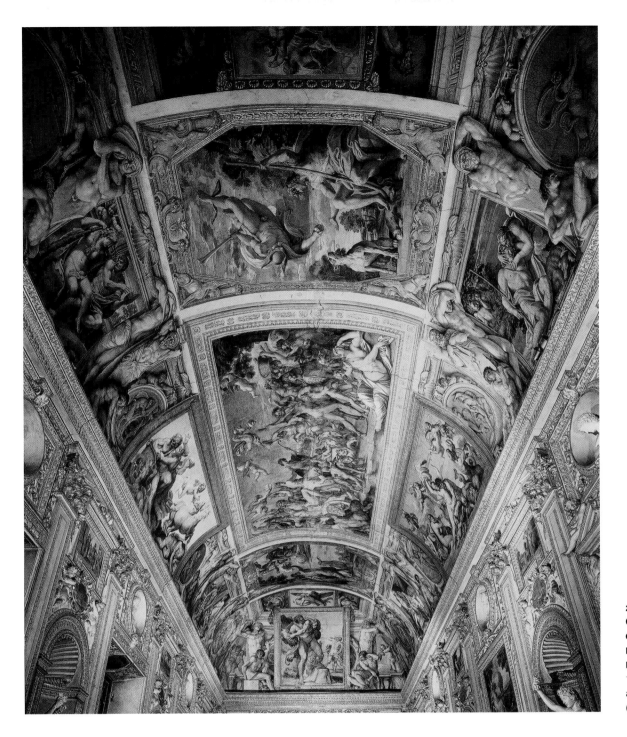

22-9 • Annibale Carracci **CEILING OF GALLERY, PALAZZO FARNESE, ROME**
1597–1601. Fresco, approx. 68 × 21′ (20.7 × 6.4 m).

the development of the arts—and art education—through its insistence on both life drawing (to achieve naturalism) and aesthetic theory (to achieve artistic harmony).

In 1595, Annibale was hired by Cardinal Odoardo Farnese to decorate the principal rooms of his family's immense Roman palace. In the long *galleria* (gallery), to celebrate the wedding of Duke Ranuccio Farnese of Parma to the niece of the pope, the artist was requested to paint scenes of love based on Ovid's *Metamorphoses* (**FIG. 22–9**). Undoubtedly, Annibale and Agostino, who assisted him, felt both inspiration and competition from the important Farnese collection of antique sculpture exhibited throughout the palace.

The primary image, set in the center of the vault, is *The Triumph of Bacchus and Ariadne,* a joyous procession celebrating the wine god Bacchus's love for Ariadne, whom he rescued after her lover, Theseus, abandoned her on the island of Naxos. Annibale combines the great northern Italian tradition of ceiling painting—seen in the work of Mantegna and Correggio (**FIGS.** 19–29, 20–19)—with his study of central Italian Renaissance painters and the Classical heritage of Rome. Annibale organized his complex theme by using illusionistic devices to create multiple levels of reality. Painted imitations of gold-framed easel paintings called *quadri riportati* ("transported paintings") appear to "rest" on

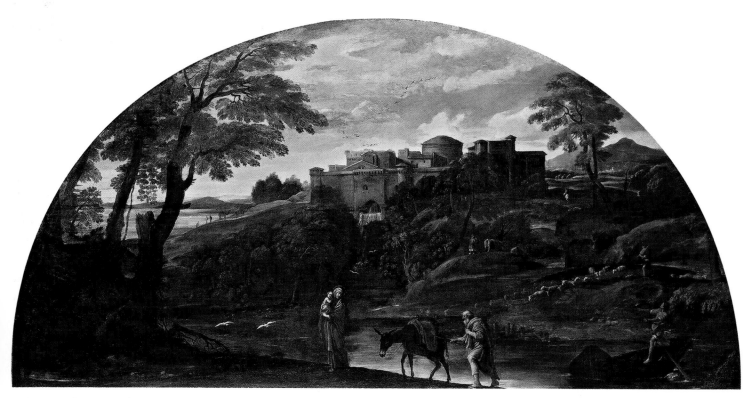

**22-10 • Annibale Carracci LANDSCAPE WITH THE FLIGHT INTO EGYPT**
1603–1604. Oil on canvas, 48 × 90½″ (1.22 × 2.29 m). Galleria Doria Pamphili, Rome.

the actual cornice of the vault and overlap "bronze" medallions that are flanked, in turn, by realistically colored *ignudi*, dramatically lit from below. The viewer is invited to compare the warm flesh tones of these youths, and their lifelike poses, with the more idealized "painted" bodies in the framed scenes next to them. Above, paintings of stucco-colored sculptures of herms (plain shafts topped by human torsos) twist and turn as they support the painted framework of the vault, exposing a variety of feelings with their expressions and seemingly communicating with one another. Many of Annibale's ideas are inspired by motifs in Michelangelo's Sistine Chapel ceiling (FIG. 20–12). The figure types, true to their source, are heroic, muscular, and drawn with precise anatomical accuracy. But instead of Michelangelo's cool illumination and intellectual detachment, the Carracci ceiling glows with a warm light that recalls the work of the Venetian painters Titian and Veronese, and seems buoyant with optimism and lively engagement.

The ceiling was highly admired, famous from the moment it was finished. The proud Farnese family generously allowed young artists to sketch the figures there, so that Carracci's masterpiece influenced Italian art well into the following century. Among those impressed at the initial viewing of the *galleria* was the nephew of Pope Clement VIII, Pietro Aldobrandini, who subsequently commissioned the artist to decorate the six lunettes of his private chapel with scenes from the life of the Virgin, sometime between 1603 and 1604. **LANDSCAPE WITH THE FLIGHT INTO EGYPT (FIG. 22–10)**, the largest of the six—one of only two that show painting

from Annibale's own hand—was probably above the altar. In contrast to the dramatic figural compositions in the Farnese gallery, the escape of the Holy Family is conceived within a contemplative pastoral landscape filled with golden light in the Venetian tradition of Giorgione (SEE FIG. 20–21). The design of the work and its affective spirit of melancholy derive, however, from a fundamental aspect of Baroque Classicism that would influence artists for generations to come. Here nature is ordered by humans. Trees in the left foreground and right middle ground gracefully frame the scene; and the collection of ancient buildings in the center of the composition forms a stable and protective canopy for the flight of the Holy Family. Space progresses gradually from foreground to background in diagonal movements that are indicated by people, animals, and architecture. Nothing is accidental, yet the whole appears unforced and entirely natural.

**CARAVAGGIO.** Michelangelo Merisi (1571–1610), known as "Caravaggio" after his family's home town in Lombardy, introduced a powerfully frank realism and dramatic, theatrical lighting and gesture to Italian Baroque art. The young painter brought an interest, perhaps a specialization, in still-life painting with him when he arrived in Rome from Milan late in 1592 and found studio work as a specialist painter of fruit and vegetables. When he began to work on his own, he continued to paint still lifes but also began to include half-length figures with them. By this time, his reputation had grown to the extent that an agent offered to market his pictures.

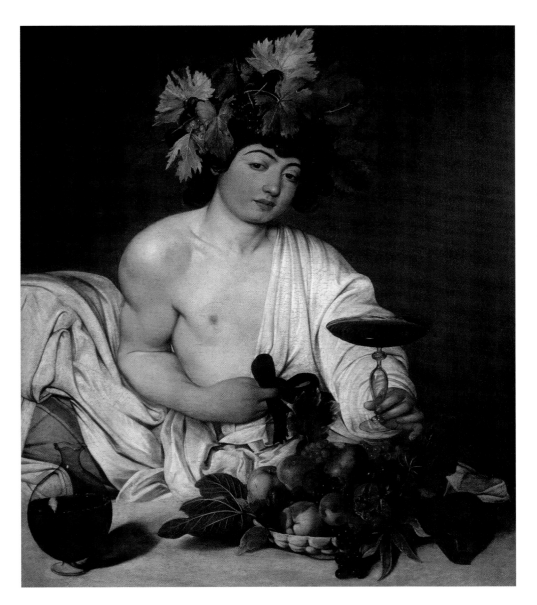

image about the transitory nature of sensual pleasure, either admonishing viewers to avoid sins of the flesh or encouraging them to enjoy life's pleasures while they can? The ambiguity seems to make the painting even more provocative.

Most of Caravaggio's commissions after 1600 were religious, and reactions to them were mixed. On occasion, patrons rejected his powerful, sometimes brutal, naturalism as unsuitable to the subject's dignity. Critics differed as well. An early critic, the Spaniard Vincente Carducho, wrote in his *Dialogue on Painting* (Madrid, 1633) that Caravaggio was an "omen of the ruin and demise of painting" because he painted "with nothing but nature before him, which he simply copied in his amazing way" (Enggass and Brown, pp. 173–174). Others recognized him as a great innovator who reintroduced realism into art and developed new, dramatic lighting effects. The art historian Giovanni Bellori, in his *Lives of the Painters* (1672), described Caravaggio's painting as

> … reinforced throughout with bold shadows and a great deal of black to give relief to the forms. He went so far in this manner of working that he never brought his figures out into the daylight, but placed them in the dark brown atmosphere of a closed room, using a high light that descended vertically over the principal parts of the bodies while leaving the remainder in shadow in order to give force through a strong contrast of light and dark…. (Bellori, *Lives of the Painters*, Rome, 1672, in Enggass and Brown, p. 79)

Caravaggio's approach has been likened to the preaching of Filippo Neri (1515–1595), the Counter-Reformation priest and mystic who founded a Roman religious group called the Congregation of the Oratory. Neri, called the Apostle of Rome and later canonized, focused his missionary efforts on ordinary people for whom he strove to make Christian history and doctrine understandable and meaningful. Caravaggio, too, interpreted his

Caravaggio painted for a small, sophisticated circle associated with the household of art patron Cardinal del Monte, where the artist was invited to reside. His subjects from this early period of the 1590s include not only still lifes but also genre scenes featuring fortune-tellers, cardsharps, and glamorous young men dressed as musicians or mythological figures. The **BACCHUS** of 1595–1596 **(FIG. 22–11)** is among the most polished of these early works. Caravaggio seems to have painted exactly what he saw, reproducing the "farmer's tan" of those parts of this partially dressed youth's skin—hand and face—that have been exposed to the sun, as well as the dirt under his fingernails. The figure himself is strikingly androgynous. Made up with painted lips and smoothly arching eyebrows, he seems to offer the viewer the gorgeous goblet of wine held delicately in his left hand, while fingering the black bow that holds his loose clothing together at the waist. Is this a provocative invitation to an erotic encounter or a young actor outfitted for the role of Bacchus, god of wine? Does the juxtaposition of the youth's invitation with a still life of rotting fruit transform this into an

# THE OBJECT SPEAKS

## Caravaggio in the Contarelli Chapel

As soon as he had established himself as an up-and-coming artist during the 1590s, Caravaggio turned to a series of important commissions for religious paintings in the chapels of Roman churches. Unlike in the Renaissance, where frescos were applied directly to the walls, Caravaggio produced large oil paintings on canvas in his studio, only later installing them within the chapels to form coordinated ensembles. Several such installations survive, giving us the precious opportunity to experience the paintings as Caravaggio and his patrons intended. One of these intact programs, in the Contarelli Chapel of San Luigi dei Francesi, was Caravaggio's earliest religious commission in Rome, perhaps obtained through the efforts of Cardinal del Monte, who had supported the artist through the 1590s.

This church served the French community in Rome, and the building itself was constructed between 1518 and 1589, begun under the patronage of Catherine de' Medici, Queen of France. The chapel Caravaggio decorated was founded in 1565 by Mathieu Cointrel—Matteo Contarelli—a French noble at the papal court who would serve as a financial administrator under Gregory XIII (pontificate 1572–1585). Although earlier artists had been called on to provide paintings for the chapel, it was only after Contarelli's death in 1585 that the executors of his will brought the decoration to completion, hiring Giuseppe Cesare in

1591 to paint the ceiling frescos, and Caravaggio in 1599 to provide paintings of scenes from the life of the patron's patron saint: *The Calling of St. Matthew* on the left wall and *The Martyrdom of St. Matthew* on the right (not visible in FIG. A), both installed in July 1600.

The commissioning document was explicit, requiring the artist to show, in *The Calling of St. Matthew* (fig. B), the saint rising from his seat to follow Christ in ministry. But Caravaggio was never very good at following the rules. Among the group of smartly

dressed Romans who form Matthew's circle of cohorts seated at the left, no one rises to leave. Art historians have not even been able to agree on which figure is Matthew. Most identify him with a bearded man in the center, interpreting his pointing gesture as a self-referential, questioning response to Jesus' call. But some see Matthew in the figure hunched over the scattered coins at far left, seemingly unmoved by Jesus' presence. In this case, the bearded figure's pointing would question whether this bent-over colleague was the one Jesus

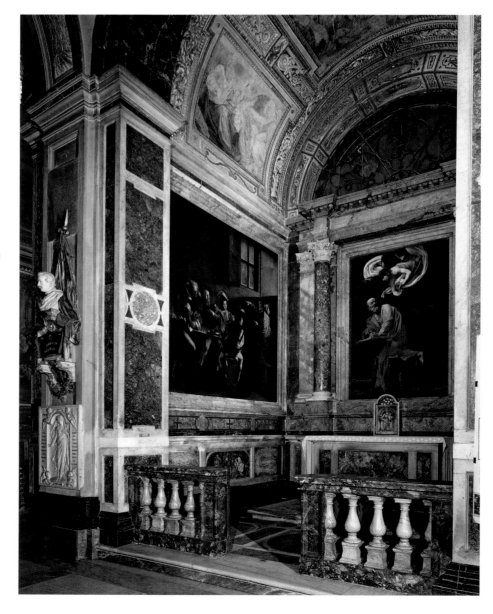

**A. CONTARELLI CHAPEL,
SAN LUIGI DEI FRANCESI**
Rome. Paintings by Caravaggio 1599–1602.

sought. The painting is marked by mystery, not by the clarity sought by Counter-Reformation guidelines.

In February 1602, Caravaggio received a second commission for the Contarelli Chapel, this time for a painting over the altar showing St. Matthew, accompanied by his angelic symbol and writing his Gospel. It was to be completed within three months, but Caravaggio did not receive payment for the picture until September of that year, and the painting he delivered was rejected. The clergy considered Caravaggio's rendering of the saint unacceptably crude and common, his cross-legged pose uncouth and unnecessarily revealing. The fleshiness of the angel, who sidles cozily up to Matthew, was judged inappropriately risqué. In short, the painting was inconsistent with guidelines for saintly decorum set for artists by the Council of Trent. Caravaggio had to paint a second, more decorous altarpiece for the chapel (seen in FIG. A), with a nobler Matthew and a more distant angel. The rejected version was snapped up by Roman collector Vincenzo Giustiniani, who actually paid for the replacement in order to acquire the more sensational original. Unfortunately, this first painting was destroyed in the 1945 bombing of Berlin during World War II.

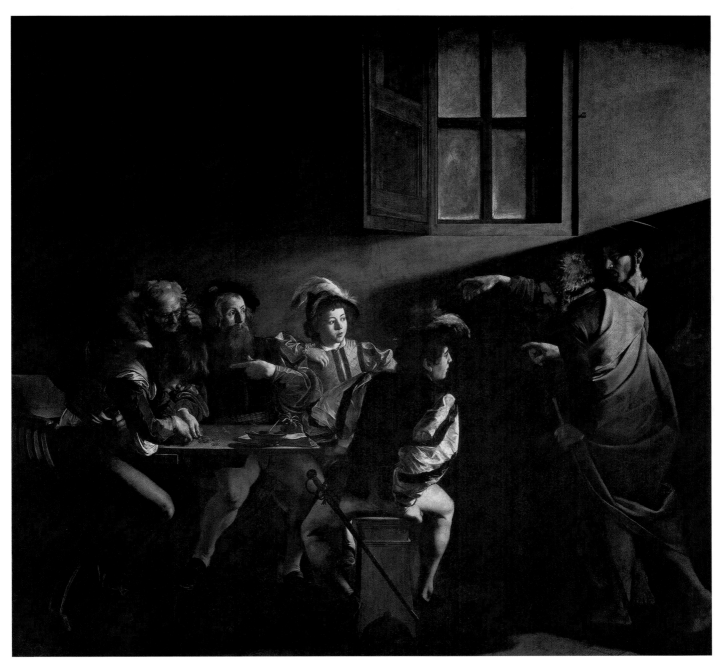

**B. Caravaggio  THE CALLING OF ST. MATTHEW**
Contarelli Chapel, Church of San Luigi dei Francesi, Rome. 1599–1600.
Oil on canvas, 10′7½″ × 11′2″ (3.24 × 3.4 m).

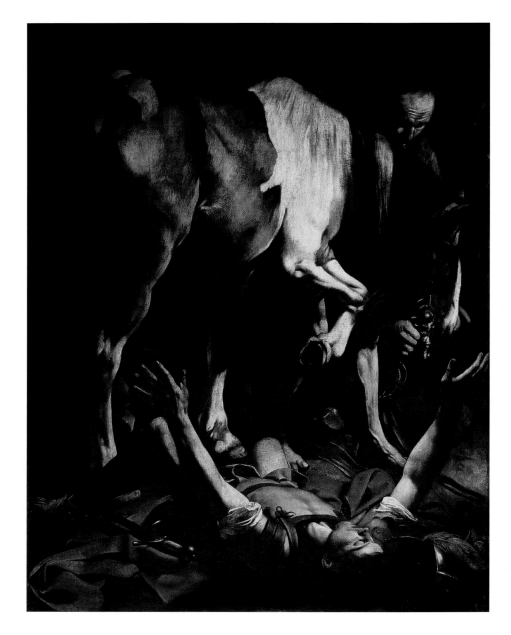

**22-12 •** Caravaggio **THE CONVERSION OF ST. PAUL**
Cerasi Chapel, Santa Maria del Popolo, Rome. c. 1601. Oil on canvas, 7′6″ × 5′8″ (2.3 × 1.75 m).

**EXPLORE MORE:** Gain insight from a primary source on Caravaggio
**www.myartslab.com**

religious subjects directly and dramatically, combining intensely observed figures, poses, and expressions with strongly contrasting effects of light and color. His knowledge of Lombard painting, where the influence of Leonardo was strong, must have aided him in his development of the technique now known as **tenebrism**, in which forms emerge from a dark background into a strong light that often falls from a single source outside the painting. The effect is that of a theatrical spotlight.

One of Caravaggio's first religious commissions, paintings for the Contarelli Chapel in the French community's church of St. Louis (San Luigi dei Francesi), included *The Calling of St. Matthew*, painted about 1599–1600 (see "Caravaggio in the Contarelli Chapel," pages 722–723). The subject is conversion, a common Counter-Reformation theme. Jesus calls Levi, the tax collector, to join his apostles (Matthew 9:9; Mark 2:14). Levi—who will become St. Matthew—sits at a table, counting or collecting money,

surrounded by elegant young men in plumed hats, velvet doublets, and satin shirts. Nearly hidden behind the back of the beckoning apostle—probably St. Peter—at the right, the gaunt-faced Jesus points dramatically at Levi with a gesture that is repeated in the presumed (other than Jesus, identities are not certain here) tax collector's own surprised response of pointing to himself, as if to say, "Who, me?" An intense raking light enters the painting from upper right, as if it were coming from the chapel's actual window above the altar to spotlight the important features of this darkened scene. Viewers encountering the painting obliquely across the empty space of the chapel interior seem to be witnessing the scene as it is occurring, elevated on a recessed stage opening through the wall before them.

The emotional power of Caravaggio's theatrical approach to sacred narrative is nowhere more evident than in his rendering of **THE CONVERSION OF ST. PAUL** for the Cerasi Chapel of Santa

Maria del Popolo (FIG. 22–12). This is one of two paintings commissioned for this chapel in 1600; the other portrayed the Crucifixion of St. Peter. The first pair was rejected when Caravaggio delivered them, and they were acquired by a private collector (see also "Caravaggio in the Contarelli Chapel," pages 722–723). This second version of Paul's conversion is direct and simple. Caravaggio focuses on Paul's internal involvement with a pivotal moment, not its external cause. There is no indication of a heavenly apparition, only Paul's response to it. There is no clear physical setting, only mysterious darkness. And Paul's experience is personal. Whereas he has been flung from his horse and threatens to tumble into the viewers' own space—arms outstretched and legs akimbo, bathed in a strong spotlight—the horse and groom behind him seem oblivious to Paul's experience. The horse actually takes up more space in the painting than the saint, and the unsettling position of its lifted foreleg, precariously poised over the sprawled body of Paul, adds further tension to an already charged presentation.

Despite the great esteem in which Caravaggio was held by some, especially the younger generation of artists, his violent temper repeatedly got him into trouble. During the last decade of his life, he was frequently arrested, initially for minor offenses such as carrying arms illegally or street brawling. But in May of 1606 he killed a man in a duel fought over a disputed tennis match and had to flee Rome as a fugitive under a death sentence. He supported himself on the run by painting in Naples, Malta, and Sicily. The Knights of Malta awarded him the cross of their religious and military order in July 1608, but in October he was imprisoned for insulting one of their number, and again he escaped and fled. Caravaggio died on July 18, 1610, just short of his 39th birthday, of a fever contracted during a journey back to Rome where he expected to be pardoned of his capital offense. Caravaggio's unvarnished realism and tenebrism influenced nearly every important European artist of the seventeenth century.

ARTEMISIA GENTILESCHI. One of Caravaggio's most brilliant Italian followers was Artemisia Gentileschi (1593–c. 1652/1653), whose international reputation helped spread the Caravaggesque style beyond Rome. Artemisia first studied and worked under her father, Orazio, one of the earliest followers of Caravaggio. In 1616, she moved from Rome to Florence, where she worked for the grand duke of Tuscany and was elected, at the age of 23, to the Florentine Academy of Design. But like many great artists, her promise as a painter was already evident in her early work. At the age of 17, while she was still part of her father's studio, she painted a stunning rendering of the popular subject of *Susannah and the Elders* (FIG. 22–13), perhaps an intentional "masterpiece," meant to showcase her talent and secure her reputation as one of the preeminent painters of the age.

The subject is biblical, drawn from a part of the Book of Daniel that was excluded from the Protestant Bible, but—perhaps consequently—especially popular as a subject in Roman Catholic art. While bathing alone in her garden, the beautiful young Susannah is observed by two lecherous elders—Peeping Toms— who threaten to claim they saw her engaged in a lovers' tryst unless

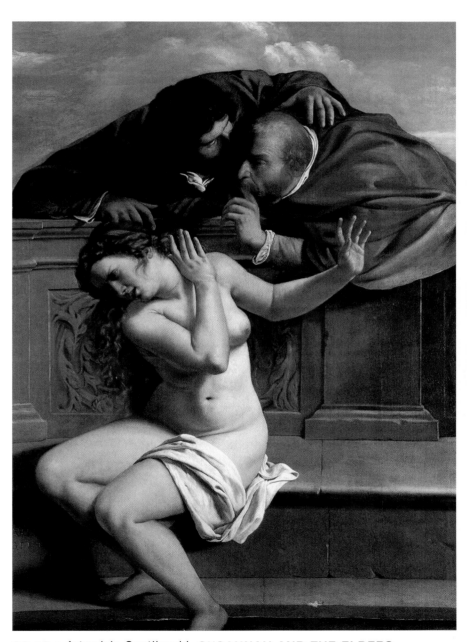

22-13 • Artemisia Gentileschi **SUSANNAH AND THE ELDERS**
1610. Oil on canvas, 67 × 47⅝″ (1.7 × 1.21 m). Count Schönborn Kunstsammlungen, Pommersfelden.

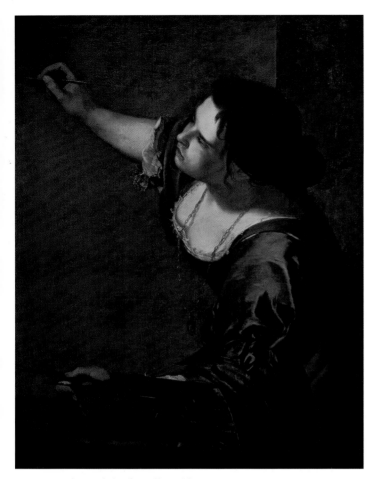

**22-14 • Artemisia Gentileschi SELF-PORTRAIT AS THE ALLEGORY OF PAINTING**
1630. Oil on canvas, 38 × 29″ (96.5 × 73.7 cm). The Royal Collection, Windsor Castle, England.

**EXPLORE MORE:** Gain insight from a primary source on Artemisia Gentileschi **www.myartslab.com**

she agrees to have sex with them. Susannah refuses to surrender her chastity, and they make good on their threat. Initially sentenced to death for her supposed sexual transgression, through the intervention of Daniel, she is proven innocent, and the two dishonest voyeurs are executed instead.

Most male artists who painted this scene emphasized Susannah's sexual allure and the elders' lustful stares, but Artemesia shifts the narrative focus to the powerless young woman's vulnerability—and this Susannah actually looks like a woman. Although female artists were excluded from using male models, Artemesia has clearly studied the appearance and anatomy of unclothed women, creating one of the first truly lifelike female nudes in the European tradition. Her interest in unvarnished naturalism is probably derived from Caravaggio. His revolutionary art is also behind the theatricality of the heroine's rhetorical gesture (recalling that of Adam when expelled from paradise in the Sistine Ceiling), the complex interlocking of the figures' postures (note the patterned relationship between the hands), and the crowding of

figures up against the picture plane. But Artemisia has blended her sources and influences into a personal rendering of a traditional subject that moves viewers to empathize with the heroine's condition, and will perhaps inspire them to emulate her righteousness in a world still dominated by overpowering men.

Twenty years after this painting, Artemisia painted a **SELF-PORTRAIT AS THE ALLEGORY OF PAINTING** (FIG. **22–14**). A richly dressed woman, with palette and brushes in hand, is totally immersed in her work. Aspects of the image are derived from Cesare Ripa's sourcebook *Iconologia* (1593), which became an essential tool for creating and deciphering seventeenth- and eighteenth-century art. For instance, *Iconologia* is the source for the woman's gold necklace with its mask pendant: Ripa writes that the mask imitates the human face, as painting imitates nature, and the gold chain symbolizes "the continuity and interlocking nature of painting, each man [*sic*] learning from his master and continuing his master's achievements in the next generation" (Maser, trans. no. 197). By painting her own features on a personification of Painting, Artemisia not only commemorates her profession but also claims her own place within it.

**22-15 • BARBERINI PALACE AND SQUARE**
1628–1636. Drawing by Lieven Cruyl, 1665. Ink and chalk on paper, 15 × 19¾″ (38.2 × 49.4 cm). Cleveland Museum of Art, Cleveland, Ohio. Dudley P. Allen Fund 1943.265

Maderno, Bernini, and Borromini collaborated on the Barberini Palace between 1628 and 1636, and in the 1670s the structure underwent considerable remodeling. The original plan is unique, having no precedents or imitators in the history of Roman palaces. The structure appears as a single massive pile, but in fact it consists of a central reception block flanked by two residential wings and two magnificent staircases. Designed to house two sides of the family, the rooms are arranged in suites allowing visitors to move through them, achieving increasing intimacy and privacy. Since Cruyl visited the city during Carnival, a float with musicians and actors takes center stage among the strollers. Carnival floats are among the ephemera of art. (Today we might call them "performance art.") Cruyl, who includes his own image at the left, published his drawings as engravings, a set of 15 plates called *Views of Rome*, in 1665.

**BAROQUE CEILINGS: CORTONA AND GAULLI.** Theatricality, intricacy, and the opening of space reached an apogee in Baroque ceiling decoration—complex constructions combining architecture, painting, and stucco sculpture. These grand illusionistic projects were carried out on the domes and vaults of churches, civic buildings, palaces, and villas, and went far beyond even Michelangelo's Sistine Chapel ceiling (SEE FIG. 20–11) or Correggio's dome (SEE FIG. 20–19). Baroque ceiling painters sought the drama of an immeasurable heaven that extended into vertiginous zones far beyond the limits of High Renaissance taste. To achieve this, they employed the system of *quadratura* (literally, "squaring" or "gridwork"): an architectural setting painted in meticulous perspective and usually requiring that it be viewed from a specific spot to achieve the desired effect of soaring space. The resulting viewpoint is called *di sotto in su* ("from below to above"), which we first saw, in a limited fashion, in Mantegna's ceiling in Mantua (FIG. 19–29). Because it required such careful calculation, figure painters usually had specialists in *quadratura* paint the architectural frame for them.

Pietro Berrettini (1596–1669), called "Pietro da Cortona" after his hometown, carried the development of the Baroque ceiling away from Classicism into a more strongly unified and illusionistic direction. Trained in Florence and inspired by Veronese's ceiling in the Doge's Palace, which he saw on a trip to Venice in 1637, the artist was commissioned in the early 1630s by the Barberini family of Pope Urban VIII to decorate the ceiling of the audience hall of their Roman palace. A drawing by a Flemish artist visiting Rome, Lieven Cruyl (1640–c. 1720), gives us a view

of the Barberinis' huge palace, piazza, and the surrounding city. Bernini's Trident Fountain stands in the center of the piazza, and his scallop-shell fountain can be seen at the right (FIG. 22–15).

Pietro da Cortona's great fresco *The Glorification of the Papacy of Urban VIII* became a model for a succession of Baroque illusionistic palace ceilings throughout Europe (FIG. 22–16). He structured his mythological scenes around a vaultlike skeleton of architecture, painted in *quadratura*, that appears to be attached to the actual cornice of the room. But in contrast to Annibale Carracci's neat separations and careful *quadro riportato* framing (SEE FIG. 22–9), Pietro's figures weave in and out of their setting in active and complex profusion; some rest on the actual cornice, while others float weightlessly against the sky. Instead of Annibale's warm, nearly even light, Pietro's dramatic illumination, with its bursts of brilliance alternating with deep shadows, fuses the ceiling into a dense but unified whole.

The subject is an elaborate allegory of the virtues of the pope. Just below the center of the vault, seated at the top of a pyramid of clouds and figures personifying Time and the Fates, Divine Providence (in gold against an open sky) gestures toward three giant bees surrounded by a huge laurel wreath (both Barberini emblems) carried by Faith, Hope, and Charity. Immortality offers a crown of stars, while other figures present the crossed keys and the triple-tiered crown of the papacy. Around these figures are scenes of Roman gods and goddesses, who demonstrate the pope's wisdom and virtue by triumphing over the vices. So complex was the imagery that a guide gave visitors an explanation, and one member of the household published a pamphlet, still in use today, explaining the painting.

**22–16 • Pietro da Cortona  THE GLORIFICATION OF THE PAPACY OF URBAN VIII**
Ceiling in the Gran Salone, Palazzo Barberini, Rome. 1632–1639. Fresco.

**22-17 •** Giovanni Battista Gaulli **THE TRIUMPH OF THE NAME OF JESUS AND FALL OF THE DAMNED**

Vault of the church of *Il Gesù*, Rome. 1672–1685. Fresco with stucco figures.

The most spectacular of all illusionistic Baroque ceilings is Giovanni Battista Gaulli's **THE TRIUMPH OF THE NAME OF JESUS AND FALL OF THE DAMNED (FIG. 22–17),** which fills the vault of the Jesuit church *Il Gesù*. In the 1560s, Giacomo da Vignola had designed an austere interior for *Il Gesù*, but when the Jesuits renovated their church a century later, they commissioned a religious allegory to cover the nave's plain ceiling. Gaulli (1639–1709) designed and executed the spectacular illusion between 1672 and 1685, fusing sculpture and painting to eliminate any appearance of architectural division. It is difficult to sort carved three-dimensional figures from

the painted imitations, and some paintings are on real panels that extend over the actual architectural frame. Gaulli, who arrived in Rome from Genoa in 1657, had worked in his youth for Bernini, from whom he absorbed a taste for drama and multimedia effects. The elderly Bernini, who worshiped daily at *Il Gesù*, may well have offered his personal advice to his former assistant, and Gaulli was certainly familiar with other illusionistic paintings in Rome as well, including Pietro da Cortona's Barberini ceiling.

Gaulli's astonishing creation went beyond anything that had preceded it in unifying architecture, sculpture, and painting. Every element is dedicated to creating the illusion that clouds and angels have floated down through an opening in the top of the church into the upper reaches of the nave. The extremely foreshortened figures are projected as if seen from below, and the whole composition is focused off-center on the golden aura around the letters IHS, the monogram of Jesus and the insignia of the Jesuits. The subject is, in fact, the Last Judgment, with the elect rising joyfully toward the name of God and the damned plummeting through the ceiling toward the nave floor. The sweeping extension of the work into the nave space, the powerful appeal to the viewer's emotions, and the near-total unity of the multimedia visual effect—all hallmarks of Italian Baroque—were never surpassed.

# SPAIN

When the Holy Roman Emperor Charles V abdicated in 1556, he left Spain and its American colonies, the Netherlands, Burgundy, Milan, and the Kingdom of Naples and Sicily to his son Philip II and the Holy Roman Empire (Germany and Austria) to his brother Ferdinand. Ferdinand and the Habsburg emperors who succeeded him ruled their territories from Vienna in Austria, but much of German-speaking Europe remained divided into small units in which local rulers decided on the religion of their territory. Catholicism prevailed in southern and western Germany and in Austria, while the north was Lutheran.

The Spanish Habsburg kings Philip III (r. 1598–1621), Philip IV (r. 1621–1665), and Charles II (r. 1665–1700) reigned over a weakening empire. After repeated local rebellions, Portugal re-established its independence in 1640. The Kingdom of Naples remained in a constant state of unrest. After 80 years of war, the Protestant northern Netherlands—which had formed the United Provinces—gained independence in 1648. Amsterdam grew into one of the wealthiest cities in Europe, and the Dutch Republic became an increasingly serious threat to Spanish trade and colonial possessions. The Catholic southern Netherlands (Flanders) remained under Spanish and then Austrian Habsburg rule.

What had seemed an endless flow of gold and silver from the Americas to Spain diminished, as precious-metal production in Bolivia and Mexico lessened. Agriculture, industry, and trade at home also suffered. As they tried to defend the Roman Catholic Church and their empire on all fronts, the Spanish kings squandered their resources and finally went bankrupt in 1692. Nevertheless, despite the decline of the Habsburgs' Spanish empire, seventeenth-century writers and artists produced some of the greatest Spanish literature and art, and the century is often called the Spanish Golden Age.

## PAINTING IN SPAIN'S GOLDEN AGE

The primary influence on Spanish painting in the fifteenth century had been the art of Flanders; in the sixteenth, it had been the art of Florence and Rome. Seventeenth-century Spanish painting, profoundly influenced by Caravaggio's powerful art, was characterized by an ecstatic religiosity combined with realistic surface detail that emerges from the deep shadows of tenebrism.

JUAN SÁNCHEZ COTÁN.    Late in the sixteenth century, Spanish artists developed a significant interest in paintings of artfully arranged objects rendered with intense attention to detail. Juan Sánchez Cotán (1561–1627) was one of the earliest painters of these pure still lifes in Spain. In **STILL LIFE WITH QUINCE, CABBAGE, MELON, AND CUCUMBER (FIG. 22–18)**, of about 1602, he plays off the irregular, curved shapes of the fruits and vegetables against the angular geometry of their setting. His precisely ordered subjects—

**22-18** • Juan Sánchez Cotán **STILL LIFE WITH QUINCE, CABBAGE, MELON, AND CUCUMBER**
c. 1602. Oil on canvas, 27⅛ × 33¼″ (68.8 × 84.4 cm). San Diego Museum of Art.
Gift of Anne R. and Amy Putnam

**22–19 • Jusepe de Ribera MARTYRDOM OF ST. BARTHOLOMEW**
1634. Oil on canvas, 41¼ × 44⅞″ (1.05 × 1.14 m). National Gallery of Art, Washington, D.C.

two of which are suspended from strings—form a long arc from the upper left to the lower right. The fruits and vegetables appear within a *cantarero* (primitive larder), but it is unclear why they have been arranged in this way. Set in a strong light against impenetrable darkness, this highly artificial arrangement of strikingly lifelike forms suggests not only a fascination with spatial ambiguity, but also a contemplative sensibility and interest in the qualities of objects that look forward to the work of Zurbarán and Velázquez.

JUSEPE DE RIBERA.    Jusepe (or José) de Ribera (c. 1591–1652) was born in Seville but studied in Rome and settled in Spanish-ruled Naples; in Italy, he was known as "Lo Spagnoletto" ("the

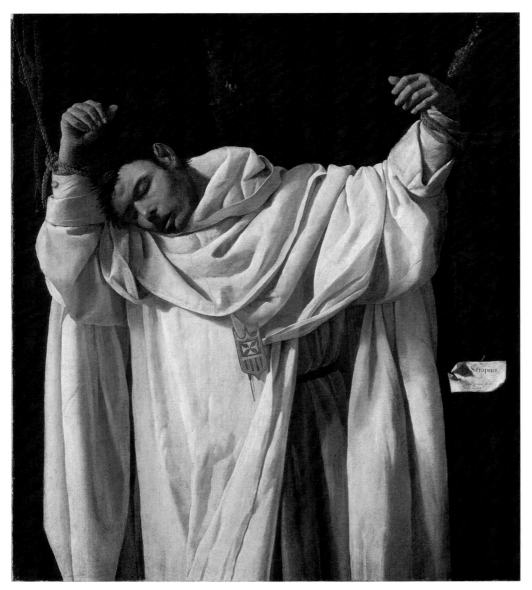

**22–20 • Francisco de Zurbarán**
**ST. SERAPION**
1628. Oil on canvas, 47½ × 40¾″ (120.7 × 103.5 cm). Wadsworth Atheneum, Hartford, Connecticut.
Ella Gallup Sumner and Mary Catlin Sumner Collection Fund

Little Spaniard"). He combined the Classical and Caravaggesque styles he had learned in Rome to create a new Neapolitan—and eventually Spanish—style. Ribera became the link extending from Caravaggio in Italy to the Spanish masters Zurbarán and Velázquez.

During this period, the Church—aiming to draw people back to Catholicism—commissioned portrayals of heroic martyrs who had endured shocking torments as witness to their faith. Ribera's painting of the **MARTYRDOM OF ST. BARTHOLOMEW**, an apostle who was martyred by being skinned alive, captures the horror of the violence to come while emphasizing the saint's spirituality and acceptance (**FIG. 22–19**). The bound Bartholomew looks heavenward as his executioner tests the sharpness of the knife that he will soon use on his still-living victim. Ribera has learned the lessons of Caravaggio well, as he highlights the intensely realistic faces with the dramatic light of tenebrism and describes the aging wrinkled flesh in great detail. The compression of the figures into the foreground space heightens our sense of being witness to this scene.

**FRANCISCO DE ZURBARÁN.** Francisco de Zurbarán (1598–1664) represents another martyrdom, but with understated control, in his 1628 painting of **ST. SERAPION (FIG. 22–20)**. Little is known of his early years before 1625, but Zurbarán too came under the influence of the Caravaggesque taste prevalent in Seville, the major city in southwestern Spain. His own distinctive style incorporated an interest in abstract design, which some have traced to the heritage of Islamic art in Spain.

Zurbarán primarily worked for the monastic orders. In this painting, he portrays the martyrdom of Serapion, member of the thirteenth-century Mercedarians, a Spanish order founded to rescue the Christian prisoners of the Moors. Following the vows of his order, Serapion sacrificed himself in exchange for Christian captives. The dead man's pallor, his rough hands, and the coarse ropes contrast with the off-white of his creased Mercedarian habit, its folds carefully arranged in a pattern of highlights and varying depths of shadow. The only colors are the red and gold of the insignia. This timelessly immobile composition is like a tragic still life, a study of fabric and flesh become inanimate, silent, and at rest.

**DIEGO VELÁZQUEZ.** Diego Rodríguez de Silva y Velázquez (1599–1660), the greatest painter to emerge from the Caravaggesque school of Seville, shared Zurbarán's fascination with objects. He entered Seville's painters' guild in 1617. Like Ribera, he began his career as a tenebrist and naturalist. During his early years, he painted scenes set in taverns, markets, and kitchens, and emphasized still lifes of various foods and kitchen utensils. His early **WATER CARRIER OF SEVILLE (FIG. 22–21)** is a study of surfaces and textures of the splendid ceramic pots that characterized folk art through the centuries. Velázquez was devoted to studying and sketching from life: The man in the painting was a well-known Sevillian waterseller. Like Sánchez Cotán, Velázquez arranged the elements of his paintings with almost mathematical rigor. The objects and figures allow the artist to exhibit his virtuosity in rendering sculptural volumes and describing contrasting textures illuminated by dramatic natural light. Light reflects in different ways off the glazed waterpot at the left and the coarser clay jug in the foreground; it is absorbed by the rough wool and dense velvet of the costumes; it

**22-21 • Diego Velázquez WATER CARRIER OF SEVILLE**
c. 1619. Oil on canvas, 41½ × 31½″ (105.3 × 80 cm). Victoria & Albert Museum, London.

is refracted as it passes through the clear glass held by the man and the waterdrops on the jug's surface.

In 1623, Velázquez moved to Madrid, where he became court painter to the young King Philip IV, a prestigious position that he held until his death in 1660. The opportunity to study paintings in the royal collection, as well as to travel, enabled the development of his distinctive personal style. The Flemish painter Peter Paul Rubens, during a 1628–1629 diplomatic visit to the Spanish court, convinced the king that Velázquez should visit Italy. Velázquez made two trips, the first in 1629–1631 and the second in 1649–1651. He was profoundly influenced by contemporary Italian painting, and on the first trip seems to have taken a special interest in narrative paintings with complex figure compositions.

Velázquez's Italian studies and his growing skill in composition are apparent in both figure and landscape paintings. In **THE SURRENDER AT BREDA** (FIG. 22–22), painted in 1634–1635, Velázquez treats the theme of triumph and conquest in an entirely new way—far removed from traditional gloating military propaganda. Years earlier, in 1625, Ambrosio Spinola, the Duke of Alba and the Spanish governor, had defeated the Dutch at Breda. In Velázquez's imagination, the opposing armies stand on a hilltop overlooking a vast valley where the city of Breda burns and soldiers are still deployed. The Dutch commander, Justin of Nassau, hands over the keys of Breda to the victorious Spanish commander. The entire exchange seems extraordinarily gracious, an emblem of a courtly ideal of gentlemanly conduct. The victors stand at attention, holding their densely packed lances upright in a vertical pattern—giving the painting its popular name, "The Lances"—while the defeated Dutch, a motley group, stand out of order, with pikes and banners drooping. In fact, according to reports, no keys were involved and the Dutch were more presentable in appearance than the Spaniards. Velázquez has taken liberties with historical fact to create a work of art that embodied an idealized rendering of the meaning of the surrender to his Spanish patron.

Velázquez displays here his ability to arrange a large number of figures and tell a story effectively. A strong diagonal, starting in the sword of the Dutch soldier in the lower left foreground and ending in the checked banner on the upper right, unites the composition and moves the viewer from the defeated to the victorious soldiers in the direction of the surrender itself. Portrait-like faces, meaningful gestures, and controlled color and texture convince us of the reality of the scene. The landscape painting is almost startling. Across the huge canvas, Velázquez painted an entirely imaginary Netherlands in greens and blues worked with flowing, liquid brushstrokes. Luminosity is achieved by laying down a thick layer of lead white and then flowing the layers of color over it. The silvery light forms a background for dramatically silhouetted figures and weapons. Velázquez revealed a breadth and intensity unsurpassed in his century, and became an inspiration to modern artists such as Manet and Picasso.

Perhaps Velázquez's most striking, certainly his most enigmatic work is the enormous multiple portrait, nearly 10½ feet tall and over 9 feet wide, known as **LAS MENINAS (THE MAIDS OF HONOR)**

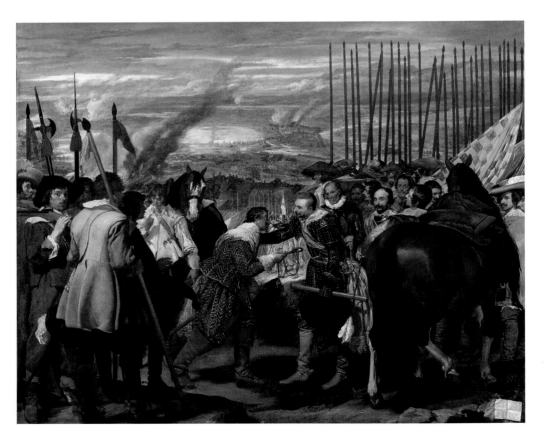

**22–22 • Diego Velázquez**
**THE SURRENDER AT BREDA (THE LANCES)**
1634–1635. Oil on canvas, 10′7⅞″ × 12′½″ (3.07 × 3.67 m). Museo del Prado, Madrid.

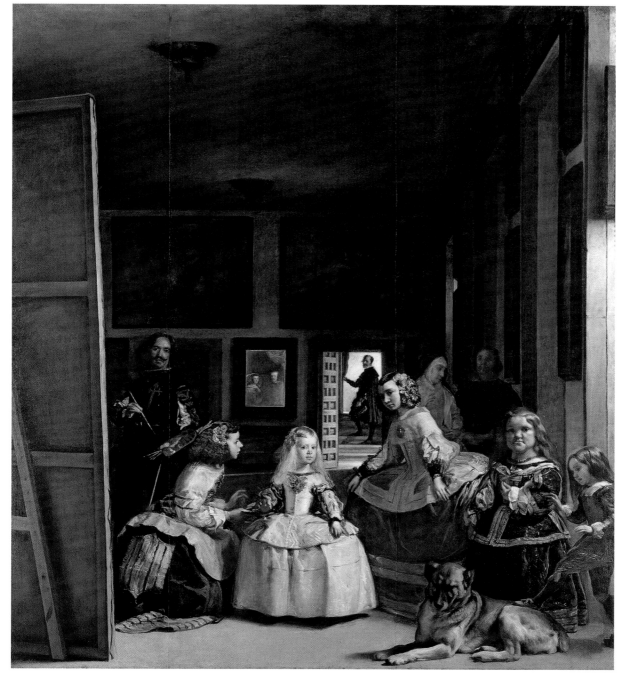

**22-23 • Diego Velázquez LAS MENINAS (THE MAIDS OF HONOR)**
1656. Oil on canvas, 10'5" × 9'½" (3.18 × 2.76 m). Museo del Prado, Madrid.

**EXPLORE MORE:** Gain insight from a primary source on Diego Velázquez www.myartslab.com

(FIG. 22–23), painted in 1656, near the end of his life. This painting continues to challenge the viewer and stimulate debate among art historians. Velázquez draws viewers directly into the scene. In one interpretation, the viewer stands in the very space occupied by King Philip and his queen, whose reflections can be seen in the large mirror on the back wall, perhaps a clever reference to Jan van Eyck's *Double Portrait of a Giovanni Arnolfini and his Wife* (SEE FIG. 18–1), which was a part of the Spanish royal collection at this time. Echoing pictorially the claim made in Jan's signature, Velázquez himself is also present, brushes in hand, beside a huge canvas. The central focus, however, is neither the artist nor the royal couple but their brilliantly illuminated 5-year-old daughter, the Infanta (princess) Margarita, who is surrounded by her attendants, most of whom are identifiable portraits.

The cleaning of *Las Meninas* in 1984 revealed much about Velázquez's methods. He used a minimum of underdrawing,

building up his forms with layers of loosely applied paint and finishing off the surfaces with dashing highlights in white, lemon yellow, and pale orange. Rather than using light to model volumes in the time-honored manner, Velázquez tried to depict the optical properties of light reflecting from surfaces. On close inspection his forms dissolve into a maze of individual strokes of paint.

No consensus exists today on the meaning of this monumental painting. It is a royal portrait; it is also a self-portrait of Velázquez standing at his easel. But fundamentally, *Las Meninas* is a personal statement. Throughout his life, Velázquez had sought respect and acclaim for himself and for the art of painting. Here, dressed as a courtier, the Order of Santiago on his chest (added later) and the keys of the palace tucked into in his sash, Velázquez proclaims the dignity and importance of painting itself.

BARTOLOMÉ ESTEBAN MURILLO. The Madrid of Velázquez was the center of Spanish art. Seville declined after an outbreak of plague in 1649, but it remained a center for trade with the Spanish colonies, where the work of Bartolomé Esteban Murillo (1617–1682) had a profound influence on art and religious iconography. Many patrons wanted images of the Virgin Mary and especially of the Immaculate Conception, the controversial idea that Mary was born free from original sin. Although the Immaculate Conception became Catholic dogma only in 1854, the concept, as well as devotion to Mary, grew during the seventeenth and eighteenth centuries.

Counter-Reformation authorities had provided specific instructions for artists painting the Virgin: Mary was to be dressed in blue and white, her hands folded in prayer, as she is carried upward by angels, sometimes in large flocks. She may be surrounded by an unearthly light ("clothed in the sun") and may stand on a crescent moon in reference to the woman of the Apocalypse (SEE FIG. 14–7). Angels often carry palms and symbols of the Virgin, such as a mirror, a fountain, roses, and lilies, and they may vanquish the serpent, Satan. The Church exported to the New World many paintings faithful to these orthodox guidelines by Murillo, Zurbarán, and others. When the indigenous population began to visualize the Christian story (SEE FIG. 29–45), paintings such as Murillo's **THE IMMACULATE CONCEPTION** provided prompts for their imaginings (**FIG. 22–24**).

### ARCHITECTURE IN SPAIN

Turning away from the severity displayed in the sixteenth-century El Escorial monastery–palace (SEE FIG. 21–15), seventeenth-century Spanish architects again embraced the lavish decoration that had characterized their art since the fourteenth century. Profusions of ornament swept back into fashion, first in huge *retablos* (altarpieces), then in portals (main doors often embellished with sculpture), and finally in entire buildings.

THE CATHEDRAL OF SANTIAGO DE COMPOSTELA. In the seventeenth century, the role of St. James as patron saint of Spain was challenged by the supporters of St. Teresa of Ávila and then by supporters of St. Michael, St. Joseph, and other popular saints. It became important to the archbishop and other leaders in Santiago de Compostela, where the Cathedral of St. James was located, to establish their primacy. They reinforced their efforts to revitalize the yearly pilgrimage to the city, undertaken by Spaniards since the ninth century, and used architecture as part of their campaign.

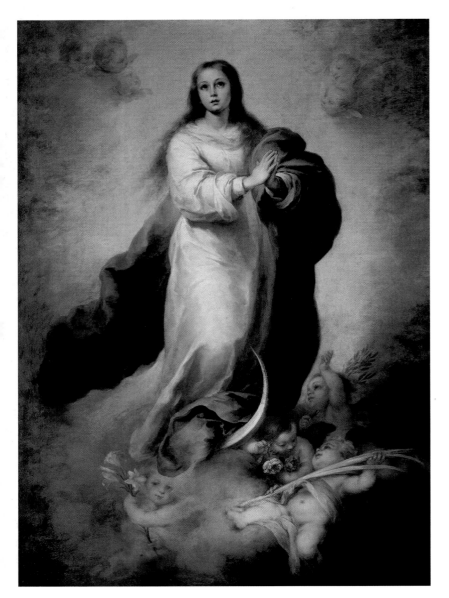

**22-24 •** Bartolomé Esteban Murillo
**THE IMMACULATE CONCEPTION**
c. 1660–1665. Oil on canvas, 81⅛ × 56⅝″
(2.06 × 1.44 m). Prado, Madrid.

**22-25 • WEST FAÇADE, CATHEDRAL OF ST. JAMES, SANTIAGO DE COMPOSTELA, SPAIN**
South tower 1667–1680; north tower and central block finished mid-18th century by Fernando de Casas y Nóvoas.

Renewed interest in pilgrimages to the shrines of saints in the seventeenth century brought an influx of pilgrims, and consequently financial security, to the city and the Church. The cathedral chapter ordered a façade of almost unparalleled splendor to be added to the twelfth-century pilgrimage church (**FIG. 22–25**). The twelfth-century portal had already been closed with doors in the sixteenth century. A south tower was built in 1667–1680 and then later copied as the north tower.

The last man to serve as architect and director of works at the cathedral, Fernando de Casas y Nóvoas (active 1711–1749), tied the disparate elements together at the west end—towers, portal, stairs—in a grand design focused on a veritable wall of glass, popularly called "The Mirror." His design culminates in a free-standing gable soaring above the roof, visually linking the towers, and framing a statue of St. James. The extreme simplicity of the cloister walls and the archbishop's palace at each side of the portal heightens the dazzling effect of this enormous expanse of glass windows, glittering, jewel-like, in their intricately carved granite frame.

# FLANDERS AND THE NETHERLANDS

Led by the nobleman Prince William of Orange, the Netherlands' Protestant northern provinces (present-day Holland) rebelled against Spain in 1568. The seven provinces joined together as the United Provinces in 1579 and began the long struggle for independence, achieved only in the seventeenth century. The king of Spain considered the Dutch heretical rebels, but finally the Dutch prevailed. In 1648, the United Provinces joined emissaries from Spain, the Vatican, the Holy Roman Empire, and France on equal footing in peace negotiations. The resulting Peace of Westphalia recognized the independence of the northern Netherlands.

## FLANDERS

After a period of relative autonomy from 1598 to 1621 under Habsburg regents, Flanders, the southern—and predominantly Catholic—part of the Netherlands, returned to direct Spanish rule. Catholic churches were restored and important commissions went to religious subject matter. As Antwerp, the capital city and major arts center of the southern Netherlands, gradually recovered from the turmoil of the religious wars, artists of great talent flourished there. Painters like Peter Paul Rubens and Anthony van Dyck established international reputations that brought them important commissions from foreign as well as local patrons.

RUBENS. Peter Paul Rubens (1577–1640), whose painting has become synonymous with Flemish Baroque art, was born in Germany, where his father, a Protestant, had fled from his native Antwerp to escape religious persecution. In 1587, after her husband's death, Rubens's mother and her children returned to Antwerp and to Catholicism. Rubens decided in his late teens to become an artist and at age 21 was accepted into the Antwerp painters' guild, a testament to his energy, intelligence, and skill. Shortly thereafter, in 1600, he left for Italy. In Venice, his work came to the attention of the duke of Mantua, who offered him a court post. His activities on behalf of the duke over the next eight years did much to prepare him for the rest of his long and successful career. The duke had him copy famous paintings in collections all over Italy to add to the ducal collection.

Rubens visited every major Italian city, went to Madrid as the duke's emissary, and spent two extended periods in Rome, where he studied the great works of Roman antiquity and the Italian Renaissance. While in Italy, Rubens studied the paintings of two contemporaries, Caravaggio and Annibale Carracci. Hearing of Caravaggio's death in 1610, Rubens encouraged the duke of Mantua to buy the artist's *Death of the Virgin*, which the patron had rejected because of its shocking realism. The duke eventually bought the painting.

In 1608, Rubens returned to Antwerp, where in 1609 he accepted a position as court painter to the Habsburg regents of Flanders, Archduke Albert and Princess Isabella Clara Eugenia, the daughter of Philip II. Ten days after that appointment, he married the 18-year-old Isabella Brandt (1596–1626), an alliance that was

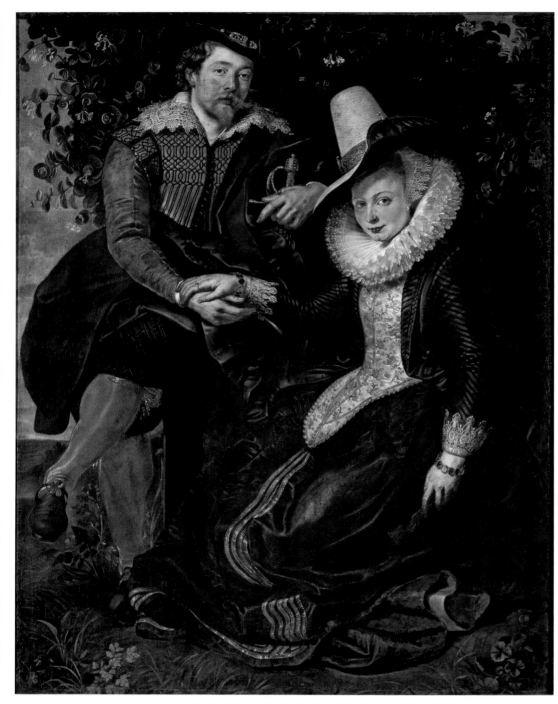

**22–26 • Peter Paul Rubens SELF-PORTRAIT WITH ISABELLA BRANDT**
1609–1610. Oil on canvas, 5'9" × 4'5" (1.78 × 1.36 m). Alte Pinakothek, Munich.

financially beneficial to the artist, then almost twice the age of his bride. He commemorated the marriage with a spectacular double portrait of himself and his bride seated together in front of a honeysuckle bower that evokes a state of marital bliss **(FIG. 22–26)**. The self-confident couple look out to engage viewers directly, and the rich detail of their lavish costumes is described with meticulous precision, foregrounding both the artist's virtuosity and the couple's wealth and sophistication. They join right hands in a traditional gesture of marriage, and the artist slips his foot into the folds of Isabella's flowing red skirt, suggesting a more intimate connection between them. They would have three children before Isabella's untimely death in 1626.

In 1611, Rubens purchased a residence in Antwerp. The original house was large and typically Flemish, but Rubens added a studio in the Italian manner across a courtyard, joining the two buildings by a second-floor gallery over the entrance portal **(FIG. 22–27)**. Beyond the courtyard lay the large formal garden, laid out in symmetrical beds. The living room permitted access to a gallery

overlooking Rubens's huge studio, a room designed to accommodate large paintings and to house what became virtually a painting factory. The tall, arched windows provided ample light for the single, two-story room, and a large door permitted the assistants to move finished paintings out to their designated owners. Through the gates at one side of the courtyard, one can see the architectural features of the garden, which inspired the architectural setting of *The Garden of Love* (SEE FIG. 22–30).

Rubens's first major commission in Antwerp was a large canvas triptych for the main altar of the church of St. Walpurga, **THE RAISING OF THE CROSS (FIG. 22–28)**, painted in 1610–1611.

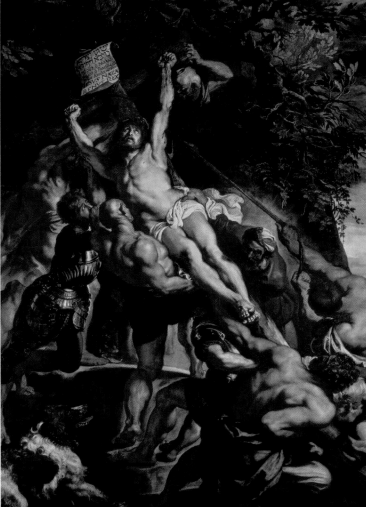

22-28 • Peter Paul Rubens **THE RAISING OF THE CROSS**
Church of St. Walpurga, Antwerp, Belgium. 1610–1611. Oil on canvas, center panel 15′1⅞″ × 11′1½″ (4.62 × 3.39 m), each wing 15′1⅞″ × 4′11″ (4.62 × 1.52 m). Cathedral of Our Lady, Antwerp.

**22-29 • Peter Paul Rubens**
**HENRY IV RECEIVING THE PORTRAIT OF MARIE DE' MEDICI**
1621–1625. Oil on canvas,
12'11⅛" × 9'8⅛" (3.94 × 2.95 m).
Musée du Louvre, Paris.

**EXPLORE MORE:** Gain insight from a primary source on Peter Paul Rubens www.myartslab.com

He extended the central action and the landscape through all three panels. At the center, Herculean figures strain to haul upright the wooden cross with Jesus already stretched upon it. At the left, the followers of Jesus join in mourning, and at the right, soldiers supervise the execution. The drama and intense emotion of Caravaggio is merged here with the virtuoso technique of Annibale Carracci, but transformed and reinterpreted according to Rubens's own unique ideal of thematic and formal unity. The heroic nude figures, dramatic lighting effects, dynamic diagonal composition, and intense emotions show his debt to Italian art, but the rich colors and careful description of surface textures reflect his native Flemish tradition.

Rubens's expressive visual language was deemed as appropriate for representing secular rulers as it was for dramatic religious subjects. Moreover, his intelligence, courtly manners, and personal charm made him a valuable and trusted courtier to his royal patrons, who included Philip IV of Spain, Queen Marie de' Medici of France, and Charles I of England. In 1621, Marie de' Medici, who had been regent for her son Louis XIII, asked Rubens to paint the story of her life, to glorify her role in ruling France, and also to commemorate the founding of the new Bourbon royal dynasty. In 24 paintings, Rubens portrayed Marie's life and political career as one continuous triumph overseen by the ancient gods of Greece and Rome.

In the painting depicting the royal engagement (FIG. 22–29), Henry IV falls in love at once with Marie as he gazes at her portrait, shown to him—at the exact center of the composition—by Cupid and Hymen, the god of marriage. The supreme Roman god Jupiter and his wife Juno look down approvingly from the clouds. A personification of France encourages Henry, outfitted with steel breastplate and silhouetted against a landscape in which the smoke of a battle lingers in the distance, to abandon war for love, as *putti* play below with the rest of his armor. The ripe colors, lavish textures, and dramatic diagonals give sustained visual excitement to these enormous canvases, making them not only important works of art but also political propaganda of the highest order.

In **THE GARDEN OF LOVE**—a garden reminiscent of his own—Rubens may have portrayed his second wife, Helene Fourment, as the leading lady among a crowd of beauties (FIG. 22–30). *Putti* encourage the lovers, and one pushes a hesitant young woman into the garden so she and her partner can join the ladies and gentlemen who are already enjoying the pleasures of nature, and of each other. The sculpture and architectural setting recall Italian Mannerism—a stone nymph presses water from her breasts to create the fountain,

herms and columns banded with rough-hewn rings flank the entrance to the pavilion that forms the approach to the grotto of Venus. All is lush color, shimmering satin, falling water, and sunset sky—rich in the visual and tactile effects so appreciated by seventeenth-century viewers.

To satisfy his clients all over Europe, Rubens employed dozens of assistants, many of whom were, or became, important painters in their own right. Using workshop assistants was standard practice for a major artist, but Rubens was particularly methodical, training or hiring specialists in costumes, still lifes, landscapes, portraiture, and animal painting who together could complete works from his detailed sketches. Among his friends and collaborators were Anthony van Dyck and his friend and neighbor Jan Brueghel.

PORTRAITS AND STILL LIFES.    One of Rubens's collaborators, Anthony van Dyck (1599–1641), had an illustrious independent career as a portraitist. Son of an Antwerp silk merchant, he was listed as a pupil of the dean of Antwerp's Guild of St. Luke at age 10. He had his own studio and roster of pupils at age 16 but was not made a member of the guild until 1618, the year after he began

**22-30 • Peter Paul Rubens THE GARDEN OF LOVE**
1630–1632. Oil on canvas, 6'6″ × 9'3½″ (1.98 × 2.83 m). Museo del Prado, Madrid.

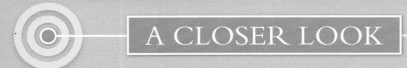

*Allegory of Sight* ▶ by Jan Brueghel and Peter Paul Rubens, from the Allegories of the Five Senses series. c. 1617–1618. Oil on wood panel, 25⅝ × 43″ (65 × 109 cm). Museo del Prado, Madrid.

Coudenberg, the Brussels residence of the patrons, appears in the background.

The double-headed eagle crowning the brass chandelier is the symbol of the Habsburg Dynasty.

On the top shelf are small-scale reproductions of sculptures by Michelangelo—slaves from the tomb of Julius II and personifications of the times of the day from the Medici tombs—and on the lower shelves are portraits of Roman emperors.

*The Tiger Hunt* seen on the back wall was a recent painting by Rubens. Along with his *Daniel in the Lions' Den* in the upper left and his and Brueghel's *Madonna and Child in a Garland of Flowers* at right, this seems to have been included to showcase the artists' latest work.

A double portrait of the patrons Albert and Isabella sits on the table, while an equestrian portrait of Albert is seen on the floor at the center of the room. Both copy actual paintings by Rubens.

Personifying sight, Juno Optica—identified by her bird, the peacock, seen in the doorway next to her head—contemplates a painting of *Christ Healing the Blind* that invokes Sight through its opposite, while linking the senses to the doctrine of salvation.

Instruments such as the telescope and magnifying glass, as well as the spectacles worn by the monkey in the immediate foreground, all refer to the sense of sight and its limitations.

This painting—the Madonna and Child is by Rubens and the framing floral wreath by Brueghel—is identical to one now in the Louvre, except it is shown larger here in proportion to the other objects in the room.

SEE MORE: View the Closer Look feature for *Allegory of Sight* **www.myartslab.com**

his association with Rubens as a specialist in painting heads. The need to blend his work seamlessly with that of Rubens enhanced Van Dyck's technical skill. After a trip to the English court of James I (r. 1603–1625) in 1620, Van Dyck traveled to Italy and worked as a portrait painter for seven years before returning to Antwerp. In 1632, he returned to England as the court painter to Charles I (r. 1625–1649), by whom he was knighted and given a studio, a summer home, and a large salary.

Van Dyck's many portraits of the royal family provide a sympathetic record of their features and demeanor. In **CHARLES I AT THE HUNT** (FIG. 22–31), of 1635, Van Dyck was able, by clever manipulation of the setting, to portray the king truthfully and still present him as an imposing figure. Dressed casually for the hunt and standing on a bluff overlooking a distant view (a device used by Rubens to enhance the stature of Henry IV; SEE FIG. 22–29), Charles, who was in fact very short, appears here taller than his pages and even than his horse, since its head is down and its heavy body is partly off the canvas. The viewer's gaze is diverted from the king's delicate and rather short frame to his pleasant features, framed by his jauntily cocked cavalier's hat and the graceful cascade

of his hair. As if in decorous homage, the tree branches bow gracefully toward him, echoing the circular lines of the hat.

Yet another painter working with Rubens, Jan Brueghel (1568–1625), specialized in settings rather than portraits. Jan was the son of Pieter Bruegel the Elder (see "Breugel's Cycle of the Months," pages 702–703), and it was Jan who added the "h" to the family name. Brueghel's and Rubens's series of allegories of the five senses—five paintings, made for Habsburg regents Princess Isabella Clara Eugenia and Archduke Albert, and illustrating sight, hearing, touch, taste, and smell—in effect invited the viewer to wander in an imaginary space enjoying an amazing collection of works of art and scientific equipment (see "A Closer Look," opposite). Their allegory of sight is a display, a virtual inventory, and a summary of the wealth, scholarship, and **connoisseurship** (the study of style to assess quality and determine authorship) that was made possible through the patronage of the Habsburg rulers of the Spanish Netherlands.

Our term, "still life," for paintings of artfully arranged objects on a table, comes from the Dutch *stilleven*, a word coined about 1650. The Antwerp artist Clara Peeters (1594–c. 1657) specialized

**22-31** • Anthony van Dyck
**CHARLES I AT THE HUNT**
1635. Oil on canvas, 8′11″ × 6′11″
(2.75 × 2.14 m). Musée du Louvre, Paris.

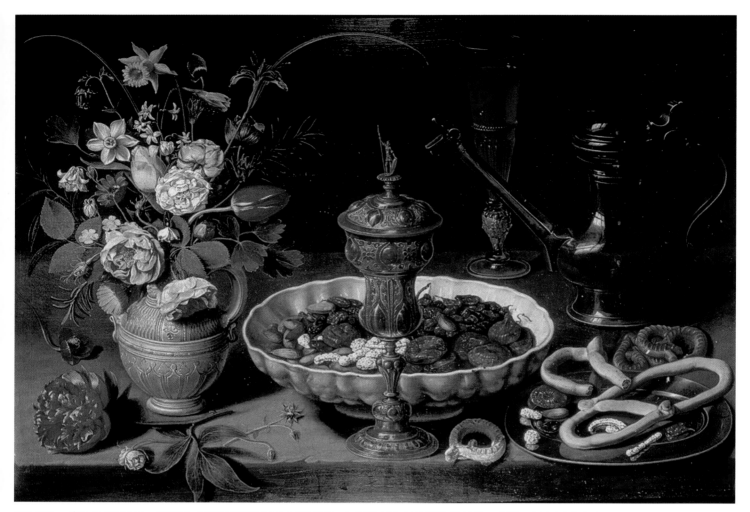

**22-32 • Clara Peeters STILL LIFE WITH FLOWERS, GOBLET, DRIED FRUIT, AND PRETZELS**
1611. Oil on panel, 20½ × 28¾" (52 × 73 cm). Museo del Prado, Madrid.

Like many "breakfast pieces," this painting features a pile of pretzels among the elegant tableware. The salty, twisted bread was called *pretzel* (from the Latin *pretiola*, meaning "small reward") because it was invented by German monks to reward children who had learned their prayers. The twisted shapes represented the crossed arms of a child praying.

in still-life tabletop arrangements (see Iconography box in the Introduction, FIG. A). She was a precocious young woman whose career seems to have begun before she was 14. Of some 50 paintings now attributed to her (of which more than 30 are signed), many are of the type called "breakfast pieces," showing a table set for a meal of bread and fruit. Peeters was one of the first artists to combine flowers and food in a single painting, as in her **STILL LIFE WITH FLOWERS, GOBLET, DRIED FRUIT, AND PRETZELS (FIG. 22–32)**, of 1611. Peeters arranged rich tableware and food against neutral, almost black backgrounds, the better to emphasize the fall of light over the contrasting surface textures. In a display of precious objects that must have appealed to her clients, the luxurious goblet and bowl contrast with simple stoneware and pewter, as do the delicate flowers with the homey pretzels. The pretzels, piled on the pewter tray, are a particularly interesting Baroque element, with their complex multiple curves.

## THE DUTCH REPUBLIC

The House of Orange was not notable for its patronage of the arts, but patronage improved significantly under Prince Frederick Henry (r. 1625–1647), and Dutch artists found many other eager patrons among the prosperous middle class in Amsterdam, Leiden, Haarlem, Delft, and Utrecht. The Hague was the capital city and the preferred residence of the House of Orange, but Amsterdam was the true center of power, because of its sea trade and the enterprise of its merchants, who made the city an international commercial center. The Dutch delighted in depictions of themselves and their country—the landscape, cities, and domestic life—not to mention beautiful and interesting objects to be seen in still-life paintings and interior scenes. A well-educated people, the Dutch were also fascinated by history, mythology, the Bible, new scientific discoveries, commercial expansion abroad, and colonial exploration.

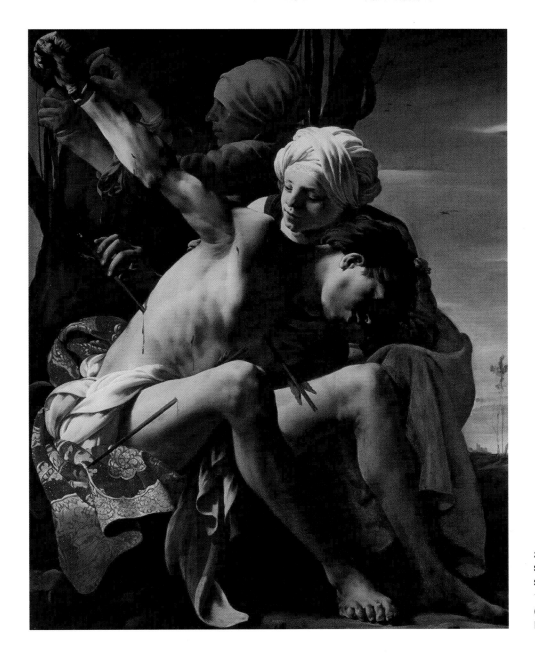

**22-33 • Hendrick ter Brugghen ST. SEBASTIAN TENDED BY ST. IRENE**
1625. Oil on canvas, 58¹⁵⁄₁₆ × 47½″ (149.6 × 120 cm). Allen Memorial Art Museum, Oberlin College, Ohio.

Visitors to the Netherlands in the seventeenth century noted the popularity of art among merchants and working people. Peter Mundy, an English traveler, wrote in 1640 that even butchers, bakers, shoemakers, and blacksmiths had pictures in their houses and shops. This taste for art stimulated a free market for paintings that functioned like other commodity markets. Artists had to compete to capture the interest of the public by painting on speculation. Specialists in particularly popular types of images were most likely to be financially successful, and what most Dutch patrons wanted were paintings of themselves, their country, their homes, their possessions, and the life around them. The demand for art also gave rise to an active market for the graphic arts, both for original compositions and for copies of paintings, since one copperplate could produce hundreds of impressions, and worn-out plates could be reworked and used again.

THE INFLUENCE OF ITALY. Hendrick ter Brugghen (1588–1629) had spent time in Rome, perhaps between 1608 and 1614, where he must have seen Caravaggio's works and became an enthusiastic follower. On his return home, in 1616, he entered the Utrecht painters' guild, bringing Caravaggio's style into the Netherlands. Ter Brugghen's **ST. SEBASTIAN TENDED BY ST. IRENE** introduced the Netherlandish painters to the new art of Baroque Italy (**FIG. 22–33**). The sickly gray-green flesh of the nearly dead St. Sebastian, painted in an almost monochromatic palette, contrasts with the brilliant red and gold brocade of what seems to be his crumpled garment. Actually this is the cope of the bishop of Utrecht, which had survived destruction by Protestants and become a symbol of Catholicism in Utrecht. The saint is cast as a heroic figure, his strong, youthful body still bound to the tree. But St. Irene (the patron saint of nurses) delicately removes one of the

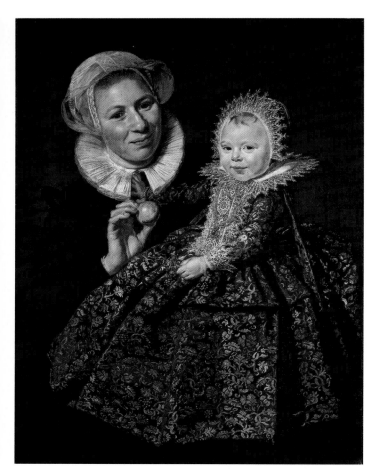

**22-34 • Frans Hals CATHARINA HOOFT AND HER NURSE**
c. 1620. Oil on canvas, 33¾ × 25½″ (85.7 × 64.8 cm). Staatliche Museen zu Berlin, Preussischer Kulturbesitz, Gemäldegalerie.

arrows that pierce him, and her maid reaches to untie his wrists. In a typically Baroque manner, the powerful diagonal created by St. Sebastian's left arm dislodges him from the triangular stability of the group. The immediacy and emotional engagement of the work are enhanced by crowding all the figures into the foreground plane, an effect strengthened by the low horizon line, another aspect of this painting that recalls the work of Caravaggio. The tenebrism and dramatic lighting effects are likewise Caravaggesque, as is the frank realism of the women's faces, with reddened noses and rosy cheeks. Rembrandt, Vermeer, and Rubens all admired Ter Brugghen's painting.

PORTRAITS. Seventeenth-century Dutch portraiture took many forms, ranging from single figures in sparsely furnished settings to allegorical depictions of groups in elaborate costumes surrounded by symbols and attributes. Although the faithful description of facial features and costumes was the most important gauge of a portrait's success, some painters went beyond likeness to convey a sense of mood or emotion in the sitter. Fundamentally, portraits functioned as social statements of the sitters' status coupled with a clear sense

of identity rooted in recognizable faces. Group portraiture documenting the membership of corporate organizations was a Dutch specialty. These large canvases, filled with many individuals who shared the cost of the commission, challenged painters to present a coherent, interesting composition that nevertheless gave equal attention to each individual portrait.

Frans Hals (c. 1581/1585–1666), the leading painter of Haarlem, developed a style grounded in the Netherlandish love of description and inspired by the Caravaggesque style introduced by artists such as Ter Brugghen. Like Velázquez, he tried to recreate the optical effects of light on the shapes and textures of objects. He painted boldly, with slashing strokes and angular patches of paint. Only when seen at a distance do the colors merge into solid forms over which a flickering light seems to move. In Hals's hands, this seemingly effortless, loose technique suggests the spontaneity of an infectious joy in life.

In his portrait of **CATHARINA HOOFT AND HER NURSE (FIG. 22–34)**, painted about 1620, Hals captured the vitality of a gesture caught within a fleeting moment in time. The portrait records for posterity the great pride of the parents in their child, but it also records their wealth in its study of rich fabrics, elaborate laces, and expensive toys (a golden rattle). Hals's depiction highlights the heartwarming delight of the child, who seems to be acknowledging the viewer as a loving family member, while her doting nurse attempts to distract her with an apple and at the same time looks out admiringly at the attention the viewer is directing to her charge.

In contrast to this intimate individual portrait are Hals's official group portraits, such as his **OFFICERS OF THE HAARLEM MILITIA COMPANY OF ST. ADRIAN (FIG. 22–35)**, of about 1627. Most artists arranged their sitters in neat rows to depict every face clearly, but Hals's dynamic composition has turned the group portrait into a lively social event. The composition is based on a strong underlying geometry of diagonal lines—gestures, banners, and sashes—balanced by the stabilizing perpendiculars of table, window, and tall glass. The black suits and hats make the white ruffs and sashes of rose, white, and baby blue even more brilliant.

The company, made up of several guard units, was charged with the military protection of Haarlem. Officers came from the upper middle class and held their commissions for three years, whereas the ordinary guards were tradespeople and craftworkers. Each company was organized like a guild, traditionally under the patronage of a saint. The company functioned mainly as a fraternal order, holding archery competitions, taking part in city processions, and originally maintaining an altar in the local church (SEE ALSO FIG. 22–38).

A painting that had long been praised as one of Hals's finest works is actually by Judith Leyster (c. 1609–1660), Hals's contemporary. A cleaning uncovered her distinctive signature, the monogram "JL" with a star, which refers to her surname, meaning "pole star." Leyster's work shows clear echoes of her exposure to the Utrecht painters who had enthusiastically adopted the

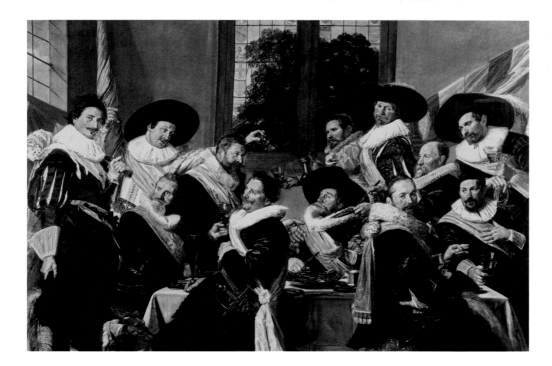

22-35 • Frans Hals **OFFICERS OF THE HAARLEM MILITIA COMPANY OF ST. ADRIAN** c. 1627. Oil on canvas, 6′ × 8′8″ (1.83 × 2.67 m). Frans Halsmuseum, Haarlem.

principal features of Caravaggio's style. Since in 1631 Leyster signed as a witness at the baptism in Haarlem of one of Hals's children, it is assumed they were close; she may also have worked in his shop. She entered Haarlem's Guild of St. Luke in 1633, which allowed her to take pupils into her studio, and her competitive relationship with Frans Hals around that time is made clear by the complaint she lodged against him in 1635 for luring away one of her apprentices.

Leyster is known primarily for informal scenes of daily life, which often carry an underlying moralistic theme. In her lively **SELF-PORTRAIT** of 1635 (FIG. **22–36)**, the artist has interrupted her work to lean back and look at viewers, as if they had just entered the room. Her elegant dress and the fine chair in which she sits are symbols of her success as an artist whose popularity was based on the very type of painting in progress on her easel. One critic has suggested that her subject—a man playing a violin—may be a visual pun on the painter with palette and brush. Leyster's understanding of light and texture is truly remarkable. The brushwork she used to depict her own flesh and delicate ruff is more controlled than Hals's loose technique, and forms an interesting contrast to the broad strokes of thick paint she used to create her full, stiff skirt. She further emphasized

the difference between her portrait and her painting by executing the image on her easel in lighter tones and softer, looser brushwork. The narrow range of colors sensitively dispersed in the composition and the warm spotlighting are typical of Leyster's mature style.

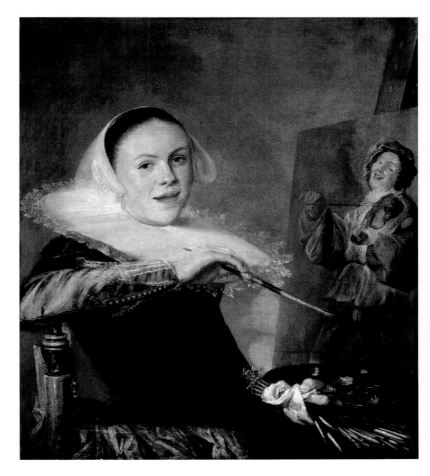

22-36 • Judith Leyster **SELF-PORTRAIT** 1635. Oil on canvas, 29⅜ × 25⅝″ (72.3 × 65.3 cm). National Gallery of Art, Washington, D.C. Gift of Mr. and Mrs. Robert Woods Bliss

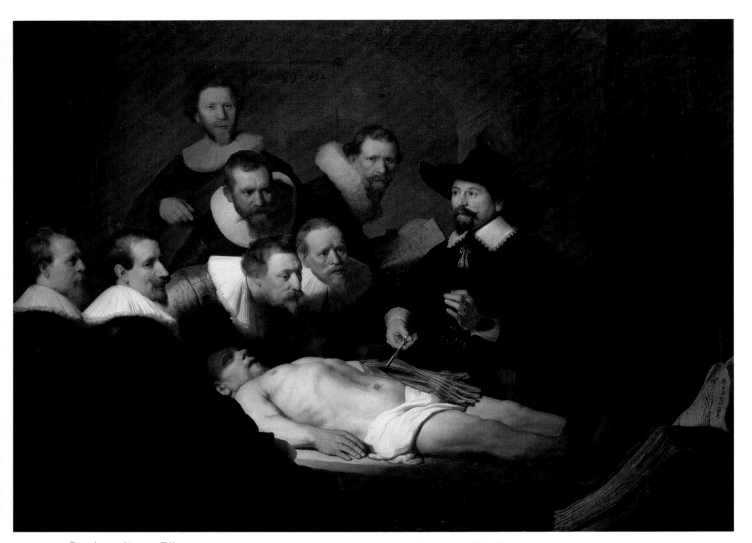

**22-37 • Rembrandt van Rijn THE ANATOMY LESSON OF DR. NICOLAES TULP**
1632. Oil on canvas, 5′3¾″ × 7′1¼″ (1.6 × 2.1 m). Mauritshuis, The Hague.

REMBRANDT VAN RIJN. The most important painter working in Amsterdam in the seventeenth century was Rembrandt van Rijn (1606–1669). One of nine children born in Leiden to a miller and his wife, Rembrandt studied under Pieter Lastman (1583–1633), the principal painter in Amsterdam at the time. From Lastman, a history painter who had worked in Rome, Rembrandt absorbed an interest in the naturalism, drama, and tenebrism championed by Caravaggio. By the 1630s, Rembrandt was established in Amsterdam primarily as a portrait painter, although he also painted a wide range of narrative themes and landscapes.

In his first group portrait, **THE ANATOMY LESSON OF DR. NICOLAES TULP** (FIG. 22–37) of 1632, Rembrandt combined his scientific and humanistic interests. Frans Hals had activated the group portrait rather than conceiving it as a simple reproduction of posed figures and faces; Rembrandt transformed it into a charged moment from a life story. Dr. Tulp, head of the surgeons' guild from 1628 to 1653, sits right of center, while a group of fellow physicians gathers around to observe the cadaver and learn from the famed anatomist. Rembrandt built his composition on a sharp

diagonal that pierces space from right to left, uniting the cadaver on the table, the calculated arrangement of speaker and listeners, and the open book into a dramatic narrative event. Rembrandt makes effective use of Caravaggio's tenebrist technique, as the figures emerge from a dark and undefined ambience, their attentive faces framed by brilliant white ruffs. Radiant light streams down to spotlight the ghostly flesh of the cadaver, drawing our attention to the extended arms of Dr. Tulp, who flexes his own left hand to demonstrate the action of the cadaver's arm muscles that he lifts up with silver forceps. Unseen by the viewers are the illustrations of the huge book, presumably an edition of Andreas Vesalius's study of human anatomy, published in Basel in 1543, which was the first attempt at accurate anatomical illustrations in print. Rembrandt's painting has been seen as an homage to Vesalius and to science, as well as a portrait of the members of the Amsterdam surgeons' guild.

Prolific and popular with his Amsterdam clientele, Rembrandt ran a busy studio, producing works that sold for high prices. The prodigious output of his large workshop and of the many followers who imitated his manner has made it difficult for

scholars to define his body of work, and many paintings formerly attributed to Rembrandt have recently been assigned to other artists. Rembrandt's mature work reflected his cosmopolitan city environment, his study of science and nature, and the broadening of his artistic vocabulary by the study of Italian Renaissance art, chiefly from engravings and paintings imported by the busy Amsterdam art market.

In 1642, Rembrandt was one of several artists commissioned by a wealthy civic-guard company to create large group portraits of its members for its new meeting hall. The result, **THE COMPANY OF CAPTAIN FRANS BANNING COCQ** (FIG. **22–38**), carries the idea of a group portrait as a dramatic event even further. Because a dense layer of grime had darkened and obscured its colors, this painting was once thought to be a nocturnal scene and was therefore called *The Night Watch*. After cleaning and restoration in 1975–1976, it now exhibits a natural golden light that sets afire the palette of rich colors—browns, blues, olive-green, orange, and red—around a central core of lemon yellow in the costume of a lieutenant. To the dramatic group composition, showing a company forming for a parade in an Amsterdam street, Rembrandt added several colorful but seemingly unnecessary figures. While the officers stride purposefully forward, the rest of the men and several mischievous children mill about. The radiant young girl in the left middle ground, carrying a chicken with prominent claws (*klauw* in Dutch), may be a pun on the kind of guns (*klower*) that gave the name (the *Kloveniers*) to the company. Chicken legs with claws also are part of its coat of arms. The complex interactions of the figures and the vivid, individualized likenesses of the militiamen make this one of the greatest group portraits in the Dutch tradition.

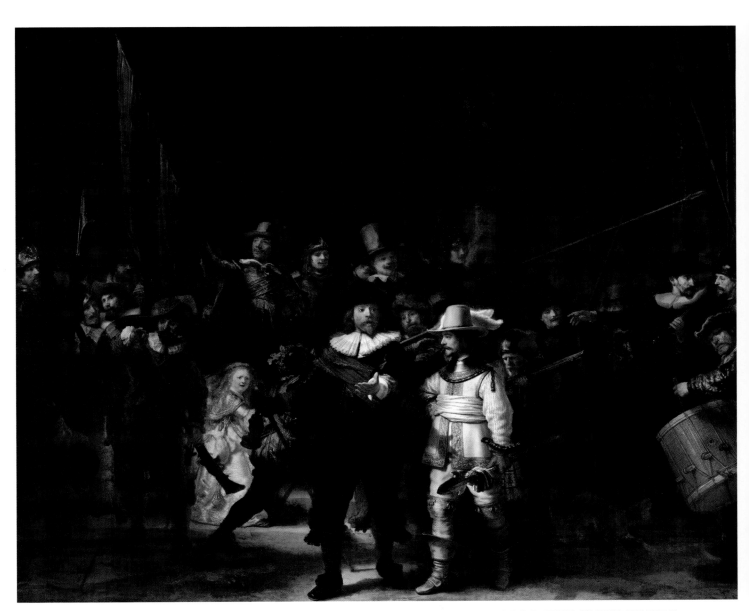

**22–38 •** Rembrandt van Rijn **THE COMPANY OF CAPTAIN FRANS BANNING COCQ (THE NIGHT WATCH)**
1642. Oil on canvas, 11′11″ × 14′4″ (3.63 × 4.37 m) (cut down from the original size). Rijksmuseum, Amsterdam.

Rembrandt was the first artist to popularize etching as a major form of artistic expression. In the **etching** process, a metal plate is coated on both sides with an acid-resistant resin that dries hard without being brittle. Then, instead of laboriously cutting the lines of the desired image directly into the plate as in an engraving (see "Woodcuts and Engravings on Metal," page 590) the artist draws through the resin with a sharp needle to expose the metal. The plate is then immersed in acid, which eats into the metal exposed by the drawn lines. By controlling the time the acid stays on different parts of the plate, the artist can make shallow, fine lines or deep, heavy ones. After the resin coating is removed from the surface of the plate, an impression is taken. If changes need to be made, lines can be "erased" with a sharp metal scraper. Not surprisingly, a complex image with a wide range of tones requires many steps.

Another intaglio technique for registering images with incised lines on a metal plate is called drypoint, in which a sharp needle is used to scratch lines directly into the metal. In drypoint, however, the burr (metal pushed up by the drypoint needle) is left in place. Unlike engraving, in which the burr is scraped off, here both the burr and the groove hold the ink. This creates a printed line with a rich black appearance that is impossible to achieve with engraving or etching alone. Unfortunately, drypoint burr is fragile, and no more than a dozen prints can be made before it flattens and loses its character. Rembrandt's earliest prints were entirely etched, but later he added drypoint to develop tonal richness.

**SEE MORE:** View a video about the process of intaglio www.myartslab.com

In his enthusiasm for printmaking as an important art form with its own aesthetic qualities, Rembrandt was remarkably like Albrecht Dürer (SEE FIGS. 21–6, 21–7). Beginning in 1627, he focused on etching, which uses acid to inscribe a design on metal plates. About a decade later, he began to experiment with making additions to his compositions in the **drypoint** technique, in which the artist uses a sharp needle to scratch shallow lines in a plate. Because etching and drypoint allow the artist to work directly on the plate, the style of the finished print can have the relatively free and spontaneous character of a drawing (see "Etching and Drypoint," above). In these works Rembrandt alone took charge of the creative process, from the preparation of the plate to its inking and printing, and he constantly experimented with the technique, with methods of inking, and with papers for printing.

**22–39 • Rembrandt van Rijn THREE CROSSES (FIRST STATE)**
1653. Drypoint and etching, 15⅛ × 17¾″ (38.5 × 45 cm). Rijksmuseum, Amsterdam.

Rembrandt's prints were sought after, widely collected, and attracted high prices, even in his lifetime.

Rembrandt's deep speculations on the meaning of the life of Christ evolve in a series of prints, **THREE CROSSES**, that comes down to us in five states, or stages, of the creative and printing process. (Only the first is reproduced here.) Rembrandt tried to capture the moment described in the Gospels when, during the Crucifixion, darkness covered the Earth and Jesus cried out, "Father, into thy hands I commend my spirit." In the first state **(FIG. 22–39)**, the centurion kneels in front of the cross while other terrified people run from the scene. The Virgin Mary and St. John share the light flooding down from heaven. By the fourth and fifth states, Rembrandt had completely reworked and reinterpreted the theme. The scene is considerably darker, and some of the people in the first state, including even Mary and Jesus' friends, have almost disappeared. The composition becomes more compact, the individual elements are simplified, and the emotions are intensified. The first state is a detailed rendering of the scene in realistic terms; by the fourth and fifth, the event has been reduced to its mysterious essence. The eternal battles of dark and light, doom and salvation, evil and good—all seem to be waged anew.

As he aged, Rembrandt painted ever more brilliantly, varying textures and paint from the thinnest glazes to thick **impasto** (heavily applied pigments), creating a rich, luminous *chiaroscuro*, ranging from deepest shadow to brilliant highlights in a dazzling display of gold, red, and chestnut-brown. His sensitivity to the human condition is perhaps nowhere more powerfully expressed than in his late self-portraits, which became more searching as he aged. Distilling a lifetime of study and contemplation, he expressed an internalized spirituality new in the history of art. In a **SELF-PORTRAIT** of 1658 **(FIG. 22–40)**, the artist assumes a regal pose, at ease, with arms and legs spread and holding a staff as if it were a baton of command. Yet we know that fortune no longer smiled on him (he had to declare bankruptcy that same year). A few well-placed brushstrokes suggest the physical tension in the

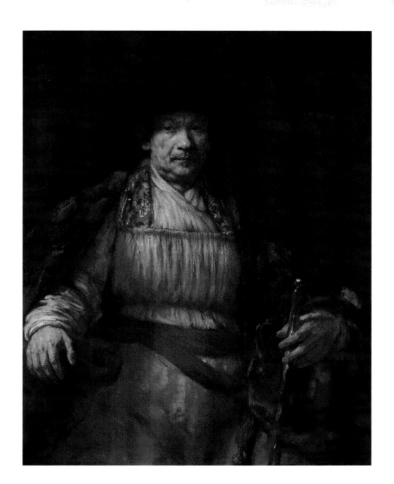

**22-40 • Rembrandt van Rijn SELF-PORTRAIT**
1658. Oil on canvas, 52⅝ × 40⅞″ (133.6 × 103.8 cm).
The Frick Collection, New York.

fingers and the weariness of the deep-set eyes. Mercilessly analytical, the portrait depicts the furrowed brow, sagging flesh, and aging face of one who has suffered pitfalls but managed to survive, retaining his dignity.

JOHANNES VERMEER.    One of the most intriguing Dutch artists of this period is Johannes Vermeer (1632–1675), who was also an innkeeper and art dealer. He entered the Delft artists' guild in 1653 and painted only for local patrons. Meticulous in his technique, with a unique compositional approach and painting style, Vermeer produced fewer than 40 canvases that can be securely attributed to him, and the more these paintings are studied, the more questions arise about the artist's life and his methods. Vermeer's **VIEW OF DELFT (FIG. 22–41)**, for example, is no simple cityscape. Although the artist convinces the viewer of its authenticity, he does not paint a photographic reproduction of the scene; Vermeer moves buildings around to create an ideal composition. He endows the city with a timeless stability by a stress on horizontal lines, the careful placement of buildings, the quiet atmosphere, and the clear, even light that seems to emerge from beneath low-lying clouds. Vermeer

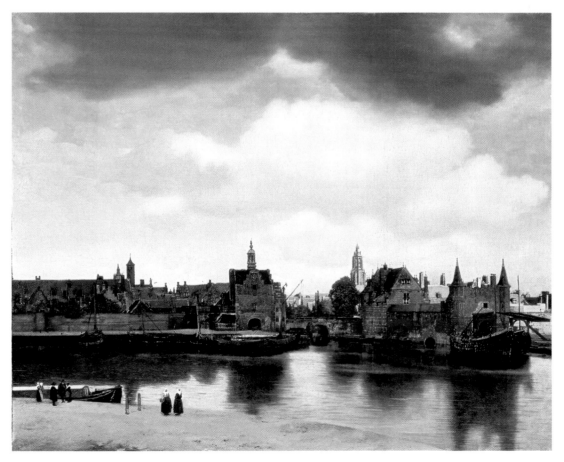

**22-41 • Johannes Vermeer VIEW OF DELFT**
c. 1662. Oil on canvas, 38½ × 46¼″ (97.8 × 117.5 cm).
Mauritshuis, The Hague.
The Johan Maurits van Nassau Foundation

may have experimented with the mechanical device known as the **camera obscura** (see Chapter 30), not as a method of reproducing the image but as another tool in the visual analysis of the composition. The camera obscura would have enhanced optical distortions that led to the "beading" of highlights (seen here on the harbored ships and dark gray architecture), which creates the illusion of brilliant light but does not dissolve the underlying form.

Most of Vermeer's paintings portray enigmatic scenes of women in their homes, alone or with a servant, occupied with some cultivated activity, such as writing, reading letters, or playing a musical instrument. These are quiet interior scenes, low-key in color, asymmetrical but strongly geometric in organization. By creating a contained and consistent architectonic world in which each object adds to the clarity and balance of the composition, Vermeer transports everyday scenes to a level of unearthly perfection. An even, pearly light from a window often gives solidity to the figures and objects in a room. All emotion is subdued, as Vermeer evokes a mood of quiet meditation. The brushwork is so controlled that it becomes invisible, except when he paints his characteristic pools of reflected light as tiny, pearl-like droplets of color.

In **WOMAN HOLDING A BALANCE** (FIG. 22–42), perfect equilibrium creates a monumental composition and a moment of

**22–42 • Johannes Vermeer WOMAN HOLDING A BALANCE**
c. 1664. Oil on canvas, 15⅞ × 14″ (39 × 35 cm). National Gallery of Art, Washington, D.C.
Widener Collection 1942.9.97

SEE MORE: View a video about Vermeer's *Woman Holding a Balance* **www.myartslab.com**

**22-43 • Gerard ter Borch**
**THE SUITOR'S VISIT**
c. 1658. Oil on canvas, 32½ × 29⅝″
(82.6 × 75.3 cm). National Gallery
of Art, Washington, D.C.

supreme stillness. The woman contemplates the balance in her right hand, drawing our attention to the act of weighing and judging. Her hand and the scale are central, but directly behind her head, on the wall of the room, is a painting of the Last Judgment, highlighting the figure of Christ the Judge in a gold aureole above her head. The juxtaposition seems to turn Vermeer's genre scene into a metaphor for eternal judgment, a sobering religious reference that may reflect the artist's own position as a Catholic living in a Protestant country. The woman's moment of quiet introspection in front of the gold and pearls displayed on the table before her, shimmering with reflected light from the window, also evokes the **vanitas** theme of the transience of earthly life, allowing the painter to comment on the ephemeral quality of material things.

GENRE SCENES. Continuing a long Netherlandish tradition, seventeenth-century genre paintings—generally made for private patrons and depicting scenes of contemporary daily life—were often laden with symbolic references, although their meaning is not always clear to us now. A clean house might indicate a virtuous

housewife and mother, while a messy household suggested laziness and the sin of sloth. Ladies dressing in front of mirrors certainly could be succumbing to vanity, and drinking parties led to overindulgence and lust.

One of the most refined of the genre painters was Gerard ter Borch (1617–1681). In his painting traditionally known as **THE SUITOR'S VISIT (FIG. 22–43)**, from about 1658, a well-dressed man bows gracefully to an elegant woman arrayed in white satin, who stands in a sumptuously furnished room in which another woman plays a lute. Another man, in front of a fireplace, turns to observe the newcomer. The painting appears to represent a prosperous gentleman paying a call on a lady of equal social status, possibly a courtship scene. The spaniel and the musician seem to be simply part of the scene, but we are already familiar with the dog as a symbol of fidelity, and stringed instruments were said to symbolize, through their tuning, the harmony of souls and thus, possibly, a loving relationship. On the other hand, it has been suggested that the theme is not so innocent: that the gestures here suggest a liaison. The dog could be interpreted sexually, as sniffing around, and the music making could be associated with sensory pleasure

**22-44 • Jan Steen THE DRAWING LESSON**
1665. Oil on wood panel, 19⅜ × 16¼″ (49.3 × 41 cm).
The J. Paul Getty Museum, Los Angeles.

evoked by touch. Ter Borch was renowned for his exquisite rendition of lace, velvet, and especially satin, and such wealth could be seen as a symbol of excess. One critic has even suggested that the white satin is a metaphor for the women's skin. If there is a moral lesson, it is presented discreetly and ambiguously.

Another important genre painter is Jan Steen (1626–1679), whose larger brushstrokes contrast with the meticulous treatment of Ter Borch. Steen painted over 800 works but never achieved financial success. Most of his scenes used everyday life to portray moral tales, illustrate proverbs and folk sayings, or make puns to amuse the spectator. Steen moved about the country for most of his life, and from 1670 until his death he kept a tavern in Leiden. He probably found inspiration and models all about him. Early in his career Steen was influenced by Frans Hals, but his work could be either very summary or extremely detailed.

Jan Steen's paintings of children are especially remarkable, for he captured not only their childish physiques but also their fleeting moods and expressions with rapid and fluid brushstrokes. His ability to capture such transitory dispositions was well expressed in his painting **THE DRAWING LESSON (FIG. 22–44)**. Here, youthful apprentices—a boy and a well-dressed young woman—observe the master artist correct an example of drawing, a skill widely believed to be the foundation of art. The studio is cluttered with all the supplies the artists need. On the floor at the lower right,

still-life objects such as a lute, wine jug, book, and skull may remind the viewer of the transitory nature of life in spite of the permanence art may seem to offer.

Emanuel de Witte (1617–1692) of Rotterdam specialized in architectural interiors, first in Delft in 1640 and then in Amsterdam after settling there permanently in 1652. Although many of his interiors were composites of features from several locations combined in one idealized architectural view, De Witte also painted faithful "portraits" of actual buildings. One of these is his **PORTUGUESE SYNAGOGUE, AMSTERDAM (FIG. 22–45)** of 1680. The synagogue, which still stands and is one of the most impressive buildings in Amsterdam, is shown here as a rectangular hall divided into one wide central aisle with narrow side aisles, each covered with a wooden barrel vault resting on lintels supported by columns. De Witte's shift of the viewpoint slightly to one side has created an interesting spatial composition, and strong contrasts of light and shade add dramatic movement to the simple interior. The elegant couple and the dogs in the foreground provide a sense of scale for the architecture and add human interest.

Today, this painting is interesting not only as a work of art, but also as a record of seventeenth-century synagogue architecture. It also reflects Dutch religious tolerance in an age when Jews were often persecuted. Expelled from Spain and Portugal from the late

**22-45 • Emanuel de Witte PORTUGUESE SYNAGOGUE, AMSTERDAM**
1680. Oil on canvas, 43½ × 39″ (110.5 × 99.1 cm). Rijksmuseum, Amsterdam. Architects Daniel Stalpaert and Elias Bouman built the synagogue in 1671–1675.

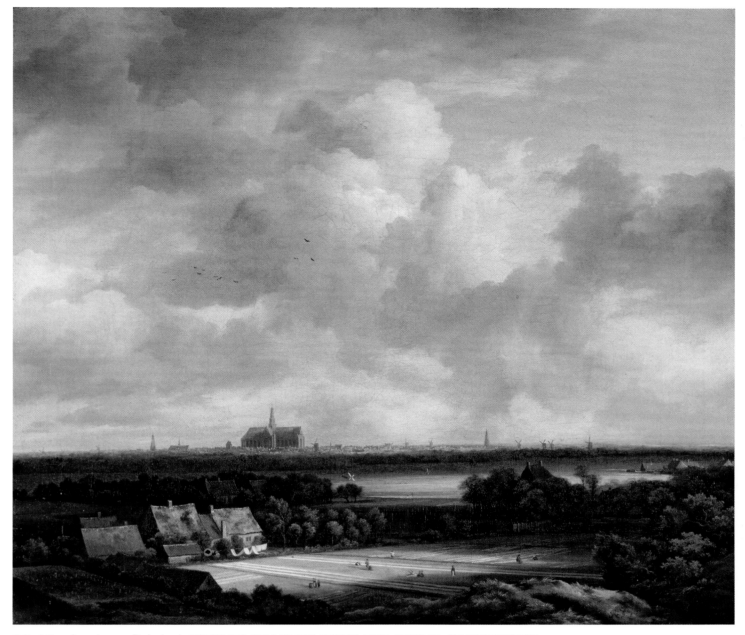

**22-46 • Jacob van Ruisdael  VIEW OF HAARLEM FROM THE DUNES AT OVERVEEN**
c. 1670. Oil on canvas, 22″ × 24¼″ (55.8 × 62.8 cm). Mauritshuis, The Hague.

fifteenth century on, many Jews had settled in Amsterdam, and their community numbered about 2,300 people, most of whom were well-to-do merchants. Fund-raising for a new synagogue began in 1670, and in 1671 Elias Bouman and Daniel Stalpaert began work on the building. With its classical architecture, Brazilian jacaranda-wood furniture, and 26 brass chandeliers, this synagogue was considered one of the most impressive buildings in Amsterdam.

LANDSCAPE.  The Dutch loved the landscapes and vast skies of their own country, but landscape painters worked in their studios rather than in nature, and they were never afraid to rearrange, add to, or subtract from a scene in order to give their compositions formal organization or a desired mood. Starting in the 1620s,

landscape painters generally adhered to a convention in which little color was used beyond browns, grays, and beiges. After 1650, they tended to be more individualistic in their styles, but nearly all brought a broader range of colors into play. One continuing motif was the emphasis on cloud-filled expanses of sky dominating a relatively narrow horizontal band of earth below.

The Haarlem landscape specialist Jacob van Ruisdael (1628/29–1682), whose popularity drew many pupils to his workshop, was especially adept at both the invention of dramatic compositions and the projection of moods in his canvases. His **VIEW OF HAARLEM FROM THE DUNES AT OVERVEEN (FIG. 22–46)**, painted about 1670, celebrates the flatlands outside Haarlem that had been reclaimed from the sea as part of a massive landfill

project. The Dutch compared it with God's restoration of the Earth after Noah's Flood. Such a religious interpretation may be referenced here in the prominent Gothic church of St. Bavo, looming on the horizon. There may be other messages as well. While almost three-quarters of this painting is devoted to a rendering of the powerfully cloudy sky, tiny humans can be seen laboring below. They are caught in the process of spreading white linen across the broad fields to bleach in the sun. This glorification of the industriousness of citizens engaged in one of Haarlem's principal industries must have made the painting particularly appealing to the patriotic local market.

STILL LIFES AND FLOWER PIECES.    The Dutch were so proud of their still-life painting tradition that they presented a flower painting by Rachel Ruysch to the French queen Marie de' Medici when she made a state visit to Amsterdam. Like genre paintings, a still-life painting might carry moralizing connotations and commonly had a *vanitas* theme, reminding viewers of the transience of life and material possessions, even art. Yet it can also document and showcase the wealth of its owner.

One of the first Dutch still-life painters was Pieter Claesz (1596/97–1660) of Haarlem, who, like Antwerp artist Clara Peeters, painted "breakfast pieces," that is, a meal of bread, fruits, and nuts. In subtle, nearly monochromatic paintings, such as **STILL LIFE WITH TAZZA (FIG. 22–47)**, Claesz seems to give life to inanimate objects. He organizes dishes in diagonal positions to give a strong sense of space—here reinforced by the spiraling strip of lemon peel, foreshortened with the plate into the foreground and reaching toward the viewer's own space—and he renders the maximum contrast of textures within a subtle palette of yellows, browns, greens, and silvery whites. The tilted silver *tazza* contrasts with the half-filled glass that becomes a towering monumental presence and permits Claesz to display his skill at transparencies and reflections. Such paintings suggest the prosperity of Claesz's patrons. The food might be simple, but the silver ornamental cup graced the tables of only the wealthy. The meticulously painted timepiece could suggest deeper meanings—it alludes to human technological achievement, but also to the inexorable passage of time and the fleeting nature of human life, thoughts also suggested by the interrupted breakfast, casually placed knife, and toppled tableware.

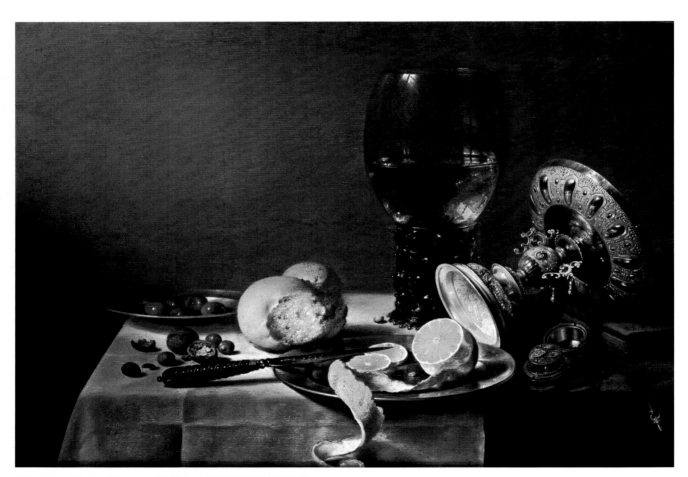

**22-47 • Pieter Claesz STILL LIFE WITH TAZZA**
1636. Oil on panel, 17⅜ × 24″ (44 × 61 cm). Royal Cabinet of Paintings Mauritshuis, The Hague.

The heavy round glass is a Roemer, a relatively inexpensive, everyday item, as are the pewter plates. The gilt cup (*tazza*) was a typical ornamental piece. Painters owned and shared such valuable props, and this and other showpieces appear in many paintings.

**22-48 •** Rachel Ruysch **FLOWER STILL LIFE**

After 1700. Oil on canvas, 30 × 24″ (76.2 × 61 cm). The Toledo Museum of Art, Ohio.
Purchased with funds from the Libbey Endowment. Gift of Edward Drummond Libbey 1956.57

offset by the strong diagonal of the tabletop. To further balance the painting, she placed highlighted blossoms and leaves against the dark left half of the canvas and silhouetted them against the light wall area on the right. Ruysch often emphasized the beauty of curving flower stems and enlivened her compositions with interesting additions, such as casually placed pieces of fruit or insects, in this case a large gray moth (lower left) and two snail shells.

Flower painting was almost never a straightforward depiction of actual fresh flowers. Instead, artists made color sketches of fresh examples of each type of flower and studied scientifically accurate color illustrations in botanical publications. Using their sketches and notebooks, in the studio, they would compose bouquets of perfect specimens of a variety of flowers that could never be found blooming at the same time. The short life of blooming flowers was a poignant reminder of the fleeting nature of beauty and of human life.

Still-life paintings in which cut-flower arrangements predominate were referred to simply as "flower pieces." Significant advances were made in botany during the seventeenth century through the application of orderly scientific methods and objective observation (see "Science and the Changing Worldview," page 756). Then, as now, the Dutch were major growers and exporters of flowers, especially tulips, which appear in nearly every flower piece in dozens of exquisite variations. The Dutch tradition of flower painting peaked in the long career of Rachel Ruysch (1664–1750) of Amsterdam. Her flower pieces were highly prized for their sensitive, free-form arrangements and their unusual and beautiful color harmonies. During her 70-year career, she became one of the most sought-after and highest-paid still-life painters in Europe—her paintings brought in twice what Rembrandt's did.

In her **FLOWER STILL LIFE** (**FIG. 22–48**), painted after 1700, Ruysch placed the container at the center of the canvas's width, then created an asymmetrical floral arrangement of pale oranges, pinks, and yellows rising from lower left to top right of the picture,

## FRANCE

Early seventeenth-century France was marked by almost continuous foreign and civil wars. The assassination of King Henry IV in 1610 left France in the hands of the queen, Marie de' Medici (regency 1610–1617; SEE FIG. 22–29), as regent for her 9-year-old son, Louis XIII (r. 1610–1643). When Louis came of age, the brilliant and unscrupulous Cardinal Richelieu became chief minister and set about increasing the power of the Crown at the expense of the French nobility. The death of Louis XIII again left France with a child king, the 5-year-old Louis XIV (r. 1643–1715). His mother, Anne of Austria, became regent, with the assistance of another powerful minister, Cardinal Mazarin. At Mazarin's death in 1661, Louis XIV began his long personal reign, assisted by yet another able minister, Jean-Baptiste Colbert.

An absolute monarch whose reign was the longest in European history, Louis XIV made the French court the envy of every ruler in Europe. He became known as *le Roi Soleil* ("the Sun King") and was sometimes glorified in art through identification

# ART AND ITS CONTEXTS

## Science and the Changing Worldview

From the mid-sixteenth through the seventeenth centuries, new discoveries about the natural world brought a sense of both the grand scale and the microscopic detail of the universe. To publish their theories and research, early scientists learned to draw or depended on artists to draw what they discovered in the world around them. This practice would continue until the invention of photography in the nineteenth century.

Artist and scientist were seldom the same person, but Anna Maria Sibylla Merian (1647–1717) contributed to botany and entomology both as a researcher and as an artist. German by birth and Dutch by training, Merian was once described by a Dutch contemporary as a painter of worms, flies, mosquitoes, spiders, "and other filth." In 1699, the city of Amsterdam subsidized Merian's research on plants and insects in the Dutch colony of Surinam in South America, where she spent two years exploring the jungle and recording insects. On her return to the Dutch Republic, she published the results of her research as *The Metamorphosis of the Insects of Surinam*, illustrated with 72 large plates engraved after her watercolors. For all her meticulous scientific accuracy, Merian carefully arranged her depictions of exotic insects and elegant fruits and flowers into skillful and harmonious compositions.

But interest in scientific exploration was not limited to the Netherlands. The writings of philosophers Francis Bacon (1561–1626) in England and René Descartes (1596–1650) in France helped establish a new scientific method of studying the world by insisting on scrupulous objectivity and logical reasoning. Bacon argued that the facts be established from observation and tested by controlled experiments. Descartes, who was also a mathematician, argued for the deductive method of reasoning, in which conclusions were arrived at logically from basic premises.

In 1543, the Polish scholar Nicolaus Copernicus (1473–1543) published *On the Revolutions of the Heavenly Spheres*, which contradicted the long-held view that the Earth is the center of the universe (the Ptolemaic theory) by arguing instead that it and the other planets revolve around the sun. The Church put Copernicus's work on its *Index of Prohibited Books* in 1616, but Johannes Kepler (1571–1630) continued demonstrating that the planets revolve around the sun in elliptical orbits. Galileo Galilei (1564–1642), an astronomer, mathematician, and physicist, developed the telescope as a tool for observing the heavens and provided further confirmation of Copernican theory but since the Church prohibited its teaching, Galileo was tried for heresy by the Inquisition and forced to recant his views.

The new seventeenth-century science turned to the study of the very small as well as to the vast reaches of space. This included the development of the microscope by the Dutch lens-maker and amateur scientist Anton van Leeuwenhoek (1632–1723). Leeuwenhoek perfected grinding techniques and increased the power of his lenses far beyond what was required for a simple magnifying glass. Ultimately, he was able to study the inner workings of plants and animals and even see micro-organisms.

Anna Maria Sibylla Merian **PLATE 9 FROM THE METAMORPHOSIS OF THE INSECTS OF SURINAM** 1719. Hand-colored engraving, 18⅞ × 13″ (47.9 × 33 cm). National Museum of Women in the Arts, Washington, D.C. Gift of Wallace and Wilhelmina Holladay Collection, funds contributed by Mr. and Mrs. George G. Anderman and an anonymous donor 1976.56

with the Classical sun god, Apollo. In a 1701 portrait by court painter Hyacinthe Rigaud (1659–1743), the richly costumed **LOUIS XIV** is framed by a lavish, billowing curtain (**FIG. 22–49**).

Proudly showing off his elegant legs, the 63-year-old monarch poses in a blue robe of state, trimmed with gold *fleurs-de-lis* and lined with white ermine. He wears the high-heeled shoes

**22-49 • Hyacinthe Rigaud**
**LOUIS XIV**
1701. Oil on canvas,
9′2″ × 7′10¾″ (2.19 × 2.4 m).
Musée du Louvre, Paris.

Louis XIV had ordered this portrait as a gift for his grandson, the future Philip V of Spain (r. 1700–1746), but when Rigaud finished the painting, Louis liked it too much to give it away and only three years later ordered a copy from Rigaud to give to his grandson. The request for copies of royal portraits was not unusual since the aristocratic families of Europe were linked through marriage. Paintings made appropriate gifts and at the same time memorialized important political alliances by recording them in visual form.

he devised to compensate for his shortness. Despite his pompous pose and magnificent surroundings, the directness of the king's gaze and the frankness of his aging face make him appear surprisingly human.

The arts, like everything else, came under royal control. In 1635, Cardinal Richelieu had founded the French Royal Academy, directing the members to compile a definitive dictionary and grammar of the French language. In 1648, the Royal Academy of Painting and Sculpture was founded, which, as reorganized by Colbert in 1663, maintained strict control over the arts (see "Grading the Old Masters," page 764). Although it was not the first European arts academy, none before it had exerted such dictatorial authority—an authority that lasted in France until the late nineteenth century. Membership of the academy assured an artist of royal and civic commissions and financial success, but many talented artists did well outside it.

## ARCHITECTURE AND ITS DECORATION AT VERSAILLES

French architecture developed along Classical lines in the second half of the seventeenth century under the influence of François Mansart (1598–1666) and Louis Le Vau (1612–1670). When the Royal Academy of Architecture was founded in 1671, its members developed guidelines for architectural design based on the belief that mathematics was the true basis of beauty. Their chief sources for ideal models were the books of Vitruvius and Palladio.

In 1668, Louis XIV began to enlarge the small château built by Louis XIII at Versailles, not far from Paris. Louis moved to the palace in 1682 and eventually required his court to live in Versailles; 5,000 aristocrats lived in the palace itself, together with 14,000 servants and military staff members. The town had another 30,000 residents, most of whom were employed by the palace. The designers of the palace and park complex at Versailles were Le Vau, Charles Le Brun (1619–1690), who oversaw the interior decoration, and André Le Nôtre (1613–1700), who planned the gardens (see "Garden Design," page 760). For both political and sentimental reasons, the old château was left standing, and the new building went up around it. This project consisted of two phases: the first additions by Le Vau, begun in 1668; and an enlargement completed after Le Vau's death by his successor, Jules Hardouin-Mansart (1646–1708), from 1670 to 1685.

Hardouin-Mansart was responsible for the addition of the long lateral wings and the renovation of Le Vau's central block on the garden side to match these wings **(FIG. 22–50)**. The three-story façade has a lightly rusticated ground floor, a main floor lined with enormous arched windows separated by Ionic columns or pilasters, an attic level whose rectangular windows are also flanked by pilasters, and a flat, terraced roof. The overall design is a sensitive balance of horizontals and verticals relieved by a restrained overlay of regularly spaced projecting blocks with open, colonnaded porches.

In his renovation of Le Vau's center-block façade, Hardouin-Mansart enclosed the previously open gallery on the main level, creating the famed **HALL OF MIRRORS (FIG. 22–51)**, which is about 240 feet (73 meters) long and 47 feet (13 meters) high. He achieved architectural symmetry and extraordinary effects by lining the interior wall opposite the windows with Venetian glass mirrors the same size and shape as the arched windows. Mirrors were small and extremely expensive in the seventeenth century, and these huge walls of reflective glass were created by fitting 18-inch panels together. The mirrors reflect the natural light from

**22–50** • Louis Le Vau and Jules Hardouin-Mansart **GARDEN FAÇADE OF THE PALACE OF VERSAILLES** with (foreground) Jean-Baptiste Tuby **NEPTUNE.** 1678–1685.

SEE MORE: View a video about Versailles **www.myartslab.com**

**22–51 • Jules Hardouin-Mansart and Charles Le Brun HALL OF MIRRORS, PALACE OF VERSAILLES**
Begun 1678. Length approx. 240′ (73 cm).

In the seventeenth century, mirrors and clear window glass were enormously expensive. To furnish the Hall of Mirrors, hundreds of glass panels of manageable size had to be assembled into the proper shape and attached to one another with glazing bars, which became part of the decorative pattern of the vast room.

the windows and give the impression of an even larger space; at night, the reflections of flickering candles must have turned the mirrored gallery into a veritable painting in which the king and courtiers saw themselves as they promenaded.

Inspired by Carracci's Farnese ceiling (SEE FIG. 22–9), Le Brun decorated the vaulted ceiling with paintings (on canvas, which is more stable in the damp northern climate) glorifying the reign of Louis XIV and Louis's military triumphs, assisted by the Classical gods. In 1642, Le Brun had studied in Italy, where he came under the influence of the Classical style of his compatriot Nicolas Poussin. As "first painter to the king" and director of the Royal Academy of Painting and Sculpture, Le Brun controlled art education and patronage from 1661/63 until his death in 1690. He tempered the warmly exuberant Baroque ceilings he had seen in Rome with Poussin's cool Classicism to produce spectacular decorations for the king. The underlying theme for the design and decoration of the palace was the glorification of the king as Apollo the sun god, with whom Louis identified. Louis XIV thought of the duties of kingship, including its pageantry, as a solemn performance, so it is most appropriate that Rigaud's portrait presents him on a raised, stagelike platform, with a theatrical curtain (SEE FIG. 22–49). Versailles was the splendid stage on which the king played the principal role in the grandiose drama of state.

## PAINTING

The lingering Mannerism of the sixteenth century in France gave way as early as the 1620s to Classicism and Caravaggism (tenebrism and the compression of large-scale figures into the foreground). Later in the century, under the control of the Royal Academy and inspired by studies of the Classics and the surviving antiquities in Rome, French painting was dominated by the Classical influences propounded by Le Brun.

Wealthy and aristocratic French landowners commissioned garden designers to transform their large properties into gardens extending over many acres. The challenge for garden designers was to unify diverse elements—buildings, pools, monuments, plantings, natural land formations—into a coherent whole. At Versailles, André Le Nôtre imposed order upon the vast expanses of palace gardens and park by using broad, straight avenues radiating from a series of round focal points. He succeeded so thoroughly that his plan inspired generations of urban designers as well as landscape architects.

In Le Nôtre's hands, the palace terrain became an extraordinary work of art and a visual delight for its inhabitants. Neatly contained expanses of lawn and broad, straight vistas seemed to stretch to the horizon, while the formal gardens became an exercise in precise geometry. The gardens at Versailles are classically harmonious in their symmetrical, geometric design but Baroque in their vast size and extension into the surrounding countryside, where the gardens thickened into woods cut by straight avenues.

The most formal gardens lay nearest the palace, and plantings became progressively less elaborate and larger in scale as their distance from the palace increased. Broad, intersecting paths separated reflecting pools and planting beds, which are called embroidered **parterres** for their colorful patterns of flowers outlined with trimmed hedges. After the formal zone of *parterres* came lawns, large fountains on terraces, and trees planted in thickets to conceal features such as an open-air ballroom and a colonnade. Statues carved by at least 70 sculptors also adorned the park. A mile-long canal, crossed by a second canal nearly as large, marked the main axis of the garden. Fourteen waterwheels brought the water from the river to supply the canals and the park's 1,400 fountains. Only the fountains near the palace played all day; the others were turned on only when the king approached.

At the north of the secondary canal, a smaller pavilion-palace, the Trianon, was built in 1669. To satisfy the king's love of flowers year-round, the gardens of the Trianon were bedded out with blooming plants from the south, shipped in by the French navy. Even in midwinter, the king and his guests could stroll through a summer garden. The head gardener is said to have had nearly 2 million flowerpots at his disposal. In the eighteenth century, Louis XV added greenhouses and a botanical garden. The facilities of the fruit and vegetable garden that supplied the palace in 1677–1683 today house the National School of Horticulture.

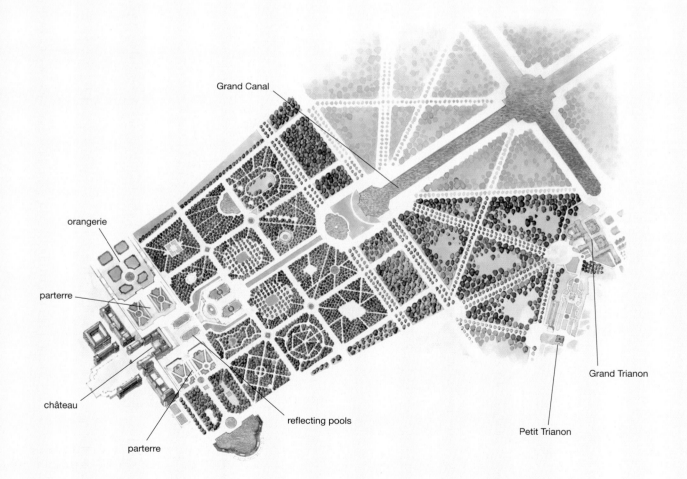

Louis Le Vau and André Le Nôtre **PLAN OF THE GARDENS OF THE PALACE OF VERSAILLES**
Versailles, France. c. 1661–1785.

**CARAVAGGIO'S INFLUENCE: GEORGES DE LA TOUR AND THE LE NAIN BROTHERS.** One of Caravaggio's most important followers in France, Georges de La Tour (1593–1652) received major royal and ducal commissions and became court painter to Louis XIII in 1639. La Tour may have traveled to Italy in 1614–1616, and in the 1620s he almost certainly visited the Netherlands, where Caravaggio's style was being enthusiastically emulated. Like Caravaggio, La Tour filled the foreground of his canvases with imposing figures, but in place of Caravaggio's focus on descriptive detail, his work revels in the effects of lighting. Often, it seems, light is his real subject (see Introduction, "A Closer Look").

La Tour painted many images of Mary Magdalen. In **MARY MAGDALEN WITH THE SMOKING FLAME (FIG. 22–52)**, as in many of his other paintings, the light emanates from a source within the picture itself, in this case the flame from a lamp. It gently brushes over hand and skull—symbol of mortality—to establish the foreground. The compression of the figure into the front of the pictorial space lends a sense of intimacy to the saint's relationship with viewers, although the Magdalen is completely unaware of our presence. Light not only unifies the painting; it creates its somber mood. Mary Magdalen has put aside her rich clothing and jewels and meditates on the frailty and vanity of human life. Even the flickering light that rivets our attention on her meditative face and gesture is of limited duration.

This same feeling of timelessness, and a comparable interest in effects of light, characterize the paintings of the Le Nain brothers, Antoine (c. 1588–1648), Louis (c. 1593–1648), and Mathieu (1607–1677). Although the three were working in Paris by about 1630 and were founding members of the Royal Academy of Painting and Sculpture in 1648, little else is known about their lives and careers. Because they collaborated closely with each other, art historians have only recently begun to sort out their

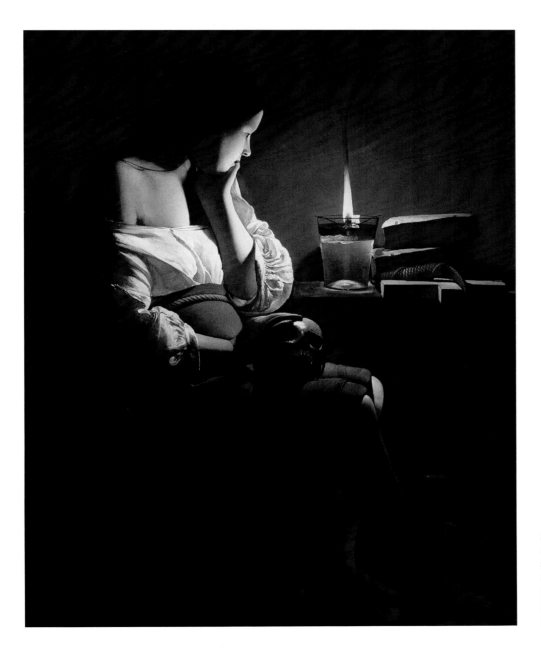

**22-52 •** Georges de La Tour
**MARY MAGDALEN WITH THE SMOKING FLAME**
c. 1640. Oil on canvas, 46¼ × 36⅛″ (117 × 91.8 cm). Los Angeles County Museum of Art. Gift of the Ahmanson Foundation (M. 77.73)

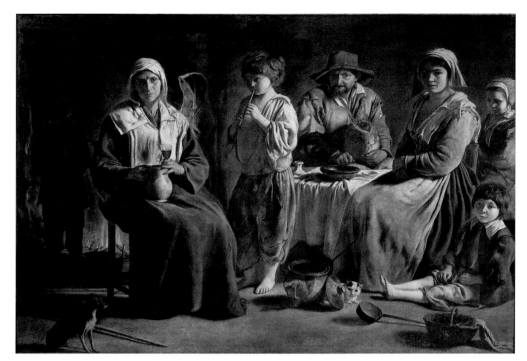

**22-53 •** Louis or Antoine Le Nain **A PEASANT FAMILY IN AN INTERIOR**
c. 1640. Oil on canvas, 44½ × 62½″ (1.13 × 1.59 m). Musée du Louvre, Paris.

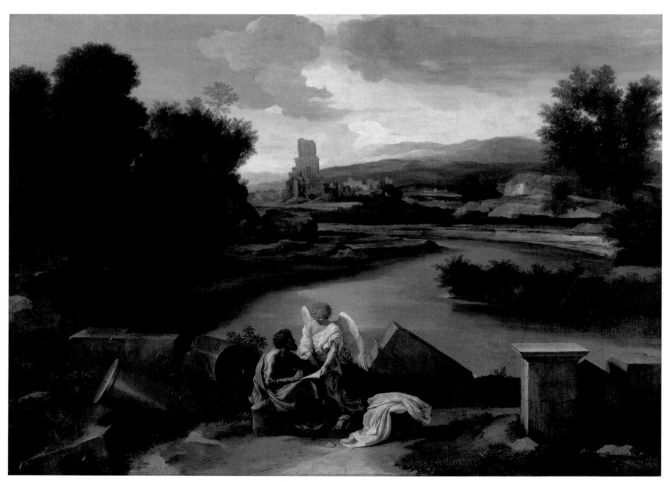

**22-54 •** Nicolas Poussin **LANDSCAPE WITH ST. MATTHEW AND THE ANGEL**
1639–1640. Oil on canvas, 39 × 53⅛″ (99 × 135 cm). Staatliche Museen, Berlin.

individual styles. They are best known for their painting of genre scenes in which French peasants pause from their honest labor for quiet family diversions. **A PEASANT FAMILY IN AN INTERIOR (FIG. 22–53)** of about 1640, probably by Louis Le Nain, is the largest, and one of the most lyrical, of these noble scenes of peasant life. Three generations of this family are gathered around a table. The adults acknowledge our presence—a spotlighted woman at left even seems to offer us some wine—whereas the children remain lost in their dreams or focused on their play. The casualness of costume and deportment is underlined by the foreground clutter of pets and kitchen equipment. It is only after we survey the frieze of figures illuminated around the table that the painting reveals one of its most extraordinary passages—a boy in the left background, warming himself in front of a fireplace and represented only as a dark silhouette from behind, edged by the soft golden firelight. Why the brothers chose to paint these peasant families, and who bought their paintings, are questions still unresolved.

THE CLASSICAL LANDSCAPE: POUSSIN AND CLAUDE LORRAIN. Painters Nicolas Poussin (1594–1665) and Claude Gellée (called "Claude Lorrain" or simply "Claude," 1600–1682) pursued their careers in Italy although they usually worked for French patrons. They perfected the French ideal of the "Classical" landscape and profoundly influenced painters for the next two centuries. We refer to Poussin and Claude as Classicists because they organized natural elements and figures into gently illuminated, idealized compositions. Both were influenced by Annibale Carracci and to some extent by Venetian painting, yet each evolved an unmistakably personal style that conveyed an entirely different mood from that of their sources and from each other.

Nicolas Poussin was born in Normandy but settled in Paris, where his initial career as a painter was unremarkable. Determined to go to Rome, he arrived there in 1624, and the Barberini became his foremost patrons. Bernini considered Poussin one of the greatest painters in Rome, and others clearly agreed. In 1639, Giovanni Maria Roscioli, secretary to Pope Urban VIII, commissioned from Poussin two large paintings showing the evangelists John and Matthew writing their gospels within expansive landscapes dotted with Classical buildings and antique ruins **(FIGS. 22–54, 22–55)**. The paintings were completed by

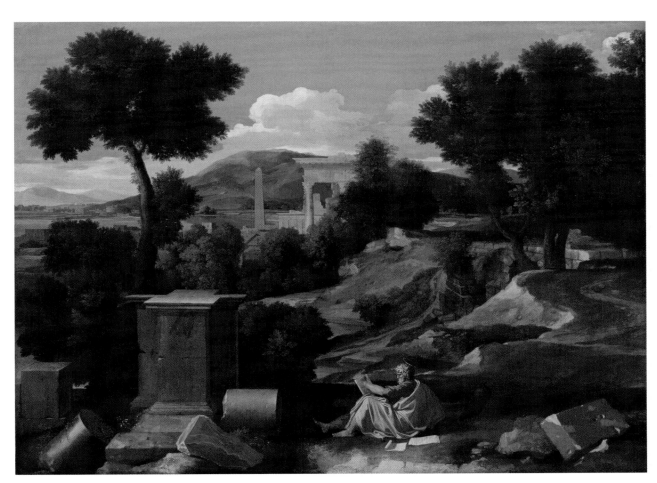

**22-55 • Nicolas Poussin LANDSCAPE WITH ST. JOHN ON PATMOS**
1640. Oil on canvas, 40 × 53½″ (101.8 × 136.3 cm). The Art Institute of Chicago. A. A. Munger Collection, 1930.500

**EXPLORE MORE:** Gain insight from a primary source by Nicolas Poussin **www.myartslab.com**

## Grading the Old Masters

The members of the French Royal Academy of Painting and Sculpture considered ancient Classical art to be the standard by which contemporary art should be judged. By the 1680s, however, younger artists of the academy began to argue that modern art might equal, or might even surpass, the art of the ancients—a radical thought that sparked controversy.

A debate arose over the relative merits of drawing and color in painting. The conservatives argued that drawing was superior to color because drawing appealed to the mind while color appealed to the senses. They saw Nicolas Poussin as embodying perfectly the Classical principles of subject and design. But the young artists who admired the vivid colors of Titian, Veronese, and Rubens claimed that painting should deceive the eye, and since color achieves this deception more convincingly than drawing, application of color should be valued over drawing. Adherents of the two positions were called *poussinistes* (in honor of Poussin) and *rubénistes* (for Rubens).

The portrait painter and critic Roger de Piles (1635–1709) took up the cause of the *rubénistes* in a series of pamphlets. In *The Principles of Painting*, de Piles evaluated the most important painters on a scale of 0 to 20 in four categories. He gave no score higher than 72 (18 in each category), since no mortal artist could achieve perfection. Caravaggio received a 0 in expression and a 6 in drawing, while Michelangelo and Leonardo both got a 4 in color and Rembrandt a 6 in drawing.

Most of the painters examined here do not do very well. Raphael and Rubens get 65 points (A on our grading scale), Van Dyck comes close with 55 (C+). Poussin and Titian earn 53 and 51 (solid Cs), while Rembrandt slips by with 50 (C–). Leonardo da Vinci gets 49 (D), and Michelangelo and Dürer with 37 and Caravaggio with 28 are resounding failures in de Piles's view. Tastes change. Someday our own ideas may seem just as misguided as those of the academicians.

---

October 1640, just before Poussin left for two years in Paris to work for Louis XIII. Perhaps they were the first installment of a set of four evangelists within landscapes, but these were the only two painted by the time of the patron's death in 1644.

These two paintings epitomize and are among the earliest examples of the new style of rigorously ordered and highly idealized Classical landscapes with figures. This artistic theme and format, created by Poussin while working in Rome, would have a long history in European painting. Although each painting was individually composed to create an ordered whole on its own, they were designed as a pair. The large clumps of trees at the outside edges form "bookends" that bring lateral closure to the broad panorama that stretches across both canvases. Their unity is signaled by the evangelists' postures, turned inward toward each other, and solidified at the lower inside corners where huge blocks of Classical masonry converge from both pictures as coordinated remains of the same ruined monument. There is a consistent perspective progression in both pictures from the picture plane back into the distance through a clearly defined foreground, middle ground, and background, illuminated by an even light with gentle shadows and highlights. In the middle distance behind St. John are a ruined temple and an obelisk, and the round building in the distant city is Hadrian's Tomb, which Poussin knew from Rome. Precisely placed trees, hills, mountains, water, and even clouds take on a solidity of form that seems almost as structural as this architecture. The subject of Poussin's paintings is not the writing evangelists but the balance and order of nature.

When Claude Lorrain went to Rome in 1613, he first studied with Agostino Tassi, an assistant of Guercino and a specialist in architectural painting. Claude, however, preferred landscape. He sketched outdoors for days at a time, then returned to his studio to compose his paintings. Claude was fascinated with light, and his works are often studies of the effect of the rising or setting sun on colors and the atmosphere. A favorite and much-imitated device was to place one or two large objects in the foreground—a tree, building, a figural group, or hill—past which the viewer's eye enters the scene and proceeds, often by diagonal paths, into the distance.

Claude used this compositional device to great effect in paintings such as **A PASTORAL LANDSCAPE** of the late 1640s **(FIG. 22–56)**. Instead of balancing symmetrically placed elements in a statement of stable order, Claude leads his viewers actively into the painting in a continuing, zigzagging fashion. A conversing couple frames the composition at the right; their gestures and the ambling of the cows they are tending lead our attention toward the left on a slightly rising diagonal, where a bridge and the traveler moving across it establish a middle ground. Across the bridge into the distance is a city, setting up a contrast between the warm, soft contours of the pastoral right foreground and the misty angularity of the fortified walls and blocks composing the distant city. More distant still are the hazy outlines of hills that seem to take this space into infinity. The picture evokes a city dweller's nostalgia and longing for the simpler and more sensuous life of the country, and it is easy to imagine the foreground shepherd extolling to his companion the superior virtues of their own life in contrast to that in the city, toward which he gestures to underline his point.

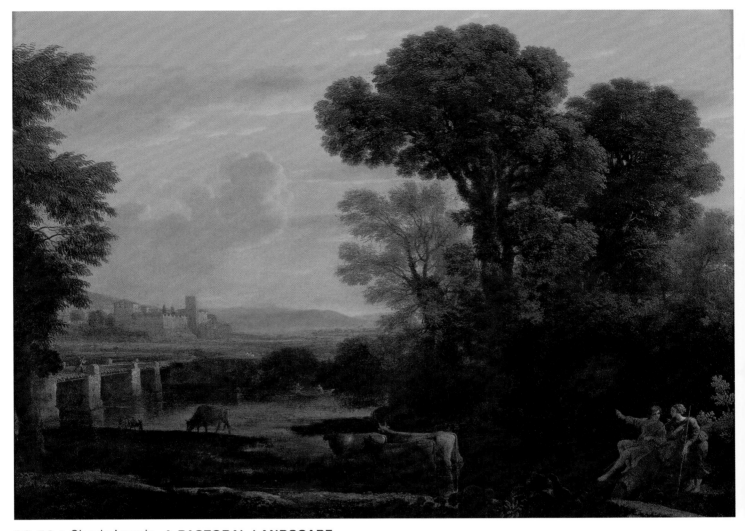

**22-56 • Claude Lorrain A PASTORAL LANDSCAPE**
c. 1648. Oil on copper, 15½ × 21" (39.3 × 53.3 cm). Yale University Art Gallery, New Haven, Connecticut.

# ENGLAND

England and Scotland were joined in 1603 with the ascent to the English throne of James VI of Scotland, who reigned over Great Britain as James I (r. 1603–1625). James increased royal patronage of British artists, especially in literature and architecture. William Shakespeare wrote *Macbeth*, featuring the king's legendary ancestor Banquo, in tribute to the new royal family, and the play was performed at court in December 1606.

Although James's son Charles I was an important collector and patron of painting, religious and political tensions that erupted into civil war cost Charles his throne and his life in 1649. A succession of republican and monarchical rulers who alternately supported Protestantism or Catholicism followed, until the Catholic king James II was deposed in the Glorious Revolution of 1689 by his Protestant son-in-law and daughter, William and Mary. After Mary's death in 1694, William (the Dutch great-grandson of William of Orange, who had led the Netherlands' independence movement) ruled on his own until his death in 1702. He was succeeded by Mary's sister, Anne (r. 1702–1714).

## ARCHITECTURE

In sculpture and painting, the English court patronized foreign artists. The field of architecture, however, was dominated in the seventeenth century by the Englishmen Inigo Jones, Christopher Wren, and Nicholas Hawksmoor. They replaced the country's long-lived Gothic style with Classicism.

INIGO JONES. In the early seventeenth century, Inigo Jones (1573–1652) introduced his version of Renaissance Classicism—based on the style of the architect Andrea Palladio—into England. Jones had studied Palladio's work in Venice, and he filled his copy of Palladio's *Four Books of Architecture*—still preserved—with notes. Appointed surveyor-general in 1615, Jones was commissioned to design the Queen's House in Greenwich and the Banqueting House for the royal palace of Whitehall.

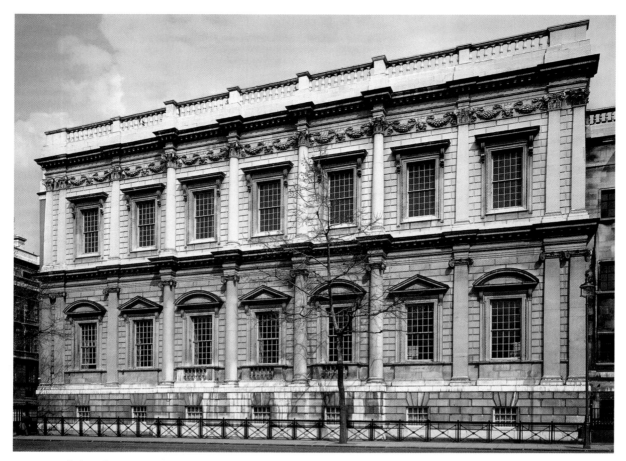

**22-57 •** Inigo Jones **BANQUETING HOUSE, WHITEHALL PALACE**
London. 1619–1622.

The **BANQUETING HOUSE** (**FIG. 22–57**), built in 1619–1622 to replace an earlier hall destroyed by fire, was used for court ceremonies and entertainments such as the popular masques—stylized dramas combining theater, music, and dance in spectacles performed by professional actors, courtiers, and even members of the royal family itself. The west front, shown here, consisting of what appears to be two upper stories with superimposed Ionic and Composite orders raised over a plain basement level, exemplifies the understated elegance of Jones's interpretation of Palladian design. Pilasters flank the end bays, and engaged columns subtly emphasize the three bays at the center. These vertical elements are repeated in the balustrade along the roofline. A rhythmic effect results from varying window treatments—triangular and segmental (semicircular) pediments on the first level, cornices with volute (scroll-form) brackets on the second. The sculpted garlands just below the roofline add an unexpected decorative touch, as does the use of different stone colors—pale golden, light brown, and white—for each story (no longer visible after the building was refaced in uniformly white Portland stone).

Although the exterior suggests two stories, the interior of the Banqueting House (**FIG. 22–58**) is actually one large hall divided by a balcony, with antechambers at each end. Ionic pilasters suggest a colonnade but do not impinge on the ideal, double-cube space,

which measures 55 feet in width by 110 feet in length by 55 feet in height. In 1630, Charles I commissioned Peter Paul Rubens—who was in England on a peace mission—to decorate the ceiling. Jones had divided the flat ceiling into nine compartments, for which Rubens painted canvases glorifying the reign of James I. Installed in 1635, the paintings show the triumph of the Stuart dynasty with the king carried to heaven on clouds of glory. The large rectangular panel beyond it depicts the birth of the new nation, flanked by allegorical paintings of heroic strength and virtue overcoming vice. In the long paintings on each side, *putti* holding the fruits of the earth symbolize the peace and prosperity of England and Scotland under Stuart rule. So proud was Charles of the result that, rather than allow the smoke of candles and torches to harm the ceiling decoration, he moved evening entertainments to an adjacent pavilion.

**CHRISTOPHER WREN.** After Jones's death, English architecture was dominated by Christopher Wren (1632–1723). Wren began his professional career in 1659 as a professor of astronomy; for him architecture was a sideline until 1665, when he traveled to France to further his education. While there, he met with French architects and with Bernini, who was in Paris to consult on designs for the Louvre. Wren returned to England with architecture books,

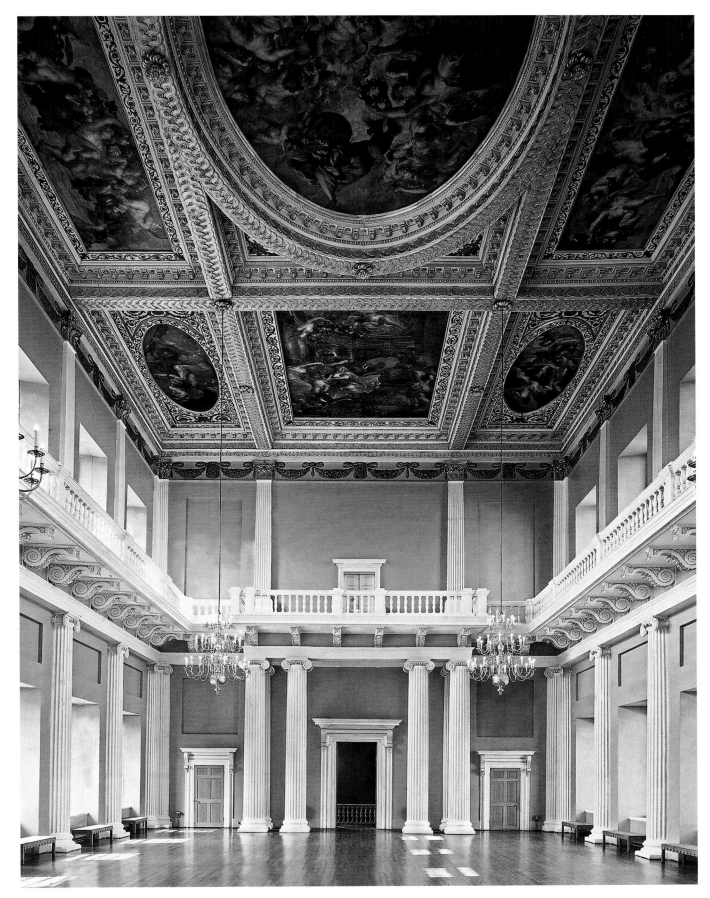

**22-58 • INTERIOR, BANQUETING HOUSE, WHITEHALL PALACE**
Ceiling paintings of the apotheosis of King James and the glorification of the Stuart monarchy by Peter Paul Rubens. 1630–1635.

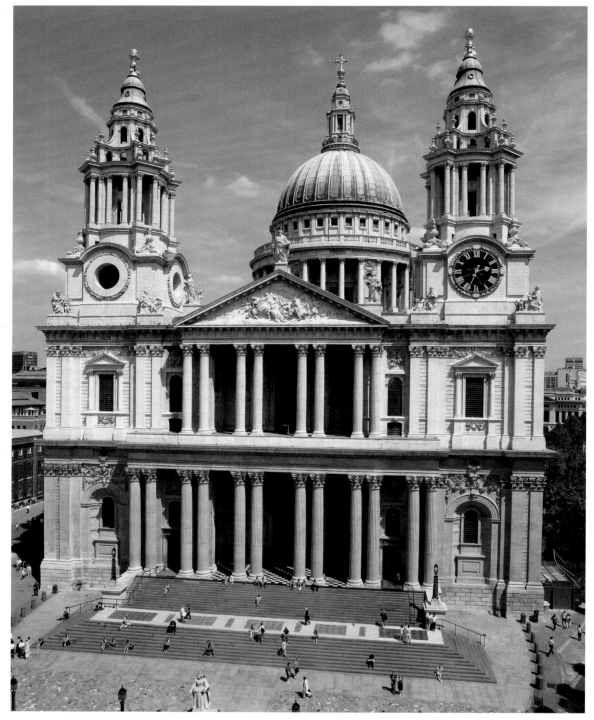

**22-59 • Christopher Wren  FAÇADE OF ST. PAUL'S CATHEDRAL**
London. Designed 1673, built 1675–1710.

**EXPLORE MORE:** Gain insight from a primary source on Christopher Wren
**www.myartslab.com**

engravings, and a greatly increased admiration for French Classical Baroque design. In 1669, he was made surveyor-general, the position once held by Inigo Jones, and in 1673, he was knighted.

After the Great Fire of 1666 destroyed large parts of central London, Wren was continuously involved in rebuilding the city.

He built more than 50 churches. His major project from 1675 to 1710, however, was the rebuilding of **ST. PAUL'S CATHEDRAL** (**FIGS. 22–59, 22–60**). Attempts to salvage the burned-out Gothic church on the site failed, and a new cathedral was needed. Wren's famous second design for St. Paul's (which survives in the so-called

masonry vault with an oculus and an exterior sheathing of lead-covered wood, but also has a brick cone rising from the inner oculus to support a tall lantern. The ingenuity of the design and engineering remind us that Wren had been a mathematician and professor of astronomy at Oxford. The columns surrounding the drum on the exterior recall Bramante's *Tempietto* in Rome (SEE FIG. 20–16), although Wren never went to Italy and knew Italian architecture only from books.

On the façade of St. Paul's (SEE FIG. 22–59), two levels of paired Corinthian columns support a carved pediment. The deep-set porticos and columned pavilions atop the towers create dramatic areas of light and shadow. Not only the huge size of the cathedral, but also its triumphant verticality, complexity of form, and *chiaroscuro* effects, make it a major monument of English architecture. Wren recognized the importance of the building. On the simple marble slab that forms his tomb in the crypt of the cathedral, he had engraved: "If you want to see his memorial, look around you."

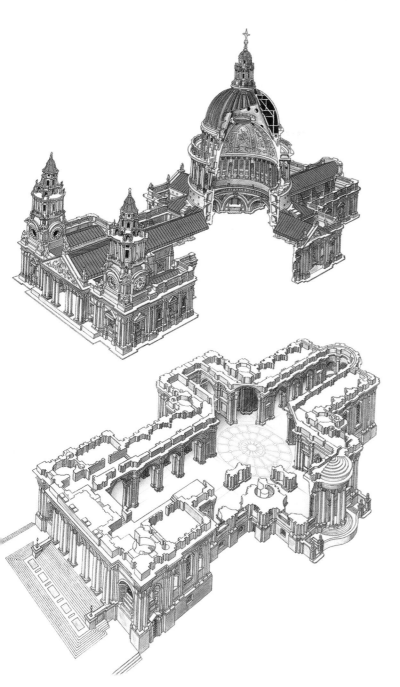

**22-60 • SCHEMATIC DRAWING OF ST. PAUL'S CATHEDRAL**

"Great Model" of 1672–1673) was for a centrally planned building with a great dome in the manner of Bramante's original plan for St. Peter's. This was rejected, but Wren ultimately succeeded both in satisfying Reformation tastes for a basilica and in retaining the unity inherent in the dome. St. Paul's has a long nave and equally long sanctuary articulated by small, domed bays. Semicircular, colonnaded porticos open into short transepts that compress themselves against the crossing, where the dome rises 633 feet from ground level. Wren's dome for St. Paul's has an interior

## THINK ABOUT IT

**22.1** Summarize the goals and interests of the Counter-Reformation, and explain the impact of the Council of Trent on Italian artists working in its wake. It may be helpful to look back to Chapters 20 and 21 in forming your answer.

**22.2** Discuss how Bernini and Caravaggio established the Baroque style in sculpture and painting respectively. Locate the defining traits of the period style in at least one work from the chapter by each of these artists.

**22.3** Trace the influence of Caravaggio's painting style by demonstrating how specific stylistic features that he pioneered were adopted by artists in other parts of Europe. Discuss at least one Spanish artist and at least one Northern European artist in your answer.

**22.4** Determine how Poussin's landscapes depart from other stylistic currents at the time. What is meant by the term "Classicism" in relation to Poussin's style? Comment on its importance for the future of French art.

**22.5** Choose two paintings of monarchs in this chapter and explain how the artists who painted them embodied the ruler's prestige and power. Are the strategies of these painters different from those employed by painters of powerful people in the sixteenth century?

**22.6** Discuss the development of portraiture, still life, and genre painting in the Dutch Republic during the seventeenth century. What accounts for the increased importance of these subjects at this time?

**PRACTICE MORE:** Compose answers to these questions, get flashcards for images and terms, and review chapter material with quizzes
**www.myartslab.com**

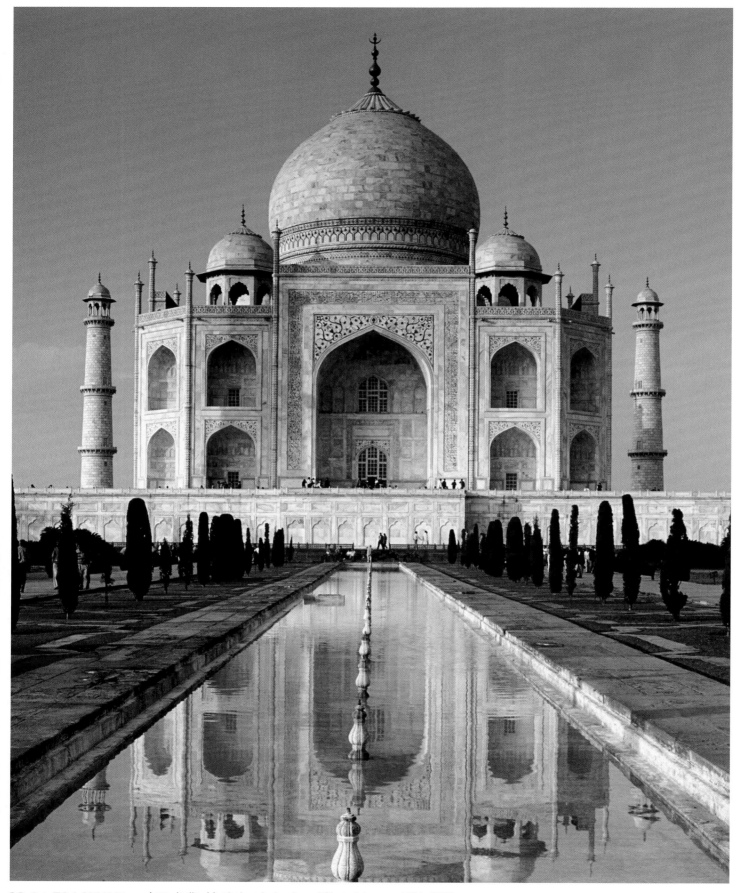

**23-1 • TAJ MAHAL**   Agra, India. Mughal period, reign of Shah Jahan, c. 1631–1648.

**abacus** (p. 108)   The flat slab at the top of a **capital**, directly under the **entablature**.

**abbey church** (p. 239)   An abbey is a religious community headed by an abbot or abbess. An abbey church often has an especially large choir to provide space for the monks or nuns.

**absolute dating** (p. 12)   A method of assigning a precise historical date to periods and objects, based on known and recorded events in the region, as well as technically extracted physical evidence (such as carbon-14 disintegration). See also **radiometric dating, relative dating.**

**abstract, abstraction** (p. 8)   Any art that does not represent observed aspects of nature or transforms visible forms into a stylized image. Also: the **formal** qualities of this process.

**academy** (p. 924)   A place of study, the word coming from the Greek name of a garden near Athens where Plato and, later, Platonic philosophers held discussions. Academies of fine arts, such as the Academy of Drawing or the Royal Academy of Painting, were created to foster the arts by teaching, by discussion, by exhibitions, and occasionally by financial aid.

**acanthus** (p. 110)   A Mediterranean plant whose leaves are reproduced in architectural ornament used on **moldings, friezes,** and **Corinthian capitals.**

**acropolis** (p. 129)   The citadel of an ancient Greek city, located at its highest point and housing temples, a treasury, and sometimes a royal palace. The most famous is the Acropolis in Athens.

**acroterion (acroteria)** (p. 110)   An ornament at the corner or peak of a roof.

**adobe** (p. 393)   Sun-baked blocks made of clay mixed with straw. Also: the buildings made with this material.

**aedicula** (p. 609)   A decorative architectural frame, usually found around a niche, door, or window. An aedicula is made up of a **pediment** and **entablature** supported by **columns** or **pilasters.**

**agora** (p. 138)   An open space in a Greek town used as a central gathering place or market. See also **forum.**

**aisle** (p. 228)   Passage or open corridor of a church, hall, or other building that parallels the main space, usually on both sides, and is delineated by a row, or **arcade,** of **columns** or **piers.** Called side aisles when they flank the **nave** of a church.

**album** (p. 795)   A book consisting of a series of painting or prints (album leaves) mounted into book form.

**allegory** (p. 625)   In a work of art, an image (or images) that symbolizes an idea, concept, or principle, often moral or religious.

**alloy** (p. 23)   A mixture of metals; different metals melted together.

**amalaka** (p. 301)   In Hindu architecture, the circular or square-shaped element on top of a spire (**shikhara**), often crowned with a **finial,** symbolizing the cosmos.

**ambulatory** (p. 228)   The passage (walkway) around the **apse** in a **basilican** church or around the central space in a **central-plan building.**

**amphora** (p. 101)   An ancient Greek jar for storing oil or wine, with an egg-shaped body and two curved handles.

**aniconic** (p. 262)   A symbolic representation without images of human figures, very often found in Islamic art.

**animal interlace or style** (p. 427)   Decoration made of interwoven animals or serpents, often found in Celtic and early medieval Northern European art.

**ankh** (p. 51)   A looped cross signifying life, used by ancient Egyptians.

**appropriation** (p. 1102)   Term used to describe the practice of some postmodern artists of adopting images in their entirety from other works of art or from visual culture for use in their own art. The act of recontextualizing the appropriated image allows the artist to critique both it and the time and place in which it was created.

**apse, apsidal** (p. 192)   A large semicircular or polygonal (and usually **vaulted**) niche protruding from the end wall of a building. In the Christian church, it contains the altar. Apsidal is an adjective describing the condition of having such a space.

**arabesque** (p. 263)   A type of linear surface decoration based on foliage and **calligraphic** forms, usually characterized by flowing lines and swirling shapes.

**arcade** (p. 172)   A series of **arches,** carried by **columns** or **piers** and supporting a common wall or **lintel.** In a **blind arcade,** the arches and supports are **engaged** (attached to the wall) and have a decorative function.

**arch** (p. 271)   In architecture, a curved structural element that spans an open space. Built from wedge-shaped stone blocks called **voussoirs,** which, when placed together and held at the top by a trapezoidal **keystone,** form an effective space-spanning and weight-bearing unit. Requires **buttresses** at each side to contain the outward **thrust** caused by the weight of the structure. **Corbel arch** (p. 16): an arch or **vault** formed by **courses** of stones, each of which projects beyond the lower course until the space is enclosed; usually finished with a **capstone. Horseshoe arch** (p. 268): an arch of more than a half-circle; typical of western Islamic architecture. **Round arch** (p. 271): arch that displaces most of its weight, or downward thrust along its curving sides, transmitting that weight to adjacent supporting uprights (door or window jambs, columns, or piers). Ogival arch: a pointed arch created by S-curves. Relieving arch: an arch built into a heavy wall just above a **post-and-lintel** structure (such as a gate, door, or window) to help support the wall above it by transferring the load to the side walls. **Transverse arch** (p. 457): an arch that connects the wall **piers** on both sides of an interior space, up and over a stone vault.

**Archaic smile** (p. 114)   The curved lips of an ancient Greek statue, usually interpreted as a way of animating facial features.

**architrave** (p. 108)   The bottom element in an **entablature,** beneath the **frieze** and the **cornice.**

**archivolt** (p. 473)   A **molded** band framing an **arch,** or a series of stone blocks that rest directly on the **columns.**

**ashlar** (p. 99)   Highly finished, precisely cut block of stone. When laid in even courses, ashlar masonry creates a uniform face with fine joints. Often used as a facing on the visible exterior of a building, especially as a veneer for the façade. Also called **dressed stone.**

**assemblage** (p. 1026)   Artwork created by gathering and manipulating two- and/or three-dimensional found objects.

**astragal** (p. 110)   A thin convex decorative **molding,** often found on Classical **entablatures,** and usually decorated with a continuous row of beadlike circles.

**atelier** (p. 944)   The studio or workshop of a master artist or craftsperson, often including junior associates and apprentices.

**atmospheric perspective** (p. 562)   See **perspective.**

**atrial cross** (p. 941)   The cross placed in the **atrium** of a church. In Colonial America, used to mark a gathering and teaching place.

**atrium** (p. 160)   An unroofed interior courtyard or room in a Roman house, sometimes having a pool or garden, sometimes surrounded by **columns.** Also: the open courtyard in front of a Christian church; or an entrance area in modern architecture.

**automatism** (p. 1056)   A technique whereby the usual intellectual control of the artist over his or her brush or pencil is foregone. The artist's aim is to allow the subconscious to create the artwork without rational interference.

**avant-garde** (p. 971)   Term derived from the French military word meaning "before the group," or "vanguard." Avant-garde denotes those artists or concepts of a strikingly new, experimental, or radical nature for their time.

**axis** (p. xxxii)   An implied line around which the elements of a picture are organized.

**axis-mundi** (p. 297)   A concept of an "axis of the world," which marks sacred sites and denotes a link between the human and celestial realms. For example, in Buddhist art, the *axis mundi* can be marked by monumental freestanding decorative **pillars.**

**bailey** (p. 473)   The outermost walled courtyard of a castle.

**baldachin** (p. 467)   A canopy (whether suspended from the ceiling, projecting from a wall, or supported by **columns**) placed over an honorific or sacred space such as a throne or church altar.

**bar tracery** (p. 507)   See **tracery.**

**barbarian** (p. 151)   A term used by the ancient Greeks and Romans to label all foreigners outside their cultural orbit (e.g., Celts, Goths, Vikings). The word derives from an imitation of what the "barblings" of their language sounded like to those who could not understand it.

**bargeboards** (p. 870)   Boards covering the rafters at the gable end of a building; bargeboards are often carved or painted.

**barrel vault** (p. 188)   See **vault.**

**base** (p. 110)   Any support. Also: masonry supporting a statue or the shaft of a **column.**

**basilica** (p. 192)   A large rectangular building. Often built with a **clerestory,** side **aisles** separated from the center **nave** by **colonnades,** and an **apse** at one or both ends. Roman centers for administration, later adapted to Christian church use.

**battered** (p. 418)   An architectural design whereby walls are sloped inward toward the top to increase stability.

**bay** (p. 172)   A unit of space defined by architectural elements such as **columns, piers,** and walls.

**beehive tomb** (p. 98)   A corbel-vaulted tomb, conical in shape like a beehive, and covered by an earthen mound.

**Benday dots** (p. 1093)   In modern printing and typesetting, the individual dots that, together with many others, make up lettering and images. Often machine- or computer-generated, the dots are very small and closely spaced to give the effect of density and richness of tone.

**bi** (p. 333)   A jade disk with a hole in the center.

**bilum** (p. 863)   Netted bags made mainly by women throughout the central highlands of New Guinea. The bags can be used for everyday purposes or even to carry the bones of the recently deceased as a sign of mourning.

**biomorphic** (p. 1057)   A term used in the early twentieth century to denote the biologically or organically inspired shapes and forms that were routinely included in abstracted Modern art.

**black-figure** (p. 105)   A style or technique of ancient Greek pottery in which black figures are painted on a red clay ground. See also **red-figure**.

**blackware** (p. 853)   A ceramic technique that produces pottery with a primarily black surface with **matte** and glossy patterns on the surface.

**blind arcade** (p. 780)   See **arcade**.

**bodhisattva** (p. 297)   In Buddhism, a being who has attained enlightenment but chooses to remain in this world in order to help others advance spiritually. Also defined as a potential Buddha.

**Book of Hours** (p. 547)   A private prayer book, containing a calendar, services for the canonical hours, and sometimes special prayers.

**boss** (p. 554)   A decorative knoblike element that can be found in many places, such as at the intersection of a Gothic **rib vault** or in the buttonlike projections of metalwork.

**bracket, bracketing** (p. 335)   An architectural element that projects from a wall to support a horizontal part of a building, such as beams or the eaves of a roof.

**buon fresco** (p. 87)   See **fresco**.

**burin** (p. 590)   A metal instrument used in **engraving** to cut lines into the metal plate. The sharp end of the burin is trimmed to give a diamond-shaped cutting point, while the other end is finished with a wooden handle that fits into the engraver's palm.

**buttress, buttressing** p. 172)   A projecting support built against an external wall, usually to counteract the lateral **thrust** of a **vault** or **arch** within. In Gothic architecture, a **flying buttress** is an arched bridge above the **aisle** roof that extends from the upper **nave** wall, where the lateral thrust of the main vault is greatest, down to a solid **pier**.

**cairn** (p.17)   A pile of stones or earth and stones that served both as a prehistoric burial site and as a marker of underground tombs.

**calligraphy** (p. 279)   Handwriting as an art form.

**calotype** (p. 968)   The first photographic process utilizing negatives and paper positives. It was invented by William Henry Fox Talbot in the late 1830s.

**calyx krater** (p. 118)   See **krater**.

**came (cames)** (p. 497)   A lead strip used in the making of leaded or **stained-glass windows**. Cames have an indented groove on the sides into which the separate pieces of glass are fitted to hold the composition together.

**cameo** (p. 178)   Gemstone, clay, glass, or shell having layers of color, carved in **low relief** to create an image and ground of different colors.

**camera obscura** (p. 967)   An early cameralike device used in the Renaissance and later for recording images of nature. Made from a dark box (or room) with a hole in one side (sometimes fitted with a lens), the camera obscura operates when bright light shines through the hole, casting an upside-down image of an object outside onto the inside wall of the box.

**canon of proportions** (p. 65)   A set of ideal mathematical ratios in art based on measurements, as in the proportional relationships among the basic elements of the human body.

**canopic jar** (p. 56)   Special jars used to store the major organs of a body before embalming, found in ancient Egyptian culture.

**capital** (p. 110)   The sculpted block that tops a **column**. According to the conventions of the **orders**, capitals include different decorative elements. See **order**. A **historiated capital** is one displaying a figural composition of a **narrative** scene.

**capriccio** (p. 912)   A painting or print of a fantastic, imaginary landscape, usually with architecture.

**capstone** (p. 99)   The final, topmost stone in a **corbel arch** or **vault**, which joins the sides and completes the structure.

**cartoon** (p. 497)   A full-scale drawing used to transfer or guide a design onto a surface (such as a wall, canvas, panel, or **tapestry**) to be painted, carved, or woven.

**cartouche** (p. 189)   A frame for a **hieroglyphic** inscription formed by a rope design surrounding an oval space. Used to signify a sacred or honored name. Also: in architecture, a decorative device or plaque, usually with a plain center used for inscriptions or epitaphs.

**caryatid** (p. 107)   A sculpture of a draped female figure acting as a **column** supporting an **entablature**.

**cassone (cassoni)** (p. 616)   An Italian dowry chest often highly decorated with carvings, paintings, **inlaid** designs, and gilt embellishments.

**catacomb** (p. 219)   A subterranean burial ground consisting of tunnels on different levels, having niches for urns and **sarcophagi** and often incorporating rooms (**cubiculae**).

**cathedral** (p. 222)   The principal Christian church in a diocese, the bishop's administrative center and housing his throne (*cathedra*).

**celadon** (p. 352)   A high-fired, transparent glaze of pale bluish-green hue whose principal coloring agent is an oxide of iron. In China and Korea, such glazes typically were applied over a pale gray **stoneware** body, though Chinese potters sometimes applied them over **porcelain** bodies during the Ming (1368–1644) and Qing (1644–1911) dynasties. Chinese potters invented celadon glazes and initiated the continuous production of celadon-glazed wares as early as the third century CE.

**cella** (p. 108)   The principal interior room at the center of a Greek or Roman temple within which the cult statue was usually housed. Also called the **naos**.

**celt** (p. 377)   A smooth, oblong stone or metal object, shaped like an axe-head.

**cenotaph** (p. 771)   A funerary monument commemorating an individual or group buried elsewhere.

**centering** (p. 172)   A temporary structure that supports a masonry **arch** and **vault** or **dome** during construction until the mortar is fully dried and the masonry is self-sustaining.

**central-plan building** (p. 228)   Any structure designed with a primary central space surrounded by symmetrical areas on each side. For example, a **rotunda** or a Greek-cross plan (equal-armed cross).

**ceramics** (p. 22)   A general term covering all types of wares made from fired clay, including **porcelain** and **terra cotta**.

**chacmool** (p. 390)   In Mayan sculpture, a half-reclining figure probably representing an offering bearer.

**chaitya** (p. 302)   A type of Buddhist temple found in India. Built in the form of a hall or **basilica**, a *chaitya* is highly decorated with sculpture and usually is carved from a cave or natural rock location. It houses a sacred shrine or **stupa** for worship.

**chamfer** (p. 780)   The slanted surface produced when an angle is trimmed or beveled, common in building and metalwork.

**chasing** (p. 776)   Ornamentation made on metal by **incising** or hammering the surface.

**château (châteaux)** (p. 691)   A French country house or residential castle. A *château fort*, is a military castle incorporating defensive works such as towers and battlements.

**chattri (chattris)** (p. 779)   A decorative pavilion with an umbrella-shaped **dome** in Indian architecture.

**chevron** (p. 350)   A decorative or heraldic motif of repeated Vs; a zigzag pattern.

**chiaroscuro** (p. 634)   An Italian word designating the contrast of dark and light in a painting, drawing, or print. *Chiaroscuro* creates spatial depth and volumetric forms through gradations in the intensity of light and shadow.

**cista (cistae)** (p. 166)   **Cylindrical** containers used by wealthy women as a case for toiletry articles such as a mirror.

**clerestory** (p. 58)   The topmost zone of a wall with windows in a **basilica** extending above the aisle roofs. Provides direct light into the central interior space (the **nave**).

**cloister** (p. 442)   An open space within a monastery, surrounded by an **arcaded** or colonnaded walkway, often having a fountain and garden. The most important monastic buildings (e.g., dormitory, refectory) open off of it. Since members of a cloistered order do not leave the monastery or interact with outsiders, the cloister represents the center of their enclosed world.

**codex (codices)** (p. 243)   A book, or a group of **manuscript** pages (folios), held together by stitching or other binding on one side.

**coffer** (p. 197)   A recessed decorative panel that is used to reduce the weight of and to decorate ceilings or **vaults**. The use of coffers is called coffering.

**coiling** (p. 845)   A technique in basketry. In coiled baskets a spiraling structure is held in place by another material.

**collage** (p. 1026)   A composition made of cut and pasted scraps of materials, sometimes with lines or forms added by the artist.

**colonnade** (p. 69)   A row of **columns**, supporting a straight **lintel** (as in a **porch** or **portico**) or a series of **arches** (an **arcade**).

**colophon** (p. 432)   The data placed at the end of a book listing the book's author, publisher, **illuminator**, and other information related to its production. In East Asian **handscrolls**, the inscriptions which follow the painting are also called colophons.

**column** (p. 110)   An architectural element used for support and/or decoration. Consists of a rounded or polygonal vertical **shaft** placed on a **base** and topped by a decorative **capital**. In Classical architecture, built in accordance with the rules of one of the architectural **orders**. Columns can be free-standing or attached to a background wall (**engaged**).

**combine** (p. 1085)   Combinations of painting and sculpture using nontraditional art materials.

**complementary color** (p. 993)   The primary and secondary colors across from each other on the color wheel (red and green, blue and orange, yellow and purple). When juxtaposed, the intensity of both colors increases. When mixed together, they negate each other to make a neutral gray-brown.

**composite order** (p. 163)   See **order**.

**composite pose** or **image** (p. 9)   Combining different viewpoints within a single representation of a subject.

**composition** (p. xxix)   The overall arrangement, organizing design, or structure of a work of art.

**conch** (p. 234)   A half-dome.

**cong** (p. 328)   A square or octagonal jade tube with a cylindrical hole in the center. A symbol of the earth, it was used for ritual worship and astronomical observations in ancient China.

**connoisseurship** (p. 741)   A term derived from the French word connoisseur, meaning "an expert," and signifying the study and evaluation of art based primarily on **formal**, visual, and stylistic analysis. A connoisseur studies the style and technique of an object to assess its relative quality and identify its maker through visual comparison with other works of secure authorship. See also **contextualism**: **formalism**.

**contrapposto** (p. 121)   An Italian term meaning "set against," used to describe the pose that results from setting parts of the body in opposition to each other around a central **axis**.

**convention** (p. 51)   A traditional way of representing forms.

**corbel, corbeling** (p. 16)   An early roofing and arching technique in which each **course** of stone projects slightly beyond the previous layer (a corbel) until the

uppermost corbels meet. Results in a high, almost pointed **arch** or **vault**.

**corbeled vault (p. 99)** See **vault**.

**Corinthian order (p. 108)** See **order**.

**cornice (p. 110)** The uppermost section of a Classical **entablature**. More generally, a horizontally projecting element found at the top of a building wall or **pedestal**. A raking cornice is formed by the junction of two slanted cornices, most often found in **pediments**.

**course (p. 99)** A horizontal layer of stone used in building.

**crenellation (p. 44)** Alternating higher and lower sections along the top of a defensive wall, giving a stepped appearance and forming a permanent shield for defenders on top of a fortified building.

**crocket (p. 585)** A stylized leaf used as decoration along the outer angle of spires, pinnacles, gables, and around **capitals** in Gothic architecture.

**cruciform (p. 232)** A term describing anything that is cross-shaped, as in the cruciform plan of a church.

**cubiculum (cubicula) (p. 224)** A small private room for burials in the **catacombs**.

**cuneiform (p. 28)** An early form of writing with wedge-shaped marks impressed into wet clay with a **stylus**, primarily used by ancient Mesopotamians.

**curtain wall (p. 1045)** A wall in a building that does not support any of the weight of the structure.

**cyclopean construction (p. 93)** A method of building using huge blocks of rough-hewn stone. Any large-scale, monumental building project that impresses by sheer size. Named after the Cyclopes (sing. Cyclops) one-eyed giants of legendary strength in Greek myths.

**cylinder seal (p. 32)** A small cylindrical stone decorated with **incised** patterns. When rolled across soft clay or wax, the resulting raised pattern or design (**relief**) served in Mesopotamian and Indus Valley cultures as an identifying signature.

**dado (dadoes) (p. 163)** The lower part of a wall, differentiated in some way (by a molding or different coloring or paneling) from the upper section.

**daguerreotype (p. 967)** An early photographic process that makes a positive print on a light-sensitized copperplate; invented and marketed in 1839 by Louis-Jacques-Mandé Daguerre.

**demotic writing (p. 77)** The simplified form of ancient Egyptian **hieratic writing**, used primarily for administrative and private texts.

**dendrochronology (p. xxxvi)** The dating of wood based on the patterns of the growth rings.

**desert varnish (p. 400)** In southwestern North America, a substance that turned cliff faces into dark surfaces. Neolithic artists would draw images by scraping through the dark surface.

**diptych (p. 215)** Two panels of equal size (usually decorated with paintings or **reliefs**) hinged together.

**dogu (p. 356)** Small human figurines made in Japan during the Jomon period. Shaped from clay, the figures have exaggerated expressions and are in contorted poses. They were probably used in religious rituals.

**dolmen (p. 17)** A prehistoric structure made up of two or more large upright stones supporting a large, flat, horizontal slab or slabs.

**dome (p. 188)** A rounded **vault**, usually over a circular space. Consists of curved masonry and can vary in shape from hemispherical to bulbous to ovoidal. May use a supporting vertical wall (**drum**), from which the vault springs, and may be crowned by an open space (**oculus**) and/or an exterior **lantern**. When a dome is built over a square space, an intermediate element is required to make the transition to a circular drum. There are two systems: A dome on **pendentives** (spherical triangles) incorporates **arched**, sloping intermediate sections of wall that carry the weight and **thrust** of the dome to

heavily **buttressed** supporting **piers**. A dome on **squinches** uses an arch built into the wall (squinch) in the upper corners of the space to carry the weight of the dome across the corners of the square space below. A half-dome or **conch** may cover a semicircular space.

**domino construction (p. 1045)** System of building construction introduced by the architect Le Corbusier in which reinforced concrete floor slabs are floated on six free-standing posts placed as if at the positions of the six dots on a domino playing piece.

**Doric order (p. 108)** See **order**.

**dressed stone (p. 85)** See **ashlar**.

**drillwork (p. 190)** The technique of using a drill for the creation of certain effects in sculpture.

**drum (p. 110)** The wall that supports a **dome**. Also: a segment of the circular **shaft** of a **column**.

**drypoint (p. 748)** An **intaglio** printmaking process by which a metal (usually copper) plate is directly inscribed with a pointed instrument (**stylus**). The resulting design of scratched lines is inked, wiped, and printed. Also: the print made by this process.

**earthenware (p. 22)** A low-fired, opaque **ceramic** ware that is fired in the range of 800 to 900 degrees Celsius. Earthenware employs humble clays that are naturally heat resistant; the finished wares remain porous after firing unless glazed. Earthenware occurs in a range of earth-toned colors, from white and tan to gray and black, with tan predominating.

**earthwork (p. 1102)** Usually very large scale, outdoor artwork that is produced by altering the natural environment.

**echinus (p. 110)** A cushionlike circular element found below the **abacus** of a **Doric capital**. Also: a similarly shaped molding (usually with egg-and-dart motifs) underneath the **volutes** of an **Ionic** capital.

**electronic spin resonance (p. 12)** Method that uses magnetic field and microwave irradiation to date material such as tooth enamel and its surrounding soil.

**elevation (p. 108)** The arrangement, proportions, and details of any vertical side or face of a building. Also: an architectural drawing showing an exterior or interior wall of a building.

**emblema (emblemata) (p. 202)** In a **mosaic**, the elaborate central motif on a floor, usually a self-contained unit done in a more refined manner, with smaller **tesserae** of both marble and semiprecious stones.

**embroidery (p. 484)** Stitches applied on top of an already-woven fabric ground.

**encaustic (p. 79)** A painting medium using pigments mixed with hot wax.

**engaged column (p. 173)** A column attached to a wall. See also **column**.

**engraving (p. 590)** An **intaglio** printmaking process of inscribing an image, design, or letters onto a metal or wood surface from which a print is made. An engraving is usually drawn with a sharp implement (**burin**) directly onto the surface of the plate. Also: the print made from this process.

**entablature (p. 108)** In the Classical **orders**, the horizontal elements above the **columns** and **capitals**. The entablature consists of, from bottom to top, an **architrave**, a **frieze**, and a **cornice**.

**entasis (p. 108)** A slight swelling of the **shaft** of a Greek **column**. The optical illusion of entasis makes the column appear from afar to be straight.

**etching (p. 748)** An **intaglio** printmaking process in which a metal plate is coated with acid-resistant resin and then inscribed with a **stylus** in a design, revealing the plate below. The plate is then immersed in acid, and the design of exposed metal is eaten away by the acid. The resin is removed, leaving the design etched permanently into the metal and the plate ready to be inked, wiped, and printed.

**Eucharist (p. 222)** The central rite of the Christian Church, from the Greek word "thanksgiving." Also known as the Mass or Holy Communion, it is based on the Last Supper. According to traditional Catholic Christian belief, consecrated bread and wine become the body and blood of Christ; in Protestant belief, bread and wine symbolize the body and blood.

**exedra (exedrae) (p. 199)** In architecture, a semicircular niche. On a small scale, often used as decoration, whereas larger exedrae can form interior spaces (such as an **apse**).

**expressionism (p. 151)** Terms describing a work of art in which forms are created primarily to evoke subjective emotions rather than a rational response.

**façade (p. 52)** The face or front wall of a building.

**faience (p. 87)** Type of **ceramic** covered with colorful, opaque glazes that form a smooth, impermeable surface. First developed in ancient Egypt.

**fang ding (p. 328)** A square or rectangular bronze vessel with four legs. The *fang ding* was used for ritual offerings in ancient China during the Shang dynasty.

**femmage (p. 1101)** From "female" and "**collage**," the incorporation of fabric into painting.

**fête galante (p. 908)** A subject in painting depicting well-dressed people at leisure in a park or country setting. It is most often associated with eighteenth-century French Rococo painting.

**filigree (p. 87)** Delicate, lacelike ornamental work.

**fillet (p. 110)** The flat ridge between the carved out **flutes** of a **column shaft**. See also fluting.

**finial (p. 308)** A knoblike architectural decoration usually found at the top point of a spire, pinnacle, canopy, or gable. Also found on furniture; also the ornamental top of a staff.

**flutes, fluted (p. 110)** In architecture, evenly spaced, rounded parallel vertical grooves incised on **shafts** of **columns** or columnar elements (such as **pilasters**).

**flying buttress (p. 496)** See **buttress**.

**flying gallop (p. 87)** Animals posed off the ground with legs fully extended backwards and forwards to signify that they are running.

**foreshortening (p. 119)** The illusion created on a flat surface in which figures and objects appear to recede or project sharply into space. Accomplished according to the rules of perspective.

**formal analysis (p. xxix)** An exploration of the visual character that artists bring to their works through the expressive use of elements such as line, form, color, and light, and through its overall structure or composition.

**Formalism, formalist (p. 1073)** An approach to the understanding, appreciation, and valuation of art based almost solely on considerations of form. This approach tends to regard an artwork as independent of its time and place of making. In the 1940s, Formalism was most ardently proposed by critic Clement Greenberg. See also **connoisseurship**.

**forum (p. 178)** A Roman town center; site of temples and administrative buildings and used as a market or gathering area for the citizens.

**four-iwan mosque (p. 271)** See **iwan** and **mosque**.

**fresco (p. 87)** A painting technique in which water-based pigments are applied to a surface of wet plaster (called **buon fresco**). The color is absorbed by the plaster, becoming a permanent part of the wall. **Fresco secco** is created by painting on dried plaster, and the color may flake off. Murals made by both these techniques are called frescoes.

**fresco secco (p. 87)** See **fresco**.

**frieze (p. 108)** The middle element of an **entablature**, between the **architrave** and the cornice. Usually decorated with sculpture, painting, or moldings. Also: any continuous flat band with **relief sculpture** or painted decorations.

**frottage** (p. 1056)   A design produced by laying a piece of paper over a textured surface and rubbing with charcoal or other soft medium.

**fusuma** (p. 818)   Sliding doors covered with paper, used in traditional Japanese construction. *Fusuma* are often highly decorated with paintings and colored backgrounds.

**gallery** (p. 236)   In church architecture, the story found above the side **aisles** of a church, usually open to and overlooking the **nave**. Also: in secular architecture, a long room, usually above the ground floor in a private house or a public building used for entertaining, exhibiting pictures, or promenading. Also: a building or hall in which art is displayed or sold. Also: *galleria*.

**garbhagriha** (p. 301)   From the Sanskrit word meaning "womb chamber," a small room or shrine in a Hindu temple containing a holy image.

**genre painting** (p. 712)   A term used to loosely categorize paintings depicting scenes of everyday life, including (among others) domestic interiors, parties, inn scenes, and street scenes.

**geoglyphs** (p. 392)   Earthen designs on a colossal scale, often created in a landscape as if to be seen from an aerial viewpoint.

**gesso** (p. 544)   A ground made from glue, gypsum, and/or chalk forming the ground of a wood panel or the priming layer of a canvas. Provides a smooth surface for painting.

**gilding** (p. 87)   The application of paper-thin **gold leaf** or gold pigment to an object made from another medium (for example, a sculpture or painting). Usually used as a decorative finishing detail.

**giornata (giornate)** (p. 537)   Adopted from the Italian term meaning "a day's work," a giornata is the section of a **fresco** plastered and painted in a single day.

**gold leaf** (p. 47)   Paper-thin sheets of hammered gold that are used in **gilding**. In some cases (such as Byzantine **icons**), also used as a ground for paintings.

**gold foil** (p. 87)   A thin sheet of gold.

**gopura** (p. 775)   The towering gateway to an Indian Hindu temple complex. A temple complex can have several different *gopuras*.

**Grand Manner** (p. 922)   An elevated style of painting popular in the eighteenth century in which the artist looked to the ancients and to the Renaissance for inspiration; for portraits as well as history painting, the artist would adopt the poses, compositions, and attitudes of Renaissance and antique models.

**Grand Tour** (p. 911)   Popular during the eighteenth and nineteenth centuries, an extended tour of cultural sites in France and Italy intended to finish the education of a young upper-class person primarily from Britain or North America.

**granulation** (p. 87)   A technique of decoration in which metal granules, or tiny metal balls, are fused onto a metal surface.

**graphic arts** (p. xxiv)   A term referring to those arts that are drawn or printed and that utilize paper as primary support.

**grattage** (p. 1056)   A pattern created by scraping off layers of paint from a canvas laid over a textured surface. See also **frottage**.

**grid** (p. 64)   A system of regularly spaced horizontally and vertically crossed lines that gives regularity to an architectural plan or in the composition of a work of art. Also: in painting, a grid is used to allow designs to be enlarged or transferred easily.

**grisaille** (p. 538)   A style of monochromatic painting in shades of gray. Also: a painting made in this style.

**groin vault** (p. 188)   See **vault**.

**grozing** (p. 497)   In **stained-glass** windows, chipping away at the edges of a piece of glass to achieve the precise shape needed for inclusion in the composition.

**hall church** (p. 518)   A church with a **nave** and **aisles** of the same height, giving the impression of a large, open hall.

**handscroll** (p. 337)   A long, narrow, horizontal painting or text (or combination thereof) common in Chinese and Japanese art and of a size intended for individual use. A handscroll is stored wrapped tightly around a wooden pin and is unrolled for viewing or reading.

**hanging scroll** (p. 795)   In Chinese and Japanese art, a vertical painting or text mounted within sections of silk. At the top is a semicircular rod; at the bottom is a round dowel. Hanging scrolls are kept rolled and tied except for special occasions, when they are hung for display, contemplation, or commemoration.

**haniwa** (p. 356)   Pottery forms, including cylinders, buildings, and human figures, that were placed on top of Japanese tombs or burial mounds.

**Happening** (p. 1085)   An art form developed by Allan Kaprow in the 1960s incorporating performance, theater, and visual images. A Happening was organized without a specific narrative or intent; with audience participation, the event proceeded according to chance and individual improvisation.

**hemicycle** (p. 508)   A semicircular interior space or structure.

**henge** (p. 18)   A circular area enclosed by stones or wood posts set up by Neolithic peoples. It is usually bounded by a ditch and raised embankment.

**hieratic scale** (p. 27)   The use of different sizes for powerful or holy figures and for ordinary people to indicate relative importance. The larger the figure, the greater the importance.

**hieroglyph** (p. 52)   Picture writing; words and ideas rendered in the form of pictorial symbols.

**high relief** (p. 304)   See **relief sculpture**.

**historiated capital** (p. 479)   See **capital**.

**historicism** (p. 963)   The strong consciousness of and attention to the institutions, themes, styles, and forms of the past, made accessible by historical research, textual study, and archaeology.

**history paintings** (p. 924)   Paintings based on historical, mythological, or biblical narratives. Once considered the noblest form of art, history paintings generally convey a high moral or intellectual idea and are often painted in a grand pictorial style.

**horizon line**   A horizontal "line" formed by the implied meeting point of earth and sky. In **linear perspective**, the **vanishing point** or points are located on this "line."

**horseshoe arch** (p. 268)   See **arch**.

**hue** (p. xxii)   Pure color. The saturation or intensity of the hue depends on the purity of the color. Its value depends on its lightness or darkness.

**hydria** (p. 139)   A large ancient Greek and Roman jar with three handles (horizontal ones at both sides and one vertical at the back), used for storing water.

**hypostyle hall** (p. 66)   A large interior room characterized by many closely spaced columns that support its roof.

**icon** (p. 237)   An image representing a sacred figure or event in the Byzantine, and later in the Orthodox, Church. Icons were venerated by the faithful, who believed them to have miraculous powers to transmit messages to God.

**iconic image** (p. 224)   A picture that expresses or embodies an intangible concept or idea.

**iconoclasm** (p. 245)   The banning or destruction of images, especially **icons** and religious art. Iconoclasm in eighth- and ninth-century Byzantium and sixteenth- and seventeenth-century Protestant territories arose from differing beliefs about the power, meaning, function, and purpose of imagery in religion.

**iconography** (p. xxxiii)   Identifying and studying the subject matter and conventional motifs or symbols in works of art.

**iconology** (p. xxxv)   Interpreting works of art as embodiments of cultural situation by placing them within broad social, political, religious, and intellectual contexts.

**iconophile** (p. 246)   From the Greek for "lovers of images." In Byzantine art, iconophiles advocated for the continued use of **iconic images** in art.

**iconostasis** (p. 245)   The partition screen in a Byzantine or Orthodox church between the **sanctuary** (where the Mass is performed) and the body of the church (where the congregation assembles). The iconostasis displays **icons**.

**idealization** (p. xxiv)   A process in art through which artists strive to make their forms and figures attain perfection, based on pervading cultural values and/or their own personal ideals.

**ideograph** (p. 331)   A written character or symbol representing an idea or object. Many Chinese characters are ideographs.

**ignudi** (p. 645)   Heroic figures of nude young men.

**illumination** (p. 425)   A painting on paper or parchment used as an illustration and/or decoration in **manuscripts** or **albums**. Usually richly colored, often supplemented by gold and other precious materials. The artists are referred to as illuminators. Also: the technique of decorating manuscripts with such paintings.

**impasto** (p. 748)   Thick applications of pigment that give a painting a palpable surface texture.

**impost block** (p. 600)   A block, serving to concentrate the weight above, imposed between the **capital** of a **column** and the springing of an **arch** above.

**incising** (p. 32)   A technique in which a design or inscription is cut into a hard surface with a sharp instrument. Such a surface is said to be incised.

**ink painting** (p. 810)   A monochromatic style of painting developed in China using black ink with gray washes.

**inlay** (p. 30)   To set pieces of a material or materials into a surface to form a design. Also: material used in or decoration formed by this technique.

**installation** (p. 1087)   Contemporary art created for a specific site, especially a gallery or outdoor area, that creates a complete and controlled environment.

**intaglio** (p. 590)   Term used for a technique in which the design is carved out of the surface of an object, such as an **engraved seal** stone. In the **graphic arts**, intaglio includes **engraving**, **etching**, and **drypoint**—all processes in which ink transfers to paper from **incised**, ink-filled lines cut into a metal plate.

**intarsia** (p. 617)   Decoration formed through wood **inlay**.

**intuitive perspective** (p. 184)   See **perspective**.

**Ionic order** (p. 108)   See **order**.

**iwan** (p. 71)   A large, **vaulted** chamber in a **mosque** with a monumental **arched** opening on one side.

**jamb** (p. 473)   In architecture, the vertical element found on both sides of an opening in a wall, and supporting an **arch** or **lintel**.

**japonisme** (p. 994)   A style in French and American nineteenth-century art that was highly influenced by Japanese art, especially prints.

**jasperware** (p. 917)   A fine-grained, unglazed, white **ceramic** developed by Josiah Wedgwood, often colored by metallic oxides with the raised designs remaining white.

**jataka tales** (p. 300)   In Buddhism, stories associated with the previous lives of Shakyamuni, the historical Buddha.

**joggled voussoirs** (p. 272)   Interlocking **voussoirs** in an **arch** or **lintel**, often of contrasting materials for colorful effect.

**joined-block sculpture** (p. 367)   A method of constructing large-scale wooden sculpture developed in

Japan. The entire work is constructed from smaller hollow blocks, each individually carved, and assembled when complete. The joined-block technique allowed the production of larger sculpture, as the multiple joints alleviate the problems of drying and cracking found with sculpture carved from a single block.

**kantharos (p. 117)** A type of Greek vase or goblet with two large handles and a wide mouth.

**keep (p. 473)** The innermost and strongest structure or central tower of a medieval castle, sometimes used as living quarters, as well as for defense. Also called a donjon.

**kente (p. 892)** A woven cloth made by the Ashanti peoples of Africa. Kente cloth is woven in long, narrow pieces in complex and colorful patterns, which are then sewn together.

**key block (p. 826)** A key block is the master block in the production of a colored **woodblock print**, which requires different blocks for each color. The key block is a flat piece of wood upon which the outlines for the entire design of the print were first drawn on its surface and then all but these outlines were carved away with a knife. These outlines serve as a guide for the accurate **registration** or alignment of the other blocks needed to add colors to specific parts of a print.

**keystone (p. 172)** The topmost **voussoir** at the center of an **arch**, and the last block to be placed. The pressure of this block holds the arch together. Often of a larger size and/or decorated.

**kiln (p. 22)** An oven designed to produce enough heat for the baking, or firing, of clay.

**kiva (p. 398)** A ceremonial enclosure, usually wholly or partly underground, used for ritual purposes by modern Pueblo peoples and Ancestral Puebloans. *Kivas* may be round or square, made of **adobe** or stone, and they usually feature a hearth and a small indentation in the floor behind it.

**kondo (p. 360)** The main hall inside a Japanese Buddhist temple where the images of Buddha are housed.

**korambo (p. 863)** A ceremonial or spirit house in Pacific cultures, reserved for the men of a village and used as a meeting place as well as to hide religious artifacts from the uninitiated.

**kore (kourai) (p. 114)** An Archaic Greek statue of a young woman.

**koru (p. 870)** A design depicting a curling stalk with a bulb at the end that resembles a young tree fern, and often found in Maori art.

**kouros (kouroi) (p. 114)** An Archaic Greek statue of a young man or boy.

**kowhaiwhai (p. 870)** Painted curvilinear patterns often found in Maori art.

**krater (p. 99)** An ancient Greek vessel for mixing wine and water, with many subtypes that each have a distinctive shape. **Calyx krater:** a bell-shaped vessel with handles near the base that resemble a flower calyx. **Volute krater:** a type of krater with handles shaped like scrolls.

**Kufic (p. 272)** An ornamental, angular Arabic script.

**kylix (p. 124)** A shallow Greek cup, used for drinking, with a wide mouth and small handles near the rim.

**lacquer (p. 22)** A type of hard, glossy surface varnish used on objects in East Asian cultures, made from the sap of the Asian sumac or from shellac, a resinous secretion from the lac insect. Lacquer can be layered and manipulated or combined with pigments and other materials for various decorative effects.

**lakshana (p. 303)** Term used to designate the thirty-two marks of the historical Buddha. The *lakshana* include, among others, the Buddha's golden body, his long arms, the wheel impressed on his palms and the soles of his feet, and his elongated earlobes.

**lamassu (p. 42)** Supernatural guardian-protector of ancient Near Eastern palaces and throne rooms, often represented sculpturally as a combination of the bearded head of a man, powerful body of a lion or bull, wings of an eagle, and the horned headdress of a god, usually possessing five legs.

**lancet (p. 502)** A tall, narrow window crowned by a sharply pointed **arch**, typically found in Gothic architecture.

**lantern (p. 458)** A turretlike structure situated on a roof, **vault**, or **dome**, with windows that allow light into the space below.

**leythos (lekythoi) (p. 141)** A slim Greek oil vase with one handle and a narrow mouth.

**linear perspective (p. 593)** See **perspective**.

**linga shrine (p. 310)** A place of worship centered on an object or representation in the form of a phallus (the lingam), which symbolizes the power of the Hindu god Shiva.

**lintel (p. 473)** A horizontal element of any material carried by two or more vertical supports to form an opening.

**literati (p. 337)** The English word used for the Chinese *wenren* or the Japanese *bunjin*, referring to well educated artists who enjoyed literature, **calligraphy**, and painting as a pastime. Their paintings are termed **literati painting**.

**literati painting (p. 791)** A style of painting that reflects the taste of the educated class of East Asian intellectuals and scholars. Aspects include an appreciation for the antique, small scale, and an intimate connection between maker and audience.

**lithography (p. 951)** Process of making a print (lithograph) from a design drawn on a flat stone block with greasy crayon. Ink is applied to the wet stone and adheres only to the greasy areas of the design.

**loggia (p. 532)** Italian term for a covered open-air gallery. Often used as a corridor between buildings or around a courtyard, loggias usually have **arcades** or **colonnades**.

**logosyllabic (p. 385)** A writing system consisting of both logograms (symbols that represent words) and phonetic signs (symbols that represent sounds, in this case syllables). Cuneiform, Maya, and Japanese are examples of logosyllabic scripts.

**longitudinal-plan building (p. 228)** Any structure designed with a rectangular shape. If a cross-shaped building, the main arm of the building would be longer then any arms that cross it. For example, **basilicas** or Latin-cross plan churches.

**lost-wax casting (p. 413)** A method of casting metal, such as bronze, by a process in which a wax mold is covered with clay and plaster, then fired, melting the wax and leaving a hollow form. Molten metal is then poured into the hollow space and slowly cooled. When the hardened clay and plaster exterior shell is removed, a solid metal form remains to be smoothed and polished.

**low relief (p. 39)** See **relief sculpture**.

**lunette (p. 223)** A semicircular wall area, framed by an **arch** over a door or window. Can be either plain or decorated.

**lusterware (p. 277)** **Ceramic** pottery decorated with metallic glazes.

**madrasa (p. 271)** An Islamic institution of higher learning, where teaching is focused on theology and law.

**maenad (p. 104)** In ancient Greece, a female devotee of the wine god Dionysos who participated in orgiastic rituals. She is often depicted with swirling drapery to indicate wild movement or dance. (Also called a Bacchante, after Bacchus, the Roman name of Dionysos.)

**majolica (p. 571)** Pottery painted with a tin glaze that, when fired, gives a lustrous and colorful surface.

**mandala (p. 299)** An image of the cosmos represented by an arrangement of circles or concentric geometric shapes containing diagrams or images. Used for meditation and contemplation by Buddhists.

**mandapa (p. 301)** In a Hindu temple, an open hall dedicated to ritual worship.

**mandorla (p. 474)** Light encircling, or emanating from, the entire figure of a sacred person.

**manuscript (p. 242)** A handwritten book or document.

**maqsura (p. 268)** An enclosure in a Muslim **mosque**, near the **mihrab**, designated for dignitaries.

**martyrium (martyria) (p. 237)** In Christian architecture, a church, chapel, or shrine built over the grave of a martyr or the site of a great miracle.

**mastaba (p. 53)** A flat-topped, one-story structure with slanted walls over an ancient Egyptian underground tomb.

**matte (p. 571)** Term describing a smooth surface that is without shine or luster.

**mausoleum (p. 177)** A monumental building used as a tomb. Named after the tomb of Mausolos erected at Halikarnassos around 350 BCE.

**medallion (p. 225)** Any round ornament or decoration. Also: a large medal.

**megalith (p. 17)** A large stone used in prehistoric building. Megalithic architecture employs such stones.

**megaron (p. 93)** The main hall of a Mycenaean palace or grand house, having a columnar **porch** and a room with central fireplace surrounded by four **columns**.

**memento mori (p. 907)** From Latin for "remember that you must die." An object, such as a skull or extinguished candle, typically found in a **vanitas** image, symbolizing the transience of life.

**memory image (p. 8)** An image that relies on the generic shapes and relationships that readily spring to mind at the mention of an object.

**menorah (p. 219)** A Jewish lamp-stand with seven or nine branches; the nine-branched menorah is used during the celebration of Hanukkah. Representations of the seven-branched menorah, once used in the Temple of Jerusalem, became a symbol of Judaism.

**metope (p. 110)** The carved or painted rectangular panel between the **triglyphs** of a **Doric frieze**.

**mihrab (p. 261)** A recess or niche that distinguishes the wall oriented toward Mecca (**qibla**) in a **mosque**.

**millefiori (p. 428)** A term derived from the Italian for "a thousand flowers" that refers to a glass-making technique in which rods of differently-colored glass are fused in a long bundle that is subsequently sliced to produce disks or beads with small-scale, multicolor patterns.

**minaret (p. 267)** A tower on or near a **mosque**, varying extensively in form throughout the Islamic world, from which the faithful are called to prayer five times a day.

**minbar (p. 261)** A high platform or pulpit in a **mosque**.

**miniature (p. 243)** Anything small. In painting, miniatures may be illustrations within **albums** or **manuscripts** or intimate portraits.

**mirador (p. 275)** In Spanish and Islamic palace architecture, a very large window or room with windows, and sometimes balconies, providing views to interior courtyards or the exterior landscape.

**mithuna (p. 302)** The amorous male and female couples in Buddhist sculpture, usually found at the entrance to a sacred building. The *mithuna* symbolize the harmony and fertility of life.

**moai (p. 859)** Statues found in Polynesia, carved from tufa, a yellowish brown volcanic stone, and depicting the human form. Nearly 1,000 of these statues have been found on the island of Rapa Nui but their significance has been a matter of speculation.

**mobile (p. 1059)** A sculpture made with parts suspended in such a way that they move in a current of air.

**modeling (p. xxix)** In painting, the process of creating the illusion of three-dimensionality on a two-dimensional surface by use of light and shade. In sculpture, the process of molding a three-dimensional form out of a malleable substance.

**module (p. 341)** A segment or portion of a repeated design. Also: a basic building block.

**molding (p. 315)** A shaped or sculpted strip with varying contours and patterns. Used as decoration on architecture, furniture, frames, and other objects.

**mortise-and-tenon (p. 19)** A method of joining two elements. A projecting pin (tenon) on one element fits snugly into a hole designed for it (mortise) on the other. Such joints are very strong and flexible.

**mosaic (p. 146)** Images formed by small colored stone or glass pieces (**tesserae**), affixed to a hard, stable surface.

**mosque (p. 261)** An edifice used for communal Islamic worship.

**Mozarabic (p. 433)** An eclectic style practiced in Christian medieval Spain while much of the Iberian peninsula was ruled by Muslim dynasties.

**mudra (p. 304)** A symbolic hand gesture in Buddhist art that denotes certain behaviors, actions, or feelings.

**mullion (p. 507)** A slender vertical element or colonnette that divides a window into subsidiary sections.

**muqarna (p. 275)** Small nichelike components stacked in tiers to fill the transition between differing vertical and horizontal planes.

**naos (p. 236)** The principal room in a temple or church. In ancient architecture, the **cella**. In a Byzantine church, the **nave** and **sanctuary**.

**narrative image (p. 224)** A picture that recounts an event drawn from a story, either factual (e.g., biographical) or fictional.

**narthex (p. 222)** The vestibule or entrance **porch** of a church.

**nave (p. 192)** The central space of a **basilica**, two or three stories high and usually flanked by aisles.

**necking (p. 110)** The molding at the top of the **shaft** of the **column**.

**necropolis (p. 53)** A large cemetery or burial area; literally a "city of the dead."

**negative space (p. 120)** Empty space, surrounded and shaped so that it acquires a sense of form or volume.

**nemes headdress (p. 51)** The royal headdress of Egypt.

**niello (p. 87)** A metal technique in which a black sulfur alloy is rubbed into fine lines **engraved** into metal (usually gold or silver). When heated, the **alloy** becomes fused with the surrounding metal and provides contrasting detail.

**nishiki-e (p. 813)** A multicolored and ornate Japanese print.

**oculus (p. 188)** In architecture, a circular opening. Oculi are usually found either as windows or at the apex of a **dome**. When at the top of a dome, an oculus is either open to the sky or covered by a decorative exterior **lantern**.

**odalisque (p. 950)** Turkish word for "harem slave girl" or "concubine."

**ogee (p. 551)** An S-shaped curve. See **arch**.

**oinochoe (p. 128)** A Greek jug used for wine.

**olpe (p. 105)** Any Greek vase or jug without a spout.

**one-point perspective** See **perspective**.

**orant (p. 222)** The representation of a standing figure praying with outstretched and upraised arms.

**oratory (p. 232)** A small chapel.

**order (p. 110)** A system of proportions in Classical architecture that includes every aspect of the building's plan, elevation, and decorative system. **Composite**: a combination of the **Ionic** and the **Corinthian** orders.

The **capital** combines **acanthus** leaves with **volute** scrolls. **Corinthian**: the most ornate of the orders, the Corinthian includes a **base**, a **fluted column shaft** with a capital elaborately decorated with acanthus leaf carvings. Its **entablature** consists of an **architrave** decorated with **moldings**, a **frieze** often containing sculptured **reliefs**, and a **cornice** with dentils. **Doric**: the column shaft of the Doric order can be fluted or smooth-surfaced and has no base. The Doric capital consists of an undecorated **echinus** and **abacus**. The Doric entablature has a plain architrave, a frieze with **metopes** and **triglyphs**, and a simple cornice. **Ionic**: the column of the Ionic order has a base, a fluted shaft, and a capital decorated with volutes. The Ionic entablature consists of an architrave of three panels and moldings, a frieze usually containing sculpted relief ornament, and a cornice with dentils. **Tuscan**: a variation of Doric characterized by a smooth-surfaced column shaft with a base, a plain architrave, and an undecorated frieze. A colossal order is any of the above built on a large scale, rising through several stories in height and often raised from the ground by a **pedestal**.

**orientalism (p. 966)** The fascination with Middle Eastern cultures.

**orthogonal (p. 140)** Any line running back into the represented space of a picture perpendicular to the imagined picture plane. In **linear perspective**, all orthogonals converge at a single **vanishing point** in the picture and are the basis for a **grid** that maps out the internal space of the image. An orthogonal plan is any plan for a building or city that is based exclusively on right angles, such as the grid plan of many major cities.

**pagoda (p. 341)** An East Asian **reliquary** tower built with successively smaller, repeated stories. Each story is usually marked by an elaborate projecting roof.

**painterly (p. xxiv)** A style of painting which emphasizes the techniques and surface effects of brushwork (also color, light, and shade).

**palace complex (p. 41)** A group of buildings used for living and governing by a ruler and his or her supporters, usually fortified.

**palazzo (p. 600)** Italian term for palace, used for any large urban dwelling.

**palmette (p. 139)** A fan-shaped ornament with radiating leaves.

**panel painting** Any painting executed on a wood support. The wood is usually planed to provide a smooth surface. A panel can consist of several boards joined together.

**parapet (p. 138)** A low wall at the edge of a balcony, bridge, roof, or other place from which there is a steep drop, built for safety. A parapet walk is the passageway, usually open, immediately behind the uppermost exterior wall or battlement of a fortified building.

**parchment (p. 243)** A writing surface made from treated skins of animals. Very fine parchment is known as **vellum**.

**parish church (p. 239)** Church where local residents attend regular services.

**parterre (p. 760)** An ornamental, highly regimented flowerbed. An element of the ornate gardens of seventeenth-century palaces and **châteaux**.

**passage grave (p. 17)** A prehistoric tomb under a **cairn**, reached by a long, narrow, slab-lined access passageway or passageways.

**pastel (p. 912)** Dry pigment, chalk, and gum in stick or crayon form. Also: a work of art made with pastels.

**pedestal (p. 107)** A platform or **base** supporting a sculpture or other monument. Also: the block found below the base of a Classical **column** (or **colonnade**), serving to raise the entire element off the ground.

**pediment (p. 108)** A triangular gable found over major architectural elements such as Classical Greek **porticoes**, windows, or doors. Formed by an **entablature** and the ends of a sloping roof or a raking **cornice**. A similar architectural element is often used decoratively

above a door or window, sometimes with a curved upper **molding**. A broken pediment is a variation on the traditional pediment, with an open space at the center of the topmost angle and/or the horizontal cornice.

**pendentive (p. 236)** The concave triangular section of a **vault** that forms the transition between a square or polygonal space and the circular **base** of a **dome**.

**peplos (p. 115)** A loose outer garment worn by women of ancient Greece. A cloth rectangle fastened on the shoulders and belted below the bust or at the waist.

**Performance art (p. 1085)** An artwork based on a live, sometimes theatrical performance by the artist.

**peristyle (p. 66)** A surrounding **colonnade** in Greek architecture. A peristyle building is surrounded on the exterior by a colonnade. Also: a peristyle court is an open colonnaded courtyard, often having a pool and garden.

**perspective (p. 184)** A system for representing three-dimensional space on a two-dimensional surface. **Atmospheric perspective**: A method of rendering the effect of spatial distance by subtle variations in color and clarity of representation. **Intuitive perspective**: A method of giving the impression of recession by visual instinct, not by the use of an overall system or program. Oblique perspective: An intuitive spatial system in which a building or room is placed with one corner in the picture plane, and the other parts of the structure recede to an imaginary vanishing point on its other side. Oblique perspective is not a comprehensive, mathematical system. **One-point** and multiple-point perspective (also called **linear**, scientific or mathematical perspective): A method of creating the illusion of three-dimensional space on a two-dimensional surface by delineating a horizon line and multiple **orthogonal** lines. These recede to meet at one or more points on the horizon (called **vanishing points**), giving the appearance of spatial depth. Called scientific or mathematical because its use requires some knowledge of geometry and mathematics, as well as optics. Reverse perspective: A Byzantine perspective theory in which the orthogonals or rays of sight do not converge on a vanishing point in the picture, but are thought to originate in the viewer's eye in front of the picture. Thus, in reverse perspective the image is constructed with orthogonals that diverge, giving a slightly tipped aspect to objects.

**photomontage (p. 1039)** A photographic work created from many smaller photographs arranged (and often overlapping) in a composition, which is then rephotographed.

**pictograph (p. 331)** A highly stylized depiction serving as a symbol for a person or object. Also: a type of writing utilizing such symbols.

**picture plane (p. 573)** The theoretical plane corresponding with the actual surface of a painting, separating the spatial world evoked in the painting from the spatial world occupied by the viewer.

**picture stone (p. 436)** A medieval northern European memorial stone covered with figural decoration. See also **rune stone**.

**picturesque (p. 917)** A term describing the taste for the familiar, the pleasant, and the agreeable, popular in the eighteenth and nineteenth centuries in Europe. Originally used to describe the "picture like" qualities of some landscape scenes. When contrasted with the **sublime**, the picturesque stood for the interesting but ordinary domestic landscape.

**piece-mold casting (p. 328)** A casting technique in which the mold consists of several sections that are connected during the pouring of molten metal, usually bronze. After the cast form has hardened, the pieces of the mold are disassembled, leaving the completed object.

**pier (p. 266)** A masonry support made up of many stones, or rubble and concrete (in contrast to a column **shaft** which is formed from a single stone or a series of **drums**), often square or rectangular in plan, and capable of carrying very heavy architectural loads.

**pietà (p. 231)** A devotional subject in Christian religious art. After the Crucifixion the body of Jesus was laid across the lap of his grieving mother, Mary. When others are present the subject is called the Lamentation.

**pietra dura (p. 781)** Italian for "hard stone." Semiprecious stones selected for color, variation, and cut in shapes to form ornamental designs such as flowers or fruit.

**pietra serena (p. 600)** A gray Tuscan limestone used in Florence.

**pilaster (p. 160)** An **engaged column**-like element that is rectangular in format and used for decoration in architecture.

**pilgrimage church (p. 239)** A site that attracts visitors wishing to venerate **relics** as well as attend services.

**pillar (p. 219)** In architecture, any large, free-standing vertical element. Usually functions as an important weight-bearing unit in buildings.

**pilotis (p. 1045)** Free-standing posts.

**pinnacle (p. 499)** In Gothic architecture, a steep pyramid decorating the top of another element such as a **buttress**. Also: the highest point.

**plate tracery (p. 502)** See **tracery**.

**plinth (p. 163)** The slablike base or **pedestal** of a **column**, statue, wall, building, or piece of furniture.

**pluralism (p. 1106)** A social structure or goal that allows members of diverse ethnic, racial, or other groups to exist peacefully within the society while continuing to practice the customs of their own divergent cultures, thus providing to artists a variety of valid contemporary styles.

**podium (p. 138)** A raised platform that acts as the foundation for a building, or as a platform for a speaker.

**polychrome, polychromy (p. 521)** The multi-colored painting decoration applied to any part of a building, sculpture, or piece of furniture.

**polyptych (p. 564)** An altarpiece constructed from multiple panels, sometimes with hinges to allow for movable wings.

**porcelain (p. 22)** A high-fired, vitrified, translucent, white **ceramic** ware that employs two specific clays—kaolin and petuntse—and is fired in the range of 1,300 to 1,400 degrees Celsius. The relatively high proportion of silica in the body clays renders the finished porcelains translucent. Like **stonewares**, porcelains are glazed to enhance their aesthetic appeal and to aid in keeping them clean. By definition, porcelain is white, though it may be covered with a glaze of bright color or subtle hue. Chinese potters were the first in the world to produce porcelain, which they were able to make as early as the eighth century.

**porch (p. 108)** The covered entrance on the exterior of a building. With a row of **columns** or **colonnade**, also called a **portico**.

**portal (p. 39)** A grand entrance, door, or gate, usually to an important public building, and often decorated with sculpture.

**portico (p. 62)** In architecture, a projecting roof or porch supported by **columns**, often marking an entrance. See also **porch**.

**post-and-lintel (p. 16)** An architectural system of construction with two or more vertical elements (posts) supporting a horizontal element (**lintel**).

**potassium-argon dating (p. 12)** Technique used to measure the decay of a radioactive potassium isotope into a stable isotope of argon, and inert gas.

**potsherd (p. 22)** A broken piece of **ceramic** ware.

**poupou (p. 871)** A house panel, often carved with designs and found in Pacific cultures.

**Prairie Style (p. 1046)** Style developed by a group of midwestern architects who worked together using the aesthetic of the Prairie and indigenous prairie plants for landscape design to design mostly domestic homes and small public buildings mostly in the midwest.

**predella (p. 548)** The base of an altarpiece, often decorated with small scenes that are related in subject to that of the main panel or panels.

**primitivism (p. 1022)** The borrowing of subjects or forms usually from non-European or prehistoric sources by Western artists. Originally practiced by Western artists as an attempt to infuse their work with the naturalistic and expressive qualities attributed to other cultures, especially colonized cultures.

**pronaos (p. 108)** The enclosed vestibule of a Greek or Roman temple, found in front of the **cella** and marked by a row of **columns** at the entrance.

**proscenium (p. 150)** The stage of an ancient Greek or Roman theater. In modern theater, the area of the stage in front of the curtain. Also: the framing **arch** that separates a stage from the audience.

**psalter (p. 253)** In Jewish and Christian scripture, a book containing the psalms, or songs, attributed to King David.

**psykter (p. 127)** A Greek vessel with an extended bottom allowing it to float in a larger krater; used to chill wine.

**putto (putti) (p. 229)** A plump, naked little boy, often winged. In Classical art, called a cupid; in Christian art, a cherub.

**pylon (p. 66)** A massive gateway formed by a pair of tapering walls of oblong shape. Erected by ancient Egyptians to mark the entrance to a temple complex.

**qibla (p. 267)** The **mosque** wall oriented toward Mecca indicated by the **mihrab**.

**quatrefoil (p. 503)** A four-lobed decorative pattern common in Gothic art and architecture.

**quillwork (p. 845)** A Native American decorative craft technique. The quills of porcupines and bird feathers are dyed and attached to materials in patterns.

**radiometric dating (p. 12)** A method of dating prehistoric works of art made from organic materials, based on the rate of degeneration of radiocarbons in these materials. See also **relative dating**, **absolute dating**.

**raigo (p. 372)** A painted image that depicts the Amida Buddha and other Buddhist deities welcoming the soul of a dying worshiper to paradise.

**raku (p. 821)** A type of **ceramic** pottery made by hand, coated with a thick, dark glaze, and fired at a low heat. The resulting vessels are irregularly shaped and glazed, and are highly prized for use in the Japanese tea ceremony.

**readymade (p. 1037)** An object from popular or material culture presented without further manipulation as an artwork by the artist.

**red-figure (p. 118)** A style and technique of ancient Greek vase painting characterized by red clay-colored figures on a black background. The figures are reserved against a painted ground and details are drawn, not engraved, as in **black-figure style**.)

**register (p. 30)** A device used in systems of spatial definition. In painting, a register indicates the use of differing groundlines to differentiate layers of space within an image. In sculpture, the placement of self-contained bands of **reliefs** in a vertical arrangement. See **registration marks**.

**registration marks (p. 826)** In Japanese **woodblock printing**, these were two marks carved on the blocks to indicate proper alignment of the paper during the printing process. In multicolor printing, which used a separate block for each color, these were essential for achieving the proper position or registration of the colors.

**relative dating (p. 12)** See **radiometric dating**.

**relic (p. 239)** A venerated object associated with a saint or martyr.

**relief sculpture (p. 5)** A three-dimensional image or design whose flat background surface is carved away to a

certain depth, setting off the figure. Called **high** or **low (bas) relief** depending upon the extent of projection of the image from the background. Called **sunken relief** when the image is carved below the original surface of the background, which is not cut away.

**reliquary (p. 299)** A container, often made of precious materials, used as a repository to protect and display sacred **relics**.

**repoussé (p. 87)** A technique of hammering metal from the back to create a protruding image. Elaborate **reliefs** are created with wooden armatures against which the metal sheets are pressed and hammered.

**rhyton (p. 88)** A vessel in the shape of a figure or an animal, used for drinking or pouring liquids on special occasions.

**rib vault (p. 495)** See **vault**.

**ridgepole (p. 16)** A longitudinal timber at the apex of a roof that supports the upper ends of the rafters.

**roof comb (p. 386)** In a Mayan building, a masonry wall along the apex of a roof that is built above the level of the roof proper. Roof combs support the highly decorated false façades that rise above the height of the building at the front.

**rosettes (p. 105)** A round or oval ornament resembling a rose.

**rotunda (p. 197)** Any building (or part thereof) constructed in a circular (or sometimes polygonal) shape, usually producing a large open space crowned by a **dome**.

**round arch (p. 172)** See **arch**.

**roundel (p. 160)** Any element with a circular format, often placed as a decoration on the exterior of architecture.

**rune stone (p. 436)** A stone used in early medieval northern Europe as a commemorative monument, which is carved or inscribed with runes, a writing system used by early Germanic peoples.

**rustication (p. 600)** In building, the rough, irregular, and unfinished effect deliberately given to the exterior facing of a stone edifice. Rusticated stones are often large and used for decorative emphasis around doors or windows, or across the entire lower floors of a building. Also, masonry construction with conspicuous, often beveled joints.

**salon (p. 905)** A large room for entertaining guests; a periodic social or intellectual gathering, often of prominent people; a hall or **gallery** for exhibiting works of art.

**sanctuary (p. 102)** A sacred or holy enclosure used for worship. In ancient Greece and Rome, consisted of one or more temples and an altar. In Christian architecture, the space around the altar in a church called the chancel or presbytery.

**sarcophagus (p. 49)** A stone coffin. Often rectangular and decorated with **relief sculpture**.

**scarab (p. 51)** In Egypt, a stylized dung beetle associated with the sun and the god Amun.

**scarification (p. 403)** Ornamental decoration applied to the surface of the body by cutting the skin for cultural and/or aesthetic reasons.

**school of artists (p. 281)** An art historical term describing a group of artists, usually working at the same time and sharing similar styles, influences, and ideals. The artists in a particular school may not necessarily be directly associated with one another, unlike those in a workshop or **atelier**.

**scribe (p. 242)** A writer; a person who copies texts.

**scriptorium (scriptoria) (p. 242)** A room in a monastery for writing or copying **manuscripts**.

**scroll painting (p. 243)** A painting executed on a rolled support. Rollers at each end permit the horizontal scroll to be unrolled as it is studied or the vertical scroll to be hung for contemplation or decoration.

**sculpture in the round (p. 5)** Three-dimensional sculpture that is carved free of any background or block.

**seals (p. 338)** Personal emblems usually carved of stone in **intaglio** or **relief** and used to stamp a name or legend onto paper or silk. In China, they traditionally employ the archaic characters appropriately known as "seal script," of the Zhou or Qin. Cut in stone, a seal may state a formal given name, or it may state any of the numerous personal names that China's painters and writers adopted throughout their lives. A treasured work of art often bears not only the seal of its maker but also those of collectors and admirers through the centuries. In the Chinese view, these do not disfigure the work but add another layer of interest.

**serdab (p. 53)** In Egyptian tombs, the small room in which the *ka* statue was placed.

**sfumato (p. 634)** Italian term meaning "smoky," soft, and mellow. In painting, the effect of haze in an image. Resembling the color of the atmosphere at dusk, *sfumato* gives a smoky effect.

**sgraffito (p. 602)** Decoration made by **incising** or cutting away a surface layer of material to reveal a different color beneath.

**shaft (p. 110)** The main vertical section of a **column** between the **capital** and the **base**, usually circular in cross section.

**shaft grave (p. 98)** A deep pit used for burial.

**shikhara (p. 301)** In the architecture of northern India, a conical (or pyramidal) spire found atop a Hindu temple and often crowned with an **amalaka**.

**shoin (p. 819)** A term used to describe the various features found in the most formal room of upper-class Japanese residential architecture.

**shoji (p. 819)** A standing Japanese screen covered in translucent rice paper and used in interiors.

**siapo (p. 874)** A type of **tapa** cloth found in Samoa and still used as an important gift for ceremonial occasions.

**silkscreen printing (p. 1091)** A technique of printing in which paint or ink is pressed through a stencil and specially prepared cloth to produce a previously designed image. Also called serigraphy.

**sinopia (sinopie) (p. 537)** Italian word taken from "Sinope," the ancient city in Asia Minor that was famous for its red-brick pigment. In **fresco** paintings, a full-sized, preliminary sketch done in this color on the first rough coat of plaster or *arriccio*.

**site-specific sculpture (p. 1102)** A sculpture commissioned and/or designed for a particular location.

**slip (p. 120)** A mixture of clay and water applied to a ceramic object as a final decorative coat. Also: a solution that binds different parts of a vessel together, such as the handle and the main body.

**spandrel (p. 172)** The area of wall adjoining the exterior curve of an **arch** between its springing and the **keystone**, or the area between two arches, as in an **arcade**.

**spolia (p. 465)** Latin for "hide stripped from an animal." Term used for fragments of older architecture or sculpture reused in a secondary context.

**springing (p. 172)** The point at which the curve of an **arch** or **vault** meets with and rises from its support.

**squinch (p. 236)** An **arch** or **lintel** built across the upper corners of a square space, allowing a circular or polygonal dome to be more securely set above the walls.

**stained glass (p. 464)** Molten glass stained with color using metallic oxides. Stained glass is most often used in windows, for which small pieces of different colors are precisely cut and assembled into a design, held together by lead **cames**. Additional details may be added with vitreous paint.

**stave church (p. 436)** A Scandinavian wooden structure with four huge timbers (staves) at its core.

**stele (stelae) (p. 27)** A stone slab placed vertically and decorated with inscriptions or reliefs. Used as a grave marker or memorial.

**stereobate (p. 110)** A foundation upon which a Classical temple stands.

**still life (p. xxxv)** A type of painting that has as its subject inanimate objects (such as food, dishes, fruit, or flowers).

**stoa (p. 107)** In Greek architecture, a long roofed walk-way, usually having **columns** on one long side and a wall on the other.

**stoneware (p. 22)** A high-fired, vitrified, but opaque **ceramic** ware that is fired in the range of 1,100 to 1,200 degrees Celsius. At that temperature, particles of silica in the clay bodies fuse together so that the finished vessels are impervious to liquids, even without glaze. Stoneware pieces are glazed to enhance their aesthetic appeal and to aid in keeping them clean (since unglazed ceramics are easily soiled). Stoneware occurs in a range of earth-toned colors, from white and tan to gray and black, with light gray predominating. Chinese potters were the first in the world to produce stoneware, which they were able to make as early as the Shang dynasty.

**stringcourse (p. 499)** A continuous horizontal band, such as a **molding**, decorating the face of a wall.

**studiolo (p. 617)** A room for private conversation and the collection of fine books and art objects. Also known as a study.

**stupa (p. 298)** In Buddhist architecture, a bell-shaped or pyramidal religious monument, made of piled earth or stone, and containing sacred **relics**.

**stylobate (p. 110)** In Classical architecture, the stone foundation on which a temple **colonnade** stands.

**stylus (p. 28)** An instrument with a pointed end (used for writing and printmaking), which makes a delicate line or scratch. Also: a special writing tool for **cuneiform** writing with one pointed end and one triangular.

**sublime (p. 955)** djective describing a concept, thing, or state of greatness or vastness with high spiritual, moral, intellectual or emotional value; or something awe-inspiring. The sublime was a goal to which many nineteenth-century artists aspired in their artworks.

**sunken relief (p. 71)** See **relief sculpture**.

**symposium (p. 118)** An elite gathering of wealthy and powerful men in ancient Greece that focused principally on wine, music, poetry, conversation, games, and love making.

**syncretism (p. 222)** A process whereby artists assimilate images and ideas from other traditions or cultures and give them new meanings.

**taotie (p. 328)** A mask with a dragon or animal-like face common as a decorative motif in Chinese art.

**tapa (p. 874)** A type of cloth used for various purposes in Pacific cultures, made from tree bark stripped and beaten, and often bearing subtle designs from the mallets used to work the bark.

**tapestry (p. 484)** Multicolored pictorial or decorative weaving meant to be hung on a wall or placed on furniture. Pictorial or decorative motifs are woven directly into the fabric of the cloth itself.

**tatami (p. 819)** Mats of woven straw used in Japanese houses as a floor covering.

**tempera (p. 141)** A painting medium made by blending egg yolks with water, pigments, and occasionally other materials, such as glue.

**tenebrism (p. 724)** The use of strong **chiaroscuro** and artificially illuminated areas to create a dramatic contrast of light and dark in a painting.

**terra cotta (p. 114)** A medium made from clay fired over a low heat and sometimes left unglazed. Also: the orange-brown color typical of this medium.

**tessera (tesserae) (p. 146)** The small piece of stone, glass, or other object that is pieced together with many others to create a **mosaic**.

**tetrarchy (p. 204)** Four-man rule, as in the late Roman Empire, when four emperors shared power.

**thatch (p. 17)** Plant material such as reeds or straw tied over a framework of poles.

**thermo-luminescence dating (p. 12)** A technique that measures the irradiation of the crystal structure of material such as flint or pottery and the soil in which it is found, determined by luminescence produced when a sample is heated.

**tholos (p. 138)** A small, round building. Sometimes built underground, as in a Mycenaean tomb.

**tholos tomb (p. 98)** See **tholos**.

**thrust (p. 172)** The outward pressure caused by the weight of a **vault** and supported by **buttressing**. See **arch**.

**tierceron (p. 554)** In vault construction, a secondary rib that arcs from a **springing** point to the rib that runs lengthwise through the **vault**, called the ridge rib.

**tondo (p. 128)** A painting or **relief sculpture** of circular shape.

**torana (p. 300)** In Indian architecture, an ornamented gateway **arch** in a temple, usually leading to the **stupa**.

**torc (p. 151)** A circular neck ring worn by Celtic warriors.

**toron (p. 417)** In West African **mosque** architecture, the wooden beams that project from the walls. Torons are used as support for the scaffolding erected annually for the replastering of the building.

**tracery (p. 502)** Stonework or woodwork applied to wall surfaces or filling the open space of windows. In **plate tracery**, openings are cut through the wall. In **bar tracery**, **mullions** divide the space into vertical segments and form decorative patterns at the top of the opening or panel.

**transept (p. 228)** The arm of a **cruciform** church, perpendicular to the **nave**. The point where the nave and transept cross is called the crossing. Beyond the crossing lies the **sanctuary**, whether **apse**, choir, or chevet.

**transverse arch (p. 457)** An **arch** that connects the wall **piers** on both sides of an interior space, up and over a stone **vault**.

**trefoil (p. 294)** An ornamental design made up of three rounded lobes placed adjacent to one another.

**triforium (p. 502)** The element of the interior elevation of a church, found directly below the **clerestory** and consisting of a series of **arched** openings. The triforium can be made up of openings from a narrow wall passageway, or it can be attached directly to the wall.

**triglyph (p. 110)** Rectangular block between the **metopes** of a **Doric frieze**. Identified by the three carved vertical grooves, which approximate the appearance of the end of a wooden beam.

**triptych (p. 564)** An artwork made up of three panels. The panels may be hinged together so the side segments (wings) fold over the central area.

**trompe l'oeil (p. 617)** A manner of representation in which the appearance of natural space and objects is re-created with the express intention of fooling the eye of the viewer, who may be convinced that the subject actually exists as three-dimensional reality.

**trumeau (p. 473)** A **column**, **pier**, or post found at the center of a large **portal** or doorway, supporting the **lintel**.

**tugra (p. 284)** A **calligraphic** imperial monogram used in Ottoman courts.

**tukutuku (p. 871)** Lattice panels created by women from the Maori culture and used in architecture.

**Tuscan order (p. 161)** See **order**.

**twining (p. 845)** A basketry technique in which short rods are sewn together vertically. The panels are then joined together to form a vessel.

**tympanum** (p. 473)   In Classical architecture, the vertical panel of the **pediment**. In medieval and later architecture, the area over a door enclosed by an **arch** and a **lintel**, often decorated with sculpture or **mosaic**.

**ukiyo-e** (p. 994)   A Japanese term for a type of popular art that was favored from the sixteenth century, particularly in the form of color **woodblock prints**. *Ukiyo-e* prints often depicted the world of the common people in Japan, such as courtesans and actors, as well as landscapes and myths.

**undercutting** (p. 214)   A technique in sculpture by which the material is cut back under the edges so that the remaining form projects strongly forward, casting deep shadows.

**underglaze** (p. 799)   Color or decoration applied to a ceramic piece before glazing.

**upeti** (p. 874)   A carved wooden design tablet, used to create patterns in cloth by dragging the fabric across it, and found in Pacific cultures.

**urna** (p. 303)   In Buddhist art, the curl of hair on the forehead that is a characteristic mark of a buddha. The *urna* is a symbol of divine wisdom.

**ushnisha** (p. 303)   In Asian art, a round turban or tiara symbolizing royalty and, when worn by a buddha, enlightenment.

**vanishing point** (p. 608)   In a **perspective** system, the point on the **horizon line** at which orthogonals meet. A complex system can have multiple vanishing points.

**vanitas** (p. 751)   An image, especially popular in Europe during the seventeenth century, in which all the objects symbolize the transience of life. *Vanitas* paintings are usually of still lifes or genre subjects.

**vault** (p. 17)   An arched masonry structure that spans an interior space. **Barrel** or tunnel vault: an elongated or continuous semicircular vault, shaped like a half-cylinder.

**Corbeled vault**: a vault made by projecting **courses** of stone. **Groin** or cross vault: a vault created by the intersection of two barrel vaults of equal size which creates four side compartments of identical size and shape. Quadrant or half-barrel vault: as the name suggests a half-barrel vault. **Rib vault**: ribs (extra masonry) demarcate the junctions of a groin vault. Ribs may function to reinforce the groins or may be purely decorative. See also **corbeling**.

**veduta** (p. 913)   Italian for "vista" or "view." Paintings, drawings, or prints often of expansive city scenes or of harbors.

**vellum** (p. 243)   A fine animal skin prepared for writing and painting. See also **parchment**.

**verism** (p. 170)   style in which artists concern themselves with describing the exterior likeness of an object or person, usually by rendering its visible details in a finely executed, meticulous manner.

**vihara** (p. 301)   From the Sanskrit term meaning "for wanderers." A *vihara* is, in general, a Buddhist monastery in India. It also signifies monks' cells and gathering places in such a monastery.

**volute** (p. 110)   A spiral scroll, as seen on an **Ionic capital**.

**votive figure** (p. 31)   An image created as a devotional offering to a god or other deity.

**voussoir** (p. 172)   The oblong, wedge-shaped stone blocks used to build an arch. The topmost voussoir is called a **keystone**.

**warp** (p. 286)   The vertical threads in a weaver's loom. Warp threads make up a fixed framework that provides the structure for the entire piece of cloth, and are thus often thicker than weft threads. See also **weft**.

**wattle and daub** (p. 17)   A wall construction method combining upright branches, woven with twigs (wattles) and plastered or filled with clay or mud (daub).

**weft** (p. 286)   The horizontal threads in a woven piece of cloth. Weft threads are woven at right angles to and through the warp threads to make up the bulk of the decorative pattern. In carpets, the weft is often completely covered or formed by the rows of trimmed knots that form the carpet's soft surface. See also **warp**.

**westwork** (p. 439)   The monumental, west-facing entrance section of a Carolignian, Ottonian, or Romanesque church. The exterior consists of multiple stories between two towers; the interior includes an entrance vestibule, a chapel, and a series of **galleries** overlooking the nave.

**white-ground** (p. 141)   A type of ancient Greek pottery in which the background color of the object was painted with a **slip** that turns white in the firing process. Figures and details were added by painting on or **incising** into this slip. White-ground wares were popular in the Classical period as funerary objects.

**woodblock print** (p. 589)   A print made from one or more carved wooden blocks. In Japan, woodblock prints were made using multiple blocks carved in **relief**, usually, with a block for each color in the finished print. See also **woodcut**.

**woodcut** (p. 590)   A type of print made by carving a design into a wooden block. The ink is applied to the block with a roller. As the ink remains only on the raised areas between the carved-away lines, these carved-away areas and lines provide the white areas of the print. Also: the process by which the woodcut is made.

**yaksha, yakshi** (p. 296)   The male (*yaksha*) and female (*yakshi*) nature spirits that act as agents of the Hindu gods. Their sculpted images are often found on Hindu temples and other sacred places, particularly at the entrances.

**ziggurat** (p. 28)   In Mesopotamia, a tall stepped tower of earthen materials, often supporting a shrine.

Susan V. Craig, updated by Carrie L. McDade

This bibliography is composed of books in English that are appropriate "further reading" titles. Most items on this list are available in good libraries, whether college, university, or public institutions. Recently published works have been emphasized so that the research information would be current. There are three classifications of listings: general surveys and art history reference tools, including journals and Internet directories; surveys of large periods that encompass multiple chapters (ancient art in the Western tradition, European medieval art, European Renaissance through eighteenth-century art, modern art in the West, Asian art, and African and Oceanic art, and art of the Americas); and books for individual Chapters 1 through 32.

## General Art History Surveys and Reference Tools

Adams, Laurie Schneider. *Art across Time*. 4th ed. New York: McGraw-Hill, 2011.

Barnet, Sylvan. *A Short Guide to Writing about Art*. 10th ed. Upper Saddle River, NJ: Pearson/Prentice Hall, 2010.

Bony, Anne. *Design: History, Main Trends, Main Figures*. Edinburgh: Chambers, 2005.

Boström, Antonia. *Encyclopedia of Sculpture*. 3 vols. New York: Fitzroy Dearborn, 2004.

Broude, Norma, and Mary D. Garrard, eds. *Feminism and Art History: Questioning the Litany*. Icon Editions. New York: Harper & Row, 1982.

Chadwick, Whitney. *Women, Art, and Society*. 4th ed. New York: Thames & Hudson, 2007.

Chilvers, Ian, ed. *The Oxford Dictionary of Art*. 4th ed. New York: Oxford Univ. Press, 2009.

Curl, James Stevens. *A Dictionary of Architecture and Landscape Architecture*. 2nd ed. Oxford: Oxford Univ. Press, 2006.

Davies, Penelope J. E., et al. *Janson's History of Art: The Western Tradition*. 8th ed. Upper Saddle River, NJ: Prentice Hall, 2010.

*The Dictionary of Art*. Ed. Jane Turner. 34 vols. New York: Grove's Dictionaries, 1996.

*Encyclopedia of World Art*. 17 vols. New York: McGraw-Hill, 1959–84.

Frank, Patrick, Duane Preble, and Sarah Preble. *Prebles' Artforms*. 10th ed. Upper Saddle River, NJ: Pearson/Prentice Hall, 2008.

Gaze, Delia, ed. *Dictionary of Women Artists*. 2 vols. London: Fitzroy Dearborn, 1997.

Griffiths, Antony. *Prints and Printmaking: An Introduction to the History and Techniques*. 2nd ed. London: British Museum Press, 1996.

Hadden, Peggy. *The Quotable Artist*. New York: Allworth Press, 2002.

Hall, James. *Dictionary of Subjects and Symbols in Art*. 2nd ed. Boulder, CO: Westview Press, 2008.

Holt, Elizabeth Gilmore, ed. *A Documentary History of Art*. 3 vols. New Haven: Yale Univ. Press, 1986.

Honour, Hugh, and John Fleming. *The Visual Arts: A History*. 7th ed. rev. Upper Saddle River, NJ: Pearson/Prentice Hall, 2010.

Johnson, Paul. *Art: A New History*. New York: HarperCollins, 2003.

Kemp, Martin, ed. *The Oxford History of Western Art*. Oxford: Oxford Univ. Press, 2000.

Kleiner, Fred S. *Gardner's Art through the Ages*. Enhanced 13th ed. Belmont, CA: Thomson/Wadsworth, 2011.

Kostof, Spiro. *A History of Architecture: Settings and Rituals*. 2nd ed. Revised. Greg Castillo. New York: Oxford Univ. Press, 1995.

Mackenzie, Lynn. *Non-Western Art: A Brief Guide*. 2nd ed. Upper Saddle River, NJ: Pearson/Prentice Hall, 2001.

Marmor, Max, and Alex Ross, eds. *Guide to the Literature of Art History 2*. Chicago: American Library Association, 2005.

Onians, John, ed. *Atlas of World Art*. New York: Oxford Univ. Press, 2004.

Sayre, Henry M. *Writing about Art*. 6th ed. Upper Saddle River, NJ: Pearson/Prentice Hall, 2009.

Sed-Rajna, Gabrielle. *Jewish Art*. Trans. Sara Friedman and Mira Reich. New York: Abrams, 1997.

Slatkin, Wendy. *Women Artists in History: From Antiquity to the Present*. 4th ed. Upper Saddle River, NJ: Pearson/Prentice Hall, 2001.

Sutton, Ian. *Western Architecture: From Ancient Greece to the Present*. World of Art. New York: Thames & Hudson, 1999.

Trachtenberg, Marvin, and Isabelle Hyman. *Architecture, from Prehistory to Postmodernity*. 2nd ed. Upper Saddle River, NJ: Pearson/Prentice Hall, 2002.

Watkin, David. *A History of Western Architecture*. 4th ed. New York: Watson-Guptill, 2005.

## Art History Journals: A Select List of Current Titles

*African Arts*. Quarterly. Los Angeles: Univ. of California at Los Angeles, James S. Coleman African Studies Center, 1967–.

*American Art: The Journal of the Smithsonian American Art Museum*. 3/year. Chicago: Univ. of Chicago Press, 1987–.

*American Indian Art Magazine*. Quarterly. Scottsdale, AZ: American Indian Art Inc., 1975–.

*American Journal of Archaeology*. Quarterly. Boston: Archaeological Institute of America, 1885–.

*Antiquity: A Periodical of Archaeology*. Quarterly. Cambridge: Antiquity Publications Ltd., 1927–.

*Apollo: The International Magazine of the Arts*. Monthly. London: Apollo Magazine Ltd., 1925–.

*Architectural History*. Annually. Farnham, UK: Society of Architectural Historians of Great Britain, 1958–.

*Archives of American Art Journal*. Quarterly. Washington, DC: Archives of American Art, Smithsonian Institution, 1960–.

*Archives of Asian Art*. Annually. New York: Asia Society, 1945–.

*Ars Orientalis: The Arts of Asia, Southeast Asia, and Islam*. Annually. Ann Arbor: Univ. of Michigan Dept. of Art History, 1954–.

*Art Bulletin*. Quarterly. New York: College Art Association, 1913–.

*Art History: Journal of the Association of Art Historians*. 5/year. Oxford: Blackwell Publishing Ltd., 1978–.

*Art in America*. Monthly. New York: Brant Publications Inc., 1913–.

*Art Journal*. Quarterly. New York: College Art Association, 1960–.

*Art Nexus*. Quarterly. Bogata, Colombia: Arte en Colombia Ltda, 1976–.

*Art Papers Magazine*. Bimonthly. Atlanta: Atlanta Art Papers Inc., 1976–.

*Artforum International*. 10/year. New York: Artforum International Magazine Inc., 1962–.

*Artnews*. 11/year. New York: Artnews LLC. 1902–.

*Bulletin of the Metropolitan Museum of Art*. Quarterly. New York: Metropolitan Museum of Art, 1905–.

*Burlington Magazine*. Monthly. London: Burlington Magazine Publications Ltd., 1903–.

*Dumbarton Oaks Papers*. Annually. Locust Valley, NY: J. J. Augustin Inc., 1940–.

*Flash Art International*. Bimonthly. Trevi, Italy: Giancarlo Politi Editore, 1980–.

*Gesta*. Semiannually. New York: International Center of Medieval Art, 1963–.

*History of Photography*. Quarterly. Abingdon, UK: Taylor & Francis Ltd., 1976–.

*International Review of African American Art*. Quarterly. Hampton, VA: International Review of African American Art, 1976–.

*Journal of Design History*. Quarterly. Oxford: Oxford Univ. Press, 1988–.

*Journal of Egyptian Archaeology*. Annually. London: Egypt Exploration Society, 1914–.

*Journal of Hellenic Studies*. Annually. London: Society for the Promotion of Hellenic Studies, 1880–.

*Journal of Roman Archaeology*. Annually. Portsmouth, RI: Journal of Roman Archaeology LLC, 1988–.

*Journal of the Society of Architectural Historians*. Quarterly. Chicago: Society of Architectural Historians, 1940–.

*Journal of the Warburg and Courtauld Institutes*. Annually. London: Warburg Institute, 1937–.

*Leonardo: Art, Science and Technology*. 6/year. Cambridge, MA: MIT Press, 1968–.

*Marg*. Quarterly. Mumbai, India: Scientific Publishers, 1946–.

*Master Drawings*. Quarterly. New York: Master Drawings Association, 1963–.

*October*. Cambridge, MA: MIT Press, 1976–.

*Oxford Art Journal*. 3/year. Oxford: Oxford Univ. Press, 1978–.

*Parkett*. 3/year. Zürich, Switzerland: Parkett Verlag AG, 1984–.

*Print Quarterly*. Quarterly. London: Print Quarterly Publications, 1984–.

*Simiolus: Netherlands Quarterly for the History of Art*. Quarterly. Apeldoorn, Netherlands: Stichting voor Nederlandse Kunsthistorische Publicaties, 1966–.

*Woman's Art Journal*. Semiannually. Philadelphia: Old City Publishing Inc., 1980–.

## Internet Directories for Art History Information: A Selected List

ARCHITECTURE AND BUILDING,
http://www.library.unlv.edu/arch/rsrce/webresources/
A directory of architecture websites collected by Jeanne Brown at the Univ. of Nevada at Las Vegas. Topical lists include architecture, building and construction, design, history, housing, planning, preservation, and landscape architecture. Most entries include a brief annotation and the last date the link was accessed by the compiler.

ART HISTORY RESOURCES ON THE WEB,
http://witcombe.sbc.edu/ARTHLinks.html
Authored by Professor Christopher L. C. E. Witcombe of Sweet Briar College in Virginia, since 1995, the site includes an impressive number of links for various art historical eras as well as links to research resources, museums, and galleries. The content is frequently updated.

ART IN FLUX: A DIRECTORY OF RESOURCES FOR RESEARCH IN CONTEMPORARY ART,
http://www.boisestate.edu/art/artinflux/intro.html
Cheryl K. Shurtleff of Boise State Univ. in Idaho, has authored this directory, which includes sites selected according to their relevance to the study of national or international contemporary art and artists. The subsections include artists, museums, theory, reference, and links.

ARTCYCLOPEDIA: THE GUIDE TO GREAT ART ON THE INTERNET
http://www.artcyclopedia.com
With more than 2,100 art sites and 75,000 links, this is one of the most comprehensive web directories for artists and art topics. The primary search is by artist's name but access is also available by title of artwork, artistic movement, museums and galleries, nationality, period, and medium.

MOTHER OF ALL ART AND ART HISTORY LINKS PAGES
http://umich.edu/~motherha
Maintained by the Dept. of the History of Art at the Univ. of Michigan, this directory covers art history departments, art museums, fine arts schools and departments as well as links to research resources. Each entry includes annotations.

VOICE OF THE SHUTTLE,
http://vos.ucsb.edu
Sponsored by Univ. of California, Santa Barbara, this directory includes more than 70 pages of links to humanities and humanities-related resources on the Internet. The structured guide includes specific subsections on architecture, on art (modern and contemporary), and on art history. Links usually include a one-sentence explanation and the resource is frequently updated with new information.

ARTBABBLE
http://www.artbabble.org/
An online community created by staff at the Indianapolis Museum of Art to showcase art-based video content, including interviews with artists and curators, original documentaries, and art installation videos. Partners and contributors to the project include Art21, Los Angeles County Museum of Art, The Museum of Modern Art, The New York Public Library, San Francisco Museum of Modern Art, and Smithsonian American Art Museum.

YAHOO! ARTS>ART HISTORY,
http://dir.yahoo.com/Arts/Art_History/
Another extensive directory of art links organized into subdivisions with one of the most extensive being "Periods and

Movements." Links include the name of the site as well as a few words of explanation.

## Ancient Art in the Western Tradition, General

Amiet, Pierre. *Art in the Ancient World: A Handbook of Styles and Forms*. New York: Rizzoli, 1981.

Beard, Mary, and John Henderson. *Classical Art: From Greece to Rome*. Oxford History of Art. Oxford: Oxford Univ. Press, 2001.

Boardman, John. *Oxford History of Classical Art*. New York: Oxford Univ. Press, 2001.

Chitham, Robert. *The Classical Orders of Architecture*. 2nd ed. Boston: Elsevier/Architectural Press, 2005.

Ehrich, Robert W., ed. *Chronologies in Old World Archaeology*. 3rd ed. 2 vols. Chicago: Univ. of Chicago Press, 1992.

Gerster, Georg. *The Past from Above: Aerial Photographs of Archaeological Sites*. Ed. Charlotte Trümpler. Trans. Stewart Spencer. Los Angeles: J. Paul Getty Museum, 2005.

Groenewegen-Frankfort, H. A., and Bernard Ashmole. *Art of the Ancient World: Painting, Pottery, Sculpture, Architecture from Egypt, Mesopotamia, Crete, Greece, and Rome*. Library of Art History. Upper Saddle River, NJ: Prentice Hall, 1972.

Haywood, John. *The Penguin Historical Atlas of Ancient Civilizations*. New York: Penguin, 2005.

Milleker, Elizabeth J., ed. *The Year One: Art of the Ancient World East and West*. New York: Metropolitan Museum of Art, 2000.

Nagle, D. Brendan. *The Ancient World: A Social and Cultural History*. 7th ed. Upper Saddle River, NJ: Pearson/Prentice Hall, 2010.

Saggs, H. W. F. *Civilization before Greece and Rome*. New Haven: Yale Univ. Press, 1989.

Smith, William Stevenson. *Interconnections in the Ancient Near East: A Study of the Relationships between the Arts of Egypt, the Aegean, and Western Asia*. New Haven: Yale Univ. Press, 1965.

Tadgell, Christopher. *Imperial Form: From Achaemenid Iran to Augustan Rome*. New York: Whitney Library of Design, 1998.

———. *Origins: Egypt, West Asia and the Aegean*. New York: Whitney Library of Design, 1998.

Trigger, Bruce G. *Understanding Early Civilizations: A Comparative Study*. New York: Cambridge Univ. Press, 2003.

Woodford, Susan. *The Art of Greece and Rome*. 2nd ed. New York: Cambridge Univ. Press, 2004.

## European Medieval Art, General

Backman, Clifford R. *The Worlds of Medieval Europe*. 2nd ed. New York: Oxford Univ. Press, 2009.

Bennett, Adelaide Louise, et al. *Medieval Mastery: Book Illumination from Charlemagne to Charles the Bold: 800–1475*. Trans. Lee Preedy and Greta Arblaster-Holmer. Turnhout: Brepols, 2002.

Benton, Janetta R. *Art of the Middle Ages*. World of Art. New York: Thames & Hudson, 2002.

Binski, Paul. *Painters*. Medieval Craftsmen. London: British Museum Press, 1991.

Brown, Sarah, and David O'Connor. *Glass-painters*. Medieval Craftsmen. London: British Museum Press, 1991.

Calkins, Robert G. *Medieval Architecture in Western Europe: From a.d. 300 to 1500*. New York: Oxford Univ. Press, 1998.

Cherry, John F. *Goldsmiths*. Medieval Craftsmen. London: British Museum Press, 1992.

Clark, William W. *The Medieval Cathedrals*. Westport, CT: Greenwood Press, 2006.

Coldstream, Nicola. *Masons and Sculptors*. Medieval Craftsmen. London: British Museum Press, 1991.

———. *Medieval Architecture*. Oxford History of Art. Oxford: Oxford Univ. Press, 2002.

De Hamel, Christopher. *Scribes and Illuminators*. Medieval Craftsmen. London: British Museum Press, 1992.

Duby, Georges. *Art and Society in the Middle Ages*. Trans. Jean Birrell. Malden, MA: Blackwell, 2000.

Fossier, Robert, ed. *The Cambridge Illustrated History of the Middle Ages*. Trans. Janet Sondheimer and Sarah Hanbury Tenison. 3 vols. Cambridge: Cambridge Univ. Press, 1986–97.

Hürlimann, Martin, and Jean Bony. *French Cathedrals*. Rev. & enlarged ed. London: Thames & Hudson, 1967.

Jotischky, Andrew, and Caroline Susan Hull. *The Penguin Historical Atlas of the Medieval World*. New York: Penguin, 2005.

Kenyon, John. *Medieval Fortifications*. Leicester: Leicester Univ. Press, 1990.

Pfaffenbichler, Matthias. *Armourers*. Medieval Craftsmen. London: British Museum Press, 1992.

Rebold Benton, Janetta. *Art of the Middle Ages*. World of Art. New York: Thames & Hudson, 2002.

Rudolph, Conran, ed. *A Companion to Medieval Art*. Blackwell Companions to Art History. Oxford: Blackwell, 2006.

Sekules, Veronica. *Medieval Art*. Oxford History of Art. New York: Oxford Univ. Press, 2001.

Snyder, James, Henry Luttikhuizen, and Dorothy Verkerk. *Art of the Middle Ages*. 2nd ed. Upper Saddle River, NJ: Pearson/Prentice Hall, 2006.

Staniland, Kay. *Embroiderers*. Medieval Craftsmen. London: British Museum Press, 1991.

Stokstad, Marilyn. *Medieval Art*. 2nd ed. Boulder, CO: Westview Press, 2004.

———. *Medieval Castles*. Greenwood Guides to Historic Events of the Medieval World. Westport, CT: Greenwood Press, 2005.

## European Renaissance through Eighteenth-Century Art, General

Black, C. F., et al. *Cultural Atlas of the Renaissance*. New York: Prentice Hall, 1993.

Blunt, Anthony. *Art and Architecture in France, 1500–1700*. 5th ed. Revised. Richard Beresford. Pelican History of Art. New Haven: Yale Univ. Press, 1999.

Brown, Jonathan. *Painting in Spain: 1500–1700*. Pelican History of Art. New Haven: Yale Univ. Press, 1998.

Cole, Bruce. *Studies in the History of Italian Art, 1250–1550*. London: Pindar Press, 1996.

Graham-Dixon, Andrew. *Renaissance*. Berkeley: Univ. of California Press, 1999.

Harbison, Craig. *The Mirror of the Artist: Northern Renaissance Art in Its Historical Context*. Perspectives. New York: Abrams, 1995.

Harris, Ann Sutherland. *Seventeenth-Century Art & Architecture*. 2nd ed. Upper Saddle River, NJ: Pearson/Prentice Hall, 2008.

Harrison, Charles, Paul Wood, and Jason Gaiger. *Art in Theory 1648–1815: An Anthology of Changing Ideas*. Oxford: Blackwell, 2000.

Hartt, Frederick, and David G. Wilkins. *History of Italian Renaissance Art: Painting, Sculpture, Architecture*. 7th ed. Upper Saddle River, NJ: Pearson/Prentice Hall, 2011.

Jestaz, Bertrand. *The Art of the Renaissance*. Trans. I. Mark Paris. New York: Abrams, 1994.

Minor, Vernon Hyde. *Baroque & Rococo: Art & Culture*. New York: Abrams, 1999.

Paoletti, John T., and Gary M. Radke. *Art in Renaissance Italy*. 3rd ed. Upper Saddle River, NJ: Pearson/Prentice Hall, 2005.

Smith, Jeffrey Chipps. *The Northern Renaissance*. Art & Ideas. London and New York: Phaidon Press, 2004.

Stechow, Wolfgang. *Northern Renaissance, 1400–1600: Sources and Documents*. Upper Saddle River, NJ: Pearson/Prentice Hall, 1966.

Summerson, John. *Architecture in Britain, 1530–1830*. 9th ed. Pelican History of Art. New Haven: Yale Univ. Press, 1993.

Waterhouse, Ellis K. *Painting in Britain, 1530 to 1790*. 5th ed. Pelican History of Art. New Haven: Yale Univ. Press, 1994.

Whinney, Margaret Dickens. *Sculpture in Britain: 1530–1830*. 2nd ed. Revised. John Physick. Pelican History of Art. London: Penguin, 1988.

## Modern Art in the West, General

Arnason, H. H. *History of Modern Art: Painting, Sculpture, Architecture, Photography*. 6th ed. Upper Saddle River, NJ: Pearson/Prentice Hall, 2009.

Ballantyne, Andrew, ed. *Architectures: Modernism and After*. New Interventions in Art History, 3. Malden, MA: Blackwell, 2004.

Barnitz, Jacqueline. *Twentieth-Century Art of Latin America*. Austin: Univ. of Texas Press, 2001.

Bjelajac, David. *American Art: A Cultural History*. Rev. and expanded ed. Upper Saddle River, NJ: Pearson/Prentice Hall, 2005.

Bowness, Alan. *Modern European Art*. World of Art. New York: Thames & Hudson, 1995.

Brettell, Richard R. *Modern Art, 1851–1929: Capitalism and Representation*. Oxford History of Art. Oxford: Oxford Univ. Press, 1999.

Chipp, Herschel B. *Theories of Modern Art: A Source Book by Artists and Critics*. California Studies in the History of Art, 11. Berkeley: Univ. of California Press, 1984.

Clarke, Graham. *The Photograph*. Oxford History of Art. Oxford: Oxford Univ. Press, 1997.

Craven, David. *Art and Revolution in Latin America, 1910–1990*. New Haven: Yale Univ. Press, 2002.

Craven, Wayne. *American Art: History and Culture*. 2nd ed. Boston: McGraw-Hill, 2003.

Doordan, Dennis P. *Twentieth-Century Architecture*. New York: Abrams, 2002.

Doss, Erika. *Twentieth-Century American Art*. Oxford History of Art. Oxford: Oxford Univ. Press, 2002.

Edwards, Steve, and Paul Wood, eds. *Art of the Avant-Gardes*. Art of the 20th Century. New Haven: Yale Univ. Press, 2004.

Foster, Hal, et al. *Art Since 1900: Modernism, Antimodernism, Postmodernism*. New York: Thames & Hudson, 2004.

Gaiger, Jason, ed. *Frameworks for Modern Art*. Art of the 20th Century. New Haven: Yale Univ. Press, 2003.

———, and Paul Wood, eds. *Art of the Twentieth Century: A Reader*. New Haven: Yale Univ. Press, 2003.

Hamilton, George Heard. *Painting and Sculpture in Europe, 1880–1940*. 6th ed. Pelican History of Art. New Haven: Yale Univ. Press, 1993.

Hammacher, A. M. *Modern Sculpture: Tradition and Innovation*. Enl. ed. New York: Abrams, 1988.

Harris, Ann Sutherland, and Linda Nochlin. *Women Artists: 1550–1950*. Los Angeles: Los Angeles County Museum of Art, 1976.

Harrison, Charles, and Paul Wood, eds. *Art in Theory: 1900–2000: An Anthology of Changing Ideas*. 2nd ed. Malden, MA: Blackwell, 2003.

Hunter, Sam, John Jacobus, and Daniel Wheeler. *Modern Art: Painting, Sculpture, Architecture, Photography*. 3rd rev. & exp. ed. Upper Saddle River, NJ: Pearson/Prentice Hall, 2004.

Krauss, Rosalind E. *Passages in Modern Sculpture*. Cambridge, MA: MIT Press, 1977.

Mancini, JoAnne Marie. *Pre-Modernism: Art-World Change and American Culture from the Civil War to the Armory Show*. Princeton: Princeton Univ. Press, 2005.

Marien, Mary Warner. *Photography: A Cultural History*. 3rd ed. Upper Saddle River, NJ: Pearson/Prentice Hall, 2011.

Meecham, Pam, and Julie Sheldon. *Modern Art: A Critical Introduction*. 2nd ed. New York: Routledge, 2005.

Newlands, Anne. *Canadian Art: From Its Beginnings to 2000*. Willowdale, Ont.: Firefly Books, 2000.

*Phaidon Atlas of Contemporary World Architecture*. London: Phaidon Press, 2004.

Powell, Richard J. *Black Art: A Cultural History*. 2nd ed. World of Art. New York: Thames & Hudson, 2003.

Rosenblum, Naomi. *A World History of Photography*. 4th ed. New York: Abbeville Press, 2007.

Ruhrberg, Karl. *Art of the 20th Century*. Ed. Ingo F. Walther. 2 vols. New York: Taschen, 1998.

Scully, Vincent Joseph. *Modern Architecture and Other Essays*. Princeton: Princeton Univ. Press, 2003.

Stiles, Kristine, and Peter Selz. *Theories and Documents of Contemporary Art: A Sourcebook of Artists' Writings*. California Studies in the History of Art, 35. Berkeley: Univ. of California Press, 1996.

Tafuri, Manfredo. *Modern Architecture*. History of World Architecture. 2 vols. New York: Electa/Rizzoli, 1986.

Traba, Marta. *Art of Latin America, 1900–1980*. Washington, DC: Inter-American Development Bank, 1994.

Upton, Dell. *Architecture in the United States*. Oxford History of Art. Oxford: Oxford Univ. Press, 1998.

Wood, Paul, ed. *Varieties of Modernism*. Art of the 20th Century. New Haven: Yale Univ. Press, 2004.

Woodham, Jonathan M. *Twentieth Century Design*. Oxford History of Art. Oxford: Oxford Univ. Press, 1997.

## Asian Art, General

Addiss, Stephen, Gerald Groemer, and J. Thomas Rimer, eds. *Traditional Japanese Arts and Culture: An Illustrated Sourcebook*. Honolulu: Univ. of Hawai'i Press, 2006.

Barnhart, Richard M. *Three Thousand Years of Chinese Painting*. New Haven: Yale Univ. Press, 1997.

Blunden, Caroline, and Mark Elvin. *Cultural Atlas of China*. 2nd ed. New York: Checkmark Books, 1998.

Brown, Kerry, ed. *Sikh Art and Literature*. New York: Routledge in collaboration with the Sikh Foundation, 1999.

Chang. Léon Long-Yien, and Peter Miller. *Four Thousand Years of Chinese Calligraphy*. Chicago: Univ. of Chicago Press, 1990.

Chang, Yang-mo. *Arts of Korea*. Ed. Judith G. Smith. New York: Metropolitan Museum of Art, 1998.

Clark, John. *Modern Asian Art*. Honolulu: Univ. of Hawai'i Press, 1998.

Clunas, Craig. *Art in China*. 2nd ed. Oxford History of Art. Oxford: Oxford Univ. Press, 2009.

Coaldrake, William H. *Architecture and Authority in Japan*. London: Routledge, 1996.

Cohen, Warren I. *East Asian Art and American Culture: A Study in International Relations*. New York: Columbia Univ. Press, 1992.

Collcutt, Martin, Marius Jansen, and Isao Kumakura. *Cultural Atlas of Japan*. New York: Facts on File, 1988.

Craven, Roy C. *Indian Art: A Concise History*. Rev. ed. World of Art. New York: Thames & Hudson, 1997.

Dehejia, Vidya. *Indian Art. Art & Ideas*. London: Phaidon Press, 1997.

Fisher, Robert E. *Buddhist Art and Architecture*. World of Art. New York: Thames & Hudson, 1993.

Fu, Xinian. *Chinese Architecture*. Ed. & exp., Nancy S. Steinhardt. New Haven: Yale Univ. Press, 2002.

Hearn, Maxwell K., and Judith G. Smith, eds. *Arts of the Sung and Yüan: Papers Prepared for an International Symposium*. New York: Dept. of Asian Art, Metropolitan Museum of Art, 1996.

*Heibonsha Survey of Japanese Art*. 31 vols. New York: Weatherhill, 1972–80.

Hertz, Betti-Sue. *Past in Reverse: Contemporary Art of East Asia*. San Diego: San Diego Museum of Art, 2004.

*Japanese Arts Library*. 15 vols. New York: Kodansha International, 1977–87.

Kerlogue, Fiona. *Arts of Southeast Asia*. World of Art. New York: Thames & Hudson, 2004.

Khanna, Balraj, and George Michell. *Human and Divine: 2000 Years of Indian Sculpture*. London: Hayward Gallery, 2000.

Lee, Sherman E. *A History of Far Eastern Art*. 5th ed. Ed. Naomi Noble Richards. New York: Abrams, 1994.

————. *China, 5000 Years: Innovation and Transformation in the Arts*. New York: Solomon R. Guggenheim Museum, 1998.

Liu, Cary Y., and Dora C.Y. Ching, eds. *Arts of the Sung and Yüan: Ritual, Ethnicity, and Style in Painting*. Princeton: Art Museum, Princeton Univ., 1999.

McArthur, Meher. *The Arts of Asia: Materials, Techniques, Styles*. New York: Thames & Hudson, 2005.

————. *Reading Buddhist Art: An Illustrated Guide to Buddhist Signs and Symbols*. New York: Thames & Hudson, 2002.

Mason, Penelope. *History of Japanese Art*. 2nd ed. Upper Saddle River, NJ: Pearson/Prentice Hall, 2005.

Michell, George. *Hindu Art and Architecture*. World of Art. London: Thames & Hudson, 2000.

————. *The Penguin Guide to the Monuments of India*. 2 vols. New York: Viking, 1989.

Mitter, Partha. *Indian Art*. Oxford History of Art. Oxford: Oxford Univ. Press, 2001.

Murase, Miyeko. *Bridge of Dreams: The Mary Griggs Burke Collection of Japanese Art*. New York: Metropolitan Museum of Art, 2000.

Nickel, Lukas, ed. *Return of the Buddha: The Qingzhou Discoveries*. London: Royal Academy of Arts, 2002.

Pak, Youngsook, and Roderick Whitfield. *Buddhist Sculpture*. Handbook of Korean Art. London: Laurence King, 2003.

Sullivan, Michael. *The Arts of China*. 5th ed., rev. & exp. Berkeley: Univ. of California Press, 2008.

Thorp, Robert L., and Richard Ellis Vinograd. *Chinese Art & Culture*. New York: Abrams, 2001.

Topsfield, Andrew, ed. *In the Realm of Gods and Kings: Arts of India*. London: Philip Wilson, 2004.

Tucker, Jonathan. *The Silk Road: Art and History*. Chicago: Art Media Resources, 2003.

Tregear, Mary. *Chinese Art*. Rev. ed. World of Art. New York: Thames & Hudson, 1997.

Vainker S. J. *Chinese Pottery and Porcelain: From Prehistory to the Present*. New York: Braziller, 1991.

## African and Oceanic Art and Art of the Americas, General

Anderson, Richard L., and Karen L. Field, eds. *Art in Small-Scale Societies: Contemporary Readings*. Upper Saddle River, NJ: Pearson/Prentice Hall, 1993.

Bacquart, Jean-Baptiste. *The Tribal Arts of Africa*. New York: Thames & Hudson, 1998.

Bassani, Ezio, ed. *Arts of Africa: 7000 Years of African Art*. Milan: Skira, 2005.

Benson, Elizabeth P. *Retratos: 2,000 Years of Latin American Portraits*. San Antonio, TX: San Antonio Museum of Art, 2004.

Berlo, Janet Catherine, and Lee Anne Wilson. *Arts of Africa, Oceania, and the Americas: Selected Readings*. Upper Saddle River, NJ: Prentice Hall, 1993.

Calloway, Colin G. *First Peoples: A Documentary Survey of American Indian History*. 3rd ed. Boston: Bedford/St. Martin's, 2008.

Coote, Jeremy, and Anthony Shelton, eds. *Anthropology, Art, and Aesthetics*. New York: Oxford Univ. Press, 1992.

Drewal, Henry, and John Pemberton III. *Yoruba: Nine Centuries of African Art and Thought*. New York: Center for African Art, 1989.

Evans, Susan Toby. *Ancient Mexico & Central America: Archaeology and Culture History*. 2nd ed. New York: Thames & Hudson, 2008.

————, and David L. Webster, eds. *Archaeology of Ancient Mexico and Central America: An Encyclopedia*. New York: Garland, 2001.

————, and Joanne Pillsbury, eds. *Palaces of the Ancient New World: A Symposium at Dumbarton Oaks, 10th and 11th October, 1998*. Washington, DC: Dumbarton Oaks Research Library and Collection, 2004.

Geoffroy-Schneiter, Bérénice. *Tribal Arts*. New York: Vendome Press, 2000.

Hiller, Susan, ed. & compiled. *The Myth of Primitivism: Perspectives on Art*. London: Routledge, 1991.

Mack, John, ed. *Africa, Arts and Cultures*. London: British Museum Press, 2000.

*Mexico: Splendors of Thirty Centuries*. New York: Metropolitan Museum of Art, 1990.

Nunley, John W., and Cara McCarty. *Masks: Faces of Culture*. New York: Abrams in assoc. with the Saint Louis Art Museum, 1999.

Perani, Judith, and Fred T. Smith. *The Visual Arts of Africa: Gender, Power, and Life Cycle Rituals*. Upper Saddle River, NJ: Pearson/Prentice Hall, 1998.

Phillips, Tom, ed. *Africa: The Art of a Continent*. New York: Prestel, 1995.

Price, Sally. *Primitive Art in Civilized Places*. 2nd ed. Chicago: Univ. of Chicago Press, 2001.

Rabineau, Phyllis. *Feather Arts: Beauty, Wealth, and Spirit from Five Continents*. Chicago: Field Museum of Natural History, 1979.

Schuster, Carl, and Edmund Carpenter. *Patterns that Connect: Social Symbolism in Ancient & Tribal Art*. New York: Abrams, 1996.

Scott, John F. *Latin American Art: Ancient to Modern*. Gainesville: Univ. Press of Florida, 1999.

Stepan, Peter. *Africa*. Trans. John Gabriel and Elizabeth Schwaiger. London: Prestel, 2001.

Visonà, Monica Blackmun, et al. *A History of Art in Africa*. 2nd ed. Upper Saddle River, NJ: Pearson/Prentice Hall, 2008.

## Introduction

Acton, Mary. *Learning to Look at Paintings*. 2nd ed. New York: Routledge, 2009.

Arnold, Dana. *Art History: A Very Short Introduction*. Oxford and New York: Oxford Univ. Press, 2004.

Baxandall, Michael. *Patterns of Intention: On the Historical Explanation of Pictures*. New Haven: Yale Univ. Press, 1985.

Clearwater, Bonnie. *The Rothko Book*. London: Tate Publishing, 2006.

Decoteau, Pamela Hibbs. *Clara Peeters, 1594–ca. 1640 and the Development of Still-Life Painting in Northern Europe*. Lingen: Luca Verlag, 1992.

Geertz, Clifford. *"Art as a Cultural System."* Modern Language Notes 91 (1976): 1473–1499.

Hochstrasser, Julie Berger. *Still Life and Trade in the Dutch Golden Age*. New Haven: Yale Univ. Press, 2007.

Holstein, Jonathan. *The Pieced Quilt: An American Design Tradition*. New York: Galahad Books, 1973.

Jolly, Penny Howell. *"Rogier van der Weyden's Escorial and Philadelphia Crucifixions and Their Relation to Fra Angelico at San Marco."* Oud Holland 95 (1981): 113–126.

Mainardi, Patricia. *"Quilts: The Great American Art."* The Feminist Art Journal 2/1 (1973): 1, 18–23.

Miller, Angela L., et al. *American Encounters: Art, History, and Cultural Identity*. Upper Saddle River, NJ: Pearson/Prentice Hall, 2008.

Minor, Vernon Hyde. *Art History's History*. Upper Saddle River, NJ: Pearson/Prentice Hall, 2001.

Nelson, Robert S., and Richard Shiff, eds. *Critical Terms for Art History*. 2nd ed. Chicago: Univ. of Chicago Press, 2003.

Panofsky, Erwin. *Studies in Iconology: Humanistic Themes in the Art of the Renaissance*. New York: Oxford Univ. Press, 1939.

————. *Meaning in the Visual Arts*. Phoenix ed. Chicago: Univ. of Chicago Press, 1982.

Preziosi, Donald, ed. *The Art of Art History: A Critical Anthology*. 2nd ed. Oxford and New York: Oxford Univ. Press, 2009.

Rothko, Mark. *Writings on Art*. Ed. Miguel López-Remiro. New Haven: Yale Univ. Press, 2006.

Rothko, Mark. *The Artist's Reality: Philosophies of Art*. Ed. Christopher Rothko. New Haven: Yale Univ. Press, 2004.

Schapiro, Meyer. *"The Apples of Cézanne: An Essay on the Meaning of Still Life."* Art News Annual 34 (1968): 34–53. Reprinted in Modern Art 19th & 20th Centuries: Selected Papers 2, London: Chatto & Windus, 1978.

Sowers, Robert. *Rethinking the Forms of Visual Expression*. Berkeley: Univ. of California Press, 1990.

Taylor, Joshua. *Learning to Look: A Handbook for the Visual Arts*. 2nd ed. Chicago: Chicago Univ. Press, 1981.

Tucker, Mark. *"Rogier van der Weyden's 'Philadelphia Crucifixion.'"* Burlington Magazine 139 (1997): 676–683.

Wang, Fangyu, et al, eds. *Master of the Lotus Garden: The Life and Art of Bada Shanren (1626–1705)*. New Haven: Yale Univ. Press, 1990.

## Chapter 1 Prehistoric Art

Aujoulat, Norbert. *Lascaux: Movement, Space, and Time*. New York: Abrams, 2005.

Bahn Paul G. *The Cambridge Illustrated History of Prehistoric Art*. Cambridge Illustrated History. Cambridge: Cambridge Univ. Press, 1998.

Bataille, Georges. *The Cradle of Humanity: Prehistoric Art and Culture*. Ed. Stuart Kendall. Trans. Michelle Kendall and Stuart Kendall. New York: Zone Books, 2005.

Berghaus, Gunter. *New Perspectives on Prehistoric Art*. Westport, CT: Praeger, 2004.

Chippindale, Christopher. *Stonehenge Complete*. 3rd ed. New York: Thames & Hudson, 2004.

Clottes, Jean. *Chauvet Cave: The Art of Earliest Times*. Salt Lake City: Univ. of Utah Press, 2003.

————. *World Rock Art*. Trans. Guy Bennett. Los Angeles: Getty Conservation Institute, 2002.

————, and J. David Lewis-Williams. *The Shamans of Prehistory: Trance and Magic in the Painted Caves*. Trans. Sophie Hawkes. New York: Abrams, 1998.

Connah, Graham. *African Civilizations: An Archaeological Perspective*. 2nd ed. Cambridge: Cambridge Univ. Press, 2001.

Coulson, David, and Alec Campbell. *African Rock Art: Painting and Engravings on Stone*. New York: Abrams, 2001.

Cunliffe, Barry W., ed. *The Oxford Illustrated History of Prehistoric Europe*. New York: Oxford Univ. Press, 2001.

Forte, Maurizio, and Alberto Siliotti. *Virtual Archaeology: Re-Creating Ancient Worlds*. New York: Abrams, 1997.

Freeman. Leslie G. *Altamira Revisited and Other Essays on Early Art*. Chicago: Institute for Prehistoric Investigation, 1987.

Garlake, Peter S. *The Hunter's Vision: The Prehistoric Art of Zimbabwe*. Seattle: Univ. of Washington Press, 1995.

Gowlett, John A. J. *Ascent to Civilization: The Archaeology of Early Humans*. 2nd ed. New York: McGraw-Hill, 1993.

Guthrie, R. Dale. *The Nature of Paleolithic Art*. Chicago: Univ. of Chicago Press, 2005.

Jope, E. M. *Early Celtic art in the British Isles*. 2 vols. New York: Oxford Univ. Press, 2000.

Kenrick, Douglas M. *Jomon of Japan: The World's Oldest Pottery*. New York: Kegan Paul, 1995.

Leakey, Richard E., and Roger Lewin. *Origins Reconsidered: In Search of What Makes Us Human*. New York: Doubleday, 1992.

Le Quellec, Jean-Loïc. *Rock Art in Africa: Mythology and Legend*. Trans. Paul Bahn. Paris: Flammarion, 2004.

Leroi-Gourhan, André. *The Dawn of European Art: An Introduction to Paleolithic Cave Painting*. Trans. Sara Champion. Cambridge: Cambridge Univ. Press, 1982.

Lewis-Williams, J. David. *The Mind in the Cave: Consciousness and the Origins of Art*. New York: Thames & Hudson, 2002.

Megaw, Ruth, and Vincent Megaw. *Celtic Art: From Its Beginnings to the Book of Kells*. Rev. & expanded ed. New York: Thames & Hudson, 2001.

O'Kelly, Michael J. *Newgrange: Archaeology, Art, and Legend*. New Aspects of Antiquity. London: Thames & Hudson, 1982.

Price, T. Douglas. *Images of the Past*. 5th ed. Boston: McGraw-Hill, 2008.

Renfrew, Colin, ed. *The Megalithic Monuments of Western Europe*. London: Thames & Hudson, 1983.

Sandars, N. K. *Prehistoric Art in Europe*. 2nd ed. Pelican History of Art. New Haven: Yale Univ. Press, 1992.

Sura Ramos, Pedro A. *The Cave of Altamira*. Gen. Ed. Antonio Beltran. New York: Abrams, 1999.

Sieveking, Ann. *The Cave Artists*. Ancient People and Places, vol. 93. London: Thames & Hudson, 1979.

White, Randall. *Prehistoric Art: The Symbolic Journey of Mankind*. New York: Abrams, 2003.

## Chapter 2 Art of the Ancient Near East

Akurgal, Ekrem. *Ancient Civilizations and Ruins of Turkey: From Prehistoric Times until the End of the Roman Empire*. 5th ed. London: Kegan Paul, 2002.

Aruz, Joan, et al, eds. *Beyond Babylon: Art, Trade, and Diplomacy in the Second Millennium B.C.* New Haven: Yale Univ. Press, and Metropolitan Museum of Art, 2008.

————, ed. *Art of the First Cities: The Third Millennium b.c. from the Mediterranean to the Indus*. New York: Metropolitan Museum of Art, 2003.

Bahrani, Zainab. *The Graven Image: Representation in Babylonia and Assyria. Archaeology, Culture, and Society Series*. Philadelphia: Univ. of Pennsylvania Press, 2003.

Boardman, John. *Persia and the West: An Archaeological Investigation of the Genesis of Achaemenid Art*. New York: Thames & Hudson, 2000.

Bottero, Jean. *Everyday Life in Ancient Mesopotamia*. Trans. Antonia Nevill. Baltimore, MD.: Johns Hopkins Univ. Press, 2001.

Charvat, Petr. *Mesopotamia before History*. Rev. & updated ed. New York: Routledge, 2002.

Crawford, Harriet. *Sumer and the Sumerians*. 2nd ed. New York: Cambridge Univ. Press, 2004.

Curtis, John, and Nigel Tallis, eds. *Forgotten Empire: The World of Ancient Persia*. Berkeley: Univ. of California Press, 2005.

Ferrier, R. W., ed. *The Arts of Persia*. New Haven: Yale Univ. Press, 1989.

Frankfort, Henri. *The Art and Architecture of the Ancient Orient*. 5th ed. Pelican History of Art. New Haven: Yale Univ. Press, 1996.

Haywood, John. *Ancient Civilizations of the Near East and Mediterranean*. London: Cassell, 1997.

Meyers, Eric M., ed. *The Oxford Encyclopedia of Archaeology in the Near East*. 5 vols. New York: Oxford Univ. Press, 1997.

Moorey, P. R. S. *Idols of the People: Miniature Images of Clay in the Ancient Near East*. The Schweich Lectures of the British Academy, 2001. New York: Oxford Univ. Press, 2003.

Polk, Milbry, and Angela M. H. Schuster. *The Looting of the Iraq Museum, Baghdad: The Lost Legacy of Ancient Mesopotamia*. New York: Abrams, 2005.

Reade, Julian. *Assyrian Sculpture*. Cambridge, MA: Harvard Univ. Press, 1999.

Roaf, Michael. *Cultural Atlas of Mesopotamia and the Ancient Near East*. New York: Facts on File, 1990.

Winter, Irene. *"Sex, Rhetoric, and the Public Monument: The Alluring Body of the Male Ruler."* In *Sexuality in Ancient Art*, edited by Natalie Kampen and Bettina A. Bergmann. Cambridge: Cambridge Univ. Press, 1996: 11–26.

Roux, Georges. *Ancient Iraq*. 3rd ed. London: Penguin, 1992.

Zettler, Richard L., and Lee Horne, ed. *Treasures from the Royal Tombs of Ur*. Philadelphia: Univ. of Pennsylvania, Museum of Archaeology and Anthropology, 1998.

## Chapter 3 Art of Ancient Egypt

Arnold, Dieter. *Temples of the Last Pharaohs*. New York: Oxford Univ. Press, 1999.

Baines, John, and Jaromír Málek. *Cultural Atlas of Ancient Egypt*. Rev. ed. New York: Facts on File, 2000.

Brier, Bob. *Egyptian Mummies: Unraveling the Secrets of an Ancient Art*. New York: Morrow, 1994.

*Egyptian Art in the Age of the Pyramids*. New York: Metropolitan Museum of Art, 1999.

*The Egyptian Book of the Dead: The Book of Going Forth by Day: Being the Papyrus of Ani (Royal Scribe of the Divine Offerings)*. 2nd rev. ed. Trans. Raymond O. Faulkner. San Francisco: Chronicle, 2008.

Freed, Rita E. Sue D'Auria, and Yvonne J. Markowitz. *Pharaohs of the Sun: Akhenaten, Nefertiti, Tutankhamen*. Boston: Museum of Fine Arts in assoc. with Bulfinch Press/Little, Brown, 1999.

Hawass, Zahi A. *Tutankhamun and the Golden Age of the Pharaohs*. Washington, DC: National Geographic, 2005.

Johnson, Paul. *The Civilization of Ancient Egypt*. Updated ed. New York: HarperCollins, 1999.

Kozloff, Arielle P. *Egypt's Dazzling Sun: Amenhotep III and His World*. Cleveland: Cleveland Museum of Art, 1992.

Lehner, Mark. *The Complete Pyramids*. New York: Thames & Hudson, 2008.

*Love Songs of the New Kingdom*. Trans. John L. Foster. New York: Scribner, 1974; Austin: Univ. of Texas Press, 1992.

Málek, Jaromir. *Egypt: 4,000 Years of Art*. London: Phaidon Press, 2003.

Pemberton, Delia. *Ancient Egypt*. Architectural Guides for Travelers. San Francisco: Chronicle, 1992.

Robins, Gay. *The Art of Ancient Egypt*. Rev. ed. Cambridge, MA: Harvard Univ. Press, 2008.

Roehrig, Catharine H., Renee Dreyfus, and Cathleen A. Keller. *Hatshepsut, from Queen to Pharaoh*. New York: Metropolitan Museum of Art, 2005.

Russmann, Edna R. *Egyptian Sculpture: Cairo and Luxor*. Austin: Univ. of Texas Press, 1989.

Smith, Craig B. *How the Great Pyramid Was Built*. Washington, DC: Smithsonian Books, 2004.

Smith, William Stevenson. *The Art and Architecture of Ancient Egypt*. 3rd ed. Revised. William Kelly Simpson. Pelican History of Art. New Haven: Yale Univ. Press, 1998.

Strouhal, Eugen. *Life of the Ancient Egyptians*. Trans. Deryck Viney. Norman: Univ. of Oklahoma Press, 1992.

Strudwick, Nigel, and Helen Strudwick. *Thebes in Egypt: A Guide to the Tombs and Temples of Ancient Luxor*. Ithaca, NY: Cornell Univ. Press, 1999.

Thomas, Thelma K. *Late Antique Egyptian Funerary Sculpture: Images for this World and for the Next*. Princeton: Princeton Univ. Press, 2000.

Tiradritti, Francesco. *Ancient Egypt: Art, Architecture and History*. Trans. Phil Goddard. London: British Museum Press, 2002.

*The Treasures of Ancient Egypt: From the Egyptian Museum in Cairo*. New York: Rizzoli, 2003.

Wilkinson, Richard H. *The Complete Temples of Ancient Egypt*. New York: Thames & Hudson, 2000.

———. *Reading Egyptian Art: A Hieroglyphic Guide to Ancient Egyptian Painting and Sculpture*. London: Thames & Hudson, 1992.

Winstone, H. V. F. *Howard Carter and the Discovery of the Tomb of Tutankhamen*. Rev. ed. Manchester: Barzan, 2006.

Ziegler, Cristiane, ed. *The Pharaohs*. New York: Rizzoli, 2002.

Zivie-Coche, Christiane. *Sphinx: History of a Monument*. Trans. David Lorton. Ithaca, NY: Cornell Univ. Press, 2002.

## Chapter 4 Art of the Ancient Aegean

Castleden, Rodney. *The Knossos Labyrinth: A New View of the "Palace of Minos" at Knossos*. London: Routledge, 1990.

———. *Mycenaeans*. New York: Routledge, 2005.

Demargne, Pierre. *The Birth of Greek Art*. Trans. Stuart Gilbert and James Emmons. Arts of Mankind, vol. 6. New York: Golden, 1964.

Doumas, Christos. *The Wall-Paintings of Thera*. 2nd ed. Trans. Alex Doumas. Athens: Kapon Editions, 1999.

Fitton, J. Lesley. *Cycladic Art*. 2nd ed. London: British Museum Press, 1999.

Getz-Gentle, Pat. *Personal Styles in Early Cycladic Sculpture*. Madison: Univ. of Wisconsin Press, 2001.

Hamilakis, Yannis, ed. *Labyrinth Revisited: Rethinking "Minoan" Archaeology*. Oxford: Oxbow, 2002.

Hendrix, Elizabeth. *"Painted Ladies of the Early Bronze Age,"* The Metropolitan Museum of Art Bulletin, New Series, 55/3 (Winter 1997–1998): 4–15.

Higgins, Reynold A. *Minoan and Mycenean Art*. New. ed. World of Art. New York: Thames & Hudson, 1997.

Hitchcock, Louise. *Minoan Architecture: A Contextual Analysis*. Studies in Mediterranean Archaeology and Literature, Pocket-Book, 155. Jonsered: P. Åströms Förlag, 2000.

Hoffman, Gail L. *"Painted Ladies: Early Cycladic II Mourning Figures?"* American Journal of Archaeology, 106/4 (October 2002): 525–550.

Immerwahr, Sara Anderson. *Aegean Painting in the Bronze Age*. University Park: Pennsylvania State Univ. Press, 1990.

Preziosi, Donald, and Louise Hitchcock. *Aegean Art and Architecture*. Oxford History of Art. Oxford: Oxford Univ. Press, 1999.

Shelmerdine, Cynthia W., ed. *The Cambridge Companion to the Aegean Bronze Age*. New York: Cambridge Univ. Press, 2008.

## Chapter 5 Art of Ancient Greece

Barletta, Barbara A. *The Origins of the Greek Architectural Orders*. New York: Cambridge Univ. Press, 2001.

Beard, Mary. *The Parthenon*. Cambridge, MA: Harvard Univ. Press, 2003.

Belozerskaya, Marina, and Kenneth D.S. Lapatin. *Ancient Greece: Art, Architecture, and History*. Los Angeles: J. Paul Getty Museum, 2004.

Boardman, John. *Early Greek Vase Painting: 11th–6th Centuries b.c.: A Handbook*. World of Art. London: Thames & Hudson, 1998.

———. *Greek Sculpture: The Archaic Period: A Handbook*. World of Art. London: Thames & Hudson, 1991.

———. *Greek Sculpture: The Classical Period: A Handbook*. London: Thames & Hudson, 1985.

———. *Greek Sculpture: The Late Classical Period and Sculpture in Colonies and Overseas*. World of Art. New York: Thames & Hudson, 1995.

———. *The History of Greek Vases: Potters, Painters, and Pictures*. New York: Thames & Hudson, 2001.

Burn, Lucilla. *Hellenistic Art: From Alexander the Great to Augustus*. Los Angeles: J. Paul Getty Museum, 2004.

Clark, Andrew J., Maya Elston, Mary Louise Hart. *Understanding Greek Vases: A Guide to Terms, Styles, and Techniques*. Los Angeles: J. Paul Getty Museum, 2002.

De Grummond, Nancy T. and Brunilde S. Ridgway. *From Pergamon to Sperlonga: Sculpture in Context*. Berkeley: Univ. of California Press, 2000.

Donohue, A. A. *Greek Sculpture and the Problem of Description*. New York: Cambridge Univ. Press, 2005.

Fullerton, Mark D. *Greek Art*. Cambridge: Cambridge Univ. Press, 2000.

Hard, Robin. *The Routledge Handbook of Greek Mythology: Based on H.J. Rose's "Handbook of Greek Mythology."* 7th ed. London: Routledge, 2008.

Hurwit, Jeffrey M. *The Acropolis in the Age of Pericles*. New York: Cambridge Univ. Press, 2004.

Karakasi, Katerina. *Archaic Korai*. Los Angeles: J. Paul Getty Museum, 2003.

Lawrence, A. W. *Greek Architecture*. 5th ed. Revised. R. A. Tomlinson. Pelican History of Art. New Haven: Yale Univ. Press, 1996.

Martin, Roland. *Greek Architecture: Architecture of Crete, Greece, and the Greek World*. History of World Architecture. New York: Electa/Rizzoli, 1988.

Neils, Jenifer. *The British Museum Concise Introduction to Ancient Greece*. Ann Arbor: Univ. of Michigan, 2008.

Osborne, Robin. *Archaic and Classical Greek Art*. Oxford History of Art. Oxford: Oxford Univ. Press, 1998.

Palagia, Olga, ed. *Greek Sculpture: Function, Materials, and Techniques in the Archaic and Classical Periods*. New York: Cambridge Univ. Press, 2006.

———, and J. J. Pollitt, eds. *Personal Styles in Greek Sculpture*. Yale Classical Studies, vol. 30. Cambridge: Cambridge Univ. Press, 1996.

Pedley, John Griffiths. *Greek Art and Archaeology*. 4th ed. Upper Saddle River, NJ: Pearson/Prentice Hall, 2007.

Pollitt, J. J. *Art and Experience in Classical Greece*. Cambridge: Cambridge Univ. Press, 1972; reprinted 1999.

———. *The Art of Ancient Greece: Sources and Documents*. 2nd ed. rev. Cambridge: Cambridge Univ. Press, 2001.

Ridgway, Brunilde Sismondo. *The Archaic Style in Greek Sculpture*. 2nd ed. Chicago: Ares, 1993.

———. *Fifth Century Styles in Greek Sculpture*. Princeton: Princeton Univ. Press, 1981.

———. *Fourth Century Styles in Greek Sculpture*. Wisconsin Studies in Classics. Madison: Univ. of Wisconsin Press, 1997.

———. *Hellenistic Sculpture 1: The Styles of ca. 331–200 b.c.* Wisconsin Studies in Classics. Madison: Univ. of Wisconsin Press, 1990.

Stafford, Emma J. *Life, Myth, and Art in Ancient Greece*. Los Angeles: J. Paul Getty Museum, 2004.

Stewart, Andrew F. *Greek Sculpture: An Exploration*. 2 vols. New Haven: Yale Univ. Press, 1990.

Whitley, James. *The Archaeology of Ancient Greece*. New York: Cambridge Univ. Press, 2001.

## Chapter 6 Etruscan and Roman Art

Bianchi Bandinelli, Ranuccio. *Rome: The Centre of Power: Roman Art to a.d. 200*. Trans. Peter Green. Arts of Mankind, 15. London: Thames & Hudson, 1971.

———. *Rome: The Late Empire: Roman Art a.d. 200–400*. Trans. Peter Green. Arts of Mankind, 17. New York: Braziller, 1971.

Borrelli, Federica. *The Etruscans: Art, Architecture, and History*. Ed. Stefano Peccatori and Stefano Zuffi. Trans. Thomas Michael Hartmann. Los Angeles: J. Paul Getty Museum, 2004.

Brendel, Otto J. *Prolegomena to the Study of Roman Art*. New Haven, Yale Univ. Press, 1979.

———. *Etruscan Art*. 2nd ed. Pelican History of Art. New Haven: Yale Univ. Press, 1995.

Conlin, Diane Atnally. *The Artists of the Ara Pacis: The Process of Hellenization in Roman Relief Sculpture*. Studies in the History of Greece & Rome. Chapel Hill: Univ. of North Carolina Press, 1997.

Cornell, Tim, and John Matthews. *Atlas of the Roman World*. New York: Facts on File, 1982.

D'Ambra, Eve. *Roman Art*. Cambridge: Cambridge Univ. Press, 1998.

Elsner, Jas. *Imperial Rome and Christian Triumph: The Art of the Roman Empire a.d. 100–450*. Oxford History of Art. Oxford: Oxford Univ. Press, 1998.

Gabucci, Ada. *Ancient Rome: Art, Architecture, and History*. Eds. Stefano Peccatori and Stephano Zuffi. Trans. T. M. Hartman. Los Angeles: J. Paul Getty Museum, 2002.

Haynes, Sybille. *Etruscan Civilization: A Cultural History*. Los Angeles: J. Paul Getty Museum, 2000.

Holloway, R. Ross. *Constantine & Rome*. New Haven: Yale Univ. Press, 2004.

Kleiner, Fred S. *A History of Roman Art*. Belmont, CA: Thomson/Wadsworth, 2007.

MacDonald, William L. *The Architecture of the Roman Empire: An Introductory Study*. Rev. ed. 2 vols. Yale Publications in the History of Art, 17, 35. New Haven: Yale Univ. Press, 1982.

———. *The Pantheon: Design, Meaning, and Progeny*. New foreword. John Pinto. Cambridge, MA: Harvard Univ. Press, 2002.

Mattusch, Carol C. *Pompeii and the Roman Villa: Art and Culture around the Bay of Naples.* Washington, D.C. National Gallery of Art, 2008.

Mazzoleni, Donatella. *Domus: Wall Painting in the Roman House.* Los Angeles: J. Paul Getty Museum, 2004.

Packer, James E. *The Forum of Trajan in Rome: A Study of the Monuments in Brief.* Berkeley: Univ. of California Press, 2001.

Pollitt, J. J. *The Art of Rome, c. 753 b.c.–337 a.d.: Sources and Documents.* Upper Saddle River, NJ: Pearson/Prentice Hall, 1966.

Polybius. *The Histories.* Trans. W.R. Paton. 6 vols. Loeb Classical Library. Cambridge, MA: Harvard Univ. Press, 2000.

Ramage, Nancy H., and Andrew Ramage. *Roman Art: Romulus to Constantine.* 5th ed. Upper Saddle River, NJ: Pearson/Prentice Hall, 2009.

Spivey, Nigel. *Etruscan Art.* World of Art. New York: Thames & Hudson, 1997.

Stamper, John W. *The Architecture of Roman Temples: The Republic to the Middle Empire.* New York: Cambridge Univ. Press, 2005.

Stewart, Peter. *Statues in Roman Society: Representation and Response.* Oxford Studies in Ancient Culture and Representation. New York: Oxford Univ. Press, 2003.

Strong, Donald. *Roman Art.* 2nd ed. rev. & annotated. Ed. Roger Ling. Pelican History of Art. New Haven: Yale Univ. Press, 1995.

Ward-Perkins, J. B. *Roman Architecture.* History of World Architecture. New York: Electa/Rizzoli, 1988.

———. *Roman Imperial Architecture.* Pelican History of Art. New Haven: Yale Univ. Press, 1981.

Wilson Jones, Mark. *Principles of Roman Architecture.* New Haven: Yale Univ. Press, 2000.

## Chapter 7 Jewish, Early Christian, and Byzantine Art

*Age of Spirituality: Late Antique and Early Christian Art, Third to Seventh Century.* New York: Metropolitan Museum of Art, 1979.

Beckwith, John. *Early Christian and Byzantine Art.* 2nd ed. Pelican History of Art. New Haven: Yale Univ. Press, 1979.

Bleiberg, Edward, ed. *Tree of Paradise: Jewish Mosaics from the Roman Empire.* Brooklyn:
Brooklyn Museum, 2005.

Cioffarelli, Ada. *Guide to the Catacombs of Rome and Its Surroundings.* Rome: Bonsignori, 2000.

Cormack, Robin, and Maria Vassilaki, eds. *Byzantium, 330–1453.* London: Royal Academy of Arts, 2008.

Cutler, Anthony. *The Hand of the Master: Craftsmanship, Ivory, and Society in Byzantium 9th–11th Centuries.* Princeton: Princeton Univ. Press, 1994.

Durand, Jannic. *Byzantine Art.* Paris: Terrail, 1999.

Eastmond, Antony, and Liz James, eds. *Icon and Word : The Power of Images in Byzantium: Studies Presented to Robin Cormack.* Burlington, VT: Ashgate, 2003.

Evans, Helen C., ed. *Byzantium: Faith and Power (1261–1557).* New York: Metropolitan Museum of Art, 2004.

———, and William D. Wixom, eds. *The Glory of Byzantium: Art and Culture of the Middle Byzantine era, a.d. 843–1261.* New York: Abrams, 1997.

Fine, Steven. *Art and Judaism in the Greco–Roman World: Toward a New Jewish Archaeology.* New York: Cambridge Univ. Press, 2005.

Freely, John. *Byzantine Monuments of Istanbul.* Cambridge: New York: Cambridge Univ. Press,
2004.

Grabar, André. *Byzantine Painting: Historical and Critical Study.* Trans. Stuart Gilbert. New York: Rizzoli, 1979.

Hachlili, Rachel. *Ancient Mosaic Pavements: Themes, Issues, and Trends.* Leiden: Brill, 2009.

Jensen, Robin Margaret. *Understanding Early Christian Art.* New York: Routledge, 2000.

Kitzinger, Ernst. *The Art of Byzantium and the Medieval West: Selected Studies.* Ed. W. Eugene Kleinbauer. Bloomington: Indiana Univ. Press, 1976.

———. *Byzantine Art in the Making: Main Lines of Stylistic Development in Mediterranean Art, 3rd–7th Century.* Cambridge, MA: Harvard Univ. Press, 1977.

Kleinbauer, W. Eugene. *Hagia Sophia.* London: Scala, 2004.

Krautheimer, Richard, and Slobodan Curcic. *Early Christian and Byzantine Architecture.* 4th ed. Pelican History of Art. New Haven: Yale Univ. Press, 1992.

Levine, Lee I., and Zeev Weiss, eds. *From Dura to Sepphoris: Studies in Jewish Art and Society in Late Antiquity.* Journal of Roman Archaeology: Supplementary Series, no. 40. Portsmouth, R.I.: Journal of Roman Archaeology, 2000.

Lowden, John. *Early Christian and Byzantine Art.* Art & Ideas. London: Phaidon Press, 1997.

Maguire, Henry. *The Icons of Their Bodies: Saints and Their Images in Byzantium.* Princeton: Princeton Univ. Press, 1996.

Mainstone, Rowland J. *Hagia Sophia: Architecture, Structure and Liturgy of Justinian's Great Church.* 2nd ed. New York: Thames & Hudson, 2001.

Mango, Cyril. *Art of the Byzantine Empire, 312–1453: Sources and Documents.* Upper Saddle River, NJ: Pearson/Prentice Hall, 1972.

Mathew, Gervase. *Byzantine Aesthetics.* London: John Murray, 1963.

Mathews, Thomas F. *Byzantium: From Antiquity to the Renaissance.* Perspectives. New York: Abrams, 1998.

———. *The Clash of Gods: A Reinterpretation of Early Christian Art.* Rev. ed. Princeton: Princeton Univ. Press, 1999.

Olin, Margaret. *The Nation without Art: Examining Modern Discourses on Jewish Art.* Lincoln: Univ. of Nebraska Press, 2001.

Olsson, Birger, and Magnus Zetterholm, eds. *The Ancient Synagogue from Its Origins until 200 c.e.: Papers Presented at an International Conference at Lund University, October 14–17, 2001.* Coniectanea Biblica: New Testament Series, 39. Stockholm: Almqvist & Wiksell International, 2003.

Ousterhout, Robert. *Master Builders of Byzantium.* Princeton: Princeton Univ. Press, 1999.

Rodley, Lyn. *Byzantine Art and Architecture: An Introduction.* Cambridge: Cambridge Univ. Press, 1994.

Rutgers, Leonard V. *Subterranean Rome: In Search of the Roots of Christianity in the Catacombs of the Eternal City.* Leuven: Peeters, 2000.

Sed-Rajna, Gabrielle. *Jewish Art.* Trans. Sara Friedman and Mira Reich. New York: Abrams, 1997.

Spier, Jeffrey, ed. *Picturing the Bible: The Earliest Christian Art.* New Haven: Yale Univ. Press, 2007.

Tadgell, Christopher. *Imperial Space: Rome, Constantinople and the Early Church.* New York: Whitney Library of Design, 1998.

Vio, Ettore. *St. Mark's: The Art and Architecture of Church and State in Venice.* New York: Riverside Book, 2003.

Webb, Matilda. *The Churches and Catacombs of Early Christian Rome: A Comprehensive Guide.* Brighton, UK: Sussex Academic Press, 2001.

Weitzmann, Kurt. *Late Antique and Early Christian Book Illumination.* New York: Braziller, 1977.

———. *Place of Book Illumination in Byzantine Art.* Princeton: Art Museum, Princeton Univ., 1975.

Wharton, Annabel Jane. *Refiguring the Post-Classical City: Dura Europos, Jerash, Jerusalem and Ravenna.* Cambridge: Cambridge Univ. Press, 1995.

White, L. Michael. *The Social Origins of Christian Architecture.* 2 vols. Baltimore, MD: Johns Hopkins Univ. Press, 1990.

## Chapter 8 Islamic Art

Al-Faruqi, Isma'il R., and Lois Ibsen Al Faruqi. *Cultural Atlas of Islam.* New York: Macmillan, 1986.

Atil, Esin. *The Age of Sultan Suleyman the Magnificent.* Washington, DC: National Gallery of Art, 1987.

Baker, Patricia L. *Islam and the Religious Arts.* London: Continuum, 2004.

Barry, Michael A. *Figurative Art in Medieval Islam and the Riddle of Bihzâd of Herât (1465–1535).* Paris: Flammarion, 2004.

Blair, Sheila S., and Jonathan Bloom. *The Art and Architecture of Islam 1250–1800.* Pelican History of Art. New Haven: Yale Univ. Press, 1995.

Denny, Walter B. *Iznik: The Artistry of Ottoman Ceramics.* New York: Thames & Hudson, 2004.

Dodds, Jerrilynn D., ed. *Al-Andalus: The Art of Islamic Spain.* New York: Metropolitan Museum of Art, 1992.

Ecker, Heather. *Caliphs and Kings: The Art and Influence of Islamic Spain.* Washington, DC: Arthur M. Sackler Gallery, Smithsonian Institution, 2004.

Ettinghausen, Richard, Oleg Grabar, and Marilyn Jenkins-Madina. *Islamic Art and Architecture, 650–1250.* 2nd ed. Pelican History of Art. New Haven: Yale Univ. Press, 2001.

Frishman, Martin, and Hasan-Uddin Khan. *The Mosque: History, Architectural Development and Regional Diversity.* London: Thames & Hudson, 1994.

Grabar, Oleg. *The Formation of Islamic Art.* Rev. and enlarged. New Haven: Yale Univ. Press, 1987.

———. *The Great Mosque of Isfahan.* New York: New York Univ. Press, 1990.

———. *Islamic Visual Culture, 1100–1800.* Burlington, VT: Ashgate, 2006.

———. *Mostly Miniatures: An Introduction to Persian Painting.* Princeton: Princeton Univ. Press, 2000.

———, Mohammad Al-Asad, Abeer Audeh, and Said Nuseibeh. *The Shape of the Holy: Early Islamic Jerusalem.* Princeton: Princeton Univ. Press, 1996.

Hillenbrand, Robert. *Islamic Art and Architecture.* World of Art. London: Thames & Hudson, 1999.

Irwin, Robert. *The Alhambra.* Cambridge, MA: Harvard Univ. Press, 2004.

Khalili, Nasser D. *Visions of Splendour in Islamic Art and Culture.* London: Worth Press, 2008.

Komaroff, Linda, and Stefano Carboni, eds. *The Legacy of Genghis Khan: Courtly Art and Culture in Western Asia, 1256–1353.* New York: Metropolitan Museum of Art, 2002.

Lentz, Thomas W., and Glenn D. Lowry. *Timur and the Princely Vision: Persian Art and Culture in the Fifteenth Century.* Los Angeles: Los Angeles County Museum of Art, 1989.

Necipolu, Gülru. *The Age of Sinan: Architectural Culture in the Ottoman Empire.* Princeton: Princeton Univ. Press, 2005.

Petruccioli, Attilio, and Khalil K. Pirani, eds. *Understanding Islamic Architecture.* New York: Routledge Curzon, 2002.

Roxburgh, David J., ed. *Turks: A Journey of a Thousand Years, 600–1600.* London: Royal Academy of Arts, 2005.

Sims, Eleanor, B. I. Marshak, and Ernst J. Grube. *Peerless Images: Persian Painting and Its Sources.* New Haven: Yale Univ. Press, 2002.

Stanley, Tim, Mariam Rosser-Owen, and Stephen Vernoit. *Palace and Mosque: Islamic Art from the Middle East.* London: V&A Publications, 2004.

Stierlin, Henri. *Islamic Art and Architecture.* New York: Thames & Hudson, 2002.

Tadgell, Christopher. *Four Caliphates: The Formation and Development of the Islamic Tradition.* London: Ellipsis, 1998.

Ward, R. M. *Islamic Metalwork.* New York: Thames & Hudson, 1993.

Watson, Oliver. *Ceramics from Islamic Lands.* New York: Thames & Hudson in assoc. with the al-Sabah Collection, Dar al-Athar al-Islamiyyah, Kuwait National Museum, 2004.

## Chapter 9 Art of South and Southeast Asia before 1200

Athérton, Cynthia Packert. *The Sculpture of Early Medieval Rajasthan.* Studies in Asian Art and Archaeology, vol. 21. New York: Brill, 1997.

Behl, Benoy K. *The Ajanta Caves: Artistic Wonder of Ancient Buddhist India.* New York: Abrams, 1998.

Behrendt, Kurt A. *The Buddhist Architecture of Gandhara.* Handbook of Oriental Studies: Section Two: India, vol. 17. Boston: Brill, 2004.

Chakrabarti, Dilip K. *India, an Archaeological History: Palaeolithic Beginnings to Early Historic Foundations.* 2nd ed. New York: Oxford Univ. Press, 2009.

Craven, Roy C. *Indian Art: A Concise History.* Rev. ed. World of Art. New York: Thames & Hudson, 1997.

Czuma, Stanisław J. *Kushan Sculpture: Images from Early India.* Cleveland: Cleveland Museum of Art, 1985.

Dehejia, Vidya. *Art of the Imperial Cholas.* New York: Columbia Univ. Press, 1990.

———. *The Sensuous and the Sacred: Chola Bronzes from South India.* New York: American Federation of Arts, 2002.

Dessai, Vishakha N., and Darielle Mason, eds. *Gods, Guardians, and Lovers: Temple Sculptures from North India, a.d. 700–1200.* New York: Asia Society Galleries, 1993.

Dhavalikar, Madhukar Keshav. *Ellora.* New York: Oxford Univ. Press, 2003.

Girard-Geslan, Maud. *Art of Southeast Asia.* Trans. J. A. Underwood. New York: Abrams, Inc., 1998.

Heller, Amy. *Early Himalayan Art.* Oxford: Ashmolean Museum, 2008.

Huntington, Susan L. *The Art of Ancient India: Buddhist, Hindu, Jain.* New York: Weatherhill, 1985.

———. *Leaves from the Bodhi Tree: The Art of Pala India (8th–12th Centuries) and Its International Legacy.* Dayton, OH: Dayton Art Institute, 1990.

Hutt, Michael. *Nepal: A Guide to the Art and Architecture of the Kathmandu Valley.* Boston: Shambhala, 1995.

Knox, Robert. *Amaravati: Buddhist Sculpture from the Great Stupa.* London: British Museum Press, 1992.

Khanna, Sucharita. *Dancing Divinities in Indian Art: 8th–12th Century a.d.* Delhi: Sharada Pub. House, 1999.

Kramrisch, Stella. *The Art of Nepal.* New York: Abrams, 1964.

———. *The Presence of Siva.* Princeton: Princeton Univ. Press, 1981.

Meister, Michael, ed. *Encyclopedia of Indian Temple Architecture.* 2 vols. in 7. Philadelphia: Univ. of Pennsylvania Press, 1983.

Michell, George. *Elephanta.* Bombay: India Book House, 2002.

———. *Hindu Art and Architecture.* World of Art. London: Thames & Hudson, 2000.

Mitter, Partha. *Indian Art.* Oxford History of Art. Oxford: Oxford Univ. Press, 2001.

Neumayer, Erwin. *Lines on Stone: The Prehistoric Rock Art of India*. New Delhi: Manohar, 1993.

Pal, Pratapaditya, ed. *The Ideal Image: The Gupta Sculptural Tradition and Its Influence*. New York: Asia Society, 1978.

Poster, Amy G. *From Indian Earth: 4,000 Years of Terracotta Art*. Brooklyn, NY: Brooklyn Museum, 1986.

Skelton, Robert, and Mark Francis. *Arts of Bengal: The Heritage of Bangladesh and Eastern India*. London: Whitechapel Art Gallery, 1979.

Stierlin, Henri. *Hindu India: From Khajuraho to the Temple City of Madurai*. Taschen's World Architecture. New York: Taschen, 1998.

Tadgell, Christopher. *India and South-East Asia: The Buddhist and Hindu Tradition*. New York: Whitney Library of Design, 1998.

Williams, Joanna G. *Art of Gupta India, Empire and Province*. Princeton: Princeton Univ. Press, 1982.

### Chapter 10 Chinese and Korean Art before 1279

Ciarla, Roberto, ed. *The Eternal Army: The Terracotta Soldiers of the First Chinese Emperor*. Vercelli: White Star, 2005.

Fong, Wen, ed. *Beyond Representation: Chinese Painting and Calligraphy, 8th–14th Century*. Princeton Monographs in Art and Archaeology, 48. New York: Metropolitan Museum of Art, 1992.

Fraser, Sarah Elizabeth. *Performing the Visual: The Practice of Buddhist Wall Painting in China and Central Asia, 618–960*. Stanford, CA: Stanford Univ. Press, 2004.

James, Jean M. *A Guide to the Tomb and Shrine Art of the Han Dynasty 206 b.c.–a.d. 220*. Chinese Studies, 2. Lewiston, NY: Mellen Press, 1996.

Karetzky, Patricia Eichenbaum. *Court Art of the Tang*. Lanham, MD: Univ. Press of America, 1996.

Kim, Kumja Paik. *Goryeo Dynasty: Korea's Age of Enlightenment, 918–1392*. San Francisco: Asian Art Museum—Chong-Moon Lee Center for Asian Art and Culture in cooperation with the National Museum of Korea and the Nara National Museum, 2003.

Li, Jian, ed. *The Glory of the Silk Road: Art from Ancient China*. Dayton, OH: Dayton Art Institute, 2003.

Little, Stephen, and Shawn Eichman. *Taoism and the Arts of China*. Chicago: Art Institute of Chicago, 2000.

Liu, Cary Y., Dora C.Y. Ching, and Judith G. Smith, eds. *Character & Context in Chinese Calligraphy*. Princeton: Art Museum, Princeton Univ., 1999.

Luo, Zhewen. *Ancient Pagodas in China*. Beijing, China: Foreign Languages Press, 1994.

Ma, Chengyuan. *Ancient Chinese Bronzes*. Ed. Hsio-Yen Shih. Hong Kong: Oxford Univ. Press, 1986.

Murck, Alfreda. *Poetry and Painting in Song China: The Subtle Art of Dissent*. Harvard-Yenching Institute Monograph Series. Cambridge, MA: Harvard Univ. Asia Center for the Harvard-Yenching Institute, 2000.

Ortiz, Valérie Malenfer. *Dreaming the Southern Song Landscape: The Power of Illusion in Chinese Painting*. Studies in Asian Art and Archaeology, vol. 22. Boston: Brill, 1999.

Paludan, Ann. *Chinese Tomb Figurines*. Hong Kong: Oxford Univ. Press, 1994.

Portal, Jane. *Korea: Art and Archaeology*. New York: Thames & Hudson, 2000.

Rawson, Jessica. *Mysteries of Ancient China: New Discoveries from the Early Dynasties*. London: British Museum Press, 1996.

Rhie, Marylin M. *Early Buddhist Art of China and Central Asia*. 2 vols in 3. Handbuch der Orientalistik. Vierte Abteilung, China, 12. Leiden: Brill, 1999.

Scarpari, Maurizio. *Splendours of Ancient China*. London: Thames & Hudson, 2000.

So, Jenny F. ed. *Noble Riders from Pines and Deserts: The Artistic Legacy of the Qidan*. Hong Kong: Art Museum, Chinese Univ. of Hong Kong, 2004.

Sturman, Peter Charles. *Mi Fu: Style and the Art of Calligraphy in Northern Song*. New Haven: Yale Univ. Press, 1997.

Wang, Eugene Y. *Shaping the Lotus Sutra: Buddhist Visual Culture in Medieval China*. Seattle: Univ. of Washington Press, 2005.

Watson, William. *The Arts of China to a.d. 900*. Pelican History of Art. New Haven: Yale Univ. Press, 1995.

———. *The Arts of China 900–1620*. Pelican History of Art. New Haven: Yale Univ. Press, 2000. Reissue ed. 2003.

Watt, James C.Y. *China: Dawn of a Golden Age, 200–750 a.d.*. New York: Metropolitan Museum of Art, 2004.

Whitfield, Susan, and Ursula Sims-Williams, eds. *The Silk Road: Trade, Travel, War and Faith*. Chicago: Serindia Publications, 2004.

Wu Hung. *Monumentality in Early Chinese Art and Architecture*. Stanford: Stanford Univ. Press, 1995.

Yang, Xiaoneng, ed. *The Golden Age of Chinese Archaeology: Celebrated Discoveries from the People's Republic of China*. Washington DC: National Gallery of Art, 1999.

### Chapter 11 Japanese Art before 1333

Cunningham, Michael R. *Buddhist Treasures from Nara*. Cleveland: Cleveland Museum of Art, 1998.

Harris, Victor, ed. *Shinto: The Sacred Art of Ancient Japan*. London: British Museum Press, 2001.

Izutsu, Shinryu, and Shoryu Omori. *Sacred Treasures of Mount Koya: The Art of Japanese Shingon Buddhism*. Honolulu: Koyasan Reihokan Museum, 2002.

Kurata, Bunsaku. *Horyu-ji, Temple of the Exalted Law: Early Buddhist Art from Japan*. New York: Japan Society, 1981.

Levine, Gregory P. A., and Yukio Lippit. *Awakenings: Zen Figure Painting in Medieval Japan*. New York: Japan Society, 2007.

McCallum, Donald F. *The Four Great Temples: Buddhist Archaeology, Architecture, and Icons of Seventh-Century Japan*. Honolulu: Univ. of Hawai'i Press, 2009.

Mino, Yutaka. *The Great Eastern Temple: Treasures of Japanese Buddhist Art from Todai-ji*. Chicago: Art Institute of Chicago, 1986.

Mizoguchi, Koji. *An Archaeological History of Japan: 30,000 b.c. to a.d. 700*. Philadelphia: Univ. of Pennsylvania Press, 2002.

Murase, Miyeko. *The Tale of Genji: Legends and Paintings*. New York: Braziller, 2001.

Nishiwara, Kyotaro, and Emily J. Sano. *The Great Age of Japanese Buddhist Sculpture, a.d. 60–1300*. Fort Worth, TX: Kimbell Art Museum, 1982.

Pearson, Richard J. *Ancient Japan*. Washington, DC: Sackler Gallery, 1992.

Ten Grotenhuis, Elizabeth. *Japanese Mandalas: Representations of Sacred Geography*. Honolulu: Univ. of Hawai'i Press, 1999.

Washizuka, Hiromitsu, Park Youngbok, and Kang Woo-bang. *Transmitting the Forms of Divinity: Early Buddhist Art from Korea and Japan*. Ed. Naomi Noble Richard. New York: Japan Society, 2003.

Wong, Dorothy C., and Eric M. Field, eds. *Horyuji Reconsidered*. Newcastle: Cambridge Scholars, 2008.

### Chapter 12 Art of the Americas before 1300

Benson, Elizabeth P., and Beatriz de la Fuente. *Olmec Art of Ancient Mexico*. Washington, DC: National Gallery of Art, 1996.

Berrin, Kathleen, ed. *Feathered Serpents and Flowering Trees: Reconstructing the Murals of Teotihuacan*. San Francisco: Fine Arts Museums of San Francisco, 1988.

Brody, J. J. *Anasazi and Pueblo Painting*. Albuquerque: Univ. of New Mexico Press, 1991.

———, Catherine J. Scott, and Steven A. LeBlanc. *Mimbres Pottery: Ancient Art of the American Southwest: Essays*. New York: Hudson Hills Press in assoc. with The American Federation of Arts, 1983.

Burger, Richard L. *Chavin and the Origins of Andean Civilization*. New York: Thames & Hudson, 1992.

Clark, John E., and Mary E. Pye, eds. *Olmec Art and Archaeology in Mesoamerica*. Studies in the History of Art, 58: Symposium Papers, 35. Washington, DC: National Gallery of Art, 2000.

Clayton, Lawrence A., Vernon J. Knight, and Edward Moore, eds. *The De Soto Chronicles: The Expedition of Hernando de Soto to North America, 1539–1543*. 2 vols. Tuscaloosa: Univ. of Alabama Press, 1993.

Coe, Michael D. and Rex Koontz. *Mexico: From the Olmecs to the Aztecs*. 5th ed. New York: Thames & Hudson, 2005.

———. *Breaking the Maya Code*. Rev. ed. New York: Thames & Hudson, 1999.

Donnan, Christopher. *Moche Portraits from Ancient Peru*. Austin: Univ. of Texas Press, 2003.

Fagan, Brian M. *Chaco Canyon: Archeologists Explore the Lives of an Ancient Society*. New York: Oxford Univ. Press, 2005.

Hall, Robert L. *An Archaeology of the Soul: North American Indian Belief and Ritual*. Urbana: Univ. of Illinois Press, 1997.

Heyden, Doris, and Paul Gendrop. *Pre-Columbian Architecture of Mesoamerica*. Trans. Judith Stanton. History of World Architecture. New York: Electa/Rizzoli, 1988.

Korp, Maureen. *The Sacred Geography of the American Mound Builders*. Native American Studies. Lewiston, NY: Mellen Press, 1990.

Kubler, George. *The Art and Architecture of Ancient America: The Mexican, Maya, and Andean Peoples*. 3rd ed. with updated bib. Pelican History of Art. New Haven: Yale Univ. Press, 1993.

Labbé, Armand J. *Shamans, Gods, and Mythic Beasts: Colombian Gold and Ceramics in Antiquity*. New York: American Federation of Arts, 1998.

Loendorf, Lawrence L., Christopher Chippindale, and David S. Whitley, eds. *Discovering North American Rock Art*. Tucson: Univ. of Arizona Press, 2005.

Martin, Simon, and Nikolai Grube. *Chronicle of the Maya Kings and Queens: Deciphering the Dynasties of the Ancient Maya*. 2nd ed. New York: Thames & Hudson, 2008.

Miller, Mary Ellen. *The Art of Mesoamerica: From Olmec to Aztec*. 4th ed. World of Art. London: Thames & Hudson, 2006.

———. *Maya Art and Architecture*. World of Art. London: Thames & Hudson, 1999.

———, and Simon Martin. *Courtly Art of the Ancient Maya*. San Francisco: Fine Arts Museums of San Francisco, 2004.

———, and Karl Taube. *The Gods and Symbols of Ancient Mexico and the Maya: An Illustrated Dictionary of Mesoamerican Religion*. London: Thames & Hudson, 1993.

Milner, George R. *The Moundbuilders: Ancient Peoples of Eastern North America*. Ancient Peoples and Places, 110. London: Thames & Hudson, 2004.

Noble, David Grant. *In Search of Chaco: New Approaches to an Archaeological Enigma*. Santa Fe, NM: School of American Research Press, 2004.

O'Connor, Mallory McCane. *Lost Cities of the Ancient Southeast*. Gainesville: Univ. Press of Florida, 1995.

Pasztory, Esther. *Teotihuacan: An Experiment in Living*. Norman: Univ. of Oklahoma Press, 1997.

Pillsbury, Joanne, ed. *Moche Art and Archaeology in Ancient Peru*. Studies in the History of Art: Center for Advanced Study in the Visual Arts, 63: Symposium Papers, 40. Washington, DC: National Gallery of Art, 2001.

Power, Susan C. *Early Art of the Southeastern Indians: Feathered Serpents & Winged Beings*. Athens: Univ. of Georgia Press, 2004.

Rohn, Arthur H., and William M. Ferguson. *Puebloan Ruins of the Southwest*. Albuquerque: Univ. of New Mexico Press, 2006.

Sharer, Robert J., and Loa P. Traxler. *The Ancient Maya*. 6th ed. Stanford, CA: Stanford Univ. Press, 2006.

Stierlin, Henri. *The Maya: Palaces and Pyramids of the Rainforest*. Köln: Taschen, 2001.

Stone-Miller, Rebecca. *Art of the Andes: From Chavin to Inca*. 2nd ed. World of Art. New York: Thames & Hudson, 2002.

———. *To Weave for the Sun: Ancient Andean Textiles*. New York: Thames & Hudson 1994.

Townsend, Richard F., and Robert V. Sharp, eds. *Hero, Hawk, and Open Hand: American Indian Art of the Ancient Midwest and South*. Chicago: Art Institute of Chicago, 2004.

Von Hagen, Adriana, and Craig Morris. *The Cities of the Ancient Andes*. New York: Thames and Hudson, 1998.

### Chapter 13 Early African Art

Ben-Amos, Paula. *The Art of Benin*. Rev. ed. Washington, DC: Smithsonian Institution Press, 1995.

Berzock, Kathleen Bickford. *Benin: Royal Arts of a West African Kingdom*. Chicago: Art Institute of Chicago, 2008.

Blier, Suzanne Preston. *The Royal Arts of Africa: The Majesty of Form*. Perspectives. New York: Abrams, 1998.

Cole, Herbert M. *Igbo Arts: Community and Cosmos*. Los Angeles: Fowler Museum of Cultural History, Univ. of California, 1984.

Connah, Graham. *Forgotten Africa: An Introduction to Its Archaeology*. New York: Routledge, 2004.

Darish, Patricia J. "Memorial Head of an Oba: Ancestral Time in Benin Culture." In *Tempus Fugit, Time Flies*, edited by Jan Schall. Kansas City, MO: The Nelson Atkins Museum of Art, 2000: 290–297.

Eyo, Ekpo, and Frank Willett. *Treasures of Ancient Nigeria*. Ed. Rollyn O. Kirchbaum. New York: Knopf, 1980.

Garlake, Peter S. *Early Art and Architecture of Africa*. Oxford History of Art. Oxford: Oxford Univ. Press, 2002.

Grunne, Bernard de. *The Birth of Art in Africa: Nok Statuary in Nigeria*. Paris: A. Biro, 1998.

Huffman, Thomas N. *Symbols in Stone: Unravelling the Mystery of Great Zimbabwe*. Johannesburg: Witwatersrand Univ. Press, 1987.

LaViolette, Adria Jean. *Ethno-Achaeology in Jenné, Mali: Craft and Status among Smiths, Potters, and Masons*. Oxford: Archaeopress, 2000.

M'Bow, Babacar, and Osemwegie Ebohon. *Benin, a Kingdom in Bronze: The Royal Court Art*. Ft. Lauderdale, FL: African American Research Library and Cultural Center, Broward County Library, 2005.

Phillipson, D. W. *African Archaeology*. 3rd ed. Cambridge World Archaeology. New York: Cambridge Univ. Press, 2005.

Schädler, Karl-Ferdinand. *Earth and Ore: 2500 Years of African Art in Terra-Cotta and Metal.* Trans. Geoffrey P. Burwell. München: Panterra, 1997.

## Chapter 14 Early Medieval Art in Europe

Alexander, J. J. G. *Medieval Illuminators and Their Methods of Work.* New ed. New Haven: Yale Univ. Press, 1994.

*The Art of Medieval Spain, a.d. 500–1200.* New York: Metropolitan Museum of Art, 1993.

Backhouse, Janet, D. H. Turner, and Leslie Webster, eds. *The Golden Age of Anglo-Saxon Art, 966–1066.* Bloomington: Indiana Univ. Press, 1984.

Bandmann, Günter. *Early Medieval Architecture as Bearer of Meaning.* New York: Columbia Univ. Press, 2005.

Brown, Michelle P. *The Lindisfarne Gospels: Society, Spirituality and the Scribe.* Toronto: Univ. of Toronto Press, 2003.

Calkins, Robert G. *Illuminated Books of the Middle Ages.* Ithaca, NY: Cornell Univ. Press, 1983.

Carver, Martin. *Sutton Hoo: A Seventh-Century Princely Burial Ground and Its Context.* London: British Museum Press, 2005.

Davis-Weyer, Caecilia. *Early Medieval Art, 300–1150: Sources and Documents.* Upper Saddle River, NJ: Pearson/Prentice Hall, 1971.

Diebold, William J. *Word and Image: An Introduction to Early Medieval Art.* Boulder, CO: Westview Press, 2000.

Dodwell, C. R. *Pictorial Arts of the West, 800–1200.* Pelican History of Art. New Haven: Yale Univ. Press, 1993.

Farr, Carol. *The Book of Kells: Its Function and Audience.* London: British Library, 1997.

Fitzhugh, William W., and Elisabeth I. Ward, eds. *Vikings: The North Atlantic Saga.* Washington, DC: Smithsonian Institution Press, 2000.

Harbison, Peter. *The Golden Age of Irish Art: The Medieval Achievement, 600–1200.* London: Thames & Hudson, 1999.

Henderson, George. *From Durrow to Kells: The Insular Gospel-Books, 650–800.* London: Thames & Hudson, 1987.

Horn, Walter W., and Ernest Born. *Plan of Saint Gall: A Study of the Architecture and Economy of and Life in a Paradigmatic Carolingian Monastery.* California Studies in the History of Art, 19. 3 vols. Berkeley: Univ. of California Press, 1979.

Lasko, Peter. *Ars Sacra, 800–1200.* 2nd ed. Pelican History of Art. New Haven: Yale Univ. Press, 1994.

McClendon, Charles B. *The Origins of Medieval Architecture: Building in Europe, a.d 600–900.* New Haven: Yale Univ. Press, 2005.

Mayr-Harting, Henry. *Ottonian Book Illumination: An Historical Study.* 2nd rev. ed. 2 vols. London: Harvey Miller, 1999.

Mentré, Mireille. *Illuminated Manuscripts of Medieval Spain.* New York: Thames & Hudson, 1996.

Nees, Lawrence. *Early Medieval Art.* Oxford History of Art. Oxford: Oxford Univ. Press, 2002.

Richardson, Hilary, and John Scarry. *An Introduction to Irish High Crosses.* Dublin: Mercier, 1990.

Schapiro, Meyer. *Language of Forms: Lectures on Insular Manuscript Art.* Ed. Jane Rosenthal. New York: Pierpont Morgan Library, 2006.

Stalley, R. A. *Early Medieval Architecture.* Oxford History of Art. Oxford: Oxford Univ. Press, 1999.

Wickham, Chris. *Framing the Early Middle Ages: Europe and the Mediterranean 400–800.* New York: Oxford Univ. Press, 2005.

Williams, John. *Early Spanish Manuscript Illumination.* New York: Braziller, 1977.

Wilson, David M. *Anglo-Saxon Art: From the Seventh Century to the Norman Conquest.* London: Thames & Hudson, 1984.

———, and Ole Klindt-Jensen. *Viking Art.* 2nd ed. Minneapolis: Univ. of Minnesota Press, 1980.

## Chapter 15 Romanesque Art

Barral i Altet, Xavier. *The Romanesque: Towns, Cathedrals and Monasteries.* Taschen's World Architecture. New York: Taschen, 1998.

Bernard of Clairvaux. *"Apologia to Abbot William."* In *Treatises I.* The Work of Bernard of Clairvaux, 1: Cistercian Fathers Series, 1. Shannon, Ireland: Irish Univ. Press, 1970: 33–69.

*The Book of Sainte Foy.* Ed. and trans. Pamela Sheingorn. Philadelphia: Univ. of Pennsylvania Press, 1995.

Cahn, Walter. *Romanesque Manuscripts: The Twelfth Century.* 2nd ed. 2 vols. A Survey of Manuscripts Illuminated in France. London: Harvey Miller, 1996.

Caviness, Madeline H. *"Hildegard as Designer of the Illustrations to her Works."* In *Hildegard of Bingen: The Context of her Thought and Art,* edited by Charles Burnett and Peter Dronke. London: Warburg Institute, 1998: 29–63.

Davis-Weyer, Caecilia. *Early Medieval Art, 300–1150. Sources and Documents.* Upper Saddle River, NJ: Pearson/Prentice Hall, 1971.

Dimier, Anselme. *Stones Laid before the Lord: A History of Monastic Architecture.* Trans. Gilchrist Lavigne. Cistercian Studies Series, no. 152. Kalamazoo, MI: Cistercian Publications. 1999.

Fergusson, Peter. *Architecture of Solitude: Cistercian Abbeys in Twelfth-Century England.* Princeton: Princeton Univ. Press, 1984.

Forsyth, Ilene H. *The Throne of Wisdom: Wood Sculptures of the Madonna in Romanesque France.* Princeton: Princeton Univ. Press, 1972.

Gaud, Henri, and Jean-François Leroux-Dhuys. *Cistercian Abbeys: History and Architecture.* Köln: Könemann, 1998.

Gerson, Paula, ed. *The Pilgrim's Guide to Santiago de Compostela: A Critical Edition.* 2 vols. London: Harvey Miller, 1998.

Grivot, Denis, and George Zarnecki. *Gislebertus: Sculptor of Autun.* New York: Orion Press, 1961.

Hearn, M. F. *Romanesque Sculpture: The Revival of Monumental Stone Sculptures in the Eleventh and Twelfth Centuries.* Ithaca, NY: Cornell Univ. Press, 1981.

Hicks, Carola. *The Bayeux Tapestry: The Life Story of a Masterpiece.* London: Chatto & Windus, 2006.

Hourihane, Colum, ed. *Romanesque Art and Thought in the Twelfth Century: Essays in Honor of Walter Cahn.* The Index of Christian Art Occasional Papers 10. University Park, PA: Penn State Press, 2008.

Kubach, Hans E. *Romanesque Architecture.* History of World Architecture. New York: Electa/Rizzoli, 1988.

Minne-Sève, Viviane, and Hervé Kergall. *Romanesque and Gothic France: Architecture and Sculpture.* Trans. Jack Hawkes and Lory Frankel. New York: Abrams, 2000.

Newman, Barbara. *Sister of Wisdom: St. Hildegard's Theology of the Feminine.* 2nd ed. Berkeley: Univ. of California Press, 1997.

Schapiro, Meyer. *Romanesque Art: Selected Papers.* New York: George Braziller, 1977.

———. *The Romanesque Sculpture of Moissac.* New York: Braziller, 1985.

———. *Romanesque Architectural Sculpture: The Charles Eliot Norton Lectures.* Ed. Linda Seidel. Chicago: Univ. of Chicago Press, 2006.

Seidel, Linda. *Legends in Limestone: Lazarus, Gislebertus, and the Cathedral of Autun.* Chicago: Univ. of Chicago Press, 1999.

Sundell, Michael G. *Mosaics in the Eternal City.* Tempe: Arizona Center for Medieval and Renaissance Studies, 2007.

Swanson, R. N. *The Twelfth-Century Renaissance.* Manchester: Manchester Univ. Press, 1999.

Theophilus. *On Divers Arts: The Foremost Medieval Treatise on Painting, Glassmaking, and Metalwork.* Trans. John G. Hawthorne and Cyril Stanley Smith. New York: Dover, 1979.

Toman, Rolf, ed. *Romanesque: Architecture, Sculpture, Painting.* Trans. Fiona Hulse and Ian Macmillan. Köln: Könemann, 1997.

Wilson, David M. *The Bayeux Tapestry: The Complete Tapestry in Color.* London: Thames & Hudson and New York: Knopf, 2004.

Zarnecki, George. Janet Holt, and Tristam Holland, eds. *English Romanesque Art, 1066–1200.* London: Weidenfeld and Nicolson, 1984.

## Chapter 16 Gothic Art of the Twelfth and Thirteenth Centuries

Barnes, Carl F. *The Portfolio of Villard de Honnecourt: A New Critical Edition and Color Facsimile.* Burlington, VT: Ashgate, 2009.

Binding, Günther. *High Gothic: The Age of the Great Cathedrals.* Taschen's World Architecture. London: Taschen, 1999.

Binski, Paul. *Becket's Crown: Art and Imagination in Gothic England, 1170–1300.* New Haven: Yale Univ. Press, 2004.

Bony, Jean. *French Gothic Architecture of the 12th and 13th Centuries.* California Studies in the History of Art, 20. Berkeley: Univ. of California Press, 1983.

Camille, Michael. *Gothic Art: Glorious Visions.* Perspectives. New York: Abrams, 1996.

Cennini, Cennino. *The Craftsman's Handbook "Il libro dell'arte".* Trans. D.V. Thompson, Jr. New York: Dover, 1960.

Coldstream, Nicola. *Masons and Sculptors.* Toronto and Buffalo, NY: Univ. of Toronto Press, 1991.

Crosby, Sumner M. *The Royal Abbey of Saint-Denis from Its Beginnings to the Death of Suger, 475–1151.* Yale Publications in the History of Art, 37. New Haven: Yale Univ. Press, 1987.

Erlande-Brandenburg, Alain. *Gothic Art.* Trans. I. Mark Paris. New York: Abrams, 1989.

Favier, Jean. *The World of Chartres.* Trans. Francisca Garvie. New York: Abrams, 1990.

Frankl, Paul. *Gothic Architecture.* Revised. Paul Crossley. Pelican History of Art. New Haven: Yale Univ. Press, 2000.

Frisch, Teresa G. *Gothic Art, 1140–c.1450: Sources and Documents.* Upper Saddle River, NJ: Pearson/Prentice Hall, 1971.

Grodecki, Louis, and Catherine Brisac. *Gothic Stained Glass, 1200–1300.* Ithaca, NY: Cornell Univ. Press, 1985.

Jordan, Alyce A. *Visualizing Kingship in the Windows of the Sainte-Chapelle.* Turnhout: Brepols, 2002.

Moskowitz, Anita Fiderer. *Nicola & Giovanni Pisano: The Pulpits: Pious Devotion, Pious Diversion.* London: Harvey Miller, 2005.

Nussbaum, Norbert. *German Gothic Church Architecture.* Trans. Scott Kleager. New Haven: Yale Univ. Press, 2000.

Panofsky, Erwin. *Abbot Suger on the Abbey Church of St.-Denis and Its Art Treasures.* 2nd ed. Ed. Gerda Panofsky-Soergel. Princeton: Princeton Univ. Press, 1979.

Parry, Stan. *Great Gothic Cathedrals of France.* New York: Viking Studio, 2001.

Sauerländer, Willibald. *Gothic Sculpture in France, 1140–1270.* Trans. Janet Sandheimer. London: Thames & Hudson, 1972.

Scott, Robert A. *The Gothic Enterprise: A Guide to Understanding the Medieval Cathedral.* Berkeley: Univ. of California Press, 2003.

Simsom, Otto Georg von. *The Gothic Cathedral: Origins of Gothic Architecture and the Medieval Concept of Order.* 3rd ed. exp. Bollingen Series. Princeton: Princeton Univ. Press, 1988.

Suckale, Robert, and Matthias Weniger. *Painting of the Gothic Era.* Ed. Ingo F. Walther. New York: Taschen, 1999.

Wieck, Roger S. *Time Sanctified: The Book of Hours in Medieval Art and Life.* 2nd ed. New York: Braziller, 2001.

Williamson, Paul. *Gothic Sculpture, 1140–1300.* Pelican History of Art. New Haven: Yale Univ. Press, 1995.

## Chapter 17 Fourteenth-Century Art in Europe

Alexander, Jonathan, and Paul Binski, eds. *Age of Chivalry: Art in Plantagenet England, 1200–1400.* London: Royal Academy of Arts, 1987.

Backhouse, Janet. *Illumination from Books of Hours.* London: British Library, 2004.

Boehm, Barbara Drake, and Jiri Fajt, eds. *Prague: The Crown of Bohemia, 1347–1437.* New York: Metropolitan Museum of Art, 2005.

Bony, Jean. *The English Decorated Style: Gothic Architecture Transformed, 1250–1350.* The Wrightsman Lectures 10th. Oxford: Phaidon Press, 1979.

Borsook, Eve. *The Mural Painters of Tuscany: From Cimabue to Andrea del Sarto.* 2nd ed. rev. & enlarged. Oxford Studies in the History of Art and Architecture. Oxford: Clarendon Press 1980.

Derbes, Anne, and Mark Sandona, eds. *The Cambridge Companion to Giotto.* Cambridge and New York: Cambridge Univ. Press, 2003.

Fajt, Jiri, ed. *Magister Theodoricus, Court Painter to Emperor Charles IV: The Pictorial Decoration of the Shrines at Karlstejn Castle.* Prague: National Gallery, 1998.

Holt, Elizabeth Gilmore, ed. *A Documentary History of Art.* 2 vols. Princeton, Princeton Univ. Press, 1982–86.

Ladis, Andrew. ed, *The Arena Chapel and the Genius of Giotto: Padua.* Giotto and the World of Early Italian Art, 2. New York: Garland, 1998.

Meiss, Millard. *Painting in Florence and Siena after the Black Death: The Arts, Religion, and Society in the Mid-Fourteenth Century.* 2nd ed. Princeton: Princeton Univ. Press, 1978.

Moskowitz, Anita Fiderer. *Italian Gothic Sculpture: c. 1250–c. 1400.* New York: Cambridge Univ. Press, 2001.

Norman, Diana, ed. *Siena, Florence, and Padua: Art, Society, and Religion 1280–1400.* 2 vols. New Haven: Yale Univ. Press, 1995.

Poeschke, Joachim. *Italian Frescoes, the Age of Giotto, 1280–1400.* New York: Abbeville Press, 2005.

Schleif, Corine. *"St. Hedwig's Personal Ivory Madonna: Women's Agency and the Powers of Possessing Portable Figures."* In *The Four Modes of Seeing: Approaches to Medieval Imagery in Honor of Madeline Harrison Caviness,* edited by Evelyn Staudinger Lane, Elizabeth Carson Paston, and Ellen M. Shortell. Farnham, Surrey: Ashgate, 2009: 282–403.

Vasari, Giorgio. *The Lives of the Artists.* Trans. Julia Conaway Bondanella and Peter Bondanella. Oxford World's Classics. New York: Oxford Univ. Press, 2008.

Welch, Evelyn S. *Art in Renaissance Italy, 1350–1500.* New ed. Oxford History of Art. Oxford: Oxford Univ. Press, 2000.

White, John. *Art and Architecture in Italy, 1250 to 1400.* 3rd ed. Pelican History of Art. Harmondsworth, UK: Penguin, 1993.

## Chapter 18 Fifteenth-Century Art in Northern Europe

*Art from the Court of Burgundy: The Patronage of Philip the Bold and John the Fearless 1364–1419.* Dijon: Musée des Beaux-Arts and Cleveland: Cleveland Museum of Art, 2004.

Baxandall, Michael. *The Limewood Sculptors of Renaissance Germany.* New Haven: Yale Univ. Press, 1980.

Blum, Shirley. *Early Netherlandish Triptychs: A Study in Patronage.* California Studies in the History of Art, 13. Berkeley: Univ. of California Press, 1969.

Borchert, Till-Holger. *Age of Van Eyck: The Mediterranean World and Early Netherlandish Painting, 1430–1530.* New York: Thames & Hudson, 2002.

Campbell, Lorne. *The Fifteenth-Century Netherlandish Schools* (National Gallery Catalogues). London: National Gallery, 1998.

Cavallo, Adolph S. *The Unicorn Tapestries at the Metropolitan Museum of Art.* New York: Metropolitan Museum of Art, 1998.

Chastel, Andrè. *French Art: The Renaissance, 1430–1620.* Paris: Flammarion, 1995.

Dhanens, Elisabeth. *Van Eyck: The Ghent Altarpiece.* New York: Viking Press, 1973.

Füssel, Stephan. *Gutenberg and the Impact of Printing.* Trans. Douglas Martin. Burlington, VT: Ashgate, 2005.

Koster, Margaret L. "The *Arnolfini Double Portrait:* A Simple Solution." *Apollo* 157 (September 2003): 3–14.

Lane, Barbara G. *The Altar and the Altarpiece: Sacramental Themes in Early Netherlandish Painting.* New York: Harper & Row, 1984.

Marks, Richard, and Paul Williamson, eds. *Gothic: Art for England 1400–1547.* London: V&A Publications, 2003.

Meiss, Millard. *French Painting in the Time of Jean de Berry: The Limbourgs and their Contemporaries.* 2 vols. New York: Braziller, 1974.

Müller, Theodor. *Sculpture in the Netherlands, Germany, France, and Spain: 1400–1500.* Trans. Elaine and William Robson Scott. Pelican History of Art. Harmondsworth, UK: Penguin, 1966.

Pächt, Otto. *Early Netherlandish Painting: From Rogier van der Weyden to Gerard David.* Ed. Monika Rosenauer. Trans. David Britt. London: Harvey Miller, 1994.

———. *Van Eyck and the Founders of Early Netherlandish Painting.* London: Miller, 1994.

Panofsky, Erwin. *Early Netherlandish Painting. Its Origins and Character.* 2 vols. Cambridge, MA: Harvard Univ. Press, 1966.

Parshall, Peter W., and Rainer Schoch. *Origins of European Printmaking: Fifteenth-Century Woodcuts and their Public.* Washington, DC: National Gallery of Art, 2005.

Plummer, John. *The Last Flowering: French Painting in Manuscripts, 1420–1530, from American Collections.* New York: Pierpont Morgan Library, 1982.

Seidel, Linda. *Jan van Eyck's Arnolfini Portrait: Stories of an Icon.* New York: Cambridge Univ. Press, 1993.

Smith, Jeffrey Chipps. *The Northern Renaissance.* London and New York: Phaidon Press, 2004.

Snyder, James. *Northern Renaissance Art: Painting, Sculpture, the Graphic Arts from 1350 to 1575.* 2nd ed. rev. Larry Silver and Henry Luttikhuizen. Upper Saddle River, NJ: Prentice Hall, 2005.

Vos, Dirk de. *The Flemish Primitives: The Masterpieces.* Princeton: Princeton Univ. Press, 2002.

Zuffi, Stefano. *European Art of the Fifteenth Century.* Trans. Brian D. Phillips. Art through the Centuries. Los Angeles: J. Paul Getty Museum, 2005.

## Chapter 19 Renaissance Art in Fifteenth-Century Italy

Adams, Laurie Schneider. *Italian Renaissance Art.* Boulder, CO: Westview Press, 2001.

Ahl, Diane Cole, ed. *The Cambridge Companion to Masaccio.* New York: Cambridge Univ. Press, 2002.

Ames-Lewis, Francis. *Drawing in Early Renaissance Italy.* 2nd ed. New Haven: Yale Univ. Press, 2000.

———. *The Intellectual Life of the Early Renaissance Artist.* New Haven: Yale Univ. Press, 2000.

Baxandall, Michael. *Painting and Experience in Fifteenth-Century Italy: A Primer in the Social History of Pictorial Style.* 2nd ed. Oxford: Oxford Univ. Press, 1988.

Boskovits, Miklós. *Italian Paintings of the Fifteenth Century.* The Collections of the National Gallery of Art. Washington, DC: National Gallery of Art, 2003.

*Botticelli and Filippino: Passion and Grace in Fifteenth-Century Florentine Painting.* Milano: Skira, 2004.

Brown, Patricia Fortini. *Art and Life in Renaissance Venice.* Perspectives. New York: Abrams, 1997. Reissue ed. Upper Saddle River, NJ: Pearson/Prentice Hall, 2006.

Christiansen, Keith, Laurence B. Kanter, and Carl Brandon Strehlke. *Painting in Renaissance Siena, 1420–1500.* New York: Metropolitan Museum of Art, 1988.

Christine, de Pisan. *The Book of the City of Ladies.* Trans. Rosalind Brown-Grant. London: Penguin Books, 1999.

Gilbert, Creighton, ed. *Italian Art, 1400–1500: Sources and Documents.* Evanston, IL: Northwestern Univ. Press, 1992.

Heydenreich, Ludwig Heinrich. *Architecture in Italy, 1400–1500.* Revised. Paul Davies. Pelican History of Art. New Haven: Yale Univ. Press, 1996.

Hind, Arthur M. *An Introduction to a History of Woodcut.* New York: Dover, 1963.

Hyman, Timothy. *Sienese Painting: The Art of a City-Republic (1278–1477).* World of Art. New York: Thames & Hudson, 2003.

King, Ross. *Brunelleschi's Dome: How a Renaissance Genius Reinvented Architecture.* New York: Walker, 2000.

Lavin, Marilyn Aronberg, ed. *Piero della Francesca and his Legacy.* Studies in the History of Art, 48: Symposium Papers, 28. Washington, DC: National Gallery of Art, 1995.

Pächt, Otto. *Venetian Painting in the 15th Century: Jacopo, Gentile and Giovanni Bellini and Andrea Mantegna.* Ed. Margareta Vyoral-Tschapka and Michael Pächt. Trans. Fiona Elliott. London: Harvey Miller, 2003.

Paoletti, John T., and Gary M. Radke. *Art in Renaissance Italy.* 3rd ed. Upper Saddle River, NJ: Pearson/Prentice Hall, 2005.

Partridge, Loren W. *The Art of Renaissance Rome, 1400–1600.* Perspectives. New York: Abrams, 1996. Reissue ed. Upper Saddle River, NJ: Pearson/Prentice Hall, 2006.

Poeschke, Joachim. *Donatello and His World: Sculpture of the Italian Renaissance.* Trans. Russell Stockman. New York: Abrams, 1993.

Pope-Hennessy, John. *Italian Renaissance Sculpture.* 4th ed. London: Phaidon Press, 1996.

Radke, Gary M., ed. *The Gates of Paradise: Lorenzo Ghiberti's Masterpiece.* New Haven: Yale Univ. Press, 2007.

Randolph, Adrian W. B. *Engaging Symbols: Gender, Politics, and Public Art in Fifteenth-Century Florence.* New Haven: Yale Univ. Press, 2002.

Troncelliti, Latifah. *The Two Parallel Realities of Alberti and Cennini: The Power of Writing and the Visual Arts in the Italian Quattrocento.* Studies in Italian Literature, vol. 14. Lewiston, NY: Mellen Press, 2004.

Turner, Richard. *Renaissance Florence: The Invention of a New Art.* Perspectives. New York: Abrams, 1997. Reissue ed. Upper Saddle River, NJ: Pearson/Prentice Hall, 2006.

Verdon, Timothy, and John Henderson, eds. *Christianity and the Renaissance: Image and Religious Imagination in the Quattrocento.* Syracuse, NY: Syracuse Univ. Press, 1990.

Walker, Paul Robert. *The Feud that Sparked the Renaissance: How Brunelleschi and Ghiberti Changed the Art World.* New York: William Morrow, 2002.

Welch, Evelyn S. *Art and Society in Italy, 1350–1500.* Oxford History of Art. Oxford: Oxford Univ. Press, 1997.

## Chapter 20 Sixteenth-Century Art in Italy

Acidini Luchinat, Cristina, et al. *The Medici, Michelangelo, & the Art of Late Renaissance Florence.* New Haven: Yale Univ. Press, 2002.

Bambach, Carmen. *Drawing and Painting in the Italian Renaissance Workshop: Theory and Practice, 1330–1600.* Cambridge: Cambridge Univ. Press, 1999.

Barriault, Anne B., ed. *Reading Vasari.* London: Philip Wilson in assoc. with the Georgia Museum of Art, 2005.

Brambilla Barcilon, Pinin. *Leonardo: The Last Supper.* Chicago: Univ. of Chicago Press, 2001.

Brown, Patricia Fortini. *Art and Life in Renaissance Venice.* Perspectives. New York: Abrams, 1997.

Cellini, Benvenuto. *Autobiography.* Rev. ed. Trans. George Bull. Penguin Classics. New York: Penguin, 1998.

Chelazzi Dini, Giulietta, Alessandro Angelini, and Bernardina Sani. *Sienese Painting: From Duccio to the Birth of the Baroque.* New York: Abrams, 1998.

Cole, Alison. *Virtue and Magnificence: Art of the Italian Renaissance Courts.* Perspectives. New York: Abrams, 1995. Reissue ed. as Art of the Italian Courts. Upper Saddle River, NJ: Pearson/Prentice Hall, 2006.

Franklin, David, ed. *Leonardo da Vinci, Michelangelo, and the Renaissance in Florence.* Ottawa: National Gallery of Canada in assoc. with Yale Univ. Press, 2005.

Freedberg, S. J. *Painting in Italy, 1500 to 1600.* 3rd ed. Pelican History of Art. New Haven: Yale Univ. Press, 1993.

Goffen, Rona. *Renaissance Rivals: Michelangelo, Leonardo, Raphael, Titian.* New Haven: Yale Univ. Press, 2002.

———. *Titian's Venus of Urbino.* Masterpieces of Western Painting. Cambridge: Cambridge Univ. Press, 1997.

———. *Titian's Women.* New Haven: Yale Univ. Press, 1997.

Hall, Marcia B. *After Raphael: Painting in Central Italy in the Sixteenth Century.* New York: Cambridge Univ. Press, 1999.

———, ed. *The Cambridge Companion to Raphael.* New York: Cambridge Univ. Press, 2005.

Hollingsworth, Mary. *Patronage in Sixteenth Century Italy.* London: John Murray, 1996.

Hopkins, Andrew. *Italian Architecture: From Michelangelo to Borromini.* World of Art. New York: Thames & Hudson, 2002.

Hughes, Anthony. *Michelangelo.* Art & Ideas. London: Phaidon Press, 1997.

Huse, Norbert, and Wolfgang Wolters. *Art of Renaissance Venice: Architecture, Sculpture and Painting, 1460–1590.* Trans. Edmund Jephcott. Chicago: Univ. of Chicago Press, 1990.

Joannides, Paul. *Titian to 1518: The Assumption of Genius.* New Haven: Yale Univ. Press, 2001.

Klein, Robert, and Henri Zerner. *Italian Art, 1500–1600: Sources and Documents.* Upper Saddle River, NJ: Pearson/Prentice Hall, 1966.

Kliemann, Julian-Matthias, and Michael Rohlmann. *Italian Frescoes: High Renaissance and Mannerism, 1510–1600.* Trans. Steven Lindberg. New York: Abbeville Press, 2004.

Landau, David, and Peter Parshall. *The Renaissance Print: 1470–1550.* New Haven: Yale Univ. Press, 1994.

Lieberman, Ralph. *Renaissance Architecture in Venice, 1450–1540.* New York: Abbeville Press, 1982.

Lotz, Wolfgang. *Architecture in Italy, 1500–1600.* Revised. Deborah Howard. Pelican History of Art. New Haven: Yale Univ. Press, 1995.

Meilman, Patricia, ed. *The Cambridge Companion to Titian.* New York: Cambridge Univ. Press, 2004.

Mitrovic, Branko. *Learning from Palladio.* New York: Norton, 2004.

Murray, Linda. *The High Renaissance and Mannerism: Italy, the North and Spain, 1500–1600.* World of Art. London: Thames & Hudson, 1995.

Partridge, Loren W. *The Art of Renaissance Rome, 1400–1600.* Perspectives. New York: Abrams, 1996.

———. *Michelangelo, the Last Judgment: A Glorious Restoration.* New York: Abrams, 1997.

Pilliod, Elizabeth. *Pontormo, Bronzino, Allori: A Genealogy of Florentine Art.* New Haven: Yale Univ. Press, 2001.

Pope-Hennessy, John. *Italian High Renaissance and Baroque Sculpture.* 4th ed. London: Phaidon Press, 1996.

Rosand, David. *Painting in Cinquecento Venice: Titian, Veronese, Tintoretto.* Rev. ed. Cambridge: Cambridge Univ. Press, 1997.

Rowe, Colin, and Leon Satkowski. *Italian Architecture of the 16th Century.* New York: Princeton Architectural Press, 2002.

Rowland, Ingrid D. *The Culture of the High Renaissance: Ancients and Moderns in Sixteenth Century Rome.* Cambridge: Cambridge Univ. Press, 1998.

Shearman, John. *Mannerism.* Harmondsworth, UK: Penguin, 1967. Reissue ed. New York: Penguin, 1990.

Vasari, Giorgio. *The Lives of the Artists.* Trans. Julia Conaway Bondanella and Peter Bondanella. Oxford World's Classics. New York: Oxford Univ. Press, 2008.

Verheyen, Egon. *The Paintings in the Studiolo of Isabella d'Este at Mantua.* Monographs on Archaeology and Fine Arts, 23. New York: New York Univ. Press, 1971.

Williams, Robert. *Art, Theory, and Culture in Sixteenth-Century Italy: From Techne to Metateche.* Cambridge: Cambridge Univ. Press, 1997.

## Chapter 21 Sixteenth-Century Art in Northern Europe and the Iberian Peninsula

Bartrum, Giulia. *Albrecht Dürer and his Legacy: The Graphic Work of a Renaissance Artist.* London: British Museum Press, 2002.

Bartrum, Giulia. *German Renaissance Prints 1490–1550.* London: British Museum Press, 1995.

Brown, Jonathan. *Painting in Spain, 1500–1700.* Pelican History of Art. New Haven: Yale Univ. Press, 1998.

Buck, Stephanie, and Jochen Sander. *Hans Holbein the Younger: Painter at the Court of Henry VIII.* Trans. Rachel Esner and Beverley Jackson. New York: Thames & Hudson, 2004.

Chapuis, Julien. *Tilman Riemenschneider: Master Sculptor of the Late Middle Ages.* Washington, DC: National Gallery of Art, 1999.

Cloulas, Ivan, and Michèle Bimbenet-Privat. *Treasures of the French Renaissance.* Trans. John Goodman. New York: Abrams, 1998.

Davies, David, and John H. Elliott. *El Greco.* London: National Gallery, 2003.

Dixon, Laurinda. *Bosch.* Art & Ideas. New York: Phaidon Press, 2003.

Foister, Susan. *Holbein and England.* New Haven: Published for Paul Mellon Centre for Studies in British Art by Yale Univ. Press, 2004.

Hayum, Andrée. *The Isenheim Altarpiece: God's Medicine and the Painter's Vision.* Princeton Essays on the Arts, 18. Princeton: Princeton Univ. Press, 1989.

Hearn, Karen, ed. *Dynasties: Painting in Tudor and Jacobean England, 1530–1630.* New York: Rizzoli, 1996.

Koerner, Joseph Leo. *The Reformation of the Image.* Chicago: Univ. of Chicago Press, 2004.

Kubler, George. *Building the Escorial.* Princeton: Princeton Univ. Press, 1982.

Nash, Susie. *Northern Renaissance Art.* Oxford History of Art. New York: Oxford Univ. Press, 2008.

Price, David Hotchkiss. *Albrecht Dürer's Renaissance: Humanism, Reformation, and the Art of Faith.* Studies in Medieval and Early Modern Civilization. Ann Arbor: Univ. of Michigan Press, 2003.

Roberts-Jones, Philippe, and Françoise Roberts-Jones. *Pieter Bruegel.* New York: Abrams, 2002.

Smith, Jeffrey Chipps. *Nuremberg, a Renaissance City, 1500–1618.* Austin: Huntington Art Gallery, Univ. of Texas, 1983.

———. *German Sculpture of the Later Renaissance, c. 1520–1580: Art in an Age of Uncertainty.* Princeton: Princeton Univ. Press, 1994.

———. *The Northern Renaissance.* London and New York: Phaidon Press, 2004.

Snyder, James. *Northern Renaissance Art: Painting, Sculpture, the Graphic Arts from 1350 to 1575.* 2nd ed. Rev. Larry Silver and Henry Luttikhuizen. Upper Saddle River, NJ: Pearson/Prentice Hall, 2005.

Strong, Roy C. *Artists of the Tudor Court: The Portrait Miniature Rediscovered, 1520–1620.* London: V&A Publications, 1983.

*The Word Made Image: Religion, Art, and Architecture in Spain and Spanish America, 1500–1600.* Fenway Court, 28. Boston: Published by the Trustees of the Isabella Stewart Gardner Museum, 1998.

Zerner, Henri. *Renaissance Art in France: The Invention of Classicism.* Paris: Flammarion, 2003.

Zorach, Rebecca. *Blood, Milk, Ink, Gold: Abundance and Excess in the French Renaissance.* Chicago: Univ. of Chicago Press, 2005.

## Chapter 22 Seventeenth Century Art in Europe

Adams, Laurie Schneider. *Key Monuments of the Baroque.* Boulder, CO: Westview Press, 2000.

Allen, Christopher. *French Painting in the Golden Age.* World of Art. New York: Thames & Hudson, 2003.

Alpers, Svetlana. *The Art of Describing: Dutch Art in the Seventeenth Century.* Chicago: Chicago Univ. Press, 1983.

———. *The Making of Rubens.* New Haven: Yale Univ. Press, 1995.

Blankert, Albert. *Rembrandt: A Genius and His Impact.* Melbourne: National Gallery of Victoria, 1997.

Boucher, Bruce. *Italian Baroque Sculpture.* World of Art. New York: Thames & Hudson, 1998.

Brown, Beverly Louise, ed. *The Genius of Rome, 1592–1623.* London: Royal Academy of Arts, 2001.

Brown, Jonathan. *Painting in Spain, 1500–1700.* Pelican History of Art. New Haven: Yale Univ. Press, 1998.

———, and Carmen Garrido. *Velásquez: The Technique of Genius.* New Haven: Yale Univ. Press, 2003.

Careri, Giovanni. *Baroques.* Tran. Alexandra Bonfante-Warren. Princeton: Princeton Univ. Press, 2003.

Chapman, H. Perry. *Rembrandt's Self-Portraits: A Study in 17th-Century Identity.* Princeton: Princeton Univ. Press, 1990.

Chong, Alan, and Wouter Kloek. *Still-Life Paintings from the Netherlands, 1550–1720.* Zwolle: Waanders, 1999.

Enggass, Robert, and Jonathan Brown. *Italian and Spanish Art, 1600–1750: Sources and Documents.* 2nd ed. Evanston, IL: Northwestern Univ. Press, 1992.

Frantis, Wayne E., ed. *The Cambridge Companion to Vermeer.* Cambridge: Cambridge Univ. Press, 2001.

———. *Dutch Seventeenth-Century Genre Painting: Its Stylistic and Thematic Evolution.* New Haven: Yale Univ. Press, 2004.

Harbison, Robert. *Reflections on Baroque.* Chicago: Univ. of Chicago Press, 2000.

Keazor, Henry. *Nicolas Poussin, 1594–1665.* Köln and London: Taschen, 2007.

Kiers, Judikje, and Fieke Tissink. *Golden Age of Dutch Art: Painting, Sculpture, Decorative Art.* London: Thames & Hudson, 2000.

Lagerlöf, Margaretha Rossholm. *Ideal Landscape: Annibale Carracci, Nicolas Poussin, and Claude Lorrain.* New Haven: Yale Univ. Press, 1990.

McPhee, Sarah. *Bernini and the Bell Towers: Architecture and Politics at the Vatican.* New Haven: Yale Univ. Press, 2002.

Millon, Henry A., ed. *The Triumph of the Baroque: Architecture in Europe, 1600–1750.* 2nd ed. rev. New York: Rizzoli, 1999.

Morrissey, Jake. *The Genius in the Design: Bernini, Borromini, and the Rivalry that Transformed Rome.* New York: William Morrow, 2005.

Puttfarken, Thomas. *Roger de Piles' Theory of Art.* New Haven: Yale Univ. Press, 1985.

Rand, Richard. *Claude Lorrain, the Painter as Draftsman: Drawings from the British Museum.* New Haven: Yale Univ. Press; Williamstown, MA: Clark Art Institute, 2006.

Ripa, Cesare. *Baroque and Rococo Pictorial Imagery. The 1758–60 Hertel Edition of Ripa's "Iconologia."* Trans. Edward A. Maser. New York: Dover, 1971.

Slive, Seymour. *Dutch Painting 1600–1800.* Pelican History of Art. New Haven: Yale Univ. Press, 1995.

Summerson, John. *Inigo Jones.* New Haven: Published for the Paul Mellon Centre for Studies in British Art by Yale Univ. Press, 2000.

Tomlinson, Janis. *From El Greco to Goya: Painting in Spain, 1561–1828.* Perspectives. New York: Abrams, 1997.

Varriano, John. *Caravaggio: The Art of Realism.* University Park, PA: The Pennsylvania State Univ. Press, 2006.

Vlieghe, Hans. *Flemish Art and Architecture, 1585–1700.* Pelican History of Art. New Haven: Yale Univ. Press, 1998. Reissue ed. 2004.

Walker, Stefanie, and Frederick Hammond, eds. *Life and the Arts in the Baroque Palaces of Rome: Ambiente Barocco.* New Haven: Yale Univ. Press; for the Bard Graduate Center for Studies in the Decorative Arts, New York, 1999.

Wheelock Jr., Arthur K. *Flemish Paintings of the Seventeenth Century.* Washington, DC: National Gallery of Art, 2005.

Wittkower, Rudolf. *Art and Architecture in Italy, 1600–1750.* 3 vols. 6th ed. Revised. Joseph Connors and Jennifer Montague. Pelican History of Art. New Haven: Yale Univ. Press, 1999.

Zega, Andrew, and Bernd H. Dams. *Palaces of the Sun King: Versailles, Trianon, Marly: The Châteaux of Louis XIV.* New York: Rizzoli, 2002.

## Chapter 23 Art of South and Southeast Asia after 1200

Asher, Catherine B. *Architecture of Mughal India.* New York: Cambridge Univ. Press, 1992.

Beach, Milo Cleveland. *Mughal and Rajput Painting.* New York: Cambridge Univ. Press, 1992.

Guy, John, and Deborah Swallow, eds. *Arts of India, 1550–1900.* London: V&A Publications, 1990.

Khanna, Balraj, and Aziz Kurtha. *Art of Modern India.* London: Thames & Hudson, 1998.

Koch, Ebba. *Mughal Art and Imperial Ideology: Collected Essays.* New Delhi: Oxford Univ. Press, 2001.

Michell, George. *Hindu Art and Architecture.* World of Art. London: Thames & Hudson, 2000.

Miller, Barbara Stoler (trans.). *Love Song of the Dark Lord: Jayadeva's Gitagovinda.* New York: Columbia Univ. Press, 1977.

Moynihan, Elizabeth B., ed. *The Moonlight Garden: New Discoveries at the Taj Mahal.* Asian Art & Culture. Washington, DC: Arthur M. Sackler Gallery, Smithsonian Institution Press, 2000.

Nou, Jean-Louis. *Taj Mahal.* Text by Amina Okada and M. C. Joshi. New York: Abbeville Press, 1993.

Pal, Pratapaditya. *Court Paintings of India, 16th–19th Centuries.* New York: Navin Kumar, 1983.

———. *The Peaceful Liberators: Jain Art from India.* New York: Thames & Hudson, 1994.

Rossi, Barbara. *From the Ocean of Painting: India's Popular Paintings, 1589 to the Present.* New York: Oxford Univ. Press, 1998.

Schimmel, Annemarie. *The Empire of the Great Mughals: History, Art and Culture.* Ed. Burzine K. Waghmar. Trans. Corinne Attwood. London: Reaktion Books, 2004.

Stronge, Susan. *Painting for the Mughal Emperor: The Art of the Book, 1560–1660.* London: V&A Publications, 2002.

Tillotson, G. H. R. *Mughal India.* Architectural Guides for Travelers. San Francisco: Chronicle Books, 1990.

———. *The Tradition of Indian Architecture: Continuity, Controversy and Change since 1850.* New Haven: Yale Univ. Press, 1989.

Verma, Som Prakash. *Painting the Mughal Experience.* New York: Oxford Univ. Press, 2005.

Welch, Stuart Cary. *The Emperors' Album: Images of Mughal India.* New York: Metropolitan Museum of Art, 1987.

———. *India: Art and Culture 1300–1900.* New York: Metropolitan Museum of Art, 1985.

## Chapter 24 Chinese and Korean Art after 1279

Andrews, Julia Frances, and Kuiyi Shen. *A Century in Crisis: Modernity and Tradition in the Art of Twentieth-Century China.* New York: Solomon R. Guggenheim Museum, 1998.

Barnhart, Richard M. *Painters of the Great Ming: The Imperial Court and the Zhe School.* Dallas: Dallas Museum of Art, 1993.

Barrass, Gordon S. *The Art of Calligraphy in Modern China.* London: British Museum Press, 2002.

Berger, Patricia Ann. *Empire of Emptiness: Buddhist Art and Political Authority in Qing China.* Honolulu: Univ. of Hawai'i Press, 2003.

Bickford, Maggie. *Ink Plum: The Making of a Chinese Scholar-Painting.* New York: Cambridge Univ. Press, 1996.

Billeter, Jean François. *The Chinese Art of Writing.* New York: Skira/Rizzoli, 1990.

Bush, Susan, and Hsio-yen Shih, eds. *Early Chinese Texts on Painting.* Cambridge, MA: Harvard Univ. Press, 1985.

Cahill, James. *The Distant Mountains: Chinese Painting in the Late Ming Dynasty, 1580–1644.* New York: Weatherhill, 1982.

———. *Hills beyond a River: Chinese Painting of the Yuan Dynasty, 1279–1368.* New York: Weatherhill, 1976.

———. *Parting at the Shore: Chinese Painting of the Early and Middle Ming Dynasty 1368–1580.* New York: Weatherhill, 1978.

Chaves, Jonathan (trans.). *The Chinese Painter as Poet.* New York: Art Media Resources, 2000.

Chung, Anita. *Drawing Boundaries: Architectural Images in Qing China.* Honolulu: Univ. of Hawai'i Press, 2004.

Clunas, Craig. *Pictures and Visuality in Early Modern China.* Princeton: Princeton Univ. Press, 1997.

Fang, Jing Pei. *Treasures of the Chinese Scholar: Form, Function and Symbolism.* Ed. J. May Lee Barrett. New York: Weatherhill, 1997.

Fong, Wen C. *Between Two Cultures: Late-Nineteenth- and Twentieth-Century Chinese Paintings from the Robert H. Ellsworth Collection in the Metropolitan Museum of Art.* New York: Metropolitan Museum of Art, 2001.

Hearn, Maxwell K., and Judith G. Smith, eds. *Chinese Art: Modern Expressions.* New York: Dept. of Asian Art, Metropolitan Museum of Art, 2001.

Ho, Chuimei, and Bennet Bronson. *Splendors of China's Forbidden City: The Glorious Reign of Emperor Qianlong.* Chicago: Field Museum, 2004.

Ho, Wai-kam, ed.. *The Century of Tung Ch'i-ch'ang, 1555–1636.* 2 vols. Kansas City: Nelson-Atkins Museum of Art, 1992.

Kim, Hongnam. *The Life of a Patron: Zhou Lianggong (1612–1672) and the Painters of Seventeenth-Century China.* New York: China Institute in America, 1996.

Knapp, Ronald G. *China's Vernacular Architecture: House Form and Culture.* Honolulu: Univ. of Hawai'i Press, 1989.

Lee, Sherman, and Wai-Kam Ho. *Chinese Art under the Mongols: The Y'uan Dynasty, 1279–1368.* Cleveland: Cleveland Museum of Art, 1968.

Lim, Lucy. ed. *Wu Guanzhong: A Contemporary Chinese Artist.* San Francisco: Chinese Culture Foundation, 1989.

Moss, Paul. *Escape from the Dusty World: Chinese Paintings and Literati Works of Art.* London: Sydney L. Moss, 1999.

Ng, So Kam. *Brushstrokes: Styles and Techniques of Chinese Painting.* San Francisco: Asian Art Museum of San Francisco, 1993.

*The Poetry [of] Ink: The Korean Literati Tradition, 1392–1910.* Paris: Réunion des Musées Nationaux: Musée National des Arts Asiatiques Guimet, 2005.

Smith, Karen. *Nine Lives: The Birth of Avant-Garde Art in New China.* Zurich: Scalo, 2006.

Till, Barry. *The Manchu Era (1644–1912), Arts of China's Last Imperial Dynasty.* Victoria, BC: Art Gallery of Greater Victoria, 2004.

Vainker, S. J. *Chinese Pottery and Porcelain: From Prehistory to the Present.* London: British Museum Press, 1991.

Watson, William. *The Arts of China 900–1620.* Pelican History of Art. New Haven: Yale Univ. Press, 2000.

Weidner, Marsha Smith. *Views from Jade Terrace: Chinese Women Artists, 1300–1912.* Indianapolis, IN: Indianapolis Museum of Art, 1988.

Xinian, Fu, et al. *Chinese Architecture.* Ed. Nancy S. Steinhardt. New Haven: Yale Univ. Press, 2002.

## Chapter 25 Japanese Art after 1333

Addiss, Stephen. *The Art of Zen: Painting and Calligraphy by Japanese Monks, 1600–1925.* New York: Abrams, 1989.

Berthier, François. *Reading Zen in the Rocks: The Japanese Dry Landscape Garden.* Trans. & essay, Graham Parkes. Chicago: Univ. of Chicago Press, 2000.

Calza, Gian Carlo. *Ukiyo-e.* New York: Phaidon Press, 2005.

Graham, Patricia J. *Faith and Power in Japanese Buddhist Art, 1600–2005.* Honolulu: Univ. of Hawai'i, 2007.

————. *Tea of the Sages: The Art of Sencha.* Honolulu: Univ. of Hawai'i, 1998.

Guth, Christine. *Art of Edo Japan: The Artist and the City 1615–1868.* Perspectives. New York: Abrams, 1996.

Hickman, Money L. *Japan's Golden Age: Momoyama.* New Haven: Yale Univ. Press, 1996.

Kobayashi, Tadashi, and Lisa Rotondo-McCord. *An Enduring Vision: 17th to 20th Century Japanese Painting from the Gitter-Yelen Collection.* New Orleans: New Orleans Museum of Art, 2003.

Lillehoji, Elizabeth, ed. *Critical Perspectives on Classicism in Japanese Painting, 1600–1700.* Honolulu: Univ. of Hawai'i Press, 2004.

McKelway, Matthew P. *Traditions Unbound: Groundbreaking Painters of Eighteenth-Century Kyoto.* San Francisco: Asian Art Museum – Chong-Moon Lee Center, 2005.

Meech, Julia, and Jane Oliver. *Designed for Pleasure: The World of Edo Japan in Prints and Paintings, 1680–1860.* Seattle: Univ. of Washington Press in association with the Asia Society and Japanese Art Society of America, New York, 2008.

Miyajima, Shin'ichi and Sato Yasuhiro. *Japanese Ink Painting.* Ed. George Kuwayama. Los Angeles: Los Angeles County Museum of Art, 1985.

Munroe, Alexandra. *Japanese Art after 1945: Scream Against the Sky.* New York: Abrams, 1994.

Murase, Miyeko, ed. *Turning Point: Oribe and the Arts of Sixteenth-Century Japan.* New York: Metropolitan Museum of Art, 2003.

Newland, Amy Reigle, ed. *The Hotei Encyclopedia of Japanese Woodblock Prints.* 2 vols. Amsterdam: Hotei Publishing, 2005.

Ohki, Sadako. *Tea Culture of Japan.* New Haven: Yale Univ. Press, 2009.

Rousmaniere, Nicole, ed. *Crafting Beauty in Modern Japan: Celebrating Fifty Years of the Japan Traditional Art Crafts Exhibition.* Seattle: Univ. of Washington Press, 2007.

Screech, Timon. *The Lens Within the Heart: The Western Scientific Gaze and Popular Imagery in Later Edo Japan.* 2nd ed. Honolulu: Univ. of Hawai'i Press, 2002.

Singer, Robert T., and John T. Carpenter. *Edo, Art in Japan 1615–1868.* Washington, DC: National Gallery of Art, 1998.

## Chapter 26 Art of the Americas after 1300

Bauer, Brian S. *Ancient Cuzco: Heartland of the Inca.* Joe R. and Teresa Lozano Long Series in Latin American and Latino Art and Culture. Austin: Univ. of Texas Press, 2004.

Berlo, Janet Catherine, and Ruth B. Phillips. *Native North American Art.* Oxford History of Art. Oxford: Oxford Univ. Press, 1998.

Bringhurst, Robert. *The Black Canoe: Bill Reid and the Spirit of Haida Gwaii.* Seattle: Univ. of Washington Press, 1991.

Burger, Richard L., and Lucy C. Salazar, eds. *Machu Picchu: Unveiling the Mystery of the Incas.* New Haven: Yale Univ. Press, 2004.

Fields, Virginia M., and Victor Zamudio-Taylor. *The Road to Aztlan: Art from a Mythic Homeland.* Los Angeles: Los Angeles County Museum of Art, 2001.

Griffin-Pierce, Trudy. *Earth is my Mother, Sky is my Father: Space, Time, and Astronomy in Navajo Sandpainting.* Albuquerque: Univ. of New Mexico Press, 1992.

Jonaitis, Aldona. *Art of the Northwest Coast.* Seattle: Univ. of Washington Press, 2006.

Kaufman, Alice, and Christopher Selser. *The Navajo Weaving Tradition: 1650 to the Present.* New York: Dutton, 1985.

Macnair, Peter L., Robert Joseph, and Bruce Grenville. *Down from the Shimmering Sky: Masks of the Northwest Coast.* Vancouver: Douglas & McIntyre, 1998.

Matos Moctezuma, Eduardo, and Felipe R. Solis Olguin. *Aztecs.* London: Royal Academy of Arts, 2002.

Matthews, Washington. *The Night Chant: A Navaho Ceremony* in Memoirs of the American Museum of Natural History, vol. 6. New York, 1902.

Moseley, Michael E. *The Incas and Their Ancestors: The Archaeology of Peru.* Rev. ed. London: Thames & Hudson, 2001.

Nabokov, Peter, and Robert Easton. *Native American Architecture.* New York: Oxford Univ. Press, 1989.

Pasztory, Esther. *Aztec Art.* Norman: Univ. of Oklahoma Press, 2000.

Rushing III, W. Jackson, ed. *Native American Art in the Twentieth Century: Makers, Meanings, Histories.* New York: Routledge, 1999.

Shaw, George Everett. *Art of the Ancestors: Antique North American Indian Art.* Aspen, CO: Aspen Art Museum, 2004.

Taylor, Colin F. *Buckskin & Buffalo: The Artistry of the Plains Indians.* New York: Rizzoli, 1998.

Townsend, Richard F., ed. *The Aztecs.* 2nd rev. ed. Ancient Peoples and Places. London: Thames & Hudson, 2000.

Trimble, Stephen. *Talking with the Clay: The Art of Pueblo Pottery in the 21st Century.* 20th anniversary. rev ed. Santa Fe. NM: School for Advanced Research Press, 2007.

Wood, Nancy C. *Taos Pueblo.* New York: Knopf, 1989.

## Chapter 27 Art of Pacific Cultures

Caruana, Wally. *Aboriginal Art.* 2nd ed. World of Art. New York: Thames & Hudson, 2003.

Craig, Barry, Bernie Kernot, and Christopher Anderson, eds. *Art and Performance in Oceania.* Honolulu: Univ. of Hawai'i Press, 1999.

D'Alleva, Anne. *Arts of the Pacific Islands.* Perspectives. New York: Abrams, 1998.

Herle, Anita, et al. *Pacific Art: Persistence, Change, and Meaning.* Honolulu: Univ. of Hawai'i Press, 2002.

Kaeppler, Adrienne Lois, Christian Kaufmann, and Douglas Newton. *Oceanic Art.* Trans. Nora Scott and Sabine Bouladon. New York: Abrams, 1997.

Kirch, Patrick Vinton. *The Lapita Peoples: Ancestors of the Oceanic World.* The Peoples of South-East Asia and the Pacific. Cambridge, MA: Blackwell, 1997.

Kjellgren, Eric. *Splendid Isolation: Art of Easter Island.* New York: Metropolitan Museum of Art, 2001.

————, and Carol Ivory. *Adorning the World: Art of the Marquesas Islands.* New Haven: Yale Univ. Press in association with the Metropolitan Museum of Art, 2005.

Küchler, Susanne, and Graeme Were. *Pacific Pattern.* London: Thames & Hudson, 2005.

Lilley, Ian, ed. *Archaeology of Oceania: Australia and the Pacific Islands.* Malden, MA: Blackwell, 2006.

McCulloch, Susan. *Contemporary Aboriginal Art: A Guide to the Rebirth of an Ancient Culture.* Rev. ed. Crows Nest, NSW, Australia: Allen & Unwin, 2001.

Moore, Albert C. *Arts in the Religions of the Pacific: Symbols of Life.* Religion and the Arts Series. New York: Pinter, 1995.

Morphy, Howard. *Aboriginal Art.* London: Phaidon Press, 1998.

Morwood, M. J. *Visions from the Past: The Archaeology of Australian Aboriginal Art.* Washington, DC: Smithsonian Institution Press, 2002.

Neich, Roger, and Mick Pendergrast. *Traditional Tapa Textiles of the Pacific.* London: Thames & Hudson, 1997.

Newton, Douglas, ed. *Arts of the South Seas: Island Southeast Asia, Melanesia, Polynesia, Micronesia; The Collections of the Musée Barbier-Mueller.* Trans. David Radzinowicz Howell. New York: Prestel, 1999.

Rainbird, Paul. *The Archaeology of Micronesia.* Cambridge World Archaeology. New York: Cambridge Univ. Press, 2004.

Smidt, Dirk, ed. *Asmat Art: Woodcarvings of Southwest New Guinea.* New York: George Braziller in assoc. with Rijksmuseum voor Volkenkunde, Leiden, 1993.

Starzecka, D. C., ed. *Maori Art and Culture.* London: British Museum Press, 1996.

Taylor, Luke. *Seeing the Inside: Bark Painting in Western Arnhem Land.* Oxford Studies in Social and Cultural Anthropology. New York: Oxford Univ. Press, 1996.

Thomas, Nicholas. *Oceanic Art.* World of Art. New York: Thames & Hudson, 1995.

————, Anna Cole and Bronwen Douglas, eds. *Tattoo: Bodies, Art, and Exchange in the Pacific and the West.* Durham, NC: Duke Univ. Press, 2005.

## Chapter 28 Art of Africa in the Modern Era

Anatsui, El. *El Anatsui Gawu.* Llandudno, Wales, UK: Oriel Mostyn Gallery, 2003.

*Astonishment and Power.* Washington, DC: National Museum of African Art, Smithsonian Institution Press, 1993.

Beckwith, Carol, and Angela Fisher. *African Ceremonies.* 2 vols. New York: Abrams, 1999.

Binkley, David A. "Avatar of Power: Southern Kuba Masquerade Figures in a Funerary Context" in *Africa-Journal of the International African Institute,* 57/1 (1987): 75–97.

Cameron, Elisabeth L. *Art of the Lega.* Los Angeles: UCLA Fowler Museum of Cultural History, 2001.

Cole, Herbert M., ed. *I Am Not Myself: The Art of African Masquerade.* Los Angeles: Fowler Museum of Cultural History, Univ. of California, 1985.

————. *Icons: Ideals and Power in the Art of Africa.* Washington, DC: National Museum of African Art, Smithsonian Institution Press, 1989.

*A Fiction of Authenticity: Contemporary Africa Abroad.* St. Louis, MO: Contemporary Art Museum St. Louis, 2003.

Fogle, Douglas, and Olukemi Ilesanmi. *Julie Mehretu: Drawing into Painting.* Minneapolis, MN: Walker Art Center, 2003.

Gillow, John. *African Textiles.* San Francisco: Chronicle Books, 2003.

Graham, Gilbert. *Dogon Sculpture: Symbols of a Mythical Universe.* Brookville, NY: Hillwood Art Museum, Long Island Univ., C. W. Post Campus, 1997.

Hess, Janet Berry. *Art and Architecture in Postcolonial Africa.* Jefferson, NC: McFarland, 2006.

Jordán, Manuel, ed. *Chokwe! Art and Initiation Among the Chokwe and Related Peoples.* Munich: Prestel, 1998.

Kasfir, Sidney Littlefield. *Contemporary African Art.* World of Art. London: Thames & Hudson, 2000.

Morris, James, and Suzanne Preston Blier. *Butabu: Adobe Architecture of West Africa.* New York: Princeton Architectural Press, 2004.

Oguibe, Olu, and Okwui Enwezor. *Reading the Contemporary: African Art from Theory to the Marketplace.* Cambridge, MA: MIT Press, 1999.

Pemberton III, John, ed. *Insight and Artistry in African Divination.* Washington, DC: Smithsonian Institution Press, 2000.

Perrois, Louis, and Marta Sierra Delage. *The Art of Equatorial Guinea: The Fang Tribes.* New York: Rizzoli, 1990.

Picton, John, et al. *El Anatsui: A Sculpted History of Africa.* London: Saffron Books in conjunction with the October Gallery, 1998.

Roberts, Mary Nooter, and Allen F. Roberts, eds. *Memory: Luba Art and the Making of History.* New York: Museum for African Art, 1996.

Roy, Christopher D. *Art of the Upper Volta Rivers.* Meudon, France: Chaffin, 1987.

Stepan, Peter. *Spirits Speak: A Celebration of African Masks.* Munich: Prestel, 2005.

Van Damme, Annemieke. *Spectacular Display: The Art of Nkanu Initiation Rituals.* Washington, DC: National Museum of African Art, Smithsonian Institution Press, 2001.

Vogel, Susan Mullin. *Baule: African Art, Western Eyes.* New Haven: Yale Univ. Press, 1997.

## Chapter 29 Eighteenth and Early Nineteenth Century Art in Europe and North America

Bailey, Colin B., Philip Conisbee, and Thomas W. Gaehtgens. *The Age of Watteau, Chardin, and Fragonard: Masterpieces of French Genre Painting.* New Haven: Yale Univ. Press in assoc. with the National Gallery of Canada, Ottawa, 2003.

Boime, Albert. *Art in an Age of Bonapartism, 1800–1815.* Chicago: Univ. of Chicago Press, 1990.

————. *Art in an Age of Counterrevolution, 1815–1848.* Chicago: Univ. of Chicago Press, 2004.

————. *Art in an Age of Revolution, 1750–1800.* Chicago: Univ. of Chicago Press, 1987.

Bowron, Edgar Peters, and Joseph J. Rishel, eds. *Art in Rome in the Eighteenth Century.* London: Merrell in association with Philadelphia Museum of Art, 2000.

Brown, David Blayney. *Romanticism.* London: Phaidon Press, 2001.

Chinn, Celestine, and Kieran McCarty. *Bac: Where the Waters Gather.* Univ. of Arizona: Mission San Xavier Del Bac, 1977.

Craske, Matthew. *Art in Europe, 1700–1830: A History of the Visual Arts in an Era of Unprecedented Urban Economic Growth.* Oxford History of Art. Oxford: Oxford Univ. Press, 1997.

Denis, Rafael Cardoso, and Colin Trodd, eds. *Art and the Academy in the Nineteenth Century.* New Brunswick, NJ: Rutgers Univ. Press, 2000.

Goodman, Elise, ed. *Art and Culture in the Eighteenth Century: New Dimensions and Multiple Perspectives.* Studies in Eighteenth-Century Art and Culture. Newark: Univ. of Delaware Press, 2001.

Hofmann, Werner. *Goya: To Every Story There Belongs Another.* New York: Thames & Hudson, 2003.

Irwin, David G. *Neoclassicism.* Art & Ideas. London: Phaidon Press, 1997.

Jarrassé, Dominique. *18th-Century French Painting.* Trans. Murray Wyllie. Paris: Terrail, 1999.

Kalnein, Wend von. *Architecture in France in the Eighteenth Century.* Trans. David Britt. Pelican History of Art. New Haven: Yale Univ. Press, 1995.

Levey, Michael. *Painting in Eighteenth-Century Venice.* 3rd ed. New Haven: Yale Univ. Press, 1994.

Lewis, Michael J. *The Gothic Revival.* World of Art. New York: Thames & Hudson, 2002.

Lovell, Margaretta M. *Art in a Season of Revolution: Painters, Artisans, and Patrons in Early America*. Early American Studies. Philadelphia: Univ. of Pennsylvania Press, 2005.

Monneret, Sophie. *David and Neo-Classicism*. Trans. Chris Miller and Peter Snowdon. Paris: Terrail, 1999.

Montgomery, Charles F., and Patrick E. Kane, eds. *American Art, 1750–1800: Towards Independence*. Boston: New York Graphic Society, 1976.

Natter, Tobias, ed. *Angelica Kauffman: A Woman of Immense Talent*. Ostfildern: Hatje Cantz, 2007.

Porterfield, Todd, and Susan L. Siegfried. *Staging Empire: Napoleon, Ingres, and David*. University Park: Pennsylvania State Univ. Press, 2006.

Poulet, Anne L. *Jean-Antoine Houdon: Sculptor of the Enlightenment*. Washington, DC: National Gallery of Art, 2003.

Summerson, John. *Architecture of the Eighteenth Century*. World of Art. New York: Thames & Hudson, 1986.

Wilton, Andrew, and Ilaria Bignamini, eds. *Grand Tour: The Lure of Italy in the Eighteenth Century*. London: Tate Gallery, 1996.

### Chapter 30 Mid to Late Nineteenth Century Art in Europe and the United States

Adams, Steven. *The Barbizon School and the Origins of Impressionism*. London: Phaidon Press, 1994.

Bajac, Quentin. *The Invention of Photography*. Discoveries. New York: Abrams, 2002.

Barger, M. Susan, and William B. White. *The Daguerreotype: Nineteenth-Century Technology and Modern Science*. Washington, DC: Smithsonian Institution Press, 1991.

Benjamin, Roger. *Orientalist Aesthetics: Art, Colonialism, and French North Africa, 1880–1930*. Berkeley: Univ. of California Press, 2003.

Bergdoll, Barry. *European Architecture, 1750–1890*. Oxford History of Art. New York: Oxford Univ. Press, 2000.

Blühm, Andreas, and Louise Lippincott. *Light!: The Industrial Age 1750–1900: Art & Science, Technology & Society*. New York: Thames & Hudson, 2001.

Boime, Albert. *The Academy and French Painting in the Nineteenth Century*. 2nd ed. New Haven: Yale Univ. Press, 1986.

Butler, Ruth, and Suzanne G. Lindsay. *European Sculpture of the Nineteenth Century*. Washington, DC: National Gallery of Art, 2000.

Callen, Anthea. *The Art of Impressionism: Painting Technique & the Making of Modernity*. New Haven: Yale Univ. Press, 2000.

Chu, Petra ten-Doesschate. *Nineteenth Century European Art*. 2nd. ed. Upper Saddle River, NJ: Pearson/Prentice Hall, 2006.

Clark, T. J. *The Painting of Modern Life: Paris in the Art of Manet and His Followers*. Rev. ed. London: Thames & Hudson, 1999.

Conrads, Margaret C. *Winslow Homer and the Critics: Forging a National Art in the 1870s*. Princeton: Princeton Univ. Press in association with the Nelson-Atkins Museum of Art, 2001.

Denis, Rafael Cardoso, and Colin Trodd. *Art and the Academy in the Nineteenth Century*. New Brunswick, NJ: Rutgers Univ. Press, 2000.

Eisenman, Stephen F. *Nineteenth Century Art: A Critical History*. 3rd ed. New York: Thames & Hudson, 2007.

Eitner, Lorenz. *Nineteenth Century European Painting: David to Cezanne*. Rev. ed. Boulder, CO: Westview Press, 2002.

Frazier, Nancy. *Louis Sullivan and the Chicago School*. New York: Knickerbocker Press, 1998.

Fried, Michael. *Manet's Modernism, or, The Face of Painting in the 1860s*. Chicago: Univ. of Chicago Press, 1996.

Gerdts, William H. *American Impressionism*. 2nd ed. New York: Abbeville Press, 2001.

Greenhalgh, Paul, ed. *Art Nouveau, 1890–1914*. London: V&A Publications, 2000.

Grigsby, Darcy Grimaldo. *Extremities: Painting Empire in Post-Revolutionary France*. New Haven: Yale Univ. Press, 2002.

Groseclose, Barbara. *Nineteenth-Century American Art*. Oxford History of Art. Oxford: Oxford Univ. Press, 2000.

Harrison, Charles, Paul Wood, and Jason Gaiger. *Art in Theory 1815–1900: An Anthology of Changing Ideas*. Oxford: Blackwell, 1998.

Herrmann, Luke. *Nineteenth Century British Painting*. London: Giles de la Mare, 2000.

Hirsh, Sharon L. *Symbolism and Modern Urban Society*. New York: Cambridge Univ. Press, 2004.

Kaplan, Wendy. *The Arts & Crafts Movement in Europe & America: Design for the Modern World*. New York: Thames & Hudson in assoc. with the Los Angeles County Museum of Art, 2004.

Kendall, Richard. *Degas: Beyond Impressionism*. London: National Gallery, 1996.

Lambourne, Lionel. *Japonisme: Cultural Crossings between Japan and the West*. New York: Phaidon Press, 2005.

Lemoine, Bertrand. *Architecture in France, 1800–1900*. Trans. Alexandra Bonfante-Warren. New York: Abrams, 1998.

Lewis, Mary Tompkins, ed.. *Critical Readings in Impressionism and Post-Impressionism: An Anthology*. Berkeley: Univ. of California Press, 2007.

Lochnan, Katharine Jordan. *Turner Whistler Monet*. London: Tate Publishing in assoc. with the Art Gallery of Ontario, 2004.

Miller, Angela L., et al. *American Encounters: Art, History, and Cultural Identity*. Upper Saddle River, NJ: Pearson/Prentice Hall, 2008.

Noon, Patrick J. *Crossing the Channel: British and French Painting in the age of Romanticism*. London: Tate Publishing, 2003.

Pissarro, Joachim. *Pioneering Modern Painting: Cézanne & Pissarro 1865–1885*. New York: Museum of Modern Art, 2005.

Rodner, William S. *J. M. W. Turner: Romantic Painter of the Industrial Revolution*. Berkeley: Univ. of California Press, 1997.

Rosenblum, Robert, and H. W. Janson. *19th Century Art*. Rev. & updated ed. Upper Saddle River, NJ: Pearson Prentice Hall, 2005.

Rubin, James H. *Impressionism. Art & Ideas*. London: Phaidon Press, 1999.

Rybczynski, Witold. *A Clearing in the Distance: Frederick Law Olmsted and America in the Nineteenth Century*. New York: Scribner, 1999.

Smith, Paul. *Seurat and the Avant-Garde*. New Haven: Yale Univ. Press, 1997.

Thomson, Belinda. *Impressionism: Origins, Practice, Reception*. World of Art. New York: Thames & Hudson, 2000.

Twyman, Michael. *Breaking the Mould: The First Hundred Years of Lithography*. The Panizzi Lectures, 2000. London: British Library, 2001.

Vaughan, William, and Francoise Cachin. *Arts of the 19th Century*. 2 vols. New York: Abrams, 1998.

Werner, Marcia. *Pre-Raphaelite Painting and Nineteenth-Century Realism*. New York: Cambridge Univ. Press, 2005.

Zemel, Carol M. *Van Gogh's Progress: Utopia, Modernity, and Late-Nineteenth-Century Art*. California Studies in the History of Art, 36. Berkeley: Univ. of California Press, 1997.

### Chapter 31 Modern Art in Europe and The Americas, 1900–1950

Ades, Dawn, comp. *Art and Power: Europe under the Dictators, 1930–45*. Stuttgart, Germany: Oktagon in assoc. with Hayward Gallery, 1995.

Antliff, Mark, and Patricia Leighten. *Cubism and Culture*. World of Art. London: Thames & Hudson, 2001.

Bailey, David A. *Rhapsodies in Black: Art of the Harlem Renaissance*. London: Hayward Gallery, 1997.

Balken, Debra Bricker. *Debating American Modernism: Stieglitz, Duchamp, and the New York Avant-Garde*. New York: American Federation of Arts, 2003.

Barron, Stephanie, ed. *Degenerate Art: The Fate of the Avant-Garde in Nazi Germany*. Los Angeles: Los Angeles County Museum of Art, 1991.

———. and Wolf-Dieter Dube. eds. *German Expressionism: Art and Society*. New York: Rizzoli, 1997.

Bochner, Jay. *An American Lens: Scenes from Alfred Stieglitz's New York Secession*. Cambridge, MA: MIT Press, 2005.

Bohn, Willard. *The Rise of Surrealism: Cubism, Dada, and the Pursuit of the Marvelous*. Albany: State Univ. of New York Press, 2002.

Bowlt, John E., and Evgeniia Petrova, eds. *Painting Revolution: Kandinsky, Malevich and the Russian Avant-Garde*. Bethesda, MD: Foundation for International Arts and Education, 2000.

Bown, Matthew Cullerne. *Socialist Realist Painting*. New Haven: Yale Univ. Press, 1998.

Brown, Milton W. *Story of the Armory Show*. 2nd ed. New York: Abbeville Press, 1988.

Chassey, Eric de, ed. *American Art: 1908–1947, from Winslow Homer to Jackson Pollock*. Trans. Jane McDonald. Paris: Réunion des Musées Nationaux, 2001.

Corn, Wanda M. *The Great American Thing: Modern Art and National Identity, 1915–1935*. Berkeley: Univ. of California Press, 1999.

Curtis, Penelope. *Sculpture 1900–1945: After Rodin*. Oxford History of Art. Oxford: Oxford Univ. Press, 1999.

Dachy, Marc. *Dada: The Revolt of Art*. Trans. Liz Nash. New York: Abrams, 2006.

Elger, Dietmar. *Expressionism: A Revolution in German Art*. Ed. Ingo F. Walther. Trans. Hugh Beyer. New York: Taschen, 1998.

Fer, Briony. *On Abstract Art*. New Haven: Yale Univ. Press, 1997.

Fletcher, Valerie J. *Crosscurrents of Modernism: Four Latin American Pioneers: Diego Rivera, Joaquin Torres-García, Wifredo Lam, Matta*. Washington, DC: Hirshhorn Museum and Sculpture Garden in assoc. with the Smithsonian Institution Press, 1992.

Folgarait, Leonard. *Mural Painting and Social Revolution in Mexico, 1920–1940: Art of the New Order*. New York: Cambridge Univ. Press, 1998.

Forgács, Eva. *The Bauhaus Idea and Bauhaus Politics*. Trans. John Bátki. New York: Central European Univ. Press, 1995.

Frampton, Kenneth. *Modern Architecture: A Critical History*. 4th ed. World of Art. London: Thames & Hudson, 2007.

Gooding, Mel. *Abstract Art*. Movements in Modern Art. Cambridge: Cambridge Univ. Press, 2001.

Grant, Kim. *Surrealism and the Visual Arts: Theory and Reception*. New York: Cambridge Univ. Press, 2005.

Green, Christopher. *Art in France: 1900–1940*. Pelican History of Art. New Haven: Yale Univ. Press, 2000.

Harris, Jonathan. *Federal Art and National Culture: The Politics of Identity in New Deal America*. Cambridge Studies in American Visual Culture. New York: Cambridge Univ. Press, 1995.

Harrison, Charles, Francis Frascina, and Gill Perry. *Primitivism, Cubism, Abstraction: The Early Twentieth Century*. New Haven: Yale Univ. Press, 1993.

Haskell, Barbara. *The American Century: Art & Culture, 1900–1950*. New York: Whitney Museum of American Art, 1999.

Herskovic, Marika, ed. *American Abstract Expressionism of the 1950s: An Illustrated Survey: With Artists' Statements, Artwork and Biographies*. New York: New York School Press, 2003.

Hill, Charles C. *The Group of Seven: Art for a Nation*. Ottawa: National Gallery of Canada, 1995.

James-Chakraborty, Kathleen, ed. *Bauhaus Culture: From Weimar to the Cold War*. Minneapolis: Univ. of Minnesota Press, 2006.

Karmel, Pepe. *Picasso and the Invention of Cubism*. New Haven: Yale Univ. Press, 2003.

Lista, Giovanni. *Futurism*. Trans. Susan Wise. Paris: Terrail, 2001.

Lucie-Smith, Edward. *Latin American Art of the 20th Century*. 2nd ed. World of Art. London: Thames & Hudson, 2005.

McCarter, Robert, ed. *On and by Frank Lloyd Wright: A Primer of Architectural Principles*. New York: Phaidon Press, 2005.

Moudry, Roberta, ed. *The American Skyscraper: Cultural Histories*. New York: Cambridge Univ. Press, 2005.

Rickey, George. *Constructivism: Origins and Evolution*. Rev. ed. New York: Braziller, 1995.

Taylor, Brandon. *Collage: The Making of Modern Art*. London: Thames & Hudson, 2004.

Weston, Richard. *Modernism*. London: Phaidon Press, 1996.

White, Michael. *De Stijl and Dutch Modernism*. Critical Perspectives in Art History. New York: Manchester Univ. Press, 2003.

Whitfield, Sarah. *Fauvism*. World of Art. New York: Thames & Hudson, 1996.

Whitford, Frank. *The Bauhaus: Masters and Students by Themselves*. Woodstock, NY: Overlook Press, 1993.

Zurier, Rebecca, Robert W. Snyder, and Virginia M. Mecklenburg. *Metropolitan Lives: The Ashcan Artists and Their New York*. Washington, DC: National Museum of American Art, 1995.

### Chapter 32 The International Scene since 1950

Alberro, Alexander, and Blake Stimson, eds. *Conceptual Art: A Critical Anthology*. Cambridge, MA: MIT Press, 1999.

Archer, Michael. *Art Since 1960*. 2nd ed. World of Art. New York: Thames & Hudson, 2002.

Atkins, Robert. *Artspeak: A Guide to Contemporary Ideas, Movements, and Buzzwords*. 2nd ed. New York: Abbeville Press, 1997.

Ault, Julie. *Art Matters: How the Culture Wars Changed America*. Ed. Brian Wallis, Marianne Weems, and Philip Yenawine. New York: New York Univ. Press, 1999.

Battcock, Gregory. *Minimal Art: A Critical Anthology*. Berkeley: Univ. of California Press, 1995.

Beardsley, John. *Earthworks and Beyond: Contemporary Art in the Landscape*. 4th ed. ebook. New York: Abbeville Press, 2006.

Bird, Jon, and Michael Newman, eds. *Rewriting Conceptual Art*. Critical Views. London: Reaktion Books, 1999.

Bishop, Claire. *Installation Art: A Critical History*. New York: Routledge, 2005.

Blais, Joline, and Jon Ippolito. *At the Edge of Art*. London: Thames & Hudson, 2006.

Buchloh, Benjamin H. D. *Neo-Avantgarde and Culture Industry: Essays on European and American Art from 1955 to 1975.* Cambridge, MA: MIT Press, 2000.

Carlebach, Michael L. *American Photojournalism Comes of Age.* Washington, DC: Smithsonian Institution Press, 1997.

Causey, Andrew. *Sculpture since 1945.* Oxford History of Art. Oxford: Oxford Univ. Press, 1998.

Corris, Michael, ed. *Conceptual Art: Theory, Myth, and Practice.* New York: Cambridge Univ. Press, 2004.

De Oliveira, Nicolas. Nicola Oxley, and Michael Petry. *Installation Art in the New Millennium: The Empire of the Senses.* New York: Thames & Hudson, 2003.

De Salvo, Donna, ed. *Open Systems: Rethinking Art c.1970.* London: Tate Gallery, 2005.

Fabozzi, Paul F. *Artists, Critics, Context: Readings In and Around American Art Since 1945.* Upper Saddle River, NJ: Pearson/Prentice Hall, 2002.

Fineberg, Jonathan. *Art Since 1940: Strategies of Being.* 2nd ed. New York: Abrams, 2000.

Flood, Richard, and Frances Morris. *Zero to Infinity: Arte Povera, 1962–1972.* Minneapolis, MN: Walker Art Center, 2001.

Goldberg, RoseLee. *Performance Art: From Futurism to the Present.* Rev. and exp. ed. World of Art. London: Thames & Hudson, 2001.

Goldstein, Ann. *A Minimal Future? Art as Object 1958–1968.* Los Angeles: Museum of Contemporary Art, 2004.

Grande, John K. *Art Nature Dialogues: Interviews with Environmental Artists.* Albany: State Univ. of New York Press, 2004.

Grosenick, Uta, ed. *Women Artists in the 20th and 21st Century.* New York: Taschen, 2001.

———, and Burkhard Riemschneider, eds. *Art at the Turn of the Millennium.* New York: Taschen, 1999.

Grunenberg, Christoph, ed. *Summer of Love: Art of the Psychedelic Era.* London: Tate Gallery, 2005.

Hitchcock, Henry Russell, and Philip Johnson. *The International Style.* New York: Norton, 1995.

Hopkins, David. *After Modern Art: 1945–2000.* Oxford History of Art. Oxford: Oxford Univ. Press, 2000.

Jencks, Charles. *The New Paradigm in Architecture: The Language of Post-Modernism.* New Haven: Yale Univ. Press, 2002.

Jodidio, Philip. *New Forms: Architecture in the 1990s.* Taschen's World Architecture. New York: Taschen, 2001.

Johnson, Deborah, and Wendy Oliver, eds. *Women Making Art: Women in the Visual, Literary, and Performing Arts Since 1960.* Eruptions, vol. 7. New York: Peter Lang, 2001.

Jones, Caroline A. *Machine in the Studio: Constructing the Postwar American Artist.* Chicago: Univ. of Chicago Press, 1996.

Joselit, David. *American Art Since 1945.* World of Art. London: Thames & Hudson, 2003.

Legault, Réjean, and Sarah Williams Goldhagen, eds. *Anxious Modernisms: Experimentation in PostwarArchitectural Culture.* Montréal: Canadian Centre for Architecture, 2000.

Lucie-Smith, Edward. *Movements in Art since 1945.* New ed. World of Art. London: Thames & Hudson, 2001.

Madoff, Steven Henry, ed. *Pop Art: A Critical History.* The Documents of Twentieth Century Art. Berkeley: Univ. of California Press, 1997.

Moos, David, ed. *The Shape of Colour: Excursions in Colour Field Art, 1950–2005.* Toronto: Art Gallery of Ontario, 2005.

Paul, Christiane. *Digital Art.* 2nd ed. World of Art. London: Thames & Hudson, 2008.

Phillips, Lisa. *The American Century: Art and Culture, 1950–2000.* New York: Whitney Museum of American Art, 1999.

*Pop Art: Contemporary Perspectives.* Princeton: Princeton Univ. Art Museum, 2007.

Ratcliff, Carter. *The Fate of a Gesture: Jackson Pollock and Postwar American Art.* New York: Farrar, Straus, Giroux, 1996.

Reckitt, Helena, ed. *Art and Feminism.* Themes and Movements. London: Phaidon Press, 2001.

Robertson, Jean, and Craig McDaniel. *Themes of Contemporary Art: Visual Art after 1980.* 2nd ed. New York: Oxford Univ. Press, 2009.

Robinson, Hilary, ed. *Feminism-Art-Theory: An Anthology, 1968–2000.* Malden, MA: Blackwell, 2001.

Rorimer, Anne. *New Art in the 60s and 70s: Redefining Reality.* New York: Thames & Hudson, 2001.

Rush, Michael. *New Media in Late 20th-Century Art.* 2nd ed. World of Art. London: Thames & Hudson, 2005.

———. *Video Art.* 2nd ed. London: Thames & Hudson, 2007.

Sandler, Irving. *Art of the Postmodern Era: From the Late 1960s to the Early 1990s.* New York: Icon Editions, 1996.

Shohat, Ella. *Talking Visions: Multicultural Feminism in a Transnational Age.* Documentary Sources in Contemporary Art, vol. 5. New York: New Museum of Contemporary Art, 1998.

Stiles, Kristine, and Peter Selz. *Theories and Documents of Contemporary Art: A Sourcebook of Artists' Writings.* California Studies in the History of Art, 35. Berkeley: Univ. of California, 1996.

Sylvester, David. *About Modern Art.* 2nd ed. New Haven: Yale Univ. Press, 2001.

Varnedoe, Kirk, Paola Antonelli, and Joshua Siegel, eds. *Modern Contemporary: Art Since 1980 at MoMA.* Rev. ed. New York: Museum of Modern Art, 2004.

Waldman, Diane. *Collage, Assemblage, and the Found Object.* New York: Abrams, 1992.

Weintraub, Linda, Arthur Danto, and Thomas McEvilley. *Art on the Edge and Over: Searching for Art's Meaning in Contemporary Society, 1970s–1990s.* Litchfield, CT: Art Insights, 1996.

# CREDITS

## Chapter 9

9.1, 9.7, 9.9, 9.13, 9.18 Rick Asher; 9.2 a, b, c, d, e, f The Bridgeman Art Library/Giraudon; 9.3 Harrapa/J.M. Kenoyer; 9.4 © Mark Kenoyer Courtesy Department of Archaeology and Museums, Government of Pakistan; 9.5 National Museum of New Delhi; 9.6 Patna Museum; 9.8 © Adam Woolfitt/Robert Harding World Imagery/Corbis; 9.10 Richard Ashworth/Robert Harding; 9.11, 9.25 Dinodia Picture Agency; 9.12, 9.14 Richard Todd/National Museum of New Delhi; 9.15 Archaeological Museum, Sarnath. Asian Art Archives, University of Michigan; 9.16 Borromeo/Art Resource, NY; 9.17 © AAAUM, University of Michigan; 9.19 AKG-Images; 9.20 Asian Art Archives/University of Michigan; 9.21 Asian Art Archives/University of Michigan; 9.22 © Robert Gill; Papilio/Corbis. All Rights Reserved; Object Speaks Henri Stierlin/National Museum of India; Closer Look Rick Asher; 9.23 © David Cumming; Eye Ubiquitous/Corbis. All Rights Reserved; 9.24 © Richard Ashworth/Robert Harding World Imagery/Corbis; 9.26 Benoy K. Behl; 9.27 Lynton Gardner; 9.28 The Norton Simon Foundation; 9.30 Borromeo/Art Resource, NY; 9.31 © AAAUM, University of Michigan; 9.32 Jean-Louis Nou/AKG Images; 9.33 © Kevin R. Morris/Corbis; 9.34 Robert Harding World Imagery

## Chapter 10

10.1 National Geographic Image Collection; 10.2 Banpo Museum; 10.3 Line drawing illustrated in Michael Sullivan, *The Arts of China*, Berkeley: University of California Press, 2008, fig. 1-14, after Wenwu, no. 1 (1988), fig. 20.; 10.4 Shanghai Museum; 10.5 Photo: Michael A. Nedzwesky © President and Fellows of Harvard College; 10.6, 10.7 Hubei Provincial Museum, Wuhan; 10.8, 10.14, 10.15, 10.16 Cultural Relics Publishing House; 10.9 The Nelson-Atkins Museum of Art, Kansas City, Missouri. Photograph by Jamison Miller; 10.10, 10.24 © Trustees of the British Museum; 10.11 National Palace Museum, Taipei, Taiwan, Republic of China; 10.12 © Corbis; 10.13 Photograph © 2008 Museum of Fine Arts, Boston; Object Speaks Cultural Relics Publishing House; 10.17 Photograph © 2008 Museum of Fine Arts, Boston; 10.18 Photo: Imaging Department © President and Fellows of Harvard College; 10.19 The Nelson-Atkins Museum of Art, Kansas City, Missouri. Photograph by Jamison Miller.; 10.20 National Palace Museum, Taipei, Taiwan, Republic of China; 10.21, 10.23 The Nelson-Atkins Museum of Art, Kansas City, Missouri. Photograph by John Lamberton; 10.22 Palace Museum, Beijing; 10.25, 10.27 National Museum of Korea, Seoul. Republic of Korea; 10.26, 10.30 © 2006 President and Fellows of Harvard College. Photo: Photographic Services; 10.28 The Ancient Art & Architecture Collection Ltd; 10.29 Tokyo National Museum DNP Archives.Com Co., Ltd

## Chapter 11

11.1 Mary and Jackson Burke Foundation, NY. Photo: Bruce Schwarz; 11.2 DNP Archives.Com Co., Ltd; 11.3 Kazuyoshi Miyoshi/Pacific Press Service; 11.4 Photo: Orion Press, Tokyo. Japan National Tourist Organization; 11.5 Japan National Tourist Organization. Horyu-ji Treasure House; 11.6 Japan National Tourist Organization; 11.7 Shosoin, Todaiji, Nara; Recovering the Past b Photo: Patricia Graham; 11.8 Benrido, Japan; 11.9 AKG-Images; 11.10 Sakamoto Manschichi Photo Research Library, Tokyo; Closer Look The Tokugawa Reimeikai Foundation; 11.11 Courtesy of the Freer Gallery of Art, Smithsonian Institution, Washington, D.C.; 11.12 Tokyo National Museum DNP Archives.Com Co., Ltd; 11.13 Photograph © Museum of Fine Arts, Boston; 11.14 Asanuma Photo Studios, Kyoto, Japan; 11.15 Photo Courtesy of Kyoto National Museum; Object Speaks a TNM Image Archives source http://TnmArchives.jp/; Object Speaks b Kenchoji, Kamakura

## Chapter 12

12.1 The Art Archive/National Anthropological Museum Mexico/Gianni Dagli Orti; 12.2 © Scala, Florence/Art Resource, NY; The Metropolitan Museum of Art, NY; 12.3 Werner Forman/Art Resource, NY; 12.4 © Yann Arthus-Bertrand/Corbis; 12.6 Art Archive; 12.7 The Cleveland Museum of Art; 12.8 © ML Sinibaldi/Corbis; 12.9 The Museum of Modern Art/Licensed by Scala-Art Resource, NY; Closer Look © Philip Baird/www.anthroarchaert.org; 12.10 © Scala, Florence/Art Resource, NY; 12.11 © The Trustees of the British Museum; 12.12 Rollout photograph © Justin Kerr; 12.13 AKG-Images/Hedda Eid; 12.14 John Bigelow Taylor; 12.15 AKG-Images/Bildarchiv Steffens; 12.16 Photograph © Museum of Fine Arts, Boston; 12.17 © Kevin Schafer/Corbis; Technique Photograph © Museum of Fine Arts, Boston; 12.18 © 2005 Photo Scala, Florence/BPK, Bildagentur fuer Kunst, Kultur und Gechsichte, Berlin; 12.19 Fowler Museum at UCLA. Photo: Don Cole; 12.20 © Gilcrease Museum, Tulsa; 12.21 Tony Linck/ Ohio Dept. of Natural Resources; 12.22 William Iseminger, 'Reconstruction of Central Cahokia Mounds.' c. 1150 CE. Courtesy of Cahokia Mounds State Historic Site.; 12.23 University of Pennsylvania Museum of Archaeology and Anthropology; 12.24 Saint Louis Art Museum; 12.25 © Richard A. Cooke/Corbis; 12.26 Corson Hirschfeld; Object Speaks a Craig Law; Object Speaks b Fred Hirschmann Photography; 12.27 Timothy O'Sullivan/National Archives and Records Administration/Presidential Library

## Chapter 13

13.1 © 1980 Dirk Bakker; 13.2 © Kazuyoshi Nomachi/Corbis; 13.3 © Werner Forman/Art Resource, NY; Art and its Contexts Neil Lee/Ringing Rocks Digitizing Laboratory/ www.SARADA.co.za/San Heritage Centre/Rock Art Research Centre/University of the Witwatersrand, Johannesburg; 13.4 From Thurstan Shaw, *Igbo-Ukwu: An Account of Archaeological Discoveries in Eastern Nigeria*. 2 vols. Evanston: Northwestern University Press, 1970; 13.5 Jerry Thompson; 13.6 The Nelson-Atkins Museum of Art. Photo: E. G. Schempf; Closer Look Photograph © 1979 Dirk Bakker; 13.7, 13.17 Eliot Elisofon Archives/National Museum of African Art/Smithsonian Institution; 13.8 Scala, Florence/Art Resource, NY/Photograph © 1995 The Metropolitan Museum of Art/; Object Speaks a The Nelson-Atkins Museum of Art, Kansas City, Missouri. Photo: Jamison Miller.; Object Speaks b, c Joseph Nevadomsky; 13.9 National Museum of African Art/Smithsonian Institution. Photo by Franko Khoury; 13.10 Getty Images, Inc.; 13.11 Source: Dorling Kindersley illustration from DK; 13.12 I Vanderharst/Robert Harding World Imagery; 13.13 Robert Harding Picture Library Ltd./Alamy; 13.15 The Pitt Rivers Museum/ University of Oxford. Photo by Heini Schneebeli; 13.16 © 2008 Image copyright The Metropolitan Museum of Art/Art Resource/ Scala, Florence

## Chapter 14

14.1 Trinity College Library/14.2 © RMN/Jean-Gilles Berizzi/14.3 Kit Weiss/National Museum of Denmark, Copenhagen/14.5 Trinity College Library, Dublin/Object Speaks a, b The British Library/Object Speaks c © Scala, Florence, Art Resource, NY/14.6 South Cross, Ahenny, county Tipperary, Ireland, 8th Century. Stone. Courtesy of Marilyn Stokstad, Private Collection/14.7 © 2008 Photo The Pierpont Morgan Library/Art Resource/Scala, Florence/14.8 Archivo Fotographico Oronoz, Madrid/14.9 © Museum of Cultural History, University of Oslo, Norway/14.10 © Carmen Redondo/CORBIS All Rights Reserved/14.12 Photo RMN/Art Resource, NY/14.13, 14.15, 14.22 © Achim Bednorz, Koln/14.17 Kunsthistorisches Museum, Vienna, Austria/14.18 Scala, Florence/Art Resource, NY/Closer Look University Library, Utrecht/14.19 Art Resource/The Pierpont Morgan Library/14.20 Art Resource/The Metropolitan Museum of Art/14.23 Rheinisches Bildarchiv, Museen Der Stadt Koln/14.24 Dom-Museum Hildesheim.Photo by Frank Tomio/14.25 Hessisches Landes-und Hochschulebibliothek/14.26 Bayerische Staatsbibliothek

## Chapter 15

15.1, 15.4, 15.9, 15.14, 15.16, 15.23 © Achim Bednorz, Koln; 15.2 Bridgeman Art Library/Giraudon; 15.3 Archivo Fotographico Oronoz, Madrid; 15.5 © The J. Paul Getty Museum, Los Angeles; 15.7 Dorling Kindersley Media Library, Stephen Conlin © Dorling Kindersley; 15.8 From Kenneth John Conant, *Carolingian and Romanesque Architecture 800–1200*. The Pelican History of Art (Penguin Middlesex, 1959; Yale, Plate 60. Penguin Books Ltd. UK; Art and its Contexts Gemeinnutzige Stiftung Leonard von Matt, Buochs, Switzerland; 15.11 Studio Folco Quilici Produzioni Edizioni 361; 15.12 A.Vasari/Index Ricerca Iconografica; 15.13 Archivi Alinari, Firenze; Art and its Contexts Calveras/Merida/Sagrista ©MNAC, 2001; 15.15 Bridgeman Art Library/Guraudon; 15.17 Erich Lessing/Art Resource, NY; 15.18 A.F. Kersting/AKG Images; 15.20 Skyscan Balloon Photography/English Heritage Photo Library; 15.21 Ghigo Roli/Index Ricerca Iconografica; 15.22 AKG-Images/Bildarchiv Monheim; 15.24 © Shorelark Elizabeth Disney/Alamy; Closer Look © Achim Bednorz, Koln; 15.25a The Bridgeman Art Library; 15.25b Cathedral Museum of St. Lazare, Autun, Burgundy, France/The Bridgeman Art Library; 15.26 © Museu Nacional d'Art de Catalunya. Calveras/Merida/Sagreista; 15.27 Art Resource/The Metropolitan Museum of Art; 15.28 Constantin Beyer; 15.29 Getty Images/De Agostini Editore Picture Library; Object Speaks a By special permission of the City of Bayeux; Object Speaks b, c Erich Lessing/Art Resource, NY; 15.30 By Permission of the President and Fellows of Corpus Christi College, Oxford (CCC Ms 157); 15.31 © The Trustees of the British Museum; Art and its Contexts a Wiesbaden Hessische Landesbibliothek; Art and its Contexts b Erich Lessing/Art Resource, NY; 15.32 Thuringer Universitats- und Landesbibliothek Jena/Ursula Seitz-Gray, Ffm; 15.33 Laboratoire Photographique, France

## Chapter 16

16.1 Sonia Halliday Photographs; 16.3 © Archivo Iconografico, S.A. /Corbis. All Rights Reserved; 16.5 © Corbis; 16.6 Herve Champollion/Caisse Nationale des Monuments Historiques et des Sites, Paris, France; 16.7, 16.11, 16.15, 16.16, 16.25, 16.26, 16.30 © Achim Bednorz, Koln; 16.8 Gian Berto Vanni/Art Resource, NY; 16.9 Art Resource/The Pierpont Morgan Library; 16.12 Sonia Halliday Photographs; 16.13 © Angelo Hornak/Corbis. All Rights Reserved; Object Speaks a Dorling Kindersley; Object Speaks b © Achim Bednorz, Koln; Art and its Contexts a Bibliothèque Nationale de France/Art Resource, NY; Art and its Contexts b Bibliothèque Nationale de France; Object Speaks c The Philadelphia Museum of Art/Art Resource NY; 16.18, 16.19 The Pierpont Morgan Library, New York/Art Resource, NY; 16.20 The British Library; Closer Look The Pierpont Morgan Library, New York/Art Resource, NY; 16.21 © London Aerial Photo Library/Corbis; 16.23 English Heritage/National Monuments Record; 16.24 Nigel Corrie/English Heritage Photo Library; 16.27 Erich Lessing/Art Resource, NY; 16.28 Hirmer Fotoarchiv, Munich,

Gertnany; 16.29 Constantin Beyer; Recovering the Past a © Alberto Pizzoli/Corbis; Recovering the Past b Ghigo Roli; 16.31, 16.34 Canali Photobank; 16.32, 16.33 Scala, Florence/Art Resource, NY; 16.35 Dorling Kindersley

## Chapter 17

17.1 Scala, Florence/Art Resource, NY; 17.2, 17.21a © Achim Bednorz, Koln; 17.3 Tosi/Index Ricerca Iconografica; 17.5 Cimabue (Cenni di Pepi)/Scala, Florence; 17.6 Galleria degli Uffizi; 17.7 Assessorato ai Musei. Politiche Culturali e Spettacolo del Comune di Padova; 17.8, 17.10, 17.13 © Quattrone, Florence; 17.9 © Studio Deganello, Padua; 17.12 © Kimbell Art Museum, Fort Worth, Texas/Art Resource/Scala, Florence; 17.14 © Archivi Alinari, Florence; 17.15 a, b Scala, Florence/Art Resource, NY; Art and its Contexts © Quattrone, Florence; 17.16 M. Beck-Coppola/Louvre, Paris/Art Resource, NY; Closer Look The Metropolitan Museum of Art/Art Resource, NY; 17.17 Art Resource/The Metropolitan Museum of Art; Object Speaks a, b, c The Walters Art Museum, Baltimore; 17.18 The Walters Art Museum, Baltimore; 17.19 Landschaftsverband Rheinland/Rheinisches Landesmuseum Bonn

## Chapter 18

18.1 © National Gallery, London/Scala, Florence; 18.2a, b Scala, Florence/Art Resource, NY; 18.3 Erich Lessing/Chartreuse de Champmol/Art Resource, NY; Art and its Contexts Bibliothèque Nationale de France; 18.4, 18.5 R.G. Ojeda/RMN/Art Resource/Musée Conde, Chantilly, France; 18.6 Bildarchiv der Osterreichische Nationalbibliothek; 18.7 Art Resource/The Metropolitan Museum of Art; 18.8 Kunsthistorisches Museum, Vienna, Austria; 18.9, 18.10 Art Resource/The Metropolitan Museum of Art; 18.11, 18.12 © National Gallery, London/Scala, Florence; Object Speaks a, b Erich Lessing/Art Resource, NY; 18.13 Derechos reservados © Museo Nacional Del Prado - Madrid; 18.14 Photograph © Museum of Fine Arts, Boston; 18.15 © 2007 Image copyright The Metropolitan Museum of Art/Art Resource, NY/Scala, Florence; Closer Look Art Resource/The Metropolitan Museum of Art; 18.16a © Quattrone, Florence; 18.16b, c Galleria degli Uffizi; 18.17 AKG Images/Erich Lessing; 18.18a Joerg P. Anders/ Art Resource/Bildarchiv Preussischer Kulturbesitz; 18.18b Image Courtesy of Reproductiefonds Vlaamse Musea NV.; 18.19 © 2007 Image copyright The Metropolitan Museum of Art/Art Resource, NY/Scala, Florence; 18.20, 18.24 © Achim Bednorz, Koln; 18.22 Art Resource, NY/Giraudon; 18.23 Musee d'art et d'histoire, Genève; 18.25 John Rylands University Library of Manchester; 18.26 Art Resource, NY/The Metropolitan Museum of Art; 18.27 Bibliothèque Mazarine, Paris, France/Archives Charmet/The Bridgeman Art Library

## Chapter 19

19.1 © National Gallery, London; 19.2, 19.4a Scala, Florence/Art Resource. NY; 19.3 Dorling Kindersley; Object Speaks a Canali Photobank; Object Speaks b Scala, Florence/Art Resource, NY; 19.5, 19.13, 19.35 © Achim Bednorz, Koln; 19.6 Index Ricerca Iconografica; Art and its Contexts a © Corbis; Art and its Contexts b Scala, Florence/Art Resource, NY; 19.7, 19.19, 19.33 © Quattrone, Florence; 19.8, 19.9, 19.12, 19.22, 19.29a, b Canali Photobank; 19.10 AKG-Images; 19.11 The Bridgeman Art Library; 19.14, 19.16, 19.20, 19.25, 19.27, 19.34 Scala, Florence/Art Resource, NY; Technique b Canali Photobank; 19.15 Cincinnati Art Museum; 19.18, 19.28 Erich Lessing/Art Resource, NY; 19.21 © National Gallery, London/Scala, Florence; 19.23 © 2007 Image © The Metropolitan Museum of Art/Art Resource, NY/Scala. Florence; Art and its Contexts © Courtauld Institute of Art Gallery, London; 19.24 Alinari/Art Resource, NY; 19.26 © National Gallery, London/Scala, Florence; 19.30 © Photo Vatican Museums; 19.32 Archivi Alinari, Firenze; Closer Look Canali Photobank; 19.36, 19.37 © Cameraphoto Arte, Venice; 19.38 © The Frick Collection, New York

## Chapter 20

20.1 © Photo Vatican Museums; 20.2 Art Resource/Musée du Louvre, Paris; 20.3 Ghigo Roli Index Ricerca Iconografica; 20.4, 20.14, 20.15 © Quattrone, Florence; 20.5 Art Resource/Musée du Louvre, Paris; Art and its Contexts Cameraphoto Arte, Venice; 20.6 Photograph © Board of Trustees National Gallery of Art, Washington, D.C.; 20.7, 20.8 Staatliche Museen zu Berlin-Preussischer Kulturbesitz Gemäldegalerie, Photo Jörg P. Anders; Closer Look © Photo Vatican Museums; 20.9, 20.13, 20.25, 20.26, 20.31, 20.35 Canali Photobank; 20.10 Galleria dell'Accademia, Florence/Scala, Florence/Art Resource, NY; 20.11 Zigrossi Bracchetti/Vatican Museums/Ikona; 20.12a © Photo Vatican Museums; Object Speaks a The Royal Collection © 2010 Her Majesty Queen Elizabeth II; Object Speaks b V&A Images; Object Speaks c © Photo Vatican Museums; 20.16, 20.40 © Achim Bednorz, Koln; 20.17 Super-Stock, Inc.; 20.18, 20.19 Scala, Florence/Art Resource, NY; 20.20 Ikona; 20.21 Cameraphoto/Art Resource, NY; 20.22 Musée du Louvre, Paris/RMN Réunion des Musées Nationaux, France. Erich Lessing/Art Resource, NY; 20.23 Embassy of Italy; Art and its Contexts Kunsthistorisches Museum Wien; 20.24 Index Ricerca Iconografica/Summerfield/Galleria degli Uffizi, Florence; 20.27 Galleria degli Uffizi; 20.28 Art Resource/The Metropolitan Museum of Art; 20.29 © National Gallery, London/Scala, Florence; 20.30 Photograph © 2008 Museum of Fine Arts, Boston; 20.32, 20.33 Kunsthistorisches Museum, Vienna, Austria; 20.34 © Photo

30.13, 30.18 Hervé Lewandowski./Art Resource/Musée du Louvre; 30.14 Jean Schormans/Art Resource/Musée d'Orsay; Art and its Contexts © 2007 Image copyright The Metropolitan Museum of Art/Art Resource,NY/ Scala, Florence; 30.15 The Carnegie Museum of Art, Pittsburgh; 30.16, 30.19 © 2007 Image copyright The Metropolitan Museum of Art/Art Resource,NY/ Scala, Florence; 30.17 © Art Resource, NY/Musée d'Orsay, Paris/RMN; Closer Look John Webb/Courtauld Institute of Art; 30.20 The State Russian Museum/Corbis. All Rights Reserved; 30.21 Jefferson Medical College of Thomas Jefferson University, Philadelphia; 30.22 Art Resource/Philadelphia Museum of Art; 30.23 Gregory R. Staley Photography; 30.24 Hampton University Museum, Hampton,Virginia; 30.25 Photography © The Art Institute of Chicago; 30.26 Musée Marmottan, Paris/Bridgeman Art Library; 30.27 The Nelson-Atkins Museum of Art,The University of Kansas, Lawrence. 30.28 Musee d'Orsay, Paris. RMN Réunion des Musées Nationaux/Art Resource, NY; 30.29 Witchita Art Museum, Kansas: 30.31 Image copyright © The Metropolitan Museum of Art / Art Resource, NY; 30.30 © National Gallery, London/Scala, Florence; 30.32 © 2002 Photo National Portrait Gallery, Smithsonian/Art Resource, NY/Scala, Florence; 30.33, 30.34 Photograph © 2006 The Art Institute of Chicago. All Rights Reserved; Object Speaks a Brooklyn Museum of Art/ Central Photo Archive; Object Speaks b Van Gogh Museum, Amsterdam (Vincent van Gogh Foundation) (s0115V/1962); 30.35 The Museum of Modern Art/Licensed by Scala-Art Resource, NY. Photograph © 2000 The Museum of Modern Art, New York; 30.36 Albright-Knox Art Gallery, Buffalo, New York; 30.37 Spencer Museum of Art,The University of Kansas, Lawrence. 30.38 The William Morris Gallery, London. E17, England; 30.39 Detroit Institute of Arts. The Bridgeman Art Library Inc.; 30.40 Musee du Louvre/RMN Réunion des Musées Nationaux, France. J. G. Berizzi/Art Resource, NY; 30.41 Nasjonalgalleriet, Oslo. Photo: J. Lathion © Nasjonalgalleriet 02. © Munch Museum/ Munch - Ellingsen Group, BONO, Oslo/DACS, London 2010; 30.42 Koninklijk Museum voor Schone Kunsten, Antwerp. Image courtesy of Reproductiefonds Vlaamse Musea NV © DACS 2010; 30.43 Hirshhorn Museum and Sculpture Garden, Smithsonian Institution. Gift of Joseph H. Hirshhorn, 1966.; 30.44 Bayerische Staatsgemaldesammlungen, Neue Pinakothek, Munich © ADAGP, Paris and DACS, London 2010; 30.45 Art Resource/ The Museum of Modern Art/SOFAM, Brussels. Photo by Ch. Bastin & J. Evrard. 30.46 Vincent Abbey Photography; 30.47 Digital Image © The Museum of Modern Art/Licensed by SCALA/Art Resource, NY; 30.48 San Diego Museum of Art; 30.49 The Samuel Courtauld Trust, Courtauld Institute of Art Gallery, London; 30.50 The W. P.Wilstach Collection. Philadelphia Museum of Art/Art Resource, NY; 30.51 V&A Picture Library; 30.52 © Paul Almasy/Corbis; 30.53 © Corbis; 30.54 Courtesy of the Library of Congress; 30.55 © Art on file/Louis H. Sullivan/ Corbis; Elements of Architecture Frederick Law Olmsted & Calvert Vaux/City of New York, Department of Parks

## Chapter 31

31.1 The Museum of Modern Art, New York/Scala, Florence/Art Resource, NY. © Succession Picasso/DACS 2010; 31.2 Photograph © Board of Trustees, National Gallery of Art, Washington, D.C. © ADAGP, Paris and DACS, London 2010; 31.3 San Francisco Museum of Modern Art. © Succession H Matisse/DACS 2010; 31.4 © 1995 The Barnes Foundation. © Succession H Matisse/ DACS 2010; 31.5 Photograph © Board of Trustees, National Gallery of Art, Washington, D.C. © Succession Picasso/DACS 2010; 31.6 The Museum of Modern Art/Licensed by Scala-Art Resource, NY. © Succession Picasso/DACS 2010; 31.7 Solomon R Guggenheim Museum. 54.1412. Georges Braque © ADAGP, Paris and DACS, London 2010; 31.8 Photography © The Art Institute of Chicago. Photo: Robert Hashimoto. © Succession Picasso/DACS 2010; 31.9 Mildred Lane Kemper Art Museum, Washington University in St. Louis. © Succession Picasso/DACS 2010; 31.10 © Succession Picasso/DACS 2010; 31.11 Staatliche Museen zu Berlin, Preussischer Kulturbesitz, Nationalgalerie. Art Resource, NY. © DACS 2010; 31.12 The Nelson-Atkins Museum of Art, Kansas City, Missouri. Photo: Jamison Miller; 31.13 Digital Image © The Museum of Modern Art/Licensed by Scala-Art Resource, NY.; 31.14 Photo: Joerg P. Anders. Location: Kupferstichkabinett, Staatliche Museen zu Berlin, Berlin, Germany © DACS 2010; 31.15 Kunstmuseum Basel. Photo: Martin Buhler/Kunstmuseum; 31.16 The Metropolitan Museum of Art, New York. Photograph © 2007 The Metropolitan Museum of Art; 31.17 Walker Art Center, Minneapolis; 31.18 The Solomon R. Guggenheim Museum, New York. © ADAGP, Paris and DACS, London 2010; 31.19 Emanuel Hoffman Foundation. Kunstsammlung Basel, Switzerland. © L & M Services, B.V. The Hague 20100105; 31.20 © L&M Services, B.V. The Hague 20100105; 31.21 The Museum of Modern Art/Licensed by Scala-Art Resource, NY © ADAGP, Paris and DACS, London 2010; 31.22 The Museum of Modern Art, New York, NY, U.S.A. Digital Image © The Museum of Modern Art/Licensed by Scala-Art Resource. © ADAGP, Paris and DACS, London 2010; 31.23 Digital Image © The Museum of Modern Art/Licensed by SCALA/Art Resource, NY.; 31.24 Musée National d'Art Moderne. Centre National d'Art et de Culture. Georges Pompidou. Réunion des Musées Nationaux/Art Resource, NY; 31.25 Stedelijk Museum Amsterdam; 31.26 © Estate of Vladimir Tatlin/RAO Moscow/Licensed by VAGA, New York, NY; 31.27 Hirshhorn Museum and Sculpture Garden,

Smithsonian Institution © ADAGP, Paris and DACS, London 2010; 31.28 © Philadelphia Museum of Art/ Scala, Florence, Art Resource, NY. © ADAGP, Paris and DACS, London 2010; 31.29 Kunsthaus Zurich Dada-Archive. © 2005 Kunsthaus Zurich. All rights reserved.; 31.30 © Philadelphia Museum of Art/Scala, Florence, Art Resource, NY. © Succession Marcel Duchamp/ ADAGP, Paris and DACS, London 2010. © Philadelphia Museum of Art © Succession Marcel Duchamp/ADAGP, Paris and DACS, London 2010; 31.32 Solomon R. Guggenheim Museum, New York. © DACS 2010; 31.33 © 2005 Photo Scala, Florence/ BPK, Bildargentur fuer Kunst, Kultur und Geschichte, Berlin. © DACS 2010; 31.34 Colby College Museum of Art. Photo: Peter Siegel; 31.35 Photograph © 2000 The Metropolitan Museum of Art/Art Resource. © The Saul Steinberg Foundation/ARS, NY and DACS, London 2010; 31.36 Photograph © 2006, The Art Institute of Chicago. All Rights Reserved; 31.37 The Minneapolis Institute of Arts. © Georgia O'Keeffe Museum/DACS, 2010; 31.38 © Digital Image, The Museum of Modern Art, New York/Scala, Florence; Closer Look Photograph © The Metropolitan Museum of Art; Photograph © 1986 The Metropolitan Museum of Art/Art Resource, NY; 31.39 Gerald Zugmann Fotographie KEG; 31.40 Anthony Scibilia/Art Resource, NY. © FLC/ADAGP, Paris and DACS, London 2010; 31.41 Heidrich Blessing/Chicago Historical Museum. © ARS, NY and DACS, London 2010; 31.42 David R. Phillips/Chicago Architecture Foundation. © ARS, NY and DACS, London 2010; 31.43 Thomas A Heinz, AIA, Photographer © Copyright Western Pennsylvania Conservancy 2007 © ARS, NY and DACS, London 2010; 31.44 Photo Grand Canyon National Park Museum Collection; 31.45 Collection of The New-York Historical Society, Neg #46309. Photo: Cass Gilbert; 31.46 © Rodchenko & Stepanova Archive, DACS 2010; 31.47 Van Abbe-museum. © DACS 2010; 31.48 © ARS, NY and DACS, London 2010; 31.49 The Menil Collection, Houston. © 2010 Mondrian/Holtzman Trust c/o HCR International,Virginia 20186 USA; 31.50 Florian Monheim/ Artur Architekturbilder Agentur GmbH, Cologne, Germany. © DACS 2010; 31.51 Photo: Jannes Linders Photography. © DACS 2010; 31.52 The Museum of Modern Art/Licensed by Scala-Art Resource, NY. © DACS 2010; 31.53 Bauhausarchiv-Museum fur Gestaltung, Berlin, Germany. © DACS 2010; Art and its Context Adk, Berlin, George Grosz-Archiv/Akademie der Kunste/Archiv Bildende Kunst © Estate of George Grosz/Licensed by VAGA, New York, NY; 31.54 Busch-Reisinger Museum. Harvard University. Photo Michael Nedzweski/© President and Fellows of Harvard College, Massachusetts. © The Josef and Anni Albers Foundation/VG Bild-Kunst, Bonn and DACS, London 2010; 31.55 Stedelijk Museum, Amsterdam. © 2010 DACS, London; 31.56 The Solomon R. Guggenheim Foundation, New York. © Salvador Dali, Gala-Salvador Dali Foundation, DACS, London 2010; 31.57 The Museum of Modern Art/Licensed by Scala-Art Resource, NY. © DACS 2010; 31.58 Wadsworth Atheneum, Hartford Connecti-cut.© Succession Miro/ADAGP, Paris and DACS, London 2010; 31.59 The Museum of Modern Art/Licensed by Scala-Art Resource. © Calder Foundation, New York/DACS London 2010; 31.60 © Tate, London 2010 /Henry Moore Foundation. Bowness/ Hepworth Estate; 31.61 Henry Moore Foundation Archive. Reproduced by permission of the Henry Moore Foundation; 31.62 © Donna VanDerZee. All Rights Reserved; Object Speaks Art Resource/The New York Public Library Photographic Services © Succession Picasso/DACS 2010 © Calder Foundation, New York/DACS London 2010; 31.63 Schomburg Center for Research in Black Culture, New York Public Library Photographic Services/Art Resource, NY; 31.64 Howard University Libraries/ American Art from the Howard University Collection; 31.65 The Phillips Collection, Washington, DC. © ARS, NY and DACS, London 2010; Art and its Contexts Courtesy of the Library of Congress; 31.66 The Art Institute of Chicago © Estate of Grant Wood/ DACS, London/VAGA, NY 2010; 31.67 National Gallery of Canada; 31.68 Photo by Trevor Mills,Vancouver Art Gallery; 31.69 Schalkwijk/Art Resource, NY. © 2010 Banco de México Diego Rivera Frida Kahlo Museums Trust, Mexico, D.F./DACS; 31.70 © 2010 Banco de México Diego Rivera Frida Kahlo Museums Trust, Mexico, D.F./DACS; 31.71 Courtesy Guilherme Augusto do Amaral/Malba-Coleccion Costantini, Buenos Aires: 31.72 Collection Art Museum of the Americas OAS, Gift of IBM; 31.73 Photograph © 2006, The Art Institute of Chicago. All Rights Reserved. © The Estate of Francis Bacon. All rights reserved. DACS 2010; 31.74 The Museum of Modern Art, New York, NY, U.S.A. Digital Image © The Museum of Modern Art/Licensed; 31.75 Solomon R. Guggenheim Museum, New York. © ADAGP, Paris and DACS, London 2010; 31.76 Albright-Knox Art Gallery, Buffalo, New York; 31.77 The Museum of Modern Art, New York/ Art Resource, NY © ADAGP, Paris and DACS, London 2010; 31.78 The Metropolitan Museum of Art. Photograph © 1998 The Metropolitan Museum of Art, New York/Art Resource, NY. © The Pollock-Krasner Foundation ARS, NY and DACS, London 2010; 31.79 Hans Namuth Ltd. © The Pollock-Krasner Foundation ARS, NY and DACS, London 2010; 31.80 Photo: Geoffrey Clements © ARS, NY and DACS, London 2010; 31.81 © 2010 Digital Image. The Museum of Modern Art, New York/Scala, Florence. © The Willem de Kooning Foundation, New York/ARS, NY and DACS, London 2010; 31.82 National Gallery of Canada. © SODRAC, Montreal and DACS, London 2010; 31.83 Collection of the artist on extended loan to the National Gallery of Art, Washington, DC. Photograph © Board of Trustees, National Gallery of Art, Washington, D.C. © ARS, NY and DACS, London 2010; 31.84

Hirshhorn Museum and Sculpture Garden, Smithsonian Institution. Photography by Lee Stalsworth © 1998 Kate Rothko Prizel & Christopher Rothko ARS, NY and DACS, London; 31.85 The Museum of Modern Art. Photograph © 2009 Digital Image, The Museum of Modern Art, New York/Scala, Florence © ARS, NY and DACS, London 2010; 31.86 © Estate of David Smith/DACS, London/ VAGA, New York 2010

## Chapter 32

32.1 Courtesy Castelli Gallery, Photo: Rudolph Burckhardt. © Jasper Johns/VAGA, New York/DACS, London 2010; 32.2 Courtesy Sonnabend Gallery. © Estate of Robert Rauschenberg. DACS, London/VAGA, New York 2010; 32.3 Courtesy of Shozo Shimamoto; 32.4 Research Library, The Getty Research institute, Los Angeles, California (980063). © Ken Heyman-Woodfin Camp; 32.5 © 2010 Image copyright The Metropolitan Museum of Art/Art Resource, NY/ Scala, Florence. Shunk-Kender © Roy Lichtenstein Foundation. © ADAGP, Paris and DACS, London 2010; 32.6 Courtesy the artist. Photo by Tony Rav Jones. © ARS, NY and DACS, London 2010; 32.7 Photograph © 2004, The Art Institute of Chicago. All Rights Reserved; 32.8 Seydou Keita/ Trunk Archive; 32.9 Kunsthalle Tubingen, Sammlung G.F. Zundel, Germany. © Richard Hamilton. All Rights Reserved, DACS 2010; 32.10 © 2010 Tate, London. Marilyn Monroe LLC under license authorized by CMG Worldwide Inc., Indianapolis, In © The Andy Warhol Foundation for the Visual Arts/Artists Rights Society (ARS), New York/DACS, London 2010; 32.11 © The Estate of Roy Lichtenstein/DACS 2010; 32.12 Yale University Art Gallery © Claes Oldenburg © Coosje van Bruggen; 32.13 © Digital image, The Museum of Modern Art, New York/Scala, Florence. © Judd Foundation. Licensed by VAGA, New York/DACS, London 2010; 32.14 © ARS, NY and DACS, London 2010; 32.15 Performed at Galerie Schmela, Dusseldorf. © Ute Klophaus/VG Bild-Kunst, Bonn. © DACS 2010; 32.16 The Museum of Modern Art/Licensed by Scala. © ARS, NY and DACS, London 2010; 32.17 Eric Pollitzer/Leo Castelli Gallery, NY. © ARS, NY and DACS, London 2010; 32.18 Whitney Museum of American Art; Closer Look The Nelson-Atkins Museum of Art, Kansas City, Missouri. Photograph by Robert Newcombe; 32.19 © Digital Image, The Museum of Modern Art, New York/Scala, Florence; Object Speaks a The Brooklyn Museum of Art. Photograph © Donald Woodman/Through the Flower. © ARS, NY and DACS, London 2010; Object Speaks b © Judy Chicago 1979. Photo © Donald Woodman. © ARS, NY and DACS, London 2010; 32.20 Photography Robert Hickerson; 32.21 Galerie Lelong; 32.22 Photo Benjamin Blackwell; 32.23 © Estate of Robert Smithson/ DACS, London/VAGA, New York 2010. Courtesy James Cohan Gallery, New York; 32.24 Photo: Wolfgang Volz. © 2005 Christo and Jeanne-Claude; 32.25 Andrew Garn © DACS 2010; 32.26 Ezra Stoller/Esto Photographics, Inc.; 32.27 The Solomon R. Guggenheim Museum, New York. Photograph by David Heald © The Guggenheim Foundation; 32.28 Matt Wargo/Venturi, Scott Brown & Associates, Inc.; 32.30 Richard Payne, FAIA; 32.31 © 2007 The Estate of Anselm Kiefer/ARS Artists Rights Society, New York; 32.32 Broad Art Foundation, Santa Monica, California © The Estate of Jean-Michel Basquiat/ADAGP, Paris and DACS, London 2010; Art and its Contexts Courtesy Guerilla Girls; 32.33 © Digital Image, The Museum of Modern Art, New York/Scala, Florence © Gerhard Richter 2010; 32.34 Courtesy the artist and Metro Pictures; 32.35 © Barbara Kruger. Photo courtesy Mary Boone Gallery, New York.; 32.36 The Solomon R. Guggenheim Museum, New York. Photo © Faith Ringgold; 32.37 Courtesy the artist; 32.38 Tujunga Wash Flood Control Channel, Van Nuys, CA. SPARC Social & Public Art Resource Center; 32.39 Photograph © 2006, The Art Institute of Chicago. All Rights Reserved; 32.40 Courtesy James Luna; 32.41 Photography © Museum of Contem-porary Art, Chicago; 32.42 Photo by David Aschkenas. © ARS, NY and DACS, London 2010; 32.43a Catherine Ursillo/Photo Researchers, Inc.; 32.43b Frank Fournier; 32.44 © Tate, London 2010 © DACS, London. © Damien Hirst. All rights reserved, DACS 2010; 32.45 The Saatchi Gallery, London. Photo: Diane Bondareff/AP World Wide Photos; 32.46 The Felix Gonzalez-Torres Foundation. Courtesy of Andrea Rosen Gallery, New York. Photo: Peter Muscato; 32.47 Courtesy of the Estate of David Wojnarowicz and PPOW Gallery. NY; 32.48 © Kiki Smith, courtesy Pace Wildenstein, New York. Whitney Museum of American Art, New York; 32.49 © Krzysztof Wodiczko. Courtesy Galerie Lelong; 32.50 John Davies Photography; Art and its Contexts © Andres Serrano/Courtesy of the artist and Yvon Lambert Paris, New York; 32.51 © Shirin Neshat. Courtesy Gladstone Gallery; 32.52 Courtesy the artist; 32.53 © Berni Searle. Courtesy of Michael Stevenson, Cape Town; 32.54 Ian Lambot/ Foster and Partners; 32.55 Richard Bryant/Esto Photographics, Inc.; 32.56 AAD Worldwide Travel Images/Alamy Images; 32.57 Holly Solomon Gallery; 32.58a, b Courtesy Bill Viola. Photo by Kira Perov; 32.59 Chihuly Inc.; 32.60 Courtesy of the artist; 32.61 Courtesy of the artist and Metro Pictures; 32.62 Photo by Chris Winget. © Matthew Barney, courtesy Barbara Gladstone Gallery (Part of the Cremaster Cycle 1994–2002); 32.63 © Vanessa Beecroft; 32.64 Courtesy the artist. Photo by Jiang Min; 32.65 Nadín Ospina; 32.66 Studio Museum in Harlem. Photo by Marc Bernier; 32.68 Courtesy Lisson Gallery; 32.67 © the artist. Courtesy James Cohan Gallery. Photo by Jason Mandella; 32.69 Photograph by Ellen Labenski, courtesy Pace Wildenstein, New York © Fred Wilson, courtesy Pace Wildenstein, New York; 32.70 Courtesy of the artist and Sikemma Jenkins & Co.

Page numbers in *italics* refer to illustrations and maps

# B

**F**

Klein, Yves, 1088–1089
    *Anthropometries of the Blue Period*, 1088
    *Leap into the Void*, 1088, 1088–1089
*Knight Watch* (Riopelle), 1077, *1078*
Knights of Christ church, Tomar, Portugal, 693, *693*
Knights Templar, 693
Knossos, Crete: palace complex, 91
    New Palace period, 86
    Old Palace period, 84–85, *85*
Knowles, Martha, xxvii
    *My Sweet Sister Emma* quilt, xxvii, *xxvii*
Koburger, Anton, 590–591, *591*
Koch-Brinkmann, Ulriche, 113
Kofun period, 356, 358–359, 817
Koi Konboro, king of Jenné, 416
Kojoin guest house, Onjoji temple, Kyoto, Japan, 819,
    *819*
Kollwitz, Käthe, 1028
    *The Outbreak*, 1028, *1028*
Konarak, India: Sun Temple, 774
Kondos, 360
Kongo, Angola, 419–420
    metalwork, 420, *421*
    sculpture, 419–420, *420*
Kongo, Democratic Republic of the Congo: sculpture,
    889, *890*
Koons, Jeff, 1112–1113
    *Pink Panther*, 1113, *1113*
Korambo (ceremonial house), Abelam, Papua New
    Guinea, 863, *863*
Kore (korai) statues, 114–115, *115*
Korea, 350, 356
    Buddhism, 297, 351, 807
    Goryeo dynasty, 352–353, 807
    Joseon dynasty, 807–810
    Korean War, 1084
    map, *327*, 792
    modern period, 810–811
    Neo-Confucianism, 807
    Three Kingdoms period, 350–351
    Unified Silla period, 352
    writing, 357
    Yi dynasty, 807
Korean art after 1279
    ceramics and porcelain, *807*, 807–808, *808*
    ink painting, 810
    painting (Joseon dynasty), *808*, 808–810, *809*, *810*
    painting (modern), 810–811, *811*
Korean art before 1279
    ceramics, 350–351, *351*, *352*, 352–353
    jewelry, 350, *350*
    painting, 353, *353*
    sculpture, 351, *351*, *352*
Kosegarten, Gotthard, 956
*Koshares of Taos* (Velarde), 853, *853*
Kosho: *Kuya Preaching* statue, 372, *372*
Kosode robes, 829, *829*
Kosuth, Joseph, 1096
    *One and Three Chairs*, 1096, *1096*
Kouros (kouroi) statues, 114, *114*, 162
Krasner, Lee, 1075, 1077
    *The Seasons*, 1076, 1077
Kraters, 99, *99*, 103, *103*, 117, 118–119, *119*, 127, 128
*Krishna and the Gopis* from *Gita Govinda* illuminated
    manuscript, 784, *785*
Kritias, 142
*Kritios Boy* statue, Athens, 121, *121*
Krug, Hans: Apple Cup, 680, *680*
Kruger, Barbara, 1109–1111
    *Untitled (Your Gaze Hits the Side of My Face)*, 1109,
    *1109*
Kuba, Democratic Republic of the Congo
    architecture, 892–893, *893*
    funerary customs, 896–897, *897*
    masks, *896*, 896–897, *897*
    textiles, 893–894, *894*
Kublai Khan, 350, 792, 794
Kufic script, 272, 276, *277*, 279, 280
Kuhn, Walt, 1042
Kushan dynasty, 302–303, 774
Kutubiya Mosque, Marrakesh, Morocco, 270, *270*
Kuya, 371–372

*Kuya Preaching* statue (Kosho), 372, *372*
Kwakwaka'wakw, 849, 850, 851
Kylix, *117*, *124*, 124–125, 128, *128*
Kyoto, Japan, 821, 825
    Daitokuji monastery, 819–820, *820*
    Kojoin guest house, Onjoji temple, 819, *819*
    Ryoanji temple garden, 816, *816*
    Taian tearoom (Sen no Rikyu), 820–821, *821*

## L

*L.H.O.O.Q.* (Duchamp), *1038*, 1038–1039
*La Citadelle: Freedom* (Savage), *1064*, 1065
La Fayette, Madame de, 905
La Mouthe cave, France, 12–13, *13*
*La Pia de' Tolomei* (Rossetti), *998*, 998–999
La Venta, Mexico, 379
    Great Pyramid, 379, *380*
    Olmec figurines, *376*, 377
Labille-Guiard, Adélaïde, 936–937
    *Self-Portrait with Two Pupils*, 936, *937*
Labrouste, Henri, 1010
    Bibliothèque Nationale, Paris, *1010*, 1010–1011
Labyrinth, Knossos, Crete, 86
Lacquer, 822
Lacquer box for writing implements (Ogata Korin), 822,
    *822*
*Ladies Preparing Newly Woven Silk* handscroll (Huizong),
    343, *343*
*Lady Sarah Bunbury Sacrificing to the Graces* (Reynolds),
    922, *922*
*Lady Xox's Vision* relief (Mayan), 388, *388*
Lagash, 28, 36
Lakshanas, 303, 362
Lalibela, Ethiopia, 419
    Bet Giorgis (Church of St. George), 419, *419*
Lam, Wifredo, 1072
    *Zambezia, Zambezia*, 1072, *1072*
Lamassus figures, Dur Sharrukin, Assyria, 42, *42*
Laming-Emperaire, Annette, 8
Lamps
    Islamic, 273, *273*
    Paleolithic, 10–11, 12–13, *13*
Lancets, 499, 502
*Landscape* (Bunsei), 814, *815*
*Landscape* (Shitao), *805*, 805–806
Landscape architecture, 917, *917*, 1014, 1114, *1115*
Landscape painting
    Aegean civilizations, 90, *91*, 92
    Chinese (Ming dynasty), 796, 796–797
    Chinese (modern), 806, *806*
    Chinese (Qing dynasty), 790, 791, *805*, 805–806
    Chinese (Six Dynasties), 336
    Dutch, 753, 753–754
    French, 762, 763, 763–764
    French (Realism), 975, *975*
    German, 688, 688–689
    Impressionism, 984, 984–987, *985*, *986*
    Italian, 720, *720*
    Japanese, 814–816, *815*, 826
    Korean, 808, 809, *809*
    Roman, 178, 185
    Romantic (American), 955, 955–956
    Romantic (English), 953, 953–955, *954*
    Romantic (German), 956, *956*
*Landscape with St. John on Patmos* (Poussin), *763*, 763–764
*Landscape with St. Matthew and the Angel* (Poussin), 762,
    763–764
*Landscape with the Flight into Europe* (Annibale Carracci),
    720, *720*
Lange, Dorothea, 1066
    *Migrant Mother, Nipomo, California*, 1066, *1066*
Langsdorff, George, 872
Lanterns, 458, 460
Lanxi Daolong, 374, *374*
Lanzón sculpture, Chavin culture, 391–392, *392*
*Laocoön and His Sons* sculpture (Hagesandros, Polydoros
    and Athenodoros), *154*, 154–155
Laozi, 334, 793
Lapita people, 860, 869
*Lapith Fighting a Centaur* relief, Parthenon, Athens, *132*,
    133

*Large Odalisque* (Ingres), 950, *950*
*The Large Bathers* (Cézanne), *1008*, 1008–1009
*The Large Blue Horses* (Marc), 1029, *1030*
*Las Meninas (The Maids of Honor)* (Velázquez), 732, *733*,
    734
Lascaux cave, France, 9–11, *10*, *11*
*Last Judgement* tympanum, Saint-Lazare cathedral, Autun,
    France (Gislebertus), 478, *478*
*Last Judgment* (Michelangelo), 666, *667*, 668
*Last Painting* (Rodchenko), 1049
*Last Supper* from Altarpiece of the Holy Blood
    (Riemenschneider), *679*, 680
*The Last Supper* (Leonardo), 634, *635*, 636
*The Last Supper* (Tintoretto), 670, *672*
*The Last Supper* fresco (Castagno), 614, 614–615
Late Classical period of Greek art. *See* Greek art, classical
Latin America. *See* Mesoamerica; Mexico; named
    countries
Latin-cross plan churches, 651
Latrobe, Benjamin Henry: U.S. Capitol, Washington,
    D.C., *958*, 958–959
Laurana, Luciano: Ducal Palace, Urbino, Italy, 615, *615*,
    617
*Lavender and Mulberry* (Rothko), 1079, *1079*, 1081
Lawrence of Ludlow, 517
Lawrence, Jacob, 1065
    *The Migration of the Negro*, 1065, *1065*
Le Brun, Charles, 758, 759
    Hall of Mirrors, Versailles, 758–759, *759*
Le Corbusier, 1033, 1045, 1057
    Notre-Dame-du-Haut, Ronchamp, France, xxviii,
    *xxviii*
    Villa Savoye, Poissy-sur-Seine, 1045, *1045*
Le Nain, Antoine, 761
Le Nain, Louis, 761
    *A Peasant Family in an Interior*, 762, 763
Le Nain, Mathieu, 761
Le Nôtre, André: gardens, Versailles, 758, 760, *760*
Le Tuc d'Audobert, France, 9, 12, *12*
Le Vau, Louis, 758
    palace of Versailles, 758, *758*
Leadership symbols in African art, 878, 879, 891–895
Leaning Tower of Pisa, Italy, 465, *465*
*Leap into the Void* (Klein), *1088*, 1088–1089
Lebel, Jean-Jacques, 1089
Leeuwenhoek, Anton van, 756
Lega, Democratic Republic of the Congo: masks,
    887–888
Léger, Ferdinand, 1025, 1070, 1073
    *Three Women*, *1032*, 1033
Lekythos, *117*, 141–142, *142*
Lenin, Vladimir, 1018
Leningrad Painter: *Ceramic Painter and Assistants Crowned
    by Athena and Victories* hydria, 148, *148*
Lenoir, Alexandre, 495
Leo III, emperor, 245, 246
Leo III, pope, 438
Leo X, pope, 638, 639, 646, 689
Leonardo da Vinci, 633, 634, 689
    *The Last Supper*, 634, *635*, 636
    *Mona Lisa*, 636, *636*, 1038
    *The Virgin of the Rocks*, 634, *634*
    *Vitruvian Man*, 637, *637*
Lepenski Vir, Serbia: house/shrine, *13*, 13–14
Leroi-Gourhan, André, 8
Leroy, Louis, 984
*Les Demoiselles d'Avignon* (Picasso), *1023*, 1023–1024
Lescot, Pierre: Louvre palace, Paris, 692, *692*
Lesyngham, Robert: Exeter cathedral, England, 555
Lewis, Edmonia, 982
    *Forever Free*, 983, *983*
Lewis-Williams, David, 8
Leyster, Judith, 744–745
    *Self-Portrait*, 745, *745*
Liang Wu Di, emperor of China, 338
Liangzhu culture, China, 326, *327*, 328, *328*
Liao dynasty, 344–345
*Liber Scivias* (Hildegard of Bingen), 487, *487*
*The Liberation of Aunt Jemima* (Saar), 1102, *1102*
*Liberty Leading the People: July 28, 1830* (Delacroix), *948*,
    948–949
Library of Celsus façade, Ephesus, *163*

Paleolithic period, 2, 3–4
   architecture, 4–5
   cave art, 8–12
   figurines, 5, 5–8, 6, 7
   religious beliefs, 8–9
   sculpture, 4, 4, 5, 5–8, 6, 7, 12, 12–13, 13
   tool-making, 2–3, 4
Palestine, 218
Palladio, Andrea (Andrea di Pietro della Gondola), 672, 765
   San Giorgio Maggiore church, Venice, 673, 673–674, 674
   Villa Rotonda, Vicenza, 674, 675
Palladio, Andrea (Andrea di Pietro della Gondola), 916
Pallava dynasty, 312
Pan, 104
Panel from an ivory box, Indian (Mughal), 782, 782
Panel painting, 535, 537, 543, 544, 558
Panofsky, Irwin, xxxiii, xxxv, xxxviii
Panoramic View of the Diamond Mountains (Geumgang-San) (Jeong Seon), 809, 809
Panthéon, Paris (Church of Sainte-Geneviève) (Soufflot), 930–932, 931
The Pantheon, Rome, 196, 196–197, 197, 198, 199
Papacy, 562, 632, See also named popes
Paper for painting (Indian), 784
Papermaking, 280, 784
Papua New Guinea, 863–864, 865–866, 874, 875
Paracas culture, 392
Parapets, 138
Parchment, 243, 280, 432
Parekklesions, 255, 256, 257
Parinirvana of the Buddha statue, Sri Lanka, 323, 323
Paris Psalter illuminated manuscript, 252–254, 253
Paris Street, Rainy Day (Caillebotte), 991, 991
Paris
   Arc de Triomphe, 949, 949–950
   Bibliothèque Nationale (Labrouste), 1010, 1010–1011
   École des Beaux-Arts, 944, 962, 965, 979, 989, 1009, 1010
   Eiffel Tower, 960, 961
   Louvre palace (Lescot and Goujon), 692, 692
   Notre-Dame cathedral, 496, 497
   Opéra (Garnier), 963–964, 964
   Panthéon (Soufflot), 930–932, 931
   revolts (1968), 1094
   Salon de la Princesse, Hôtel de Soubise (Boffrand), 904, 905–906
   Saint-Denis, abbey church, 426, 494, 494–495, 497, 549, 549
   Sainte-Chapelle, 508, 508–509, 509, 511
   salons, 904, 905–906
Paris, Matthew, 512
   Historia Anglorum, 512, 513
Parish churches, 239
Parker Pearson, Mike, 19
Parks
   Central Park, New York City (Olmsted and Vaux), 1014, 1014
   early designs, 1014
   Stourhead, Wiltshire, England (Flitcroft and Hoare), 917, 917
Parler, Heinrich and Peter, 557, 559
   Holy Cross church, Schwäbisch Gmünd, 557, 557, 558, 559
Parler, Heinrich and Peter, 557, 559
   Holy Cross church, Schwäbisch Gmünd, 557, 557, 558, 559
Parma, Italy, 650, 653
Parmigianino (Francesco Mazzola), 662
   Madonna with the Long Neck, 662, 662
Parnassus (Mengs), 914, 914
Parnassus fresco (Raphael), 630
Paros, 82, 114
Parsa. See Persepolis
Parthenon, Athens, 130–131, 131
   Doric frieze, 132, 133
   "Elgin Marbles," 32
   historical background, 130
   Ionic frieze, 133, 133–135, 135
   Lapith Fighting a Centaur relief, 132, 133
   pediments, 131–133

processional frieze, 133, 133–135, 135
Passage graves, 17–18
Pastels, 912
Pasteur, Louis, 962
A Pastoral Landscape (Claude Lorrain), 764, 765
The Pastoral Concert (Titian), 656, 656
Patrons of art, xl
   American government, 1065, 1066, 1120
   Flemish, 561, 568, 571, 572, 582
   in France, 585
   in Italy, 593, 594–595, 609, 638
   in the Netherlands, 696, 742
   popes, 632
   private individuals, 633, 638, 650, 696
   women, 658, 690
Pattern and Decoration movement, 1101
Paul III, pope, 666, 668
Paul V, pope, 713
Pauline Borghese as Venus (Canova), 914–915, 915
Pausanias, 145, 169
Pausias, 148
Pavlov, Ivan, 1018
Pax Romana, 174
Paxton, Joseph: The Crystal Palace, London, 1009, 1009–1010
"Peacock and Dragon" fabric (William Morris), 998
A Peasant Family in an Interior (Louis Le Nain), 762, 763
Pech-Merle cave, France, 1, 1
Pedestals, 107, 163
Pediments, 108, 111–113, 112, 113, 131–133
Peeters, Clara, xxxvi, 741–742
   Still Life with Fruit and Flowers, xxxiv, xxxvi
   Still Life with Flowers, Goblet, Dried Fruit, and Pretzels, 742, 742
Peláez, Amelia, 1071
   Marpacífico (Hibiscus), 1070, 1071
Pelican figurehead, Florida Glades culture, 397, 397
Pelouze, Madame, 690
The Pencil of Nature (Talbot), 968
Pendentives, 232, 236, 236–237
"Peplos Kore" statue, Athens, 115, 116
Peplos, 115, 133, 140
"The Perfect Moment" exhibition (Mapplethorpe), 1120
Performance art, 1085
   See also Conceptual art
   African (Yoruba), 884, 884–885
   American, 1085, 1087, 1087, 1088, 1089, 1112, 1113, 1130, 1130
   French, 1088, 1088–1089
   Japanese, 1087, 1087
   women, 1089
Perfume bottle, Egyptian, 72, 73
Pergamon, 151, 152
   Altar, 152, 153, 154
Perikles, 128–129, 130
Peristyles and peristyle courts, 66, 108, 161, 180, 180, 181
Perón, Juan, 1073
Perpendicular style, 555
Perry, Lilla Cabot, 986
Perry, Matthew, 813, 830
Persephone, 104
Persepolis, Persia, 45, 46, 47, 142
Persia (Persians), 44–47, 120–121, 142, 217, 219
Personal Appearance #3 (Schapiro), 1101, 1101
Perspective, 255, 567, 608
   atmospheric (aerial), 562, 608, 611
   intuitive, 184, 562
   linear, 593, 594, 605, 608, 608, 611, 613, 620
Peru
   Andean cultures, 391
   Chavin de Huantar, 391–392
   Incas, 839–843
   Machu Picchu, 841, 841–842
   Moche culture, 393–394
   Nazca culture, 392
   Paracas culture, 392
Perugia, Italy: Porta Augusta, 160, 161
Perugino (Pietro Vannucci), 621
   Crucifixion with Saints, 622, 622
   Delivery of the Keys to St. Peter, 608, 621, 621–622
Pesaro Madonna altarpiece (Titian), 657, 657–658

Pesaro, Jacopo, 656–657
Peter of Illyria, 227
Petrarch, 530, 531
   The Triumphs, 531
Petroglyphs, 400
"Pharaoh," origin of term, 65
Pheidias, 130–131
   Athena statue, Acropolis, Athens, 130, 130
   processional frieze, Parthenon, Athens, 133, 133–135, 135
Philip Augustus, king of France, 493
Philip II, king of Macedon, 142
Philip II, king of Spain, 679, 692–693, 694, 729
Philip III, king of Spain, 729
Philip IV, king of Spain, 729, 732, 738
Philip the Bold, duke of Burgundy, 562
Philip the Fair, 696
Philip the Good, duke of Burgundy, 570, 573, 696
Philip V, king of Spain, 938
Phillips, James, 880–881
Philosophy
   and the Enlightenment, 904
   Chinese, 333–335, 345, 349
Phoebus, 104
Photography
   Culture Wars photography, 1115
   digital, 970, 1115, 1127–1128, 1128
   documentary, 1066, 1066, 1089, 1089–1090
   early, 962, 967–970, 967–970
   and feminist art, 1109, 1109–1111, 1110
   Modern, 1040–1042, 1041, 1061, 1061, 1064
   portraits, 967, 967, 970, 970, 1090, 1090
   postcolonial art, 1121, 1121
   processes, 967–969, 970
   since 1950, 1084, 1089, 1089–1090, 1090
Photomontage, 1039
Photo-Secession, 1041
Picasso, Pablo, 1017, 1021–1022, 1062
   Blue Period, 1022
   Cubism, 1016, 1017, 1021, 1025, 1025–1026, 1026
   Family of Saltimbanques, 1022, 1022
   Glass and Bottle of Suze, 1025, 1025–1026
   Guernica, 1062, 1062–1063
   Les Demoiselles d'Avignon (The Young Ladies of Avignon), 1023, 1023–1024
   Ma Jolie, 1016, 1017
   Mandolin and Clarinet, 1026, 1026
   Portrait of Daniel-Henry Kahnweiler, 1025, 1025
   primitivism, 1022, 1023, 1023–1024
   Rose Period, 1022, 1022
Picaud, Aymery, 458
Picnic at the Lotus Pond (Sin Yunbok), 809–810, 810
Pictographs, 331, 331, 400
Picture plans, 573
Picture stones, 436, 436
Picturesque, 917
Piero della Francesca, 617, 618
   Baptism of Christ, 618, 618
   Battista Sforza and Federico da Montefeltro, 618, 619
   Triumph of Federico and Battista, 618, 619, 620
Piers, 266, 457, 470
Pietà (Michelangelo), 641, 641, 642
Pietra dura, 781
Pietro da Cortona (Pietro Berrettini), 727
   The Glorification of the Papacy of Urban VIII, 727, 727
Pietro serena, 600
Pilasters, 160
Piles, Roger de, 712, 764
Pilgrimage churches, 239, 457–458, 459
Pilgrimage to the Island of Cythera (Watteau), 907, 907–908
Pilgrims and pilgrimages, 453, 454, 457, 458
   Five Pillars of Islam, 267
Pillars, 219
Pilotis, 1045
Pima, 943
Pine Spirit (Wu Guanzhong), 806, 806
Pink Panther (Koons), 1113, 1113
Pinnacles, 499, 499
Piranesi, Giovanni Battista, 913
   View of the Pantheon, 913, 913
Pisa, Italy

Constructivism, *1049*, 1049–1050
Cubism and Futurism, *1034*, 1034–1035, *1035*
painting (Realism), 979, *981*
Realism, 979
Socialist Realism, 1050–1051, *1051*
Ruysch, Rachel, 754, 755
*Flower Still Life*, 755, *755*
Ryoanji temple garden, Kyoto, Japan, 816, *816*

## S

Saar, Betye, 1102
*The Liberation of Aunt Jemima*, 1102, *1102*
Saarinen, Eero: Trans World Airlines (TWA) Terminal,
John F. Kennedy Airport, New York City, 1104,
*1104*
*Sacrifice of Isaac* door panels, San Giovanni baptistery,
Florence, Italy (Brunelleschi and Ghiberti), 601, *601*
Safavid dynasty, 282
architecture, *285*, 285–286
Saffron, 81
Saharan rock art, 405–406, *407*, 883
Said, Edward, 966
Saint Catherine monastery, Mount Sinai, 245
Saint Cyriakus convent church, Gernrode, Germany,
446–447, *447*
Saint Elizabeth of Hungary church, Marburg, Germany,
518, *518*
Saint Francis church, Assisi, Italy, 523, *523*, 526, 526–527
Saint George church (Bet Giorgis), Lalibela, Ethiopia,
419, *419*
Saint James Cathedral, Santiago de Compostela, Spain,
453, 454, 458, *459*, 460, 734–735, *735*
Saint Mark cathedral, Venice, Italy, 251, *251*
Saint Mary of the Assumption cathedral complex, Pisa,
Italy, 464–465, *465*
*Saint Matthew* from *Codex Colbertinus* illuminated
manuscript, 486, *486*
Saint Maurice cathedral, Magdeburg, Germany, 446,
520–521, *521*
*Saint Maurice* statue, Saint Maurice cathedral, Magdeburg,
Germany, 520, *521*
Saint Michael church, Hildesheim, Germany, 446
doors of Bishop Bernward, 448, *449*, 450
Saint Peter's basilica, Rome, 651, 668
baldacchino (Bernini), 713–714, *715*
new building (1506, Bramante), 650, 651, *651*
new building (1546–1564, Michelangelo), 651, *651*,
*668*, 668–669
new building (1607–1612, Maderno), 651, *651*, 713,
*714*
old church, 651, *651*
piazza (Bernini), 651, 713, *714*, 715
sculptures, 641, *641*, 642, 713–715, *715*
Saint Vitus cathedral, Prague, Czech Republic, 557, 559
Saint Wolfgang Altarpiece (Pacher), 587, *588*, 589
Saint-Denis, abbey church, Paris, 426, *494*, 494–495,
497
stained glass, 495, *496*, 497
*Virgin and Child*, 549, *549*
Sainte Foy abbey church, Conques, France, 458, 462
Sainte-Chapelle, Paris, *508*, 508–509, *509*, 511
stained glass, 508–509, *509*, 511
Sainte-Geneviève church, Paris. *See* Panthéon, Paris
Saint-Lazare cathedral, Autun, France, 458, 477–479, *478*,
*479*
Saint-Maclou church, Rouen, France (?Robin), 585–586,
*586*
Saint-Martin-du-Canigou, Pyrenees, France, *456*, 457
Saint-Pierre priory church, Moissac, France, 474–476,
*475*, *476*, 477
Saint-Savin-sur-Gartempe abbey church, Poitou, France,
*469*, 469–470
Saint-Simon, Henri de, 971
Saladin, 455
Salcedo, Sebastian: *Virgin of Guadalupe*, 941, *942*
Salimbeni, Lionardo Bartolini, 593, 594
Salisbury Cathedral, Wiltshire, England, *515*, 515–516,
*516*
Saljuqs, 270–271
Salon d'Automne, 1019, 1020
Salon de la Princesse, Hôtel de Soubise, Paris (Boffrand),

904, 905–906
Salon des Refusés, 976
Salons, *904*, 905–906
Saltcellar of King Francis I (Cellini), 665, *665*
Salt-paper prints, 967–968, *968*
Samarkand, Uzbekistan, 275
Shah-i Zinda funerary complex, 276, *276*
Samarkand, Uzbekistan, 275
Shah-i Zinda funerary complex, 276, *276*
Samoa, 860, 869, 872, 874, 877
Samurai warriors, 370–371, 375, 817, 821
arms and armor, 371, *371*
San Carlo alle Quattro Fontane church, Rome
(Borromini), 717, 717–718, *718*
San Clemente church, Rome, 465, *466*, 467
mosaics, 467, *467*
San Climent church, Taull, Spain, 468, *468*
San Giorgio Maggiore church, Venice, Italy (Palladio),
*673*, 673–674, *674*
San Giovanni baptistery door panels, Florence, Italy, 532,
*533*, 534, *534*, 601, *601*, 605, *606*, 607, *607*
San Giovanni baptistery doors, Florence, Italy, 532, *533*,
534, *534*
San Lorenzo church, Florence, Italy, 597, *597*, 600, *648*,
648–649, *649*
San Lorenzo, Mexico, 379
colossal heads, 379–380, *380*
San Marco monastery, Florence, Italy, xl, *xl*
San peoples: rock art, 408, *408*
San Pietro church, Rome, 650, *650*
San Vitale church, Ravenna, 237, *237*, *238*, 239, *239*, 240,
241
San Xavier del Bac mission, Tucson, Arizona, 941, 943,
*943*
Sánchez Cotán, Juan: *Still Life with Quince, Cabbage, Melon
and Cucumber*, 729, 729–730
Sanchi, India: Great Stupa, *299*, 299–302, *300*
Sanctuaries, 102, *106*, 107–108
Sanctuary of Apollo, Delphi, *106*, 107–108
*Charioteer* statue, 125, *125*
Treasury of the Siphnians, *107*, 107–108, *108*
Sanctuary of Zeus, Olympia, Greece, 102
Sand drawing, *854*, 854–855, 862, 875, 1076
Sanskrit, 295, 774
Sant Vincenc church, Cardona, Spain, 457, *457*
Santa Costanza church, Rome, *227*, 227–229, *228*
Santa Fe Indian School, *853*, 853
Santa Felicità church, Florence, Italy, 597, 660, *660*, *661*,
662
Santa Maria del Carmine church, Florence, Italy, 611
Santa Maria della Vittoria church, Rome, 716, 716–717
Santa Maria delle Grazie monastery, Milan, Italy, 634, *635*
Santa Sabina church, Rome, *226*, 227
Santa Sophia cathedral, Kiev, *249*, 249–250
Santa Trinità church, Florence, Italy, *623*, 623–624
Sant'Apollinare in Classe, Ravenna, 241, 241–242
Santiago de Compostela, Spain: Saint James cathedral,
453, 454, 458, *459*, 460, 734–735, *735*
Santo Domingo abbey, Silos, Spain: *Christ and Disciples on
the Road to Emmaus* relief, *452*, 453
Sapi people, 421
hunting horn, *421*
Sappho, 107
Saqqara, Egypt: Djoser's tomb complex, 53, *54*, *55*
Sarcophagi, 49
from Cerveteri, 165, *165*
of Constantina, Rome, *229*, 229–230
*Indian Triumph of Dionysus*, 203, 206, *206*
of Junius Bassus, Rome, 230, *230*
*Married Couple (Larth Tetnies and Thanchvil Tarnai)
Embracing*, 166, *166*
Sargon I, 33, 36
Sargon II, 41
Sarnath, India
*Lion Capital* from an Ashokan pillar, *296*, 297–298
*Standing Buddha*, 306, *306*
Sarsen stones, 19
Satire in art, 920–921, *921*
Savage, Augusta, 1064–1065
*La Citadelle: Freedom*, *1064*, 1065
Savonarola, Girolamo, 625
Sayoko, Eri, 832

*Dancing in the Cosmos* ornamental box, 832, *832*
Scandinavia, in the Middle Ages, 427, 435, 436. *See also*
Denmark; Norway
Scarabs, 51, 66, 82
Scarification, 403, 413, 884, 886
Schaden, Otto, 49
Schapiro, Miriam, 1101
*Dollhouse*, 1101
*Personal Appearance #3*, 1101, *1101*
Schedel, Hartmann, 590
Schiele, Egon, 1028–1029
*Self-Portrait Nude*, 1028, 1029, *1029*
Schinkel, Karl Friedrich: Altes Museum, Berlin, *958*, 958
Schliemann, Heinrich, 91, 95, 96, *96*, 98
Schliemann, Sophia, 96, *96*
Schmidt-Rottluff, Karl, 1026
*Three Nudes-Dune Picture from Nidden*, 1026–1027,
*1027*
Schneeman, Carolee: *Meat Joy*, *1088*, 1089
Schoenberg, Arnold, 1031
Schoenmaeker, M.H.J., 1052
Scholasticism, 493
Schongauer, Martin, 589, 683, 684
*Demons Tormenting St. Anthony* engraving, 589, *590*
*The School of Athens* fresco (Raphael), 631, 639, *640*
Schregel, Sebald, 590–591
Schröder House, Utrecht, Netherlands (Rietveld), 1053,
*1053*
Schröder-Schröder, Truus, 1053
Schwäbisch Gmünd, Germany: Holy Cross church
(Parler), 557, *557*, *558*, 559
Schwitters, Kurt, 1039
*Merzbild 5B (Picture-Red-Heart-Church)*, 1039, *1039*
Science
advances in, 712, 755, 756, 962, 1018
and art, 922, *923*, 924–925
and the Enlightenment, 904, 922, 924
Baroque period, 712, 742, 755, 756
Sckell, Friedrich Ludwig von, 1014
*The Scream* (Munch), 1002, *1002*
Screen, House of Chief Shakes of Wrangell (Tlingit), 849,
*849*, 851
Scribes, 242
Scriptoria, 242, 429, 432, 442, 486
Scrolls, 243
*See also* Handscrolls; Hanging scrolls
Scrovegni (Arena) Chapel, Padua, Italy, 537–540,
*538–540*
Sculpture
*See also* Figurines
abstract, *1035*, 1035–1036, *1036*
Abstract Expressionism, *1080*, 1081
Aegean civilizations, 82, 83–84, *84*
African (Baule), *889*, 889–890
African (Benin), 883
African (Fang), 898–899, *899*
African (Kongo), 419–420, *420*, 889, *890*
African (Nkanu), 888, *888*
African (Nok), 407–408, *408*, 883
African (Yoruba), 402, 403, 406, 883–884, *884*, *894*,
894–895, *895*
Akkadian, 33, *33*, 36
assemblages, 1026, *1026*
Aztec, 837–838, *838*
Baroque (Italian), 713–714, *715*, 715–717, *716*
biomorphic forms, *1060*, 1060–1061
Buddhist (Indian), *296*, 296–297, 300, 301, *303*,
303–304, 306, *306*, 307, 772–773, *773*
Buddhist (Japan), 361, *361*
Buddhist (Sri Lanka), 323, *323*
Buddhist (Thailand), 319, *319*, 777, *777*
Carolingian, 438, *438*
Chinese (Liao dynasty), 344, 344–345
Chinese (Qin dynasty), 324, 325, 332
Chinese (Six Dynasties), 338, *338*
Chinese (Sui dynasty), 339, 339–340
Christian (early), 225, 229
Cubism, 1026, *1026*, 1034, *1034*, 1035, *1035*
Egyptian, 59, 59–60, *60*, 68, *68*, 74, 74–75, 78, *78*
Etruscan, 162, *162*
feminist, 1102, *1102*
fourteenth century (French), 547, 549, *549*

tomb of Ramose, *69*, 69–70
Theft of art, 32, 49, 135
Theodora, empress of Justinian, 233, 234, *240*, 241
Theodora, empress of Theophilus, 245, 246
Theodosius I, emperor, 230
Theophilus, emperor, 245, 246
Theophilus, monk, 464, 497
Theravada Buddhism, 297, 319, 320, 323, 777
Thermo-luminescence dating, 12
*Third of May, 1808* (Goya), *940*, 940–941
*Thirty-Six Views of Mt. Fuji* (Hokusai), 827
Tholos, 138
Tholos tombs, 98–99
*Thomas Mifflin and Sarah Morris (Mr. and Mrs. Mifflin)* (Copley), *902*
Thomas of Witney: Exeter Cathedral, England, *554*, 554–555
Thomas, Henrietta, xxvii
  *My Sweet Sister Emma* quilt, xxvii, *xxvii*
Thompson, Florence, 1066, *1066*
Thomson, Tom, 1067
  *The Jack Pine*, 1067–1068, *1068*
Thornton, William: U.S. Capitol, Washington, D.C., 958, *958*
*Thoughts on the Imitation of Greek Works in Painting and Sculpture* (Winckelmann), 913–914
*A Thousand Peaks and Myriad Ravines* (Wang Hui), *790*, 791
*Three Crosses* (Rembrandt), 748, *748*
*Three Dancers and Two Musicians* (Midjaw Midjaw), 862, *862*
Three Kingdoms period, 350–351
*Three Nudes-Dune Picture from Nidden* (Schmidt-Rottluff), 1026–1027, *1027*
*Thus Spake Zarathustra* (Nietzsche), 1026
Thutmose I, 66, 68
Thutmose II, 68
Thutmose III, 64, 65, 66, 68
Ti, tomb, 61
*Ti Watching a Hippopotamus Hunt* relief, 61, *61*
Tiberius, 178
Tibet
  Tangka painting, 776, *776*
  Tantric Buddhism, 773, 776
Tiercerons, 554
Tikal, Guatemala, *384*, 385–386
Tiles, Islamic, 264, *275*, 275–276, 277
*Tilted Arc* (Serra), 1113–1114, *1114*
Timbuktu, Mali, 416
Times Square Show, New York City (1980), 1107
Timur (Tamerlane), 275
Timurid dynasty, 275, 276
Tintoretto (Jacopo Robusti), 670–672
  *The Last Supper*, 670, *672*
Tipis, 846, 847, 848
Titian (Tiziano Vecellio), 655–656, 658, 659
  *Isabella d'Este*, 658, *658*
  *The Pastoral Concert*, 656, *656*
  *Pesaro Madonna* altarpiece, 657, 657–658
  *"Venus" of Urbino*, 659, *659*
Titus, 187, 188, 219
  Arch, Rome, *186*, 187–188, 219
Tivoli, Italy: Hadrian's Villa, 199, *199*, *200*, 201
Tiy, portrait, 72, *72*
Tlingit, 849, *849*, 851, *851*
Toba Sojo: *Frolicking Animals* handscroll, 370, *370*
Todaiji temple, Nara, Japan, 361–363
  Great Buddha Hall (Daibutsuden), 361–362, 364
  Shosoin Imperial Repository, 362–363
Tokonoma (alcoves), 819, *819*, 820–821
Tokugawa era, 813, 821, 825, 830
Tokugawa Ieyasu, 818, 821
Tokyo, 831, *See also* Edo
Tomar, Portugal: Knights of Christ church, 693, *693*
Tomb effigies, 481, *481*
Tomb model of a house, Han dynasty, China, *334*
Tomb of Constantina (Santa Costanza church), 227–228, *229*
Tomb of Galla Placidia, Ravenna, *232*, 232–233, *233*
Tomb of Giuliano de' Medici (Michelangelo), 648, *648*
Tomb of Pakal the Great, Palenque, Mexico, *386*,

386–388
Tomb of Ramose, Thebes, Egypt, *69*, 69–70
Tomb of the Diver, Paestum, Italy, 122, *122*
  *A Diver* wall painting, 122, *123*
  *Symposium Scene* wall painting, 122, *123*
Tomb of the Reliefs, Cerveteri, Italy, *164*, 165
Tomb of the Triclinium, Tarquinia, Italy, *164*, 165
Tomb of the Warrior Priest, Sipán, Peru, 394
Tombs
  African (Benin), 410–411
  African (Igbo-Ukwu), 408–409, *409*
  Andean cultures, 394
  beehive, 98–99
  catacombs, 219, 224, *224*
  Chinese, *324*, 325, 328, 332
  Christian (early), 228, *232*, 232–233, *233*
  Egyptian. *See* Tombs, Egyptian
  Etruscan, 162, 165–166
  Indian, *770*, 771, 779–781, *781*
  Islamic, *276*, 276
  Japanese, 356, 817
  Mayan, 385, *386*, 386–388
  Mycenaean, 95, *98*, 98–99, *99*
  Neolithic, 13–14, *17*, 17–18
  Pacific cultures, 867–868, *868*
  passage graves, 17–18
  Renaissance, 648, *649*
  shaft graves, 95, 98
  ship burials, 427–428, *428*, 435, *435*
  Sumerian, 34
  tholos, 98–99
Tombs, Egyptian
  decoration, 61, *61*, 62–63, *63*, *69*, 69–70
  Djoser's complex, Saqqara, 53, *54*, 55
  mastabas, 53, *54*, 55, *55*
  pyramids, stepped, 53, *54*, 55
  pyramids at Giza, 55, 55–59, *56*, *57*, *58*
  Ramose, Thebes, *69*, 69–70
  rock-cut, *62*, 62–63
  Tutankhamun, 49, 73
Tondi, 128, *128*, *210*, 210–211
Tonga, 860, 874
Toomer, Jean, 1061
Topkapi Palace, Istanbul, 283, *284*
Torah, 218, 510
Toranas, 300
Torc (Celtic), 152, *152*
Tori Busshi: *Shaka Triad*, Horyuji temple, Nara, Japan, 361, *361*
Torons, 417
Torres-García, Joaquín, 1073
  *Abstract Art in Five Tones and Complementaries*, 1073, *1073*
*Torso of a Young Man* (Brancusi), *1036*, 1036
Toshusai Sharaku: *Onoe Matsusuke as Matsushita Mikinoshin*, 826
Toulouse-Lautrec, Henri de, 1006
  *Jane Avril*, *1006*, 1006–1007
*Tower of Babel* wall painting, 469, 469–470
Towns
  *See also* City plans; Villages
  Egyptian, 50, 64
  Neolithic, 5, 326
Toyotomi Hideyoshi, 817–818
Tracery, *499*, 502, 507
Trajan, 190, 191, 194, 195–196
  Column, Rome, *194*, 194–196, *195*
  Forum, Rome, 191–192, *192*, *193*, 194
Trans World Airlines (TWA) Terminal, John F. Kennedy Airport, New York City (Saarinen), 1104, *1104*
Transepts, 227, 228
*The Transfiguration of Christ with Sant'Apollinare* mosaic, Sant'Apollinare, Ravenna, *241*, 241–242
Transverse arches, 457
*Travelers Among Mountains and Streams* (Fan Kuan), *346*, 346–347
"Treasure trove," 214, 428
Treasury of Atreus, Mycenae, *98*, 98–99, *99*
Treasury of the Siphnians, Delphi, *107*, 107–108, *108*
Treaty of Waitangi, New Zealand, 875
*Tree of Jesse* from *St. Jerome's Commentary on Isaiah*

illuminated manuscript, 488–489, *489*
*Tree of Life* (Mendieta), 1101, *1101*
Trefoils, 294, 518
*Très Riches Heures* illuminated manuscript (Limbourg brothers), 566–568, *567*
*The Tribute Money* fresco (Masaccio), 611–612, *612*
Trier, Germany: Basilica (Audience Hall of Constantius Chlorus), 207, *208*
Triforiums, *499*, 502
Triglyphs, 110, 111
Tringham, Ruth, 20
Trinity Church, New York City (Upjohn), 957, *957*
*Trinity with the Virgin, St. John the Evangelist and Donors* fresco (Masaccio), 609–610, *610*
Triptychs, 252, 564
  *Annunciation* from Mérode Altarpiece (Master of Flémalle), 571–573, *572–573*
  *Garden of Earthly Delights* (Bosch), 696–697, 697–699, *698*
  Portinari Altarpiece (Goes), 580–582, *582–583*
  *The Raising of the Cross* (Rubens), 737, 737–738
Trissino, Giangiorgio, 672
*Tristan and Iseult at the Fountain; Capture of the Unicorn* ivory relief, *553*
*Triumph of Federico and Battista* (Piero della Francesca), 618, *619*, 620
*The Triumph of Bacchus and Ariadne* ceiling, Palazzo Farnese, Rome (Annibale Carracci), *719*, 719–720
*The Triumph of the Name of Jesus and Fall of the Damned* ceiling, Il Gesù church, Rome, *728*, 728–729
*The Triumphs* (Petrarch), 531
*Trolley, New Orleans* (Frank), *1089*, 1089–1090
Trompe l'oeil effects, 617, 683
Troy, 91
*True View of Kojima Bay* (Ike Taiga), *825*, 825–826
Trumeaus, 473, 475–476, *476*
Tubuan masks, New Britain, Papua New Guinea, 866, *867*
Tucker, Mark, xxxvi, xxxviii, xli
Tucson, Arizona: San Xavier del Bac mission, 941, 943, *943*
Tufa, 160
Tugras, 284, *284*
Tunic, Inca, *842*, 843
Tunisia: Great Mosque of Kairouan, 266–267, *267*
Tupuhia, Teve, 869, *869*, 872
Turkey. *See* Anatolia
Turner, Joseph Mallord William, 953, 955, 974
  *The Burning of the Houses of Lords and Commons, 16th October 1834*, *954*, 955
  *Slavers Throwing Overboard the Dead and Dying-Typhoon Coming On ("The Slave Ship")*, *954*, 955
Tuscan order, 161, 163, 189
Tutankhamun, 72
  funerary mask, *48*, 49, 73
  tomb, 49, 73
*Twelve Views of a Landscape* handscroll (Xia Gui), 348–349
Twickenham, England: Strawberry Hill (Walpole), *918*, 919–920, *920*
Twin figures (ere ibeji), Yoruba, Nigeria (Akiode), 883–884, *884*
Twining, 845
*Two Equestrian Figures* figurines, Tang dynasty, China, *343*, 343
Two Grey Hills style, *834*, 835
*The Two Fridas* (Kahlo), *1069*, 1069–1070
Tympanums, 473, *473*, 477, 478, *478*
Tzara, Tristan, 1039

## U

U.S. Capitol, Washington, D.C. (Latrobe and Thornton), 958, 958–959
Uccello, Paolo, 593, 613
  *The Battle of San Romano*, *592*, 613
Ukiyo-e woodblock prints, *827*, 827–828, 994
Ukraine: mammoth-bone houses, 4–5, *5*
*Ulugali'i Samoa: Samoan Couple* (Kihara), 877, *877*
Umayyad dynasty, 263, 265, 268
Undercutting, 214
Underglaze painting, 799
*The Unicorn is Found at the Fountain* from *The Hunt of the*

Walker, Kara, 1135
  *Darkytown Rebellion*, *1134*, 1135
Wall hanging (Anni Albers), *1056*
Wall paintings
  *See also* Cave art; Frescoes; Murals
  Aegean civilizations, *80*, 81, 90, *91*, 92–93, *92–93*
  in catacombs, *218*, 219, *224*, 224–225, *225*
  Chinese (Tang dynasty), 340, *340*
  Christian (early), 223, *223*, *224*, 224–225, *225*
  Egyptian, 50, 62–63, *63*, 76, *76*
  Etruscan, 122, *123*, 162, *163*, *164*, 165
  Gothic, 526–527, *527*
  Greek (classical), 122, *122*, *123*
  Indian, 306–307, *307*, *318*, 318–319
  Japanese, 818–820, *820*
  Jewish (early), *218*, 219, 220, *220*, 222
  Minoan, 87, *88*
  Neolithic, 14
  Roman, *158*, 159, 181, 182, *182*, *183*, 183–185, *184*, *185*, 187
  Romanesque, 468, *468*, *469*, 469–470
Wall, Jeff, 1127–1128
  *After "Invisible Man" by Ralph Ellison, The Preface*, 1128, *1128*
Walpole, Horace, 919
  Strawberry Hill, Twickenham, England, *918*, 919–920, *920*
Walter of Memburg, 554
*The Waltz* (Claudel), 1004, *1004*
Wampum, 844–845, *845*
"The Wanderers," 979
Wang Hui: *A Thousand Peaks and Myriad Ravines*, 790, 791
Wang Xizhi, 337, 338
  *Feng Ju*, 337–338, *338*
Wapepe navigation charts, Marshall Islands, 867, *867*
War: art as spoils, 32, 49
War of Independence. *See* American Revolution
Warhol, Andy, 1091–1092, 1106, 1128
  *Marilyn Diptych*, 1092, *1092*
Warka Head, Uruk, 32, *32*
Warp, 892
*Warrior Chief Flanked by Warriors and Attendants* plaque, Benin, Nigeria, *414*, 414–415
*Warrior krater*, Mycenae, 99, *99*
Washington, D.C.
  U.S. Capitol (Latrobe and Thornton), *958*, 958–959
  Vietnam Veterans Memorial (Lin), 1114, *1115*
Washington, George, 937, 938, *938*
Watchtowers, 345, *345*
*Water Carrier of Seville* (Velázquez), *731*, 731–732
Water in Islamic art, 264, 275
*Watson and the Shark* (Copley), 929–930, *930*
Watson, Brook, 929–930
Watteau, Jean-Antoine, 906
  *Pilgrimage to the Island of Cythera*, *907*, 907–908
  *The Signboard of Gersaint*, *906*, 906–907
Wattle and daub construction, 17
*Waves at Matsushima* (Tawaraya Sotatsu), *823*, 823–824
*The Weary Herakles* statue (Lysippos), 145–146, *146*
Weaving
  African, 892, *893*
  Andean cultures, 392, 394
  carpets, 286
  Native American, *834*, 835, 851, *851*, *854*, 854–855
  techniques, 43, 286, 394
Webb, Philip: chair from Sussex range, *998*
Wedding chests, 616, *616*
Wedgwood, Josiah, 917, 919
Wedgwood pottery, 917, *918*, 919
Weft, 892
Weil-am-Rhein, Germany: Vitra Fire Station (Hadid), *1124*, 1125
Weissenhofsiedlung exhibition, Stuttgart, Germany (1927), 1057
*Well of Moses* (Sluter), 564–565, *565*
West Papua, New Guinea, 863, 864–865
West, Benjamin, 913, 926
  *The Death of General Wolfe*, 926–927, *927*
*Western Paradise of Amitabha Buddha* wall painting, Gansu, China, 340, *340*
Westworks, Corvey abbey church, 439, *440*, 441

Wet-plate glass negatives, 968
Weyden, Rogier van der, xl–xli, 574, 578, 582
  *Crucifixion Triptych with Donors and Saints*, xxxviii, xxxix
  *Crucifixion with the Virgin and St. John the Evangelist*, xxxvi–xli, *xxxvii*, xli
  *Deposition*, 578, 578–579
  *St. Luke Drawing the Virgin and Child*, *579*, 579–580
*Whirling Log Ceremony* tapestry (Klah), *854*, 854–855
Whistler, James Abbott McNeill
  lawsuit, 999
  *Nocturne in Black and Gold, The Falling Rocket*, 999, *1000*, 1000–1001
White Temple, Uruk, *29*
The White House rock shelter, Ancestral Puebloan, *401*
White-ground painted vases, 141–142, *142*
Whitehall Palace, London, 765–766, *766*, *767*
Whiteread, Rachel, 1119, 1121
  *House*, 1119, *1119*, 1121
Wiligelmo, 474
  *Creation and Fall* relief, Modena Cathedral, 474, *474*
William of Orange, 735, 765
William of Sens, 501
William Penn's Treaty with the Delaware wampum belt, Native American (Delaware), 844–845, *845*
William the Conqueror (William, Duke of Normandy), 454, 483, 484
Wilson, Fred, 1134
  *Chandelier Mori* from *Speak of Me As I Am* installation, *1134*, 1135
  *Mining the Museum*, 1134
  *Speak of Me As I Am* installation, 1134–1135
Wiltshire, England
  Stonehenge, 15, *18*, 18–20
  Stourhead park (Flitcroft and Hoare), *917*, 917
Winckelmann, Johann Joachim, 913–914, 927, 930
*Windmill Psalter* illuminated manuscript, 512–514, *514*
Wine bottle, Korean (Joseon dynasty), *807*, 807
Winsor, Jackie: *Burnt Piece*, *1099*, 1099
*Winter Landscape* (Sesshu), *815*, 815–816
Winter, Irene, 27
Wittgenstein, Ludwig, 1096
Witz, Konrad, 587
  *Miraculous Draft of Fishes*, 587, *587*
Wodiczko, Krzysztof: *The Homeless Project Vehicle*, 1118–1119, *1119*
Wojnarowicz, David, 1117, 1118
  *Untitled (Hands)*, *1117*, 1117–1118
Wolfe, James, 926
Wolgemut, Michael, 591, *591*, 683
Wollstonecraft, Mary, 1100
Wols (Wolfgang Schulze), 1072
  *Painting*, 1072, *1072*
*Woman Clothed with the Sun* from *Morgan Beatus* (Maius), *433*, 433–434
*Woman from Brassempouy* figurine, France, 7, 7–8
*Woman from Dolní Věstonice* figurine, Czech Republic, 7, *7*
*Woman from Willendorf* figurine, Austria, 6, *6*
*Woman Holding a Balance* (Vermeer), 750, 750–751
*Woman I* (Willem de Kooning), *1077*, 1077
*Woman or Goddess with Snakes* figurine, Knossos, Crete, 87–88, *88*
*The Woman with the Hat* (Matisse), 1020, *1020*
Womanhouse, 1101
*Womb World mandala*, Japanese (Heian period), 365, *365*
Women
  in academies, 924, 925, 932, 937
  Africa, 886
  Ancestral Puebloan, 397
  and Bauhaus, 1056
  Assyrian, 43
  Egyptian, 64, 67–68
  feminist art, 1089, 1094, 1099–1102, 1108, 1109–1111, 1130
  Georgian silver artists, 919
  in guilds, 566
  Inca, 840
  Islamic, 1121
  Japanese, 367
  Native American, 835, 845, 846, 848, 852, 854
  Ottonian period, 447
  Pacific cultures, 862, 863–864, 866, 869

  as patrons of art, 658, 690
  in performance art, 1089
  Roman, 159
  Romanesque period, 487
  and salons, 905
  and Surrealism, 1058
  Viking, 435
Women artists
  Aegean civilizations, 82
  African American, 982–983, 1064–1065, 1102, 1111–1112, 1135
  Albers, Anni, 1056
  Amaral, Tarsila do, 1070–1071
  Anguissola, Sofonisba, 664
  Baca, Judith F., 1111–1112
  Bateman, Ann, *919*
  Bateman, Hester, *919*
  Beecroft, Vanessa, 1130
  Bonheur, Rosa, 975–976
  Bourgot, 566
  Brandt, Marianne, 1056
  Burrows, Alice, *919*
  Carr, Emily, 1068
  Carriera, Rosalba, 911–912
  Cassatt, Mary, 988, 991
  Chicago, Judy, 1099, 1100, 1101
  Christine de Pizan, 531
  Claudel, Camille, 1003, 1004
  Colter, Mary, 1048
  Cooke, Elizabeth, *919*
  Delaunay-Terk, Sonia, 1031, 1032, 1033
  Dunn, Dorothy, 853
  Ende, 434, 566
  Fontana, Lavinia, 664
  Frankenthaler, Helen, 1077, 1079
  Gentileschi, Artemisia, 725–726
  Girodet-Trioson, Anne-Louise, 936
  Goncharova, Natalia, 1034
  Greek, 146, 148
  Guda, 488, 566
  Guerrilla Girls, 1108
  Hepworth, Barbara, 1060
  Hesse, Eva, 1097
  Hildegard of Bingen, 487
  Höch, Hannah, 1039
  Jumbo, Julia, 835
  Kauffmann, Angelica, 913, 924, 925, 926
  Kihara, Shigeyuki, 877
  Kollwitz, Käthe, 1028
  Krasner, Lee, 1077
  Labille-Guiard, Adélaïde, 936–937
  Lady Murasaki, 363, 367
  Lewis, Edmonia, 982–983
  Leyster, Judith, 744–745
  Lin, Maya, 1114
  Martinez, Maria Montoya, 852–853
  medieval, 566
  Mehretu, Julie, 900–901
  Mendieta, Ana, 1101
  Merian, Anna Maria Sibylla, 756
  Modersohn-Becker, Paula, 1028
  Montbaston, Jeanne de, 566
  Morisot, Berthe, 978, 984, 988–989
  Morisot, Edma, 988
  Morley, Elizabeth, *919*
  Moser, Mary, 924
  Mukhina, Vera, 1051
  Murasaki, Lady, 817
  Near East, 43
  Neshat, Shirin, 1121
  O'Keeffe, Georgia, 1042–1043
  Oppenheim, Meret, 1058
  Peeters, Clara, xxxvi, 741–742
  Peláez, Amelia, 1071
  prehistoric, 7
  Properzia de' Rossi, 654
  quiltmakers, xxvii–xxix, 1111
  Renaissance, 566, 632
  Ringgold, Faith, 1111
  Roman, 159
  Ruysch, Rachel, 754, 755
  Saar, Betye, 1102